CITYSCAPES

COLUMBIA HISTORY OF URBAN LIFE SERIES

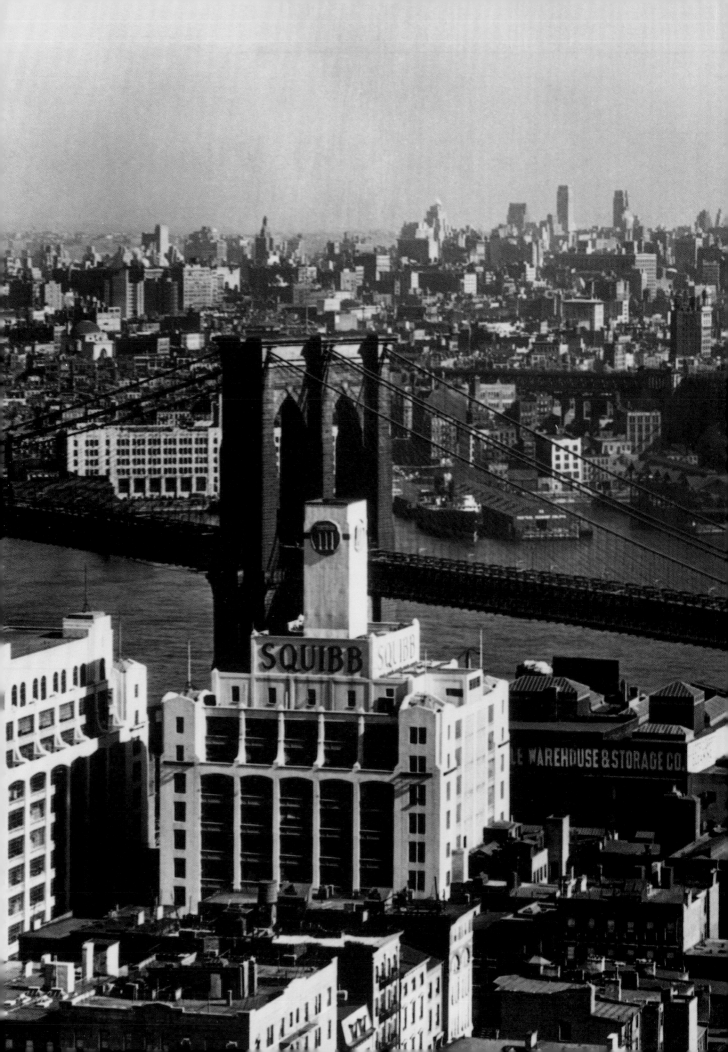

A HISTORY OF NEW YORK IN IMAGES

CITYSCAPES

HOWARD B. ROCK AND DEBORAH DASH MOORE

WITH THE ASSISTANCE OF DAVID LOBENSTINE

COLUMBIA UNIVERSITY PRESS

NEW YORK

Columbia University Press
Publishers Since 1893
New York Chichester, West Sussex

Copyright © 2001 Columbia University Press

Published with the cooperation of the Museum of the
City of New York, New-York Historical Society, and New York Public Library.

Title page photograph, pp.ii–iii: Samuel Gottscho, *View from Roof of Saint George Hotel*.
Photograph, p.vi: Lee Sievan, *Movie Posters and Wash Lines, 1940s*.
Photograph, p.x: Traffic at Broadway and Duane, c.1870.

Library of Congress Cataloging-in-Publication Data
Rock, Howard B., 1944–
Cityscapes : a history of New York in images / Howard B. Rock and Deborah Dash Moore.
p.cm. — (Columbia history of urban life series)
Includes bibliographical references and index.
ISBN 0–231–10624–6 (acid-free paper)
1. New York (N.Y.)—History—Pictorial works. I. Moore, Deborah Dash, 1946– .
II. Title. III. Columbia history of urban life.
F128.37 .R6 2001
974.7'1—dc21 00-047546

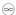

Casebound editions of Columbia University Press books are printed on permanent and durable acid-free paper

Book design by Yolanda Cuomo with Kristi Norgaard / NYC

Printed in China

c 10 9 8 7 6 5 4 3 2 1

COLUMBIA HISTORY OF URBAN LIFE SERIES

The Columbia History of Urban Life, Kenneth T. Jackson, General Editor

Deborah Dash Moore, *At Home in America: Second Generation New York Jews* — 1981

Edward K. Spann, *The New Metropolis: New York City, 1840–1857* — 1981

Matthew Edel, Elliott D. Sclar, and Daniel Luria, *Shaky Palaces: Homeownership and Social Mobility in Boston's Suburbanization* — 1984

Steven J. Ross, *Workers on the Edge: Work, Leisure, and Politics in Industrializing Cincinnati, 1788–1890* — 1985

Andrew Lees, *Cities Perceived: Urban Society in European and American Thought, 1820–1940* — 1985

R. J. R. Kirkby, *Urbanization in China: Town and Country in a Developing Economy, 1949–2000 A.D.* — 1985

Judith Ann Trolander, *Professionalism and Social Change: From the Settlement House Movement to Neighborhood Centers, 1886 to the Present* — 1987

Marc A. Weiss, *The Rise of the Community Builders:The American Real Estate Industry and Urban Land Planning* — 1987

Jacqueline Leavitt and Susan Saegert, *From Abandonment to Hope: Community-Households in Harlem* — 1990

Richard Plunz, *A History of Housing in New York City: Dwelling Type and Social Change in the American Metropolis* — 1990

David Hamer, *New Towns in the New World: Images and Perceptions of the Nineteenth-Century Urban Frontier* — 1990

Andrew Heinze, *Adapting to Abundance: Jewish Immigrants, Mass Consumption, and the Search for American Identity* — 1990

Chris McNickle, *To Be Mayor of New York: Ethnic Politics in the City* — 1993

Clay McShane, *Down the Asphalt Path: The Automobile and the American City* — 1994

Clarence Taylor, *The Black Churches of Brooklyn* — 1994

Frederick Binder and David Reimers, *"All the Nations Under Heaven": A Racial and Ethnic History of New York City* — 1995

Clarence Taylor, *Knocking at Our Own Door: Milton A. Galamison and the Struggle to Integrate New York City Schools* — 1997

Andrew S. Dolkart, *Morningside Heights: A History of Its Architecture and Development* — 1998

Jared N. Day, *Urban Castles: Tenement Housing and Landlord Activism in New York City, 1890–1943* — 1999

Craig Steven Wilder, *A Covenant with Color: Race and Social Power in Brooklyn* — 2000

For my father, Manuel Rock,
who has never ceased to inspire a love of learning
and
my beloved out-of-towner, MacDonald Moore,
who became a consummate
New Yorker and taught me how to see the city anew

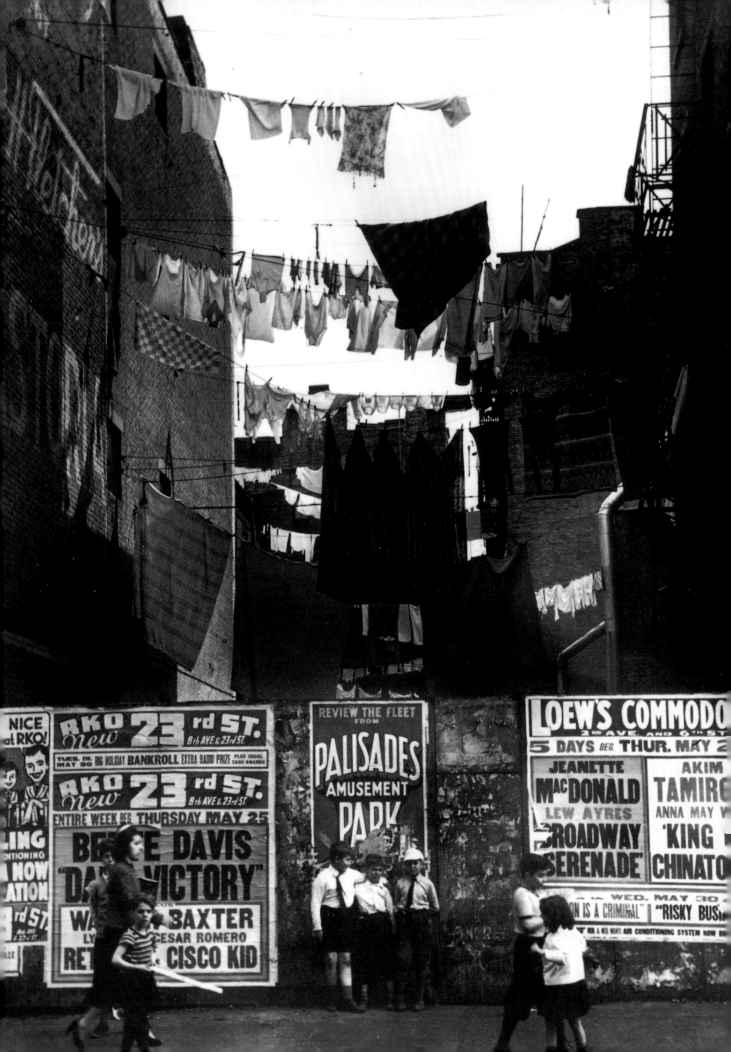

CONTENTS

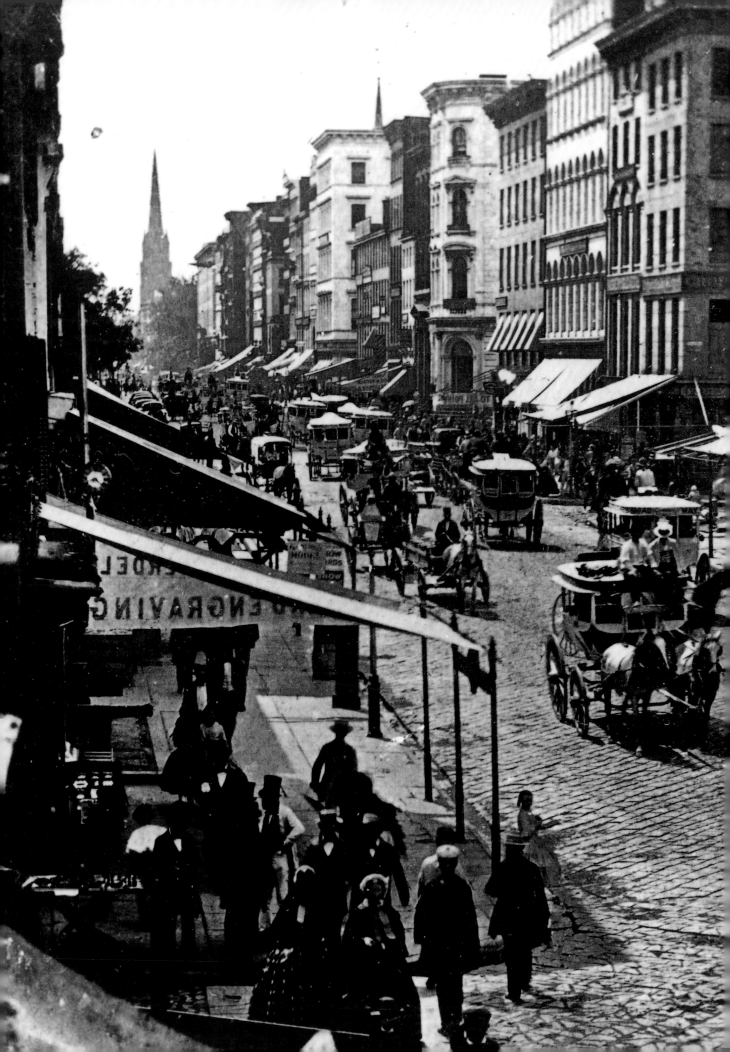

ACKNOWLEDGMENTS

All books involve collaboration, this book, perhaps more than most: we are deeply indebted to more individuals than we can name. New York City has inspired artists and photographers almost since its inception. Without the desire to record their impressions, this book could not have been conceived. Although the source of each image is listed at the back of the book, we want particularly to express our gratitude to the numerous photographers who shared their images of New York City with us, often inviting us into their homes and studios, and to the city's great libraries, museums, and historical societies that maintain extensive collections recording the changing face of life in New York. In particular we must single out Wayne Furman of Special Collections at the New York Public Library; Peter Simmons, Associate Director of the Museum of the City of New York; and Nicole Wells, head of rights and reproductions at the New-York Historical Society. They all generously supported this book.

The book emerged from a reunion of old college classmates, long out of touch, who discovered that they shared a common enthusiasm for the history of New York City and the ways it had been pictured in the past. Inspired initially to revisit John Kouwenhoven's classic, *The Columbia Historical Portrait of New York*, we soon recognized how much the understanding of the city's history had developed since 1953. The book took shape as a joint effort, with Howard Rock handling the historical material from 1623 to 1884 and Deborah Dash Moore tackling the more contemporary period. We agreed to incorporate as much of the new scholarship as feasible, paying attention to issues of race, gender, and ethnicity. Our aesthetic sensibilities diverged. Howard Rock particularly admires the etchings, lithographs, and drawings popular in nineteenth-century periodicals. Deborah Dash Moore prizes the power of photographs to represent the city.

There are many New York Cities. To represent them vibrantly, coherently, and equitably is an immense challenge. These stories of telling images could not have been presented without the assistance of many fine librarians and archivists. At the New York Public Library, Radames Suarez was always helpful in making certain that orders for prints were accurate and filled correctly, while Sharon Frost handled the many requests for photographs with care and diligence. The knowledgeable staff at the Museum of the City of New York, especially Barbara Buff, Elizabeth Ellis, Eileen Kennedy Morales, and Deborah Waters, gave generously of their time and knowledge of the museum's vast collections. Jamie Brogan assembled extensive information on permissions that often led to

rewarding encounters with individual photographers, and Anne Easterling handled fulfillment. At the New-York Historical Society, Wendy Shadwell, the experienced head of the Map and Print Room and an expert on New York in her own right, was a great asset, as was Holly Hinman, who hunted down images that were often difficult to locate.

We were fortunate to tackle research on the twentieth century with the superb assistance of David Lobenstine. His youthful perspectives as well as his research skills proved invaluable. Chosen as a Vassar Ford Scholar for the summer of 1997, David plunged into the difficulties of locating, viewing, and assembling photographs of New York City in the twentieth century. He rapidly learned the etiquette of archival research and charmed most archivists with his forthright respect and excellent research methods. Although he had grown up in the city as had I (D. D. M.), he knew a very different place, and his perspectives—from his surprise that the World Trade Towers were built only in the 1970s (they had always been there to his memory) to his ignorance of frozen custard (a term that was not in his vocabulary)—reminded that author of what was part of New York's history. A second summer of research expanded not only into editorial work for us, as David read and commented on the text of chapters 4 through 6, but into a career. Then in the summer of 1999, another Vassar Ford Scholar, Rachel Weinstein, helped with the important details of preparing and labeling the actual photographs for submission to Columbia University Press. We are grateful for their hard work, enthusiasm, and dedication, which allowed us to complete researching and writing within the confines of an academic's schedule.

Although the New York Public Library, Museum of the City of New York, and New-York Historical Society provided the bulk of the images in the book, the collections of a host of other institutions complemented the big three. In Brooklyn, the Brooklyn Museum of Art's Division of Prints and Photographs, guided with skill by Barbara Millstein, and the print collection at the Brooklyn Public Library provided vital images of the borough and former city. Ms. Millstein also generously introduced us to the stunning work of Breading Way and George Brainerd and provided introductions to Arthur Leipzig and Vivian Cherry. Jennifer Noonan and Dara Sicherman at the Brooklyn Museum helped locate individual photographers, and Ruth Janson assisted with permissions. In Queens, the LaGuardia and Wagner Archives of LaGuardia Community College, CUNY, headed by the indefatigable Richard K. Lieberman, was a valuable source of images on the borough. Robert Dishon, archivist, proved both efficient and helpful. At the Schomburg Center for Research in Black Culture, Anthony Toussaint assisted in locating familiar and new images of Harlem. Pedro Juan Hernandez at the Centro de Estudios Puertorriqueños at Hunter College, CUNY, introduced us to the Justo A. Martí Photographic Collection, which documents Puerto Rican life throughout the city. At Millbank Memorial Library, Teachers College, Columbia University, David Ment, head of Special Collections, quickly produced some excellent images of public schools, and Bette Weneck, head librarian, agreed to waive fees. Unable to travel to Louisville to view the extensive photographic collection assembled by Roy Stryker for Standard Oil (New Jersey) in the 1940s, we relied on the expertise of Susan Knoer, at Special Collections: Photographic Archives of the Ekstrom Library, University of Louisville, with excellent results. An equally rich but utterly different collection of fine photographs awaited us at the Metropolitan Museum of Art's Department of Drawings and Prints, which we studied under the careful guidance of Heather Lemonedes.

Over a decade ago, Howard Greenberg rediscovered the photographs and photographers of the New York Photo League. His enthusiasm and passion for these images of New York in the 1930s, 1940s, and 1950s inspired others. Although he runs an eponymous gallery devoted to exhibiting and selling photographs and not a museum or archive, he graciously helped us spend several long days viewing his extensive collection. Margit Erb at the Howard Greenberg Gallery took care of our many requests with speed. Mary Early at Hemphill Fine Arts gallery in Washington, D.C., displayed a similar helpful enthusiasm for the photographs of Godfrey Frankel, as Robert K. Newman at the Old Print Shop did for the prints of Martin Lewis. Sally Forbes at the Beaux Arts Alliance shared her love and knowledge of Esther Bubley's photographs.

At Florida International University, George Valcarce of the photography department spent many hours with us working on images. We are very grateful to him. So, too, are we indebted to FIU for a sabbatical and to the head of Sponsored Research, Thomas Breslin, who provided two substantial grants. Vassar College supported us not only through its Ford Scholar program of funded summer grants but also through a research grant-in-aid to help cover costs of acquiring photographs. The help of our colleagues at Vassar, who never doubted that a professor of religion could write a visual history of New York City, is much appreciated. Pamela Brumberg and William Lee Frost at the Lucius N. Littauer Foundation understood the needs of our enterprise. We are grateful to the foundation for its fulsome support and encouragement.

A very special thanks to Ted (Edwin G.) Burrows, coauthor, with Mike Wallace, of *Gotham: A History of New York City to 1898*, the Pulitzer prize–winning study that will rank with the very finest of books on urban history published in the twentieth century. Ted was kind enough to send us many chapters prior to publication, chapters that were of considerable assistance in envisioning the patterns of the city's growth. I (H. R.) would like to thank many scholars. Some helped locate images; among them, Elizabeth Blackmar, Hasia Diner, Mona Domosh, Eli Faber, Thomas J. Frusciano, Timothy J. Gilfoyle, John Grafton, Marilynn Wood Hill, Graham Hodges, Mary Lui, Marilyn H. Petit, Kenneth Scherzer, Richard B. Stott, Wendell Tripp, and David Voorhees. John Adler, publisher of Harpweek, the invaluable collection of *Harper's Weekly*, now on the Web, gave important assistance. My sister, Marcia Rock, a skilled documentary producer, generously loaned us many of her images. I hope to collaborate with her in the not-too-distant future. My mentor and friend, Carl E. Prince, has always been there to guide me when I needed his counsel. So, too, has Patricia Bonomi; I was her first teaching assistant, and she is still helping. Finally, I want to acknowledge Hope Wine, who provided support over the long haul.

We are grateful, as well, for the opportunity to present material from the book at the Urban History Seminar of the Chicago Historical Society and appreciate the interest of Michael Ebner, who invited us, as well as the incisive comments of those scholars who attended the seminar. Deborah Dash Moore values several conversations with Arthur Goren, David Hammack, David Nasaw, and Moses Rischin on aspects of twentieth-century New York City history. The editorial comments of Andrew Bush and MacDonald Moore materially improved the text of the prologue, helping me at an important moment.

At Columbia University Press Kate Wittenberg, senior executive editor, has sustained her support of and devotion to this project from its earliest inception to its fulfillment. Such constancy is a rare attribute in the world of publishing, and we appreciate her twin gifts of patience and enthusiasm for such a complicated project. Her assistant, Jim Burger, succored the two cartons of prints and photographs during a complicated relocation of the press, making sure nothing was lost. Linda Secondari assumed responsibility for finding the right designer for this book, a critical task. Sarah St. Onge edited the book with care and precision, and Ronald Harris took charge of managing the complicated job of coordinating image and text. We are grateful to all of them.

This book carries two dedications, by Howard Rock and Deborah Dash Moore, respectively:

This book is dedicated to my father, who instilled in me a love of learning. He is never happier than when sitting with his books and personal research. My wife, Ellen, has always encouraged me in my work, and I owe her a great deal. My sons, David and Daniel, both now headed for careers based on writing and the arts and letters will, I hope, appreciate this book.

Howard B. Rock, Miami, July 2000

Our two sons, Mordecai and Mikhael, have always been enthusiastic supporters of their mother's projects, and this one is no exception. Both love the city and revel in its diversity and challenge. That they have chosen to live in the city brings me great joy. I have dedicated this book to my out-of-towner husband, MacDonald. Like many New Yorkers, he discovered the city as a young man, fell in love with its pavements and canyons, and constantly carried a camera, the better to see it.

Deborah Dash Moore, New York City, July 2000

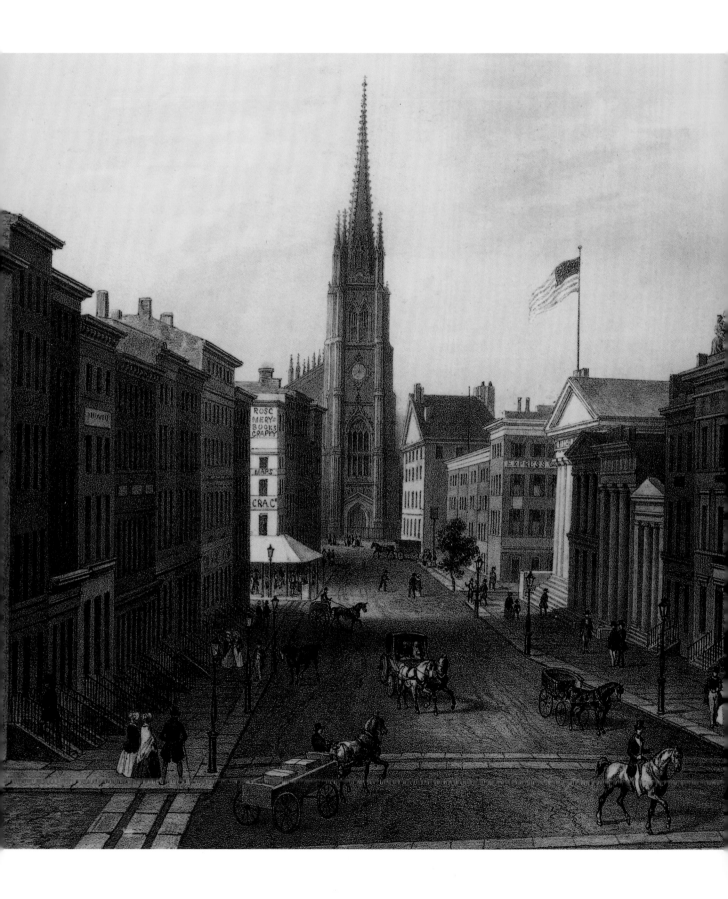

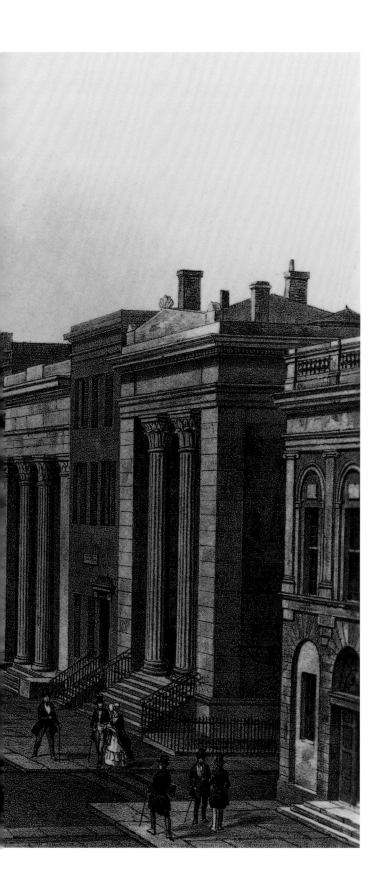

PROLOGUE

As Gotham became
the economic capital of the United States, Wall Street
attained iconic national standing. Images of the street
multiplied from the beginning of the nineteenth cen-
tury, when New York merchants, bankers, and specu-
lators, whose businesses centered on and around that
street, rose to prominence. Americans credited the
nation's financial leaders with responsibility for the
movement of large amounts of capital, the rise and fall
of significant fortunes, and the welfare of Americans of
all walks of life.

Examining a lithographic reproduction from the
mid-nineteenth century displays several themes. The
lithograph, made in 1850 by August Koellner, por-
trays Wall Street as a regal avenue, even though it
shows commerce on a human scale, with wagons
plodding through the streets (P.1). Largely rebuilt
after the great fire of 1835, many of Wall Street's new
buildings were constructed in the Greek Revival style,
with columns and classical features that gave the
street a sense of majesty and power. A sparkling new
Trinity Church—the tallest and most significant

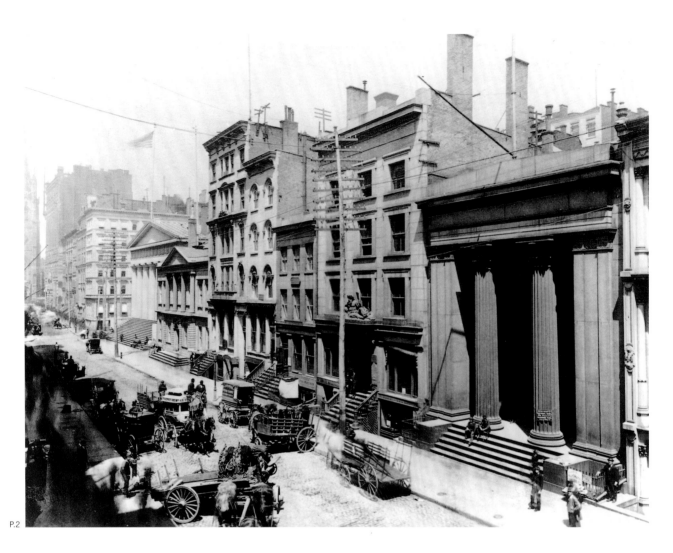

P.2

structure—watches over the street from its perch at the corner of Broadway. At the far right is the Bank of America, while two doors down stands the Merchant's Bank boasting similar classical pomp. At the far left the Insurance Building houses various companies. Over all flies the flag of the U.S. Customs House.

By contrast, nineteenth-century photographs of Wall Street, such as this one from 1882, reveal a rather narrow and drab scene (P.2). Is the photograph more truthful than the lithographic image? Not necessarily, for the lithographs reflect New Yorkers' personal perspective. For them, Wall Street was a magnificent, sometimes frightening forum, the setting for panics as well as gain. Many artists drew illustrations of crowded streets filled with anxious brokers and merchants who often appear prosperous, if not always in control.

In the photography of the twentieth century, after the erection of skyscrapers, the perspective shifts. Berenice Abbott views Wall Street from an aerial vantage point (P.3). People have nearly disappeared, seen only as specks on the distant streets at the bottom of the canyon. Trinity

Church, dwarfed by the skyscrapers, has vanished from view. Men and women may have created Wall Street, but it has lost any human scale. Skyscrapers dominate what little space remains. People move about in granite chasms; if not mastered, they are no longer the masters.

New York City inscribed skyscrapers as emblems of the modern metropolis. Yet the romantic possibilities of skyscrapers required space and distance for perspective as well as distinctiveness. Perhaps the first skyscraper to capture the imaginations of New Yorkers stood well north of lower Manhattan at the Twenty-third Street intersection of Broadway and Fifth Avenue, a popular shopping site. The Fuller Flatiron Building rose in an unbroken wall from the street on a triangular plot of land. At its apex, visible from Madison Square to the north, the building was only six feet wide. Daniel Burnham designed the twenty-three

P.1. August Koellner, *Wall Street*. **P.2.** Wall Street, 1882.
P.3. Berenice Abbott, Wall Street.

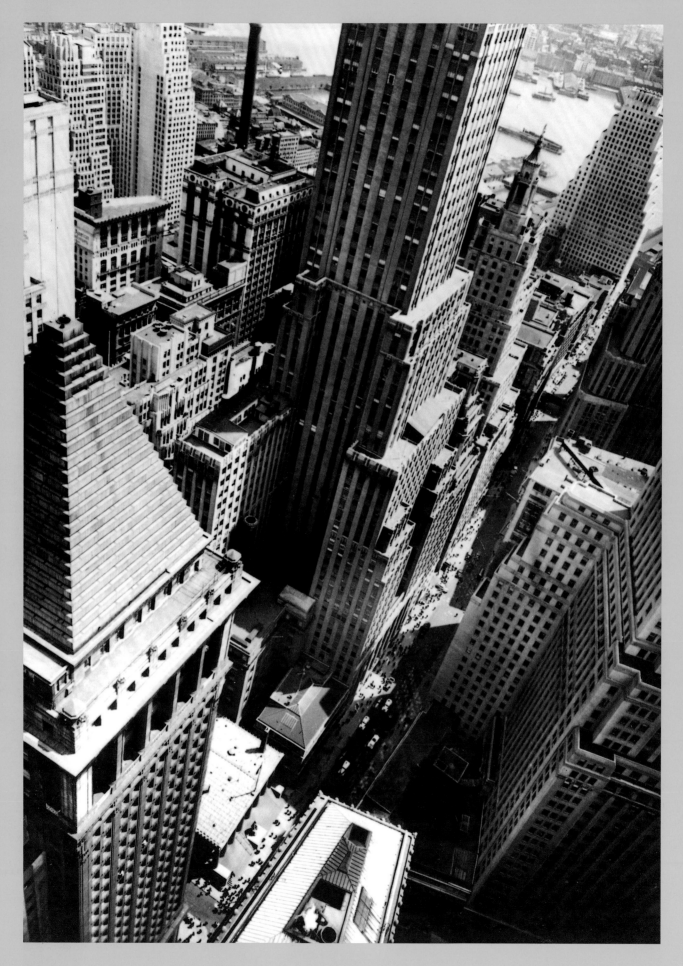

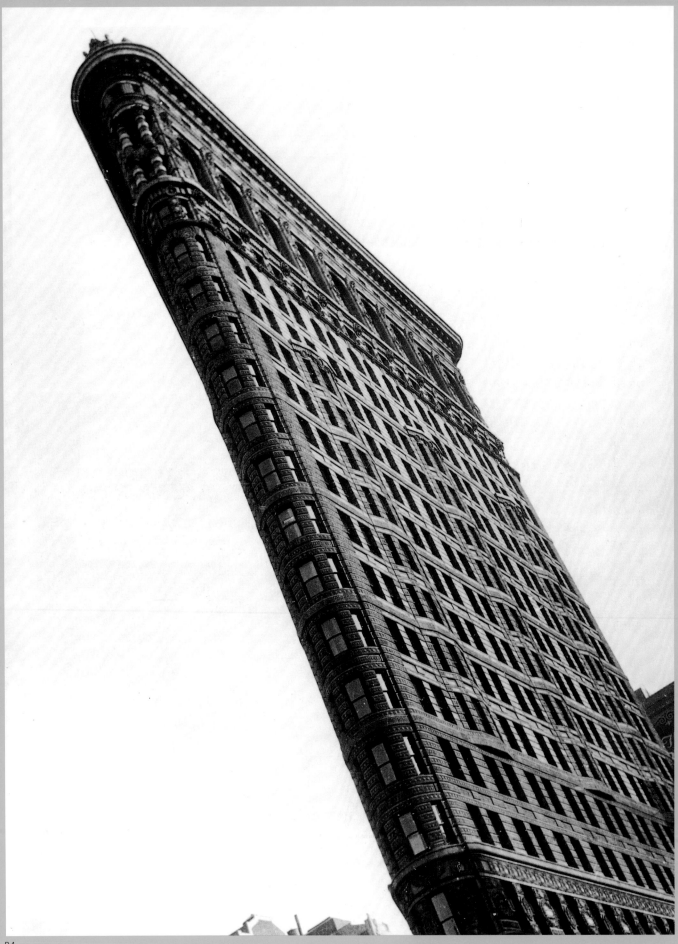

story tower in 1903, and it immediately excited observers, who compared it to the prow of an enormous steel ship.

Standing so far from city hall and the concentration of tall buildings, the Flatiron Building expressed the triumphal march of urban form uptown. The 1905 photograph of the Detroit Publishing Company documents civic pride (P.5). In this image, the building dominates the intersection, rising well above its neighbors, which included many fashionable stores along Broadway. The flow of traffic on trolleys as well as the movement of pedestrians accentuates the building's scale and grace. Although employing the halftone process, the photograph suggests the clarity of etching, inviting comparison with popular nineteenth-century portraits of the city.

Before skyscrapers could become New York's signature urban gesture, they needed to be clothed in an aura. If the Flatiron's placement made it a visible object of urban progress, Edward Steichen's photograph transformed it into an almost mystical feature of the urban landscape (P.6). The delicate trees in the foreground and the light sky behind integrate the building into the city. Using new, faster lens technology, Steichen took the photograph at dusk shortly after the building was finished. The absence of the peak accentuates the building's height. Steichen's image expresses romance, lyricism. The hack drivers waiting for customers convey a sense of human scale. The glow of street lights punctuates the growing darkness, and the city seems to float in silence in the shimmer of light reflected on the wet pavement. With its smooth and subtle tones, the photograph shares more with painting than etching. Steichen's vision fashioned the Flatiron Building into a New York icon.

A quarter century later the Bauhaus architect Walter Gropius photographed the Flatiron Building from a perspective that emphasizes its modernity as an isolated tower (P.4). The building appears to thrust into the sky at an angle, the narrow curved apex soaring upward into space. Gropius's point of view eliminates the street, park, people, vehicles, even almost all the other buildings. This new perspective on a romantic urban building strips it of its ethereal lyricism. The vision, however, celebrates its character as a changing monument at a time when its neighborhood had declined from elegant commerce into garment manufacture. By portraying the Flatiron

Building in abstracted isolation, Gropius suggests that it is a monument to change that typifies the urban environment. It suggests, too, that we can no longer know New York apart from the history of its images.

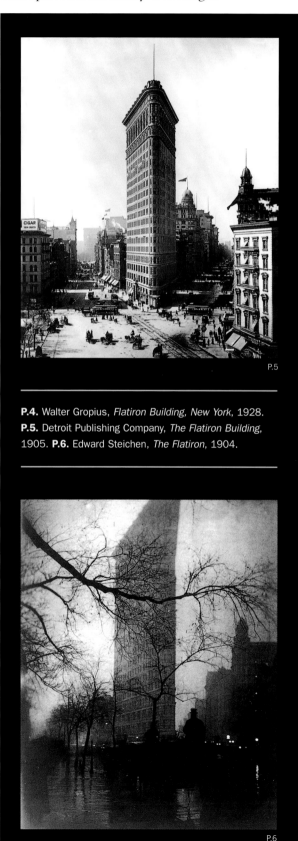

P.5

P.4. Walter Gropius, *Flatiron Building, New York*, 1928. **P.5.** Detroit Publishing Company, *The Flatiron Building*, 1905. **P.6.** Edward Steichen, *The Flatiron*, 1904.

P.6

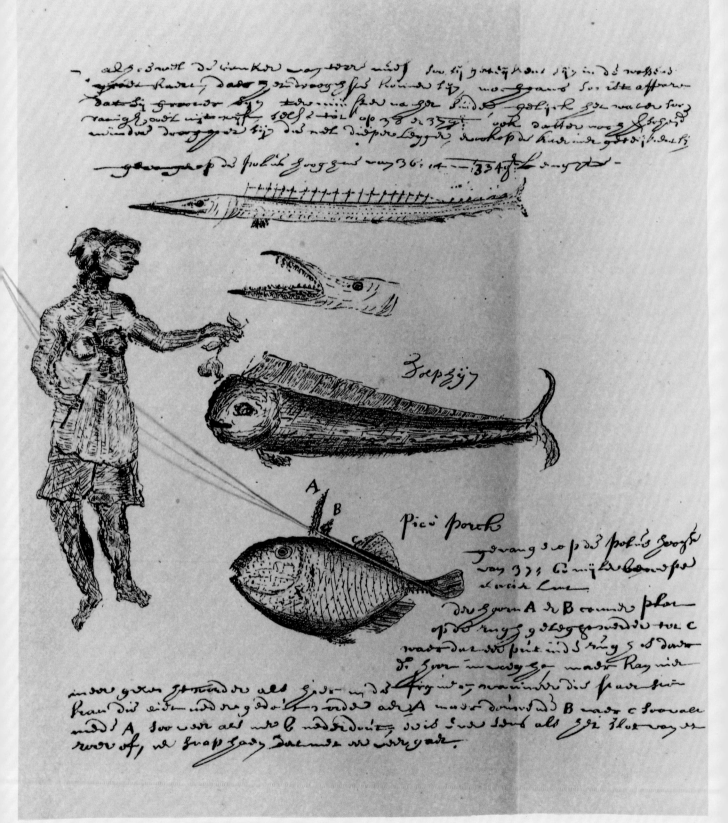

1

1623–1783

New York City was born New Amsterdam in the Dutch golden age. Its character of entrepreneurial excellence and cosmopolitan population has endured for nearly four hundred years. Dutch merchants of the seventeenth century established a mercantile empire stretching into the East Indies and the Southern and Northern hemispheres of the Americas. These merchants, the cream of Amsterdam society, created a culture that produced great art and architecture and a princely lifestyle. The visions of Amsterdam, the headquarters of the Dutch West India Company, the elegant Stadthuys, the spotless houses, graceful furniture, and exquisite dress and posture of the elite presented in the works of such great Dutch artists as Rembrandt and Vermeer today gives us a glimpse of this culture's majesty.

The colony of New Netherlands was founded in the search for empire by the Dutch West India Company following the explorations of Henry Hudson and the enterprise of several private traders in the Hudson River. After intense competition the Dutch West India Company received a charter that granted it a monopoly and the governance of the new colony.

Trade stood at the center of the Dutch interest in North America, where the chief commodity was fur. The first settlement, dating from 1623, was Fort Orange, near the present Albany. The first permanent settlement on Manhattan was established in 1626, when Director Peter Minuit purchased the island from the Indians for goods valued at sixty guilders ($24). Intending the island to serve as a watering spot for ships as well as the farms and livestock necessary to supply his colony with food, Minuit imported cattle—dogs and rabbits already roamed the island freely—and designed a fort to protect the simple settlement. In the 1620s, when Fort Orange proved indefensible from Indians, New Amsterdam became the only viable settlement in New York, with about three hundred inhabitants.

1.2

When the Dutch settled in what is today's New York, they encountered a strong and vibrant Indian community known as the Lenape, one group of more than a dozen settlements between modern-day Connecticut and New Jersey. About fifteen thousand Lenape lived within the current city boundaries, speaking Munsee, a Delaware dialect. Rather than congregating in large organized tribes, they resided in small groups that moved from campsite to campsite. Numerous Indian trails ran through Manhattan, including one from the Battery to Inwood, along the spine of the island. Known encampments on Manhattan were at City Hall Park and on the Hudson at Gansevoort Street.

The Lenape moved seasonally. Possessing only light tools and weapons, including the bow and arrow, they grew maize, melons, and squash on fields made more arable by the slash-and-burn technique and hunted deer, turkeys, and wildfowl. They lived in longhouses made of bark and clay that could be easily constructed or dismantled. The clans were matrilineal, with work divided along gender lines: women reared the children and planted, and men hunted and fished. By the early seventeenth century the men had become involved in the European fur trade and had adapted European tools.

There is one extant picture of a Lenape, a drawing by Jaspar Danckaerts of a woman in Brooklyn, dating from around 1680 (1.1). The picture also shows some of the

fish observant visitors found. And a representation of a Lenape longhouse can be found in a book published early in the twentieth century, Reginald Bolton's *Indian Life of Long Ago in the City of New York*, which incorporated drawings of the homes and tools of the Lenape (1.2).

Ultimately, the Lenape were doomed, overwhelmed by the powerful Iroquois confederation to their north and European hostility that resulted in harsh and debilitating wars during the first half of the seventeenth century.

The Dutch engraver Joost Hartgers created the earliest view of the settlement of New Amsterdam (1.3). There is some question as to how familiar he actually was with his subject, as the fort in his engraving has five bastions (as the original plans projected), while only four were actually built. Still, the number of dwellings and the two mills (one for wood and the other for grain) accord with most descriptions. The image is reversed, however: the fort was on the Hudson and not the East River.

New Amsterdam at this stage largely consisted of the fort, primitive and decrepit as it was, and the harbor. The large Dutch company ships and the Indians in their canoes indicate that the settlement's focus was trade, with the fort providing protection. The small houses scattered around the fort are just primitive wooden huts built of tree bark, in contrast to the company storehouse, which is made of stone. This was not a city but a trading site, a Dutch outpost (a seven-week voyage via the West

Indies) at the far reaches of the empire. Indeed, the intention was that after the fort was constructed, all the inhabitants would move inside, secure from sudden attack. But the fort, built only of earthenwork, crumbled in less than two years and, while repaired, was never a strong defense. A new fort was not completed until 1635.

In this primitive settlement, there was little but military life: no culture, architecture, literacy. Existence was very stark. Inhabitants farmed their homesteads on the island or worked as tradesmen, but the emphasis was on trade, mainly in furs. A sample ship's cargo in this era included around seven thousand beaver skins, seven hundred otter skins, fifty mink, and thirty-five wild cat, as well as oak, timber, and hickory.

Internal dissension marked New Amsterdam's early years, with petitions complaining of miscreant directors frequently flowing to Holland. The first director, Peter Minuit, was replaced in 1632 by Bastien Krol. A year later Wouter Van Twiller took over, and he gave way in 1638 to the equally inept Indian hater Willem Kieft. Losing money, the company tried to economize by creating patroonships, large privately owned landed estates whose masters would bring over emigrants and bear all expenses. It also relaxed its monopoly on the fur trade. Manhattan island, however, remained in its domain.

A pen and ink survey of the island executed in 1639 was likely made to itemize for the West Indian Company its various farms or "boueries." It is called the Manatus Map, a name drawn from the inset that reads, "Indication of principal places on the Manatus [Manhattan]" (1.5). (The word *Manatus* may have meant "island of the hills," a reference to the topography.) There is little attention to the village of Manhattan, partly because of the purpose for which the map was created but also because of the agricultural nature of the settlement at this period. There was little coherence to the community; in fact, the earliest known city ordinance was promulgated around the time the map was drawn. While this does not totally prove that urban life was

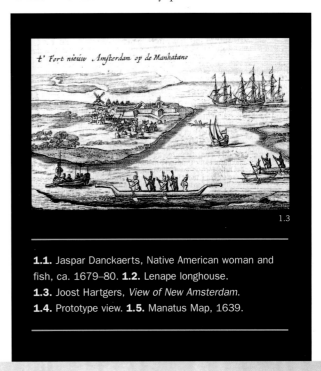

t' Fort nieûw Amsterdam op de Manhatans

1.3

1.1. Jaspar Danckaerts, Native American woman and fish, ca. 1679–80. **1.2.** Lenape longhouse.
1.3. Joost Hartgers, *View of New Amsterdam*.
1.4. Prototype view. **1.5.** Manatus Map, 1639.

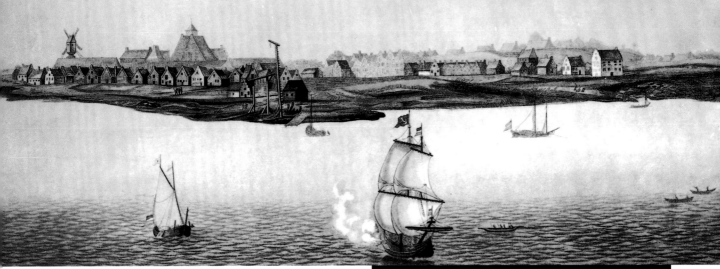

1.4

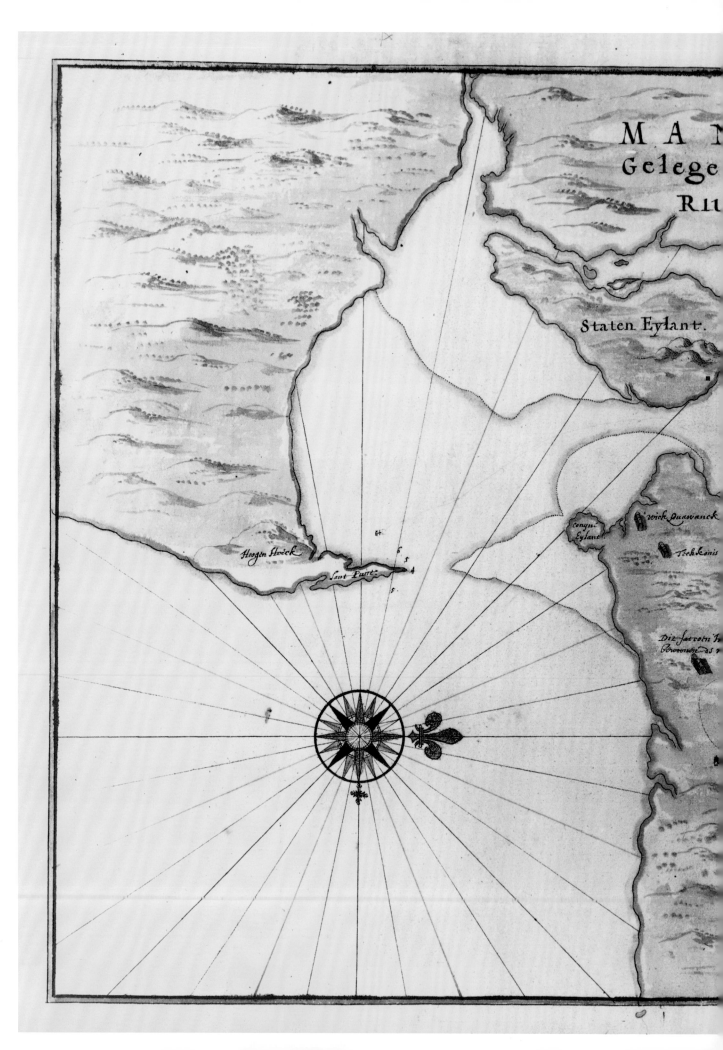

M A N
Gelege
R11

Staten Eylant.

Hoogen Hoeck

Sant Punt

conyni
Eylant

wick Quavanck

Tschkonis

Diz facroti
Bowoonshe as

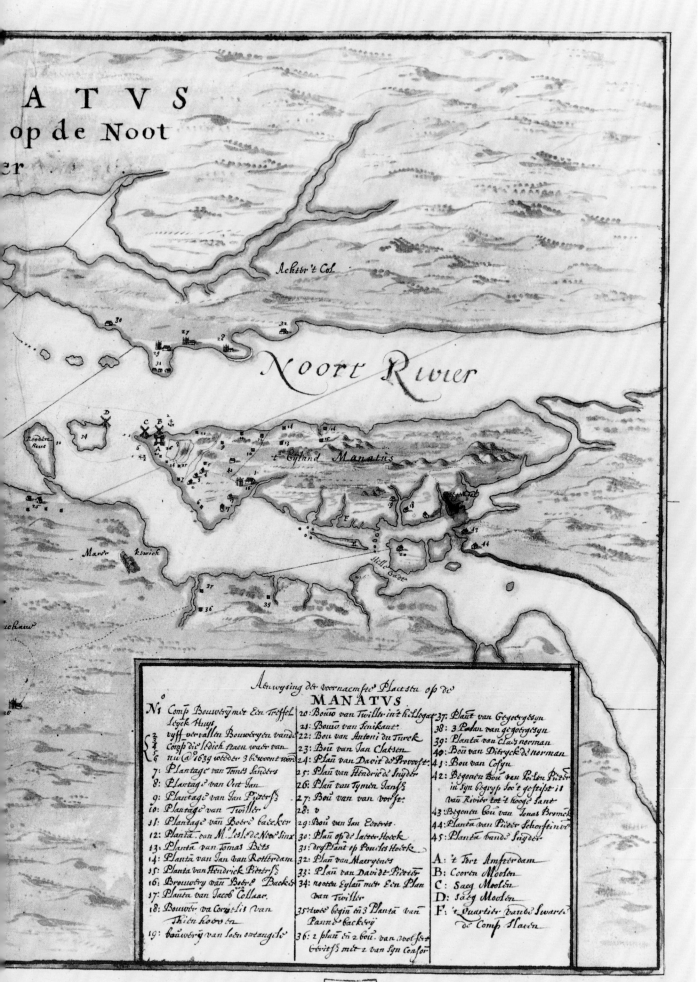

absent, it certainly shows that New Amsterdam was little more than an agricultural settlement and trading post for the important furs assembled at Fort Orange.

Numbers 2 through 5 on the map indicate the companies' farms, which were located along the East River. The other farms belonged to various Dutch settlers, including baker Barent Swart (11) and Danish immigrant Jan Pietersen van Housem (9). Village artisans also had their own farms, among them tailor Hendrick Jansen's on Nut Island (24). Settlement had clearly spread beyond the island, including the new farm of the Dane Jonas Bronck (43) and that of Wolphert Gerritsen van Couwenhoven on Long Island (36). The island's topography is evident here, displaying the heights of upper Manhattan as well as the outlet of the Collect Pond that forms the south side of noted Corlear's Hook, named after Jacob van Corlear (17). Indian longhouses are pictured on Coney Island (Conyné Eylant).

By the early 1650s, the village had prospered. The famed prototype view of 1653, an English watercolor painted after the English occupation but based on an earlier drawing, reveals considerable growth (1.4). But this maturity had not come easily. Poor leadership under Kieft had triggered a vicious Indian war. At its worst, Manhattan was almost deserted: "There are no more than five or six spots inhabited at this date. These are threatened by the Indians every night with fire, and by day with slaughter of people and cattle."[1]

In 1647, a new director, Peter Stuyvesant, arrived and established the first city council. Taxes were collected and new ordinances enacted, particularly regulating the sale of alcohol to both whites and Indians. Stuyvesant ordered landholders to build decent buildings to replace run-down structures. By 1653 new immigrants had arrived, repairs had been made to the fort, a permanent municipal government system was in place that included a court, and a school and seventeen taverns were in operation.

The most notable objects in the prototype view are the fort, whose wall can be seen at the far left; the large double-gabled building inside the fort, which is the church; and the governor's house, which is at the left of the church. Also to the left of the church are the jail and barracks for the Dutch troops. While the fort was in poor condition early in 1653, by the summer it was in good repair. This was the center of the city. It encompassed the largest buildings and the facilities that represented the Dutch state, the Dutch church, and the Dutch West India Company. It was a commercial town, of course. The most striking sights are the crane and "gallows," which was actually either a weigh beam or a signal post. The landing area at the tip of Manhattan was the first market area, where every Saturday goods from the country were unloaded and sold in the open air. The houses, built in Dutch gabled style, belonged to the city residents, many of whom were burghers. Two of the homes in front of the church have been identified, one as belonging to a shoemaker, Cornelis Tenisson, and the other to a sailmaker, Tunis Zeuylmaker. Numbered among the structures to the right of the crane were the important storehouses of the Dutch West India Company. The company remained dominant in the city, controlling the leasing of all lots until 1654, when the burgomasters of the municipal government took over. In the background a haystack is visible, while at the far right is the city tavern, which was converted in 1653 into the Stadt Huys, or city hall. There were in all seventeen taverns and a brewery, probably the third house from the city tavern. City life was often barren, lonely, cold, and primitive. The importance of drink and comradeship in the many public houses cannot be overestimated.

By 1660, New Amsterdam had grown to a full-fledged municipality.

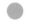

The Dutch West India Company wanted to demonstrate the success of their outpost, so the picture that emerges in the prototype watercolor reveals a well-kept and flourishing settlement.

By 1660, just six years before the English captured the city and all New Netherlands from the Dutch, filling in the gap in their North American holdings, New Amsterdam had grown to a full-fledged municipality. It

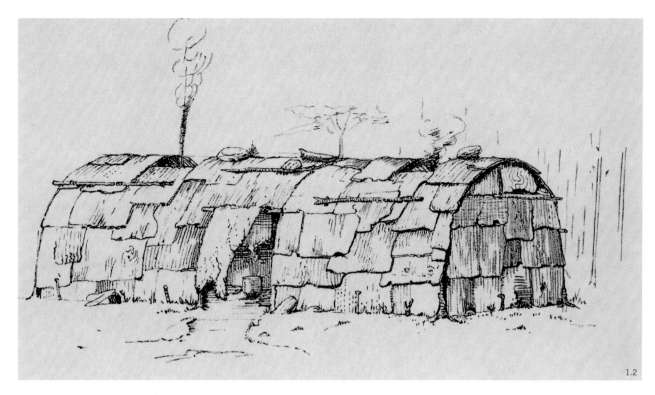

1.2

When the Dutch settled in what is today's New York, they encountered a strong and vibrant Indian community known as the Lenape, one group of more than a dozen settlements between modern-day Connecticut and New Jersey. About fifteen thousand Lenape lived within the current city boundaries, speaking Munsee, a Delaware dialect. Rather than congregating in large organized tribes, they resided in small groups that moved from campsite to campsite. Numerous Indian trails ran through Manhattan, including one from the Battery to Inwood, along the spine of the island. Known encampments on Manhattan were at City Hall Park and on the Hudson at Gansevoort Street.

The Lenape moved seasonally. Possessing only light tools and weapons, including the bow and arrow, they grew maize, melons, and squash on fields made more arable by the slash-and-burn technique and hunted deer, turkeys, and wildfowl. They lived in longhouses made of bark and clay that could be easily constructed or dismantled. The clans were matrilineal, with work divided along gender lines: women reared the children and planted, and men hunted and fished. By the early seventeenth century the men had become involved in the European fur trade and had adapted European tools.

There is one extant picture of a Lenape, a drawing by Jaspar Danckaerts of a woman in Brooklyn, dating from around 1680 (1.1). The picture also shows some of the fish observant visitors found. And a representation of a Lenape longhouse can be found in a book published early in the twentieth century, Reginald Bolton's *Indian Life of Long Ago in the City of New York*, which incorporated drawings of the homes and tools of the Lenape (1.2).

Ultimately, the Lenape were doomed, overwhelmed by the powerful Iroquois confederation to their north and European hostility that resulted in harsh and debilitating wars during the first half of the seventeenth century.

The Dutch engraver Joost Hartgers created the earliest view of the settlement of New Amsterdam (1.3). There is some question as to how familiar he actually was with his subject, as the fort in his engraving has five bastions (as the original plans projected), while only four were actually built. Still, the number of dwellings and the two mills (one for wood and the other for grain) accord with most descriptions. The image is reversed, however: the fort was on the Hudson and not the East River.

New Amsterdam at this stage largely consisted of the fort, primitive and decrepit as it was, and the harbor. The large Dutch company ships and the Indians in their canoes indicate that the settlement's focus was trade, with the fort providing protection. The small houses scattered around the fort are just primitive wooden huts built of tree bark, in contrast to the company storehouse, which is made of stone. This was not a city but a trading site, a Dutch outpost (a seven-week voyage via the West

1

COLONIAL SEAPORT

1623–1783

New York City was born New Amsterdam in the Dutch golden age. Its character of entrepreneurial excellence and cosmopolitan population has endured for nearly four hundred years. Dutch merchants of the seventeenth century established a mercantile empire stretching into the East Indies and the Southern and Northern hemispheres of the Americas. These merchants, the cream of Amsterdam society, created a culture that produced great art and architecture and a princely lifestyle. The visions of Amsterdam, the headquarters of the Dutch West India Company, the elegant Stadthuys, the spotless houses, graceful furniture, and exquisite dress and posture of the elite presented in the works of such great Dutch artists as Rembrandt and Vermeer today gives us a glimpse of this culture's majesty.

The colony of New Netherlands was founded in the search for empire by the Dutch West India Company following the explorations of Henry Hudson and the enterprise of several private traders in the Hudson River. After intense competition the Dutch West India Company received a charter that granted it a monopoly and the governance of the new colony.

Trade stood at the center of the Dutch interest in North America, where the chief commodity was fur. The first settlement, dating from 1623, was Fort Orange, near the present Albany. The first permanent settlement on Manhattan was established in 1626, when Director Peter Minuit purchased the island from the Indians for goods valued at sixty guilders ($24). Intending the island to serve as a watering spot for ships as well as the farms and livestock necessary to supply his colony with food, Minuit imported cattle—dogs and rabbits already roamed the island freely—and designed a fort to protect the simple settlement. In the 1620s, when Fort Orange proved indefensible from Indians, New Amsterdam became the only viable settlement in New York, with about three hundred inhabitants.

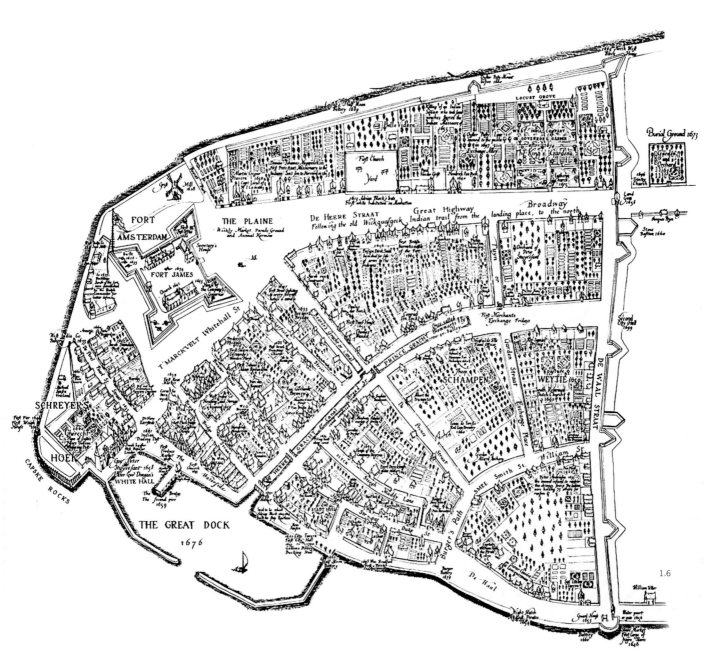

was the entrepôt port for all New Netherlands, including Long Island, the Hudson River patroons, and Fort Orange (Albany). Furs and tobacco were the most significant commodities passing through, but many agricultural products also sailed in and out. The maturing of the municipality is evident in the city records. The city demanded that wooden buildings give way to less flammable stone structures. Regulations for markets increased. The traditional assize governing the price of bread was imposed. Provisions were made for orphans and the growing number of poor. New Amsterdam established two forms of freemanship: "Great Burgher," for merchants, and "Small Burgher," for ordinary craftsmen. The city fathers promulgated sanitation rules that dealt with questions such as whether pigs should be

allowed to wander the streets and privies emptied into the thoroughfares. And to safeguard the city, a new palisade wall was constructed.

In 1660 the city commissioned a survey to find sites for newcomers and determine who owned what and where. While the original plan was lost, a copy has been discovered in the Italian village of Castello on which the Dutch West India Company complained that there were too many open spaces with large plots and gardens.

Judging from the Castello plan and other research, the Holland Society produced a drawing of the town of New Amsterdam in the late 1660s (1.6). The population in

1.6. Holland Society plan.

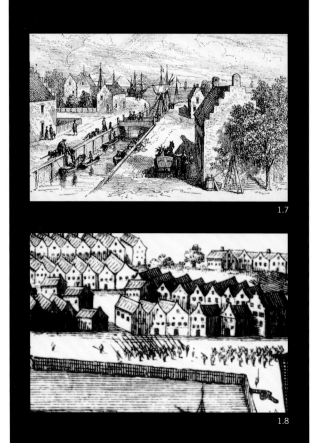

1.7

1.8

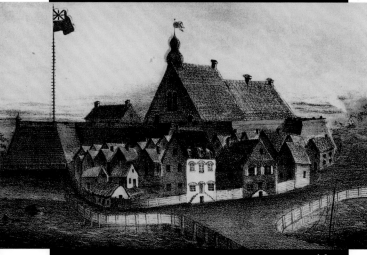

1.9

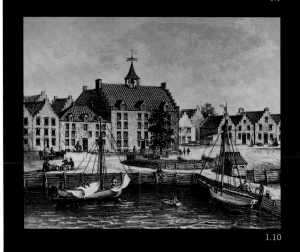

1.10

1660 was 1500, living in 320 houses. A glance at the drawing indicates that most residents built close to the East River, although a number of dwellings had been constructed near the Hudson River and along what would become Broadway. Each of the blocks has extensive gardens and orchards, confirming the Dutch West India Company's observation. The fort, home to a few hundred Dutch soldiers and housing the town's church and the official residence of the company's governor, remains the most prominent feature of the city. Outside is the Marckvelt, where biweekly markets were held.

Schreyers Hoek, Dutch for "Weeper's Point," owes its name to the fact that it served as the place of embarkation for small boats heading into the harbor to link with the large sailing ships anchored there. For many this occasion represented the last time they would see friends and relatives. Here stood the elegant home built by Governor Stuyvesant. Behind his house was the Gherect, or place of justice, which held the gallows and whipping post. Next door was the home of Stuyvesant's brother-in-law, Nicholas Verlett, later bought by Jacob Leisler. Across Pearl Street could be found the home of Jacob Steendam, New Amsterdam's first poet, and Trijin Jonas, the city's first midwife, as well as the dwelling of Annetje Bogardus, the wealthy widow of Minister Evardus Bogardus.

Directly north of Schreyers Hoek, along the waterfront, lived Dr. Hans Kierstide (known locally as "Doctor Hans"). Arriving from Germany as a refugee, Doctor Hans began mainly by tending to the company's soldiers but soon went into private practice and became quite wealthy. The nearby street of eminent burgomaster Cornelius Steenwyck contained a bakeshop, a hatter's shop, two taverns, and two warehouses. Directly across Bridge Street were the Dutch West India Company's warehouses, along with the homes of a number of prominent citizens such as Hendrik Kip and Jane Holmes, widow of one of the town's first English settlers, George Holmes. The city's first hospital was also constructed there in 1659.

The city's elementary or "Trivial" school could be found to the east in the Schampen block. The city's *Schout* (sheriff and prosecutor) and *Fiscal* (secretary),

Nicasius de Sille, lived here. The Wheytie block, originally a grant to Dominie Samuel Drisius, remained undeveloped. East of that, the triangular block at the northeast of the town belonged to the wealthy merchant Goovert Loockermans; later it was owned by Captain Kidd. There stood the house of chimney sweep Peter Andrison, whom the company refused to ransom when he was captured by Indians.

Moving back toward the south along the East River, the section bordering the newly built canal, or Heere Gracht, contained the Stadt Huys, or city hall, originally the city tavern. Here lived the most prominent Jewish merchant in Manhattan, Abraham de Lucena, who occupied the house and warehouse of Rutger Jacobsen. Four taverns also could be found there. In 1643 the Dutch West India Company constructed barracks for their slaves in this section.

While few period drawings remain, a number of nineteenth-century illustrations, likely based on earlier models, offer a glimpse inside the city. Perhaps the most impressive of the structures outside the fort was the Stadt Huys, built in 1642 by the West India Company as the city tavern and depicted here in an 1867 engraving fashioned on an earlier original (1.10). During conflicts with the Indians it formed a place of refuge. Financial difficulties prompted the company to deed it to the city in 1653, when it came to be used for city government. An impressive building with Dutch gable architecture, much too big for strictly municipal proceedings, it also housed lodgers and city prisoners. Public auctions took place on its steps. The Stadt Huys symbolized the evolution of municipal government from complete control

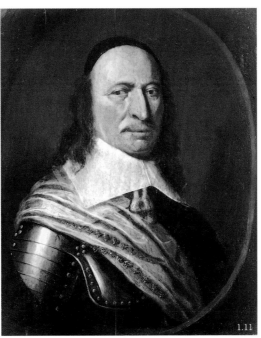

1.11

New Amsterdam was
far from a primitive outpost.

by the company to increasing power wielded by the city's burghers. Director Stuyvesant struggled with city elders over taxes, expenditures, and defense and increasingly yielded to the elected council. By the end of Dutch rule Stuyvesant, though a respected and revered man, was far from a despot.

A nineteenth-century image portrays the city's canal, an outlet along Broad Street known as the Heere Gracht (1.7). Unfortunately, residents often threw their "rubbish, filth, ashes, dead animals" and the like into it. The city's burgomasters appealed to Stuyvesant and his council for assistance in controlling this problem, and by early 1660 the canal had been further excavated and completed. Homeowners on both sides paid for the labor, though not without protest and delay. Under-Schout Resolved Waldron was made superintendent of the canal, in charge of keeping out filth and ensuring that boats could enter in an orderly manner. One problem with the canal was that at low tide the water drained out, leaving in its wake "a great and unbearable stench" as well as a shortage of water for use in fighting fires. Eventually the city ordered a lock built to maintain the water in the canal. This worked for a while but in 1663 another lock had to be constructed, again to counter "the unbearable stench." Homeowners were ordered to "dig out and carry away two feet in depth of mud." Whether the city needed a canal consid-

1.7. Heere Gracht Canal. **1.8.** Restitutio view (detail).
1.9. The Strand. **1.10.** Stadt Huys, 1679. **1.11.** Hendrick Couturier, *Petrus Stuyvesant.*

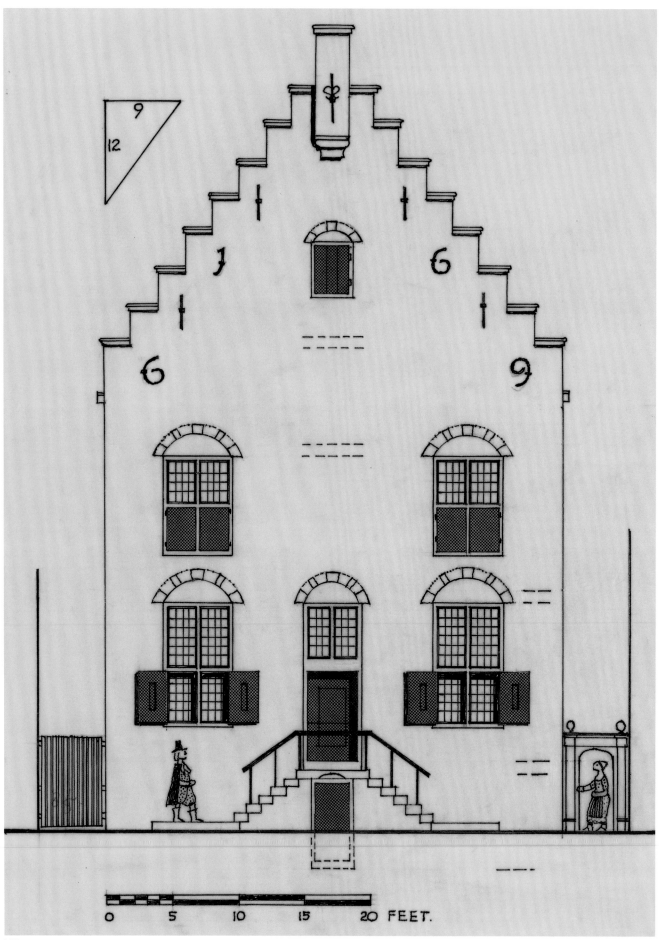

9
12

7 6

6 9

0 5 10 15 20 FEET.

1.12

ering its excellent harbor location is questionable, as uncertain as whether its windmills were appropriate. Both were part of the Dutch tradition, however, and endured, if with some difficulty, during the years of Dutch rule.[2]

Perhaps the most impressive feature of New Amsterdam and early New York was the Strand, later called Whitehall Street (1.9). In the picture, the fort and church loom in the background while the large house of the Director Stuyvesant, later to be occupied by Mayor Dongan under British rule, fills the foreground. It is a typical Dutch house, with a gabled facade and double staircase, a stoop, and a large door. Indeed, the entire town had a Dutch architectural look, as one visitor noted: "Most of the houses are built in the old way with the gable end toward the street; the gable end of brick & the other wall of planks. . . . The streetdoors are generally in the middle of the houses and on both sides are seats, on which during fair weather, the people spent almost the whole day." Another visitor noted that the houses were "very stately and high. The Bricks . . . are of divers Coulers and laid in checkers, being glazed, look very agreable"; while inside the rooms were "neat to admiration."[3]

The population of Dutch New Amsterdam was diverse, but no portraits survive of the soldiers, artisans, or tavern keepers. The only contemporary record is the Restitutio portrait of the city, made to honor the brief reconquest of New Amsterdam by the Dutch in 1670 (1.8). In the street stand small figures with weapons, perhaps the local militia or Dutch soldiers. This is the only visual record of the hundreds of New Amsterdam's ordinary citizens.

The most prominent of all these residents, Peter Stuyvesant, was a disciplined company official, a strongly religious man devoted to making the colony a success (1.11). After serving an apprenticeship in the Dutch West Indies, where he lost his leg storming a fort, he proved an adept diplomat and staunchly loyal Dutch patriot. He took over a city almost devoid of discipline and rife with corruption and mismanagement. Under his tutelage it grew into a more orderly society. His strong sense of prerogative made him a powerful executive who stimulated the town burghers in turn to assert their own authority. In

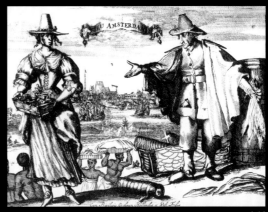

1.13

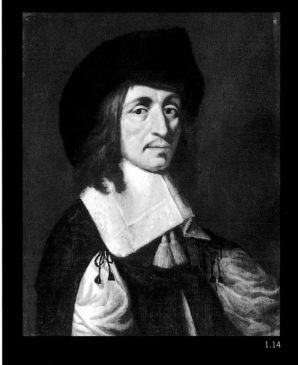

1.14

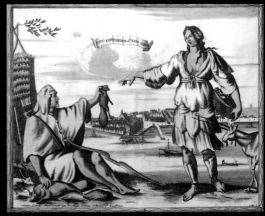

1.15

1.12. Jaap Schipper, Leisler house, 1669–70. **1.13.** Slaves and Barbados trader, 1642. **1.14.** Cornelis Steenwyck, ca. 1668. **1.15.** Indian man and woman and fur, 1673.

the process a dynamic municipal government emerged.

Cornelis Steenwyck, a prominent burgomaster and rich storekeeper and merchant, arrived in New Amsterdam before 1651 (1.14). He invested in shipping, trading goods as diverse as salt and slaves to the East Indies and Europe. Stuyvesant turned to him when he pawned brass cannon in order to replenish the company treasury. Involved in the deliberations leading to the surrender of the city to the English in 1664, Steenwyck subsequently became mayor in 1668–69. As a burgomaster he was responsible for town government, zoning, sanitation, regulation of food, and assorted other problems of municipal life.

The economy of New Amsterdam was a failure from the viewpoint of the Dutch West India Company. After pouring increasing resources into the community with little profit, it eventually allowed merchants and patroons greater economic freedom, charging them fees in order to gain revenue. Many merchants did well, not just in fur but also in extensive slave and West Indies trading. The slave trade was an essential part of New Amsterdam's economy. A number of slaves lived in New Amsterdam from its earliest years, doing manual labor for the company. The Dutch substantially increased its slave trade, and the number of slaves rose from over forty to over three hundred in 1660. The early slaves brought to New Amsterdam were allowed to own property and were subject to the same laws as whites. They could legally marry and could on occasion

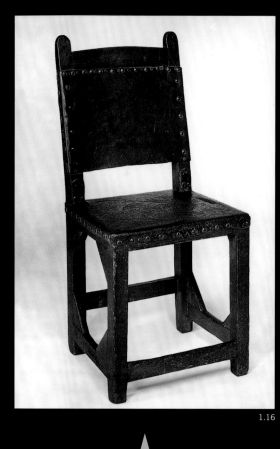

1.16

Despite its diverse population, New Amsterdam replicated in miniature the life of the golden age of Holland.

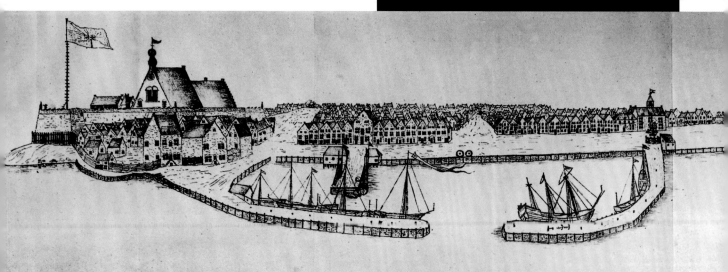

1.17

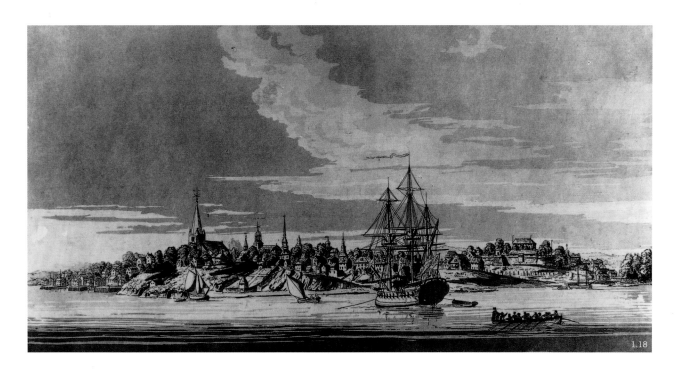

earn their freedom. This 1643 engraving of a Barbados trader together with slaves, with New Amsterdam visible in the background, illustrates the city's status as a trading post in the Dutch empire, as well as the centrality of slavery, both as trade and as labor (1.13).

A 1673 view of New Amsterdam (by then New York) engraved in Holland by Aldert Meijer was based on descriptions of the port town (1.15). The significance of the fur trade is apparent in the image. Furs were the primary reason for founding the colony and for many years its main source of income. Forty years later the community still depended on Indian trade, not just for furs but also for meat and fish. The prominence of the native American in the engraving indicates the large role indige-

nous inhabitants played in the lives of city dwellers.

Despite its diverse population, New Amsterdam was primarily a seventeenth-century Dutch town that replicated in miniature the life of the golden age of Holland. While there was no theater and little formal music, by the 1660s the city was far from a primitive outpost. The buildings reflect Dutch culture; for example, an architect's drawing of the house of Jacob Leisler, constructed in 1669–70 shows the outlines of a typical if large Dutch home (1.12). Ornaments and other material artifacts also remained true to the patterns laid out in the old country. Furniture was both made locally and imported, especially from Boston. This simple chair with square Spanish cedar legs and leather nailed to the back may have been in the home of Sara Rapalje, one of the first children born in New Netherlands (1.16).

Both New Amsterdam and the colony of New Netherlands were surrounded by growing English colonies and an expanding British empire. New Netherlands was thus internally divided, constantly battling against the dissension of its many English settlers, especially those on Long Island. England and Holland engaged in a number of naval and mercantile wars. For example, intent on a monopoly of trade from New England through the Carolinas, Britain passed the

1.16. Dutch chair. **1.17.** Jaspar Danckaerts, *Labadist view*, 1679–80. **1.18.** "Atlantic Neptune" view, 1773.

13

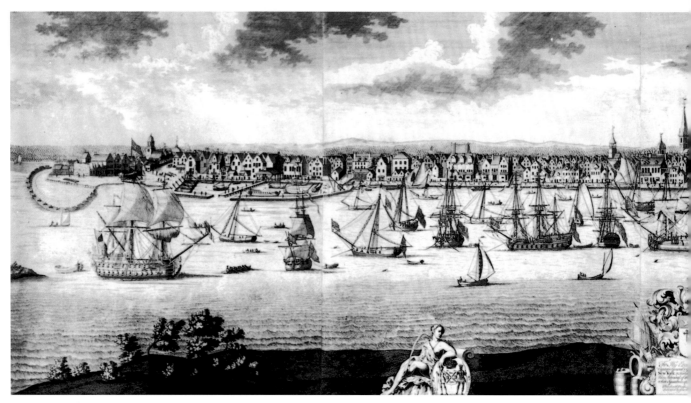

Navigation Acts, limiting entry to its colonies to British ships. Spearheading the legislation was the duke of York, brother of King Charles II and a leader of those eager to expel the Dutch from North America and reap colonial rewards. In 1664 Charles II made his brother proprietor of New York, the former New Netherlands, and Colonel Richard Nicholls sailed into New Amsterdam harbor with four frigates carrying two thousand soldiers. Stuyvesant wanted to fight, but the inhabitants preferred to negotiate a truce maintaining their civil and economic rights. New Amsterdam became the duke's.

While an English flag now flew atop the newly renamed Fort James, New York did not become an English city overnight. The inhabitants and language of the streets remained mostly Dutch, as did local laws and customs. The English were only one of many nationalities present in the city. Anglicization would take decades. When two followers of a religious sect known as the Labadists, Jaspar Danckaerts and Peter Sluyter, arrived in 1672, they still found a Dutch metropolis where the most elegant home was owned by the prominent Dutch merchant Jacob

While an English flag now flew upon the newly renamed Fort James, New York did not become an English city overnight.

Leisler and the largest homes along the waterfront belonged to Dutch burghers. The city was now called New York, but its physical appearance and society remained true to New Amsterdam.

Jaspar Danckaerts, an amateur artist, made several pencil drawings of New York (1.17). The largest depicts the new dock built by Governor Edmund Andros and surrounded by moles, or breakwaters of stone and timber. On pilings at the foot of the dock stands a new marketplace and a weigh house. The canal is gone, replaced by Broad Street, which was to become the city's main commercial byway. This was the point of anchorage for West Indian trading ships carrying wheat, furs, livestock, lumber, and fish, the core of the city's economy. At the left is the Strand, where the home of Jacob Leisler stands next to that of the mayor, Captain Thomas Delavell. He resided in Whitehall, formerly Stuyvesant's grand dwelling. The large Dutch West India Company warehouse still stood at the end of the new dock, though it was now called the King's Warehouse. Surrounding it lived some of the city's more prominent citizens, including Cornelis Steenwyck and Dominie Samuel Drisius.

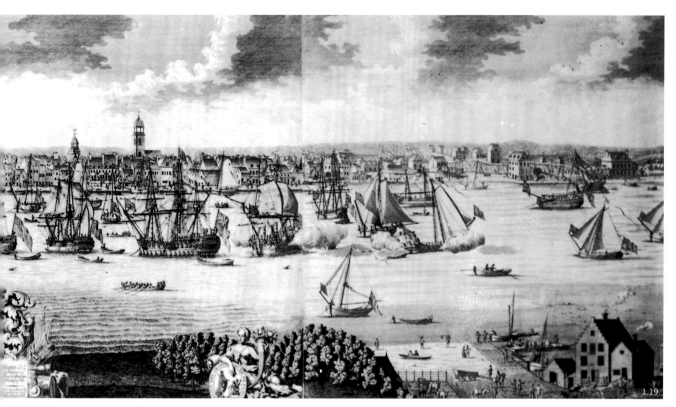

The city's slaughterhouse, now removed beyond the city limits, can be seen at the far right.

In contrast to the Labadist view, a famous copper engraving completed in 1717 by William Burgis, an immigrant who lived in both Boston and New York, is a study in Anglicization (1.19). Instead of giving prominence to the fort (though it is still seen at the far left), the engraving features at its center the Anglican house of worship, Trinity Church. This impressive structure, the tallest depicted, symbolizes English life and society and the important position of the Anglican religion. To its immediate left is the City Hall, noted for its rounded dome and flying the British flag. Next to that is the former dominant religious institution, the Dutch Reformed Church. To Trinity's right is the French Huguenot church, l'Eglise du Saint Esprit, built in 1704. At the former center of Dutch architecture, the Strand, the houses of Leisler and Stuyvesant are now burnt-out shells; the Stadt Huys has been torn down. While most structures south of Wall Street retain the Dutch style, new buildings reflect English Georgian design. Still notable in this city, now numbering more than sixty-five hundred inhabitants, are the ships, markets, and splendid homes revealing the centrality of trade and the wealth of commerce. The scene is one of motion, from the firing of the ships' cannon, probably in honor of the birthday of King George on May 28, 1717, to the images of shipbuilders, carters, coach drivers, and pedestrians. In the harbor can be seen both British naval frigates and private yachts, including one identified as belonging to Colonel Lewis Morris. To leave no doubt about who owns the city, British flags flutter throughout the view, along with the arms of the royal governor, Colonel Robert Hunter.

Another engraving, drawn as part of "The Atlantic Neptune," a series of figures, charts, and plates used by the British Admiralty, does not emphasize commerce, prosperity, or growth but instead features the hilly topography of lower Manhattan (1.18). Concerned with geography, the admiralty produced a pastoral view of New York. Large as it was for North America, New York was not London and could still be depicted as a typical English town, in which churches stand out

Ships, markets, and splendid homes reveal the centrality of trade.

1.19. Burgis view, 1717.

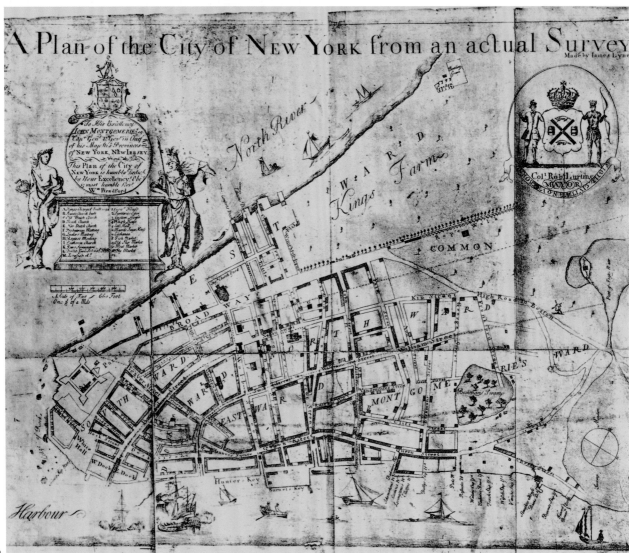

amid hills and trees. The end result
illustrates how an artist's perspec-
tive and intention shape the por-
trayal of a subject.

There were a number of settle-
ments and then towns, both English
and Dutch, in what are now the bor-
oughs of New York City, among them Gravesend and
Flatbush. On Manhattan island the first settlement out-
side the city was Nieuw Haàrlem, which was set up as an
outer defense for New Amsterdam (1.21). It was built on
the order of Director Stuyvesant in 1658, between what
are today 125th and 126th Streets. A connecting road
was constructed by company slaves. The early inhabi-
tants included French, Walloons, Dutch, Danes, Swedes,
and Germans. Most were artisans with little agricultural
experience. The town grew slowly, and as drawn appears
to be a sleepy village, seemingly miles outside the city,
sitting amid the country estates of the wealthiest New

Yorkers, most notably Morrisania,
which belonged to Lewis Morris, a
prominent merchant and politician.
Haarlem retained a Dutch flavor;
the church depicted, the only one in
town, is the Second Reformed
Dutch Church, begun in 1686 (the
first was built in 1665).

The growth and increasing residential segregation of
New York City so lavishly illustrated in the Burgis
engraving can also be traced in the first engraved map
printed in New York City (1.20). The survey was con-
ducted by James Lyne, an enterprising citizen who also
served as a constable and night school teacher of "arith-

1.20. Bradford-Lyne map, 1730. **1.21.** Nieuw Haarlem, 1765.
1.22. John Wollaston, *Mary Spratt Provoost Alexander*, ca. 1750.
1.23. Augustus Jay.

metick in all its parts, Geometry, Trigonometry, Navigation, Surveying, Gauging, Algebra, and sundry other parts of Mathematical Learning."[4] He delineated the wards of the city, districts established by the Dongan Charter of 1686. This first charter divided the city into five inner wards and a sixth, the Out Ward, that consisted of all the area north of immediate settlement. Of the settled wards, the West Ward encompassed land from Broadway to the Hudson, the South and Dock Wards were at the southern tip of Manhattan, the East along the growing area adjacent to the East River but north of the original area of settlement. The North Ward included the area north of Wall Street in the center of the city. Lyne's survey, known as the Bradford-Lyne map, for its publisher William Bradford, also introduces a new ward, the Montgomerie Ward, named after the governor.

The map's key places the city's famous institutions. It also illustrates the social and ethnic divisions of the seaport. The wealthiest citizens lived around the commercial center of town, Hanover Square, which was filled with imported wares, particularly on Queen, Broad, Dock, Smith, and Duke Streets. There the mansions of the De Peyster, Beekman, and Livingston families stood amid shops, taverns, and workshops. The East, South, and Dock Wards had the highest assessed taxes. Many craftsmen lived there, working in the mercantile trades; two-thirds of all shipwrights and tailors resided in the East Ward, while silversmiths and coopers were found mainly in the North Ward, and blacksmiths in the Out Ward. Not surprisingly, more craftsmen and most manual unskilled laborers resided in the poorer wards. Also of interest were the ethnic divisions, with the Dutch, now less prominent and less well off than the English elite, concentrated in the North and Out Wards. The smaller religious communities clustered together, usually in the East Ward.

Following the British takeover, the city underwent a slow process of Anglicization. The terms of the surrender allowed for freedom of worship and the retention of all property by the original owners. This guaranteed the city's continuing cosmopolitan and mercantile character. At first, the Dutch remained at the center of power and influence. But immigration from Holland virtually stopped, so

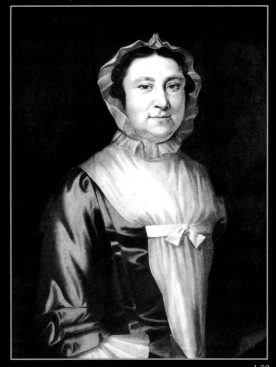

1.22

Following the British takeover, the city underwent a slow process of Anglicization.

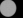

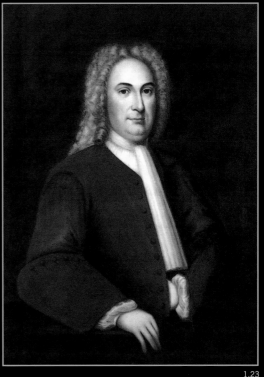

1.23

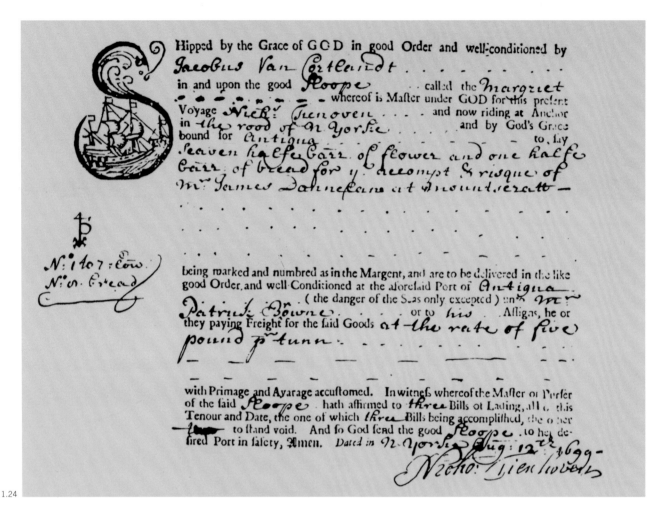

Hipped by the Grace of GOD in good Order and well-conditioned by *Jacobus Van Cortlandt* in and upon the good *Sloope* . . . called the *Margriet* whereof is Master under GOD for this present Voyage *Nich: Tienoven* . . . and now riding at Anchor in *the rood of N Yorke* and by God's Grace bound for *Antigua* to lay *Seaven halfe Barr of flower and one halfe Barr of bread for ye accompt & risque of Mr James Donneson at Mountserrat* —

N: 1 to 7: Flow
N: 8: Bread

being marked and numbred as in the Margent, and are to be delivered in the like good Order, and well Conditioned at the aforesaid Port of *Antigua* . . . (the danger of the Seas only excepted) un*to Mr Patrick Browne* or to *his* . . . Alligns, he or they paying Freight for the said Goods *at the rate of five pound pr tunn*

with Primage and Avarage accustomed. In witness whereof the Master or Purser of the said *Sloope* . . . hath affirmed to *three* Bills of Lading, all of this Tenour and Date, the one of which *three* Bills being accomplished, the other *two* to stand void. And so God send the good *Sloope* . . . to her desired Port in safety, Amen. Dated in *N Yorke Aug: 12th 1699* —

Nicho: Tienhoven

1.24

within a few generations Trinity Church became the site of worship for the city's elite, intermarriage of Dutch and English grew increasingly common, and the Dutch language gradually disappeared. Even so, the city remained by far the most pluralist of all the English colonies.

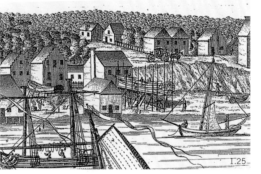

1.25

Portraits of some of the city's prominent citizens show influence of these developments. Mary Spratt Provoost Alexander was the child of a Dutch mother and Scottish father, evidence of the growing trend toward intermarriage (1.22). She became a shopkeeper. Augustus Jay, grandfather of the patriot John Jay, was an immigrant French Huguenot, one of the most successful of this growing community, who during his lifetime affiliated with the Dutch Reformed, the French, and then Trinity Church (1.23).

New York City's economy depended on trade, principally with the West Indies, especially the islands' extensive sugar trade. When trade flowed, the city prospered. At times of intense competition or when the price of sugar fell, the economy faltered. The city endured a number of very difficult economic downturns, particularly in the 1730s. Even so, New York's standard of living was two to three times that of New England, twice that of Pennsylvania, and more than 50 percent greater than Virginia's. The city thrived on trade and credit, supporting the colony's wealthiest men, individuals able to build beautiful city mansions and country estates and speculate in real estate and manufacturing. The great prosperity of these leading citizens also led to sharp dis-

ABRAHAM DELANOY,

Takes this Method to inform his Cuſtomers, and the Public in general,

THAT he has removed from Ferry-Street to a houſe in Horſe and Cart-Street, near the North Church; where he propoſes to continue his buſineſs of pickling oyſters and lobſters, and alſo puts up fried oyſters ſo as to keep a conſiderable time even in a hot climate. 86

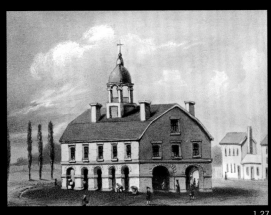

1.24. Bill of lading, 1699. **1.25.** Burgis detail: shipbuilding. **1.26.** Abraham Delanoy, Pickle ad, 1773. **1.27.** Broad Street Exchange. **1.28.** Burgis detail: Brooklyn ferry.

parities in the distribution of wealth.

Details from the Burgis portrait illustrate the city's economy. The presence of ships points to the supremacy of overseas commerce as well as coastal trade (1.25). By 1750 New York had 157 registered vessels and by 1762, after the French and Indian War, there were 477 vessels, totaling 19,500 tons. Other signs of economic growth appear in the work of the city's tradesmen: the image of the Brooklyn ferry features butchers driving their cattle to market to feed the growing number of inhabitants (1.28). More significant evidence of trade is provided by a bill of lading, dated 1699, for flour and bread shipped from New York by merchant Jacobus Van Cortlandt (1.24). And while advertisement was still in its infancy, newspapers did carry ads for wholesalers such as Abraham Delanoy (1.26).

A number of markets existed in the city for sale of goods, usually in the open air. In 1751 several gentlemen, using their capital and a grant of twelve hundred pounds from the common council, financed the construction of the Broad Street Exchange, which opened in 1752 (1.27). It contained an open-air marketplace at ground level, complete with an arcade, for street sales; upstairs were rooms with twenty-foot ceilings suitable for dinners, concerts, and assemblies, as well as other small meeting areas. The Exchange Coffee House leased one of these rooms and became a mercantile gathering point where commercial news was readily available.

The wealthiest of mercantile New Yorkers often had their origins in humbler beginnings but grew to found affluent dynasties through business skill as well as the exploitation of political connections and the fortunes of trade and war. The rich possessed elegant homes in the city as well as country estates. Nineteenth-century depictions of these residences, such as the De Peyster Mansion, later Governor Clinton's home, display the elegance and opulence of the dwellings of the mercantile elite (1.31).

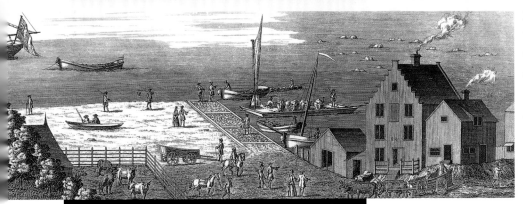

1.29

1.30

1.31

1.32

New York's economy flourished under the British Navigation Acts that regulated trade. The unbounded search for wealth, however, often led to smuggling. The quest for illegal riches, one of the more extreme manifestations of the city's commercial spirit, is perhaps nowhere better exemplified than in the story of William Kidd, the notorious pirate (1.29). After gaining wealth and a ship in the West Indies, Kidd moved to New York. There, he became partner to some of the richest New Yorkers, such as Nicholas Baird and Frederick Philipse, who also engaged in piracy. Working for them, he moved into one of New York's finest homes, just north of Wall Street, and helped fund the construction of Trinity Church. He later formed a connection with Robert Livingston and Governor Bellomont and went off to the Indian Ocean, allegedly to hunt pirates but actually to engage in piracy himself. When he returned from his exploits he lost his political connections and was arrested and later hanged. His adventures typify the overriding quest for wealth common to the city's elite and its royal officials.

The lifeblood of any preindustrial city was supplied by its community of skilled craftsmen. They provided both the ships and the ship supplies, tailored the clothing, constructed the buildings, and produced some of the city's more elegant furnishings (which took their place among imported wares). Few illustrations survive of colonial New York City artisans at work other than the pictures of shipwrights, butchers, and drovers in the Burgis engraving. But there are fine examples of their craft, both in English and Dutch vernacular.

Craftsmen's art was based on the "mysteries" that had been practiced and handed down from master to apprentice and journeymen over the years. Most of the products were ordinary: plain chests, loaves of bread, barrels. But artisans also produced great handicrafts that could compare with their English and French counterparts, such as the two-handled punch bowl created around 1700 by Gerrit

1.29. Woodcut of Captain Kidd. **1.30.** Onckelbag punch bowl, ca. 1700. **1.31.** De Peyster Mansion. **1.32.** Brinckerhoff secretary, ca. 1700. **1.33.** Trade card of Samuel Prince, ca. 1770. **1.34.** Card table. **1.35.** Chest of drawers.

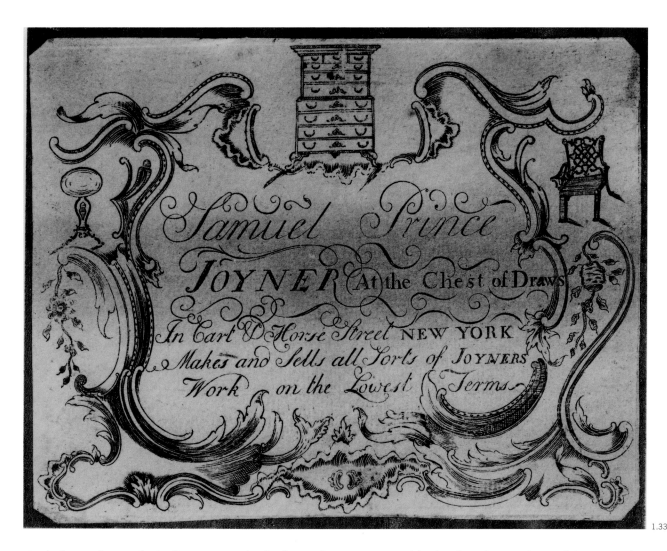

Onckelbag and a Brinckerhoff secretary made of cedarwood with beechwood and walnut inlays of flower and scrolls (1.30, 1.32). The two large lower drawers are constructed of pine and tulip wood. Both of these pieces represent the persistence of Dutch traditions into the English era.

Most of the finer craftsmen, though men of middling standing, tailored their work to the tastes of the elite. Gambling and card playing was one of the most popular entertainments of the wealthy, and a card table from the shop of Marinus Willet, with pockets for chips and coins, illustrates this relationship of craftsmen and clients (1.34).

A rare colonial trade card was discovered in a chest of drawers made in the Chippendale mode, a simple yet luxurious style, by Samuel Prince a "joyner" (1.33, 1.35). He worked at "At the Sign of the Chest of Drawers" on the Cart and Horse Street (later William Street) and made this piece of furniture around 1770.

In 1817 the artist Joseph B. Smith drew a scene from John Street, a typical

artisan neighborhood in the North Ward housing cabinetmakers, painters, and tallow chandlers, including William Colgate, the founder of the Colgate soap empire (1.36). At the center of the drawing is the John Street Methodist Church, a Wesleyan chapel intended to reach the middling and lower classes. The steeple at the left belongs to the Middle Dutch Church; the one at the right to the First German Reformed Church. Standing at the chapel door is the sexton, Peter Williams, later a successful tobacconist and founder of the city's first Methodist church for blacks. The small wooden houses

1.34

1.35

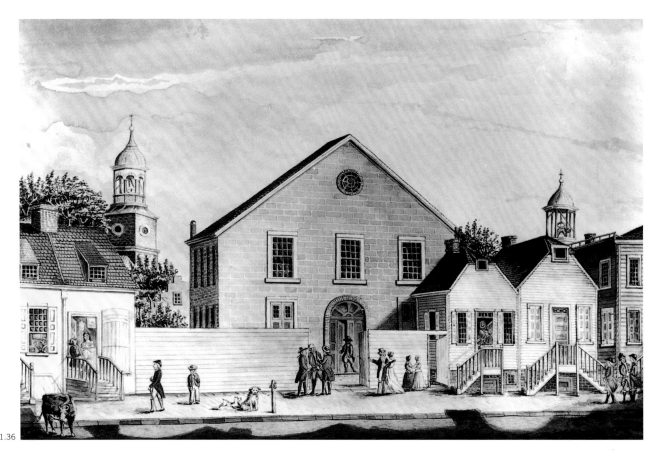

1.36

flanking the church usually served as shops and dwellings, and in some cases housed a number of families and renters.

At the English accession the population of New York numbered 1500 whites, 300 slaves, and 75 freedmen; forty years later, in 1703, there were 4400 whites and 600 to 700 blacks. As the city's commerce grew, so, too, did the slave trade and the slave population. A cheap work force was a valuable commodity in a labor-short market. Not only did the wealthy purchase slaves as domestic servants, but craftsmen also used them in their shops. In 1703 slaves composed 14 percent of the city's population, and 40 percent of the city's whites owned at least one slave. In 1711 a market was established at the foot of Wall Street where slaves were brought for purchase or lease (1.38). From 1703 to the Revolution 7500 more slaves arrived, and ultimately blacks composed up to 20 percent of the city's popula-

RUN AWAY

THE 18th Inſtant at Night from the Subſcriber, in the City of New-York, four Negro Men, Viz. LESTER, about 40 Years of Age, had on a white Flannel Jacket and Drawers, Duck Trowſers and Home-ſpun Shirt. CÆSAR, about 18 Years of Age, cloth-ed in the ſame Manner. ISAAC, aged 17 Years cloathed in the ſame Manner, except that his Breeches were Leather; and MINGO, 15 Years of Age, with the the ſame Clothing as the 2 firſt, all of them of a middling Size, Whoever delivers either of the ſaid Negroes to the Subſcriber, ſhall receive TWENTY SHILLINGS Reward for each beſide all reaſon-able Charges. If any perſon can give Intelligence of their being harbour'd, a reward of TEN POUNDS will be paid upon conviction of the Offender. All Maſters of Veſſels and others are forewarn'd not to Tranſport them from the City, as I am reſolved to proſecute as far as the Law will allow. WILLIAM BULL. N. B. If the Negroes return, they ſhall be pardon'd. - 88

1.37

tion, a larger proportion than any place outside the southern colonies. An ad offering a reward for the capture of runaways illustrates the commerce in slaves (1.37).

City life gave slaves considerable freedom of movement and assembly and the opportunity to establish their own community. This liberty also allowed the possibility of conspiracy and rebellion and indeed New York City had two slave uprisings. In the first, in 1712, about twenty-five slaves stole weapons, set fire to a building, and killed citizens attempting to put out the fire. Twenty blacks were hanged, three were burned to death, one broken on the wheel, and one starved to death in chains. These draconian punishments were symptomatic of the fear that pervaded the city's white inhabitants. Thirty years later another conspiracy included among its participants a number of poor whites involved in fencing stolen goods. A Catholic dissident may also have been involved. Allegedly, the plot-

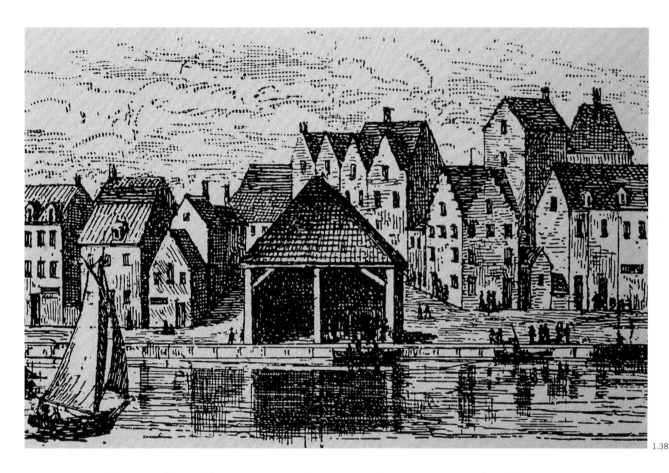

ters planned to burn the fort and kill the city's leaders. An informer and bad luck prevented any real harm other than the destruction of the fort, but again tough measures were taken as four whites and seventeen blacks were hanged and thirteen blacks burned at the stake. An engraving of an execution that appeared in *Valentine's Manual* may depict one of the hangings in 1741 (1.39).

Religion was central to the lives of colonial New Yorkers, whatever their faith or country of origin. The growth of the different churches allows a glimpse into the city's changing ethnic and social patterns. The city's first church was, of course, the Dutch Reformed church, built in 1642, that towered over the ramparts of Fort Amsterdam. With the capture of the city by the English, the chapel in the fort became the home of Anglican services. The first Anglican church, Trinity Church, was built according to English architectural traditions; construction lasted from 1696 to 1698, and the steeple was not completed until 1711 (1.40). Trinity served the newly dominant Anglican elite, along with many Dutch who become members either out of sincere changes of faith or in order to remain at the top of society in a

British seaport. In a number of cases, Dutch men joined the church, while the women adhered to the Dutch tradition. As the English grew more dominant, Trinity was enlarged, first in 1724 and then from 1735 to 1776. In the end, it towered over the Dutch church. By the mid-eighteenth century the governor, lieutenant governor, council, and city's elite attended services there. Rather than expand their building, the Dutch built a second chapel. The New Dutch Church, which supplanted the first Dutch church built in 1692 and later came to be known as the Middle Dutch Church, was erected on Nassau Street from 1727 to 1731 (1.43). The religious home to the large number of Dutch citizens who clung to their traditions, it was built on land owned by the wealthy Dutch merchant Rip Van Dam. The picture of this church is one of the few extant internal views of colonial New York.

1.36. Joseph B. Smith, Artisan neighborhood. **1.37.** Ad for runaway slaves. **1.38.** Slave market. **1.39.** *Ye execution of Goff ye Neger of Mr. Kochins on ye Commons.*

Yᵉ execution of Goff Yᵉ Neger of

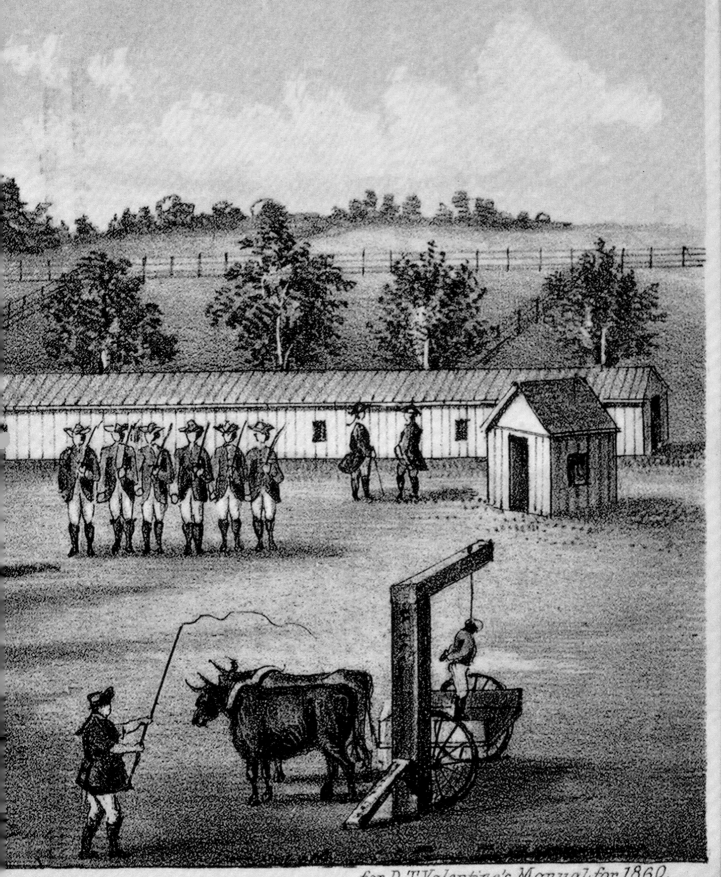

for D.T.Valentine's Manual for 1860.

Mr. Hochins on ye Commons

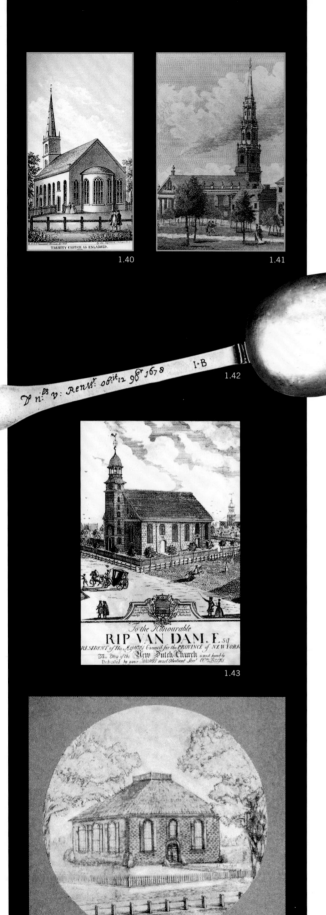

1.40

1.41

1.42

1.43

1.44

Other religious groups thrived in this polyglot city. The Huguenots built their first church, l'Eglise du Saint Esprit in 1704, an edifice of stone covered with plaster (1.45). These French refugees had settled in New York in large numbers after the Edict of Nantes and became an integral part of the city's economy. Dissenting sects had small chapels, including the Methodists, who opened their first chapel on John Street in 1768 (see 1.36). This was the first Methodist church in America; prior to its construction, Methodists held services in a rigging loft. The Lutherans built their first small church at Rector and Broadway in 1676. The Jews, who had established a presence under Stuyvesant and then disappeared through assimilation, reemerged as Dutch-speaking Sephardim from the West Indies, Surinam, France, and England. They were joined by Ashkenazi Jews from the German states. This population of perhaps 150 congregated in the area of Mill Street and around 1730 erected the small Mill Street Synagogue (1.44). The president of the congregation was generally Ashkenazi, while services followed Sephardic ritual. The common council's circumvention of British laws that might have impeded Jewish standing and business practices indicates how Jews were valued in the city.

The most elegant church was St. Paul's, a chapel of Trinity, constructed between 1764 and 1766 (1.41). It represented old New York at the height of its wealth (from the colonial wars) and refinement. Designed by architect Thomas McBean, who had studied under James Gibb, a disciple of Wren, it was modeled after St. Martin's in the Fields in London. Its elegant Georgian, classical spirit (note the Ionic columns) epitomized the gentility that now dominated the city.

Religion involved far more than the construction of great and small houses of worship. It permeated the lives of wealthy, middling, and poor New Yorkers. After the first printing press was established by William Bradford in 1693, prayer books were commonly printed.

"The Espousals," a pamphlet by Gilbert Tennent, is evidence of a powerful revival that swept New York in the 1730s, part of the Great Awakening (1.47). Tennent advocated the need for spiritual rebirth and rejected tra-

ditional patterns of worship and congregation. When George Whitefield, the great English evangelist and disciple of Wesley, arrived in New York he preached before two thousand in the Presbyterian church (the Anglican and Dutch Reformed churches had refused him their facilities) and then to as many as seven thousand outdoors. Men and women moaned and screamed, bewailing their fate and praying for redemption. He appealed largely to common folk who may have been uncomfortable in the city's more prominent churches.

New Yorkers expressed their religious and ethnic identities in life-cycle ceremonies. Those who could afford it marked these events with special gifts. The Dutch gave presents at funerals, often to pallbearers. A mourning spoon made by silversmith Cornelius Van der Burch was given to commemorate the death of Dominie Nicholas van Rensselaer, who died in 1678 (1.42). Describing a Dutch funeral in New York, Jedidiah Morse reported:

The funeral customs are equally singular. None attend them without a previous invitation. At the appointed hour they meet at the neighboring houses or stoops, until the corpse is brought out. Ten or twelve persons are appointed to take the bier all together, and are not relieved. The clerk then desires the gentlemen . . . to fall into procession. They go to the grave, and return to the house of mourning in the same order. Here the tables are handsomely set and furnished with cold and spiced wine, tobacco and paper, and candles and paper, &c. to light them. The conversation turns upon promiscuous subjects.[5]

Rituals were performed by Christians and Jews alike. For the latter, circumcision symbolized the covenant between the Jewish community and God, and the tools used to perform the ceremony were imbued with great significance (1.46).

Literacy was not common among New Yorkers. In 1700 only about a fifth of them could read, a proportion that rose to two-fifths by 1750. One reason was the lack

1.40. Trinity Church. **1.41.** St. Paul's Chapel. **1.42.** Mourning spoon, 1678. **1.43.** New (Middle) Dutch Church, 1731. **1.44.** Mill Street Synagogue. **1.45.** French church. **1.46.** Circumcision implements. **1.47.** Sermon of Gilbert Tennent, 1735. **1.48.** *The English and Low-Dutch School-Master*, 1730.

1.45

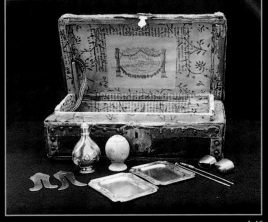

1.46

THE
ESPOUSALS
Cattune OR *Noble* 1735
A Paffionate Perfwafive to a Marriage with the Lamb of God,

WHEREIN

The Sinners Mifery
AND
The Redeemers Glory
is Unvailed in.

A Sermon upon *Gen.* 24 49. Preach'd at *N. Brunfwyck, June* the 22d, 1735.

By *Gilbert Tennent*, A. M.
And Minifter of the Gofpel there.

Qui Chriftam neifct, nil eft fi cetera difcit,
Qui Chriftum difcit, fat eft fi cetera nefcit.

NEW-YORK,
Printed by *J. Peter Zenger*, 1735.

1.47

THE
English and *Low-Dutch*
SCHOOL-MASTER.

CONTAINING

Alphabetical Tables of the moſt Common Words in *English* and *Dutch*. With certain Rules and Directions whereby the *Low-Dutch* Inhabitants of *North-America* may (in a ſhort time) learn to *Spell*, *Read*, *Underſtand* and *Speak* proper *English*. And by the help whereof the *English* may alſo learn to *Spell*, *Read*, *Underſtand* and *Write* *Low-Dutch*.

By *FRANCIS HARRISON*,
School-Maſter, in *Somerſet-County*, in *New-Jerſey, America.*

NEW-YORK:
Printed and Sold by *W. Bradford.* 1730:

DE
Engelsche en Nederduytsche
SCHOOL - MEESTER.

BEHELSENDE

Verschydene Tafelen, na de order van *A*, *B*, in gericht van de gemeenste Woorden, in 't *Engels* en *Duytsch*. Met eenige Regels en Onderwysingen, waardoor de *Nederduytsche* Inwoonders van *Nort America* in korten tyt de *Engelsche* Taal mogen leeren *Spellen, Leesen, Verstaan* en *Spreeken*. Ende de *Engelsche* in 's gelyks mogen leeren *Spellen, Leesen, Verstaan* en *Schryven*, in de *Nederduytsche* Taal.

Opgestelt door *FRANCIS HARRISON*, School-Meester, in *Somerset-County*, in *Nieuw-Jersy*, in *America*.

NIEUW-JORK:
Gedrukt en te Koop by *W. Bradfordt.* 1730.

of common school education. New York City did not have public schools until well after the Revolution. Instead, schools were established by private instructors and, for the poor, by charities and churches. The Society for the Propagation of the Gospel attempted to woo Dutch children to Anglicanism. They published bilingual prayer books and schoolbooks in English and Dutch, a tactic that hastened the Anglicization process that eliminated Dutch as a common language by the mid-eighteenth century. *The English and Low-Dutch School-Master* (1730) is exemplary of the books published—with evangelical purpose or not—by schoolmasters intent on reaching a bilingual population of students (1.48). For many literate New Yorkers, the most common form of reading matter, aside from the Bible, was likely an almanac such as the one printed by Bradford in 1710 that contained news of the tides as well as a record of holidays and other items of interest (1.49).

The New York Society Library was founded the same year as King's College—1754—partly to ensure that students at the college would have books other than those on Anglican theology but also to initiate a spirit of inquiry among the people. In its efforts to encourage widespread learning and research and enhance the city's culture, the institution functioned like other circulating libraries, loaning books to its members, who in turn contributed to a general purchasing fund. The library's first bookplate contains classical allusions to the arts and sciences, representing New York as a new Athens (1.51). The society continues to this day.

The most significant educational event during the colonial era was the founding of King's College in 1754. This stirred a heated political debate between the Delancey faction, which wanted an Anglican institution to train ministers, and the Livingston faction, which saw in the occasion a plot to establish the Anglican religion. Eventually chartered by Lieutenant Governor Delancey, the college opened in Trinity Church. In 1760 it constructed its own

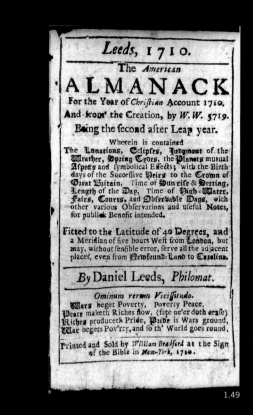

1.49

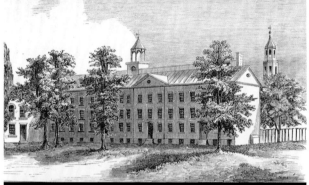

1.50

1.49. *Bradford Almanac*, 1710. **1.50.** King's College. **1.51.** Seal of the New York Society Library, ca. 1760. **1.52.** Howdell-Canot view (King's College), 1763. **1.53.** Samuel Johnson.

1.51

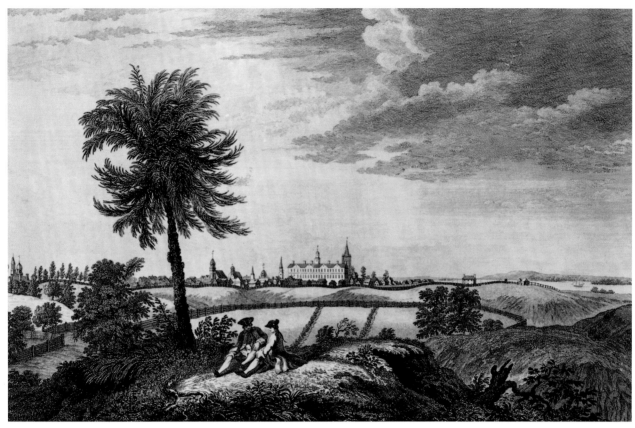

1.52

three-story building housing a library, apartments for students and faculty, and a general assembly hall. Visible from afar, it was one of the city's most glorious structures, an emblem of culture and refinement for both metropolis and colony (1.50).

The Howdell-Canot view drawn by Captain Thomas Howdell, portrays King's College from the southeast (1.52). On the right is the Hudson. The steeple of Trinity Church soars behind the college. At the far left is St. George's Church and the jail. The two young men in the forefront may have been students. To enter the college they would have had to pass exams given by the president ensuring that they could translate Caesar, Sallust, and Cicero from Latin and the Gospels from Greek into Latin.

The first president of King's College, Samuel Johnson, was an Anglican rector from Connecticut who studied Bishop Berkeley's philosophy (1.53). While not a narrow-minded sectarian, he insisted that the college be an extension of a legally established church. The college fol-

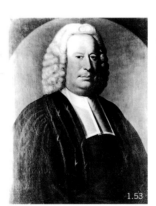

1.53

lowed a traditional classical curriculum emphasizing Greek and Latin literature as well as logic, rhetoric, and natural and moral philosophy.

Access to King's College depended on an individual's family background and economic status. Little material evidence remains of the lives of children of unskilled laborers or craftsmen. A number of valuable portraits of the elite endure, however, such as the one of six-year-old Jane Beekman painted in 1766 by John Durand (1.54). She is dressed as a woman, complete with corset, and holds a book open to a page of Erasmus to indicate her strong intellect. These portraits do not recognize childhood as a separate stage of development. Even so, toys have survived, for example, bells and whistles, and especially dolls. These two girls' dolls were brought to New York from England. One is named "Mary Jenkins" after the girl who owned it in 1743, and the other "Abigail Van Rensselaer," also named for its owner and dating from around 1760 (1.55, 1.56). They

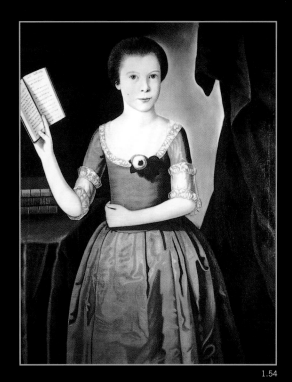

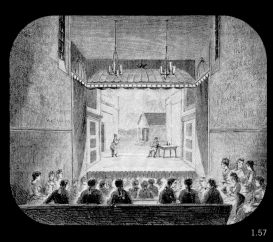

1.54. John Durand, *Miss Jane Beekman,* 1766. **1.55.** Doll: "Abigail Van Rensselaer," 1760. **1.56.** Doll: "Mary Jenkins," 1743. **1.57.** John Street Theater, interior. **1.58.** John Street Theater, exterior. **1.59.** Assize printed in the *New York Gazette,* May 28, 1764. **1.60.** Quart measure. **1.61.** City Hall, 1791.

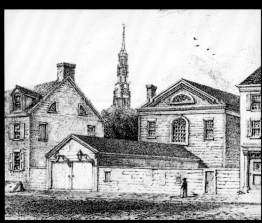

were carved out of wood, waxed, and then dressed in popular ladies' fashions.

Theatrical productions were staged in the city from the early years of the eighteenth century. The first theater, known as the Theater of Nassau Street, was located in a house owned by Rip Van Dam. Its first professional production was *Richard III,* performed in 1750. The theater closed in 1754 after the company left for Philadelphia, returning in 1758.

The best-known colonial theater was the John Street Theater, built in 1767 (1.57, 1.58). The Puritan strain in America despised theater, and Protestants consistently opposed staged performances. During the Revolution and immediately after the war, theaters were closed as part of the republican crusade, and the John Street company headed for Jamaica. A number of early playbills survive as well as a depiction of one of the actresses and scenes of both the theater's interior and exterior. There is also considerable theatrical criticism in newspapers and publications.

New York City received its first charter from Governor Dongan in 1683; this was later confirmed in the Montgomerie Charter of 1730. A propertied corporation, it possessed the authority—accepted by the citizenry—to create a seaport. The city used its property and its power to shape all aspects of city life but especially to foster economic growth, such as by selecting water lots and directing improvements through private contractors.

The city was governed by elected aldermen and assistant aldermen in each ward, together with an executive composed of the mayor, recorder, sheriff, coroner, and clerk, all appointed by the governor. The mercantile and professional elite dominated the aldermanic posts, but artisans often took lower positions, especially that of constable. The city regulated much of the municipality's commerce. It set standard weights and measures in the market, using quart beakers imported from London and certified by the lord mayor (1.60). It also set and published the assize (the price of loaves sold by bakers, which depended on the current price of flour), established cartmen's rates, inspected goods, and regulated and policed

the streets (1.59). Its courts handled all but the most serious criminal offenses.

The City Hall, completed in 1700 stood near Trinity Church on Broad Street, the major municipal thorough-fare (1.61). Replacing the old New Amsterdam Stadt Huys, it cost three hundred pounds and represented the triumph of English domination. With rooms for the common council, it served as the meeting place for the colony's assembly, the mayor's court, and the colony's supreme court. Its basement held the jail.

Municipal responsibility involved care for the poor. New York was a city of sharp contrasts, populated by both the wealthiest merchants in the colony and some of the poorest inhabitants. The almshouse, built in 1733 out of stone and brick, contained a poorhouse, workhouse, and municipal prison (1.62). At this time, the city's attitude toward the poor had hardened. A strict regimen including corporal punishment, deprivation of meals, and a long workday at the poorhouse kept the inmate numbers down. Hard times would increase the poor to numbers far higher than traditional congregational relief could handle, as in the 1730s, when the price of sugar fell markedly and a smallpox epidemic took the lives of 549 people. Between 1736 and 1740 the almshouse held half of the people in the city receiving poor relief, and between 1741 and 1745, it held three-quarters of them.

Given the number of wooden structures in the city, fire fighting was one of the most critical municipal responsibilities. In 1658 the Dutch had established a "rattle watch" to patrol the city, charging its representatives with sounding their rattles in case of fire. The first city-recognized fire company was founded in New York in 1737, when the corporation authorized the election of a select group of up to thirty-seven "strong, able, discreet, honest and sober men" to be appointed "Firemen of the City of New York."[6] Ultimately each ward housed a volunteer company under the supervision of the city, and by 1770 the city had 170 firemen and eight engines.

Serving in a fire department was a great

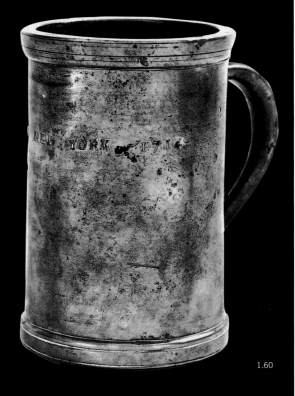

Affize of Bread, Flour at 13/3. per C.
A White Loaf of the finest Flour,
to weigh 2 lb. 1 oz. for four Coppers
Ditto of ditto, to weigh——1 lb. ½ oz. for two Coppers
Published the 11th May, 1764.

PRICES Current in NEW-YORK.

Wheat, per Bushel—	4s 6d	Beef per Barrel,—	6os od
Flour,—	13s od	Pork —	100s od
Brown Bread,—	12s od	Salt —	3s od
West-India Rum,—	3s 9d	Bohea Tea— —	8s od
New-England ditto,	2s 9d	Bees Wax —	1s 8d
Muscovado Sugar,—	50s od	Chocolate per Doz.	26s od
Single refin'd ditto,	1s 2d	Nut Wood —	32s od
Molasses,—	2s 3d	Oak ditto —	22s od

1.59

1.60

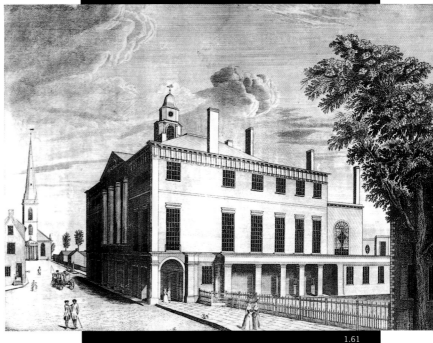

1.61

1.62

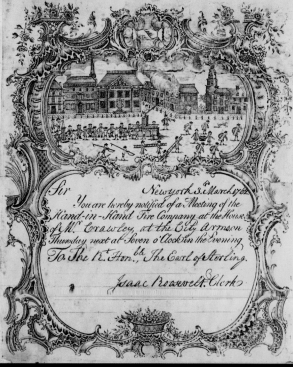

1.63

civic honor, a source of pride and fraternity. The first known and only extant fire certificate is decorated with an image of an unknown New York street where firemen are working in disciplined order, led by a marshal with a speaking trumpet (1.64). The pumping engine, imported from England, stands in the center, and the ladder carriers march alongside the bucket carriers.

After a brief honeymoon of goodwill between the English and Dutch followed by the seizure of New York by the Dutch fleet and a short reoccupation, James, duke of York and proprietor of the colony, appointed a loyal captain, Edmund Andros, as governor. Brooking little resistance, Andros improved the city and its mercantile image and promoted trade with the West Indies but was recalled because of local protest. Returning in 1688, by which time the duke of York had been crowned James II, Andros took control of the dominion of New England, a new administrative rearrangement that linked New York to New England. As a Catholic supporter of a Catholic monarch, Andros was unpopular, particularly among the Calvinist Dutch.

A beaker engraved in the mid-1740s in New York illustrates the popular anti-Catholic feelings that helped overthrow James II in England and made Andros so unpopular in New York (1.63). The engravings on the cup echo the popular belief that the pope and the devil were intertwined in evil conspiracies. Artisans even celebrated Pope's Day, November 5, in commemoration of the defeat of the Catholic attempt to blow up Parliament. Artisans, sailors, and youths frolicked in the city's streets, attending speeches, parades, and bonfires.

After the overthrow of James II and the accession of William and Mary in the Glorious Revolution of 1688, New Englanders arrested and deported Andros. In New York City, amid uncertainty and fear of Catholic invasion, Jacob Leisler seized power, holding it through military rule for the next two years. A wealthy Dutch merchant, once a company soldier, Leisler saw himself as

1.62. Almshouse. **1.63.** Cup of the Glorious Revolution, mid-1740s.
1.64. Hand-in-Hand Fire Company certificate, 1753.
1.65. Proclamation of Governor Hunter, 1715.

1.64

By His Excellency

Robert Hunter, Esq; Capt. General and Governour in Chief
of the Provinces of *New-Jersey*, *New-York* and Territories depending
thereon in *America*, and Vice Admiral of the same, &c.

A Proclamation.

WHEREAS the Proprietors of Province of *New-Jersey* have nominated
and appointed *James Smith*, Esq; to be Keeper of the Records for the
said Proprietors; And *James Alexander*, Gent. to be Surveyor General
of the Lands in the said Province; which Nomination and Appointment His
Majesty has been graciously pleased to approve of. And by his Royal Letters
to me, Dated at St. *James*'s the Ninth Day of *May*, 1715. in the first Year
of his Reign, has Commanded me to Assist and Countenance the aforesaid
Persons in the Execution of their Respective Offices, in a manner most Effectual
to prevent all Disputes and Divisions which may arise among his Majesties
Subjects here. I have therefore thought fit hereby to forbid all persons what-
soever, Except the said *James Smith* and *James Alexander*, and their Lawful De-
puties, to Execute the said Offices of Register and Surveyor. And all Officers,
Magisterial and Ministerial are hereby Required to give the said *Smith* and
Alexander Suitable Countenance and Assistance in the Execution and Discharge
of their Respective Offices.

Given under My Hand and Seal at Arms at Perth-Amboy the Seventh Day of
November, *in the Second Year of the Reign of our Soveraign Lord* GEORGE,
of Great Britain, France and Ireland, KING, *Defender of the Faith*,
Annoq; Domini 1715.

By his Excellencys Command,

J. *Barclay*, Pro. Secry.

Ro. Hunter.

God Save the King.

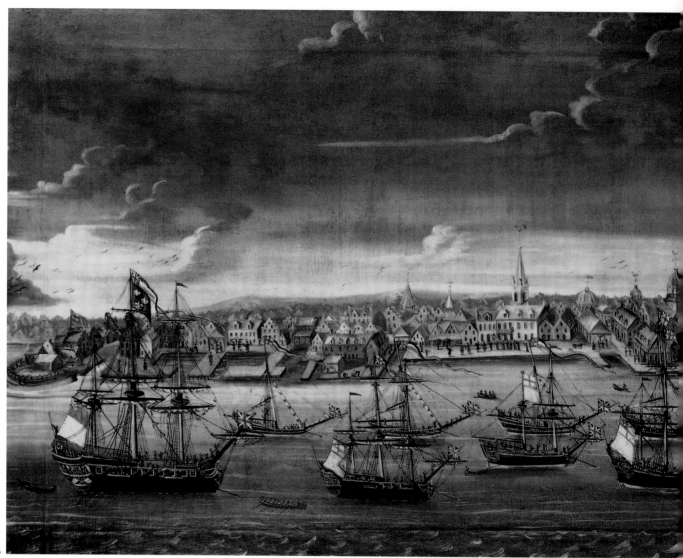

1.66

defender of the Calvinist faith, a Roman Cincinnatus and keeper of Dutch tradition. When British rule returned the newly appointed governor, Henry Sloughter, arrested Leisler, who was was tried for treason, hanged, and quartered. The Leisler Rebellion brought to the fore the divide between the traditional Dutch resentful of English influence and wealth and the English and Dutch who had adjusted and often profited under English rule. Not until the administration of Governor Robert Hunter (1710–19) did peace prevail. Hunter's adept political skill and use of his prerogatives created a temporary harmony. An elegantly printed 1713 proclamation of Hunter effectively communicates the power and majesty of British rule (1.65).

After the fires of the Leisler Rebellion faded away, pol-

itics became intensely factional. The most telling event for both the city and the colony took place in 1733. A rapacious governor, William Cosby, attempted to seize power and wealth by nearly any means necessary. When the *New York Weekly Journal*, edited by printer John Peter Zenger and supported by Cosby's rival, Lewis Morris, attacked the governor as a corrupt, vulgar, arrogant Englishman, Cosby charged Zenger with libel and had him jailed at high bond. At the trial, the jury exceeded its prescribed role—determining whether or not Zenger had published the newspaper—and decided that, contrary to English common law, truth should be a defense against libel even if that truth tended to discredit the government. It was a landmark case.

New York's political disputes occurred within the larg-

City. Merchants gained fortunes inconceivable in prior years and spent their new wealth on luxuries such as carriages and fashionable clothing. This in turn raised the income of many of the city's craftsmen.

Along with the provision of military supplies, a lucrative trade was privateering. Private merchant ships captured enemy vessels, whose cargoes went as prizes to the backers and crew of the privateer. A painting made in the 1750s depicts captured French ships (1.66). The anonymous artist's patriotic pride is manifest in the prominent place accorded the French prizes. In the background, the city has a prosperous mercantile look.

As the Revolution neared, two major factions repeatedly vied for power in the city. The faction headed by James Delancey, the jurist who had presided at the Zenger trial, was connected to the city's mercantile elite. The Livingstons, headed by Philip and William, located their power base in landed interests in the Hudson River Valley. Both groups were wealthy, with multiple financial interests.

Factional politics popularized politics. In close elections in the city, factions, whether quarreling over the Zenger affair or King's College, appealed to ordinary tradesmen and cartmen. This encouraged in the populace a political awareness that was critical for the Revolution. When serious issues divided the colonies from the mother country, this history of political mobilization among many elements of urban society made New York a leader in the movement toward independence.

The year 1765 was not a good one for the city as British merchants' direct marketing led to a shortage of credit and a disastrous economic recession. With the added burdens of increased immigration and higher prices, poor relief rose markedly. When the British government passed a Stamp Act demanding revenue from many and sundry transactions, both merchants and craftsmen turned against the mother country. The merchants initiated nonimportation, but the artisans, forging themselves into the Sons of Liberty, took to the streets and tore down the houses of the British commander, Major James, and of Lieutenant Governor Colden.

The repeal of the Stamp Act in 1766 was justly celebrated in the city, and a statue of King George was erect-

er context of imperial relations. The city played a central role in the dominant mercantile philosophy that viewed colonies as important security bastions. Colonies freed nation-states of the need to buy supplies from enemies and, indeed, facilitated a favorable balance of trade when they could deliver export goods. As jewels in and of the crown, they provided many theaters of action in the wars for imperial supremacy fought among Britain, France, and Spain during the eighteenth century. During the French and Indian War (1756–63) expenditures authorized by Prime Minister William Pitt benefited New York

1.66. Privateers with French prizes, ca. 1757. **1.67.** Engraving celebrating the repeal of the Stamp Act, 1765.

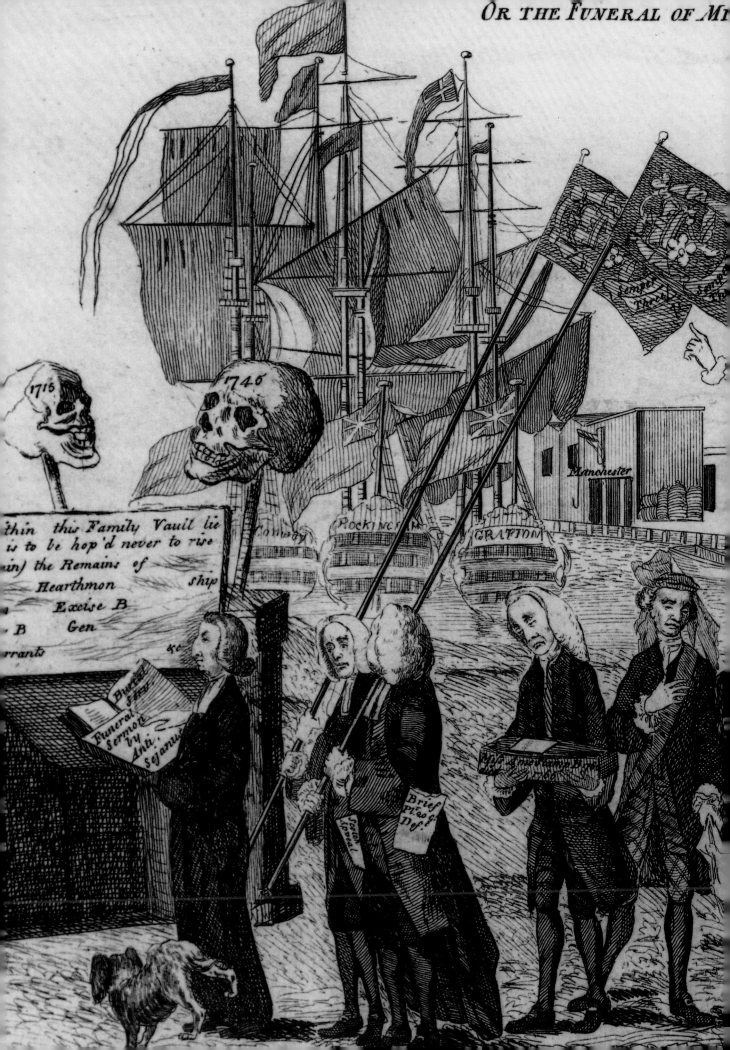

1715

1746

thin this Family Vault lie
is to be hop'd never to rise
in) the Remains of
Hearthmon ship
Excise B
B Gen
rrants &c

Conway

ROCKINGHAM

GRAFTON

Manchester

Funeral Sermon by Anti. Sejanus

Sexton Funeral

Brief pt 20 £ Def.

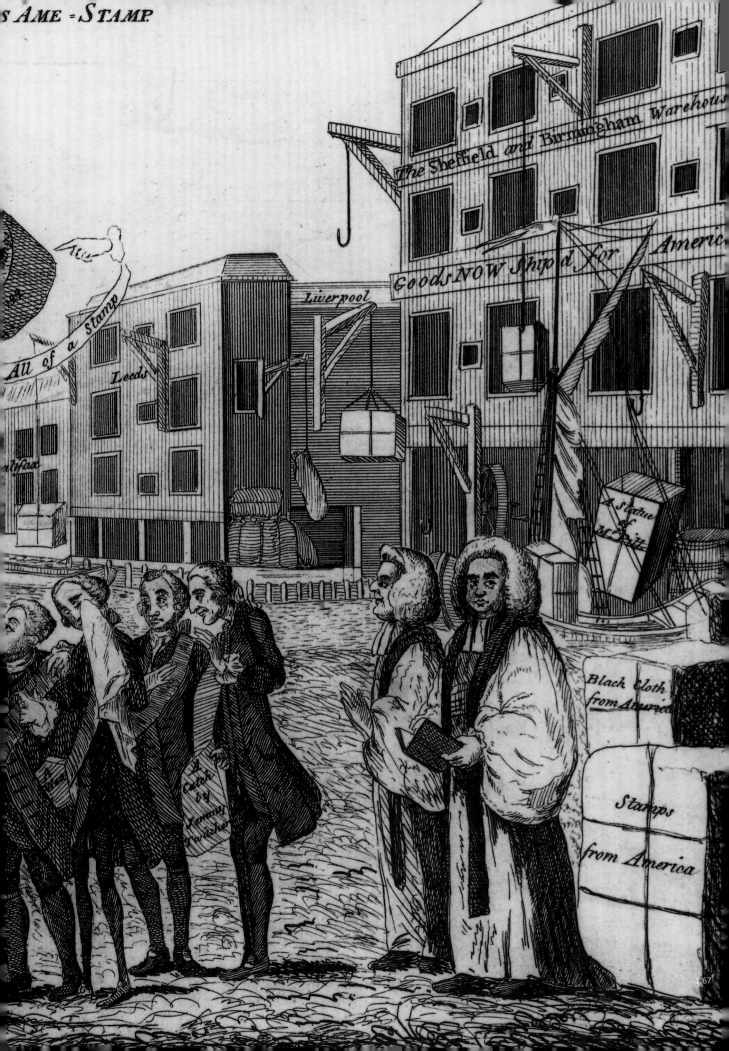

1.68

Factional politics

popularized politics.

1.69

ed for the occasion. An engraving satirized the former proponents of the tax (1.67). In it "Reverend Mr. Anti-Sejanus," a British proponent of the measure, leads the funeral procession of "Mr. George Stamp," born in 1765 and "died hard in 1766." The skulls represent the two Jacobite rebellions of 1715 and 1745, perhaps a warning against threats to liberty. The flags display stamps and a white rose. Other stamp supporters and two priests march in the procession. On the docks sit the stamps and "black cloth" returned from America, while nearby goods from English ports, along with a statue of Mr. Pitt, wait to be loaded onto the ships on the Thames, named after British ministers who had opposed the act: Rockingham, Grafton, and Conway.

The next major confrontation occurred in 1770, when nonimportation was again invoked to protest the Townshend Act, a revenue act of 1767 that taxed a few significant imports but not internal sales. The Sons of Liberty erected a Liberty Tree at Golden Hill (today's William Street) near Montayne's Tavern (1.68). British soldiers pulled it down repeatedly, only to have it reerected each time with greater reinforcement. A brawl broke out between soldiers and cartmen, and one cartman was killed. The situation worsened when the assembly voted to resume supplying British troops. Alexander McDougall was jailed for composing an angry broadside attacking the assembly: *To The Troubled Inhabitants of the City and Colony of New York*. While in jail, he became a hero to the middling classes. A drawing by a visiting Frenchman shows the liberty pole. At the left is Montayne's Tavern, a favorite gathering place for politicians as well as artisans. In the center is the jail, and at the right the solder's barracks.

While the most famous tea party took place in Boston, the Townshend Act was equally unpopular in New York. Three thousand may have gathered in the streets to protest this bill in December 1773, and when one ship refused to return to England as its sister vessel had, it was

1.68. Drawing of Battle of Golden Hill, 1770. **1.69.** *The Patriotick Barber of New York*, 1774. **1.70.** Bernard Ratzer, Map, ca. 1770.

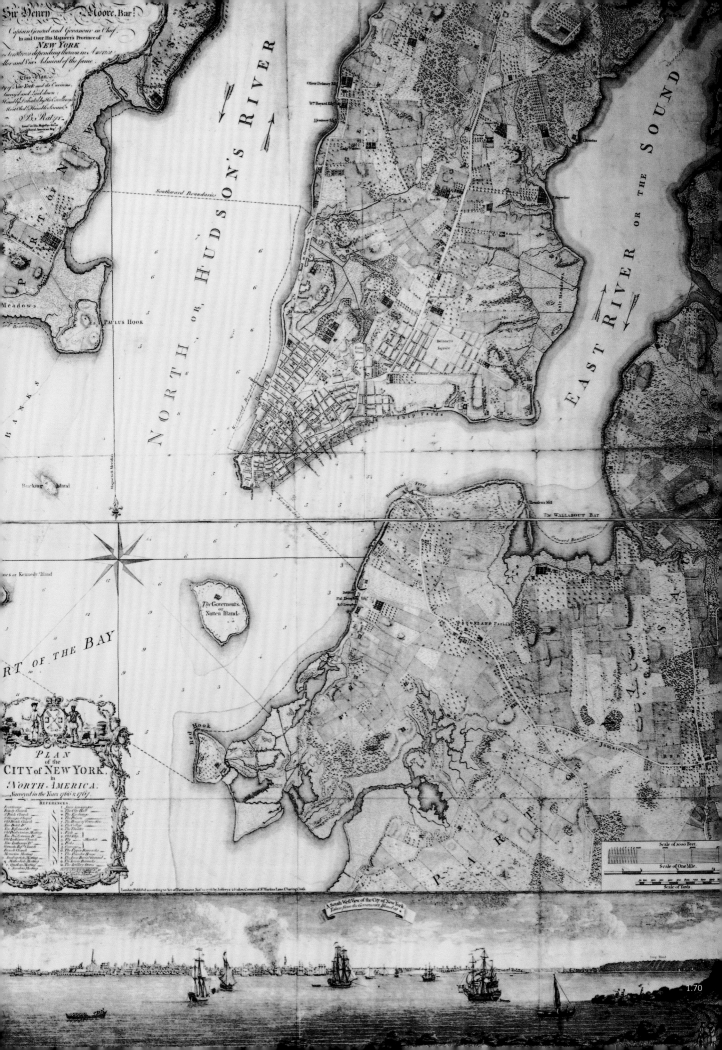

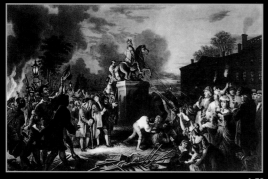

boarded and the tea dumped overboard. The notorious Coercive Acts followed, and though aimed only at Massachusetts, they electrified New York after Paul Revere, traveling on horseback, informed the city. British rule crumbled. The city came under the governance of moderates, largely merchants, and more radical figures representing the city's artisans through the so-called Committee of Mechanics. The two worked together in cautious alliance as the mechanics moved toward a position of ever greater power.

The tension in the city as the British lost power and public anger escalated against British soldiers stationed in the city can be seen in the cartoon *The Patriotick Barber of New York* (1.69). Though printed in England, it depicted a pro-American New York scene on Barclay Street in which barber Jacob Vandenburgh, a well-known Son of Liberty, refuses to shave Captain John Crozer. Crozer had entered the shop disguised but when identified was forced to leave half shaved. In the background are a number of wigs, no doubt symbolic of Whig ideals, and posted on the wall are the "Articles of Association," the agreement of the city's merchants not to trade with Britain and a copy of a speech by the American champion, William Pitt, now Lord Chatham. Names of the Sons of Liberty are on the boxes in the forefront.

The political situation deteriorated rapidly after the tea party. The provincial assembly replaced the assembly, which had lost all power, while New York City continued under the governance of an ad hoc committee of mechanics and merchants. The British withdrew from the city and abandoned Fort George. Many representatives of New York's large Loyalist following left for England. A state of siege settled over the city after General Washington sent General Charles Lee to prepare the island's defenses.

After Lexington, Concord, and Bunker Hill, the British decided to move their operations to New York, a more central North American location with a larger

1.71 Archibald Robertson, British troops off Staten Island.
1.72. John McRae, Tearing down the statue of George III.
1.73. Proclamation of General Washington. **1.74.** Thomas Davies, Battle of Fort Washington, 1776.

proportion of British followers. The British forces, numbering over thirty-two thousand sailors and soldiers and representing 40 percent of the ships and men of the Royal Navy, arrived in the fleet captained by Admiral Sir Richard Howe, who was accompanied by his brother, General Sir William Howe, the overall commander. The citizens of New York lined the wharves to gape in wonderment as vessel after vessel—over one hundred and twenty—sailed into the harbor. Captain Archibald Robertson, an army engineer, drew a watercolor depicting the event on July 12, shortly before the invasion (1.71). Prior to the arrival of the British forces, Washington had marched his troops from New England and posted them in the city. At that time, he issued a proclamation to the city's citizens warning of an impending British attack (1.73). He finally ordered all civilians out of the city on August 17.

Washington had more than ten thousand troops in New York and had increased fortifications, among other defenses, constructing Forts Washington and Lee on opposite sides of the Hudson to prevent British penetration. Ten days after the British arrived, the Declaration of Independence was read aloud to American troops, who immediately marched to the statue of George III erected six years earlier and toppled it, intending to use its four thousand pounds of lead for bullets. This event was often pictured by artists, among them, John McRae, who produced a stirring image in 1850, based on an earlier engraving (1.72).

British rule crumbled.

The British had a disciplined professional army, one of the best in the world. The forces were well equipped and experts on the topography of the country they were planning to subdue. A map made around 1770 by Lieutenant Bernard Ratzer, an engineer in the Sixtieth Foot Regiment, was likely used by both General Howe and the war office to plan military strategy (1.70). The territory it depicts extends to what is today Fiftieth Street and includes parts of Long Island and New Jersey.

For the Battle of Long Island, Washington stationed the bulk of his men in Manhattan and across the island in

1.74

1.75

Brooklyn, today's Brooklyn Heights. Because of high ground there, he hoped that the British would launch a frontal charge similar to the one at Bunker Hill and suffer like consequences. Instead, Howe landed his troops from Staten Island and marched secretly overnight into Jamaica Pass, which the Americans had left virtually unguarded. With this maneuver, the British caught the Americans from two sides and forced them to flee to their fortifications on the East River. Had Howe chosen to close off the river with his fleet, all might have been lost. But fearing heavy casualties and possible fire boats and still hoping for a peaceful settlement, he decided to forgo this option, and Washington brought his men back to New York. Even then Howe might have landed in mid-Manhattan and trapped the American army in the city, but again he delayed, and the American forces escaped to Harlem Heights and then north to White Plains and New Jersey. The Battle of Long Island was a tremendous disaster for the Americans. Yet although they

Ten days after the British arrived, the Declaration of Independence was read aloud to American troops.

lost the city, the army survived to fight another day.

Against his better judgment Washington agreed to hold on to Fort Washington, hoping that its height and escape routes on the Hudson would secure its three thousand men and military supplies. This turned out to be a major blunder: Howe laid siege to the fort and gained control of the river, forcing the surrender of all the men and ammunition. Washington quickly retreated to New Jersey in desperate straits with losses totaling thirty-six hundred killed or wounded and four thousand captured and his generals losing confidence in his leadership.

Artillery Captain Thomas Davies, already in his third tour of duty in America, made sketches of the Battle of Fort Washington and the capture of Fort Lee. In the first sketch, a view from the Harlem River, the British frigate *Pearl* is firing at Fort Washington (1.74). British ships are clearly in control of both waterways. The house on the lower right belonged to John Nagle; built in 1736, it was located at what are

today Tenth Avenue and 213th Street. Harlem Heights, where Washington briefly held out after retreating from the city, is visible in the rural, uninhabited wilds of upper Manhattan.

The second drawing by Davies illustrates the attack on Fort Lee, which is located in New Jersey, directly across the Hudson from Fort Washington (1.75). Advance warning allowed the Americans to evacuate before the British arrival, four days after the loss of Fort Washington on November 16. The British had hoped to trap the Americans by executing a difficult assault, led by General Cornwallis, in which men climbed a trail up the Palisades. The Americans escaped, but not without losing valuable supplies. With this crushing defeat, it only seemed a matter of time before Washington surrendered.

After its capture in the summer of 1776, New York remained in British hands, serving as military headquarters until 1783. This long period of occupation began most inauspiciously with a major, though accidental conflagration that started in a tavern on September 20 and destroyed between five hundred and one thousand dwellings and buildings, one-quarter of the city. Trinity Church was among the losses, and a Thomas Barrow engraving of Trinity in ruins is the most notable visual evidence of this fire (1.77).

Loyalists flocked to the city, swelling the population to thirty thousand. They were joined by troops moving in and out, sometimes as many as ten thousand at a time. Many of the new residents were wealthy, and the city was alive with theatrical productions, assemblies, and sporting events. Eight hundred slaves, offered their freedom, joined the British ranks in Brooklyn. Many more deserted their masters and fled to the city and nearby regions under British control. Some lived in primitive conditions outside the city.

For much of the population, embitterment followed joy. The British ruled by military law, refusing to permit civilian government. Soldiers plundered frequently, and shortages were constant, especially in housing. Many refugees resorted to living in tents. Inflation

was exorbitant, with up to 800 percent increases in food and fuel prices. Meanwhile, British officers and commanders lived more comfortably than ever. Corruption was rampant.

From the American standpoint, by far the most noteworthy aspect of occupation was the use of the city to house American prisoners. Up to eight hundred were kept in the infamous Provost Prison, and hundreds more were incarcerated in the cavernous Rhinelander

1.76

1.75. Thomas Davies, *Attack on Fort Lee*, 1776.
1.76. *Jersey* prison ship. **1.77.** Thomas Barrow, *Ruins of Trinity Church*, 1780.

1.77

Sugar House. There men starved to death or died of smallpox, yellow fever, or cholera, not to mention because of the brutal treatment under Provost Marshall William Cunningham. As many as two thousand may have died. Worse yet were the prison ships, up to twenty in New York harbor, the most notorious being the *Jersey* (1.76). There, men became walking skeletons, deprived of food and fresh air. Before the war ended, eleven thousand five hundred died. The memory of this terrible corollary of British occupation—vividly rendered in this engraving of a scene from the *Jersey*—embittered Americans for generations.

The final chapter of the war was a disaster for Loyalists in the city. Harassed by patriots coming to reclaim their property and threatened by confiscatory laws, forty thousand abandoned New York, along with four thousand former slaves. Patriots filled the streets, American flags flew from every house, and the American troops, led by General Washington, marched down the Bowery to Pearl Street. That night a grand dinner was held at Fraunces Tavern, and illuminations lit the sky over a city jubilant in celebration. There are many illustrations marking this event, though none are contemporary. One engraving of Washington's victorious march through the city was based on a painting by Howard Pyle, who worked for *Harper's Weekly* and was known for the careful way he researched the subjects of his many historical works of art (1.78). The day was a holiday in New York for a century after 1783.

1.78. Howard Pyle, Evacuation day.

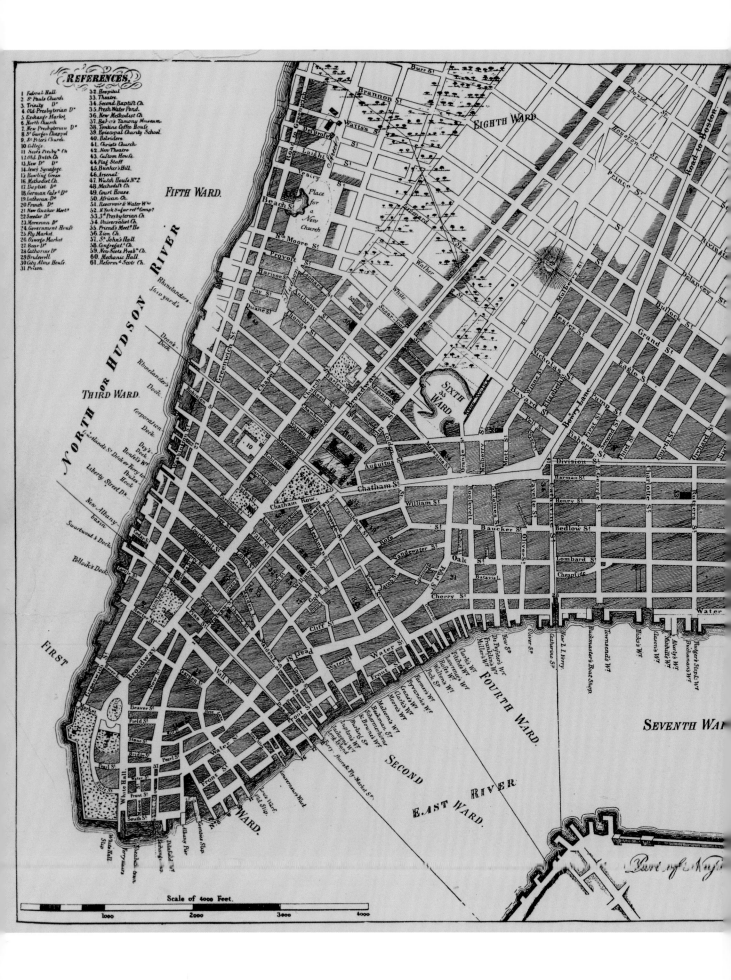

FIFTH WARD.

EIGHTH WARD

NORTH OR HUDSON RIVER

THIRD WARD.

Rhinelander's Ship yard's

Drark Dock

Rhinelander's Dock

Corporation Dock

Dey's Dock

Bennets W°f Dock

Cortlandt St Dock or Ferry to Paulis Hook

New Albany Bassin

Liberty Street Dock

Sweetwent's Dock

Pollock's Dock

SIXTH 9/5 WARD

Place for a New Church

FIRST

WARD

BROADWAY

FOURTH WARD.

SECOND

EAST WARD.

EAST RIVER

SEVENTH WAR

Water

New S°
Oliver S°
Catharine S°
New I.I. Ferry
Buckmaster's Boat Shop
Townsend's W°f
Fleks W°f
Masons W°f
Always W°f
Buchanans W°f
Nichols W°f
Rutgers Slip & W°f

Scale of 4000 Feet.

1000 2000 3000 4000

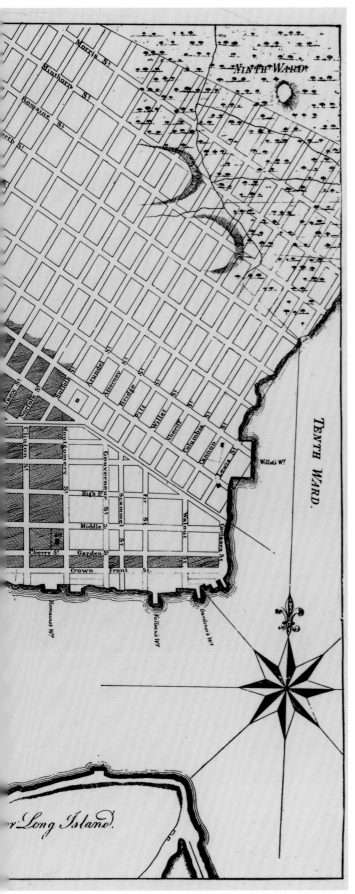

2

1784-1829

The American Revolution left Americans, including New Yorkers of every condition, in a mood of high optimism. To many citizens, particularly those of the middling and lower ranks, the country's independence meant an end to limitations on social and economic opportunity. Indeed, New York in this era saw remarkable growth. Geographically the city spread well beyond its colonial confines, moving steadily up the island. The Collect Pond was filled, streets were graded and extended, and an overall grid plan was designed and implemented. A map from 1808 indicates the scope of the city's growth as it extended its northern boundaries year by year (2.1). The population grew from 18,000 at the end of the revolution to 33,000 by 1790, 60,439 in 1800, 96,373 in 1810, 123,706 in 1820, and 197,112 in 1830, an overall increase of more than one thousand percent. The modest though prosperous colonial seaport became the nation's largest metropolis and its economic capital.

Its population already the most heterogeneous of any city in the republic, New York grew even more

diverse with the increasing immigration of the Irish. New neighborhoods sprang up; old neighborhoods changed. Financial growth was strong but not uniform, and if the hopes of some were fulfilled, others became disenchanted as their economic and social horizons shrank. New York's politics were tough and bitter, played out within the new republican spirit. Culturally the city blossomed with theater, music, and its first public art gallery. New construction included fifty-nine churches and a City Hall that remains an architectural masterpiece. To live in New York after the Revolution was never dull: not easy, sometimes perilous, but imbued with an energy and drive stimulated by the Spirit of '76. New York was defining what it meant to be a city in a new republic.

The best way to get an overview of republican New York is to wander from the tip of Manhattan outward, as a visitor might have done. While living in New York in 1790, President George Washington was fond of taking a fourteen-mile round-trip excursion through the city, up the island, and then back.

New York remained, of course, a port city in the nation's most favorable harbor, and any journey should start at the water's edge. No resident lived more than a few minutes' walk from the Hudson or East River, and awareness of water was omnipresent. A 1793 drawing by Alexander and Archibald Robertson, who established their own art academy in the city, looks east toward the city from the Hudson (2.3). The scene depicts New York from just above Wall Street to the Battery, at the tip of the island.

Given the era of optimistic patriotism, the American flag occupies the center of the drawing. Notable landmarks are, from the left (north), Trinity Church. The dome to the right of the mast belongs to City Hall. The large structure just north of

the flag is the Government House, built to house the offices of the federal government and later used as a customs house and museum. A heterogeneous population amid the wealthiest buildings signals the republican spirit of New York, particularly in the 1790s.

Bowling Green was the elite's favored place of resi-

Bowling Green. 1827.

2.2

2.1. New York map, 1808. **2.2.** Millionaires Row, on Greenwich Street. **2.3.** Robertson view of New York, 1793. **2.4.** William Bennett, Battery and Bowling Green, 1826.

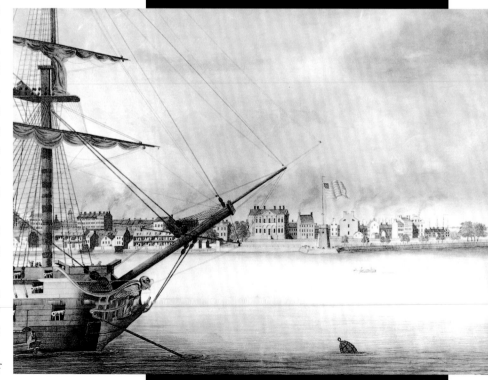

2.3

50

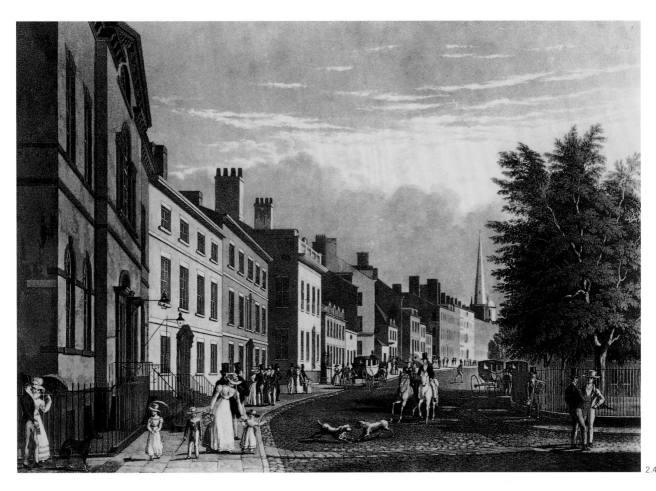

dence throughout the early national era. Prior to the Revolution the park area had been maintained privately by individuals who were likely repaid for their efforts by bowling fees. After the Revolution, the Battery area became the site for promenade and recreation for all citizens, for revelry on the Fourth of July, and for public mourning after the deaths of Hamilton and Washington.

The elegance of this section of the seaport grew throughout the era, and by 1826, the date of an aquatint by William Bennett, it displayed all the signs of wealth appropriate to the nations's most prosperous metropolis (2.4). As more and more merchants enriched by the city's booming trade built separate Federal mansions, they chose to situate their houses in Bowling Green. Some buildings dated to the colonial era, such as the Kennedy Mansion, visible at the left of the engraving. At this time it was occupied by the French consul, a lady's boarding school, and other tenants, before passing in 1810 to the Prine family. Later it became a hotel, the

Washington, which it remained until the 1850s. Next to the Kennedy mansion, at 3 Broadway, was the home of John Watts, Esq., and next to that the mansion of Robert R. Livingston, perhaps the state's most renowned citizen, scion of the family and the chancellor of the state. The next two homes were the Stevens domicile and the Van Cortland mansion, later Atlantic Gardens, at this time partly in use as a boarding school run by Miss Eliza Casey. At the top of the picture Broadway continues toward Trinity and Grace churches.

These mansions were built of brick and stone in the Federal style. Attractive but not ostentatious, they were commonly symmetrical, often with dormer windows on the third floor, a high stoop, and a recessed front door. Wealth and its displays eventually challenged Republican simplicity, but prior to the 1830s these neighborhoods were not exclusive, and artisans and even laborers could be found living nearby. The area was also heavily at risk during yellow fever epidemics.

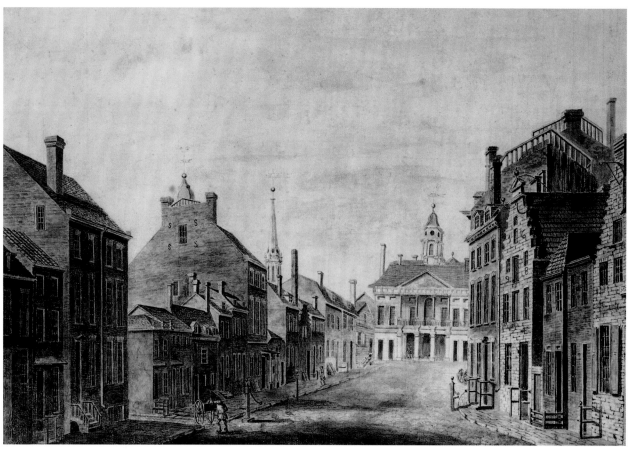

2.5

In 1815, after the War of 1812, the city sold the land of the Custom House to developers, who then built Millionaires Row (or "Nob Row," after nabob) on Greenwich Street from the Battery to Morris Street (2.2). Some of the city's wealthiest men settled there, including auctioneer John Hone, Jr., at 1 Bowling Green, and, next door, merchant Peter Schenk, a pioneering manufacturer of cotton goods who had a factory at Fishkill Landing. While some of the wealthier families were moving up Broadway, the Bowling Green area remained popular throughout the Republican era.

Heading north from the merchant homes, a block west on Pearl Street—the thoroughfare famous for the retail and wholesale outlets of the city's mercantile elite—and then north again on Broad Street would bring one to the noted intersection of Broad and Wall Streets. A 1797 view communicates the preindustrial atmosphere of old buildings and mixed architecture, free of the sense of haste and commercial ambition that was already so much a part of the city's character (2.5). The lithograph derived from a drawing by John Joseph Holland, a theatrical scene painter, which partly

accounts for its style. The building at the center is City Hall, with the steeple of St. Paul's visible to the left. This was a mixed neighborhood, as were nearly all but the outer wards prior to 1800. The building at the southwest corner of Wall and Broad, Dutch-framed and gabled, was owned by a tailor and occupied by a widow. There, Alexander Hamilton confronted a hostile crowd to defend the Jay Treaty in 1795. The homes were occupied (and often rented by) middling residents, among them a schoolmistress, a tailor, and a cooper, along with merchants and gentlemen, such as Lemountis Noe, who owned the large building with the weathervane. Washington stood on the balcony of City Hall, facing Broad Street, when he took his first inaugural oath in 1789. The view, leading to City Hall, site of the beginning of the new American government, is a statement of republican simplicity in an increasingly complex city.

A right turn on Wall Street at City Hall followed by a three-block stroll would bring one to the Tontine Coffee House, the commercial center of the city. Using a tontine association, five merchants built this commercial mecca in 1792–93 on the site of the old

2.6

Merchants' Coffee House. A large painting by Francis Guy wondrously catches the spirit of commercial New York (2.6). Merchants inspect their wares at its center; the wooden store behind them sold furniture. This was the heart of the New York financial district, although residences were scattered throughout the area. The city's banks were located near the Tontine, the early home of the nascent stock market.

The docks were the gateway to the city. Goods vital to the lives of New Yorkers entered by both local ferry and ocean-bound sail, and merchants imported and exported wares for both the city and hinterlands. An engraving by William Bennett of South Street and Maiden Lane depicts energetic activity reminiscent of the bustle of merchants in the scene of the Tontine Coffee House, but thirty years have passed, and the growth of the city and its buildings is startling (2.7). Four-story brick mercantile buildings, the working quarters of retailers and wholesalers, have replaced the ramshackle artisan shops of the earlier decade. The city's trade exports, which already totaled over $2.5 million in 1790, had reached $35 million by 1825.

The population was denser, the boats more closely packed, and the buildings taller. New York's commercial lead over its sister seaport cities widened every year as it became the nation's financial capital. South Street itself, seventy feet wide, was created between 1798 and 1801 by order of the Common Council to improve the piers. New sea walls were built, and then the space between them was filled in with rubbish; soon afterward three- to four-story warehouses fronted the docks.

Crossing the island to the Hudson River docks, one would find a scene of similar mercantile endeavor, although the details differed. In place of ocean and coastal schooners, elongated canal boats appear. The opening of the Erie Canal in 1825 ensured New York's place as the largest city in the country and entry point for immigrants seeking a water route to the West. Docked on the Hudson, canal boats intending to sail to

2.5. John Holland, Broad Street, 1797. **2.6.** Francis Guy, Tontine Coffee House, ca. 1798.

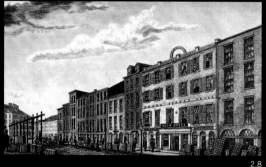

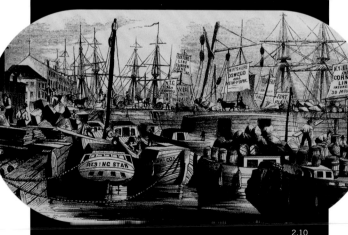

Albany and from there to be pulled by mules or horses to Buffalo lay alongside sailing ships that would likewise travel to Albany before connecting with canal boats for the trip to Buffalo, Oswego, and points west (2.10). Most of these ships carried freight, as New York became the nation's foremost point of embarkation for exports from the hinterlands and goods going inland.

Further North, Pearl Street, once the main thoroughfare of New Amsterdam and formerly fronting the East River, was now a favored location for the businesses of many prominent merchants, wholesale and retail (2.8). The street was known for warehouses, stores, and some of the finest establishments in the city. In the 1790s the stores lacked display windows, but one of the Peabody views drawn and engraved by M. Osborne in 1830 shows large windows filled with appealing consumer displays. Gotham's shoppers found their way to Pearl Street to acquire furnishings for their homes or to make other major purchases. The growing wealth of the elite fostered a robust consumerism, but it also signaled a threat to republican equality. Disparities in income increased, and by 1800 the top 20 percent owned 80 percent of the city's assessed wealth, while the lower 50 percent owned only 5 percent.

In 1789 one had only to travel a mere fifteen blocks north of the Tontine Coffee House to trade commercial bustle for bucolic peace. Archibald Robertson captured such a scene, a drawing of the Collect Pond (from the Dutch "Kolch"), a small freshwater lake at the present site of Foley Square (2.9). In the winter it was a popular gathering place for ice skaters, while in warmer weather it was a site for hikes and picnics, the high hill to the east of Broadway being an especial favorite. As the city expanded northward, however, the peaceful lake fell victim to the commercial needs of the city. Once the source of the nearby Tea Water pump that for a time supplied the city with its best drinking water, by the end of the eighteenth century it was becoming polluted and noxious from dumping. Between 1803 and 1811 a canal was dug to drain it. Canal Street, one hundred feet wide, had at its center the ditch emptying the Collect (2.11). Bordered with

2.7. William Bennett, South Street and Maiden Lane, 1827. **2.8.** M. Osborne, Pearl Street, 1830. **2.9.** Archibald Robinson, Collect Pond, 1798. **2.10.** Canal boats on the Hudson River. **2.11.** Canal Street.

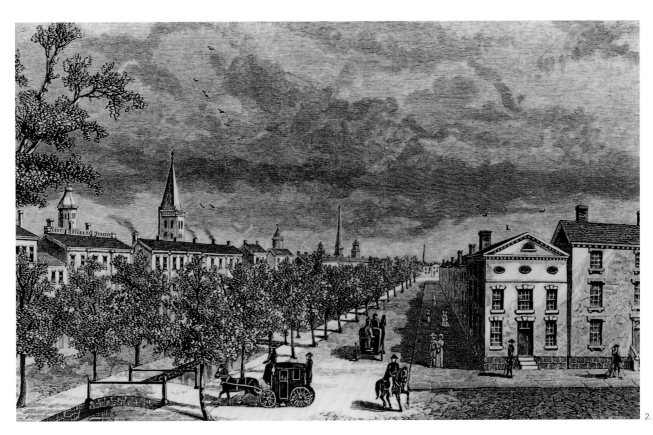

2.11

shade trees, it stretched northwest from Broadway to the Hudson River. Despite its bucolic appearance, the canal soon became an odoriferous public sewer and was covered in 1819. Even this did not solve the problem, however; lacking air traps, it remained a sewer, if a closed one.

Most of the city's working population, from artisans and grocers and other small merchants to cartmen, unskilled laborers, blacks, and immigrants, dwelt north of the business center of the city in the outer wards, the Fourth through the Seventh. The Fourth Ward was a middling sector of the city, with over 50 percent of the holding property valued between one and ten thousand dollars. Buildings were wooden rather than brick or stone; streets were narrow and often unpaved, making for perilous going in winter and rain; neighborhoods were crowded; trees were less common and parks nonexistent.

William P. Chappel produced a number of scenes of the New York of his childhood from memory. Born to Huguenot parents, he worked in the city as a tinsmith.

Republican New York

was a walking city.

This Fourth Ward scene, *The Dog Killer and Cart* (1813), is set near the docks, between Roosevelt and Dover (2.13). At the right is a bootmaker's shop with its traditional sign. Behind the gate is a boardinghouse, possibly owned by Daniel Davis, where single journeymen, apprentices, and sailors commonly resided. Next to that, wares on display, is a tailor's store, likely that of Elizabeth Davis. Adjoining this store is a grocery, where food and drink were readily available. (The Humane Society reported in 1810 that one of every seven families supported themselves, at least in part, by selling liquor; by 1817 the city issued licenses to over two thousand groceries and taverns to sell "strong drink.") In the foreground a dog killer collects a victim, trailing blood from the boardinghouse. Wandering animals constituted one of the chief nuisances in early national and antebellum New York City.

A lithograph of Provost and Chapel Streets in the Fifth Ward, based on a drawing by a French visitor, was produced in 1815 and published in Paris in 1825

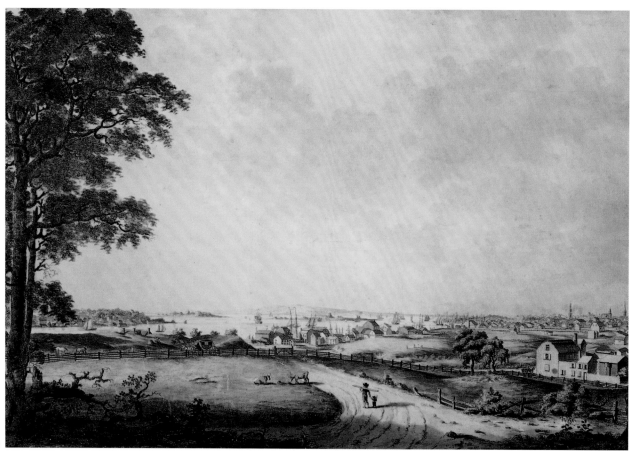

2.12

(2.15). Buildings faced the street in front with an alley in back. In the rear were yards and sheds, along with privies and workshops. The yards held vegetable gardens and animal pens. Hogs, the most common animals, also roamed the streets. While they caused serious hazards they also did much to control the garbage problem in the outer wards. For many families they meant the difference between starvation and survival during the harsh winter months. (Because of this, they remained on the streets into the 1850s despite constant complaints.) Homes such as these were nearly always rented by their occupants and contained numerous residents. They could hold three or four journeymen fami-

2.13

lies as well as a few single boarders. Intense crowding was becoming common in the early republic.

A famous engraving of Five Points, executed in 1828, offers a Brueghelesque view of a crowded area at Anthony and Cross Streets in the Sixth Ward (2.14). The artist, while picturing the many groceries and liquor shops and other wooden frame structures that would have housed large families in one- to two-room apartments, depicts a profusion of classes mixing in the streets, from a dandy with a monocle, through merchants and retailers, to rowdies of all races. Among the wandering pigs are carriages carrying members of the elite past men fighting in the street. Although densely crowded and the poorest sector of the city, Five Points was still a crossroads traversed by all classes. Twenty years later the area would become the most notorious section of the city, noted for its crime, gambling, prostitution, and abject poverty. It was also the

2.12. Charles-Balthazar-Julien Fevret de Saint Memin, view from Mount Pitt. **2.13.** William P. Chappel, *The Dog Killer and Cart.* **2.14.** Five Points, 1827. **2.15.** Provost and Chapel Streets, 1815.

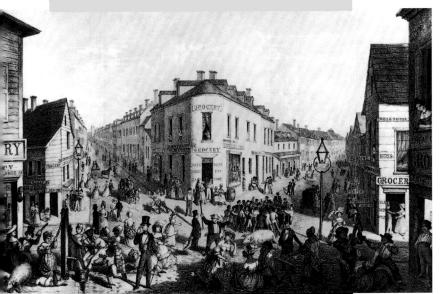

2.14

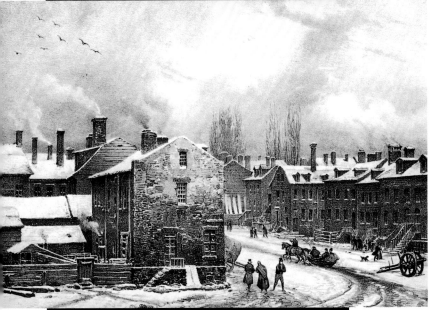

2.15

Five Points

was a crossroads,

traversed by

all classes.

home of many of the city's African-American residents.

Republican New York was a walking city. As crowded as the city could be, it encompassed but a few miles of the lower end of Manhattan, only stretching just beyond Houston Street by 1830. Further north, outer ward homes, shops, and manufactories soon gave way to farms and country estates. It took less than an hour from the bustling activity of Pearl and South streets or from the crowded dwellings in the Fifth Ward to reach a country setting. Nowhere is this better portrayed than in the famed Mount Pitt view executed in 1796 (2.12). Saint Pitt, at the lower right, belonged to Robert Livingston, who purchased it after it was seized as a Loyalist estate. The meandering country lane is the present Division Street. The hamlet in the center surrounds the United States naval yard. The spires and masts of the city can be seen in the background, while the tip of Long Island is visible on the left. I. M. Phelps Stokes notes that this drawing, one of the two "most beautiful views of late eighteenth-century New York that exists," inspired his *Iconography of Manhattan Island*.[1]

Beyond the city boundaries, Manhattan Island was the setting for a number of prominent country estates. One such, Richmond Hill, was engraved for *New York Magazine* in 1799 (2.17). At one time the home of Vice Presidents John Adams and Aaron Burr, it was one of the finest manors on Manhattan, located in today's Greenwich Village near MacDougal and Charleston and overlooking the Hudson River. As Mrs. Adams noted, in front of her the "noble Hudson rolls its majestic waves," to the north were plains and "pastures full of cattle," and to the south stood city buildings, especially church spires. Pines and oaks added beauty, while "the partridge, woodcock and the pigeon" provided a "lovely variety of birds serenade."[2]

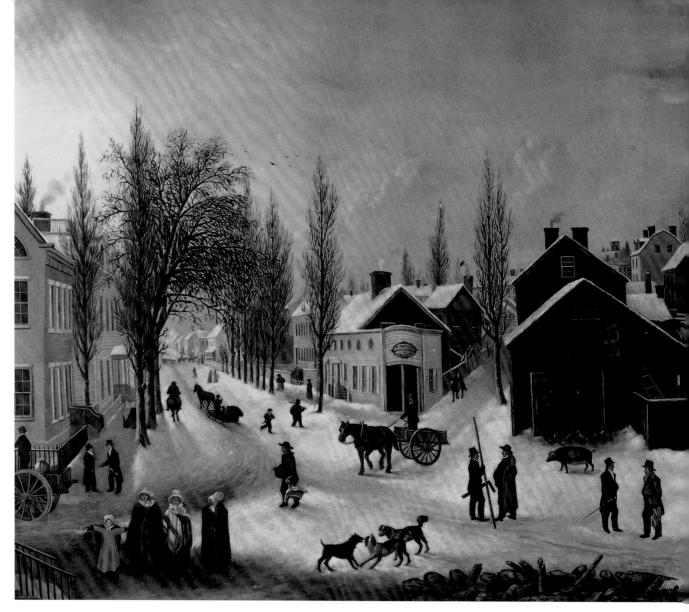

Farther out, Harlem remained a quiet Dutch country village, a good spot for a day's outing or even a vacation or safe retreat from the ravages of yellow fever. A 1798 drawing by Archibald Robertson depicts Harlem's third church, built in 1788, its roof and spire painted red (2.18). If it were standing today this church would be found on First Avenue between 124th and 125th streets.

Brooklyn was a small town across the river from Manhattan, a city of craftsmen and modest merchants, as captured in Francis Guy's famous winter scene, dating from 1817 to 1820 (2.16). The building at the center left, behind the cartmen, is Benjamin Meeker's house and carpenter shop. Across the street is a barn and slaughterhouse. The white frame house to the right is the home of Thomas

Birdsall, and next door is a butcher shop. Also depicted are a blacksmith's, a carriage shop, a wood yard, and Mrs. Chester's coffee room (behind the open yard in the middle of the painting).

New York City rose to economic dominance in the early nineteenth century because of its unequaled natural harbor, only seventeen miles from the Atlantic, its deepwater harbors on the East River and then the Hudson, and the opening of the Erie Canal, which made the city the center of both immigration and national trade to the West. By 1821 38 percent of the nation's import commerce was conducted in New York; by 1836 this proportion increased to 62 percent. The city was the center of the investment banking and stock trades. Behind all this stood an aggressive and inventive merchant class

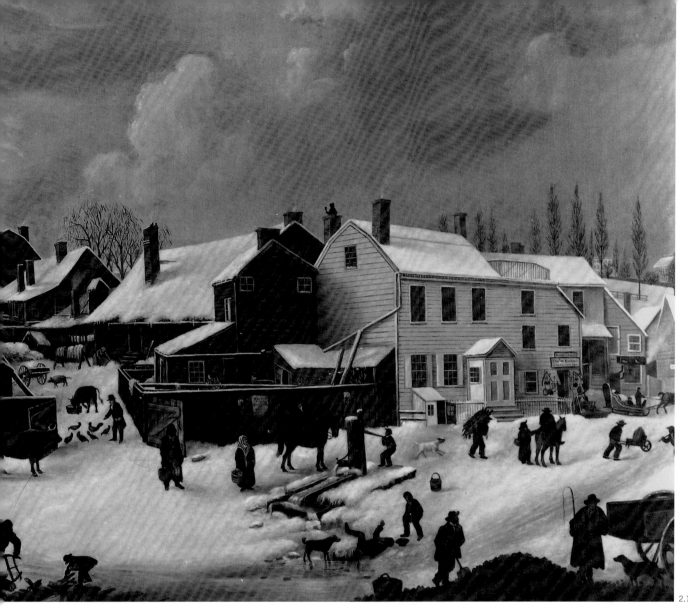

that came to dominate American trade with Latin America, Europe, and China, as well as the cotton trade. The city's mercantile elite now included immigrants such as John Jacob Astor and New Englanders such as Arthur and Lewis Tappan. Many Yankee entrepreneurs migrated to New York, whose commercial horizons were not to be equaled.

The most prominent early symbol of the merchant's standing was the Tontine Coffee House, which also served as the first stock market. In 1827 the merchants built a new exchange. A distinguished structure designed by Martin Thompson, it was one of the first buildings constructed in the Greek Revival mode (2.20). The interior featured a grand rotunda, majestic windows, and tall classical columns (2.21). The structure communicated commercial grandeur in a republi-

can vernacular, worthy of a capitol building of the financial capital. The exchange burned down in 1835.

Stocks—largely government, bank, and insurance bonds—were first sold on Wall Street in 1792 and later in the Tontine Coffee House and then in the Merchants' Exchange. Although the number of securities remained limited throughout the early national era, this did not prevent speculation and panic. The Duer Panic of 1792 ensued when former Assistant Secretary of the Treasury William Duer unscrupulously pushed up the stock of the city's banks, only to see them collapse. The experience was painful

2.16. Francis Guy, Brooklyn, 1817–20. **2.17.** Cornelius Tiebout, Richmond Hill, 1790. **2.18.** Archibald Robertson, Harlem, 1798.

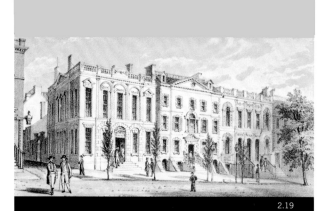

2.19

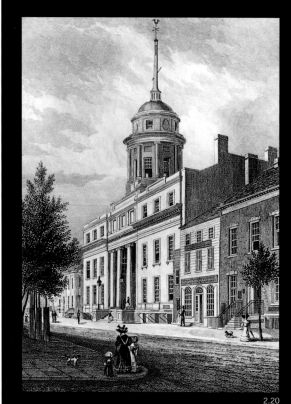

2.20

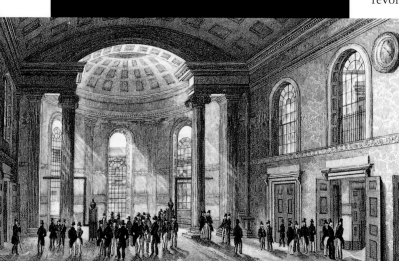

2.21

for merchants and artisans, many of whom lost money as a result of this fraudulent scheme.

New York's success in achieving commercial prominence stemmed not only from the economic acumen of its merchants but from the use of financial instruments and institutions. Banking supplied both commercial and investment capital. As early as 1798 Wall Street boasted two major banks. The Bank of New York, on Wall and William, was the city's first bank, chartered in 1784 under a document written by Alexander Hamilton. To its right stood the New York Insurance Company, founded in 1798 to provide fire insurance; next to it is a branch of the First Bank of the United States (2.19).

Although there were only five banks in the city prior to the War of 1812, by 1825 there were twenty-four, far more than in any other city. The credit offered by these banks helped the city capture the cotton trade from a South lacking financial resources and capital. Indeed, as early as 1810 one-quarter of the cotton traveling from the South to Liverpool went through New York. Banking was not seen as unrepublican as long as it was available to all. Credit was in great demand, by financiers and merchants but also by artisans, who sought to expand their enterprises. All banking institutions issued bank notes that were accepted as cash, though sometimes at a discount. New York's banks also discounted notes of other banks and of merchants.

Part of the business revolution that allowed a rapid expansion of the U.S. economy prior to the industrial revolution involved the growth of secure information from newspapers, incorporation, and insurance. Enterprise was much more likely if risks could be reduced through insurance, and New York was an important supplier of marine and fire insurance. A number of emblems, such as an engraving of firemen quenching a blaze, seek to communicate the importance of this industry. Alexander Anderson (1775–1872), one of the foremost engravers of his age, designed the Mutual Assurance Company logo, among others (2.22). Anderson was educated as a medical student but gave this up to become one of the city's finest artists, depicting many

[No. 680]

Mutual Affurance Company,

)R I N S U R

S E S From L

[R E, I n NEW

HIS POLICY Witneffeth, That

Thomas Randall

ne, and by thefe Prefents becoming a Member of the MUTUAL ASSURANCE COMPANY of the City of New-York, purfuant to a Deed of Settl

2.22

aspects of metropolitan life.

New York proprietors, from artisans to merchants, sought to enter the new marketplace and take advantage of economic opportunities promised by the American Revolution. Nowhere can this better be seen than in the numerous advertisements, trade cards, and broadsides issued by the city's entrepreneurs, large and small. Great expectations were not always fulfilled, but optimism rarely waned in the early republic; indeed, trade cards often incorporated patriotic themes. While many artisan ads were simple, others—such as the one reproduced here, created for Samuel

Behind New York City's rise to American economic dominance was an aggressive and inventive merchant class.

Maverick, a copper-plate printer, by the well-known engraver Peter Maverick—could be quite elaborate (2.27).

The city's most populous sector, the heart and soul of early national New York, was the artisan community. Composing perhaps 60 percent of the metropolitan work force, artisans (also known as mechanics, craftsmen, and tradesmen) occupied the center of the preindustrial seaport economy. They could be both employers (masters) and wage earners (journeymen). Their professional identities derived from traditional skills acquired over long years of training through apprenticeship and journeyman standing. By definition skilled laborers, they possessed their own tools and the "mystery" of their particular crafts. Although the climb from journeyman to master craftsman was becoming more difficult and less frequent, some achieved finan-

2.19. Banks and insurance company, Wall Street. **2.20.** Merchants' Exchange. **2.21.** Merchants' Exchange, interior, 1831.
2.22. Alexander Anderson, Mutual Insurance Company.

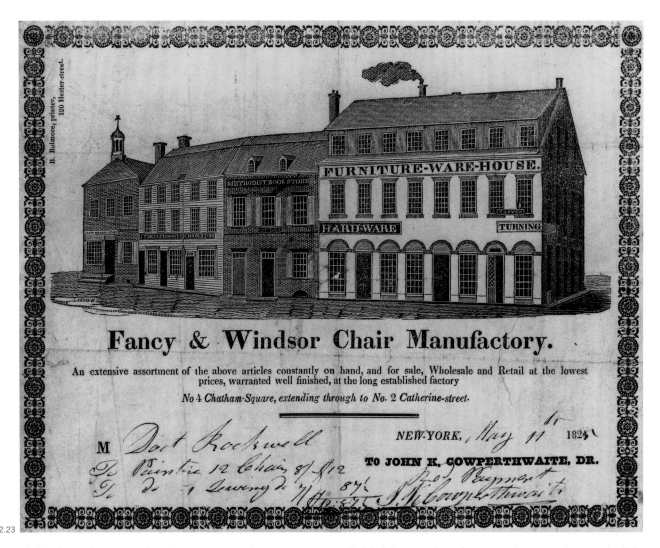

METHODIST BOOK STORE

FURNITURE-WARE-HOUSE.

HARD-WARE

CARVER

TURNING

Fancy & Windsor Chair Manufactory.

An extensive assortment of the above articles constantly on hand, and for sale, Wholesale and Retail at the lowest prices, warranted well finished, at the long established factory

No 4 Chatham-Square, extending through to No. 2 Catherine-street.

M NEW-YORK, May 11 1824

TO JOHN K. COWPERTHWAITE, DR.

2.23

cial independence, earning incomes, amassing wealth, and establishing businesses on a scale not possible in colonial America. Artisans found a place either in the burgeoning local market made possible by the city's dramatic growth and/or in the expanding export trade with its outlets to other markets, particularly the South and the West Indies. One of the most-well-known professions was chair making, a branch of cabinetmaking. New York was a center of this trade, and the size of this enterprise in the Eighth Ward is representative of the increasingly large-scale artisan operations to be found throughout the city.

A master owning such an enterprise would employ journeymen and apprentices working on the different floors of a manufactory/warehouse such as the one pictured in this broadside (2.23). Many of these workers would be highly skilled, and the labor would be divided into such tasks as carving, turning, and gilding. Local sale of the chairs manufactured in this concern took place two doors down at the Chair Store, also depicted in the broadside. Merchants could also buy wholesale from the warehouse for direct export shipment from nearby docks. The broadside also pictures a hat manufactory at the left of the warehouse. Hats were another item produced in large quantities in New York for both local consumption and export.

2.24

Cabinetmakers both crafted the nation's finest wood products and manufactured chairs, particularly Windsor chairs, by the thousands. A trade bill for W. Buttre's Fancy Chair Manufactory illustrates the interior of the establishment (2.25). Supervised by the master, highly skilled journeymen perform tasks as varied as turning (using the lathe), painting, weaving chair bottoms, and lacquering. New York's most prominent

cabinetmaker was Duncan Phyfe, an immigrant Scotsman who arrived in New York nearly penniless and eventually owned a warehouse, showroom, and workshop that employed over one hundred journeymen. Phyfe was a master of Federal furniture making. This eagle back chair (1810–15) is a product of Phyfe, replete with carefully carved legs, fine upholstery, and republican eagle (2.24). The new style, influenced by Thomas Sheraton, had more intricate engraving and a lighter touch than eighteenth-century styles. The picture of Phyfe, tool in hand, was probably made by a fellow craftsman (2.26).

The seaport sustained artisans as they maintained the seaport, as a depot not only for local manufactures but also for the production and outfitting of ocean-worthy vessels. Shipbuilding was the largest craft undertaking in this and other republican cities. It involved the combined work of shipwrights, riggers, caulkers, sailmakers, ropemakers, and other skilled mechanics. Master shipwrights often worked as contractors, hiring other masters who in turn hired journeymen for particular aspects of a job. In the case of a government-commissioned naval boat, the navy would hire masters who would hire journeymen or other masters as necessary. In this painting of the launching of the battleship *Ohio*, the variety of boats in the harbor, including an early steamboat, indicates the extent of the work performed in this trade (2.29). The festivities accompanying the launching are but one sign of the patriotic republican spirit that dominated all aspects of urban life in the generation after the Revolution and was particularly strong in the craftsman community. The Brooklyn Naval Yard produced the nation's top frigates, including the *Ohio*, launched on May 30, 1820. By that year the yard had a complex organization that included a shed housing two hundred apprentices. In such a diverse industry, there was little room for master craftsmen; shipyards hired large numbers of journeymen, some skilled, some semiskilled.

2.23. Broadside, Fancy and Windsor Chair Manufactory, 1824.
2.24. Eagle back chair, 1810. **2.25.** Trade bill, W. Buttre's Fancy Chair Manufactory. **2.26.** Portrait of Duncan Phyfe.
2.27. Samuel Maverick ad.

2.25

2.26

2.27

2.28

2.29

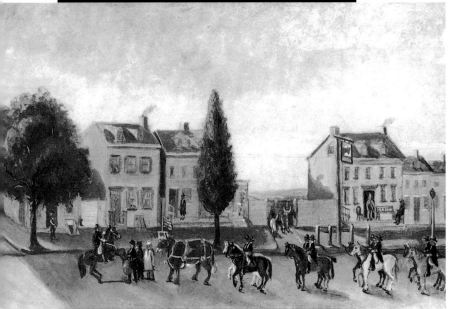

2.30

One of the great achievements in American technology occurred in early national New York through the collaboration of Robert Livingston and Robert Fulton, a Pennsylvanian experienced in both the practice and theory of steam navigation. After studying in France, Fulton, funded by Livingston, who had secured a monopoly on steamship travel out of New York, and assisted by New York artisans, particularly shipwright Charles Brown, constructed a 146-foot-long ship, the *Clermont*. The vessel set sail for Albany on August 17, 1807, much to the delight of a crowd that was unsure whether it was to witness a momentous achievement or a terrible explosion. The excursion was a success, and New York's shipyards under Fulton's direction produced six steamboats by 1812. This drawing of the *Clermont* on her maiden voyage was made in the middle of the nineteenth century (2.28).

While most masters worked in the open marketplace of the new nation, a number of trades deemed vital to public safety remained under mercantile regulation. To prevent monopolies the city required that every cartman own his horse and cart and operate as an independent proprietor. Many lived in the Sixth Ward, where they stabled their horses next to their living quarters. Cartmen did all the hauling for the city, delivered goods to the docks, paved and regulated roads, and supplied firewood and often water to private dwelling.

The city regulated cartmen strictly. They had to display a license and were subject to fines and suspensions for selling firewood above the set price. Their fees were set and published by the city. In return for submitting to paternal supervision, drivers expected protection from unlicensed haulers and were particularly intent that neither blacks nor foreigners be allowed in the trade. While they succeeded in keeping out blacks, a number of Irish immigrants entered the trade because of labor during the War of 1812. This led to angry denunciations from cartmen, who argued that men whose "fathers having

2.28. The maiden voyage of the *Clermont*. 2.29. Launching of the battleship *Ohio* (watercolor attributed to William J. Bennett). 2.30. William P. Chappel, Bull's Head Inn, 1808. 2.31. License of George Hurst. 2.32. Alexander Anderson, cartman at work.

relinquished individual interest and substance with spilling theire Blood & Laying down theire Lives to obtain the Rights and privalages of free men" should not have to lose their business to aliens because they had to serve in the military.[3] The license reproduced here was issued to George Hurst as a hand cartman (2.31). Hurst, the son of a London ship captain, had moved to New York with his family in 1825 after his father's death. The license cost twelve dollars. The cartman in the illustration is likely gathering manure from the streets for sale to the nearby farms (2.32). This was a lucrative trade supervised by the municipality.

Butchers, too, needed licenses, as well as access to the coveted stalls in the city's public markets. Cattle and hogs arrived daily from the countryside. Some were penned and slaughtered in the outer wards, much to the chagrin of neighbors. The most famous hangout for the meat handlers was the Bull's Head Tavern, whose proprietor after 1790 was none other than Henry Astor, brother of New York's wealthiest citizen, John Jacob Astor. In petitions to the common council, butchers accused Henry of attempting to corner the market for livestock "by riding into the Country to meet the drovers of Cattle, coming to the New York markets, and purchasing them to sell again to other Butchers."[4] While the common council was unable to halt Astor's practice, it did strictly regulate butchers, issuing licenses and stall assignments only after its market committee examined applications and their attendant recommendations. Visible in the center of this Chappel painting is the pen for holding cattle; the tavern is at the right (2.30). In the foreground, butchers parade behind a bedecked bull. At the far left a boot sticks out of a cellar, likely indicating that a shoemaker's workshop occupied the basement dwelling. The Bull's Head Tavern was the end of the road for cattle driven over King's Bridge to nearby slaughterhouses. In 1825 200,000 cattle made this last march. Then the tavern was sold, and the new depot for cattle was moved up to Third Avenue and Twenty-fourth Street, an area that became known as Bull's Head Village.

Butchers sold meat in public stalls. Obtaining a stall required letters of recommendation, and the location of the stall determined the success of the enterprise. The market pictured here, the Fly Market, was the city's busiest because of its location near the docks (2.35). Gaining a stall there meant nearly certain success for a butcher. City inspectors and the market committee regulated the scales and quality of the meat, disciplining butchers for misconduct. One was suspended in 1805 for falsely selling meat to members of the Shearith Israel Congregation "as Cosher or fit for that congregation to eat."[5] Butchers were a proud, arrogant, and often rough group of tradesmen, known as the city's rowdies and particularly hostile to immigrants. From their ranks sprang the Bowery B'hoys, who would become so prominent in city life.

Viewing themselves as guardians of the new republican nation, master craftsmen proudly portrayed their standing in the membership certificates of their various societies. From the late eighteenth century on, masters founded benevolent societies to provide social security (death benefits, education for members' children, assis-

2.31

2.32

2.33

2.34

2.35

2.33. William P. Chappel, house raising, Tenth Ward.
2.34. Hatters' membership certificate, 1795.
2.35. Fly Market, 1816. 2.36. General Society of
Mechanics and Tradesmen, membership certificate, 1791.

tance for retirement), to lobby for tariff protection, and to offer fraternal outlets. The most famous of these was the General Society of Mechanics and Tradesmen, founded in 1785 (2.36). It included leading masters of all trades and was known for its patriotic orations and festive holiday banquets. A certificate from 1791 communicates the artisan's sense of his key place in society with the blacksmith's hammer at the top (taken from the English blacksmith society) and its motto "By Hammer and Hand, all Arts do stand." At the upper right is a representation of benevolence: an emissary of the society bringing aid to the widow and children of a deceased member. At the middle right is the first of several illustrations of artisan trades, in this instance a turner and his journeyman crafting an article of furniture. At the lower right is a representation of the building crafts, both shipbuilding and land construction. The classical columns symbolize the close connection Americans felt to the Roman republic. At the lower left is a portrayal of the American frontier: virgin forest, peaceful stream, fisherman, and mill, together with the industrious ploughman, the counterpart of the industrious mechanic, at work breaking American soil. At the center left is a blacksmith's shop, representative of the symbol and motto at the top center. The upper left depicts American liberty in the form of a classically garbed woman; behind her, a similarly robed woman holds a honeycomb: a symbol of industry and peace. At the left is an American Indian, rendered as noble savage, who exemplifies the new world, free of European iniquities.

The hatters' certificate displays three themes important to New York masters: republicanism (represented by the eagle), the significance of the craft (communicated by the motto, as well as the hat that takes pride of place in the image), and the harmony of the workshop (portrayed by the master shaking the hand of his journeyman) (2.34). Masters saw themselves as the protectors of their trades, leaders whose authority should remain unchallenged by their employees.

Journeymen found early national New York a challenging venue, with opportunities for advancement fraught with economic risk, frustration, and conflict. While in the smaller trades the rise from journeyman to

master was still common, this was not the case in the city's largest crafts. The demands of capital were too great, and the need for wage labor such that more and more journeymen remained in that station their entire working lives. Nowhere was this more true than in the construction trades. Employing more than two-fifths of the city's journeymen in 1819 (two thousand men), the trade was financed by merchant capital and directed by master builders who hired and paid journeymen as needed. The increasing disproportion between journeymen and masters is illustrated in a Chappel watercolor of a master builder directing nine journeymen in the construction of a house in the Tenth Ward (Eldridge and Allen Streets) at the city limits (2.33). In this scene, the frame of the broad side of the

house is being set. In house construction, a whole side was assembled on the ground and then lifted into place with long poles. The other sides would then be lifted up, and beams, braces, and studding pinned and nailed.

Masters required a disciplined work ethic and attempted to uncouple journeymen from preindustrial work habits of long breaks for alcoholic beverages, irregular hours, and absenteeism. The tendency to take breaks at will is illustrated in the woodcut of *L'Absent Carpenter*, while the broadside of the master builders reveals the tension between masters and journeymen over labor conditions (2.41, 2.39). (Lest the reference to masons in the broadside confuse, it should be noted that these craftsmen were essential in the construction of larger buildings

The heart and soul of early national New York was the artisan community.

2.36

made of brick and stonework when they worked with carpenters under the supervision of the master builder.)

Conditions were particularly difficult in the two poorest trades: shoemaking and tailoring. Shoemakers produced both for the southern and West Indian slave markets and for local consumption (2.37). For quantity production, masters required less skill but demanded longer hours at cheaper wages. Shoemakers worked at piece rates, either in workshops or at home. Workdays ranged from twelve to fourteen hours. The shoemakers were the most militant journeymen. Forming disciplined societies, they demanded that employers hire only society members and pay them a negotiated wage. If an employer violated these rules, the journeymen would refuse to work for him. Shoemaker journeymen, along with cabinetmakers, carpenters, masons, and printers, staged labor protests that included walkouts,

appeals for public boycotts, and the establishment of journeymen-owned and -operated stores. At one point in 1809 strikes were so common that it appeared that all construction might stop in the city.

Tailors were among the poorest paid of the city's journeymen (2.40). Like other journeymen they were threatened by the growing labor pool coming to the city from abroad and the hinterlands but also by women who could produce the "slop work," or ready-to-wear clothing, that was increasingly common. Some master tailors hired women at less than half the wage of male journeymen, triggering a long walkout during the Panic of 1819.

Despite the occupation's low public standing and difficult financial circumstances, journeymen tailors produced elegant clothing of great sophistication for both men and women of high social standing. The men's suit of 1785 depicted here reflects eighteenth-century fashion, featuring a fine greatcoat, an embroidered waistcoat, turned-up cuffs, knee breeches, and silk stockings (2.43). This style would soon be replaced by the more republican outfit of trousers, black double-breasted frock coats, and top hats (see fig. 3.20). For women, the 1815 dress pictured here is typical of republican fash-

2.37. Alexander Anderson, shoemakers at work. 2.38. Customs House, detail, 1796. 2.39. Broadside, master builders, 1805. 2.40. Tailor at work. 2.41. *L'Absent Carpenter.* 2.42. Ad for sale of slave. 2.43. Men's suit, 1785. 2.44. Woman's dress, 1815.

2.37

2.38

WHEREAS experience has shewn that much irregularity and confusion has taken place for want of a uniform regulation, pointing out the proper time to be observed by Carpenters and Masons, so as to suit the different seasons, and the wages from time to time established, to enable them to work ten hours in the long, and nine hours in the short days,—

It was therefore, after due deliberation, Resolved, by the Company of MASTER BUILDERS, at their Stated Meeting, held on the 11th of March 1805, That in future the following regulations should be observed as nearly as well may be.

	To begin in the Morning.	Time at Breakfast.	Time at Noon.	Time to quit Work.	Working Hours.
	Hours.	Hours.	Hours.	Hours.	
1. From Second Monday in March to First Day of April, at	6	1	1	6'	10
2. From First of April to First of May, . . .	6	1	1½	6' 30"	10
3. From First of May to First of September, .	6	1	2	7'	10
4. From First of September to Second Monday in October,	6	1	1½	6' 30"	10
5. From Second Monday in October to Second Monday in November,	7		1	6'	10
6. From Second Monday in November to First Day of March,	7		1	5'	9
7. From First of March to Second Monday in do.	6' 30"	1	1	5' 30"	9

ANDREW MORRELL, President.

THOMAS HEWITT, Secretary.

Printed by Isaac Collins & Son, New-York.

2.39

ions (2.44). Replacing the whalebone bodices and hooped petticoats of the mid-eighteenth century, the newer styles, inspired by French couture, featured high-waisted dresses with low, round necklines, altogether a freer and more natural look.

New York had the largest urban black community and slave population in North America. In 1790 more than one in three households owned a slave, and two-thirds of the black population (3,262) were enslaved. The number of slaves actually increased in the 1790s as many artisans, thriving in the prosperous commercial climate, bought a slave or two. This ad from a 1785 issue of the *New York Packet* indicates that in the full flush of republican victory slavery still flourished in New York City (2.42). But reformers demanding an end to slavery—in part because it was incompatible with the legacy of '76—prevailed a decade later. With the passage of the Gradual Emancipation Act of 1799 most blacks received or bought their freedom. The African-American population grew rapidly, reaching 13,976 in 1830.

Although segregation was not legal and there were no distinct black neighborhoods, African-Americans lived very separate lives, both at work and at home. The majority worked in unskilled labor at the bottom of the economic and social ladder. A number worked in the streets hauling goods or peddling products such as buttermilk (2.38, 2.50). A common sight at public markets was the spectacle of blacks, having sold their few goods,

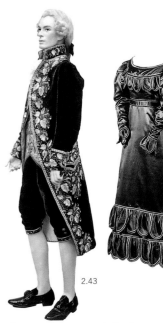

2.44

2.43

gaining a few extra pence by performing shakedown dancing for the public (2.47). While not slaves, many still worked as domestic servants, as they had under perpetual bondage (2.45). A watercolor by Baroness Hyde de Neuville, who visited New York in 1810, depicts an African-American woman with her scrub brush (2.48).

Blacks were responsible for the collection of garbage and waste. By 1810 twenty-five cartmen were employed "for the purpose of Collecting the Garbage and offals from Yards and Kitchens for which purpose they shall Ring the Bell at Suitable Distance to notify

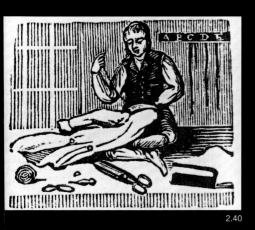

2.40

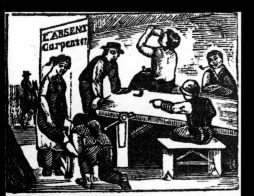

2.41

FOR SALE,
A likely NEGRO BOY,
About fourteen years old,
brought up in a gentleman's family, understands all kind of house-work, and is a very active smart lad; has had the small-pox and measles: Sold on account of the owners having gone to Europe.
ALSO,
A small parcel of old and particular Madeira WINE, in wood and bottles. Enquire at No. 19, Crown-street.
53

2.42

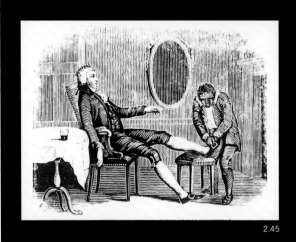

2.45

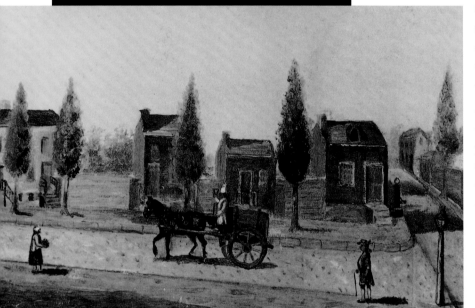

2.46

inhabitants to bring out the same and put it into the Carts" (1799 ordinance). Chappel depicted a well-known garbage collector, Pot Pye Palmer, driving through the streets in 1805 (2.46).

Although few artists took notice, African-Americans made considerable progress in the early republic. One survey conducted in 1810 found that over a quarter of free black heads of household worked as artisans, and some were small proprietors (master craftsmen). They also operated countless cook and oyster shops throughout the city. Evidence of these accomplishments is found in *Freedom's Journal*, a black-owned and -operated newspaper that began publication in 1827 (2.49). Along with a history of the black revolution in Haiti and accounts of efforts to abolish slavery, the paper contained anecdotes about successful black entrepreneurs and advertisements for such African-American businesses as the cleaning establishment of James Gilbert.

One of the finest examples of upward mobility was Peter Williams (2.51). Born a slave in New York, he labored for a tobacconist before being sold to the Wesley Chapel, where he worked as sexton. After the Revolution he purchased his freedom and became a successful independent tobacconist. With the approval of the Methodist Church, in 1799 he founded the Zion African Methodist Episcopal church, where blacks could worship free of racial discrimination or condescension. Another interesting illustration of middle-class black society, published in the second volume of Frances Trollope's *Domestic Manners of the Americans*, shows a well-dressed couple strolling in a park (2.52).

Nowhere is the predicament of New York's African-American community so apparent as in the plight of chimney sweeps. These pitiful creatures were a common subject of the city's artists, most notably Nicolino Calyo, who painted *Chimney Sweep at Rest* (2.53). Because of the narrow chimneys and the danger of fires, it was necessary

2.47

2.45. Alexander Anderson, domestic servant.
2.46. William P. Chappel, Pot Pye Palmer, 1805.
2.47. Shakedown dancing. **2.48.** Baroness Hyde de Neuville, *Costume of a Scrubwoman*, n.d.
2.49. Commercial ad. **2.50.** Alexander Anderson, buttermilk seller. **2.51.** Peter Williams.

for young boys—dressed only in their underwear—periodically to climb up, down, and around the flues to clean them. This loathsome duty could cause tuberculosis, eye infections, scar tissue, lacerations, and the dreaded "sooty wart," a disease of the scrotum leading to sterility or death. From the eighteenth century on, the task became the exclusive occupation of blacks. Often homeless, sleeping either in the streets or soot warehouses, they were a constant focus of municipal reform. The boys' miserable state fueled demands for government intervention, but almost of equal importance to the city fathers was the public nuisance they created with their morning screams in search of customers and their delinquency as they roamed the city's streets and alleyways.

Black master sweeps, entrepreneurs seeking recognition as independent businessmen and republican citizens, employed these wretched boys. Dressed in elegant black hats and tailcoats, a traditional dress dating to the sixteenth century, they were nearly as noteworthy as their ragged apprentices (2.54). City officials and citizen reformers accused these men of undue cruelty for their failure to shelter, clothe, educate, or compensate these lads while at the same time beating them mercilessly for any failure and forcing them into hot and narrow flues

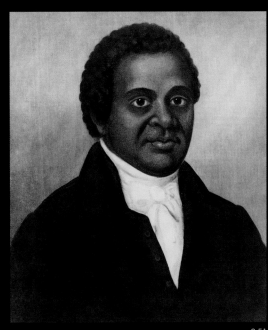

regardless of peril. Observing that "the soot and dirt which collect on their bodies from year to year defend them from inclement weather nearly as well as their tattered cloathing," one of its committees urged the common council to take responsibility for "the little sufferers."[6]

The masters, of course, fought against reforms that would eliminate their occupation in favor of city supervision. Arguing that most of them treated their apprentices fairly and attempted to educate and shelter them, they went on to remind the city fathers that "some of their number have served in the revolutionary war & some of them received wounds" and contended in republican language that they were "men of colour, a class of people, who might have heretofore been greatly despised; but they now live in a

Economy is the Road to wealth.—And a penny saved is a good as two pennys earned. Then call at the United States CLOTHES DRESSING Establishment,

JAMES GILBERT,

Who has removed from 411 to 422 Broadway, and continues as usual to carry on the Clothes Dressing in correct and systimatical style; haing perfect knowledge of the business, having been legally bred to it, his mode of cleaning and Dressing COATS, PANTALOONS, &c. is by STEAM SPONGING, which is the only correct system of CLEANING, which he will warranted extract all kinds of STAINS, GREASE-spots. Tar, Paint &c. or no pay will be taken.

N B The public are cautioned against the imposture of those who attempt the Dresing of clothes, by STEAM SPONGING. who are totally unacquainted with the business as there are many Establishments which have recently been opened in this city.

☞ All kinds of Tailoring Work done at the above place.

All clothes left to be cleaned or repaired will be good for one year and one day—if not claimed in that time, they will be sold at public auction.

2.49

2.50

2.51

2.48

more enlightened age, and are fully persuaded that your Honorable Body will treat every man, whether white or black, according to his deserts."[7]

Although women were largely confined to the home and generally it was considered degrading for a female to work in public, for those living at or near poverty, married or not, the streets provided a major source of income. Peddling was an acceptable if demeaning occupation, and women would frequently set up tables adjoining the public markets and on the streets. Figure 2.35, for example, shows female hucksters selling vegetables brought in from the country in front of the famous Fly Market near the East River in the Second Ward. Women peddlers were common subjects for children's books (2.55). Alexander Anderson produced this scene of a mother and daughter, the scale in the daughter's right hand suggesting that the pair were peddlers (2.56). At this level, color lines were no barrier, and both black and white women worked as street peddlers.

Engraver Alexander Anderson grew up in New York and knew the various and onerous chores a woman had to perform to maintain her household. Cooking was an often arduous task, and, without refrigeration, daily marketing trips were necessary. Perhaps the worst job of all was washing and ironing. The use of lye caused constant irritation to the hands, and the endless trips to and from the pumps carrying heavy buckets of water also took their toll (2.57).

At this point in New York's history, while the American Revolution had given women some opportunity to emerge from the hitherto strictly sheltered and enclosed domestic world, popular opinion still considered female abilities at craft or intellect to be limited. Women entered the middling world of artisans by taking over a deceased husband's business, assisting in a family enterprise, or working in one of the few trades open to them. Male artisans, however, resisted letting

2.52. Black couple in a park, 1826. **2.53.** Nicolino V. Calyo, *The Chimney Sweep at Rest*, ca. 1831. **2.54.** Alexander Anderson, master and apprentice. **2.55.** Woman peddler. **2.56.** Alexander Anderson, mother and daughter peddlers.

2.53

2.54

15

RADISHES!
"Radishes! Any Radishes!
"Here's your fine Radishes!"
Radishes! Radishes!
I hold them to view,
Turnip or carrot form,
As fine as e'er grew.

In the spring, we have the above cry along our streets, by children and women, who buy them of the gardeners, and for one cent a bunch profit, will trudge about the streets of New-York, with a large long basket hanging on their arms, full of Radishes. They sell six radishes for a cent, and six-pence will buy one to six of them. They are esteemed an excellent radish.

2.55

2.56

women enter their trades, fearing that this would lower wages and their crafts' status, since women were, as the journeymen tailors argued in 1819, "very inadequate to perform the work of a Tailor. . . . Women are incomplete."[8] The millinery shop was the exclusive province of women, however, and dressmaking, too, sometimes fell under their purview. A unique scene by Alexander Anderson shows women performing various operations of dressmaking as well as attending to customers (2.59).

Women in the more comfortable homes of the gentry and near elite, with servants to perform most household chores and free of the need to work either in shops or on the streets, occupied their many leisure hours with needlework and visiting female acquaintances. While not able to attend Columbia College or the trade schools, young women could attend private schools, where they learned French, music, drawing, and other niceties of refined culture. Such a school was depicted by Alexander Anderson (2.60).

Many women could execute needlework of considerable delicacy and beauty. It was important for young women to learn dexterity in this art. An 1825 sampler by Mary Varick features a republican motif, including a bust of Washington, an American eagle, a reference to the famous cherry tree, and a biblical inscription: "As a jewel of gold in a swine's snout so is a fair woman which is without discretion" (2.58).

Religion animated Republican New York as the number of churches increased by fifty-nine. While the Anglican and Dutch Reformed faiths remained prominent, Catholicism and other Protestant sects made new inroads. Anti-Catholicism had permeated colonial New York, and very few Catholics lived in the city. As late as 1784, when the first Catholic parish was organized, only two hundred Catholics resided in the city. A small church, St. Peter's, was built, but the first cathedral, St. Patrick's, on Mott Street, only opened in 1815, seven years after the establishment of the Diocese of New York

2.57

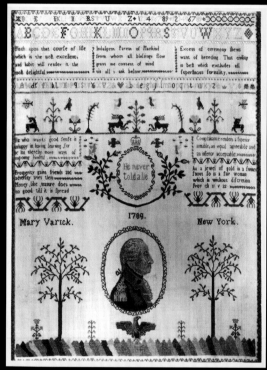

2.58

2.59

2.57. Alexander Anderson, women doing laundry. **2.58.** Varick sampler. **2.59.** Alexander Anderson, dressmaking shop. **2.60.** Alexander Anderson, school for young ladies.

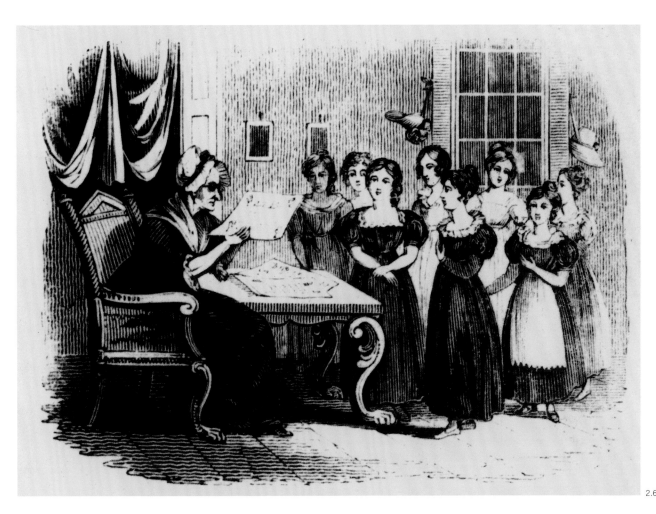

(2.61). By then the community had grown from a small group of Irish immigrants to about fifteen thousand. Immigrants kept arriving, most of them Catholic and Irish. In 1825 immigrants made up 20 percent of the population, and the Catholic Church grew ever more important in the life of the city.

The early national period, known for the second Great Awakening and the rise of evangelicalism, inspired the construction of five new Methodist and Baptist churches in New York. A larger sanctuary replaced the John Street Church (2.64). Artisans and other members of the city's working class found simple but direct sermons and liturgy appealing. They were also drawn to the lack of hierarchy and concern with social status as well as the emphasis on immediate rebirth that dominated evangelical thinking. Another bonus was that these churches, unlike the

The American Revolution gave women opportunity to emerge from the sheltered domestic world.

Anglican and Dutch Reformed congregations, did not assess pew rents.

Counter to these religious traditions, the Painite creed attacked organized religion as authoritarian, contrary to reason and a revived human spirit. A spokeswoman in the tradition of Tom Paine, Fanny Wright visited New York and spoke of the sexual and social oppression of women. She favored free and improved public schools for the poor and opposed the clergy and Christianity in its current form. While the highly controversial Wright sparked strong opposition, she appealed to many artisans. She purchased the Ebenezer Baptist Church on Broome Street, remodeled it with a Greek facade, placed pictures of Paine and Shelley on its front windows, and renamed it the Hall of Science (2.63). A

2.61

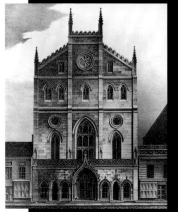

2.62

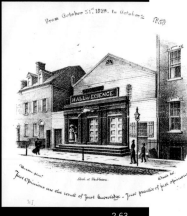

2.63

2.61. St. Patrick's Cathedral, 1830. 2.62. A. J. Davis, Masonic Hall, 1830. 2.63. Hall of Science, 1829. 2.64. Methodist church, 1800. 2.65. William P. Chappel, baptism at Corlear's Hook, 1811. 2.66. William P. Chappel, infant funeral, 1807. 2.67. Alexander Anderson, coffin bearing. 2.68. William P. Chappel, adult funeral, 1809.

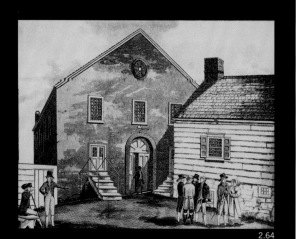

2.64

day school and Sunday schools flourished there, and the establishment also housed a library. Its main hall held twelve hundred and was often filled with artisans attending lectures on science and religion.

When Fanny Wright first arrived in New York, she spoke at Masonic Hall, another home to radical republican religion and one of twenty-seven lodges in the city (2.62). Freemasonry stressed fraternity, rationalism, and tolerance and attracted children of the Enlightenment, most notably DeWitt Clinton. This lithograph of the imposing neo-Gothic building on Broadway between Duane and Pearl is the work of A. J. Davis.

Religious ritual permeated metropolitan life. Particularly noteworthy were the funeral processions down the city streets. William Chappel painted two. The first is an 1809 infant procession at the site of the Methodist Episcopal Church (2.66). It was customary for women to wear white on these occasions. Behind them follow representatives of the clergy. Chappel's second funeral painting depicts a procession honoring "Wife, the husband & Children on Stanton Street in the Seventh Ward" (2.68).

Baptism was another religious ritual that frequently took place outdoors. A third Chappel painting illustrates a baptism at Corlear's Hook on the East River early on a Sunday morning in 1811 (2.65).

Yellow fever epidemics plagued the city, and the mortality rates were frightful. In 1795 732 New Yorkers, mostly poor, died from such an epidemic. In 1798 the state created a permanent health office headed by a commissioner chosen by the common council who had power to issue and enforce ordinances. Despite precautions, that same year another epidemic killed 2086, five percent of the population. It was not uncommon, especially during one of these all too numerous epidemics, to see a corpse being carried through the street, a grim reminder of the proximity of death (2.67).

In the young republic education took on a new meaning. For a republican government to succeed, citizens must be adequately educated. Not surprisingly, then, the movement for free public education blossomed during

2.65

this era. Until then, there were tutors available for the boys and girls of the city elite and paid teachers for those who could afford their classes. For the rest, the only alternative was charity schools, many affiliated with a church.

The movement for public education, spearheaded by Thomas Eddy and DeWitt Clinton, led to the opening of the first public school in 1804 and the first building in 1806. In 1825 the Public School Society managed to get state funding for the new public schools, which eventually replaced most charity schools. Through its efforts about half the city's children between the ages of five and fifteen began to attend school. In 1829 public schools educated just under 40 percent of the children in school, but by 1850 more than 80 percent of the city's pupils were enrolled in these institutions. New York City pioneered the transition to the common school. While most early sessions had to be held in cellars or church basements, new schools soon opened on sites donated by Henry Rutgers and Trinity Church. One such was Free School No. 1, located on what is now the site of the municipal building

(2.71). To save money, teaching was done according to the Lancastrian method, whereby students or monitors taught other students in small groups under a teacher's supervision (2.69). Common schools admitted children over the age of five and were not divided into specific grades.

In 1825 John Griscom secured the construction of the city's first high school at Crosby and Grand Streets (2.74). This low-tuition private school for boys opened with 650 eager students; a girls' school opened its doors at the same time. The work of maintaining this second school proved to be too much for Griscom; moreover, very few girls applied. He closed the school in 1831, selling it to the Mechanics' Society. High schools would have to wait until the 1850s to find acceptance in New York culture. Still, although very few students continued formal classes after the age of twelve or thirteen, education did not end after grammar school. Many students of artisans' trades learned from books published in the United States and Europe, and a few went to the city's various evening schools for adults.

2.66

2.67

2.68

FIRST INFANT SCHOOL IN GREEN STREET NEW YORK.

Imbert's Lithography.

A. Robertson del.

VIEW FROM THE ROSTRUM

Monitor Nine & Six? *Scholars Fifteen! &c.*

VIEW FROM THE GALLERY.

Imbert's Lithography

A. Robertson del.

The Children Marching & Reciting aloud,"Twice two's Four &c,"

2.69

Education meant opportunity, however limited, in the emerging republican society. This was true even for the city's free black population, many of whom held republican views and ambitions. Nevertheless, while no law mandated it, education in New York was segregated. Schools for African-Americans, funded by the Manumission Society, began classes in 1787. The first building was erected in 1815, and others soon followed (2.72).

The city's sole institution of higher learning, King's College, suffered serious losses during the Revolution. Among the casualties were its library and museum. After the war it was reorganized by the state legislature and reopened as Columbia University. In 1787 William Samuel Johnson, like his father before him (see fig. 1.53), became president of the university (2.70). In sharp contrast to his father, however, Johnson, an attorney and signer of the Declaration of Independence, was a conservative republican.

2.70

Though housed in the same building, Columbia differed from its predecessor. Less than half the students were Anglican, and many lived in the city rather than on campus. Republican-minded students and faculty challenged the Greek-based classical curriculum, introducing more classes in ethics, philosophy, and politics. Student literary societies became popular. Members would meet weekly in the evenings to present papers and debate public controversies. An engraving by A. Godwin of DeWitt Clinton's membership certificate of the Columbia College Society for the Progress of Letters, features images from industry, science, and learning, the symbols of classical republicanism (2.73).

Colonial New York City's government, the corporation, acted as a private body. Its main concern was real estate, and rather than taxing residents, it used its ownership of land and its willingness to sell valuable tracts, especially on the waterfront, to require private individuals to improve wharves, piers, and streets. But republicanism demanded more. The city government now was in charge of pursuing the best interests of the whole population, and this brought both greater responsibilities and a need

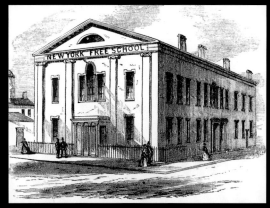

2.71

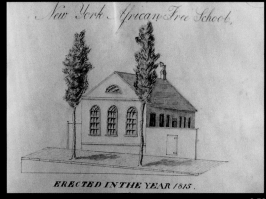

2.72

2.73

2.69. Lancastrian method. **2.70.** S. L. Waldo, *William Samuel Johnson*. **2.71.** Free School No. 1. **2.72.** Page from John Burns's penmanship book, New York African Free School. **2.73.** A. Godwin, Columbia University Literary Society Certificate. **2.74.** New York High School. **2.75.** William Guy Wall, City Hall, 1830.

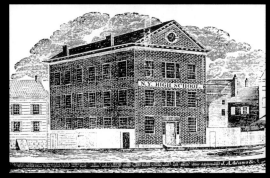

2.74

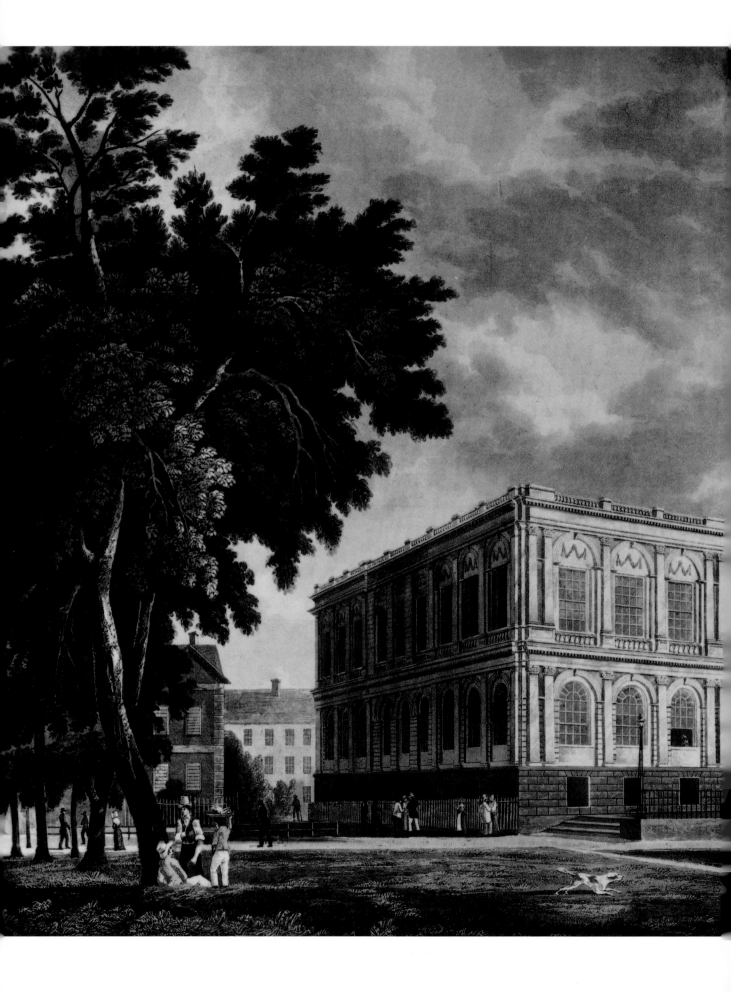

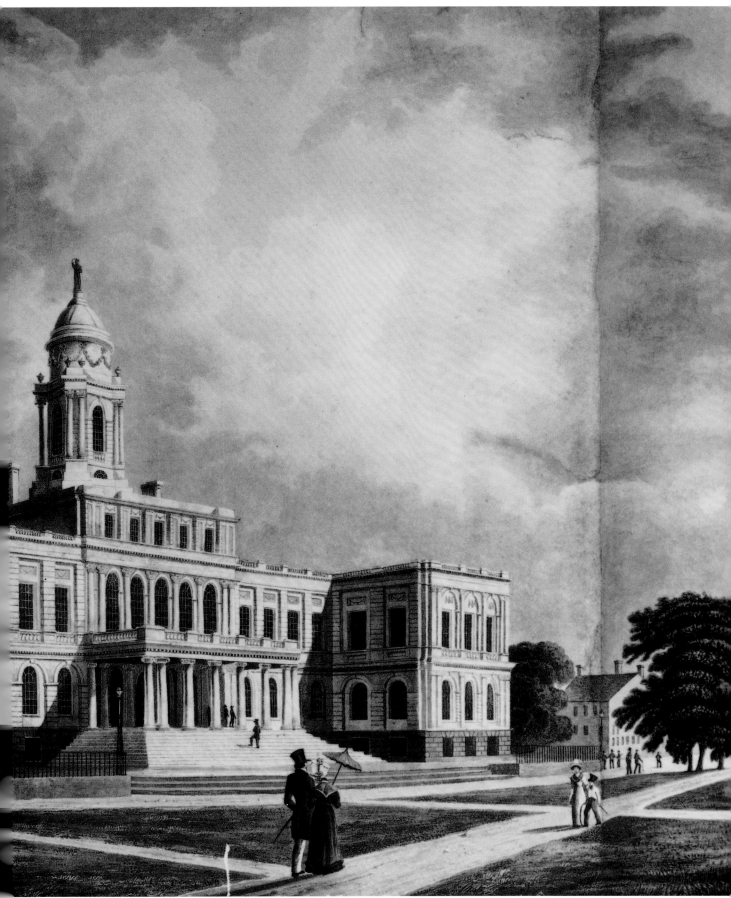

2.75

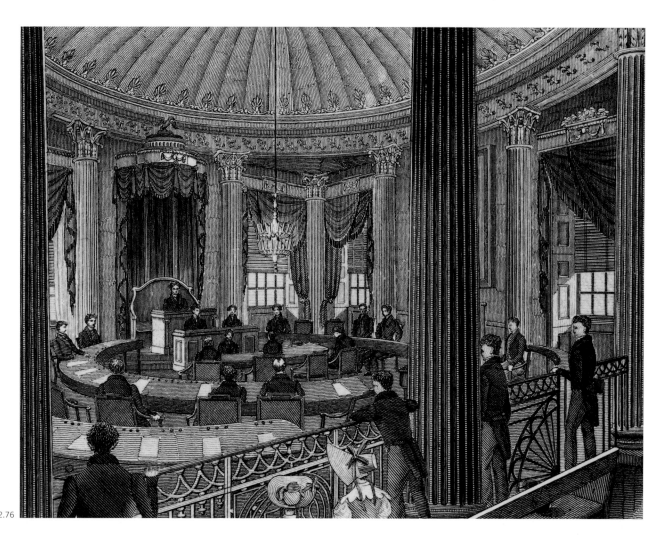

for more revenue. Thus with the state's approval the city began to tax residents to maintain the municipality's quality of life.

The site of the city government, City Hall, remained the same after the British left. For one year (1789–90) it became the seat of the federal government and was remodeled by Pierre L'Enfant (see fig. 1.61), and city and state magistrates relocated to the Broad Street Exchange. By 1800 City Hall could not house all the city's offices, and the search for a new site began.

On March 24, 1800, the common council announced a committee to evaluate construction of a new City Hall. The decision to build a grand Federal-style edifice was clearly a statement by the leaders of the city. The building was designed by two prominent architects, French-born Joseph François Mangin, who also designed the Park Theater and St. Patrick's Cathedral, and John McComb, Jr., son of the architect who had designed Hamilton's home. McComb supervised construction. To save money and in the belief that the city

would not grow quickly, the common council finished the rear in brownstone instead of marble. The building cost nearly a half million dollars, and McComb struggled year after year for appropriations.

The result was one of the city's landmarks: the first building to rival the city's finest churches in elegance, refinement, and majesty. A notable view by William Guy Wall shows the French Renaissance facade, especially apparent in the swagged window panels (2.75). The overall design (from a Palladian model) was Federalist, inspired by symbols of Roman republicanism. Once inside, a visitor could marvel at the marble staircase surrounding a splendid rotunda and a gallery encircled by Corinthian columns (2.76). The new City Hall was the signature building of Republican New York.

New York after the Revolution was a dangerous place.

2.76. Council chamber, City Hall, 1830.
2.77. Newgate Prison.

One resident remembered that no one wandered north of Broadway "without carrying pistols."[9] Led by Thomas Eddy, who was influenced by European penal reform, the state revised its criminal code to a more republican model, abandoning corporal punishment and limiting capital punishment to treason, murder, and theft from a church. For the incarceration of those who committed serious crimes, a state prison, named Newgate, was erected along the Hudson (in Greenwich Village) (2.77). Eddy served as warden, and the prison emphasized religious and moral education tempered with strict discipline, including a rule of silence at work, meals, and after dinner in the evening. In reality, however, the prison was overcrowded and troubled with violence, riots, and breakouts. Many of the inmates were West Indian blacks; a fifth were women.

The stepping mill, was used for grinding grain (2.82). It was a cylinder twenty feet by six feet, and two groups of sixteen prisoners would take turns operating it for eight dreadful minutes at a stretch. The exercise was intended to terrify and discipline lazy vagrants and petty criminals. Prisoners also made shoes, much to the dismay of the city's shoemakers, who objected to the competition.

Convicted debtors unable to pay could be imprisoned at the will of the creditor. They were kept in a dilapidated structure near City Hall, where a visitor found "squalid Misery seated on her filthy throne, with Poverty and Vice, Oppression and Sickness, officiating as her ministers" (2.78).[10] In 1809 over eleven hundred New Yorkers were confined for nonpayment of debts of less than twenty-five dollars. They were fed and clothed by charitable institutions, usually the Humane Society. In 1817 the law was changed to affect only those with debts over twenty-five dollars, but even so, in 1828 one thousand New Yorkers still served time in the jail.

Until 1811 vagrants and misdemeanor offenders were housed along with the poor in the Bridewell (2.80). The city had built this three-story almshouse in 1797, at a cost of $130,000. It immediately became overcrowded. This house of confinement along with one built in 1775 signaled that poverty was a harsh and ever-present reality of early national New York. So many lived at or near subsistence level that any natural or political interruption to the city's economic life could force them to turn to municipal relief. In winter the city supplied firewood to the poor, most

2.77

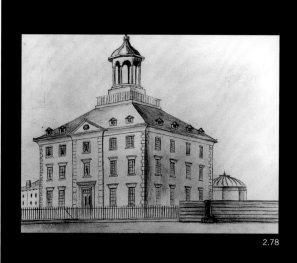

2.78

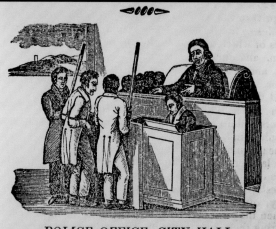

POLICE OFFICE, CITY HALL.

2.79

2.78. Debtor's prison. **2.79.** Constables with staves.
2.80. The Bridewell, 1808. **2.81.** New York Hospital.
2.82. Stepping mill.

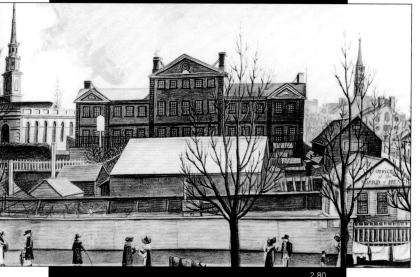

2.80

of them native born. In 1800 charity was responsible for the survival of ten thousand (out of a population of eighty thousand). In 1814, during the war, over nineteen thousand people were on poor relief. In this illustration, a charity school run by the Free School Society stands in front of the Bridewell; the yet uncompleted City Hall is at the left. The spire of the Brick Presbyterian Church is visible at the left and that of St. Paul's at the right. The Bridewell can also be seen at a distance in the picture of the Collect Pond (see fig. 2.9).

In 1816 the common council moved the miscreant, vagrant, ill, and poor to Bellevue, a new site at the East River and 24th Street, far removed from the general population. At this time, it dedicated the old almshouse as the New York Institution of Learned and Scientific Establishments, part of its attempt to foster the arts in a republican society. Organizations representing the city's intellectual pursuits—among them the American Academy of Fine Arts, the New-York Historical Society, and the Scudder Museum—promptly moved in, and the new institution served as an intellectual center until the city declined to renew its lease in 1830.

During the annual spring elections, each ward elected two constables. Usually from the artisan class, they formed the core of the police force, along with marshals appointed by the mayor. In addition, at night, watchmen (who worked by day as unskilled laborers) patrolled, lighting streetlamps and looking for fires.

The constables, who carried staves as the symbol of their office, were charged with apprehending offenders and bringing them to court (2.79). Cases of small magnitude could be tried before an alderman or justices of the peace, while more serious cases were heard at the mayor's court, which was composed of the mayor and the recorder.

New York Hospital, located on Broadway between Duane and Anthony Streets, was founded as a private institution under a royal charter in 1770 (2.81). During the Revolution, the British used it as a barracks for their troops. After independence it became a public hospi-

tal, responsible for providing free treatment to new immigrants and the poor. It also housed the city's first nursing school, as well as a research library. It was the scene of the famous Doctors' Riot in which five thousand citizens, enraged at rumors of a grave robbery carried out in order to perform anatomical experiments, converged on the hospital, destroying laboratories and taking medical students hostage. Before the riot ended the militia was called, and three citizens were shot.

Lacking a sound water supply, New York relied on 249 public wells and a number of superior private wells, such as the Tea Water Pump, which tapped a spring outside the city. In the early nineteenth century, the city

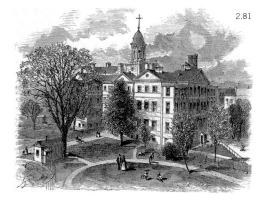

2.81

chose not to construct its own municipal supply, depending instead on the newly chartered Manhattan Company. This firm, however, was far more interested in banking than in water: it had used its political connections to include in its contract with the city a clause allowing it to use its funds to establish a bank, the forerunner of the Chase Manhattan Company. The company erected a reservoir on Chambers Street that held an insufficient amount of water—132,600 gallons rather than the million the city needed—used wooden rather than iron pipes, and failed to collect water from the north. The company did build a facade with Doric columns and a sculpture of Oceanus, but this did nothing to

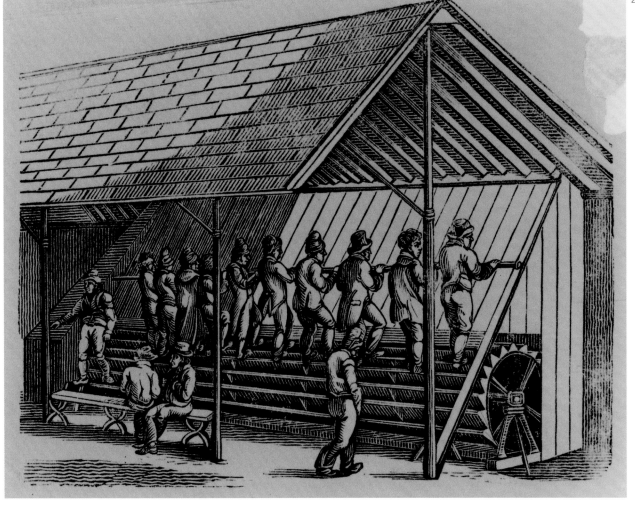

2.82

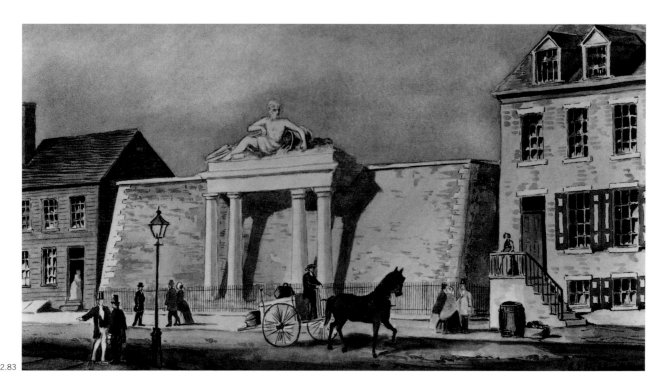

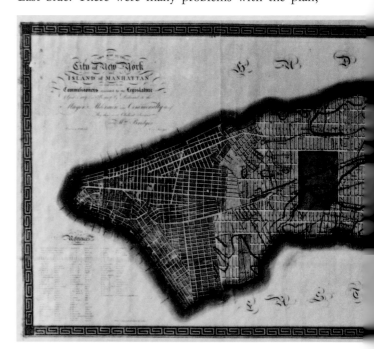

solve the city's water shortage (2.83). The absence of good water led to serious sanitary conditions, particularly among the poor. Privatization had not worked.

While the city did not establish its own fire department, all citizens were required to have leather buckets at hand to combat fires in their neighborhoods. The city also relied on its seventeen engine companies, for which it purchased engines. These companies functioned almost as fraternal clubs of artisans and small merchants, holding dinners and sponsoring other activities. Each member was licensed by the city and required to be in attendance at fires as well as to maintain equipment and report to meetings. An elegant fireman's certificate, engraved by Peter Maverick, suggests the pride individuals took in belonging to one of these companies (2.84).

The city fathers wanted an attractive, orderly city. As the city grew northward, they laid down rules for improvements and assessed local property owners to finance the paving of streets. Residents often felt that they lived in chaos, what with the cartmen constantly unloading dirt, their carts rattling through the streets, and laborers digging up old highways and setting pavements. But the city was determined to assert order. A

committee of the common council presented the famous grid plan, approved by the state legislature in 1811 (2.85). It laid out 155 east-west streets, each to be sixty feet wide and separated from its neighbors by two hundred feet in each direction; the twelve north-south avenues were to be one hundred feet wide. The plan ignored topography and the need for circles and squares, though it did provide for four small parks as well as a militia parade ground and a large market on the Lower East Side. There were many problems with the plan,

2.83. Manhattan Company reservoir. **2.84.** Peter Maverick, fireman's certificate. **2.85.** 1811 grid plan.

including its rigidity, a dearth of north-south thorough-fares, an absence of sites for public buildings, and lots that were too shallow. The layout would also result in a city doomed to endless traffic congestion because of all the intersections. In *Public Property and Private Power*, legal scholar Hedrik Hartog describes the grid plan as a statement of public philosophy, a mental construction whose appeal allowed it to triumph over the reality of urban life and growth, despite its many flaws. Jefferson and the republican spirit argued that man's reason and sense of order would lead to social improvement. The famous grid plan expressed this outlook.

Although the John Street Theater resumed operations after the Revolution, its status as the theater of choice in New York was soon overtaken by the Park Theater, built in 1795–98 across from St. Paul's Chapel and the most popular venue throughout the 1820s. Many of England's prominent actors as well as America's best thespians graced its stage. A key accompanies a well-known watercolor by John Searle to permit the identification of some of New York's finest society, including DeWitt Clinton and Robert and Mrs. Lenox. In this scene, the audience is watching the farce *Monsieur Tonson* (2.86). Notice the presence of the band and the actors performing a dance.

This painting, however, presents an inaccurate picture

of New York theaters during the republican era. Theaters were open and attended by all levels of society. Along with the elite in the orchestra and boxes, artisans, including journeymen, as well as manual laborers could be

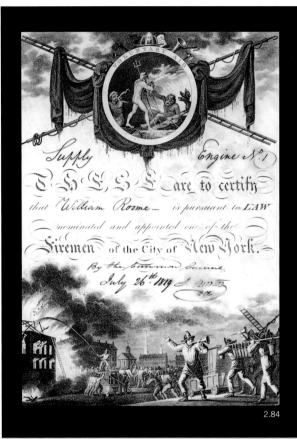

2.84

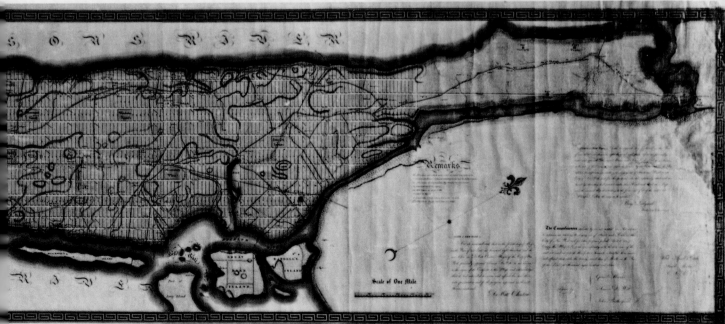

2.85

2.86

2.87

found in the pit and gallery, tickets to which cost but twenty-five or fifty cents. Each section had its own entrance. Playhouses were divided into social zones, and in the pits prostitutes roamed and plebeian theatergoers were wont to express freely their displeasure with actions on stage, throwing vegetables and eggs if angered.

To accommodate different tastes an evening would consist of an overture followed by the main piece and then a farce or short opera. During the intervals between the primary features the audience might be entertained by individual singers, comedians, or acrobats. Shakespeare was very popular, as were farces and pieces ridiculing British pomp and exalting American republican simplicity and reenacting revolutionary heroism (2.87).

New York was also home to a black theater, the African Grove, which opened in 1821 under the direction of William Henry Brown, a West Indian. Many whites attended this theater, along with the upper crust of the city's African-American community. Whites sat in their own special section. As in white theaters, Shakespeare was performed, in addition to lighter fare. Unfortunately, the theater was subject to constant harassment and violence, and after a vicious assault in 1823, in which a number of actors were stripped and beaten, it closed. A handbill for a performance remains (2.89).

Music could be heard in republican New York at church services and concerts, as well as in home parlors. Sheet music for the harpsichord, an instrument both produced locally and imported into the city, was readily available for purchase (2.88).

Some of America's finer artists, such as John Vanderlyn and John Trumbull, who painted portraits of many of the city's leading citizens, lived and worked in New York. In 1802 Edward Livingston and his brother, Robert R. Livingston, formed the American Academy of Fine Arts. Leading merchants and professionals subscribed to purchase European sculptures to decorate the interior. The academy opened its first gallery in 1816 in the new city hall.

2.86. John Searle, Park Theater, 1822. **2.87.** Playbill for *The Saw Mill*, 1824. **2.88.** *The Conquest of Belgrade*. **2.89.** Playbill, African Grove Theater, 1821.

THE
CONQUEST OF BELGRADE,
a Sonata
for the HARPSICHORD or PIANO FORTE,
BY SCHROETTER.

NEW-YORK, PRINTED FOR G. GILFERT & Cº
at their MUSICAL MAGAZINE, Nº 191.
BROAD-WAY.

2.88

In 1819 John Vanderlyn had a falling-out with the academy over a controversial painting, *Ariadne Asleep on the Island of Naxos*, that included a reclining nude. Funded by John Jacob Astor and other men of prominence, he opened the Rotunda, a public gallery on Chambers Street built in a Greek Pantheon design with a thirty-foot-high dome (2.91). Its prize display was the *Panoramic View of the Palace and Garden of Versailles*, a grand mural, 12 feet high and 1165 feet in length, that can be viewed today at the Metropolitan Museum of Art. It may be that Versailles was not the best subject for a republican audience. In any case, the Rotunda failed to attract audiences, and Vanderlyn moved to Europe. But the Rotunda also represented a movement by the city's artists to remove themselves from the control of wealthy mercantile patrons such as those who funded the Academy of

Fine Arts. In republican New York artists sought to assert their right to participate in the marketplace, and the National Academy of Design, which soon forced the academy out of business, was controlled by artists, not merchants.

New York's first museum, the Tammany, was organized by Gardiner Baker in 1793 to house a collection devoted to the history of America.[11] On display was a collection of Indian artifacts and plant and animal specimens. Baker also introduced live animals and machine models. Reorganized as the American Museum in the early 1820s, it then occupied a prominent spot near City Hall (2.90).

The museum took on a particularly republican cast in 1794 during the Reign of Terror in France, when it displayed a guillotine imported from France that severed the wax heads of aristocrats in front of spectators. An ad in the the *Columbian Gazetteer* read: "This instrument

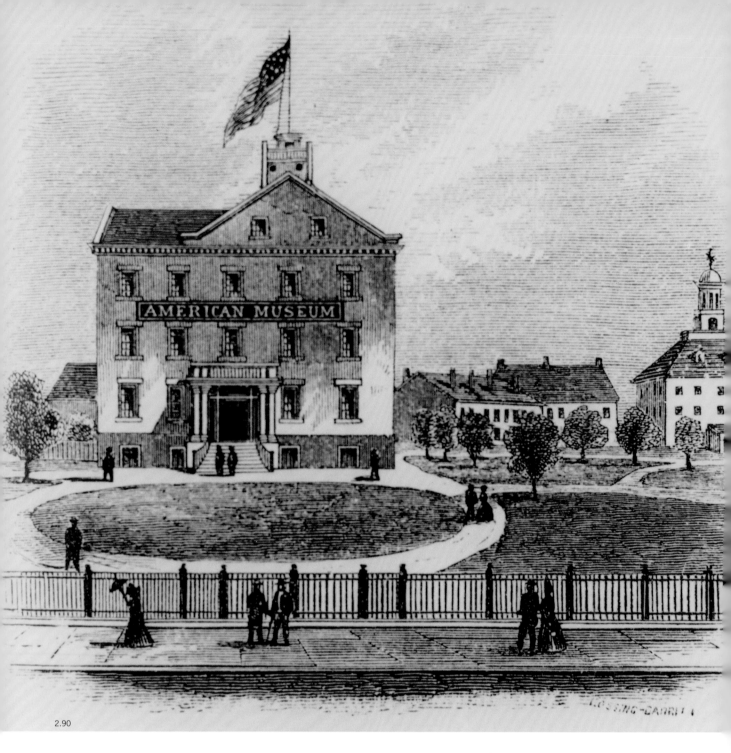

2.90

will not be found on examination to be in miniature, but a complete guillotine in every respect, and one capable of performing the part for which it was originally designed in France. . . . Every visitor to the Museum may, if they wish, have access to the guillotine, it may be seen with the beheaded figure, or by itself; when the machine is seen alone, nothing appears horrible."[12]

For those New Yorkers seeking culture and relaxation outside the city a trip to the Elgin Garden offered a happy option (2.92). The garden was operated by David Hosack, a professor of botany at Columbia College and former physician, who was present at the Burr-Hamilton duel in 1804. Closer to the city were the Vauxhall Gardens, located on Broadway between what are now Fourth Street and Astor Place (2.93). In 1804 Joseph Delacroix leased this garden from Astor, who had acquired it as part of his plan to purchase as

2.90. American Museum, 1825. **2.91.** Vanderlyn's Rotunda, 1830. **2.92.** Elgin Garden, 1811. **2.93.** Vauxhall Gardens. **2.94.** William P. Chappel, bathing party. **2.95.** Pewterers' flag.

much Manhattan property as possible. The urban retreat boasted a large garden, gravel walks, and statues. Visitors could listen to a band and purchase ice cream and other refreshments. Fireworks were set off on holidays, and balloons trips ascended periodically. Another popular summer recreation was swimming in the East River above the shipyards (today's Eighth Street). A nice sandy beach called Dandy Point was the destination of bathers in this Chappel painting (2.94).

2.91

Politics and patriotism were tightly intertwined in the early national era. Well aware of both the fragility and the significance of the new experiment in republicanism, New Yorkers celebrated their triumph in the streets on the Fourth of July and other historic occasions. The first republican event took place in the summer of 1788 as the convention in Poughkeepsie was debating whether or not to ratify the Constitution. There was little doubt about the position of the city's merchant and artisan community,

2.92

which expected the new charter to increase both trade and economic growth as well as to usher in a strong nation-state. To persuade the delegates, New York organized an elaborate parade. Artisans marched by trade and banner, and the star of the procession was the good ship *Hamilton*, named after the city's prominent citizen and a top booster of the Constitution (2.102). The motto of the banner of the pewterers (2.95), the only surviving artifact of the parade, is a statement of classical republicanism:

2.93

> *The Federal Plan Most Solid & Secure*
> *Americans Their Freedom Will Endure*
> *All Arts Shall flourish in Columbia's Land*
> *And All her Sons Join as One Social Band.*

Washington's inauguration and residency in New York, the capital city, was a source of great pride to the city's residents. The common council had already remodeled the City Hall to house the government and was intent on building a fine residence for the president. But

2.94

SOLID AND PURE.

The Federal Plan Moft Solid & Secure
Americans Their Freedom Will Enfure
All Artf Shall Flourish in Columbias Land
And All her Sons Join as One Social Band

SOCIETY of PEWTERERS

the capital was moved to Philadelphia late in 1790 as part of a political bargain to allow passage of Hamilton's funding and assumption plan, so the city had only one year to bask in the limelight. Had the government remained in New York, the city might have become another Paris or London, acting as the economic, cultural, and political center of the country. The relocation of the capital divorced the political from these other aspects of national life, in which New York still excelled.

When Washington arrived in New York Harbor prior to his inauguration, a flotilla of boats "in all their naval ornaments" greeted him. In one sloop were "twenty Gentlemen and Ladies with most excellent voices, [who] sung an ode prepared for the Purpose to the tune of 'God save the King,' welcoming their chief to the seat of Government."[13] Washington's arrival in New York has been commemorated in a number of paintings

that impart an almost mythic quality to the event and personify republicanism (2.101). Washington's inauguration on April 20, 1789, was also part of an elaborate ceremony. He took the oath from Robert Livingston on the balcony of the City Hall, then called Federal Hall, surrounded by crowds of cheering New Yorkers.

The Fourth of July occasioned both solemnity and festivity. Parades were held, with the various crafts and professions of the city often marching by trade. These were followed by an oration, after which each group retired to an elegant dinner, highlighted by toast after toast to America's past, present, and glorious future. A Chappel painting depicts the 1812 celebration (2.96). At the left is Tammany Hall. Leading the procession and dressed as Indian sachems are members of Tammany, a Democratic political club that began as a fraternal club based on Indian customs. A number of

2.96

citizens wear military attire to celebrate the day, while a black drummer stands in their midst. At the right, along Broadway, booths provide refreshments.

New Yorkers recognized that the completion of the Erie Canal linking the east with the Great Lakes and the western states bordering them meant that their city would continue to grow faster than any other metropolis, reaching commercial heights that could hardly be conceived. (Indeed, the price of goods from the Great Lakes to the city soon plummeted from $100 a ton to $9 a ton. By 1850 goods valued at $200 million reached the city annually.) Celebration of the event, captured in a painting by J. L. Morton, was climaxed by the arrival on November 4, 1825, of Governor Clinton, the godfather of the canal, on board the *Seneca Chief* (2.97). Two casks of Lake Erie water were ceremoniously dumped into New York Harbor. A grand procession marched though the streets, with the city's different craftsmen handsomely attired and holding emblems of their trades. Huge fireworks displays lit up the night.

Politics were fierce: at stake was the legacy of the American Revolution.

Politics in the early republic were fierce. Nothing less was at stake than the legacy of the American Revolution and the nature of the new republican experiment. Federalists, led by Alexander Hamilton, a New Yorker, argued for a deferential society, in which those of the middling classes would willingly defer to the better educated. Their opponents, the Jeffersonian Democratic-Republicans, responded with appeals to and for an egalitarian citizenship in which all citizens were considered capable of exercising independent political judgment.

Political debates in New York were waged largely during the annual elections for the state assembly and for corporation offices ranging from alderman to constable. Democracy took deep roots in the city. Interested resi-

2.96. William P. Chappel, 1812 Fourth of July parade.
2.97. J. L. Morton, *Canal Celebration*, 1825. **2.98.** *A Peep into the Antifederal Club.* **2.99.** William Charles, *The Tory Editor and His Apes.* **2.100.** *The Finishing Stroke*, 1807.

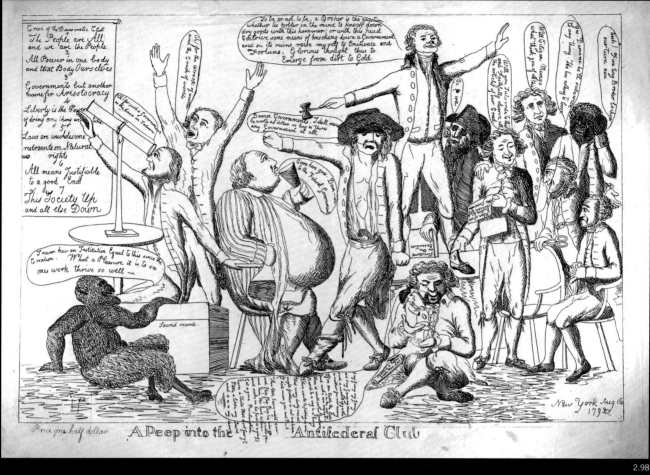

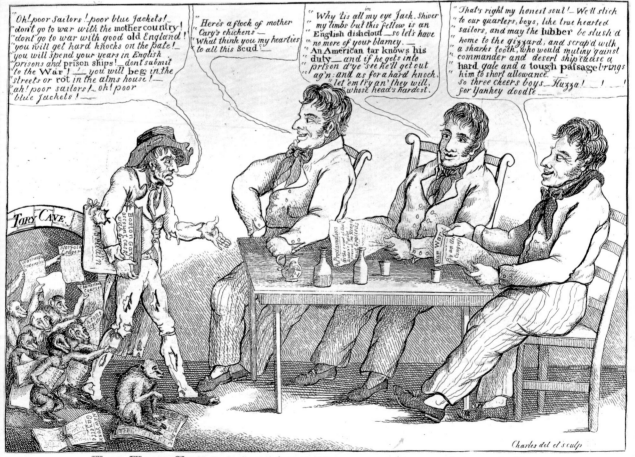

The finishing
STROKE.

Every Shot's a Vote,

and every Vote

KILLS A TORY!

DO YOUR DUTY, REPUBLICANS,

Let your exertions this day

Put down the Kings

AND TYRANTS OF BRITAIN.

LAST DAY.

April, 1807.

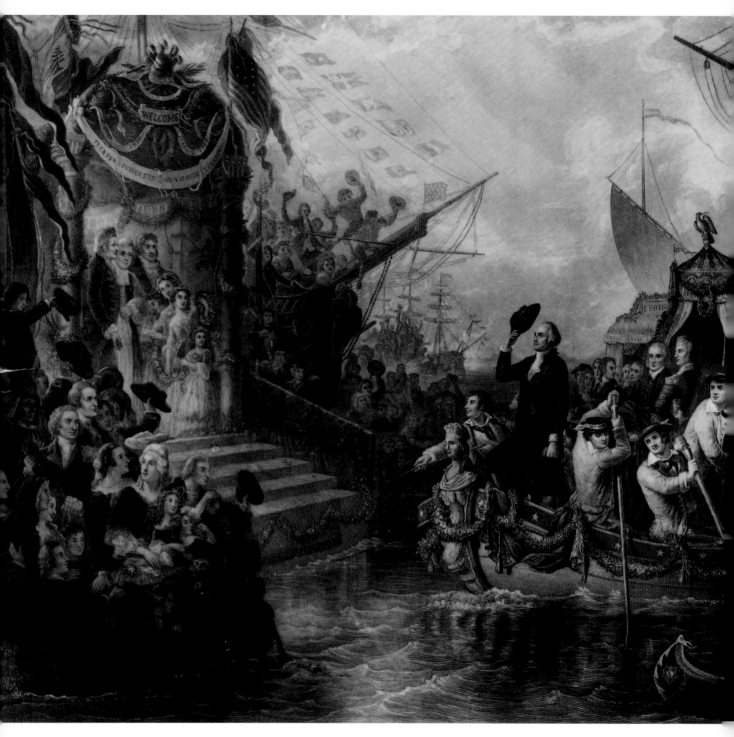

dents decided nominations at local taverns. Campaigns reached the streets in the form of newspaper articles and broadsides, as well as through the strident voices of stump orators. Hamilton and Burr were noted for their appearances in the hustings. During the early years of the French Revolution, many Jeffersonians supported the French on the streets by wearing French fashions, abandoning their powdered wigs, and danc-

ing to French waltzes. Federalists saw the new French influence as a dangerous political poison.

The Federalist outlook is well described in the broadside *A Peep into the Antifederal Club*, which depicts Republicans as Jacobins, upholders of the dreaded French Revolution, and in cartoons pillorying the Jeffersonian ideology of egalitarianism (2.98). Although the Jeffersonians were far more pro-South

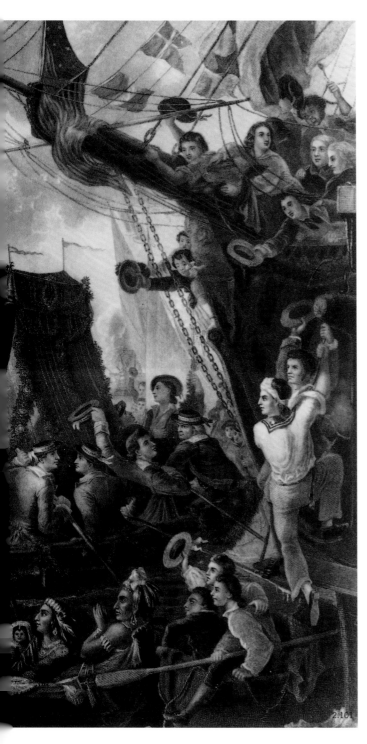

appears under a smoky oil lamp, his false outlook based on the French philosophes.

The balance of power in New York City often made the difference in the state assembly and played a major role in the election of Jefferson in 1800. Artisans made up a majority of the voters, and their swing to the egalitarian Jeffersonians in the mid-1790s meant that the Republicans would largely control New York's local government and politics. The Republicans excoriated the Federalists for being pro-English, labeling them Tories and aristocrats, and, because of their opposition to the War of 1812, termed them unpatriotic.

Broadsides proclaiming that every vote for a Republican was like a shot during the Revolution reveal a favorite and very effective Republican tactic: portraying each election as a new battle in the American Revolution (2.100). Particularly during the War of 1812, the Jeffersonians constantly reiterated that theirs was the only true patriotism. Even the local charter nomination had a masthead with a ship and the slogan "free trade and sailors' rights." A cartoon by English emigré William Charles shows a withered Tory (Federalist) editor and his apes trying to persuade the loyal American seamen to desert the cause (2.99). Such energetic vilification points to the steadily rising star of the Jeffersonians and the swiftly setting sun of the Federalists, who would no longer be a major political force in New York after the war ended in 1815.

2.102

and proslavery than were the Federalists, the Federalists put racism into their appeal as well. Jefferson stands on the platform. Tom Paine, a favorite target of the Federalists, is the man holding the shears. A second cartoon compares Washington with Jefferson, finding the first, who is placed under a laurel wreath, to be a great man in history, his philosophy grounded in order, law, and religion (2.103). Jefferson

2.101. Washington's arrival in New York.
2.102. Good ship *Hamilton*.
2.103. Jefferson compared with Washington.

LOOK ON THIS PICTURE

See what a grace was seated on this brow:

An eye like Mars to threaten and command,

A combination, and a form, indeed,

Where every God did seem to set his seal,

To give the world assurance of a man.

THIS WAS

SOPHISMS
NOTES ON VIRGINIA
TOM PAINE
CONDORCET
VOLTAIRE

AND ON THIS.

HERE IS_____

_____ like a mildew'd ear,
Blasting his wholesome brother_____

Vide Hamlet.

ARING LATTING, PROJECTOR.

ROBERTSON & SEIBERT LITH. 141 FULTON ST. N.Y.

LATTING OBSERVATORY

W.ᵐ NAUGLE, ARCHITE.

NEAR 6.ᵀᴴ AVENUE, & BETWEEN 42.ᴺᴰ, & 43.ᴿᴰ STREETS, NEW YORK.

3.1

3

1830–1884

ew York had become the leading American city during the first three decades of the nineteenth century. But over the next fifty years it emerged as an urban center worthy of the name of metropolis.

Thanks both to the Erie Canal, which offered a safe and inexpensive water route to the west, and to its naturally guarded harbor, New York was the main port of entry to the nation. Its population soared from 197,112 in 1830 to 803,358 in 1860 and nearly 1.2 million in 1880. It was the national center of trade and banking, and the country's greatest financiers resided there in luxurious dwellings. Simultaneously, hundreds of thousands of immigrants, mostly Irish and German, who had fled from poverty and political oppression settled in the city. As industrialization gathered speed, New York became the site of a growing number of manufactories in lower Manhattan and nearby Queens, New Jersey, and Brooklyn.

Though not without a sizable middle class, Gotham was a city of contrasts, with extremes of poverty and affluence. The nation's cultural center, boasting elegant theaters and opera houses, galleries, expositions, and concerts, it also had its share of crowded tenements and crime-ravaged neighborhoods. Its politics were exuberant and harsh. Some of the most lasting images of poverty and urban squalor, overcrowding and misery, come from this era of affluent excess and private mansions.

Panoramic pictures and bird's-eye views gained popularity in the United States prior to the Civil War. Artists used these media to show off the growth of the nation's great cities. Many artists spent weeks and months canvassing a city to get all the details correct. Various techniques were employed, among them lithography and chromolithography. A panorama executed by John Bornet in 1853 offers a sweeping view of New York (3.2). The harbors teem with commercial life. New Jersey in the foreground stretches from the Palisades to Hoboken and Jersey City, while the cities of Brooklyn and Williamsburg,

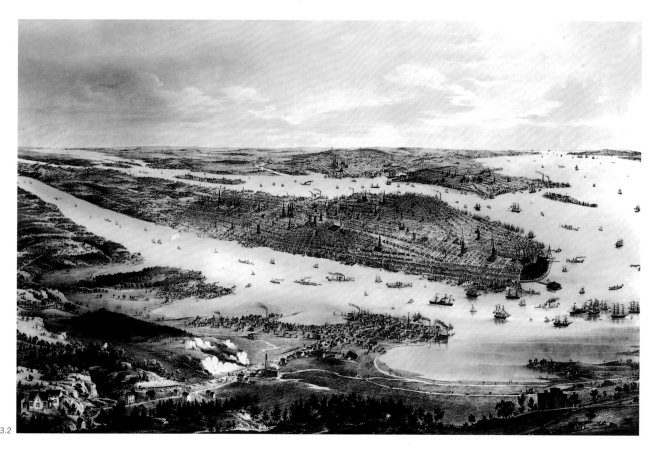

3.2

shown at the upper right, have grown to considerable size, housing many of the city's working and middle classes, who commuted to their jobs via one of the East River ferries. The city had expanded rapidly northward, each year pushing its upper boundary, at this point Fifty-ninth Street. Yet at midcentury the northern half of the island remained largely woodlands.

In 1853, in honor of the World's Fair, New York erected the Latting Observatory, near what is now Fifth Avenue and Forty-second Street. Depicted here in a lithograph based on a drawing by the architect, William Naugle, the structure was constructed of timber and iron bracing (3.1). At a height of three hundred fifty feet it was the tallest building in North America. Two elevators took passengers to the top. A great attraction themselves, the elevators, a new invention, would change the shape of the city. A panoramic view by Benjamin Franklin Smith, Jr., taken from the third landing—three hundred feet high—shows the growing city at midcentury (3.3). In the center foreground is the Crystal Palace, also built for the World's

Gotham was a
city of contrasts, with
extremes of poverty
and affluence.

Fair; next to it is the Croton Reservoir. At the left is Croton Garden, with its fountain. Fifth Avenue to the left and Sixth Avenue to the right were fashionable addresses. (As the city grew, the wealthy tended to settle in the middle of the island, taking horse trains and omnibuses to work. Further to the east and west lived the middling classes, clerks, and professionals.) In the distance across the river is the still undeveloped land that would become Queens.

The Crystal Palace was inspired by the structure of the same name in London. Built in the shape of a Greek cross, it housed four thousand exhibits of the new technological marvels of the age, including scientific instruments, gas lights, telegraphic equipment, and all kinds of machinery. An average of six thousand visitors from all over the country visited the Crystal Palace until its unfortunate destruction in a spectacular fire on October 5, 1858.

A south view from Union Square, less than two miles below the Latting Observatory, provides another vision of Manhattan (3.4). This lithograph was executed by C. Bachman, likely a German immigrant artist. Again, the

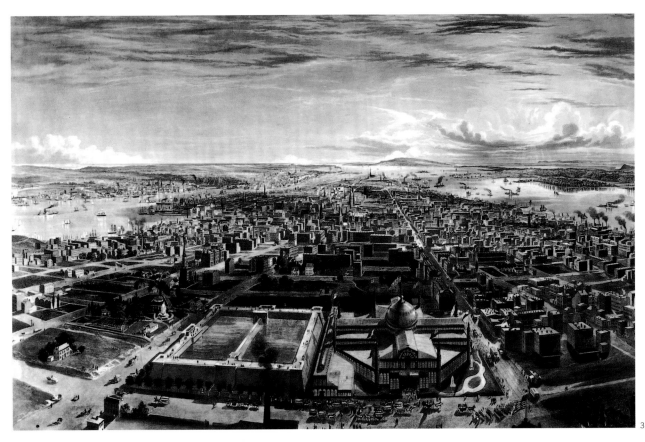

genteel areas at the center of the island are the main focus. The trees of Washington Square Park can be seen, though not the elegant brownstones. Fifth Avenue is the tree-lined street north of the park. Along the square are churches and fashionable mansions, homes of the elite. The commercial areas stretch far into the horizon. Union Square, festooned with birdhouses, fountains, and gas lighting and surrounded by elegant brownstones, was developed by Samuel Ruggles in the 1830s. It became a prime residence for the city's elite in the 1840s. The Church of the Ascension, St. Clement's Episcopal Church, and the First Presbyterian Church are all on Fifth Avenue, near the square. Grace Church, at Broadway and Tenth, is visible (see fig. 3.53), and to its left is the Collegiate Dutch Reformed Church.

The constant motion and life of the metropolis is ably captured in an 1848 color aquatint by John William Hill and engraver Henry Pappril, who present a geometrically fascinating view of the city's architecture (3.5). A panoramic view a few miles further south and also facing south, taken from St Paul's, at City Hall Park, this engraving reveals the lower part of the city, the former republican city. Churches remain prominent, and from the left can be seen St. George, the North Dutch Church, the Middle Dutch Church, and Trinity. The center of the illustration focuses on Broadway; the famous Barnum Museum is at the left.

This was both the center of mercantile New York and the home of much of its working class, including many newly arrived immigrants. In the 1830s nearly all the finer residential homes were either torn down or converted to warehouses or offices. The retail area moved further up Broadway. Streets were widened. Financed by the city's banks, in 1834 alone 877 commercial buildings were erected, mostly with three or more stories, in contrast to the more common two-story buildings of the republican era. Lower Manhattan was now a financial and manufactory center. This part of the city was known for its unrelenting movement. Tens of thousands of people worked in the small and medium-sized manufactories housed in its buildings.

As the population of New York swelled and the city expanded uptown, many New Yorkers found it necessary to move and move again. The poor moved nearly every

3.1. Latting Observatory, 1853. **3.2.** John Bornet, Bird's-eye view panorama, 1853. **3.3.** Benjamin Franklin Smith, View from Latting Observatory, 1855.

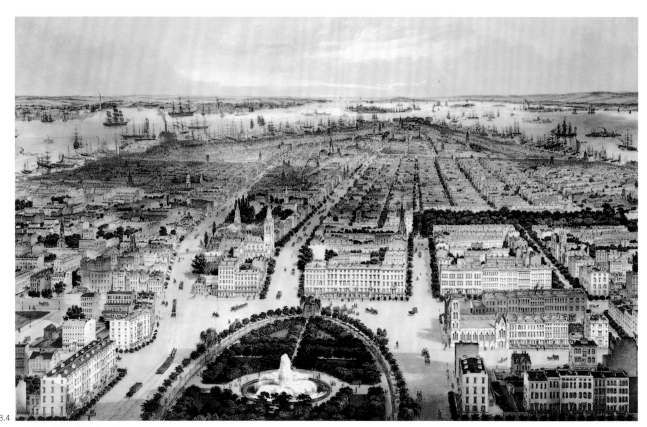

3.4

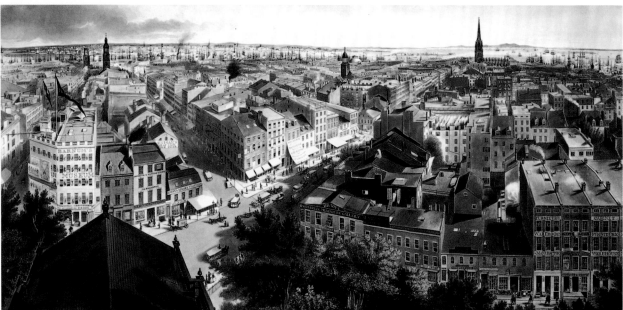

3.5

year, but the wealthy were mobile as well. As Henry James noted in *Washington Square*, "That's the way to live in New York—to move every three or four years." As these moves took more and more New Yorkers further from their places of employment, they required transportation. The first means of mass transportation were crowded stages known as omnibuses. Ambitious entrepreneurs formed stage lines that grew to ten companies, running 255 licensed stages, by 1846. In the following decade over one hundred thousand people rode nearly seven hundred stages daily. Traffic could be terrible. George Foster commented that on Broadway, at the Astor Hotel, you "see on average, fifteen omnibuses pass each way, every minute, and for the greater part of the day, all full."[1] Sometimes this resulted in what would today be deemed gridlock.

No street had more traffic than Broadway, the city's main commercial thoroughfare and the major north-south

highway. Crossing was a hazardous adventure. Many omnibus routes began at South Ferry and moved up Broadway. Although by 1870 railroads had lured away many passengers, an 1870 photograph shows one omnibus after another, only a few yards apart, plodding up Broadway at Duane (3.8).

More expensive and efficient transportation came in the form of horse-drawn railroads. While the rise of these opened upper Manhattan to rapid development, corruption riddled the granting of monopolies and franchises to investors who financed railroad construction. Soon, despite their objections, omnibus companies were not permitted north of City Hall. In the fifties five street railroads were built on the East and West Sides. Permitted to charge no more than five cents per ride, they quickly became a prominent fixture of the city and soon were extended to connect to the steam railroads in the north, which were only allowed as far south as Twenty-seventh Street. There, carriages were attached to horses.

In the 1860s the search for ways to move more people faster, free from street traffic, resulted in the construction of the first elevated railroad, on the West Side, above Greenwich Street and between Dey and Twenty-ninth Streets. The first el was operated by cable connected to steam generators, but too many breakdowns caused the line to fail. In the 1870s, however, steam locomotives running on steel rather than iron superstructures made these the preferred mode of transportation and changed the face of the city. The West Side Line along Sixth Avenue sported pavilion roofs and heated waiting rooms for a largely middle-class clientele, while the Third Avenue East Side line served mainly the working classes. A serious drawback was the loud noise, as well as the soot and cinders that created hazards for those working or residing nearby.

Two pictures of Chatham Square, one from 1859 showing horse-drawn carriages (3.6) and the second from 1881 depicting the el station (3.7), reveal the dramatic change

3.4. C. Bachman, View from Union Square, 1849. **3.5.** John William Hill, View from St. Paul's, 1848. **3.6.** Chatham Square, 1859. **3.7.** El at Chatham Square, 1881. **3.8.** Traffic at Broadway and Duane, c. 1870. **3.9.** El at Coenties Slip, 1879.

3.6

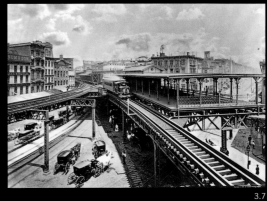

3.7

As the population of New York swelled and the city expanded uptown, many New Yorkers found it necessary to move and move again.

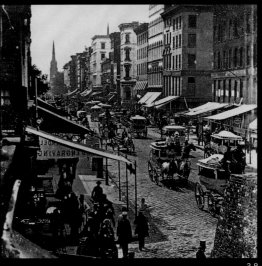

3.8

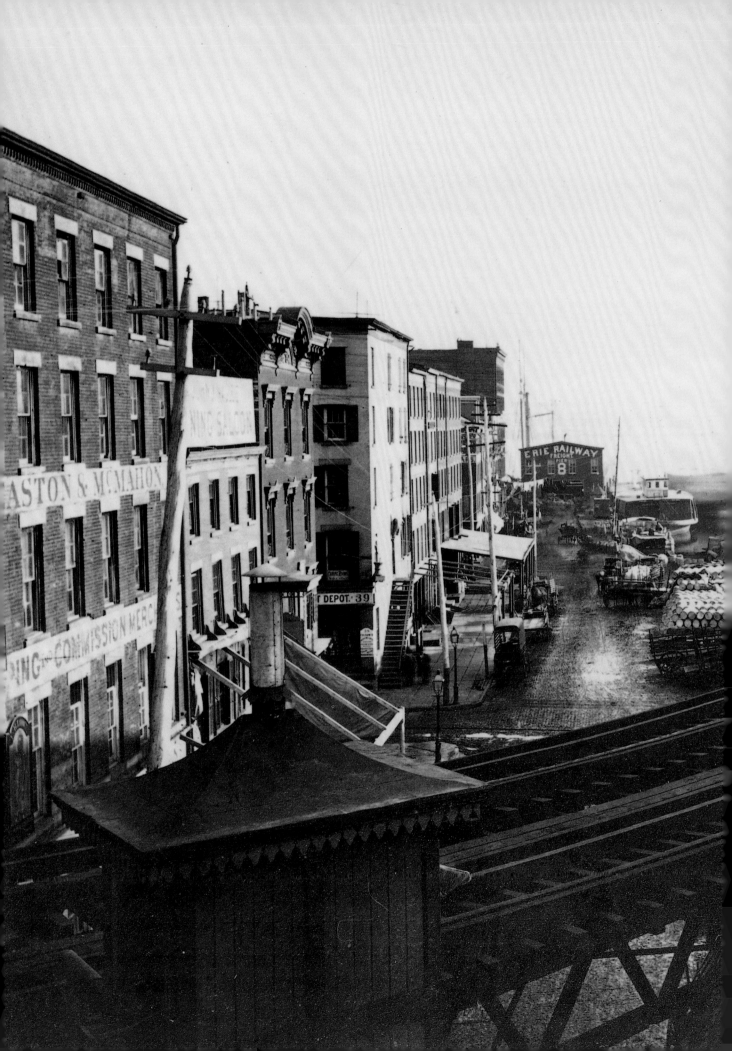

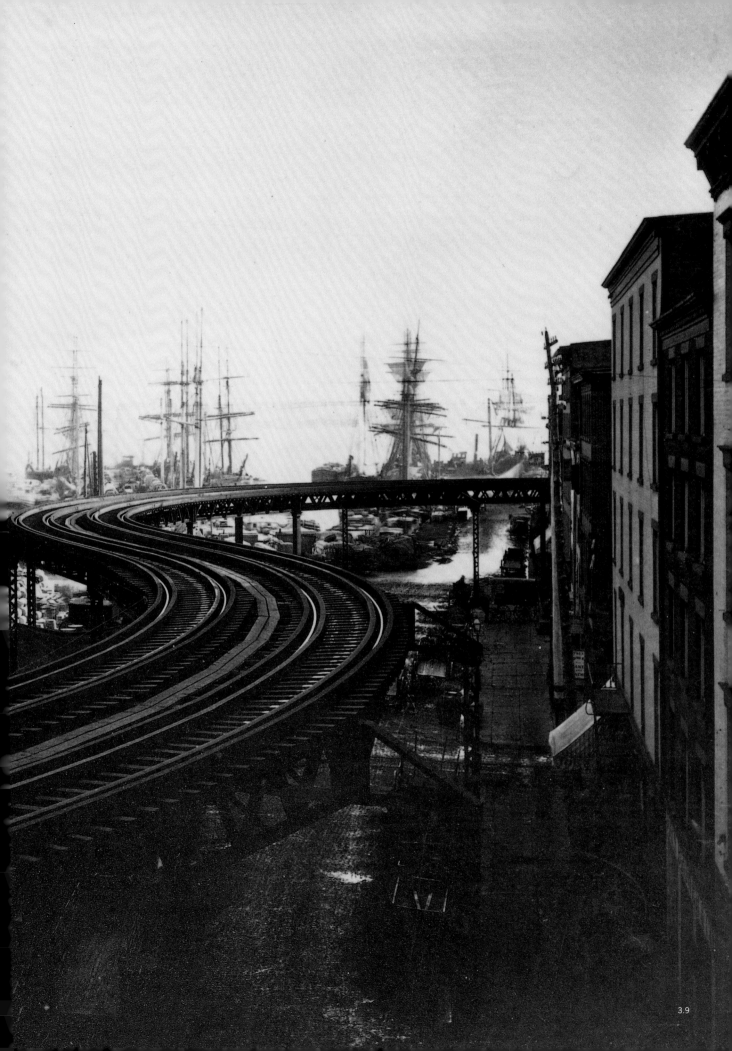

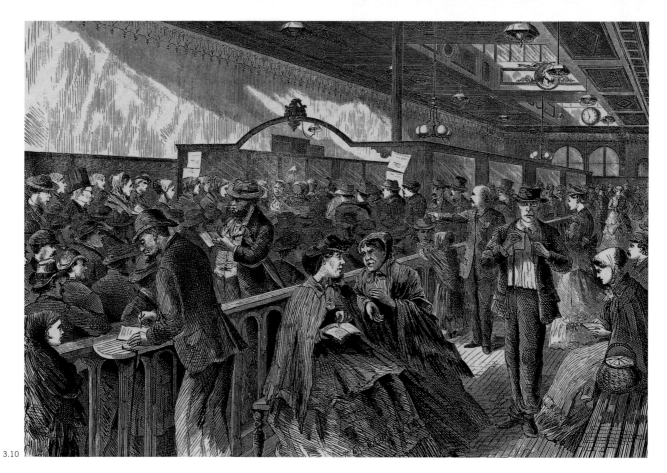

3.10

introduced by the railroad. The els provided opportunities for photographers to capture both the sense of the growing city and the geometric curves and patterns that the railroad inserted into the metropolis, particularly the famous S curve at Pearl Street. Set in the oldest section of New York, at Coenties Slip, the track winds through the crooked and narrow streets of earliest New York (3.9).

Cornelius Vanderbilt consolidated the New York and Harlem Railroad, which ran along Fourth Avenue, and the railroads running along the Hudson (New York and Hudson Railroad) into the New York Central. Vanderbilt began construction of the thirty-seven-acre Grand Central Depot as the single terminus for the city (3.11). Completed in 1871 at Fourth Avenue and Forty-second Street, in a French Second Empire design in brick, with a cast-iron trim, it included space for the offices of the new conglomerate railroad and became a landmark of New York life. The Forty-second Street facade was 240 feet long, while the train shed was protected by an 80,000-square-foot glass roof covering twelve tracks. Grand Central symbolized the integration of America's railroads within the nation's financial capital.

New York, holding the same status in the United States as Paris in France, emerged as the country's financial cen-

ter. At its core were the city's merchants and industrialists. While the city had always boasted men of wealth, in this era fortunes grew at a pace and in quantities that could not have been imagined in the earlier republican society, an age that prided itself on its sense of equality.

Wall Street, the Main Street not only of New York's but also of America's finance, was known throughout the world by midcentury. As noted in the prologue, while photographs often depict it as a narrow street in gray hues, artists rendered it differently, as in an 1850 lithograph by August Koellner (fig. P.1), where it stands as a majestic street of bank and insurance buildings constructed in an imposing Greek Revival style.

New York was the center of the nation's banking system. With the demise of the Second Bank of the United States, the major New York banks, such as the Bank of New York and the Manhattan Company, served as a central bank for the United States. Like the Bank of the United States, they were able to clear bank notes and present them to the originating institutions for payment,

3.10. Dividend day at Bowery Savings, 1870. **3.11.** Grand Central Depot, 1872. **3.12.** Nathaniel Currier, New Merchants' Exchange.

3.11

New York
emerged as the
country's financial
center.

3.12

using the New York Clearing House Association, which was organized in the 1850s. Some banks were devoted to investment banking, underwriting securities, while others were more traditional commercial banks, such as the Bowery Savings Bank, which initially attracted low- and middle-income depositors to its first office on the Bowery. An illustration from *Harper's Weekly* pictures Dividend Day in 1870 at the bank's Grand Street office, which opened in 1834 (3.10).

New York's merchants and financiers continued to lead the nation in the years prior to and after the Civil War. By 1850 they carried half of the country's imports and a third of its exports. Despite the distance, much of the gold in California ended up in the hands of New York financiers, who also enlisted Europeans to invest. The grand Merchants' Exchange built in 1827 was destroyed in a large conflagration in 1835. Wasting no time, the city's mercantile elite immediately commenced work on a new Merchants' Exchange, which is majestically depicted in a lithograph by Nathaniel Currier (3.12). The new exchange was built in Greek Revival, a popular architectural style inspired by the movement for Greek independence. A granite monument to commerce designed by Isaiah Rogers, it featured a facade of Westchester marble and a Corinthian colonnade of twelve columns, with an eighty-foot dome towering over its entrance hall. At the top stood a cupola for the telegraph. This expensive and imposing structure, housing the stock exchange, various brokers and insurance companies, and a reading room, reminded all citizens of the power and position of the city's merchants, men who traded to all parts of the country and the world, who dominated both canal and cotton trade, and who had connections in Latin America, the Orient, and throughout Europe. The exchange was the financial hub not only of the city but also of the United States.

While the New York Stock Exchange began in the 1790s, only in the years before the Civil War did it acquire prominence, bringing both great wealth and financial disaster to investors. In the

early years it involved a rather small collection of traders who bought and sold government, bank, and insurance bonds. With the advent of canals and railroads, new, highly speculative securities were added to the mix. The exchange rented quarters in the Merchants' Exchange and was by far the largest tenant when the new Merchants' Exchange opened in 1842. In 1865 it moved into its own building on Broad Street. The stock exchange held two sessions per day. Although there were many swindlers among the traders, and it was not uncommon to see watered stock traded, the market allowed investors such as August Belmont and Junius Spencer Morgan (father of J. P. Morgan) to underwrite U.S. railroads and other ventures, bringing capital into the economy.

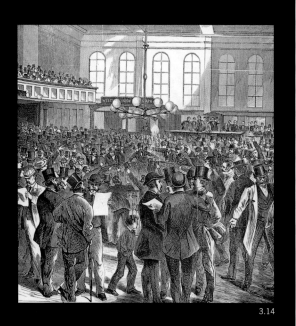

3.13

3.13. Curbside brokers, 1872. **3.14.** The Gold Room, 1869. **3.15.** *Ye Jolly Brokers of Ye New York Stock Exchange.* 1870.

3.14

During a session of the exchange, the chair would call out the name of a stock, which members could then sell or buy. A number of illustrations depict the color and fury of the antebellum market. During the Civil War the stock exchange forbade speculation in gold as unpatriotic (the price fell or rose in relation to Union greenback paper money, depending on the Union army's victories or defeats). The gold exchange moved into its own quarters, known as the Gold Room (3.14). Enormous fortunes were won or lost, and the frenzy of trading in the pits was intense, never more so than during Jay Gould's unsuccessful attempt to corner the nation's gold market on Black Friday, September 24, 1869. "Yells and shrieks filled the air" when it appeared that Gould had won, only to have the government enter the market. The suspense was nearly unbearable, with "the labor of years disappearing and reappearing" and "fortunes melting away in a second."[2] The stock market and related speculation made many a fortune, but the largely unregulated market could easily turn on a heretofore successful investor.

Traders unwilling or unable to spend $400 on a seat in the exchange sold at the curb side. Later this would become the American Stock Exchange. The illustration of such curbside brokers reproduced here includes a Shylock figure, reflecting the anti-Semitism of the era (3.13).

Wall Street was not for the faint of heart. Attempts were made to issue watered stocks well above the value of firms. In this atmosphere caricatures of those who pushed the market up and down became well known. An 1870 photograph from original sketches relates the attempt of Gould and his partners to prevent Commodore Vanderbilt from taking over their Erie Railroad by issuing seemingly unlimited stock without regard to value (3.15).

Few restraints held back the stampede to attain riches through speculation, despite the risks. By their nature volatile, markets fluctuated, and in hard times, when the city endured years of depression, many newly made fortunes would disappear. George Templeton Strong described the process: "Pop-pop—one after another they go off—and their substance vanishes in flames."[3]

With the demise of the Bank of the United States and the subsequent failure of additional banks, a major eco-

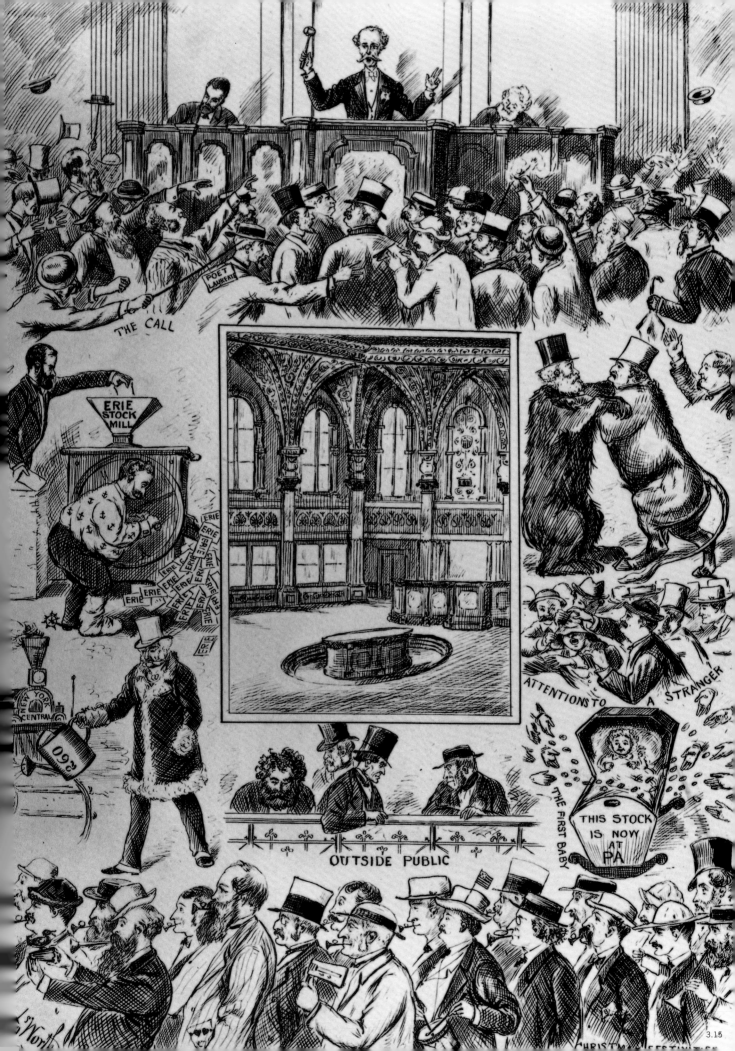

THE CALL

POET LAUREATE

ERIE STOCK MILL

ERIE

NEW YORK CENTRAL

260

ATTENTIONS TO A STRANGER

THE FIRST BABY

THIS STOCK IS NOW AT PA

OUTSIDE PUBLIC

3.15

3.16

nomic shock—the Panic of 1837—overtook the city. This was followed by a prolonged financial downturn that stretched into the 1840s. A cartoon by Edward W. Clay representing the outlook of the Loco Focos, an antibanking political movement, shows the state of *The Times*, portraying Wall Street as home to and source of pawnshops and liquor stores (3.16). This distrust of speculation was not an uncommon reaction to the intense greed and wealth of the era, when most citizens did not share in the spoils. Satiric signs read "S. Rumbottle Liquor Store" and "Peter Pillage Attorney at Law."

The infusion of California gold into the nation led to increased issuance of bank notes and a second recession, the Panic of 1857. On October 13, fifty-seven of the city's fifty-eight banks ceased specie payments. Another severe economic downturn ensued, hurting many New Yorkers, though the stock market quickly recovered. Observers imagined that only the end of time with its final conflagration would put an end to Wall Street speculation and swindles. During a panic frantic crowds gathered in front of the stock exchange, as depicted in a famous painting by James Cafferty and Charles G. Rosenberg entitled *Wall Street, Half Past Two O'Clock, October 13, 1857* (3.17). At the far right is the wealthiest man in New York, railroad entrepreneur Cornelius Vanderbilt. The man in the middle with the light coat is also a major railroad financier, Jacob Little, known as the inventor of short sales. After promising to sell shares he did not yet own, he would spread rumors about the firm, forcing its price down, and then pocket the difference between what he could buy the stocks for and what the earlier purchaser had agreed to

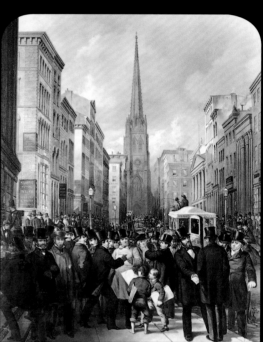

3.17

3.16. Edward W. Clay, *The Times*. 1837. **3.17.** James Cafferty and Charles G. Rosenberg, *Wall Street, Half Past Two O'Clock, October 13, 1857*, 1857. **3.18.** Edwin Whitefield, View of Brooklyn, 1844. **3.19.** A. R. Waud, *West Street*, 1869.

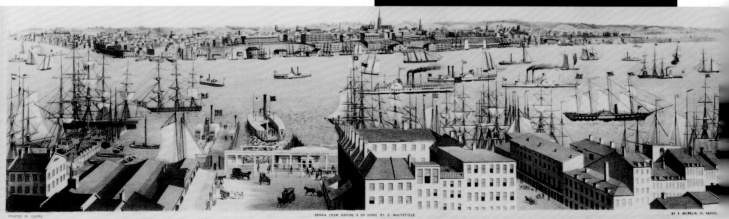

3.18

pay. He was also involved in schemes to corner markets and became known as Ursa Major, or Great Bear.

While fortunes were made, unmade, and remade on Wall Street, much of New York's wealth continued to be accumulated through coastal domestic and transatlantic trade. The port of New York remained the great entryway to the United States. The natural harbor and mercantile expertise that had created New Amsterdam and New York thrust

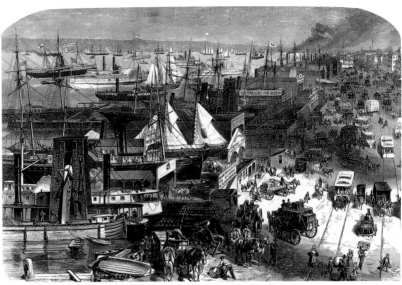

3.19

Gotham into the role of a world-class city. Its merchants bought, sold, and transported the largest quantity of the country's export products. By 1860 two-thirds of the nations's imports passed through the port of New York. The first packet lines to Liverpool, the Black Ball lines, sailed regularly, using New York as their terminus. Passage took less than forty days. Soon thereafter transatlantic steamships crossed in less than two weeks. New York was also the hub of a growing trade with Latin America, importing Brazilian coffee, Argentinian hides, and Mexican silver. Its clipper ships even sailed to China for valued silks and porcelains. By 1836 over twelve hundred vessels could be seen at anchor in the East and Hudson Rivers, a number that rose to three thousand by 1850. New York merchants controlled the southern cotton trade as well, buying, selling, and transporting the nation's most critical export.

To stand at the docks was to be at the center of constant motion, the hub of the economy of the United States. A visitor who could avoid being shoved by incoming passengers, merchants, dockworkers, sailors, and wholesalers and trampled by the passing carts would be astounded by the volume and the diversity of water traffic. Magnificent clipper ships, small coastal vessels, ferries, canal boats, Hudson River steamers, transatlantic steamers, and pleasure boats were all visible in the harbor. Some made the short (four minutes by steam) ferry trip to Brooklyn, while others embarked for month-long voyages to the Orient.

An 1844 lithograph by Edwin Whitefield illustrates the traffic in the East River (3.18). The Fulton Street ferry can be seen preparing to leave for Brooklyn as a carriage

approaches to board. To the right is Schermerhorn Row, today's South Street Seaport. In the river, just to the right of the Brooklyn ferry are three domestic steam ships and to their right is the *Great Western*, one of the first ships to cross the river using steam-driven engines (in 1838). On the left are the great clipper ships, perhaps just returned from their long journeys to the Orient. A few years after this drawing was completed, the gold rush would find many ships steaming and sailing to California. Ship tonnage increased by 60 percent in the 1850s, as the city's merchants supplied the new miners and entrepreneurs, provided transportation, and secured the prized commodity in their vaults.

The *Harper's Weekly* engraving *West Street* gives a good example of the bustle of the Hudson River docks (3.19). West Street also harbored the noted oyster boats that brought fresh oysters, sold by the thousands in oyster shops throughout the city to New Yorkers who had a seemingly endless appetite for this shellfish. This image is of the shop at the Fulton Street ferry (3.21).

The advent of the Erie Canal meant that New York could compete with manufacturing in the hinterlands. Gotham's merchants had the choice of either purchasing imports at wholesale auction at the docks or selling the city's own products to their connections in Louisville, Cleveland, Rochester, or Cincinnati. With the cheap price of transportation, New Yorkers could undersell local hinterland products and compete in quality.

These extending markets fueled New York's growth from a strong handicraft-producing seaport to the nation's leading site for manufactures in the 1850s. While com-

EXTENSIVE CLOTHING WAREHOUSES

DEVLIN & CO.

J. DEVLIN,
JON. OGDEN,
S.W. JESSUP,
R.C. OGDEN.

459 & 461 Broadway,
Cor. of Grand St. New York.

DEVLIN & CO.

258 & 260 Broadway,
Cor. of Warren St. New York.

J. DEVLIN,
JON. OGDEN,
S.W. JESSUP,
R.C. OGDEN.

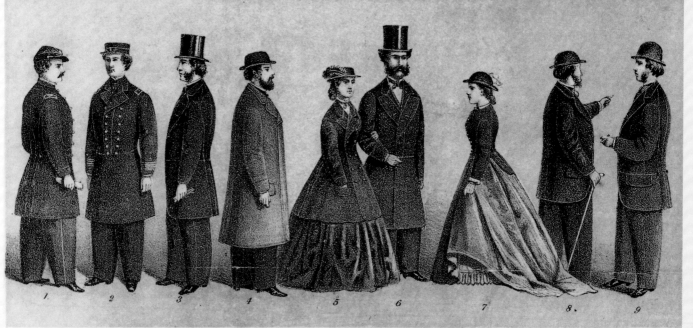

1. 2. 3. 4. 5. 6. 7. 8. 9.

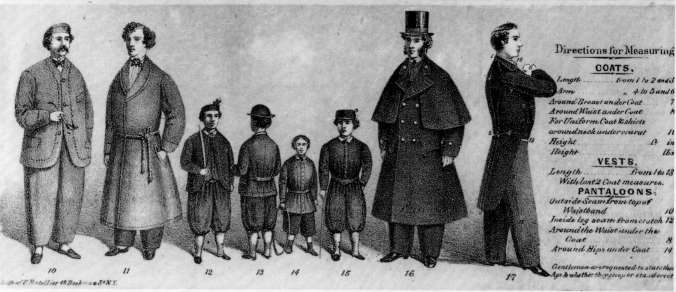

Lith. of F. Ratellier 48 Beekman St. N.Y.

10 11 12 13 14 15 16 17

Directions for Measuring

COATS.

Length	from 1 to 2 and 3
Arm	" 4 to 5 and 6
Around Breast under Coat	7
Around Waist under Coat	8
For Uniform Coat & shirts around neck under cravat	11
Height	ft in
Height	Usual

VESTS.

Length	from 1 to 13
With last 2 Coat measures.	

PANTALOONS.

Outside Seam from top of Waistband	10
Inside leg seam from crotch	12
Around the Waist under the Coat	8
Around Hips under Coat	14

Gentlemen are requested to state their Age & whether they stoop or stand erect.

3.20

merce remained the greatest source of income ($20,841,000 in 1840), manufacturing expanded ($12,504,000). The huge increase in population, largely attributable to the arrival of working-age immigrants, augmented the city's industries, both large and small.

No single trade dominated New York. Large factories existed together with small shops, even within a single trade such as printing. New York did, however, become the hub of the American textile industry, often forcing many country establishments out of business. The needle crafts were the largest of the city's trades, and there were a number of big firms. In 1818 Connecticut-born Henry Sands Brooks opened a store on Cherry Street to provide custom-made clothing to both genteel and seafaring customers; his sons expanded the enterprise to include ready-made garments. In the 1840s they opened this store on Catharine Street that catered to different classes (3.22).

Despite clichés portraying the Irish American as laborer, municipal worker, low-paid sanitation hand, or small subsistence shopkeeper, there were many successful Irish entrepreneurs. One was Daniel Devlin, who arrived in 1834, went out West, where he worked as a clerk on a steamboat, and then began a successful clothing manufactory in Louisville, Kentucky. Devlin married a wealthy Irishwoman in New York and eventually established Devlin and Co., a business that by 1860 was worth $1.5 million, with three Broadway stores and customers all over the South. His outfit had a strict departmental structure, or division of labor, supervised by his extended family. It sold by fixed price rather than barter, advertising "low profit, promptness, and cash." It produced both custom- and ready-made clothes and won over many of the wealthy Catholics of the city (3.20).

Along with firms that subcontracted most of their work, as in the tailoring and shoemaking trades, a number of large, highly capitalized industries prospered in the city until rising real estate prices forced them out after the Civil War. Among the most prominent were metalworks. The city's largest firm, the Novelty

Ironworks, took up five acres on the East River at Twelfth Street (3.23). Its staff included a superintendent, eleven clerks, and eighteen departments, each headed by a foreman. *Harper's Monthly* reported that it formed "a regularly organized community, having, like any state or kingdom, its gradation of rank, its established usages, its written laws, its police, its finance, its record, its rewards, and its penalties."[4] The company used steam power to build marine engines.

Also important was the Singer Sewing Machine factory, located at Centre and Elm Streets in 1851, whose product changed the lives of tens of thousands of laborers and many more consumers. Singer employed one hundred carefully organized men and used steam to power its equipment, adopting mass production methods previously used only in armories. The sewing machines were packaged on the floor above. By 1860 the factory was producing thirteen thousand machines a year and changing the garment industry (3.24).

Advances in the printing press allowing for the publication of much-higher-quality newspapers and books with more pages at much faster speeds made printing a major

3.20. Devlin and Co., 1854. 3.21. Oyster shop, Fulton Market, 1867. 3.22. Brooks Clothing Store, Catharine Street, 1845.

3.21

3.22

3.23

3.24

★

**No single
trade dominated
New York.**

●

3.25

industry. The most important development involved the use of the Hoe ten-cylinder press and rotary presses powered by steam that could produce twenty thousand sheets in an hour (3.25). By the late 1850s New York housed 104 newspapers that produced 78 million issues a year, including major voices such as the *Evening Post*, the *Tribune*, and the *Times*; weeklies such as *Harper's*; and many smaller literary and technical publications.

The republican craftsman was not as central to the life of the city at midcentury as he had been at the turn of the century. In many of the larger crafts, independence was difficult, and even when achieved it did not necessarily allow for economic standing of much consequence because the fierce competitive pressures of the market often led to very small profits. As one report noted: "Many of these small employers after using any and every means to keep themselves afloat (and injuring the trade as much as they are able) go down; and either return to the ranks or leave the city to try elsewhere; then there are many more who keep up and for many years hang about the skirts of the trade, picking up stray jobs here and there, taking them for any price they can get."[5]

But by no means was the small producer driven out of the city. Coexisting with the large enterprises, thousands of small shops continued in business throughout the metropolis, even as many industries moved toward steam-driven and factorylike organization. While few could afford a Hoe cylindrical printer, many could purchase an 1858 Gordon jobber to operate small custom print enterprises (3.28). The Trinity Building, built in 1852, housed twenty small commercial outfits when it was photographed in 1868. Five stories tall and located near Trinity Church, it was one of the city's earliest office buildings (3.26).

New York was not only the national center of American finance and manufacturing, it was also a retail paradise.

3.23. Alexander Anderson, Novelty Ironworks, 1851.
3.24. Singer Sewing Machine factory, 1851. **3.25.** Hoe's ten-cylinder rotary press. **3.26.** Trinity Building, 1868.

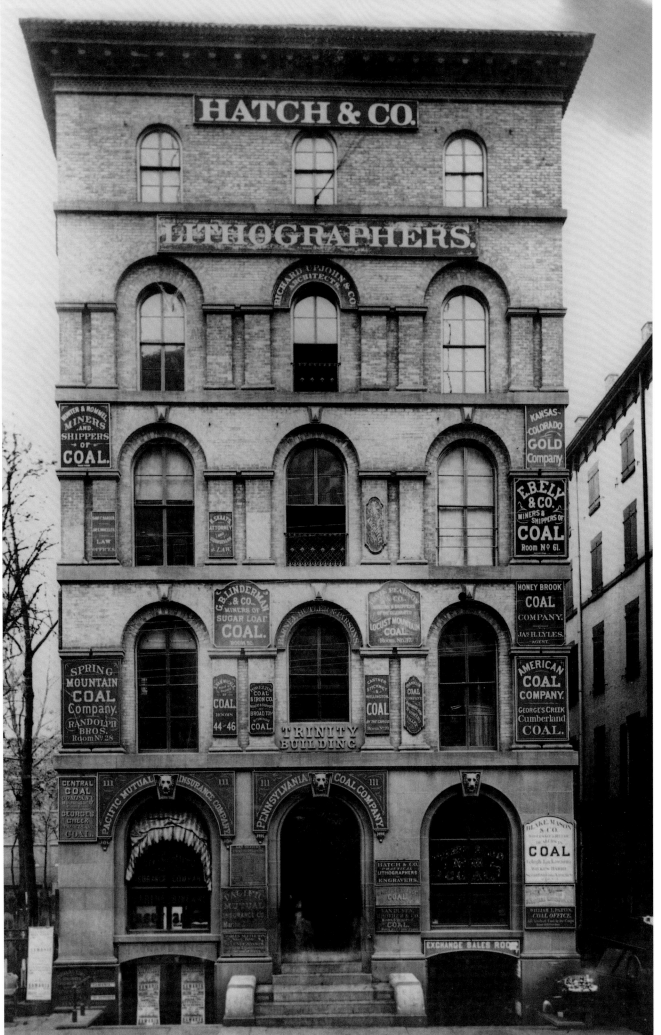

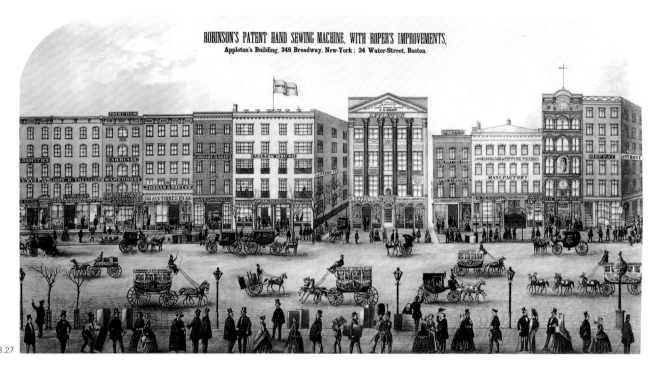

ROBINSON'S PATENT HAND SEWING MACHINE, WITH ROPER'S IMPROVEMENTS,
Appleton's Building, 348 Broadway, New-York; 34 Water-Street, Boston.

3.27

The road to and through that world of delight was Broadway, the city's main artery. The wealth created by commerce and industry put into circulation large sums of money available for domestic consumption by both the elite and the middle classes, and they came to Broadway to spend it. This vibrant commercial spirit is well depicted in an 1855 lithograph by F. Heppenheimer that portrays buildings generally five to six stories high to accommodate the manufacturers, auctioneers, and retailers of this busy shopping district (3.27). The building at the center is the famed Appleton's stationer store.

3.28

Twenty years later, in this Currier and Ives view of Broadway looking north at the new post office from just below Fulton Street in the 1870s, the buildings, now equipped with elevators, have risen to as many as nine stories (3.31). The post office itself, a symbol of the wealth of the Gilded Age, was built from 1869 to 1875 in a French classical style of granite and marble, its walls ten and a half feet thick. Appropriately, given the city it served, it was the largest post office in the world. Inside, twenty-nine-foot ceilings created a spacious atmosphere. A unifying theme in all the scenes of Broadway is a robust commercial spirit. Contrast the drawings by contemporary artists

shown here with photographs taken of Broadway (see fig. 3.8). The early photographs show a narrow, rather drab street, while the artists depict a wide thoroughfare full of color and life.

Broadway's commercial jewels, New York's first department stores symbolized the affluence created by the city's booming consumer culture. Alexander T. Stewart, an Irish immigrant who at his death in 1876 was the city's second wealthiest man, pioneered in creating them. Stewart came to New York from Belfast. In 1823 he opened a small dry goods store and never ceased expanding. During the Panic of 1837 he purchased merchandise at very low prices and opened a five-story enterprise at 257 Broadway.

In 1846, recognizing the need to attract women shoppers and hoping to benefit from the sales volume made possible by the growing wealth in the city, Stewart set about creating an appropriate feminine environment that

3.27. F. Heppenheimer, Broadway, Anthony to Franklin, 1855.
3.28. Gordon press jobber. **3.29.** Stewart marble palace, 1850.
3.30. Elevator at Lord and Taylor. **3.31.** Currier and Ives, Broadway, 1875.

was removed from the workplace, emphasized civic and cultural association, and provided for leisure and socializing. He built his famed marble palace, a white Italian Renaissance–style building modeled after the Traveler's Club in London, made for consumers who "yearned for the trappings of nobility."[6] Large plate glass windows held displays intended to attract shoppers. Inside were an eighty-foot dome, chandeliers, promenades, and ceiling frescoes. Middle-class and upper-class women were further enticed by the "Ladies' Parlor" on the second floor, with its large Parisian mirrors. The store, through economies of scale, offered more goods at reasonable prices—no bargaining permitted—allowing more New Yorkers into the new world of consumption. It also encouraged customers to browse unaccompanied, another important innovation (3.29).

The department store brought women of the upper and middling classes back to the downtown areas and changed the temper of the neighborhood. It introduced a sense of civility into the commercial sectors of the metropolis; previously, men had limited such constrained behavior to those dimensions of city life deemed part of the social sphere. Other stores followed Stewart's model, and as the fashionable residences of the city moved northward, so, too, did department stores. Lord and Taylor built a store at Twenty-ninth and Broadway in 1869, complete with passenger elevators (3.30). Stewart opened a new store on the site of an old farm between Ninth and Tenth Streets on Broadway, the famed cast-iron palace, also known as the Palace of Trade. Designed by John Kellum in a palazzo style and constructed of materials produced locally by the Cornell Iron Works, it was raised at the immense cost of $2,755,000. The use of iron and glass allowed for larger windows and more natural light, and a large rotunda and skylight dominated an interior that covered more than eight acres (3.32, 3.33). Five hundred male clerks and cash boys worked the floors under strict, timed discipline,

3.29

3.30

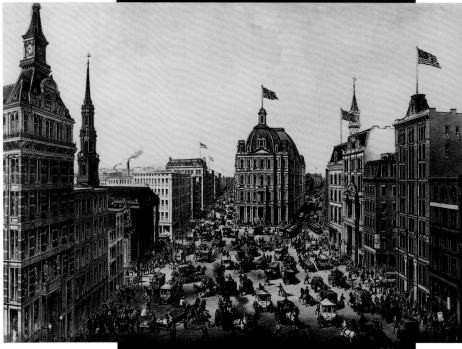

3.31

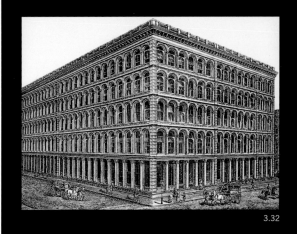

3.32

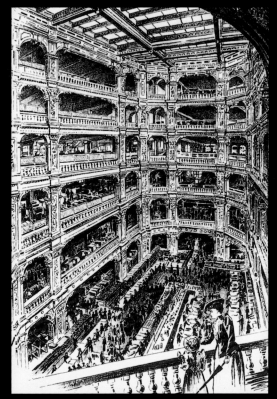

3.33

3.32. Stewart cast-iron palace. **3.33.** Interior, Stewart cast-iron palace. **3.34.** Fifth Ward Museum Hotel, 1864. **3.35.** H. R. Robinson. *A New York Belle*, 1846. **3.36.** F. Heppenheimer. St. Nicholas Hotel, 1855. **3.37.** Women promenading, Domestic Sewing Machine Company.

3.34

while in the upper stories women labored to make many of the ready-to-wear garments sold below. It was hard to keep up with the demand. In 1872 a reporter estimated that a lady of fashion would likely possess a wardrobe worth more than $20,000. The store was a great success, taking in the immense sum of $10,000 per day. But although it was a city landmark, the structure drew a great deal of criticism. One writer noted that it had done "more to retard architectural progress in New York than any other dozen buildings," but as a Cincinnati journalist observed, it attracted the public as a "fairy place of ancient story."[7]

There is no evidence of the lower classes outside the Parisian-designed Domestic Sewing Machine Company in an 1883 scene of shoppers sporting fashionable bustled outfits at Fourteenth and Broadway (3.37). The new consumer culture that had spread throughout New York by midcentury is similarly well represented in an 1846 lithograph by H. R. Robinson of a young lady in Stewart's Department Store at noon and in front of her mirror at night (3.35). Robinson's lithograph also illustrates how women's entry into public spheres of consumption commercialized their private domestic spaces.

Paralleling the department stores' displays of wealth and commercial splendor were the city's grand hotels. One visitor remarked that "one of the first things that strikes a stranger on arrival in New York are the major hotels, of which there are an immense number in every part of the town." They could accommodate hundreds of visitors at a time, and as one guest noted, they were "more like towns than hotels," with lavish dining rooms, specialty shops, and splendid carpets.[8] One of the grandest was the St. Nicholas Hotel, a six-story structure with six hundred rooms located at Broome on Broadway, depicted here in an 1855 Heppenheimer lithograph (3.36). The hotel boasted gaslight chandeliers, central heating, and steam-powered washing machines.

A small but unusual institution in the Fifth Ward was the Museum Hotel on Broadway and Franklin. Inside, the visitor would find not only a bar but also a gallery of stuffed animals and other historical displays (3.34).

In the early decades of the nineteenth century, New York's merchant princes lived downtown. As this area became more commercial and less hospitable to genteel

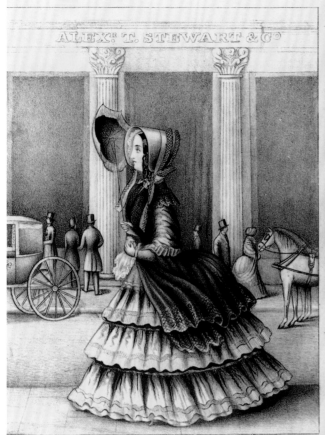

A NEW YORK BELLE.

NOON. & NIGHT.

3.35

3.36

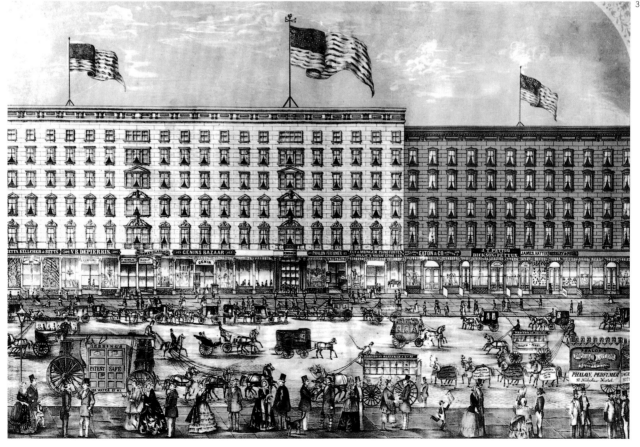

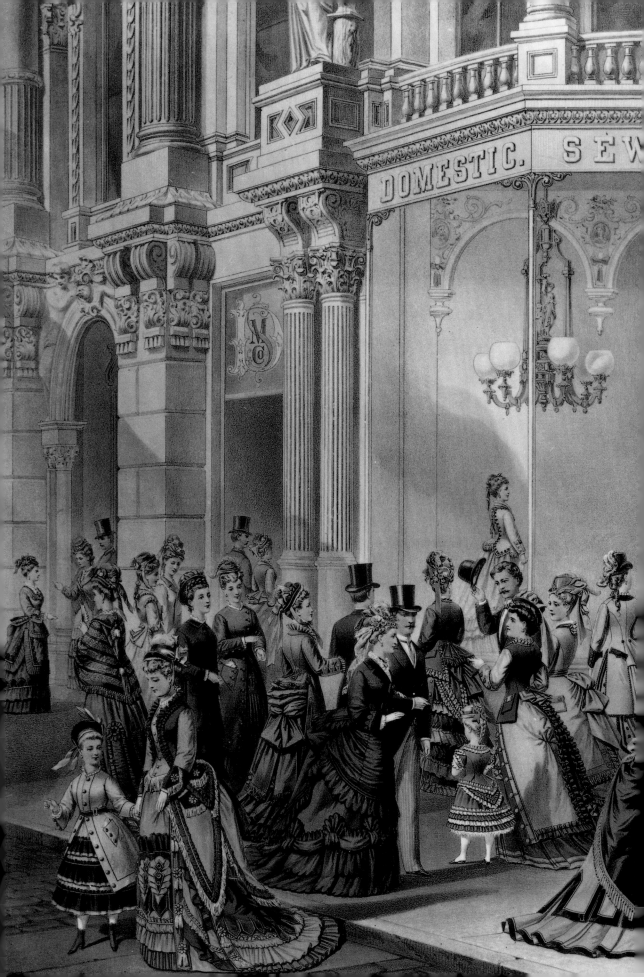

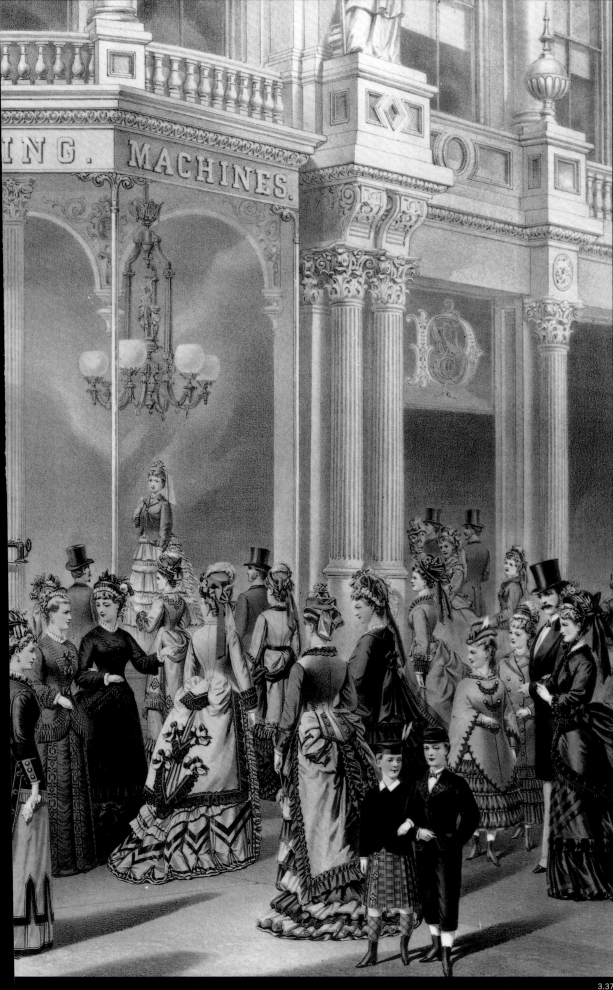

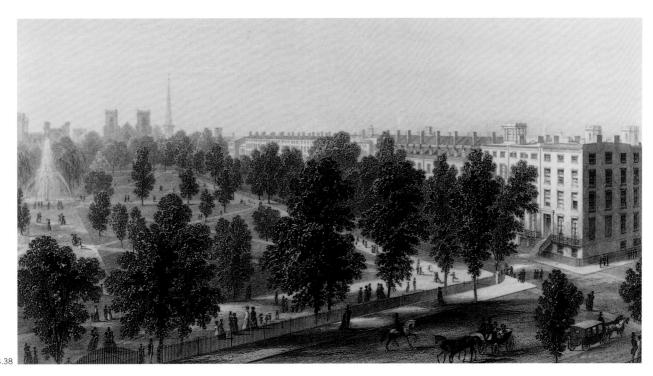

3.38

living, Gotham's elite began a relentless move uptown. The first step in the early 1830s involved relocating from the Battery and Bowling Green to the Broadway neighborhood, around the new City Hall. A favorite early choice was the parallel lanes running west to the Hudson. Park Place, an elegant street, was one of the prime locations in the thirties and into the forties (3.39). Here residents lived in Federalist row houses built of brick with high stoops and recessed doors in settings of quiet, tree-lined elegance. Similar homes could be found on Murray and Vesey.

In this period the wealthiest ward (containing the highest-assessed real estate in 1833) was the Fifteenth, today's Washington Square area. Some of the finest homes in the city were erected in the 1830s on Bleecker Street, Bond Street, and Waverly Place. Row houses, a style that began in this era, remained a favorite throughout the nineties. Many early row houses were not designed by architects but built by carpenters and builders following builders' guides.

Federalist architecture gave way in the thirties and forties to the Greek Revival mode, both in public buildings such as the

3.39

Merchants' Exchange and in private residences. As one visitor noted, "The Greek mania here is at its height, as you infer from the fact that everything is a Greek temple from the privies in the back court, through the various grades of prison, theater, church, custom-house and state house."[9] Not that different from Federalist architecture, Greek Revival stressed history and majesty rather than symmetry and proportion. Many builders decorated the exteriors of homes with fine ornamental ironwork. An outstanding example of Greek Revival construction was the famed Colonnade Row, designed by Alexander Jackson Davis and modeled after English architecture in Bath and London that featured monumental buildings laid out in terraces or crescents (3.41). Behind the Doric columns and heavy cornices were nine townhouses. Some of these residences sold for the heretofore unheard-of price of $30,000, and some of the city's most eminent figures, including John Jacob Astor, chose to live here. Soon the elite moved on to Fifth Avenue, however, and Lafayette Place became primarily commercial.

Along Washington Square Park stood another Greek Revival terrace, designed by Ithiel Town and still some of

the city's most elegant housing (3.40). It had a contiguous cornice at the top, each door had Doric columns, and the fences were adorned with Greek lyres and keys. Washington Square itself was purchased by the city in 1826 as a parade ground. The north side, owned by Sailors' Snug Harbor, was allotted to builders through hundred-year leases. A combination of Federal architecture and, more commonly, the Greek Revival style, these edifices still stand today. Those drawn to the square were largely of New England and Scottish Presbyterian background and could be seen promenading among its trees and fountains late in the afternoon (3.38).

As the city grew steadily northward, so, too, did the residential districts. Indeed, all but the working classes moved with it. The choice element of new construction was brownstone, or dark red sandstone, available in nearby quarries and used as facing over brick and wood frames. These structures were typically built over a high basement, about twenty feet wide, with a formal parlor and dining room on the first floor, bedrooms on the upper floors, and servants' quarters in the garret. As an 1865 photograph of Fifth Avenue at Twenty-first Street reveals, Fifth Avenue was a street of churches and brownstones, the most fashionable address in the city (3.43). Note the Union Club and Dutch Reformed Church at the far right.

With the growing availability of mass transit, developers and speculators also built row on row of brownstones for the middle classes, such as these on West Forty-sixth Street (3.42). Real estate was very expensive, and apartments, already fashionable in Paris, provided a solution for the middle classes and moderately affluent. In the seventies and eighties, a number of large apartment buildings went up on the still largely unpopulated West Side. The venerable Dakota, named for its frontier setting on Central Park West and Seventy-second Street and in honor of recent discoveries of

3.40

Gotham's elite began a relentless move uptown.

3.38. Washington Square. 3.39. C. W. Burton and John Smilie, Park Place, 1831. 3.40. Greenwich Village townhouses. 3.41. Colonnade Row, 1833.

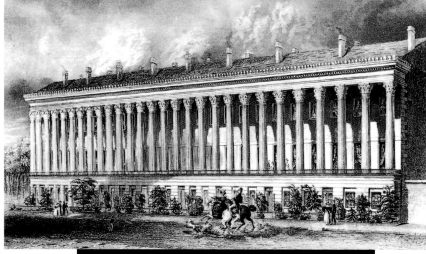

3.41

gold, was built in 1884 by Henry J. Hardenbergh (3.44). Its apartments aimed to attract the elite to the West Side. *New York, 1880* notes that "the Dakota was an undisputed masterpiece, far and away the grandest apartment house of the Gilded Age in New York, and rivaling, if not exceeding, in logic and luxury any comparable building in Paris or London."[10] The Dakota had fifty-eight suites with fifteen-foot ceilings and space for servants and parties as well as an interior carriage court. Its trademark was its skyline, dominated by turrets, gables, dormers, and chimneys. It rented out immediately to prosperous professionals and men of business.

After the Civil War, as the United States entered the

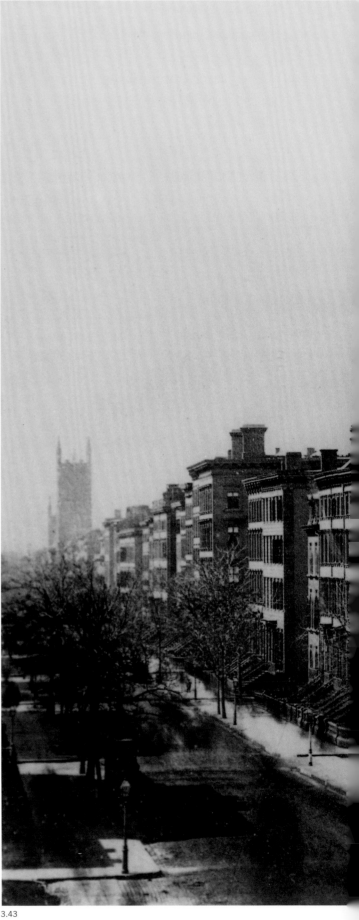

3.43

⭐

Developers and speculators built row upon row of brownstones for the middle classes.

●

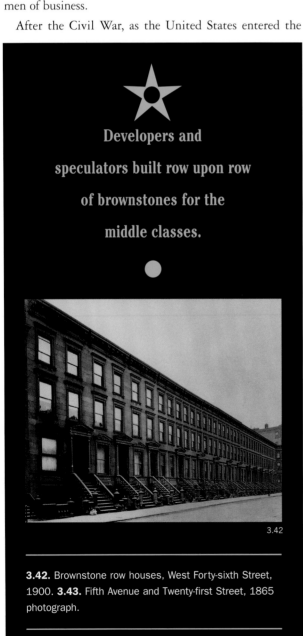

3.42

3.42. Brownstone row houses, West Forty-sixth Street, 1900. **3.43.** Fifth Avenue and Twenty-first Street, 1865 photograph.

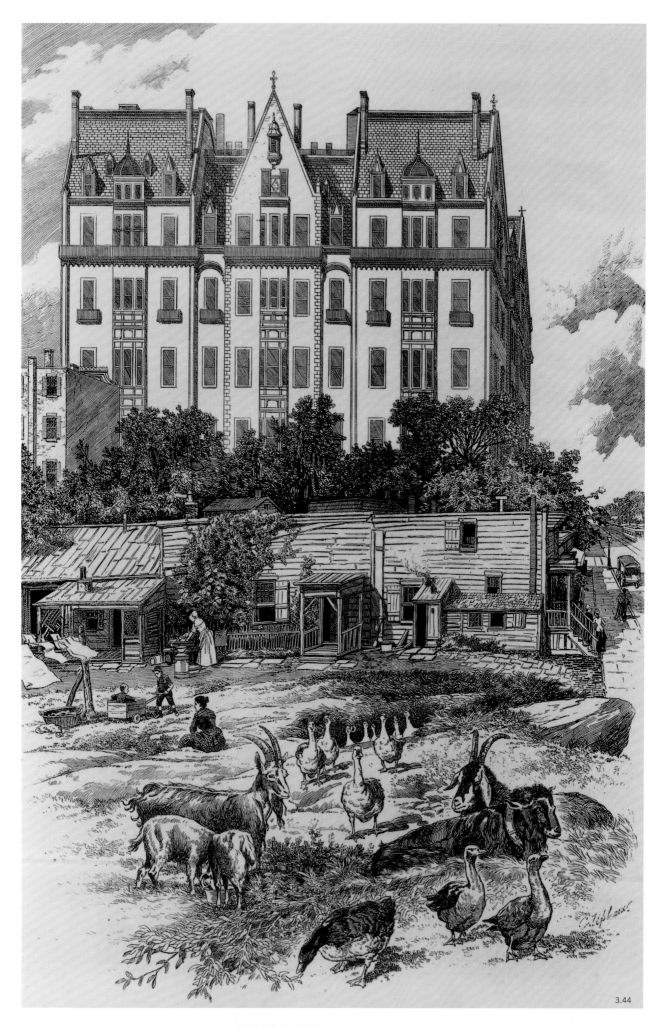

3.44

Gilded Age, the level of wealth in New York reached new heights. So, too, did the amount of money the gentry could spend on their homes. *New York, 1880* states that during the Gilded Age merchant capitalists had their first opportunity "to house themselves in splendid houses of a kind hitherto reserved for royalty."[11] A number of spectacular mansions were built on Fifth Avenue. One of the earliest and most splendid was the palazzo-style Stewart Mansion, at Fifth Avenue and Thirty-fourth Street, which was completed in 1869. *Harper's* exclaimed that it would "stand as long as the city remains" (it was demolished in 1901). Designed by John Kellum, who was also the architect of Stewart's second department store, the mansion required the labor of five hundred workers for five years at a cost of $5 million. The main rooms, which included a seventy-five-foot-long art gallery, were covered with marble and tile and boasted eighteen-foot ceilings. Stewart enjoyed his new mansion only briefly; his widow lived there for ten more years. Its ornate Greek, Renaissance, and French styling, unashamedly ostentatious and luxurious, illustrated both the splendor wealth could purchase and a willingness to build opulent monuments to the self. Surrounded by a moat, this was the city's most important symbol both of wealth and of the sharp contrast between the wealthy and the poor (3.45).

William H. Vanderbilt, son of Cornelius, erected another great statement of wealth on Fifth Avenue from 1879 to 1882 (3.46). Vanderbilt inherited $90 million from his father, along with the presidency of the New York Central Railroad. He proceeded to put together a railroad empire that stretched to Minneapolis, and at his death his fortune amounted to $200 million. Vanderbilt purchased the land on Fifth Avenue between West Fifty-first and West Fifty-second Streets and there erected monumental buildings to trumpet his prominence. Six to seven hundred workers con-

3.45

3.44. Dakota Apartments, 1889. **3.45.** Stewart mansion, 1869. **3.46.** Vanderbilt mansion. **3.47.** Bird's-eye view of Brooklyn, 1859.

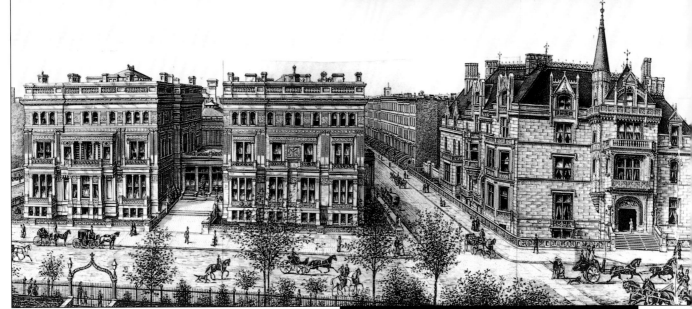

3.46

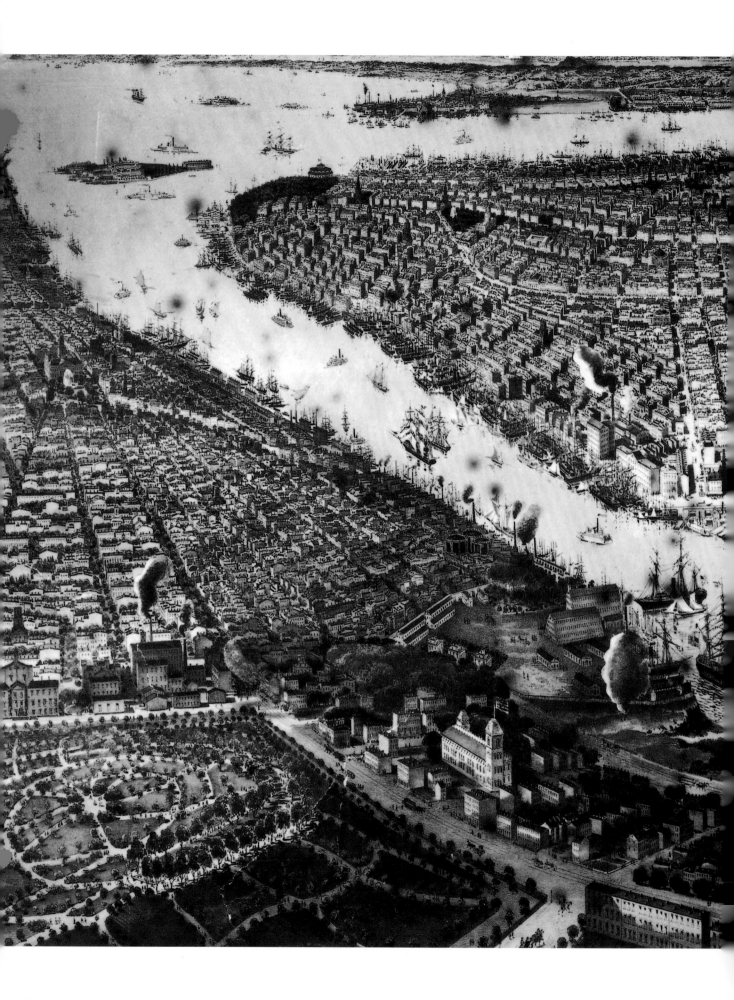

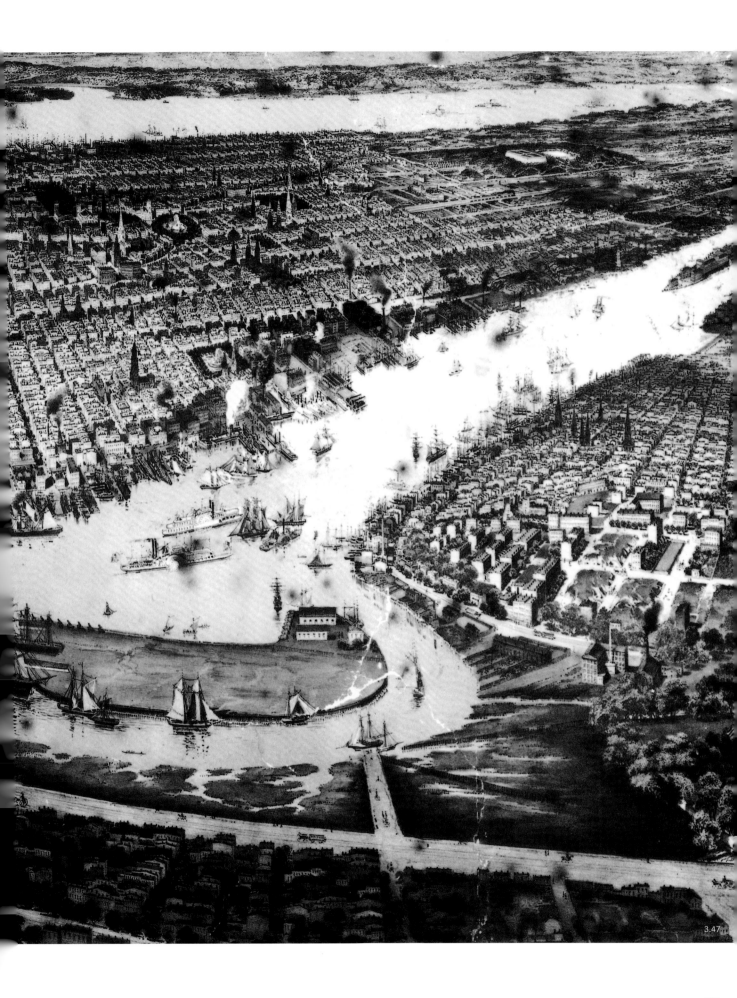

3.47

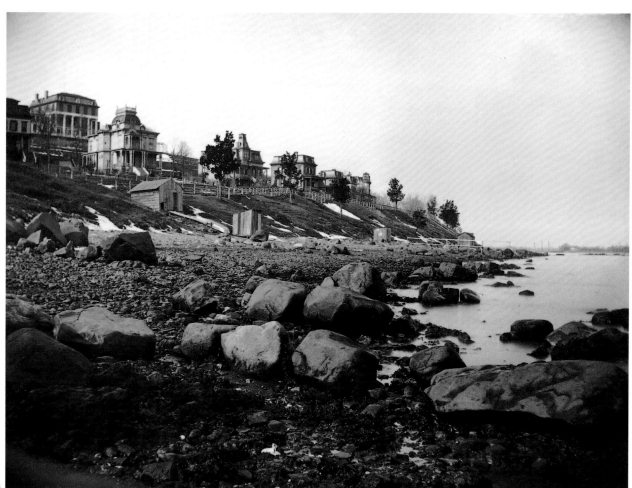

3.48

3.49

structed the buildings, about two hundred fifty of whom worked indoors as carvers. The lobby was a magnificent Pompeian room highlighted by marble walls and mosaics. Vanderbilt lived in the mansion on the right. It contained four floors with ceilings between fifteen and sixteen feet high. Inspired by a French Renaissance design, it was intended to outdo the Stewart mansion. The chateau at the far right, designed by Richard Morris Hunt after sixteenth-century French models, was built for Cornelius's grandson, William K. Vanderbilt. It opened in 1883 with a lavish costume ball set amid imported tapestries that was the great social event of the season. The house became a world-famous architectural landmark and the first of many chateaus constructed for the wealthy. Even critics sensed that it represented more than ostentation.

As the population of New York City grew 250 percent between 1840 and 1860, the metropolitan area surrounding the city tripled in size. Part of this expansion came from industries connected to the city that were attracted by the cheaper real estate on the outskirts. The availability of transportation meant that commuters could now live in northern Manhattan, Brooklyn, Queens, or what would become the Bronx.

In Brooklyn, working- and middle-class commuters climbed aboard the ferries every morning for a five-minute ride to Manhattan and their jobs. Brooklyn grew rapidly from a small town of just over 15,000 in 1830 to a much larger city of 266,661 in 1860 and 566,663 in 1880. It expanded by incorporating other towns, attracting new manufacturing industries that could no longer afford Manhattan real estate, and luring many new immigrants to relocate within its limits. Many lived and worked in Brooklyn as artisans and factory workers, while others commuted to New York. At Brooklyn's heart throbbed a working-class city. An 1859 panorama view by

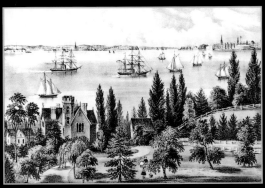

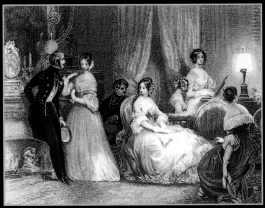

3.50

3.51

3.53

3.48. George B. Brainerd, New Brighton, Staten Island. **3.49.** Garfield Place, Prospect Park, Brooklyn. **3.50.** Currier and Ives, *New York Bay, from Bay Ridge.* **3.51.** Soiree, 1845. **3.52.** Nicholas Kittell(?), Mr. and Mrs. Charles Henry Carter, 1848. **3.53.** August Koellner, Grace Church.

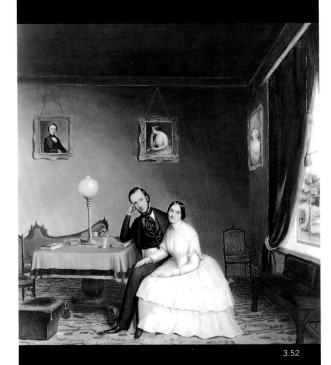

3.52

John Bachmann drawn from Brooklyn and directly facing Kip's Bay highlights the Brooklyn Naval Yard, an important site of work and construction throughout the nineteenth century (3.47). To its right is Williamsburg (eventually incorporated into Brooklyn), and to the left is the original city, laid out in a rectangular grid plan developed in 1839 that also featured a number of wide avenues and park squares.

Attempting to attract the wealthy, real estate developers proclaimed that Brooklyn was as close to the Merchants' Exchange "as Tenth Street but requiring only half the time to pass, on account of the rapid transit over the long ferries between the two cities."[12] Sections of Brooklyn, such as Brooklyn Heights, became retreats where genteel New Yorkers could live in countrylike splendor and still, with the help of railroads and ferries, do business in the heart of the metropolis. Farther out, Bay Ridge (south Brooklyn today) was designed by architect Alexander Jackson Downing as a Gothic retreat into the past, far from the modern metropolis (3.50). Similarly, Garfield Place became Brooklyn's gold coast in the 1880s, as mansions and elegant row houses for professionals and businessmen lined its blocks. A photograph reveals a single famous house designed by C. P. H. Gilbert and located on Garfield Place next to a two-family house designed by G. P. Chapelle (3.49). On Staten Island, in New Brighton, families lived far removed from the big city. A photograph by George B. Brainerd evokes a sense of seaside peacefulness that seems to share little with the pace of urban life (3.48).

Like Europe, New York was home to many soirees and coteries where talk of literature and philosophy abounded. New York's most famous salon, in imitation of Madame de Stael's, was that of Ann Lynch Botta, who was married to a professor of Italian literature. At her parlor could be found Edgar Allan Poe, Herman Melville, Margaret Fuller, and other literati conversing on the need for a new national literature, the British romantics, the role of women in society, and the significance of Mary

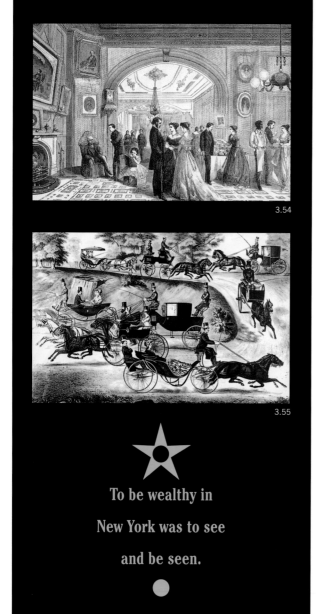

3.54

3.55

**To be wealthy in
New York was to see
and be seen.**

●

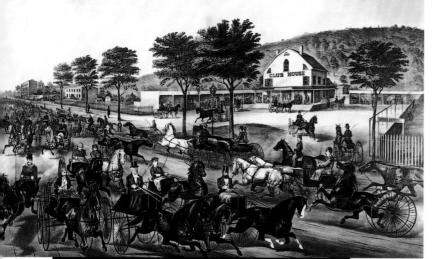

3.56

Wollstonecraft and the bluestockings. Able "to exchange the passwords of inspiration with poets and painters,"[13] hers was only the most well known of the salons favored by the city's elite (3.51).

Pictures of genteel family life capture scenes of elegance and luxury. Many portraits were painted of prominent and ambitious families such as that of Charles Carter, a physician at New York Hospital. The portrait here shows husband and wife at their home at 11 Bleecker Street in 1848. The painter, probably Nicholas Kittell, portrays the parlor, where ladies gathered to sew and guests were entertained. The furniture is Gothic, the paintings hung high according to the style of the times. The most elegant item in the room is the floral carpet. Mrs. Carter's dress is typical of the Victorian costume of the period, revealing no ankle and little neck (3.52).

These family portraits display the home as a place of harmony, family, culture, and domesticity. It was the woman's domain, far from the competitiveness of the street, the marketplace, the political arena. Women are as prominent as the men in these portraits, unlike scenes of the city's public areas, where the activities of even eminent women were limited to shopping, socializing, the church, and reform associations.

The Episcopal, Dutch Reformed, and other churches most frequented by the wealthy followed the gentry uptown. Grace Church relocated to Broadway and Tenth Street in 1846; a marble spire added after the Civil War transformed it into a temple nearly as stately as a European cathedral, as this image by August Koellner reveals (3.53). Stewart built his mammoth cast-iron department store across the street from the church in 1869. Such juxtapositions of religion and commerce extended beyond mere location. Later in the century, church decoration for holidays such as Easter and Christmas inspired window dis-

3.54. New Year's Day visits, 1868. **3.55.** Currier and Ives, *Fashionable "Turn-Outs" in Central Park*, 1866. **3.56.** Harlem Lane, 1868. **3.57.** Sheet music for *The Boz Waltzes*, 1842.

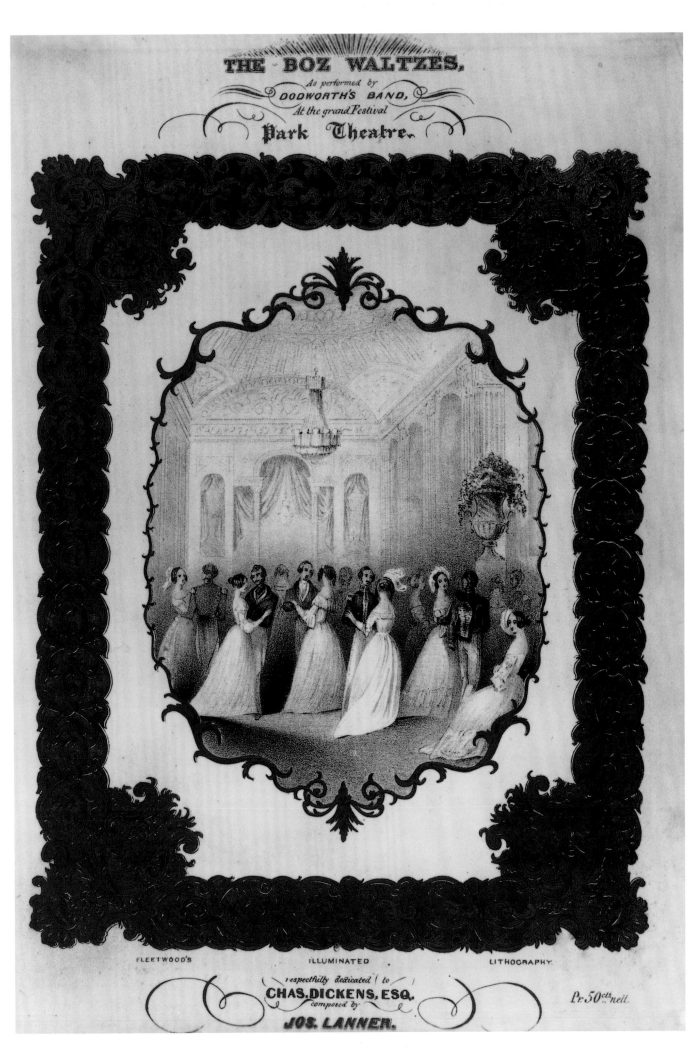

THE BOZ WALTZES,

As performed by

DODWORTH'S BAND,

At the grand Festival

Park Theatre.

FLEETWOOD'S ILLUMINATED LITHOGRAPHY.

respectfully dedicated to

CHAS. DICKENS, ESQ.

composed by

JOS. LANNER.

Pr.50cts. neit.

3.5

3.58

3.59

plays at the stores as "a complementary yet contested relationship between American Christianity and the modern consumer culture."[14] The new aesthetic cultivated a religion of beauty, of ritual adornment, that suited the tastes of upper-class New Yorkers.

To be wealthy in New York was to see and be seen. Walking remained fashionable, but greater affluence made carriages available to more and more New Yorkers, and late afternoon rides in the city and park became as customary as the promenade. A well-known Currier and Ives print, *Fashionable "Turn-Outs" in Central Park*, depicts the East Drive from Fifty-ninth Street and Fifth Avenue to the Mall (3.55). The artist, Thomas Worth, shows eight different fashions. An unusual sight was the phaeton at the upper left, covered by a parasol and driven by a woman (though overseen by a groom). Gloria Deak has identified the various vehicles: at the top right is a brougham, one of the most popular and useful carriages in the city; down the road is a gig, or "gentleman's vehicle."

Other genteel customs included New Year's Day calls, up to a hundred on this single day. The city's social elite were well known to each other. They married and socialized within a tight circle, and the visits of the men on the first of the year affirmed their community (3.54).

Currier and Ives produced a number of lithographs tracing the love the city's wealthy gentlemen bore for the sport of racing. In the late sixties Harlem Lane was the most common site, a route extending from today's 110th Street to 168th Street. In this image trotters pace against each other on a summer Sunday afternoon in 1868. Financiers Cornelius Vanderbilt and August Belmont can be seen among others at their rigs (3.56).

Dancing was a crucial art to young men and women of the city's gentry. Waltzes and polkas were popular, and any person of fashion could make his or her way across the dance floor. The cover page of the sheet music for *The Boz Waltzes* depicts genteel dancing and was dedicated to Charles Dickens's New York visit in 1842 (3.57).

THE HUSBAND. THE WIFE.

MARRIED LIFE IN NEW YORK.

3.60

3.62

For women of wealth, genteel life meant dressing in elegant fashions and maintaining as near perfect an appearance as possible. New York women of the Gilded Age eagerly imitated French modes, and women's fashions in general became more conservative. The necklines were higher, the waistlines lower, and the contour of the body hidden by a corset; hair was pulled back, often covered with a bonnet. Now in style were lower hemlines and layers of petticoats and ruffles, fringes, and lace, with skirts

3.61

FIRTH, HALL & POND
PIANOFORTE & MUSIC WAREHOUSE.
N! Franklin Square New York.

as wide as six feet in circumference, requiring up to eight times more fabric than an eighteenth-century outfit. French cosmetics were popular as well. In 1869 George Ellington published his didactic *Women of New York*, in which he depicts some of the ritual involved in becoming a "Belle of Fifth Avenue."

Along with being cinched into the tight-fitting and uncomfortable corsets necessary to mold normal figures to fashionable slimness, the pursuits of beauty could include bandaging ankles to keep them small and elegant coiffure and face enameling (3.58, 3.59). Ellington observed that all this emphasis on appearance, together with plentiful leisure time and working husbands, could lead to upper-class dalliance (3.60).

The arts were a favorite source of recreation among New Yorkers. The preferred venue before 1880 was the Academy of Music, which opened in 1854 at Fourteenth Street and Irving Place (3.62). Initially, the management hoped to attract a broad public, even charging entry fees as small as twenty-five cents and offering a thousand-dollar prize for an original American opera. The experiment

3.58. Bandaging ankles, 1869. **3.59.** Enameling the face, 1869. **3.60.** Married life in New York, 1869. **3.61.** Woman at piano, Firth ad. **3.62.** Academy of Music, interior and exterior, 1856. **3.63.** Jenny Lind, in *The Daughter of the Regiment*, Baxter print.

3.63

3.64

failed, however, and the academy became a cultural oasis of the upper crust. Built with donations from New York's wealthiest citizens, it held over four thousand seats. The academy was suitable for grand opera as well as the New York Philharmonic, which was formed in 1842. Other ornate opera houses were erected prior to the academy, among them, the Astor (see fig. 3.136), but none survived more than a few years because of the operating costs involved. The academy finally failed in the 1880s, when the Metropolitan Opera (see fig. 5.62) was built, supported by many of the city's elite, most notably William H. Vanderbilt, who could not get boxes at the academy.

Castle Garden attracted New Yorkers of the middling and Bowery classes. A former fort near the battery con-

verted to an entertainment center, its most popular visitor was undoubtedly Jenny Lind, who drew mass audiences from all walks of life (3.63). Singing arias from many operas as well as popular songs, the "Swedish Nightingale" delighted thousands of New Yorkers. One critic noted that at her concert "there was real sublimity in the scene when Jenny Lind's voice, after one of her brilliant soarings into the highest heaven of melody, floated away in silence, and a hush as complete as death fell upon the house."[15] Her tour was promoted by showman P. T. Barnum, and his deft use of advertisement and promotion, which included parades and visits to the archbishop, drew unprecedented crowds and a gross of $290,000.

The center of a major music industry, New York pro-

duced pianos for the nation. Steinway and Sons, started by German immigrants, had a large industrial plant in the city. By 1860 one in every fifteen hundred homes purchased a piano. No woman of refined standing would have been allowed to remain ignorant of music and instrumental skills. Many advertisements geared toward the ladies showed their attachment to the art of music (3.61).

Upper-class New Yorkers commonly collected and otherwise supported the fine arts. William H. Vanderbilt designed his mansion partly with his art collection in mind. When it opened, it had a gallery to which the public was admitted once a week by invitation only (3.65).

Many well-known artists resided in and around New York, among them Thomas Cole and Asher Durand of the Hudson River School and genre painter William Sidney Mount. Winslow Homer worked for *Harper's Weekly*. These painters often exhibited at the National Academy of Design, an institute founded in 1826 by Samuel F. B. Morse and others to promote the work of young artists. Constructed of white and dark marble in a Venetian Gothic style after the palace at San Marco, it stood at Fourth Avenue and Twenty-third Street. The first floor housed a studio with plaster casts from antiquity, the second had offices and a library, and the third was for exhibitions (3.66).

In 1870 members of the city's gentry, among them railroad executive William T. Johnson and attorney William P. Choate, together with painters John Frederic Kensett and Worthington Whittredge, founded the Metropolitan Museum of Art as an educational institution and cultural shrine for the city. They chose a site on Fifth Avenue because of its location adjoining Central Park. Its first building was a red brick structure in neo-Gothic style designed by Calvert Vaux. The exterior of the building was the subject of much criticism for its lack of elegance, but the columned halls, glassed roof, and pavilions in the interior were very popular. Through a tax, the city contributed $500,000. The museum's first important collection consisted of Dutch and Flemish paintings (3.64).

In their campaign for the museum, the city's gentry propounded the themes of "metropolitan destiny, civic responsibility, and moral

3.65

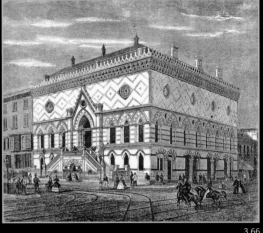

3.66

3.64. Metropolitan Museum of Art. **3.65.** Vanderbilt art gallery, 1885. **3.66.** National Academy of Design, 1865. **3.67.** American Museum of Natural History, 1877.

3.67

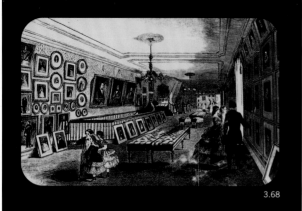

3.68

3.70

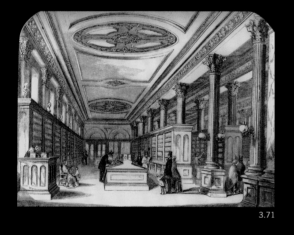

3.71

3.68. Brady daguerreotype gallery, 1861.
3.69. Walt Whitman. **3.70.** Bohemian scene at Pfaff's.
3.71. Appleton's Book Store. **3.72.** Astor Library,
interior. **3.73.** Astor Library.

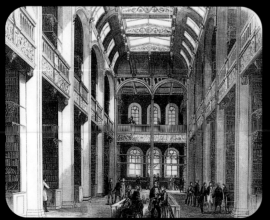

3.72

3.69

uplift."[16] Yet how to civilize the people if the people could not come? Not until 1891, eleven years after its opening and only with considerable pressure from the state legislature, did the museum open its doors on Sundays, making it accessible to the working classes.

Since all great European cities could boast of a natural history museum, prominent New Yorkers desiring their city to be included among the world's leading metropolises and seeking the social prestige of underwriting a new museum founded the American Museum of Natural History. Based on a specific idea of scientist Albert Bickmore, it opened in 1869 at the Central Park Armory with a display of a number of specimen collections. The museum was popular from the start; 856,773 visitors passed through its doors in the first nine months of 1876. In 1874, with President Grant looking on, the cornerstone was laid for a new building on Central Park West between Seventy-seventh and Eighty-first Streets; it opened a few years later. Built by Vaux and Jacob Wrey Mould in a Gothic design, the ground floor housed mammals; the first floor, birds; and the top floor, fossils (3.67). In the 1880s the museum opened on Sundays and inaugurated programs for teachers as it became a major civic attraction. A new and larger building opened in 1892.

The daguerreotype, invented in 1839 by the French painter Louis Jacques Mandé Daguerre, achieved instant popularity, and nowhere more so than in New York, which by 1853 had more studios than all of England (3.68). Now not only the rich could afford to have their images preserved, especially as the price for a portrait fell from five dollars in the 1840s to two dollars in the early fifties. Many photographers opened their own studios, including William Brady, who set up shop on Broadway. Sitters had to stay still for twenty seconds, and sometimes it was necessary to immobilize their heads mechanically. Despite such drawbacks, the invention of the medium opened a new world, permitting the representation of the city and its people in a manner inconceivable a decade before.

A vibrant literary community flourished in New York. Perhaps no one was as well known as Walt Whitman, who worked and wandered through the city as a poet, of course, but also as a journeyman, printer,

reporter, carpenter, and publisher (3.69). Herman Melville lived in Gotham for a time, as did Margaret Fuller and Edgar Allan Poe. One hangout known as a gathering place for Bohemian literary figures was the restaurant of George Pfaff, a German immigrant (3.70). Whitman often frequented the spot, along with poet Ada Clare, comic Artemus Ward, drama critic Fitz-James O'Brien, and actress and poet Ada Isaacs Mencken. Some saw them as Bohemians, flaunting social mores, as they appear in this caricature; others considered them distinguished literary figures.

New Yorkers who wanted to buy books might make a trip to Appleton's Book Store. The firm originated in 1825, when Daniel Appleton moved to New York from Massachusetts to open a grocery and bookstore. After 1831 he began to publish. His firm eventually became the city's second largest publishing house, smaller only than Harper's. The neoclassical design of the salesroom, clearly reflective of great respect for reading and the pursuit of letters, fostered an almost reverential atmosphere (3.71).

New York also could boast of a great library. When John Jacob Astor died in 1848 he left a bequest of

3.74

3.75

3.76

$400,000 to establish a research library (3.73). Six years later the first independent reference library in the United States to be built with a private endowment opened free to the public (though not in the evenings). The building, still standing today, was erected in a Romanesque red-brick-and-brownstone design; inside were large, skylit, colonnaded rooms for readers and a magnificent collection of 175,000 volumes (3.72).

During the 1830s and 1840s advances in print technology allowed the publication of penny presses: newspapers that sold for a penny and were smaller in size than the large and more costly newspapers of the republican era. The first newspaper to use this method was the *New York Sun*, edited by Benjamin Day; it was closely followed by James Gordon Bennett's *New York Herald*. Reporting on local news of interest to all classes, covering crime, Wall Street, city politics, and the theater, the *Herald* featured investigative reporting, personal ads, and inventive advertisements. It soon had a circulation of twenty thousand; until then, average newspaper circulation had reached only seventeen hundred. Gotham became a city of newspaper readers. Newspaper row on Park Row faced Printing House Square, which was located close to City Hall, an important source of breaking news (3.74). At the center is the *New York Times*, the largest daily paper in the United States after the Civil War, known for its investigative reporting, particularly its exposé of the Tweed ring and municipal corruption. In the 1880s the *Times* erected its new building around its old edifice, never missing a day of publication. The *Tribune*, edited by Horace Greeley, was a staunchly Whig newspaper, fiercely antislavery. A major success, it continued strong after Greeley's death, building a handsome early skyscraper to house the massive printing equipment and office space (3.75). Richard Morris Hunt designed the early skyscraper using brick instead of iron and showing more concern for style than bulk. At nine stories and 260 feet, it was the tallest building in the United

3.74. Printing House Square. 3.75. J. L. Giles, new Tribune Building, 1875. 3.76. Columbia University, 1885. 3.77. Free Academy, 1871. 3.78. Cane rush, Columbia University, 1882. 3.79. University of the City of New York.

States in 1875. Known for its mansard roof and imposing clock tower, which was modeled after the campanile of the thirteenth-century Palazzo Vecchio in Florence, it set a new style for commercial building. In this wood engraving by J. L. Giles, it towers over Broadway.

Higher education remained largely the domain of the city's gentry class, with Columbia College the school of choice. Columbia stayed in its Park Place residence until just before 1857, when it moved uptown to new quarters at Madison and Forty-ninth. The Gothic Hamilton Hall, designed by C. C. Haight and modeled after Oxford with its tower and turrets and chimneys and oriels, faced inward, creating a quadrangle and sealing off the campus from the city; it housed classrooms, faculty offices, and the president's room (3.76). Columbia continued to enroll small, select classes, and one critic, land developer Samuel Ruggles, wondered in 1854 "why the College, surrounded by more than fifty thousand youths, of age suitable for college study . . . teaches but one hundred and forty."[17] Yet although critics urged the college to accept more social responsibility, its move uptown signaled clearly its intention to remain among the elite that supported it. Only after the Civil War did Columbia rise to eminence among the world's universities.

For local youth, Columbia was a place of leisured learning, featuring such adolescent rituals as the Cane rush, in which sophomores wrestled freshmen. If the freshmen won, they could carry canes on campus; if not, they had to forgo this symbol of standing (3.78).

If Columbia was unwilling to reach out beyond the children of the elite or to change its classical curriculum, a new institution, the University of the City of New York (today's New York University), was less exclusive. Opening in 1831 in a neo-Gothic building on Washington Square designed by A. J. Davis, it was established to provide a more practical curriculum aimed at the children of mercantile and professional families, includ-

3.77

3.78

3.79

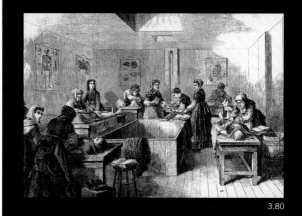

3.80

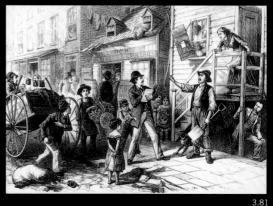

3.81

The most famous of the native-born working classes were the Bowery B'hoys, young men who lived in and around the Bowery, working in the city industries.

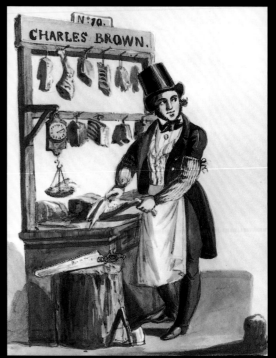

3.82

ing artisan households (3.79). Plans even included the provision of free tuition to a dozen scholarship students. The first presidents were Presbyterian and Dutch Reformed; they attempted to pursue both a classical and a Protestant evangelical approach. The earliest years drew mostly Presbyterian students from outside the city, but in the 1850s half the students came from the metropolis. Even so, the ideal of a new university in tune with the mercantile ethos of the city remained unfulfilled. A third college, the Free Academy, was founded in 1847 after winning approval in a citywide referendum (3.77). Located at Lexington Avenue and Twenty-third Street in a neo-Gothic building designed by James Renwick, it was established as part of the public school system to make higher education available to talented graduates in order "to give us intelligent mechanics." It offered a nonclassical, practical curriculum. Although some ambitious sons of artisans and laborers enrolled, few could afford not to work. More students were the children of the gentry: merchants and ministers, lawyers and physicians. The school adopted a curriculum that emphasized the classics. In the early years many German Jews also attended City College, as it would come to be known. Eventually, it was incorporated into the free school system.

While women attended both public schools and private academies, they struggled to gain any higher education beyond that of teaching credentials. New York had a number of medical schools, most notably at Bellevue Hospital, but none were open to women until the founding of the Medical College for Women at Twelfth Street and Second Avenue. Established during the Civil War by Dr. Clemence Lozier, it graduated female physicians, including the first African-American, Dr. Susan Smith, in 1870. This remarkable illustration in *Frank Leslie's Illustrated Newspaper* depicts the main dissecting room in 1870 (3.80).

The growing working classes of New York City lived in neighborhoods scattered throughout Manhattan, as well as in Brooklyn, a short ferry ride away. Artisans and sweatshop workers, cartmen and domestic servants resided in the older commercial areas of the city and in the wards near the Hudson and East Rivers. An engraving depicting a a census canvas in the Fourth Ward in 1879 gives a sense

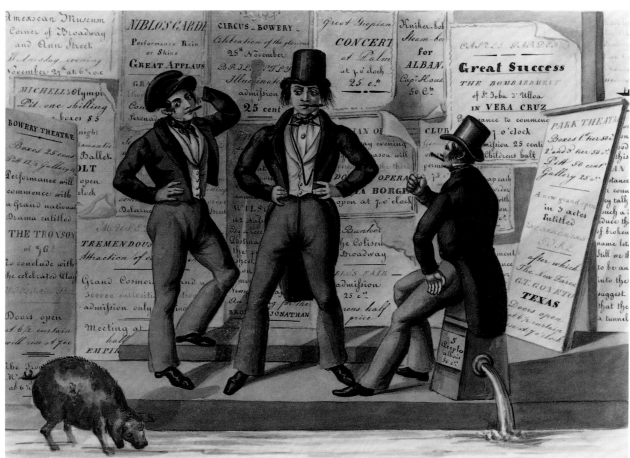

of a typical working-class neighborhood (3.81). On the street level are businesses, but many of the upper floors are used as multifamily residences.

New York was, in Kenneth Scherzer's words, an "unbounded community," in the sense that all wards had groups of different ethnicities along with native-born residents. There were ethnic concentrations, however; for example, the Lower East Side became a popular home for many Irish and German immigrants.

The most famous of the native-born working classes were the Bowery B'hoys, young men who lived in and around the Bowery, working in the city industries, sometimes as skilled craftsmen and small entrepreneurs and sometimes as laborers. The traditional occupation for this group was butchery, its practitioners known for rowdyism and toughness. Nicolino Calyo painted 1840s portraits of both a

butcher and Bowery B'hoys, *The Soap Locks*, that effectively evoke the Bowery spirit (3.82, 3.83). Members of a youth culture, the B'hoys would parade boastfully in the streets, bandying private slang expressions and dressed in inexpensive but fancy clothing, parodying the elegant dress of the gentry with their stovepipe hats and flaring trousers. Although often considered a homegrown New York product, B'hoy culture also reflected a multiethnic construction that included aspects of Irish and German culture.

New York was a city of great contrasts. Only a short walk off Fifth Avenue would bring a pedestrian to crowded housing and enclaves of immigrants. While some immigrants did well, most struggled to secure a foothold. Many areas of the city were notorious for their dilapidated and crowded housing, the gangs roaming their streets, and intense poverty.

While the Irish had always lived in the city (there were about sixteen thousand in 1816), their presence became most pronounced in the 1830s, when two hundred thousand arrived at the port (though many did not stay). After the potato famines of the 1840s hundreds of thousands more arrived. By 1855 Irish immigrants made up from a

3.80. Albert Berghaus, Medical College for Women, 1870.
3.81. Fourth Ward census canvas, 1879. **3.82.** Nicolino V. Calyo, *Butcher at His Stand*, ca. 1840. **3.83.** Nicolino V. Calyo, *The Soap Locks* (Bowery B'hoys), ca. 1840.

quarter to a half of the population of sixteen of the city's twenty-two wards. By 1860 there were more than two hundred thousand Irish in the city, about one quarter of the population. The Irish composed 86 percent of the city's laborers and 74 percent of its domestic servants, as well as many of its artisans. They soon became a significant force in the city and, because they were quickly naturalized by the Democrats, a formidable voting bloc, usually favoring the Democrats of Tammany Hall.

Arrival of immigrants was haphazard and examination for disease perfunctory until Castle Garden, formerly the site of large concerts, was transformed into an emigration landing depot in May 1855. Vessels landed six miles away, and a state officer boarded the ship, where he would check the passenger list and escort the ship to the depot. In the 1855 painting by Samuel Waugh, *The Bay and Harbor of New York*, immigrants can be seen disembarking at the Battery (3.84). At Castle Garden (in the background), customs officers would examine luggage as health officers did the same to passengers. After that, immigrants, headed to the streets of New York, perhaps to check for employment opportunities at the labor exchange. Many others continued traveling to the West. It was common to spy their carts in the streets, families walking behind them, heading for the steamship depot or train stations (3.86).

3.84. Samuel Waugh, *The Bay and Harbor of New York*, ca. 1855. **3.85.** Bishop Hughes. **3.86.** Emigrant wagon. **3.87.** St. Patrick's Cathedral, 1873.

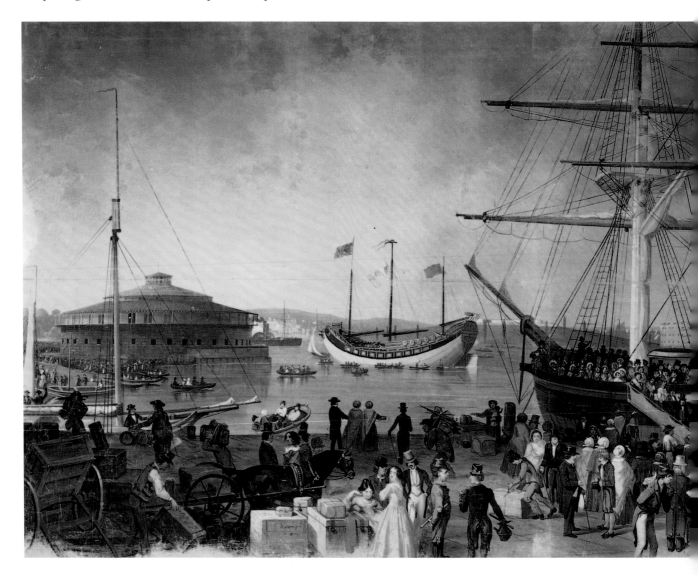

Irish achievements were considerable. John Hughes, bishop of New York from 1842 to 1864, championed the Irish cause (3.85). He opposed compulsory public schooling, overseeing the construction of a Catholic school network. He also built nineteen churches, more than doubling the number in the city in 1844 (fourteen). Of the nineteen churches, thirteen were for the Irish and the rest for the Germans. Perhaps the most significant symbol of Irish prominence was the construction of St. Patrick's Cathedral, which was financed by both wealthy Catholics and the small contributions of Irish immigrants (3.87). Construction started in 1858, but the cathedral was not completed until 1879, at a final cost of $1.9 million. Designed by James Renwick in a Gothic style inspired by the Cologne Cathedral (its interior was patterned after

3.85

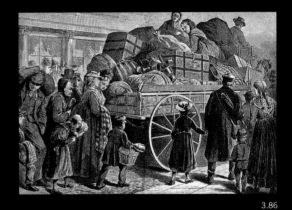

3.86

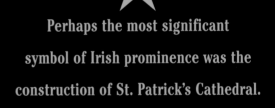

Perhaps the most significant symbol of Irish prominence was the construction of St. Patrick's Cathedral.

3.84

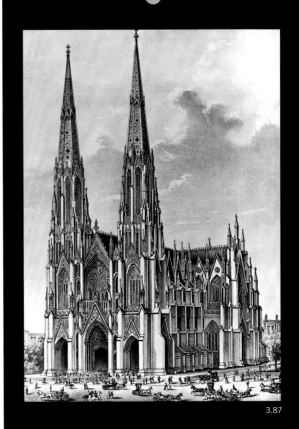

3.87

3.88

Despite their achievements,
the Irish experienced many hardships
during these years.

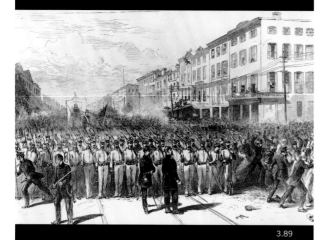

3.89

English cathedrals), the church has spires that reach 330 feet. The completion of such a major cathedral represented a serious challenge to the city's Protestants and in part motivated the construction of St. John the Divine. When Currier and Ives issued a drawing of the new St. Patrick's in 1858, at the start of construction, it was already a significant symbol of Irish standing.

The Irish public presence in the city also registered each year during the St. Patrick's Day parade, always a moment of pride for the Irish. Originally a minor procession, after 1853 the parade expanded to the point where it brought other activities in the city to a halt. An illustration of the parade in Union Square in 1871 shows the elaborate dress of the marchers, walking alongside uniformed Irish workers and police. The magnitude of the celebration was yet another signal of the Irish rise from famine toward middle-class respectability (3.90).

Despite their achievements, the Irish experienced many hardships during these years, often living at or well beneath the edge of poverty. Violence and dangerous gangs were not uncommon. One of the most notorious was the Dead Rabbits, a gang of young Irishmen known for wearing red-striped pantaloons. The name meant "seriously bad dudes" in the Bowery's lingo. The Dead Rabbits were known for their skirmishes with other Bowery gangs composed of native-born Americans (3.88).

The Irish arrived in the United States with strong political affiliations and Anglophobe politics. Both Protestant and Catholic Irish sent money back home to support their causes. When in 1871 the local Protestant Orange Order decided to march in commemoration of the triumph of William of Orange and the Protestant cause, much to the dismay of the Irish Catholics, a riot ensued (3.89). Called in to restore order, the militia killed 76 and injured 165 in what became known as the "Slaughter on Eighth Avenue." The riot terrified the city's gentry, who were aware of the violence of the Paris Commune and wanted to prevent a similar uprising. For them, the main concern was to control the streets and the city. The police commissioner lamented that more were not killed as "in such a large city such a lesson was needed every few years."[18]

After the riot of July 1871, cartoonist Thomas Nast portrayed the Irish as similar to apes. In a cartoon

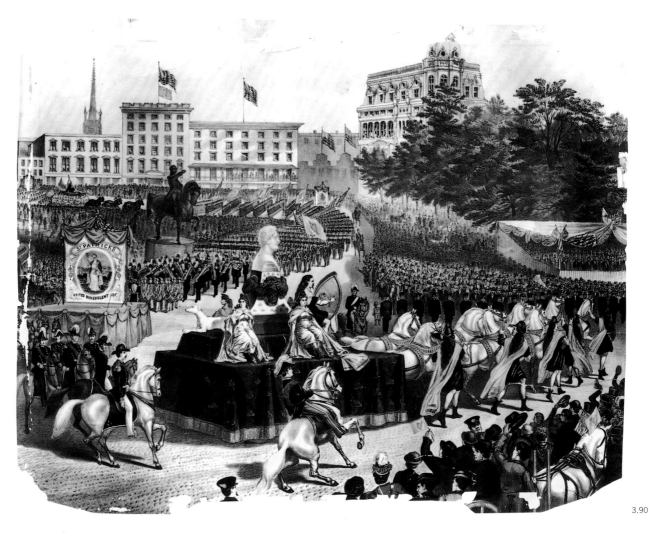

3.90

"America," rendered as a stern-visaged woman, uses a whip labeled "Law" to hold back a murderous semihuman Irishman (3.91). Nast's cartoon reflects a general fear among native-born Americans that illiterate immigrants threatened to overwhelm the republic. These perceptions had encouraged the rise of nativism and the growth of the Know-Nothing Party.

3.91

The New York Irish were often considered racist. Yet although they generally opposed the Republican cause and Lincoln and rioted when faced with the draft (see figs. 3.181, 3.182), they, too, were a patriotic lot and sent off their own Irish regiment, the Sixty-ninth, to fight in the Civil War. Flying the green flag, recruiters for the regiment emphasized patriotism and duty to one's native land in order to equate American military service with Irish nationalism. A parade of the Sixty-ninth demonstrated to New Yorkers that the Irish were as patriotic as other citizens (3.92). Many fought at Bull

Run and then reenlisted after their ninety-day commitment expired.

Germans had resided in the city since the seventeenth century, and by 1790 there were twenty-five hundred Germans and two German Lutheran churches as well as a German Reform church. The German population reached twenty-four thousand in 1840 and then boomed as over two hundred thousand Germans entered the city, settling largely in what became known as Little Germany, or Kleindeutschland, an area east of the Bowery and north of Division Street that extended to Avenue D near the East River. Overall, they lived in sections of the city either adja-

3.88. *A "Dead Rabbit," Sketched from Life.* **3.89.** Riot on Eighth Avenue, 1871. **3.90.** St. Patrick's Day parade, 1871.
3.91. Thomas Nast cartoon, *Bravo! Bravo!*, 1871. **3.92.** Irish regiment, Mott and Prince Streets, 1861.

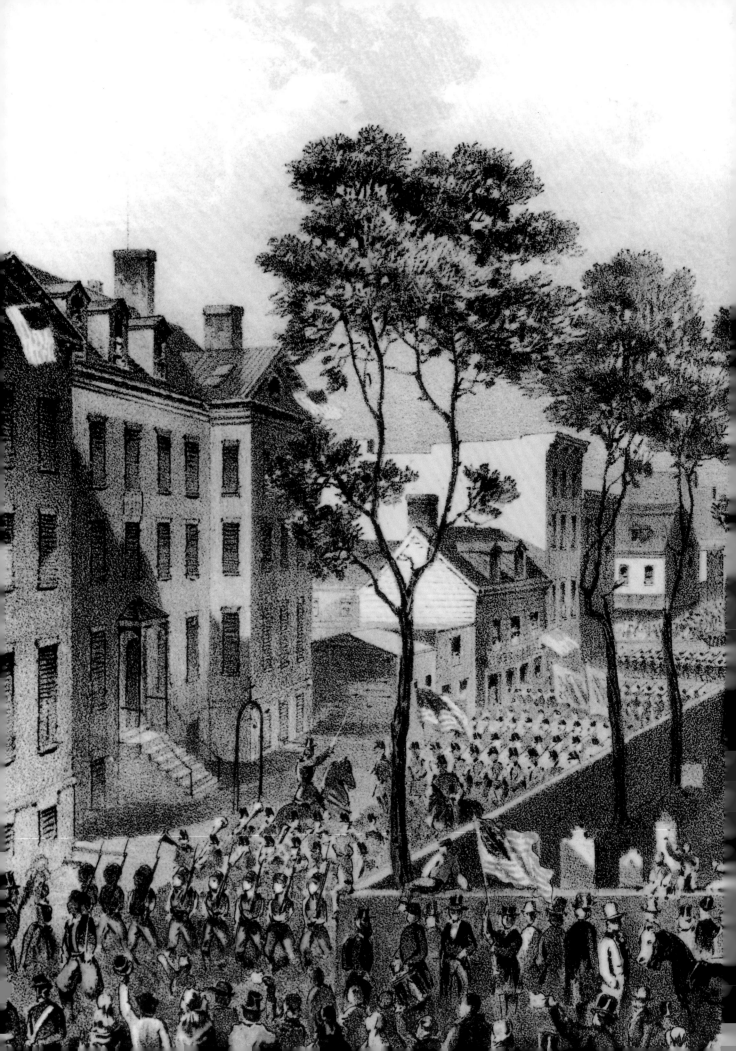

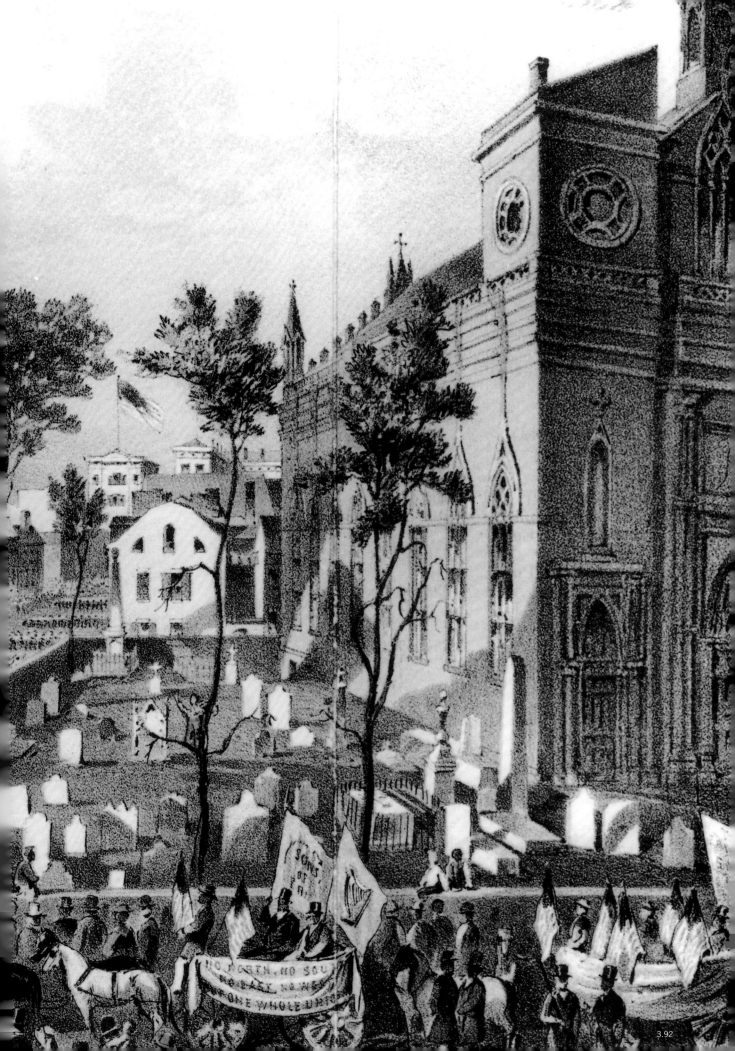

3.92

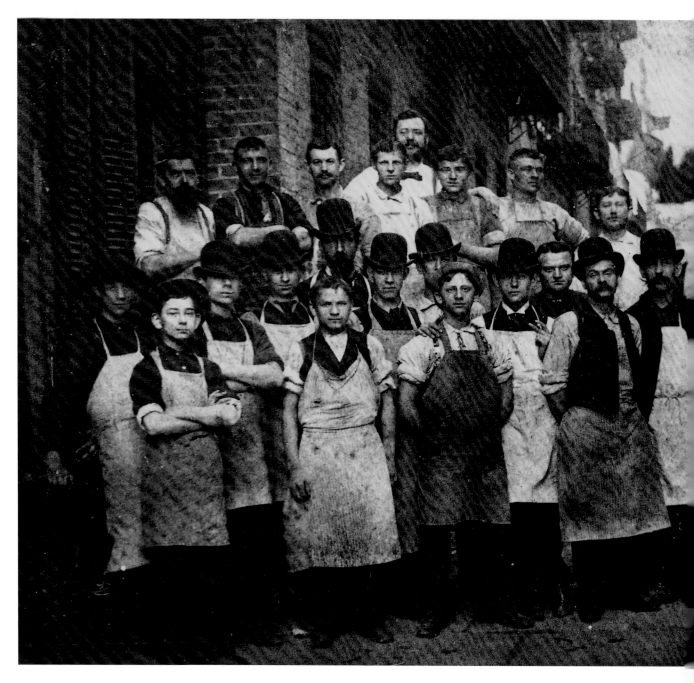

cent to or coinciding with the largest concentration of Irish residents.

Some Germans emigrated because of political ideology and repression, particularly after the failed revolution of 1848. Some were strongly Calvinist or Lutheran, while others were free thinkers who joined the Unitarian church or Ethical Culture Society, founded by Felix Adler, a German Jew, in 1876. Unlike the Irish, most German immigrants spoke no English and continued to use their native tongue for years after their arrival; the majority was also more secular than the Irish.

Some Germans became successful entrepreneurs, the Steinway family among them. Employees of a smaller German piano factory, Jacob Brothers, posed for a picture on Avenue D in the 1880s (3.93). Germans also became successful brewers. The Schaefer brewery, one of seven breweries in Manhattan, was the city's first manufacturer of lager beer, a beverage that gained immediate popularity in the city. Germans often drank this beer in beer halls that presented stage performances (3.94). Also common among the Germans were singing societies, as well as the Turnverein, societies of artisans that promoted health and physical education, supported labor unions and radical causes, including the abolition of slavery, and emphasized German culture. These societies would often parade to areas such as Jones Woods, today's Upper East Side, to listen to

3.93

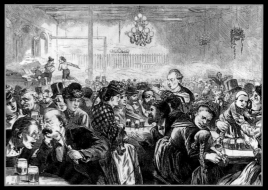

3.94

More secular than the Irish, German immigrants supported societies of artisans that promoted health and physical education, championed labor unions and radical causes, and emphasized German culture.

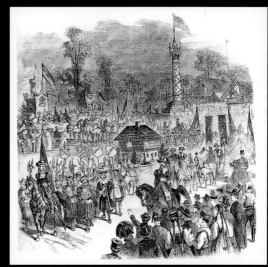

3.95

music, perform, or hold gymnastic contests (3.95). In this illustration several groups have gathered near City Hall for a public reception. In summer society members might venture as far as the Rockaways, to the Bauern Haus, a hotel operated by Frederick Schmidt, who erected a German carousel on the grounds as a special attraction (3.98).

Prior to 1800 the Jews of New York—the largest Jewish community in the new nation—supported one synagogue. By the 1850s, however, they had organized twenty-seven synagogues and forty fraternal organizations, along with a Jewish hospital and Jewish newspapers. The rise in both the size and significance of the Jewish community resulted from an influx of German

3.93. Jacob Brothers, 1888. **3.94.** German beer hall, 1877. **3.95.** German singing societies.

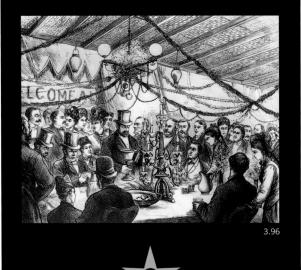
3.96

⭐

Jewish religious

culture took root

in the city.

●

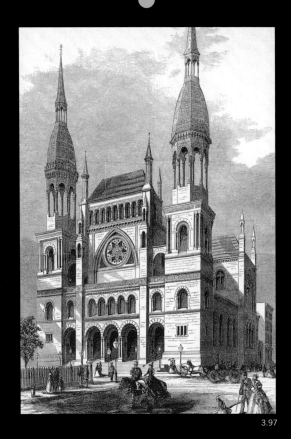
3.97

3.96. Sukkot celebration. **3.97.** Temple Emanu-El, 1868.
3.98. Bauern Haus, ca. 1880. **3.99.** Matzo factory,
Chatham Street, 1868.

immigrants. German Jews emigrated because, despite growing emancipation in their native states, many Jews could neither work nor marry. Young and poor, most came individually or in small groups as single men and women.

Many Jews had backgrounds in commerce. They gravitated to Chatham Square in the Sixth Ward and other areas shared by the lower classes near and east of the Bowery. They worked in such trades as tailoring, glasswork, bookbinding, and jewelry. A number became successful retailers, expanding their trades. A glazier would move from working for wages to starting his own business. A peddler would open a shop on Chatham Square and then move to lower Broadway. By far the most popular trades for Jewish immigrants were within the garment industry. Women worked alongside their husbands or, particularly among widows, opened their own stores and boardinghouses.

Relying on traditions of community spirit, Jewish immigrants founded fraternal lodges and aid organizations, including hospitals and orphanages. German Jews introduced Reform Judaism, whose congregations built new synagogues that reflected the impact of their enlightenment and assimilation and expressed their desire to become more American. The opening of the grand Temple Emanu-El in 1868, located on Fifth Avenue and Forty-third Street and designed by Leopold Eidlitz and Henry Fernbach in a Moorish and Saracenic style modeled on the reform synagogue in Berlin, signaled the rise of the Jews of New York. (The first reform synagogue, formed in 1845 as a German literary society, had used rented rooms in the Lower East Side.) This house of worship seated eighteen hundred on its ground floor and another five hundred in the balcony (3.97).

Jewish religious culture took root in the city. Increasingly, the New York papers illustrated Jewish practices, such as the observance of the fall harvest festival of Sukkot held at Emanu-El in 1876 (3.96); and the preparation of unleavened bread for Passover at the matzo factory on Chatham Street (3.99). (For more recent representations of Jewish holidays, see figs. 5.73 and 6.95).

In 1840 New York's African-American population totaled about sixteen thousand, as much as 5 percent of the population of the city; with the large immigration of Germans and

3.98

Irish; however, its proportion dwindled to less than 2 percent (12,574) by the Civil War. Most blacks lived near the Sixth Ward until the 1830s, when some drifted west and south of Greenwich Village while others moved uptown to the West Side between Tenth and Thirtieth Streets in what became known as

3.99

the Tenderloin District. An engraving of Baxter Street, in the Fifth Ward, depicts a section of the city with a substantial African-American population (3.100).

The Gradual Emancipation Act of 1799, while allowing ownership of slaves in this period, resulted instead in the almost immediate disappearance of slavery. The black population of New York was a free community. It was, however, vulnerable to the Fugitive Slave Act, and slave catchers regularly entered the city looking for runaways. While most blacks lived in close proximity to whites, their world was segregated. They could not ride with whites on public transport and had separate public schools, which were supported by the city.

Most African-Americans were poor. Often in competition with the Irish and Germans for unskilled jobs, a number worked as waiters and domestic servants. Many men worked as unskilled laborers. Yet while there is no question of the poverty and prejudice suffered by African-Americans, a few

3.100 3.103

3.101

achieved significant prominence. Some black artisans managed their own shops and were worth thousands. A drawing of prominent blacks promenading on Fifth Avenue gives a fascinating glimpse into the black upper crust (3.102). The accompanying article in the *New York Illustrated News* noted that "our influential Colored Citizens have recently taken this magnificent promenade under their supervision, turning out on Sundays and holidays, with a degree of splendor and enthusiasm quite startling to a reflective mind."[19] The white spectators are certainly startled: their world had been invaded; the promenade, an important public ritual, had been appropriated by representatives of a group that most citizens felt did not belong on Fifth Avenue.

As the illustration of the toffs on promenade makes plain, blacks cared as much about dress as the white gentry did. An illustration of Toko in 1845, dressed as a B'hoy, shows that they shared in Bowery tradition as well. In any case, whether on Fifth Avenue or on the Bowery, they aspired to full citizenship (3.103).

Black institutions flourished, and they included newspapers, churches, anti-slavery associations, and literary societies. Perhaps no institution was as instrumental in maintaining a sense of community as the black church. The A.M.E. Zion Church started by Peter Williams (see fig. 2.51) had grown, receiving hundreds of worshipers at the sanctuary at West Tenth and Bleecker, which proudly flies the American flag in this 1867 illustration (3.104). Peter Williams, Jr., an Episcopal clergyman, was a leader in both black education and the antislavery movement. New York's African-American community assisted many slaves in their escape, among them Frederick Douglass. A moment of great pride, equal in significance to the St. Patrick's Day parade, was the procession of seven thousand African-Americans down Fifth Avenue, past the Stewart Mansion, to celebrate

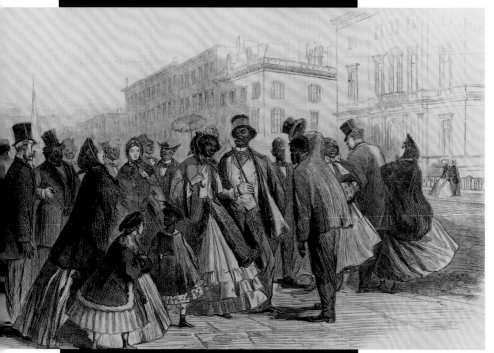

3.102

passage of the Fifteenth Amendment, which guarantees the right to vote regardless of race (3.105).

New York also housed a small Chinese population, numbering in the hundreds at midcentury and as much as two thousand after the Civil War. Some lived in the Sixth Ward above Chatham Square, while others were scattered throughout the city. The Chinese had mutual aid societies as well as gangs. Groceries, steam laundries, and restaurants were the most common Chinese enterprises. Their community was extremely close-knit, particularly after the passage of the Chinese Exclusion Act in 1882. This image of a lunchroom comes from an article on Chinatown published in *Cosmopolitan* in 1888 (3.101).

In the largest industries in New York, particularly in the needle crafts, most production was handled as outwork. Cutters would give pieces to journeymen or other subcontractors, who would then fashion the finished garments. A major innovation was the invention in the 1850s of the sewing machine, a device that allowed for faster and larger production. Work was completed either at home or in garrets, as suggested by the classic image of the sweat shop that dominates representations of the garment industry in mid-nineteenth-century New York. Only about a third of all clothing was produced in such manufactories as the Thomson Skirt Manufactory (see fig. 3.111). An illustration from *Harper's* from 1890 shows a typical scene in the life of the garment worker until the end of the nineteenth century: stooped figures carry home stacks of cut goods to be sewn and returned a few days later (3.106). (For a different image as seen through the camera's lens, see fig. 4.46.)

The pace in this industry, as in all American industry, was fast, much more so than in Europe. Workers were generally young, and hard work was expected. Wages in some of the trades, especially textiles and shoemaking,

3.104

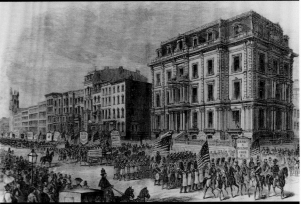
3.105

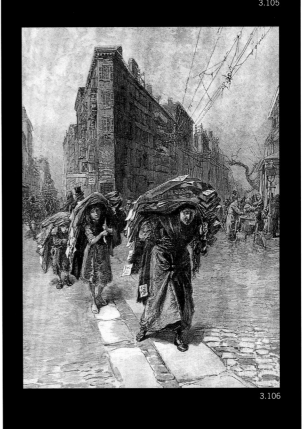
3.106

3.100. Baxter Street, Five Points, 1861. **3.101.** Chinese lunchroom. **3.102.** *Our Best Society.* **3.103.** Toko, 1845. **3.104.** A.M.E. Zion Church, 1869. **3.105.** African-American parade celebrating the Fifteenth Amendment, 1870. **3.106.** W. A. Rogers, Workers with cut goods for home assembly, 1890.

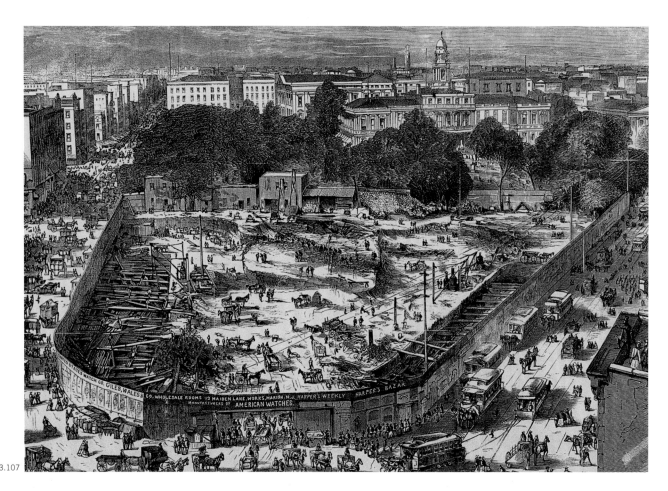

3.107

were low, and all members of a family had to work in order to survive, although women received only half the wages of men.

Many New Yorkers, particularly immigrants, worked as petty retailers and unskilled labor-

3.108

ers. The city, state, and federal governments employed many immigrants as unskilled laborers. The building of the new post office (see fig. 3.31) required thousands of Irish, German, and native-born cartmen and laborers, and the rise of the Democratic Party in New York, with its ability to attract Irish votes, resulted in many Irish being hired as city laborers (3.107). Street sweepers, especially, were Irish, courtesy of Tammany Hall. Unfortunately, private contractors often did the hiring and were woefully unsuccessful at the mammoth job of keeping the overcrowded, manure-filled city streets clean (3.109).

New York contained a growing middle class, accounting for close to a third of its population, that ranged from physi-

cians, attorneys, and architects at the high end to clerks, bookkeepers, accountants, and middling artisan entrepreneurs at the lower end. Well dressed and with the finest of manners, clerks in the lace room at A. T. Stewart's cast-iron palace were proud of their standing (3.108).

Women, too, could be found in the middling ranks, working as clerks or skilled craftswomen for publishers. Most women who worked, however, were from the working and immigrant classes and labored long hours for paltry wages. The most likely source of employment, particularly for Irish women, was the needle trades, in which half the female labor force was engaged. (Domestic service was the second most common trade.) Thomson's Skirt Manufactory was a textile firm that manufactured in house, using sewing machines rather than sending work out for completion (3.111). In the illustration, note the discipline and order, as well as the motto, "Strive to Excel." Young women, too, were expect-

ed to work, as this illustration of young women and girls working as tobacco strippers demonstrates (3.110). For girls from working-class families, school might be attended occasionally, but their families depended on their income for subsistence.

Laborers in the largest-volume manufactories worked under difficult conditions. In 1853 the *New York Times* reported that a minimal standard of living required an income of five hundred dollars a year but that the average income for most artisans was only three hundred. To get by, women and children worked and wives took in boarders. Accordingly, during periods of strong economic growth, when workers had leverage, labor movements arose. Craft workers organized by trade and formed the General Trades' Union in 1834. The first such unity organization formed in the United States; it included fifty-two local unions. Many strikes followed, intent on establishing the ten-hour workday and gaining better wages. The ideas of labor radicals, emphasizing George Henry Evans's doctrines of turning over the national domain to workers and establishing worker-owned shops, also influenced workers.

The Panic of 1837 and the hard recession years that followed effectively stifled labor activism. In the late forties, however, the large influx of immigrants bolstered new efforts at organization, though not without division over the inclusion of unskilled laborers and tension between native-born workers and immigrants. Indeed, the fear that immigrant laborers would either take the jobs of native-born mechanics or drive their wages down further fueled the rise of a nativist organization, the American Laboring Confederacy, which appealed to both capital and labor against the rising numbers of immigrants. Hoping to stem the tide of "alien cheap labor," *The Champion of American Labor* displayed patriotic emblems and nostalgic images of the republican artisan workshop on its masthead (3.112).

Unions arose anew in the 1850s, and many strikes took place before and after the Civil War, except during the years immedi-

3.109

3.110

3.107. Construction of post office, 1869. **3.108.** Lace room at A. T. Stewart's. **3.109.** Paul Frenzeny, City sweepers at roll call, 1868. **3.110.** *Little Tobacco Strippers.* **3.111.** Thomson's Skirt Manufactory, 1859.

3.111

THE CHAMPION OF AMERICAN LABOR

A WEEKLY FAMILY PAPER, DEVOTED TO THE MORAL, INTELLECTUAL AND SOCIAL IMPROVEMENT OF THE LABORING CLASSES.

PUBLISHED BY AN ASSOCIATION OF MECHANICS. · · · · · · TERMS $1.50 PER ANN., IN ADVANCE, OR THREE CENTS WEEKLY TO THE CARRIERS. · · · · · · · · · · · OFFICE NEW-YORK.

VOL. 1. NEW-YORK, SATURDAY, JULY 24, 1847. 3.112 NO. 1

ately following the Panic of 1857. After the Civil War and now largely under the leadership of German socialists, the labor movement increased its militance, inspiring terror among employers. One issue was the length of the workday. This drawing depicts an 1872 march through the Bowery demanding an eight-hour workday (3.113). The illustrator is clearly unsympathetic, as demonstrated by the slogans he chose to inscribe on the banners, such as "8 hours peaceably if possible forcibly if we must." Strikes were not uncommon, and neither was the use of strikebreakers. An engraving in *Leslie's* shows striking drivers being restrained by police as nonunion laborers prepare to reopen the Second Avenue Line (3.116).

While a few Germans, Irish, and African-Americans prospered, the majority, along with thousands of native-born New Yorkers and newcomers to the city from the hinterlands, struggled—often unsuccessfully—to maintain a subsistence income. Horace Greeley, editor of the *New York Tribune*, lamented in 1848 that "there are fifty thousand People in this City who have not the means of a week's comfortable subsistence and know not where to obtain it."[20] New York was growing so rapidly that it could not absorb and house either immigrants or natives with comfort. Most Germans and Irish crowded into wards near the East River, particularly above the Fourth Ward. The Fourth, Sixth, and Thirteenth Wards had population densities near or exceeding two hundred thousand inhabitants per square mile.

After the Civil War, the labor movement increased its militance, inspiring terror among employers.

Living conditions were very difficult.

The most notorious ward was the Sixth, and the most notorious section of the Sixth was the famous Five Points district located not far from City Hall at the intersection of Cross, Anthony, Little Water, Orange, and Mulberry Streets. There stood the Old Brewery, erected in 1797 to produce beer but converted long since to a boardinghouse, crammed with hundreds of residents, mostly black and Irish (3.114). Surrounding this dilapidated lodging were numerous taverns, oyster cellars, and brothels populated with pickpockets, gamblers, and thieves (3.115). Many other residents in and around Five Points dwelled in cellars. As Baird Taylor observed, all a visitor could see was "everywhere the same crowd of unwashed humanity, the same rags, and filth, the same stifling stagnant atmosphere."[21] Yet even amid the poverty signs of commercial life abounded. Down the streets leading into Five Points a black baker, an Irish shoemaker, a Jewish used-clothes dealer, and many other small retailers carried on their businesses. Five Points intrigued local artists, attracted by what they perceived as its patterns of depravity.

3.112. Masthead, *The Champion of American Labor*, July 24, 1847. **3.113.** Parade for the eight-hour day, 1872. **3.114.** Five Points, 1852. **3.115.** Five Points barroom, 1860. **3.116.** Strike of Second Avenue drivers, 1869.

So many people lived subsistence existences that any major downturn in the economy, vagaries of seasonal employment, or even changes in the weather could be disastrous. The Reverend Samuel Prine stated in 1834 that a full fifth of the city, seventy-five thousand residents, lived on charity. In the winter of 1854 one charity alone aided sixty thousand desperate New Yorkers. *Harper's* drawings reveal the lengths to which New Yorkers would go. In a scene reminiscent of Dickensian London, some scavenged through garbage on a barge in the Hudson River, looking for rags, coal, or anything they could sell for a few cents (3.120).

To escape the miseries of poverty, some New Yorkers turned to drugs. Opium, which was legal, was popular in New York in the tenements, as well as among prostitutes and among some of the middle and upper classes (3.119).

Few New Yorkers could afford to purchase their own homes. The middle classes used apartments, boardinghouses, and occasionally hotels. Immigrants and native New Yorkers with only subsistence incomes often chose old warehouses, breweries, or commercial buildings that were converted as cheaply as possible into multiresident housing. These became known as tenements ("tenant-houses").

Soon, builders erected tenements specifically to alleviate the problems of overcrowding and squalor. These were rectangular buildings constructed on lots twenty-five feet wide and one hundred thirty feet deep. Four stories in height, each building held four apartments to a floor, arranged in railroad fashion requiring a resident to go through a room to reach the next. Usually only two of the eighteen rooms to a floor—those on the front—received sunlight from the street. There was little ventilation or light, less plumbing, and only a single common privy in the backyard. Soon, tenements were built higher but never better; they became the worst slums in the city. Danger of typhus abounded. An 1867 state law regulating tenements accomplished little. Owners seldom did more than the minimum

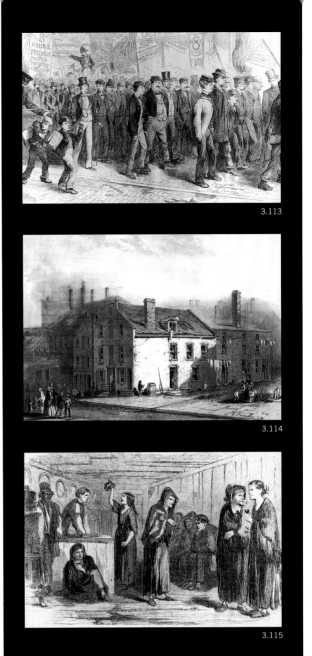

3.113

3.114

3.115

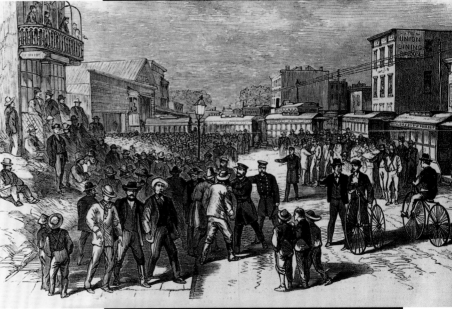

3.116

3.117

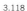

3.119

3.120

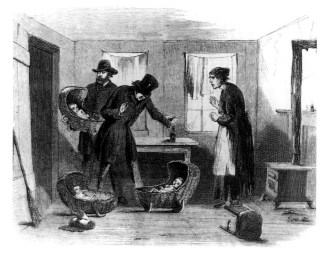

3.118

required and were slow to make repairs. The population density in the Fourth Ward reached 290,000 per square mile.

A picture of the first tenement on Cherry Street shows how little light there was (3.117). This building housed five hundred people and had an infant mortality rate of 44 percent. The death rate in the tenements was thirty-six to forty per thousand (the nationwide average was twenty-three). There was inadequate sanitation, and garbage could be found piled in the streets and in the homes. A sanitation report observed that half a million inhabitants were "submerged in filth and half-stifled in an atmosphere charged with all the elements of death." The inspector noted that "it is only by personal inspection that one can learn to what depths of social and physical degradation human beings can descend."[22]

Squatting in yet undeveloped land was another option for the poor looking for cheap housing. Squatter settlements could be found north of the city, including the area that would become Central Park (3.123). Small shacks were constructed on earthen floors, and livestock roamed freely in and around the tiny homes. Some residents used public transportation to get to work in the city or else hitched rides on carts. Others sold groceries in situ or found handicraft work to do inside their meager shelters. (For a twentieth-century image of squatters, see fig. 4.123.)

Crime abounded on those streets of Gotham dominated by the city's lower classes. Artists favored scenes of nefarious activity, such as this one depicting the fencing of stolen goods (3.122). By 1871 James McCabe estimated that there were

thirty thousand professional thieves in the city. He devoted whole sections of his book *Lights and Shadows of New York Life* to professional thieves, both the apparently respectable white-collar variety and the pickpockets, river thieves, female thieves, fences, and "roughs" of street crime. An engraving of a fence store on Chatham Street in the Sixth Ward shows a bearded Jew ogling a stolen watch, a stereotype typical of this anti-Semitic era.

Children growing up in the rough neighborhoods of New York also appealed to the city's illustrators. Over a third of the city's population toward midcentury, they often made a startling sight, roaming the streets seemingly without any parental supervision. *Harper's Weekly* published a number of engravings of street urchins. One shows young peddlers being brought before the commissioners of charity under the vagrancy law that allowed the arrest of children five to fourteen found on the streets (3.121). Some children were sent home; others were subjected to the strict discipline of the House of Refuge. In 1867 *Harper's* also published a large illustration entitled *The Newsboys' Lodging House*. Thousands of newsboys worked the city's highways, many of them orphans; some of these lived in this lodging house provided by the Children's Aid Society above the office of the *Sun* on Fulton Street. They were charged four cents a meal and five cents a night (3.124).

Perhaps the worst images of children depicted the notorious baby farms in the tenements where foundling infants were dispatched to be treated with little care by overworked women. Surrounded by poor sanitation and disease, their mortality rate was high, recalling the statistics of similar unfortunates in eighteenth-century London (3.118).

Women succumbed to a range of crimes, including shoplifting, but in Gotham the vice (though not a crime) most associated with females of the lower classes was prostitution. Perhaps 10 percent of all women, numbering somewhere around twenty-five thousand, worked in the city at one time or another as prostitutes. Nor was the trade relegated solely to women who were destitute. Many females who worked as domestics for minimal wages could earn five or ten times more as prostitutes. Women might come and go in the trade, regarding it as a means of social mobility. A few madams became wealthy, attending prominent social

3.121

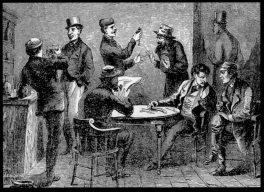

3.122

3.117. Cherry Street tenement, 1860s. **3.118.** Baby farms, 1859. **3.119.** Smoking opium, ca. 1880. **3.120.** Stanley Fox, Beech Street Dumping Barge,1866. **3.121.** Paul Frenzeny, Street peddlers, 1869. **3.122.** Fence store, 1871. **3.123.** D. E. Wyand, Squatters in Central Park, 1869. **3.124.** C. B. Bush, *The Newsboys' Lodging House*. 1867.

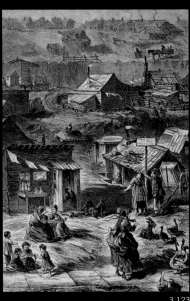

3.123

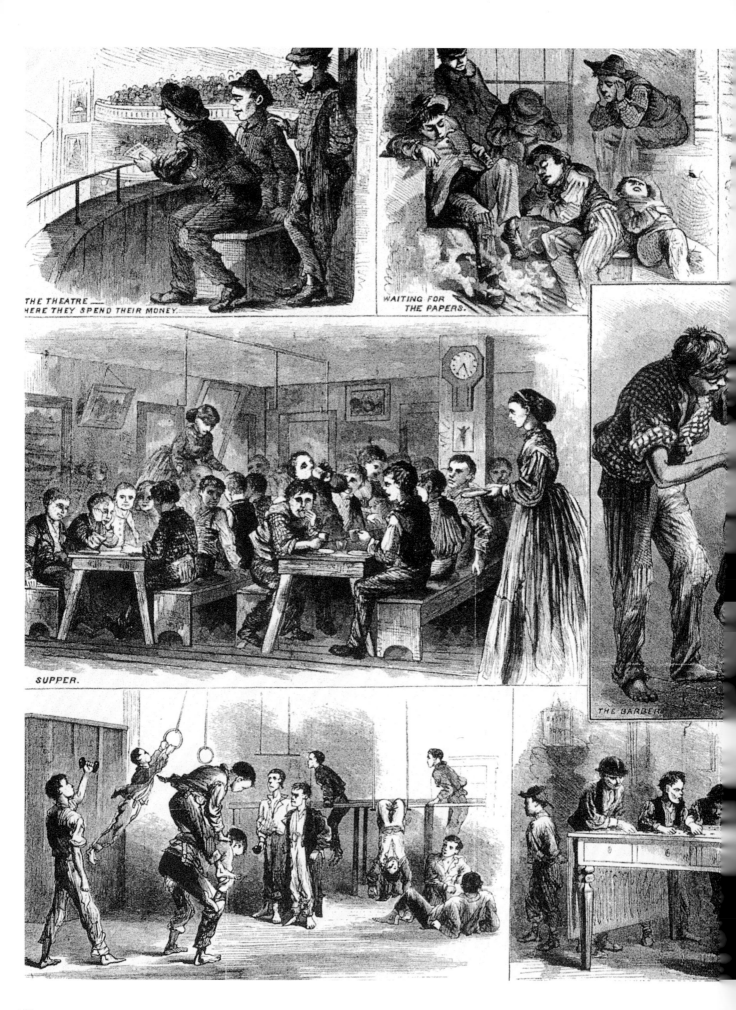

THE THEATRE —
WHERE THEY SPEND THEIR MONEY.

WAITING FOR
THE PAPERS.

SUPPER.

THE BARBER.

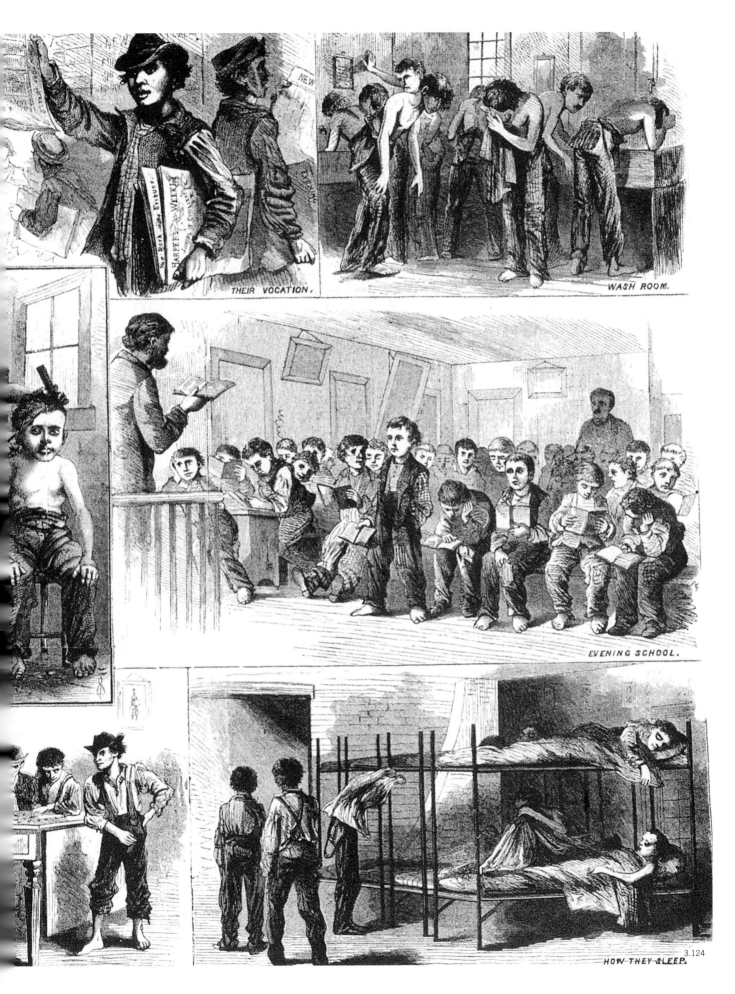

THEIR VOCATION.

WASH ROOM.

EVENING SCHOOL.

HOW THEY SLEEP.

3.124

167

3.125

events. Many New Yorkers made money from prostitution, among them prominent families such as the Livingstons, who owned lucrative real estate that they used for brothels. Most brothels were located either on the East Side or along Broadway, often bordering on and

3.126

intruding into genteel neighborhoods. These houses featured pianos, servants, and expensive liquor. Those near the water tended to be dance halls, offering live vaudeville entertainment as well as dancing with the entertainers in the main hall while rooms in the rear catered to those interested in sexual encounters.

Many prostitutes came from the Irish and native New York population. One notorious area known for its brothels was Corlear's Hook, near the ferries, where commuters might gain some anonymous time with a prostitute (3.126). The word "hooker" owes its coinage to this well-known erotic landmark. The famous 1850 illustration in *New York by Gaslight*, "Hooking a Victim," by Serrell and Perkins—which only incidentally depicts the

standard mode of street illumination in mid-nineteenth-century New York—presents an all-too-typical New York street scene (3.125). A drawing of John Allen's dance hall depicts a well-known establishment in the poorer Water Street area near the docks (3.127). Allen was a religious man and required that Bibles be placed in all of the rooms.

Crime and prostitution were often connected. An image from the *National Police Gazette* portrays a kind of morality tale: two young dandies pick up a couple of prostitutes on the street, the group retires to a private room to drink and dally, and one man wakes up robbed the next morning (3.129). But prostitutes suffered as victims as well. After the 1830s women needed physical protection from police and gangs, and, for a considerable sum, pimps—called "Broadway Statues"—took over the job of securing and protecting women (3.128).

The antebellum era saw numerous riots aimed at individual brothels. Usually the mayhem was initiated by

male gangs, whose antics included not only destruction of property but violent attacks on the women inside. One notorious gang of Bowery B'hoys, led by Tom Hyer, a former heavyweight boxing champion, raided at least four brothels from 1836 to 1838, in one case gang-raping the women inside. Political connections saw Hyer released and back in business.

Other cases of violence involving the murder of prostitutes made headlines for weeks in the new penny press. Perhaps the most notorious involved Helen Jewett, a woman from Maine, and Richard Robinson, a well-thought-of clerk to a garment maker. When Jewett was found murdered in bed, her room on fire, all circumstances pointed to Robinson; he was, however, acquitted in a spectacular trial. Historian Thomas Gilfoyle describes the "sporting man" mentality of the antebellum era, a changing sexual ethos that accepted that men, married and unmarried, could have access to prostitutes and other rough sports. This outlook advocated bravado and masculinity while denigrating femininity. Robinson was a single man who, while an industrious clerk by day, led such a sporting life at night (3.133). Alfred F. Huffy's postmortem portrait of Jewett portrays an attractive woman, holding a letter and parasol, endowed with very small hands and feet in line with the current standard of feminine comeliness (3.132). A. E. Baker based this image of Robinson on a miniature.

The classes of the Bowery had their own culture and entertainment. To walk on the Bowery on Saturday night, as this scene in *Harper's* depicts, was to enter a world filled with all kinds of excitement (3.130). Taverns and small hotels, small circus shows, street corner comics, dance halls, brothels, billiard parlors, oyster houses, strolling German bands, variety shows, and popular theaters abounded. The capital of the Bowery was the Bowery Theater. Though founded in 1826 with genteel support as an alternative to the Park Theater, after 1830 it began to court the "pit audience." Shows featured spectacle and melodrama and were especially noted for portrayals of the Bowery B'hoys. There were no subscriptions, no reserved seats; business was strictly first come, first served. Spectators felt free to shout at the actors or even pelt those they disliked. Audiences raptly watched stories in which

3.127

3.125. Serrell and Perkins, *Hooking a Victim*, 1850. **3.126.** Corlear's Hook, 1847. **3.127.** John Allen's dance hall, 1868. **3.128.** *Broadway Statues*, 1879. **3.129.** Prostitute thieves and accomplice, 1879.

3.128

3.129

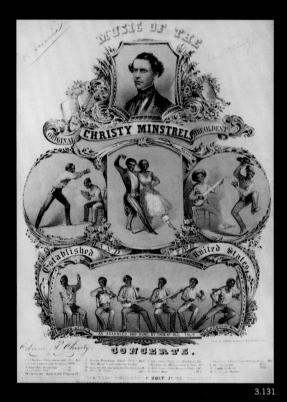

3.130. Saturday night on the Bowery, 1871. **3.131.**
Christy Minstrels sheet music cover. **3.132.** Alfred F.
Hussy, *The Real Helen Jewett*, 1836. **3.133.** A. E. Baker,
Richard Robinson, 1836. **3.134.** "Jumping Jim Crow" min-
strel show, 1833. **3.135.** Frank Chanfrau as Mose, 1848.

heroes such as Mose Humphrey performed feats similar to the exploits of the twentieth-century Superman, picking up street cars in order to save the innocent—particularly his girl, Lize—and punish the guilty. Mose represented the youth culture of the Bowery in a heroic mode (3.135). Whitman described the audience as "the best average of American-born mechanics."[23]

Also popular at the Bowery Theater and in other smaller venues in the district were minstrel shows. New York was the center of these entertainments. As created by a New Yorker, Thomas "Daddy" Rice (shown here acting at the Bowery in 1853), who had wandered west as a stagehand and small-time player, the minstrel show featured a white man in blackface sporting the costume of a ragged, lazy "Negro" and singing in an exaggerated dialect (3.134). Minstrelsy introduced many of Stephen Foster's tunes, including "Dixie," to U.S. audiences. According to the minstrel formula, a show opened with sentimental songs, interspersed with comic olios, and concluded with farces. Many jokes punctuated the performances. At its height before the Civil War, minstrelsy dominated the entertainment scene, with four or five theaters offering shows at the same time. Perhaps the form represented an opportunity for the white Bowery community to buttress its status and sense of superiority by safely mocking elite and upper-class customs from behind the camouflage of blackface. At the same time, minstrelsy allowed audiences to feel an exaggerated pride in their whiteness in opposition to "degenerate" black culture. Or, in the more benevolent view of historian Robert Toll, "minstrelsy provided a nonthreatening way for vast numbers of white Americans to work out their ambivalence about race at a time when that issue was paramount."[24] A sheet music cover for the Christy Minstrels advertises the shows of E. P. Christy, for whom Foster wrote songs at ten dollars each (3.131). Christy and his brother, George (in female dress), appear in the center vignette.

Legitimate theater attracted crowds as well, and Shakespeare drew audiences from all classes. But the bard also occasioned a serious clash between the classes in 1849. The dispute began when an American Shakespearean actor, Edwin Forrest, was criticized and ill treated during a European tour. Soon thereafter the famous British Shakespearean actor William Macready

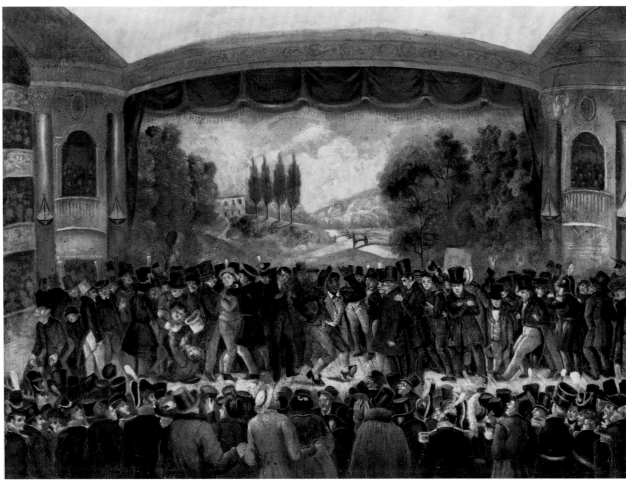

3.134

visited New York to act in a play at the Astor Opera House. The Astor had been built by and for the gentry in 1847 as an acceptable place to see and be seen. Upholstered subscription chairs replaced the pit, and above it were two tiers of boxes. Five hundred bench seats in the gallery were carefully cordoned off from the rest of the audience. The theater was the city's most prominent symbol of wealth and refinement.

Citizens of the Bowery disrupted Macready's performance, rioting and pelting the actor with fruit and vegetables. Macready's supporters, including forty-seven prominent citizens who sent a letter of support to the British thespian, insisted that the show continue. A frightened mayor called out the Twenty-seventh Regiment, and when the Bowery B'hoys charged the theater, the soldiers fired on the crowd, leaving twenty-two dead and forty-eight wounded. One observer noted that the riot signified that "the hatred of wealth and privilege is increasing all over the world and ready to burst out whenever there is the

3.135

slightest occasion."[25] It was one of the most violent class confrontations to take place in New York. The Astor never recovered and closed shortly afterward (3.136).

The working classes on and near the Bowery and the East Side particularly favored blood sports, especially cock fighting, dog fighting, and rat baiting. These were all sports in which spectators laid bets as to which animal would destroy the others in the pit. The most popular venue was Kit Burn's Sportsman's Hall, a three-story building on Water Street. The center of the building held an oval pit surrounded by seats for two hundred fifty spectators, though the audience generally ran to five hundred. Most popular were rats versus dogs, and dogs versus dogs. The ASPCA constantly raided the establishment but failed to close it down (3.137).

New York in the antebellum era boasted one famous, even glorious museum: Barnum's American Museum (3.139). Having bought the failed remains of the Scudder

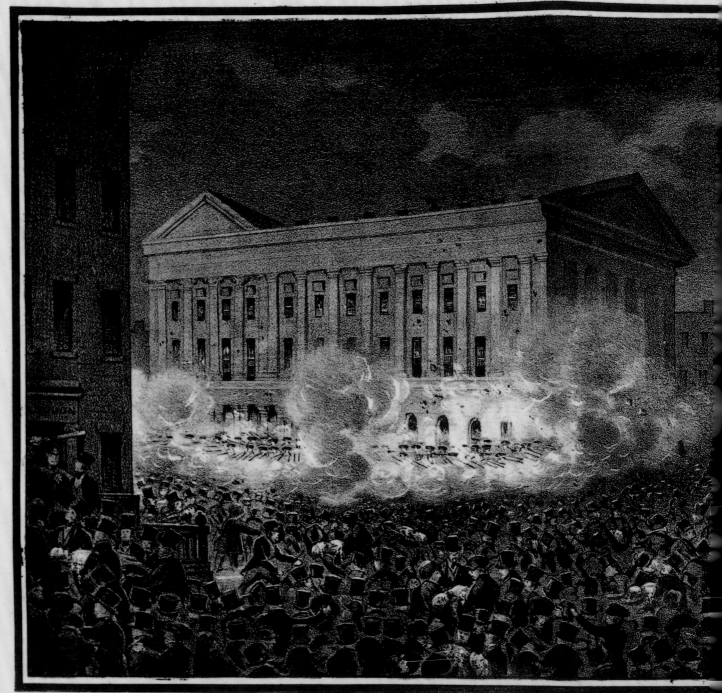

Pab.d at Eltons 90 Nassau St

GREAT RIOT AT THE ASTOR PLACE OPER

Showing the dense Multitude of spectators when the Military fired. Killing

| Killed | | | | | | |
|---|---|---|---|---|---|
| Geo. W. Gedney | Aged 30 | Mothew Cahan | Aged 28 | Geo. W. Taylor | |
| Wm Butler. | 27 | Owen Burns | 30 | Thos Keurnin | |
| Neil Gray Mellis | 27 | Asa F. Collins | 45 | Thimothy Macgª | |
| Timothy Burns | 18 | Thos Burman | 20 | Kelly | |
| Geo. A. Curtis | 22 | Tho Aylwood | 19 | Stephen Kehoe | |
| Bridget Fagan. | | | | | |

172

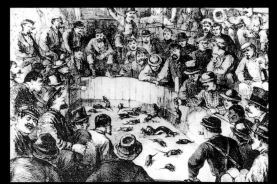

3.137

To walk on the Bowery

on Saturday night was to enter

a world filled with all

kinds of excitement.

3.138

3.136. Currier and Ives, Astor Place riot, 1849. **3.137.**
Blood sport at Kit Burn's Sportsman's Hall: rat versus
weasel, 1880. **3.138.** "The Happy Family" and visitors,
1853. **3.139.** Barnum's Museum.

Lith of B.F.Butler 96 Fulton St

HOUSE NEW YORK

d wounding about — 70 Persons.

Aged 21	Geo W. Brown	Aged 21
23	Henry Otten	—
19	Andrew McKinley	25
—	Geo Lincoln	30
24	Jno McClennehan	—

3.136

3.139

3.140

3.141

3.142

Museum, showman Phineas T. Barnum took over the enterprise in 1841. Through relentless advertisement and publicity stunts, he attracted thirty-eight million visitors from 1841 to 1865 (the population of the United States in 1865 was only thirty-five million). In the museum were collections of stuffed animals, skeletons, busts, Roman and Indian artifacts, minerals, and automaton figures, as well as live menageries, including the first hippopotamus in America, an aquarium with a shark, and various human oddities such as a four-year-old child weighing two hundred twenty pounds. One of the most popular attractions was "The Happy Family," a menagerie of animals, purchased in England, that lived together in Edenic harmony (3.138). There were also working displays of glassblowers and daguerreotype artists at work, along with phrenologists and fortunetellers who would perform readings for a fee. An auditorium seating three thousand offered moralistic entertainment—praising temperance—for the whole family. Outside, on a balcony overlooking Broadway, an orchestra played so poorly that spectators went inside to get away from the noise. All in all, it was quite a spectacle; everyone went.

During the Republican era the Free School Society, headed by De Witt Clinton and later named the Public School Society, constructed schools throughout the city. It sought and finally received state funding, and in 1842 the state established a true public school system with schools spread throughout the city. Despite the strong objections of Irish and German Catholics led by Bishop Hughes, who accused the schools of trying to impose a Protestant creed on Catholics, the system grew quickly. In 1853 the society, which was privately run, gave way to an elected board of education. More schools were erected, some holding as many as one thousand students, such as No. 37 at Fourth Avenue and Eighty-seventh Street (3.140). Most children started school at age six or seven and attended primary school for six years and grammar school for two, leaving

3.140. Public School No. 37. 3.141. Cooper Union. 3.142. Grammar school girls, 1881. 3.143. Grammar school boys. 3.144. American Anti-Slavery Society *Almanac*, 1839. 3.145. Beecher "selling" slave.

3.143

at the age of fourteen. Many of the poorer children never matriculated, but the system succeeded with the children of the middle classes. With the growth of mass education, the teaching force became increasingly feminized. Teaching was one of the few professional options for women, though the salaries were very low. Blacks attended separate schools until the 1880s.

By 1854 New York's twenty-eight Catholic schools enrolled perhaps half the city's Catholic children. Bishop Hughes objected to the assimilationist attitude of public school administrators, stating that Catholic children attending public schools became "intractable, disobedient, and even contemptuous towards their parents."[26] Indeed, the goal of the public schools was to Americanize immi-

grants in an attempt to achieve uniformity within the city.

School centralization increased as the schools were overseen by inspectors, who reported to the commissioners. After the Civil War the public school system continued to expand, including grammar schools that enrolled older children in grades five through eight. These were usually segregated by sex. In a photograph of Grammar School No. 55 on West Twentieth Street taken in the mid-1870s, boys sit with folded hands, left over right, a posture dictated by school policy, while an engraving from *Leslie's* of a girls' grammar school shows the students doing morning calisthenics to music (3.143, 3.142). (For another version of calisthenics, see fig. 4.117.)

A significant effort to extend advanced learning to the general public was initiated with the Cooper Union

—VOL. I. NO. 5.—

THE AMERICAN ANTI-SLAVERY ALMANAC,

FOR

1840,

BEING BISSEXTILE OR LEAP-YEAR, AND THE 64TH OF AMERICAN INDEPENDENCE. CALCULATED FOR NEW YORK; ADAPTED TO THE NORTHERN AND MIDDLE STATES.

NORTHERN HOSPITALITY—NEW YORK NINE MONTHS' LAW.

The slave steps out of the slave state, and his chains fall. A free state, with another chain, stands ready to re-enslave him.

Thus saith the Lord, Deliver him that is spoiled out of the hands of the oppressor.

NEW YORK:

PUBLISHED BY THE AMERICAN ANTI-SLAVERY SOCIETY, NO. 143 NASSAU STREET.

3.145

3.146

Institute, which opened at Astor Place in 1859. Founded by industrialist Peter Cooper, it contained a reading room that remained open until ten at night, along with classrooms and rooms for the practice of art and technology. It held evening classes to accommodate the needs of the working classes. Two thousand students, from clerks to blacksmiths, filled each classroom from the start. The ornate $500,000 building also housed the famous Great Hall, where speakers representing all political and social viewpoints could be heard (3.141).

Reform movements flourished during the antebellum era. Belief in the ability of men and women to alleviate if not eliminate the evils of drink and poverty and to ameliorate conditions in prison and other institutions as well as to abolish slavery made this a time of great controversy and division. New York City was a central address for reform movements. It housed the national headquarters for the American Anti-Slavery Society, started by New England abolitionist William Garrison and the evangelical New York City merchant William Tappan. Despite riots and harassment, the society sent tracts through the U.S. mails, though this led to counterattacks and the noted gag rule by Congress. The *Almanac* was but one of its many publica-

3.147

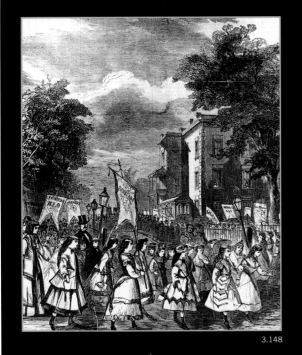

3.148

⭐

New York City was a central address for reform movements.

●

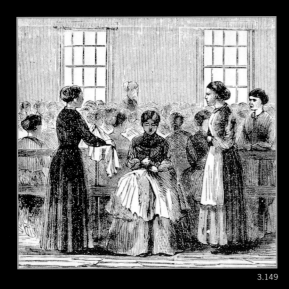

3.149

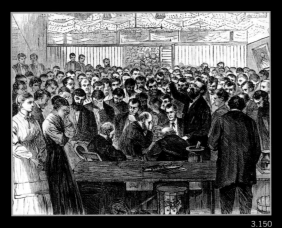

3.150

tions (3.144). The popular Reverend Henry Beecher of Brooklyn, one of the most charismatic of the metropolis's clergy, caused a sensation when he "sold" a slave from his pulpit, a stunt designed to prompt congregants to give money and jewelry to redeem fugitive slaves (3.145).

Some societies attempted to assist the poor, whose numbers and plight quickly overwhelmed the resources of the municipality. The AICP (Association for Improving the Condition of the Poor), founded as a Protestant missionary effort, sent visitors to the poorest wards with the intention of teaching residents how to become self-suffi-

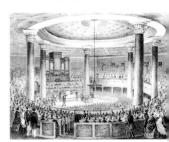

3.151

cient as well as dispensing limited amounts of direct aid. The association criticized direct philanthropy and in difficult times advocated "a hard-hearted relief program to drive the poor out of and away from the city."[27] The other major relief organization was the Children's Aid Society, founded by Charles Loring Brace, which sent delinquent children off to the West to work on farms, far from the city's corrupting influence. Sunday schools represented another attempt to help children, both physically and spiritually. Various Protestant denominations held Sunday classes for children throughout the city. An illustration from *Harper's Weekly* features an anniversary parade of sixty thousand Sunday school children in Prospect Park in 1885. The annual parade began in 1838, two decades after the initiation of the first Sunday school classes (3.148).

Germans and Irish in New York shared a favorite pastime—drinking—with many of the native-born Bowery B'hoys. On street corners in such areas as Five Points or the Bowery—indeed, in nearly every working-class neighborhood—taverns and groceries sold liquor. In 1849 Father Theobald Matthews visited New York, enrolling 150,000 members in support of temperance (the illustra-

3.146. Colored Orphans Asylum, 1861. **3.147.** Father Matthew administering temperance pledge. **3.148.** Brooklyn Sunday school parade. **3.149.** Magdalen Society asylum, 1872. **3.150.** Prayer meeting, Allen Dance Hall, 1868. **3.151.** Broadway Tabernacle, 1845.

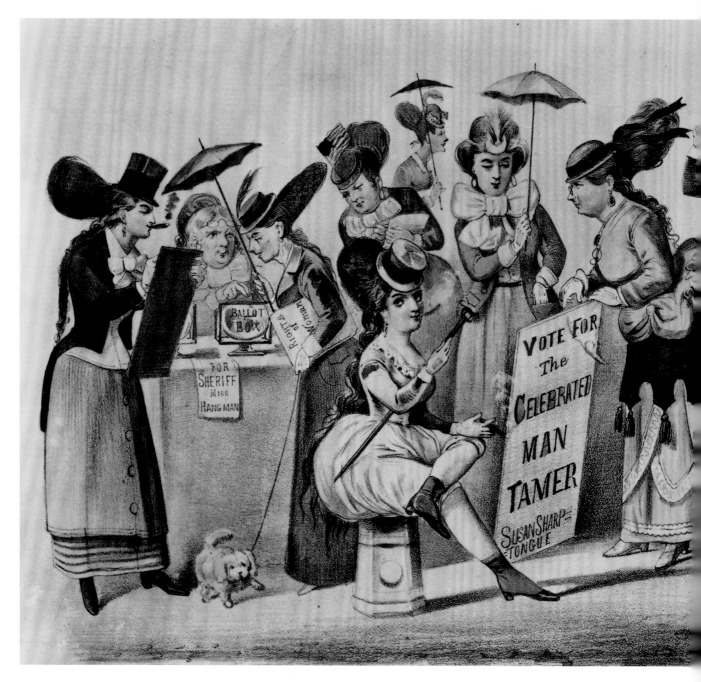

tion depicts him administering the pledge) (3.147). At St. Patrick's Day parades, temperance workers marched under their own banner.

The Magdalen Society, originally the New York Female Moral Reform Society, began its attempts to rescue the city's prostitutes in 1830. The society founded a house of refuge on West Twenty-fifth Street in 1831 and then moved to East Eighty-eighth Street in 1850. Administering the Magdalen Society was often the task of women from the city's upper classes, who both pitied the young prostitutes and resented the time their spouses spent at local brothels (3.149).

Two Quaker women helped found the Colored Orphans

Asylum in 1837, aided by a grant from the city of twenty lots on Fifth Avenue at Forty-third Street. Blacks also helped to support the inmates, who came from broken homes throughout the city (3.146).

Evangelical movements participated in many of these causes as well as sponsoring their own, holding prayer services in the worst neighborhoods along the waterfront, even at John Allen's notorious dance hall (3.150). In

3.152. Currier and Ives, *The Age of Brass; or, The Triumph of Woman's Rights.* 1869. **3.153.** H. Balling, Virginia Woodhull attempting to vote, 1871. **3.154.** Bathroom, Croton plumbing.

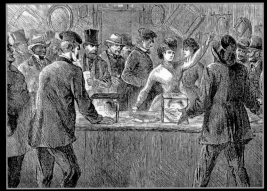

3.153

Women, active in reform movements, also worked to improve their own position in society.

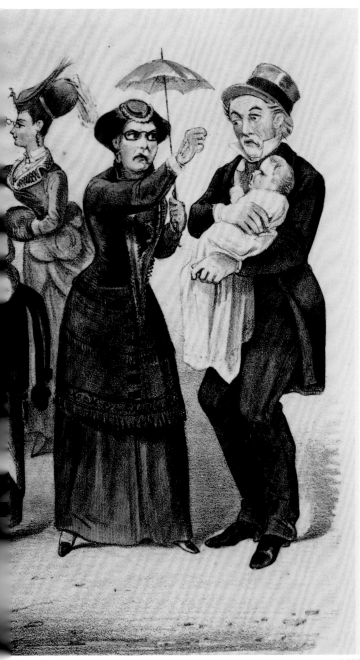

3.152

1835, in response to the large crowds drawn by evangelists such as Charles G. Finney, the city's elite constructed the Broadway Tabernacle at Broadway and Worth. In this large rotunda, Finney and others mesmerized, frightened, and enlightened New Yorkers for hours at a time (3.151).

Women, active in a number of reform movements, also worked to improve their own position in society. They succeeded in gaining greater property rights, but on the issue of suffrage they encountered strong opposition. In 1860 a national women's rights convention was held at the Cooper Union, led by Susan B. Anthony and Elizabeth Cady Stanton. The movement for the vote failed to gain much support among either sex, however, and inspired

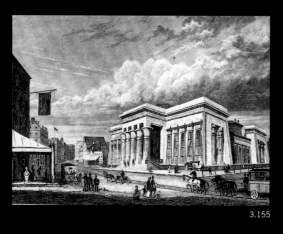

3.155

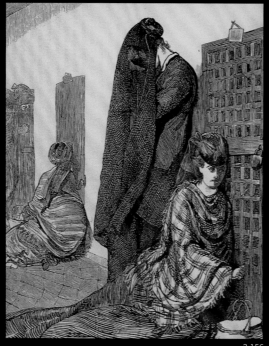

3.156

3.155. The Tombs, 1850. **3.156.** Tombs interior, 1870.
3.157. Regulation uniform of the New York Police, 1853.
3.158. Joseph Becker, Randall's Island Poorhouse,
1875. **3.159.** Jefferson Market Courthouse, 1867.

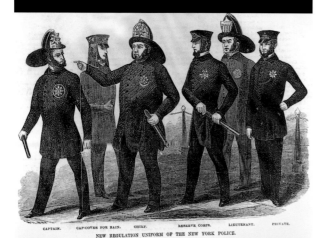

CAPTAIN. CAP-COVER FOR RAIN. CHIEF. RESERVE CORPS. LIEUTENANT. PRIVATE.
NEW REGULATION UNIFORM OF THE NEW YORK POLICE.

3.157

considerable satire against women who forsook their allotted role in society (consider this 1869 Currier and Ives print [3.152]). Greater notoriety ensued when Victoria Woodhull, an attractive woman from the Midwest who had been befriended by Cornelius Vanderbilt, made a small fortune and began her own newspaper advocating free love as a means of attacking the sexual double standard. Entering the fray for suffrage, she championed direct action and went to the polling place with five other women in 1871, only to be turned away (3.153).

While reform movements attempted to transform character and halt moral decay, the city took charge of maintaining order. This was a difficult task for an underfunded government that was constantly reorganized by the state and sundered by political ambition and corruption. The accepted role of city government was to be strictly concerned with the welfare of the people. As such, it was under the direct supervision of the state. In 1821 the state allowed the common council the right to elect its own mayor, and in 1830 it separated the mayor from the council and gave that position veto power. The first direct election of a mayor took place in 1833. In 1849 the state reorganized the city into ten separate departments, each of which, with the exception of the police force, was headed by an elected figure. Corruption scandals led to more reorganization in 1853, when power shifted to boards of aldermen and councilmen, and again in 1857, when a Republican legislature reduced the authority of the mayor, making the comptroller and counsel separate elected officials.

Reformers, according to Edward Spann, considered New York's government "the greatest failure in American life."[28] The city, however, though overwhelmed by the huge growth in population and the needs of its citizens and enterprises, did build the Croton waterworks and a new sewer system. It also ran the emergent public schools, erected new docks, regulated markets, issued franchises for municipal gas supplies, established a new police force, and bought and developed Central Park.

The city opened the Croton Aqueduct in 1842, built after seven years of planning and labor for around $12 million. The construction of the forty-one-mile aqueduct and reservoir that rose thirty-eight feet above street level at Fifth Avenue and Forty-second Street was a wonder of modern

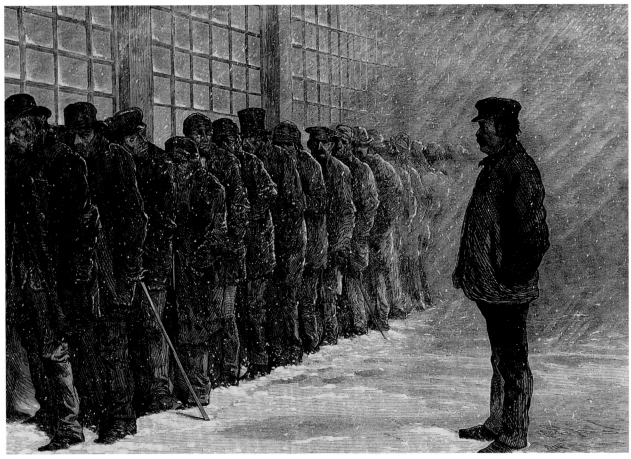

3.158

technology. An adequate and secure water supply heralded a
new era for the city, facilitating growth and bringing indoor
plumbing to many upper- and middle-class households
(3.154). The reservoir also made possible a new sewer system
in the 1840s that hastened the disappearance of the noxious
and disease-laden privies. Even so,
as late as 1859 three-quarters of
streets, all in the poorer areas of the
city, still lacked sewers.

Taking care of the poor, the sick,
and the criminal classes was one
responsibility New York shared
with reform groups. On Blackwell's
Island (today's Roosevelt Island), removed from society as
many reformers advocated, lived the unfit and miscreant.
There the city built the workhouse, the New York
Penitentiary (which could accommodate over two thousand
short-term offenders), and three hospitals, including the
smallpox hospital and the almshouse. Reformers had little
patience with vagrants, whom they considered lazy malin-
gerers. Their cure was arrest, a quick trial of only a few min-
utes, and up to six months of breaking stones and fabricat-

3.159

ing bricks. Randall's Island contained the houses of refuge
for juveniles and the poorhouse. A picture in *Leslie's* of men
at the poorhouse in winter captures the starkness of poverty
and harshness of treatment at this remote corner of the city
(3.158).

The city operated the infamous
Tombs, its house of detention.
Built at the location of the Old
Collect Pond, it was designed in
1835 (completed in 1838) from a
representation of an Egyptian
tomb with massive frontal
columns (3.155). Though intend-
ed to confine only two hundred men and women, it often
held twice that number. Inside its walls was a courtyard
connected to the main prison by the famous "Bridge of
Sighs." There were four tiers of cells, with light coming
only from the ends of the corridors (3.156). The Tombs
also housed a woman's prison and a "bummer's tank" for
drunks, as well as a chapel and two courts. If convicted of
major crimes, inmates would be transported to prison in
the dreaded Black Marias. Trials took place at the Tombs

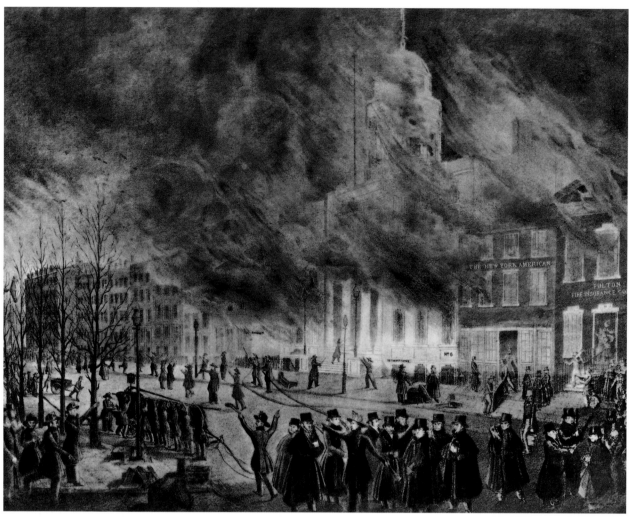

3.160

and other venues, including the Jefferson Market Courthouse. This engraving depicts a number of destitute individuals at the bar (3.159).

The city had to maintain order in the streets. With so many competing nationalities and so much poverty, crime rose. Walt Whitman wrote that "New York is one of the most crime-haunted and dangerous cities in Christendom. There are hundreds—thousands—of infernal rascals in our floating population." *The New York Times* declared that "stabbing and shooting are in vogue in the public streets."[29] Statistically, crime was not as high as it is now, but fear was ever present. The old police force of marshals and night watchmen was inadequate, and in 1845 the force was reorganized with eight hundred salaried policemen. Many of these worked at desks, however, and only half were available at night. Edward Spann notes that in 1856 London had one policeman for every 351 citizens; New York had one for every 812. The police were often involved in scandals, accepting bribes in return for allowing illegal saloons

and other centers of vice to operate.

During Mayor Fernando Wood's first term, the police force became more professional. New chief George Matsell instilled tighter discipline, required officers to spend less time off the streets, and initiated the military-style parade. Telegraphic connections were established between stations. Matsell cracked down on streetwalkers and unlicensed saloons. It was impossible, however, to separate the police from politics, and they became pawns in fierce partisan fights. The force became a crucial source of patronage, and Democrats handed the city's Irish many appointments.

In 1853 the city's police donned uniforms (3.157). Prior to that their only identifying mark was a star-shaped badge of office: uniforms were deemed unrepublican. In 1857 patrolmen commenced carrying service revolvers. Increasingly, they became a potent fixture on the city scene.

The danger of catastrophe threatened from fire as much as from urban disorder. Not until 1865, however, did the city organize a metropolitan fire-fighting force. If there was little

honor in serving as a ward constable and even less as night watchman, the fraternal and potential political rewards of serving in a volunteer fire company remained high, and the system endured through the Civil War. Different ethnic companies sometimes quarreled instead of fighting fires, however, and party politics often intervened in the selection of the city's chief engineer (Boss Tweed began his career as the leader of Fire Company Number 6.) Volunteer companies carried considerable clout, and their parades were well attended by political dignitaries. New horse-drawn equipment helped modernize the force, as did the Croton Reservoir with its ready supply of water. After the Civil War the Republican legislature organized the Metropolitan Fire Department, replacing the forty thousand volunteers with a thousand professionals, establishing a system of fireboxes, and requiring specialization of function, discipline, rank, and merit. The fire department took its place alongside the police department as a leading protective service (3.162).

Fires were all too common, and as the city grew in size, wealth, and stature it remained exceptionably vulnerable to this threat. Artists drew many pictures of the city during and after some of its great fires. This lithograph by A. Hoffy depicts the conflagration of 1835 that destroyed the Merchants' Exchange, much of Wall Street, and thirteen acres of the city's most valuable commercial property (674 buildings). Note the busy firemen who have their hands full both maintaining order at the scene and putting out the fire (3.160).

The rising numbers of immigrants and the militance of workers trying to organize during the depression that followed the Panic of 1873 prompted the construction of twenty-nine armories, at a cost of $2.5 million. Armories were built near wealthy neighborhoods to protect the property of the rich from looting by the poor. The most notable was located between Fourth and Lexington at Sixty-sixth Street. With its foot-and-a-half-thick door and holes for rifles, it gave the elite the peace of mind to move to nearby Lenox Hill, safe from the dangerous classes.

The militia was called on to suppress disorder, during strikes or frays such as the Astor Place Riot. The Seventh Regiment, as the city's guard was known, was headquartered in the Tompkins Market Armory at Third Avenue and Sixth Street. Built from 1856 to 1860, this was the first building in the city specifically constructed to house a regiment. Erected in an Italianate palazzo style, it contained two large drill halls and eleven rooms for company meetings. The third floor was a single large drill room. The building also housed a library of military science (3.161).

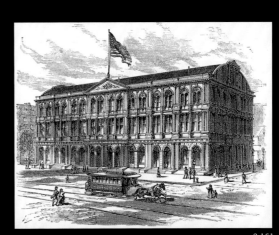

3.161

3.160. Merchants' Exchange Fire, December 16, 1835. **3.161.** Seventh Regiment Armory. **3.162.** *Reception of Firemen by the Mayor.* **3.163.** Joshua H. Beal panorama (detail), New York caisson, 1876.

RECEPTION OF FIREMEN BY THE MAYOR, COUNCIL, ETC

3.162

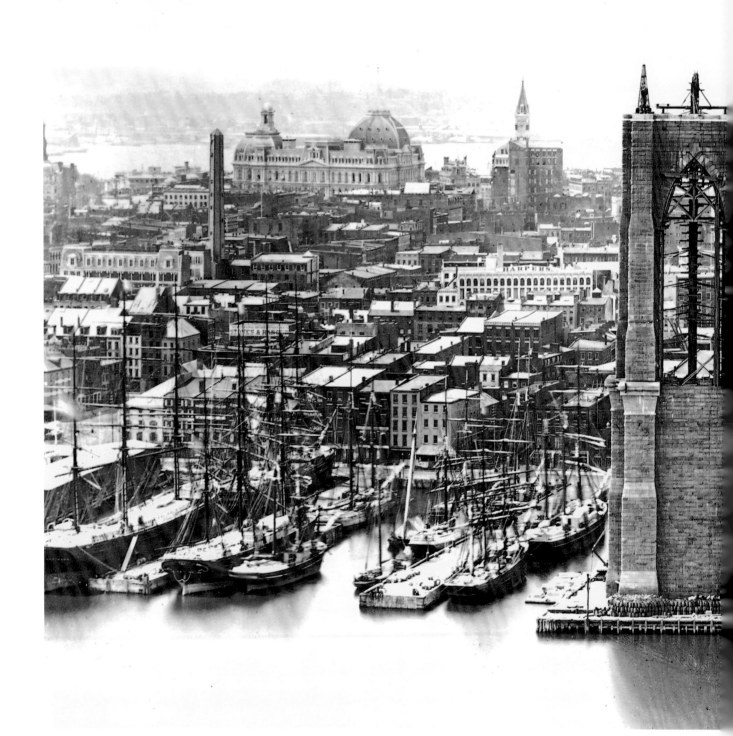

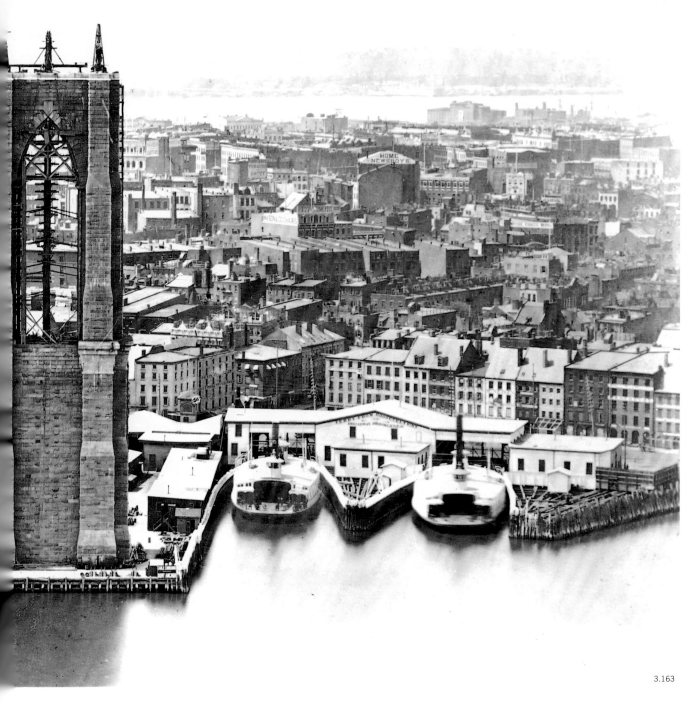

3.164

3.165

3.164. W. P. Snyder. Baseball at Polo Grounds, 1886.
3.165. Christmas Day, 1870. **3.166.** Greenwood
Cemetery. **3.167.** Brooklyn Bridge traffic, 1883.
3.168. Brooklyn Bridge construction, New York
approach, 1877. **3.169.** Overview of Central Park, 1863.

It may have been difficult for any politician to bring order to an increasingly fragmented society, but there were times when New Yorkers came together in moments of civic pride. Parades ranged from local marches by the fire companies to celebrations of such major events as the opening of the Croton Reservoir. By far the greatest celebration took place in May 1883 at the opening of the Brooklyn Bridge. The work was inspired by John A. Roebling (who died before it was begun) and his son, Washington Roebling, who, disabled by the bends while installing the caissons, supervised construction with the help of his wife from his Brooklyn Heights apartment (3.168). The New York caisson (which had to be dug much deeper than the Brooklyn caisson) measured 172 by 102 feet and was 20 feet thick at the top. Pictured here in a Beal panorama, it stood out as a great monument to progress to the thousands of New Yorkers who passed it daily in ferries (3.163). In looking forward to construction, the elder Roebling speculated that the bridge would be "not only the greatest . . . in existence, but it will be the greatest engineering work of this continent, and of the age." Roebling further declared that its great towers "will serve as landmarks to the adjoining cities, and they will be entitled to be ranked as national monuments."[30]

The longest suspension bridge in the world (5989 feet, 1595 over the river), this engineering marvel took the lives of twenty workmen during construction. One hundred fifty thousand people crowded over it on opening day, which was highlighted by a visit from President Chester Arthur. Many people used the bridge, some crossing by streetcar, some by horse cart, and others on foot (3.167). Commuting from Brooklyn was now even easier and cheaper. The aerial perspective offered by the bridge gave New Yorkers a new view of their city. The bridge became a symbol for the city, for the age itself. What couldn't man accomplish?

Holidays such as Christmas also brought New Yorkers together.

3.166

Indeed, New Yorkers changed the American way of celebrating Christmas. Santa Claus was largely the invention of John Pintard, leader of the New-York Historical Society, who based the character on St. Nicholas, the patron saint of New Amsterdam (taken from Washington Irving). With the composition of the memorable poem "The Night Before Christmas" by Clement Clark Moore, the Episcopal bishop of the New York diocese, Christmas became a major day of family celebration and subsequently a commercial holiday dedicated to gift giving (3.165).

3.168

Athletics such as the growing sport of baseball united New Yorkers. Baseball gained popularity before the Civil War, and in 1846 the New York Knickerbocker Club, an organization of white-collar workers, organized a league and issued a rule book. Some of the teams turned professional, putting players on salary. A popular pastime, especially among the middle classes, was either to play as an amateur or watch a game. One of the first stadia for baseball, though built originally for polo in 1876, was the Polo Grounds, where the Giants and Metropolitans played. A *Harper's* engraving depicts over fif-

teen thousand spectators watching the Giants play Brooklyn, winning in eleven innings in an 1886 National League game (3.164).

Prior to 1850 New York had a shortage of park space. The most popular retreat was Jones Woods on the Upper East Side, which adjoined the East River. The Greenwood Cemetery in Brooklyn opened in 1838 with landscaped grounds and a variety of monuments (3.166). Overlooking New York Bay, Greenwood contained over twenty miles of paths wandering over 478 acres. Tens of thousands of New Yorkers visited every summer to escape the city, especially on Sundays, when people would flock there to seek peace amid its winding wooded paths. But nearly a million people needed more recreational space. The city's well-traveled fathers realized that without parks—made difficult because of the grid plan of 1811 that accommodated little undeveloped land—New York would never compare with London or Paris. The wealthy needed space to ride in carriages, while reformers hoped for an alternative to the saloon. Consequently, a movement to establish a major park was

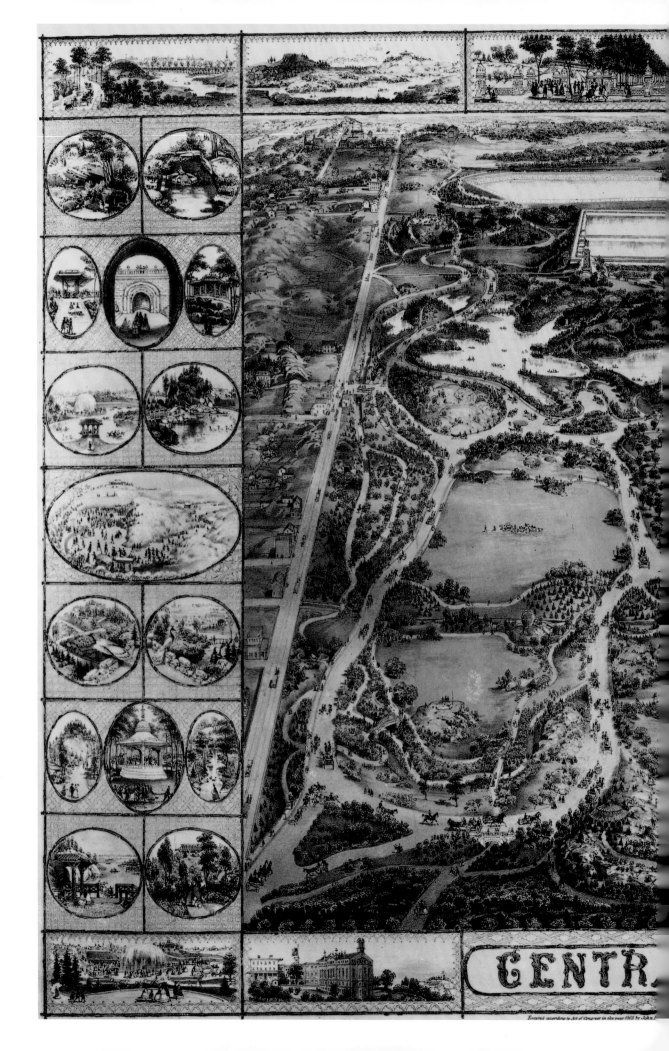

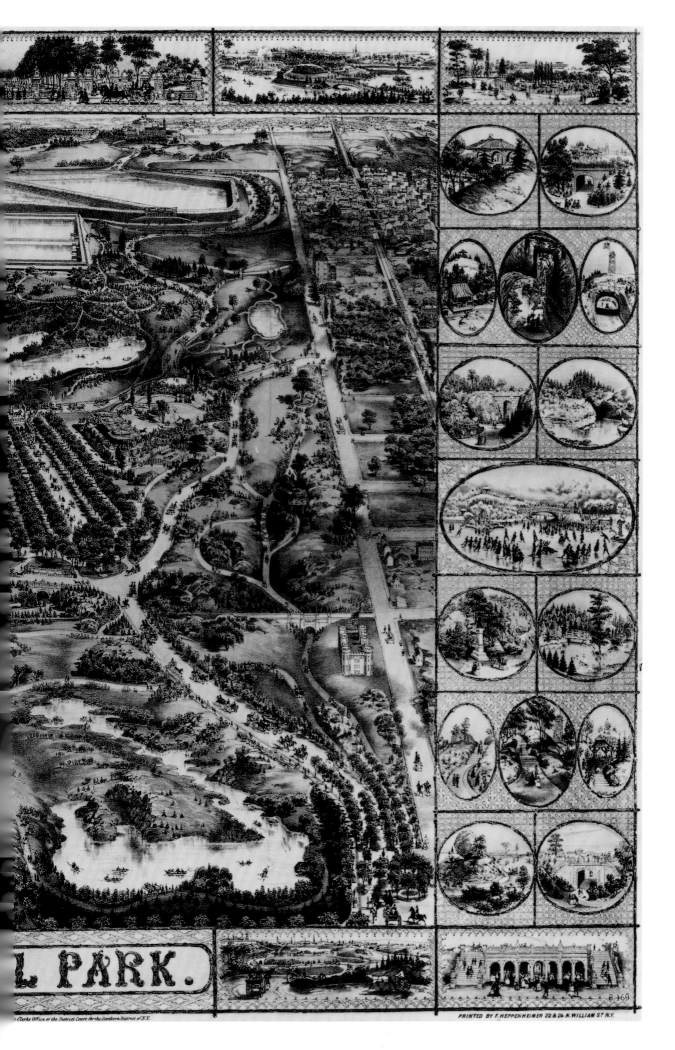

L PARK.

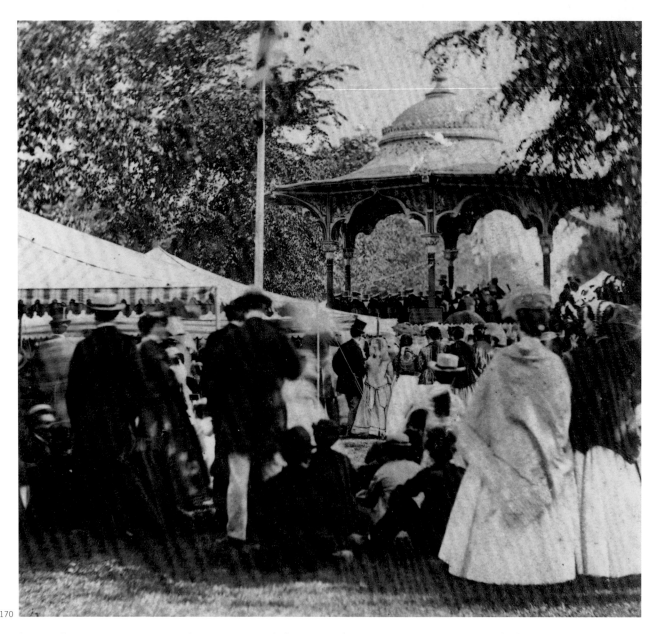

3.170

born. After rejecting Jones Wood, the city settled for the present location of Central Park. Landowners to the west and east of the park's boundaries were eager to eliminate the shanty towns on their property and their personal interests influenced site selection. After a contest, a design by Frederick Law Olmsted and Calvert Vaux was accepted, the "Greensward plan." Captured in this Heppenheimer lithograph of 1863, it offered pastoral (meadows), picturesque (Ramble), and formal (Promenade) settings (3.169). In their proposal the two designers noted that "the time will come when New York will be built up, when all the grading and filling will be done. . . . There will be no suggestions left of its present varied surface, with the single exception of a few acres contained in the Park."[31]

The southern section of the park enclosed the more formal settings, including the Mall and the Bethesda Fountain, while the northern section remained more rustic. Many of the buildings constructed in the park were of a Gothic design favored by Olmsted and Vaux. Construction required twenty thousand Irish laborers to work for many long, hard days in a rocky and swampy terrain. Two hundred seventy thousand trees and shrubs were planted to create the new landscape; sixteen hundred residents were displaced from black, German, and Irish communities within the confines of the proposed park.

3.171

3.172

3.173

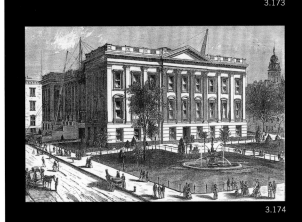

3.174

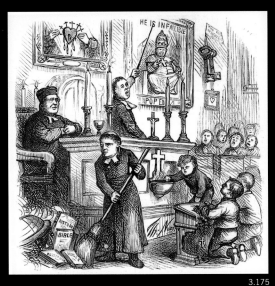

3.175

The park at first attracted upper-class carriage riders, and then middle-class New Yorkers began using the park for skating and weekend concerts. Wealthy German Jews recaptured the spirit of European watering places at the Mineral Springs Pavilion (3.171). Many Germans and Irish did not patronize the park at first because of rules against group picnics. Soon, however, the park became a popular gathering site for the whole city, and in 1865 seven million visitors visited the uptown Elysian field. Many popular concerts took place outdoors in the park. A stereopticon from the 1870s shows a well-dressed audience probably listening to a Saturday concert (3.170). In 1884, when Protestants, who considered music making a desecration of the Sabbath, began to lose their influence over public policy, Sunday afternoon concerts were instituted, scheduled for times when working-class New Yorkers might attend. Sixty thousand people showed up for the first Sunday afternoon band concert, a majority of them women. The concerts presaged the changing usage of the park. It quickly became a monument to democracy, a gathering place for all the classes and peoples of New York. Now the city could stand tall with other world metropolises.

3.176

The problems of antebellum New York were clearly exposed in the raucous, sometimes violent enacting of the city and state politics. The critical divisions that threatened to sunder the individualistic character of Gotham surfaced at election time and in the operation of city government. Race, religion, ethnicity, immigration, and class pervaded and often poisoned the political atmosphere. For politics to give voice to the disparate elements in a community, allowing them to create a harmonious society in which all interests are heard, majority rule must be followed but minority rights fully respected. New York often fell lamentably short of this ideal.

3.170. Music Day in Central Park. **3.171.** Sunday morning, Mineral Spring Pavilion in Central Park. **3.172.** J. McNevin, Tammany Hall, election night, 1859. **3.173.** Nast cartoon on Tweed corruption. **3.174.** Stanley Fox, Tweed courthouse, 1871. **3.175.** Catholicism in public schools (cartoon), 1870. **3.176.** Boss Tweed.

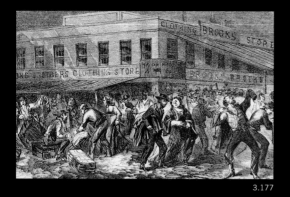

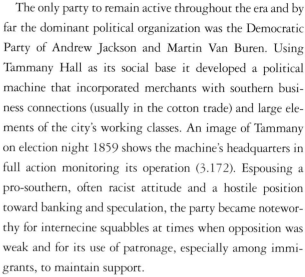

3.177. Looting of Brooks Brothers, 1863. **3.178.** Throwing brickbats, 1857. **3.179.** Street barricades, 1857. **3.180.** *The Miscegenation Ball.* **3.181.** Lynching, Clarkson Street, 1863.

The only party to remain active throughout the era and by far the dominant political organization was the Democratic Party of Andrew Jackson and Martin Van Buren. Using Tammany Hall as its social base it developed a political machine that incorporated merchants with southern business connections (usually in the cotton trade) and large elements of the city's working classes. An image of Tammany on election night 1859 shows the machine's headquarters in full action monitoring its operation (3.172). Espousing a pro-southern, often racist attitude and a hostile position toward banking and speculation, the party became noteworthy for internecine squabbles at times when opposition was weak and for its use of patronage, especially among immigrants, to maintain support.

Democrats took politics seriously. Intensely partisan primary contests occurred at the ward level that involved many constituents. The use of force at election time was not uncommon. The Tammany Hall crowd also had colorful if sometimes corrupt leaders, such as the Bowery's Mike Walsh, an insurgent editor of a radical newspaper who typified both the party's racism and the populism that appealed to many immigrants. As a congressman he was pro-South, seeking to form a coalition of northern workers and southern planters. Mayor Fernando Wood also began as a populist but ended up as a pro-southern leader who advocated New York's secession from the Union. After the Civil War Boss William Tweed (3.176) and his followers captured municipal government, swindling the city out of millions of tax dollars through bribery, graft, and blatant corruption until they were exposed by the *New York Times* and the cartoons of Thomas Nast (3.173). Perhaps Tweed's lasting legacy is the famed Tweed courthouse, the construction of which was budgeted for $250,000 in 1858 but by the time of its completion in 1878 had cost over $12 million, twice the price of Alaska (3.174). It took so long to build because of the demands of graft and bribery. Despite the corruption, the

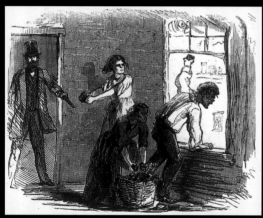

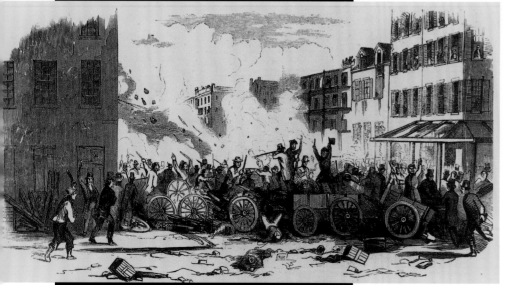

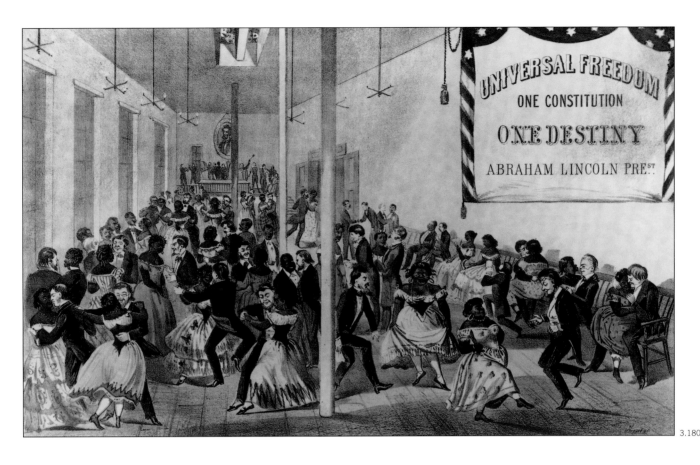

3.180

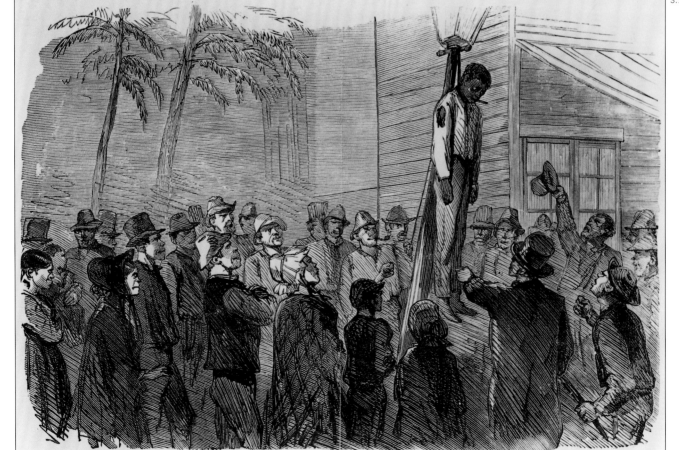

3.181

structure designed by John Kellum in a classical style became one of the city's most attractive and elegant public buildings. In an aesthetic sense it was a cousin of nearby City Hall, but the eras that saw construction of the two buildings could not have been more different.

Opposed to the Democrats were the national Whig Party and its successor in 1856, the Republican Party. Both these organizations had the support of most of the city's non-southern merchants as well as much of the German community and elements of the middling and working classes. But they had an uphill battle and won few municipal elections, though many statewide. While they supported reform, they often invoked nativist rhetoric to appeal to those appalled by the influx of immigrants, who were often characterized as undemocratic aliens. Both parties attacked Democratic corruption and were subject to bitter attacks in return.

New Yorkers also could choose from a number of third parties, among them some radical workers' organizations and others such as the Know Nothings, who were overtly hostile to the waves of immigration. Nast's Boss Tweed cartoon betrays this hostility in its depiction of Irishmen as primatelike, while a *Harper's* engraving with an anti-Catholic theme clearly targets the danger of Irish influence in the city's educational system (3.175). Nast suggests that Catholics have taken over the schools, relegating history and the Bible to the dustbin. Nativist fears were powerful and deep and an important element in municipal politics.

Politics fails when a segment of the community resorts to violence to assert its own interests and gain recognition of its grievances. This was not uncommon in antebellum New York. When the Republican legislature, led by temperance reformers, attempted in 1857 to implement the near-complete prohibition of alcoholic beverages, riots resulted. Irish gangs, notably the Dead Rabbits, put up street barricades, and Germans, furious at the assault on their traditions, also fought the militias in the streets (3.178, 3.179). One hundred people were injured and twelve killed. That same year, when Mayor Fernando Wood refused to comply with the Republican legislature's

3.182. Union soldiers quelling draft riot, 1863.

3.182

197

laws dissolving his police force, the militia invaded City Hall to arrest him.

By far the city's greatest political struggle, between Republican leaders and Democratic followers, took place during the Civil War. Over one hundred thousand New Yorkers volunteered for the Union army, and many others held fairs and supported the war effort. But there was strong antagonism in the city against Lincoln and his policies and between the Irish and black communities, particularly after federal troops were used to protect black strikebreakers against Irish longshoremen. Already hostile to the war and encouraged in their opposition by the Democratic Party and Fernando Wood, working-class Democrats were deeply incensed by the decision to draft by lottery citizens who could not pay for substitutes. Refusing to accept the draft, many Irish and other Democratic sympathizers took to the streets. Again barricades appeared at intersections. In the days of rioting that ensued targets included prominent Republicans and their property and African-American citizens and their institutions. Mobs looted Brooks Brothers, burned the Colored Orphan Asylum to the ground, and lynched a number of blacks cornered in the streets (3.177, 3.181). Only the entry of troops returning from Gettysburg ended the violence, too late for the one hundred five souls who lay dead (3.182).

The deep racist feelings unleashed by the Civil War in New York are well expressed in the Democratic political caricature *The Miscegenation Ball*, commemorating an event alleged to have taken place at the headquarters of the Lincoln Central Campaign Club. Clearly implied is that a victory for the Republicans would mean amalgamation of the races (3.180).

At the cessation of fighting, reconciliation was achieved at least in part in this deeply divided city as its citizens collectively celebrated the end of the war. A second moment of civic harmony followed the tragic death of Abraham Lincoln. The city went into mourning. Grieving onlookers lined the streets when the casket of the slain president passed through en route to burial in Springfield, Illinois (3.183).

3.183. Lincoln funeral cortege, City Hall, 1865.

3.183

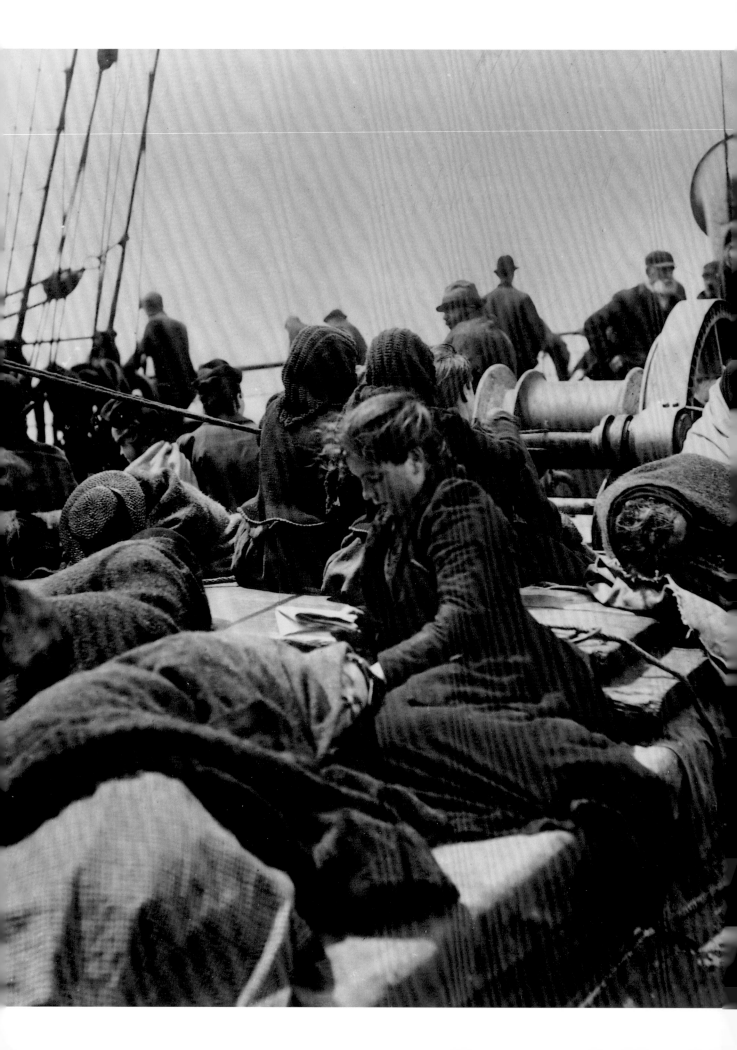

4.1

4

1885–1939

4.2

he 1876 United States centennial produced an enduring icon of New York City and its national significance as an immigrant port of entry: the Statue of Liberty (4.2). It stood in New York harbor on an appropriately giant pedestal, a gift from the French Republic. Designed by the French sculptor Frederic Auguste Bartholdi, Liberty Enlightening the World acquired her most profound meaning through a poem written by Emma Lazarus. A Sephardic Jew moved by the plight of persecuted Jews fleeing Russian pogroms, Lazarus penned an ode to "The New Colossus." Its lines, "Give me your tired, your poor, Your huddled masses yearning to breathe free," inspired hundreds of thousands of immigrants. Liberty, towering over New York bay, beckoned them with her promise. By 1898, the year New York became a city of five boroughs, 85 percent of its population of 3.4 million was foreign-born or had foreign-born parents. Edward Bierstadt's image probably dates from 1886, the year the statue was dedicated.

Immigrants were the most precious cargo of the many ships arriving in New York City, although they were rarely treated as such. Through their labor these men and women would completely transform their new home. Most immigrants arrived in steerage, the cheapest and most crowded form of ocean travel. The Byrons' 1893 photo of the S.S. *Pennland* of the Red Star Line suggests just how difficult the ocean journey was (4.1).

Joseph Byron knew about immigration firsthand. Arriving with his family in New York City from England in 1888, he rapidly established himself as a society and magazine photographer. His son, Percy, followed in his father's footsteps and the two loved to take busman's holidays, photographing the city whenever they could spare some time during the decades around the turn of the century.

They were not alone. Photography intrigued increasing numbers of men and women, who carried their bulky cameras into the city's streets to record urban life. Diverse motivations propelled these photographers to see different facets of the city: some catalogued street types, others documented the appalling poverty of the working classes, still others portrayed a landscape of modernity. By the 1920s they took advantage of smaller and faster cameras to focus on the quotidian details of urbanism. As printing technologies developed, photographs edged drawings off the pages of newspapers and assumed the mantle of authoritative reportage. Yet some New Yorkers spurned such commercial uses of photography. During the Depression, the establishment of the New York Photo League linked the early documentary photographers to a new generation committed to using the power of photography to effect social change.

The federal government took control over immigration in 1891, and the following year federal authorities moved immigration processing to Ellis Island, within view of New York City and the Statue of Liberty but separate from them. Between 1892 and 1924 71 percent of U.S. immigrants—roughly sixteen million people—entered the country through Ellis Island.

"The day of the emigrants' arrival in New York was the nearest earthly likeness to the final Day of Judgment, when we have to prove our fitness to enter Heaven," wrote a journalist in 1914.[1] With trepidation, immigrants climbed the steep stone steps to enter the Great Hall, the large domed reception room subdivided by metal railings. Those pictured below had passed the first mental inspections (4.4).

Lewis W. Hine completed his graduate studies in sociology at Columbia University in 1905, the year he photographed immigrants arriving at Ellis Island. "If I could tell the story in words," he later reflected, "I wouldn't need to lug a camera."[2] Hine turned to photography to promote his liberal ideas. With the passion of a social worker, he captured images of ordinary men and women aspiring to the American dream. His empathy for his subjects is palpable.

Initially few families could afford passage for more than a male breadwinner. After working hard and saving his money, a husband was expected to send for his wife and children. Many years could elapse before families were reunited. By then, husbands often had Americanized, while their wives usually remained true to traditional ways of thinking, dressing, speaking, and acting. The moment of meeting was often difficult. Hine photographed this Italian mother and child in tradition-

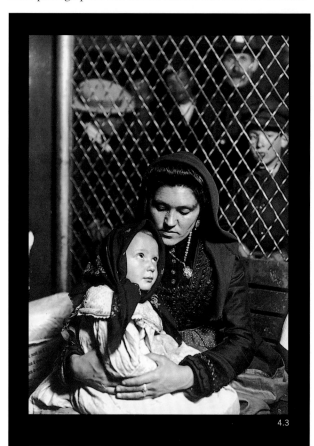

4.3

4.1. Joseph and Percy Byron, *Steerage Deck, S.S. Pennland of the Red Star Line*, 1893. **4.2.** Edward Bierstadt, *Statue of Liberty, Bedloes Island, New York Harbor*, ca. 1890. **4.3.** Lewis W. Hine, *Mother and Child, Italian, Ellis Island*, 1905. **4.4.** Edwin Levick, *The Pens at Ellis Island*, 1902–5. **4.5.** Lewis W. Hine, *Young Russian Jewess at Ellis Island*, 1905.

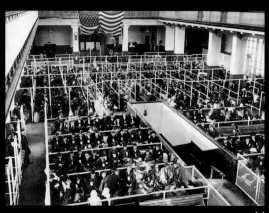

4.4

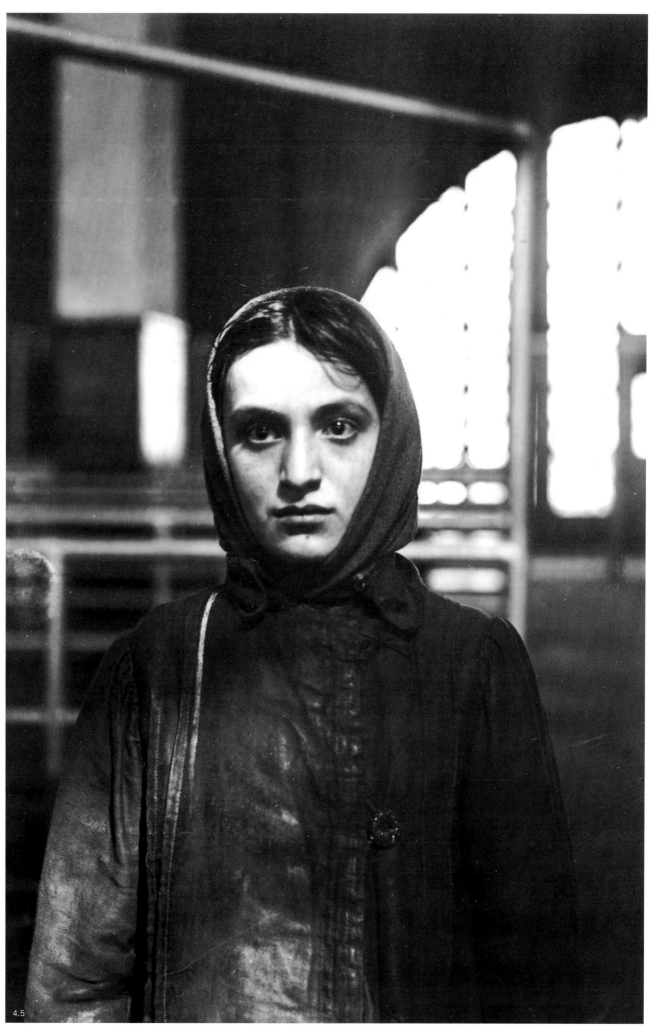

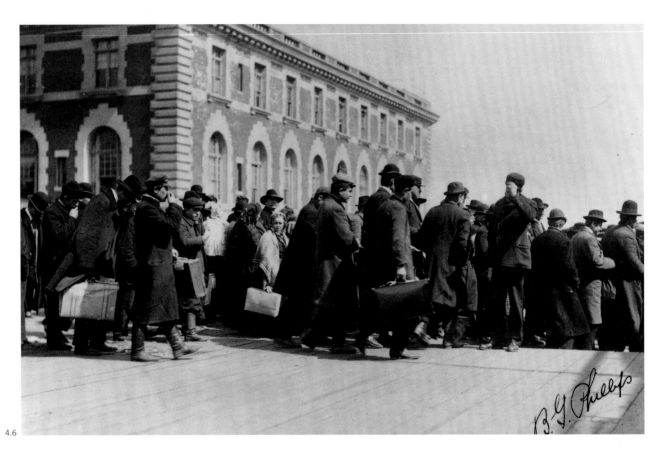

4.6

al garb sitting on a bench in front of the detention cell as though they were the Madonna and baby Jesus (4.3). "Sometimes 1700 immigrants were crowded into a room which was built to accommodate 600," Hine wrote in the caption accompanying the photograph, calling attention to the men's faces looming behind the wire mesh fence.

Some fiercely independent women, unencumbered except by their dreams and responsibilities, voyaged alone to New York. Jewish women made up almost half the total immigration of Jews to the United States from 1880 to 1914. Single young women in their teens or twenties wanted not just to better their lot but also to redefine what it meant to be a woman. They dreamed of opportunities to learn as well as labor, to create as well as raise families. Their militancy, energy, and zeal built a powerful garment union movement in New York and strengthened the campaign for women's suffrage. To prevent pimps from preying on them, the National Council of Jewish Women provided staff to guide newcomers to its dormitory in Harlem. In his caption for the photo of a solitary young woman, Hine quoted the poet Walt Whitman: "Inquiring, tireless, seeking what is yet unfound, But where is what I started for so long ago—And

why is it still unfound" (4.5).

In the peak year of 1907 over a million immigrants entered the United States. Ferries ran twenty-four hours a day to New York City and points in New Jersey (4.6). New York City's population mushroomed because of immigration, growing at a rate of roughly a million inhabitants per decade: from 3.4 million in 1900 to 4.7 million in 1910, to 5.6 million in 1920, and to 6.9 million in 1930. After the restriction of immigration in 1924 and the onset of the Depression in 1930 the pace slackened, reaching 7.4 million on the eve of World War II.

For immigrants and natives alike, the new city loomed, a vision of ambition whether viewed from the water or from atop the skyscrapers huddled together in lower Manhattan. Of the changes transforming the city, few could compare to the rise of its skyline. A fortuitous intersection of geology (notably New York's bedrock substratum), technology (including the inven-

4.6. B. G. Phillips, *Leaving Ellis Island*, 1907. **4.7.** Berenice Abbott, *Trinity Churchyard and Wall Street Towers*, 1934. **4.8.** Andre Kertesz, *Steel Frame and Construction Worker*, ca. 1937.

tion of elevators, electricity, and iron framing, and the development of such public utilities as heat, water, and plumbing), economy (rising land values and an expanding financial center), and psychology (the identification of height with prestige and power) produced the city's skyscrapers. A need for specialized buildings, as compared to the popular mixed uses of the nineteenth century, fueled construction of ever taller towers at the turn of the century.

As the United States' industrial power increased, so did New York's centrality as a site of corporate headquarters, finance capital, and insurance. Skyscrapers, the city's signature, assumed new heights and shapes in response to a 1916 zoning law designed to provide adequate light and air to the street. The law mandated building setbacks to conform to an "angle of light" plane. Towers could rise to unlimited heights as long as they occupied only a quarter of the area of their lots. The concentration of money and workers in tall buildings set along narrow streets laid out in colonial times was particularly notable in the financial district.

Berenice Abbott returned to New York from Paris at the end of the 1920s and photographed the city after its big boom in skyscraper construction. Her *Changing New York* (1937), one of the decade's most influential exhibitions and books, fixed the urban image of Depression-era America. Abbott emphasized the background and great depth of field, defying commonsense photographic conventions. She discovered "a new urgency here" and found "poetry in our crazy gadgets, our tools, our architecture." Her visual rhythms and reordered space "formalized the off-balance quality of the city itself," as Colin Westerbeck and Joel Meyerowitz observe.[3]

Houses of finance quickly eclipsed church steeples, casting shadows of the profane over holy places. The contrast between sacred and mundane repeatedly attracted photographers' attention until church spires dwindled into ineffectual gestures. Pioneer sociologist Max Weber argued that Protestantism's understanding of work as a calling coupled with a religious ethic of acquisition and worldly asceticism fueled the spirit of industrial capitalism. Abbott's photograph of Trinity churchyard at the foot of Wall Street portrays the close proximity of the temples of finance and industry with the Episcopalian elite (4.7).

Trinity faces geometric patterned windows as pedestrians and gravestones dance between the light and shadow. Designed by Richard Upjohn (1844–46), Trinity Church's Gothic spire

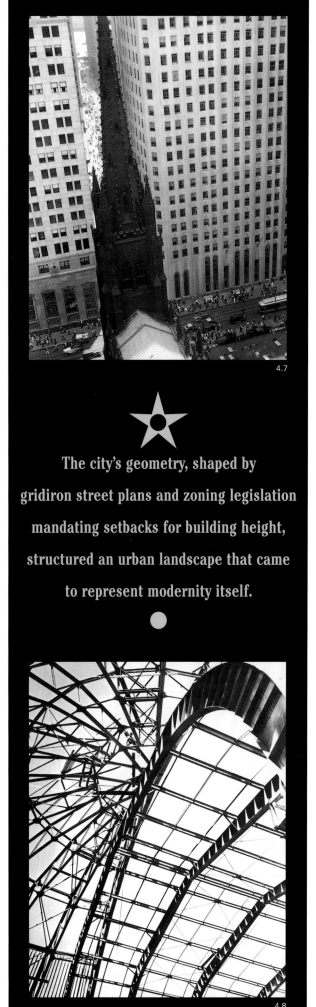

4.7

The city's geometry, shaped by gridiron street plans and zoning legislation mandating setbacks for building height, structured an urban landscape that came to represent modernity itself.

4.8

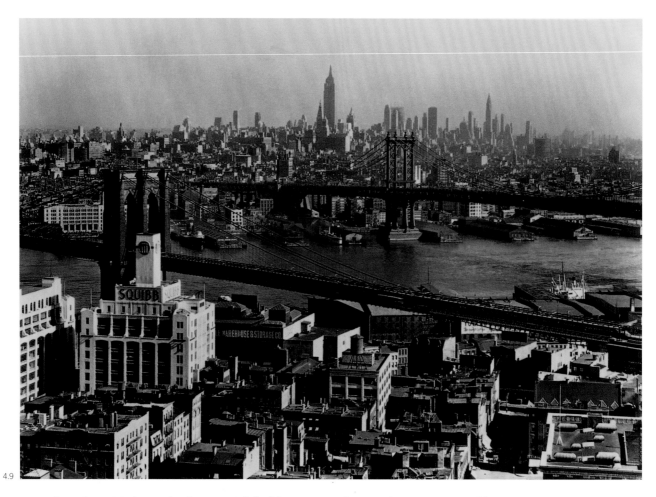

4.9

towered over lower Manhattan (see figs. 2.2, 3.6) for fifty years, until 1894, when the Manhattan Life Insurance Building was completed at 66 Broadway.

The city's geometry, shaped by gridiron street plans and zoning legislation mandating setbacks for building height, structured an urban landscape that came to represent modernity itself. "Manhattan was engaged in revolutionizing its architectural identity, and shifts in architecture always spell shifts in the psyche of the people who build it," argues cultural scholar Ann Douglas. Although Americans built skyscrapers in other cities, in 1929 188 of the 377 buildings over twenty stories high could be found in New York City. If buildings "have designs on us" and "insist on speaking for us," then New Yorkers constantly grappled with their transformed environment, the world they built and inhabited.[4] Coming from Europe, where there were few skyscrapers, Andre Kertesz incorporated them into his modernist aesthetic, finding sinuous curves in rectangular steel frame construction (4.8).

Soaring above Manhattan were views that took one's breath away. The skyline became an icon of New York; then it became the mental image summoned by the word "city."

No one did more than Samuel H. Gottscho to fix the image of New York as a city of towering heights and glorious panoramas. His photographs proclaim a New York commensurate with its boosters' protestations: as the greatest city in the world. Born in Brooklyn, Gottscho took his first photograph on Coney Island in the summer of 1896. After spending two decades as a traveling fabric salesman, he decided to pursue his passion for photography. He brought his son-in-law, William H. Schleisner, into his business but outlived him. Gottscho often took photographs for builders who wanted him to preserve images of their buildings.

The panorama from the roof of the Saint George Hotel in Brooklyn exemplifies Gottscho's perspective (4.9). Down below on the streets near the Squibb Pharmaceutical factories stand the squalid tenements of Talman Street (see fig. 4.61). But regardless of the foreground, the eye is drawn to the long horizontal spans of the Brooklyn and Manhattan bridges and the Empire State Building gleaming in the sunlight.

Brooklyn's shore commanded an equally impressive view

(4.10). Sitting across from Lower Manhattan, two boys watch a tug steam by and give us a sense of scale. The slanting shadows delineate the forest of skyscrapers with their window patterns. The Cities Service Building takes center stage, with 120 Wall Street on the left (see fig. 6.4) and City Bank Farmers Trust just behind it.

Although immigrant workers and their children built New York City, their labor on skyscrapers particularly inspired a sense of heaven on earth. Skyscrapers married earth and air, masculine technology and matriarchal impulses.

The rapid construction of the Empire State Building, with its use of mass production techniques, attracted attention. The building's promoters, self-made millionaire John J. Raskob and industrialist Pierre S. du Pont, deliberately fostered a competition with the Chrysler Building to see which would attain the title of the world's tallest building. Construction superintendants employed all the recent innovations in engineering and managerial efficiency, from bulldozers and cranes to scaffolding, chutes, and paint sprayers—a temporary restaurant was even installed on the site to cut down on lunch time—to speed the building to completion. A thoroughly modern enterprise designed to yield maximum profit on investment, the Empire State Building broke records not only for height but for speed of construction. It cost $5 million less than expected and was finished forty-five days ahead of schedule, but fourteen men lost their lives in accidents.

For decades the world's tallest building (1250 feet, or 102 stories tall) and most famous skyscraper, the Empire State Building stands on two acres of land at the corner of Thirty-fourth Street and Fifth Avenue. Built from the inside out to maximize rentals and window views, the building was constructed at the rate of almost a floor a day. Urban historian Carol Willis writes that "at the peak of operations 3500 persons were employed on construction, and in one ten-day period fourteen stories were added to the frame." Neither modest tenants (many of them in the button business) nor the difficulties of renting space during the Depression diminished the building's iconic significance. New Yorkers bragged about it, seeing it as a symbol of the city itself.

Lewis Hine's photographs of men at work on the project capture none of the frenzied pace (4.11). Instead his images hymn a lyrical paean to labor, both alone and in cooperation with other men. Hine emphasizes grace and skill, the breathtaking welding of Heaven to Earth and its promise of redemption

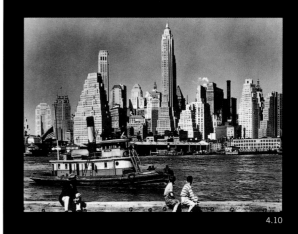

4.10

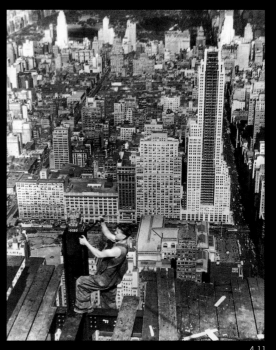

4.11

4.9. Samuel Gottscho, *View from Roof of Saint George Hotel.* **4.10.** Samuel Gottscho, *Pier Looking Over East River.* **4.11.** Lewis W. Hine, *Empire State Building Construction*, 1931. **4.12.** Lewis W. Hine, *Icarus*, 1931.

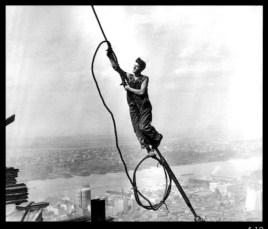

4.12

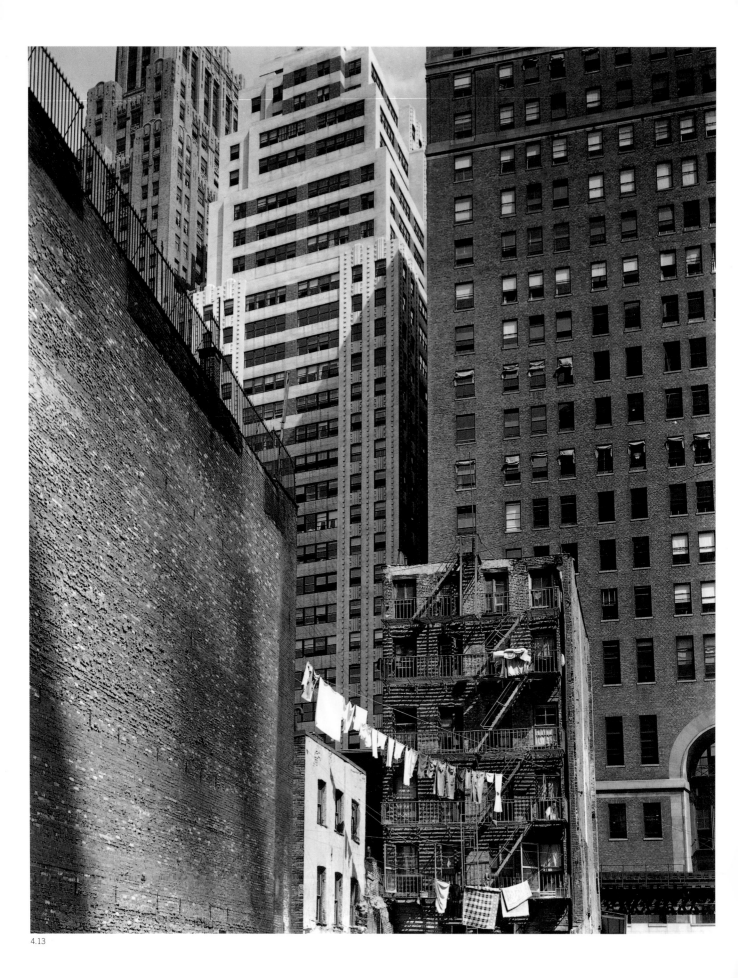

4.13

4.14

through labor. His photographs imagine a new world being born, a tower reaching to the skies.

Hine's *Icarus*, unlike the Greek son who flies too close to the sun and falls to Earth, soars above the city tethered by his skill and strength to steel cables (4.12). Hine wrote in 1933 that his photographs of working men offset the misconception of industry as "many of our material assets, fabrics, photographs, motors, airplanes and whatnot—'just happen,' as the product of a bunch of impersonal machines."[6]

Viewed from the ground, the new overwhelmed the old. For Abbott, an old tenement stands as haunting reminder to the new surrounding it (4.13). The theme appealed to many photographers struck by the constant contrasts in the city.

A city of islands, New York drew sustenance from its harbor, a place of work, of transit, and of leisure. The port of New York became the world's busiest and remained so for more than fifty years. Multiple modes of transportation converged at the water's edge: ships at dock and on the move, ferries carrying commuters and vehicles, trains and trucks moving goods to the city's mar-

Viewed from the ground, the new overwhelmed the old.

kets and industries. Between 1885 and 1930 thousands of structures were built. "Virtually every foot of shoreline was occupied by some kind of maritime building: basins, docks, piers, wharves, seawalls, as well as the headquarters of traders, shipbuilders, blacksmiths, rope makers, riggers, oyster merchants, brewers, carpenters," to list just a few. Kevin Bone calls the port "a gateway village between the metropolis and the sea," a place where the rigid order of the city's grid dissolved into a haphazard maritime urban world. South Street, along the East River, bustled with produce from the many wharves lining the shore. The Fulton Fish Market and the Fulton Street Ferry stood at the intersection of South and Fulton Streets.

Movement dominated, but occasionally quiet moments could be found. Closer inspection revealed that all was not work. In the summer boys cooled off by taking dips in the river

4.13. Berenice Abbott, *Construction, Old and New, 38 Greenwich Street*, August 12, 1936. **4.14.** Fulton fish market, ca. 1892.

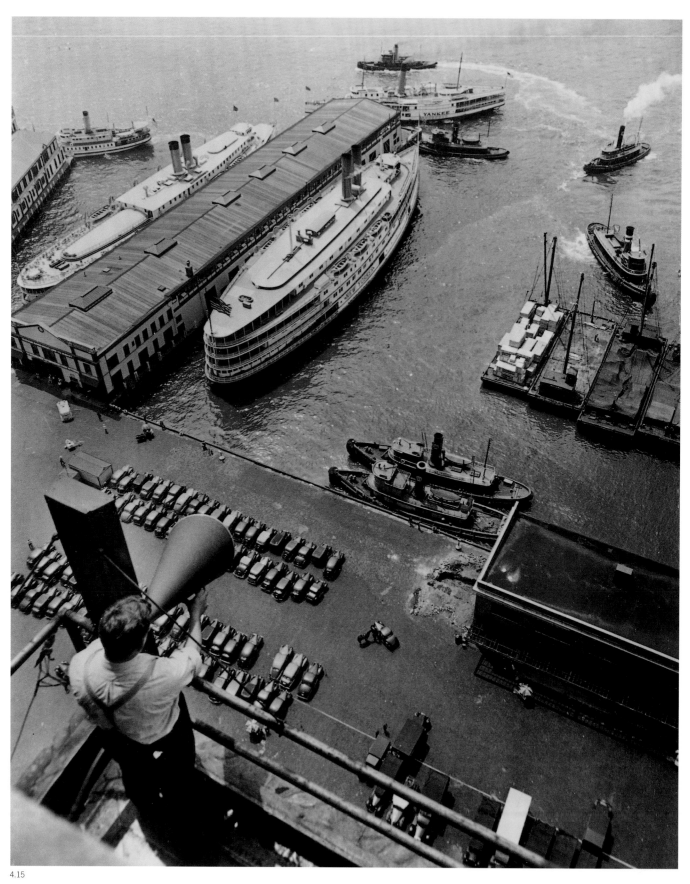

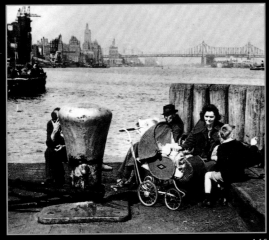

4.16

A city of islands,
New York drew sustenance
from its harbor—
a place of work, of transit,
and of leisure.

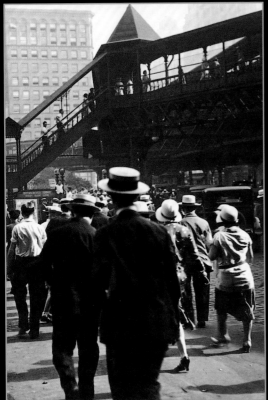

4.17

(4.14). The men, busy in their tasks, ignore the kids, who have stripped and left their clothes in a pile. Notice how clothing defines the job. The workman's rubber boots and overalls easily identify him as blue collar, while the wholesale merchants clustered on the dock broadcast their status with their derbies and white collars. By the water's edge, the ships seem far more grand than the structures on land. The spires of the cargo schooners thrust way beyond the roofs of the warehouses.

Andre Kertesz, captured varied aspects of the waterfront. His long shot looking down on the New York harbor emphasized abstract design, a favored perspective (4.15). He observed the dramas of the street and public places, often finding them performances of anomie and alienation. A mother and her two children, one still in a baby carriage, share an empty pier on the East River around Twenty-third Street with two older men (4.16). Kertesz offers an intimate, personal glimpse of a very public activity, showing how easy it was, in a city of seven million, to be alone together. The river mediated the pier's public space, giving each person room.

Crossing over to Manhattan could be accomplished by ferry-boat or by bridge. The Staten Island Ferry, inaugurated in 1816, carried commuters from suburban Staten Island to work. Ferry companies operated large and elegant steamboats. New piers constructed in the Hudson and along the shore beneath Brooklyn Heights accommodated these floating palaces. Many included covered sheds to protect cargo and passengers from the weather.

Although men predominate in the early morning crowd exiting the Staten Island Ferry at Whitehall Street, well-dressed young women also commute (4.17). Both men and women were heading for white-collar jobs in offices, the women to work as "typewriters" and the men as clerks. A massive influx of white- and pink-collar labor serviced New York's rapidly growing economy at the turn of the century. These workers implemented, managed, processed, and recorded the flow of information to national and global markets. A veritable army of commuters helped to sustain and expand the skyscraper city.

4.15. Andre Kertesz, *New York Harbor*, ca. 1938. **4.16.** Andre Kertesz, *East River Pier Around Twenty-third Street*, 1937. **4.17.** Wendell S. MacRae, *Crowd from Staten Island Hurrying from Ferry to Work at 8:30 A.M.*, 1930s.

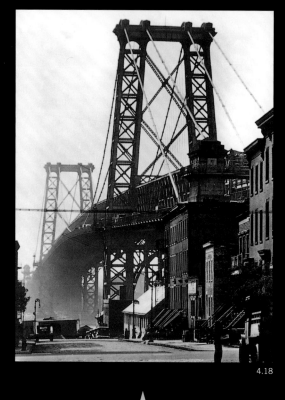

4.18

Bridges increasingly eclipsed ferries as New York invested in building greater numbers of them.

●

4.19

Bridges increasingly eclipsed ferries as New York invested in building greater numbers of them in the early 1900s. Bridges carried pedestrians, rapid transit, automobiles, and trucks. They represented substantial investments in urban infrastructure as well as symbols of beauty and marvels of engineering.

The Williamsburg Bridge connected Delancey Street on the Lower East Side with Marcy Street in the Williamsburg section of Brooklyn. The tenement clearance required for construction of its entrance ramps and widening Delancey Street displaced over ten thousand residents and encouraged many Jewish immigrants to look for new and better homes in Brooklyn. The project began as a joint venture of the cities of New York and Brooklyn and took seven years to complete. When it opened in 1903, the Williamsburg Bridge was the longest and heaviest suspension bridge in the world but was also considered ungainly and graceless. Abbott viewed the bridge from Brooklyn at the corner of South Eighth and Berry streets on April 28, 1937, and let the bridge's awkward angularity elevate the drab pattern of slanting metal stoops and vertical windows (4.18).

New Yorkers also saw their bridges as natural wonders, the lacy fretwork of steel a version of the moving architecture of trees, the wisps of locomotive smoke an echo of puffs of clouds. Hell Gate Bridge arches between Ward's Island and Queens, carrying Pennsylvania Railroad tracks. Gustav Lindenthal designed the bridge to bypass the New York, New Haven, and Hartford system. He built a steel arch at a time when engineers consigned the arch to history, overtaken by girder and beam construction. Abbott photographed Hell Gate from Astoria Park, Queens, on a beautiful spring day in May 1937 (4.19). The bridge's parabolic curves transpose the suspension cables of the Queensboro bridge in the background.

Responding to public pressure, the newly created Port Authority of New York and New Jersey started work on the George Washington Bridge in 1925 to link New York City at 178th Street with Fort Lee in New Jersey. Othmar Ammann, a Swiss immigrant, designed and engineered the bridge, intending to sheathe its two monumental towers in granite like the Brooklyn Bridge. But the bridge's early completion within its budget doomed the exterior sheathing because of Depression-era constraints and the towers' extraordinary strength, designed to carry two decks.

The longest suspension bridge in the world in 1931, the bridge stands 212 feet above the Hudson River, connecting rocky heights on both the New York and Jersey shores. Gottscho's image of the bridge when it first opened to vehicular traffic captures its grace (4.20).

After completing the George Washington Bridge, Ammann accepted responsibility for designing and engineering bridges

4.20

for the Triborough Bridge Authority. The creation of independent public authorities to finance and construct expensive public works came in response to the stock markets' collapse. Ammann's work included the Triborough Bridge that connected Manhattan, the Bronx, and Queens and the Bronx Whitestone Bridge across the East River linking the

northern Bronx with Whitestone, Queens.

New construction of skyscrapers, especially on streets laid out in the colonial era, produced canyons perpetually in shadow. Such images came to characterize the financial district and the workings of finance capital. Abbott's claustrophobic shot of Exchange Place, people only tiny specks on the street below, conveys the cramped vertical space (4.21). Taken in 1934, the photo compresses time and space into elongated rectangles and presents the stock exchange in the wake of the 1929 crash as anxiety producing and suffocating.

Not all skyscrapers were associated with finance. The Byrons photographed the sixty-story Woolworth Building towering over City Hall (in the lower right forefront) at the beginning of the skyscraper boom (4.22). Completed in 1913, it held title as the world's tallest building until 1929, when the Chrysler Building surpassed it. Designed by Cass Gilbert to be a "cathedral of commerce," the building borrows elements from European churches, including those at Reims, Antwerp, and Malines. In the background stand the City Investing Building and the Bankers Trust Building. The

4.18. Berenice Abbott, *Williamsburg Bridge*, April 28, 1937. **4.19.** Berenice Abbott, *Hell Gate Bridge*, 1937. **4.20.** Samuel Gottscho, *George Washington Bridge*, 1931. **4.21.** Berenice Abbott, *Exchange Place*, ca. 1934.

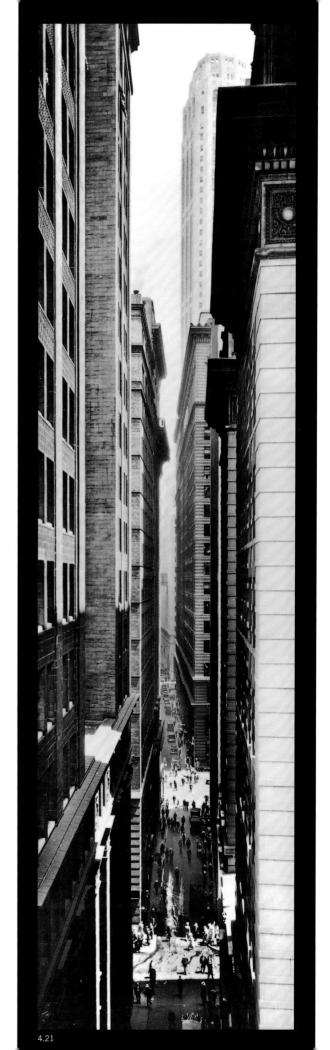

4.21

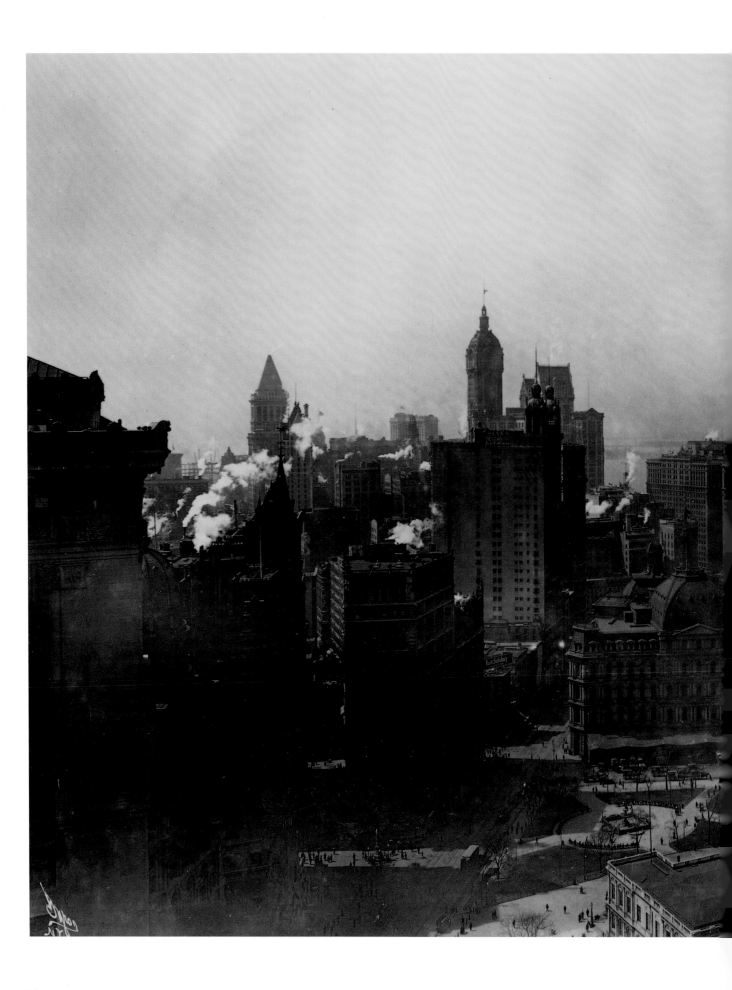

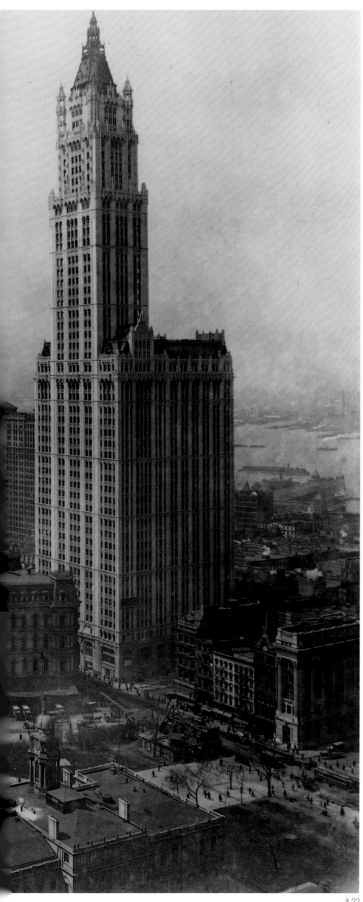

hulking triangular post office building, symbol of an earlier era, faces City Hall across the park.

Advertisements adorned skyscrapers, themselves advertisements for corporations. Advertising developed in the twentieth century as a major service industry, and New York City was its hub. The First Annual Advertising Show in 1906 attracted enough exhibitors to fill Madison Square Garden (4.24). "If your business isn't worth advertising," shouted the large banner adorning the hall, "advertise it for sale." Soon the concentration of advertising agencies on Madison Avenue would make the street synonymous with the art of promotion, just as the name of Wall Street immediately conjured finance.

Abbott's photograph of Columbus Circle from behind a large sign communicates the ubiquity of commercial ads on buildings and billboards (4.23). Looking north, Broadway is to the left and Central Park West, obscured by the sign, is on the right. Advertising dwarfs the monument in the center of the circle. Commercial culture rules the city.

Beneath the brazen billboards, commerce took many forms, from simple street peddling to pushcart vendors to large department stores. Street peddling from individual carts or baskets could be found throughout the city, unlike the large-scale pushcart markets that developed initially in immigrant Jewish districts.

Alice Austen, a gifted amateur, photographed street types at the turn of the century, using the new technique to convey the immediacy of the urban scene. Austen grew up in Clear Comfort, a seventeenth-century homestead on Staten Island. A

Advertisements adorned skyscrapers, themselves advertisements for corporations.

4.22. Joseph and Percy Byron, *View with Back of City Hall.*

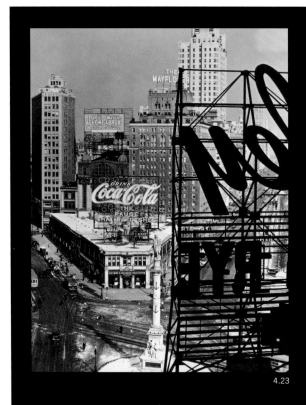

The concentration
of advertising agencies
on Madison Avenue
would make the street
synonymous with the art
of promotion.

4.23

4.23. Berenice Abbott, *Columbus Circle*, 1934.
4.24. Joseph and Percy Byron, *The Annual Advertising Show*, May 1906.

4.24

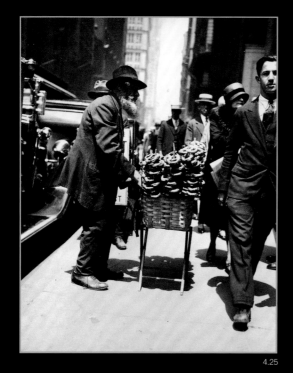

4.25

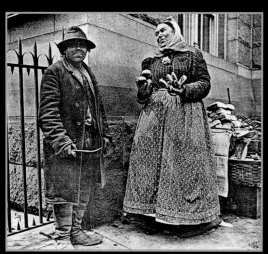

4.26

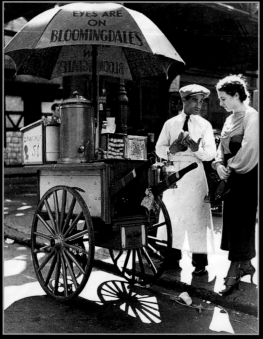

4.27

daughter of privilege, Austen cataloged the city's street types with an almost didactic directness. The pretzel vendor, often a woman, was a regular feature of urban life (4.26). Austen found this woman at South Ferry and took her picture next to a recently arrived immigrant in 1896.

Rudolph Simmon's more pointed photograph contrasts a pretzel peddler's poverty and age with the youth and prosperity of his potential customers, who ignore him (4.25).

Street vendors solicited sales, learned to recognize their regular customers, and flirted with young working women. John Muller's photograph of a hot dog vendor captures the dialogue of body language, the vaguely erotic overtones of an ordinary commercial encounter on the street (4.27).

Pushcart peddling allowed vendors to rent space on the street. Pushcart markets started on the Lower East Side with Jewish mass immigration in the 1880s, gradually spreading to other sections of Manhattan and then to the Bronx and Brooklyn. During the Depression sixty markets operated around the city. In 1930 one critic considered "the pushcart markets are as characteristic a part of the New York pageant as the skyscrapers."[8] At first they were illegal—vendors were forbidden to remain in one spot longer than half an hour—but city ordinances eventually accommodated the markets, then regulated and restricted them to certain streets, and finally, under Mayor Fiorello LaGuardia's administration, removed them to covered market buildings.

Pushcart markets flourished in every poor neighborhood. By 1925 Jews monopolized the pushcart trade in merchandise but shared the vending of vegetables and fruits with Italians. Roy Perry photographed the Harlem pushcart market on 145th Street and Eighth Avenue from above (4.28). More typical perspectives appear in Hine's 1912 photo of market day on the Lower East Side (4.29) and Andreas Feininger's image showing how curbside shopping from pushcarts competed with stores on the Lower East Side (4.30).

Vendors specialized in their produce, often selling items par-

4.25. Rudolph Simmon, *Elderly Man Selling Pretzels*, 1929–30.
4.26. Alice Austen, *Pretzel Vendor with Emigrant*, 1896.
4.27. John Muller, *Hot Dog Vendor*. **4.28.** Roy Perry, *Harlem Pushcarts*, 1938–40. **4.29.** Lewis W. Hine, *Market Day in Jewish Quarter of Lower East Side*, 1912.

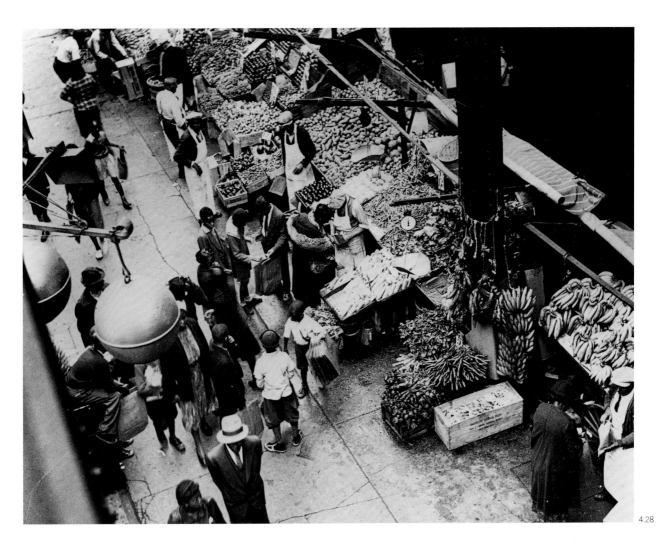

4.28

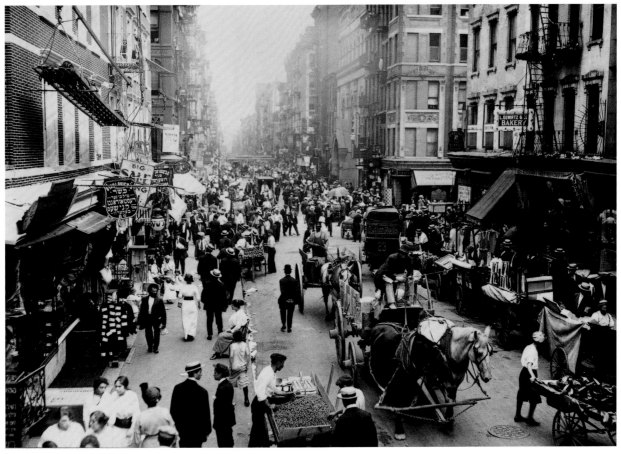

4.29

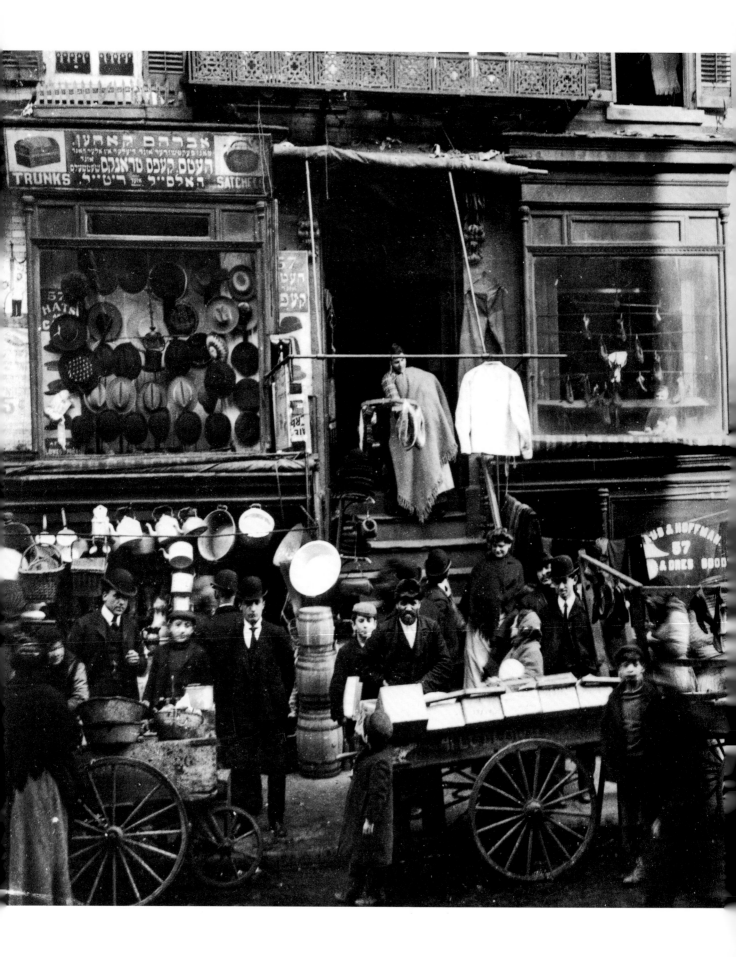

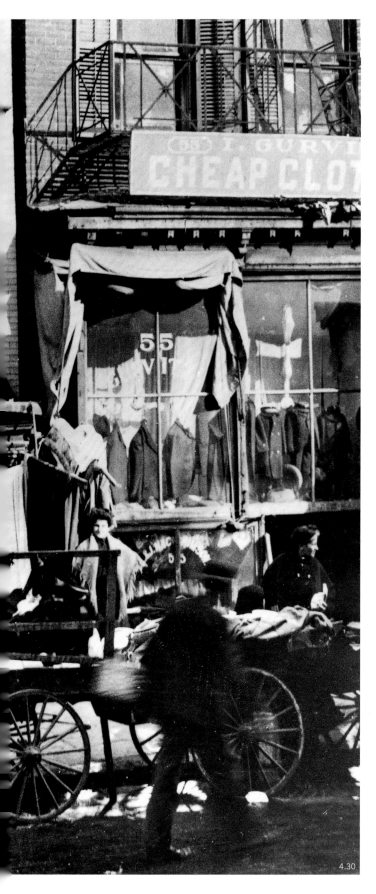

ticularly valued by local residents but not available in grocery stores. Customers could buy small quantities and pay very little. For a frugal housewife, this usually meant daily shopping trips to stretch the budget. In pushcart markets, historian Daniel Bluestone notes, "poor people sold food and merchandise to other poor people."[9]

Pushcart peddlers aspired to shops of their own, and many saved to invest in a store. Though more secure than peddlers, shopkeepers nevertheless eked out a precarious existence, prospering in good times and struggling to survive during difficult years. Ethnic concentration in types of stores—Italians controlled 90 percent of the shoe repair business, for example—as well as neighborhood specialization characterized local commerce. Most shops recruited the entire family's labor, wives, husbands, and children, although often women and children worked in the back or upstairs, where the family lived.

Iceboxes represented improvement in the standard of living of many New Yorkers, but they required regular purchases of ice. Electric refrigerators, introduced in the 1920s, remained beyond the budgets of working-class families during the Depression. Sidney Kerner photographed these men at an ice store in Brooklyn (4.32). This combination wholesale and retail store also sold coal and kerosene to warm houses in winter.

Sid Kerner discovered photography as a teenager in 1937, when the New York Photo League was organizing. Members believed, as Kerner did, that "as I live, I photograph, and as I photograph, I live."[10] Seeking to document their times and lives and to express concerns for social justice, Photo League members produced powerful collective documents of New York City life. Kerner studied photography with Sid Grossman (see fig. 5.31) and recalled passionate discussions with him about photography lasting into the early morning hours.

Newsstands could be found on corners throughout New York, a city with over fifty papers. With its strong visual images and gritty reporting, the *Daily News* (1918) gained a circulation exceeding one million by 1926. The most popular newspaper in the United States, this first American tabloid dramatically changed journalism, as Pulitzer's *World* had done fifty years earlier. Abbott photographed this newsstand on the southwest corner of Thirty-second Street and Third Avenue on

4.30. Andreas Feininger, *Pushcarts, Hester Street.*

4.31

★

Ever present,

commerce took many forms,

from simple street peddling

to pushcart vendors,

from small family shops to

large department stores.

●

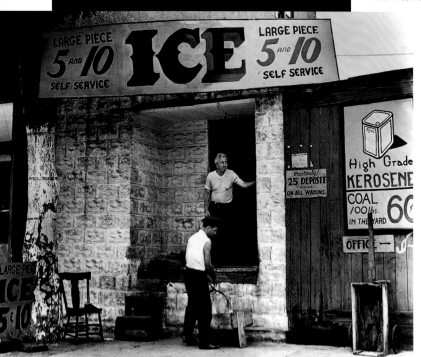

4.32

November 19, 1935 (4.33). The Greek-American owner, James Stratakos, built and operated the stand, which handled over two hundred magazines and papers reflecting diverse tastes in reading.

Separate bakeries produced bread and cakes for each ethnic market. Jewish immigrants savored rye bread and challah for the sabbath; Italian immigrants liked crusty loaves, long or round. Commercial success depended on family and ethnic support networks. Hine took his photograph of a teenager behind the counter of an Italian bakery in 1913, titling it *A Case of Truancy* (4.34). "This Italian boy is not yet fourteen," he wrote in his caption, "but he is devoted to his brother's bakery shop on Sullivan Street near Houston, and only goes to school when he has to." Such sacrifice and cooperation allowed small family businesses in such ethnic neighborhoods as Greenwich Village to survive and flourish.

Wholesale markets carved out specialized districts in the city, as did commercial and financial interests. Meat and poultry, spices, tea and coffee, even fresh flowers: each claimed its piece of urban turf. Greenwich Street on Manhattan's West Side served fresh produce vendors as well as dry goods stores, supplying thousands of small stores throughout New York. Congestion characterized the market area, even as the financial district encroached on it. Abbott's photograph of Lower West Street, to the west of Greenwich Street, dramatizes the contrast between the grandeur of towers of finance and the squalor of remaining warehouses (4.31). By 1936 most wholesale commercial warehouses had shifted to the Brooklyn waterfront. (For an image of the Fulton Fish Market suffering from similar encroachment, see fig. 6.2.)

Specialized commercial districts catered to different classes and tastes. Greenwich Village, home not only to Italian immigrants but to bohemian artists and writers, including a small homosexual community, consumed books in larger quantities than other neighborhoods. Jessie Tarbox Beals, herself a resi-

4.31. Berenice Abbott, *West Street*, 1936.
4.32. Sidney Kerner, *Ice 15¢*, 1938. **4.33.** Berenice Abbott, *Newsstand*, November 19, 1935.
4.34. Lewis W. Hine, *A Case of Truancy*, 1913.

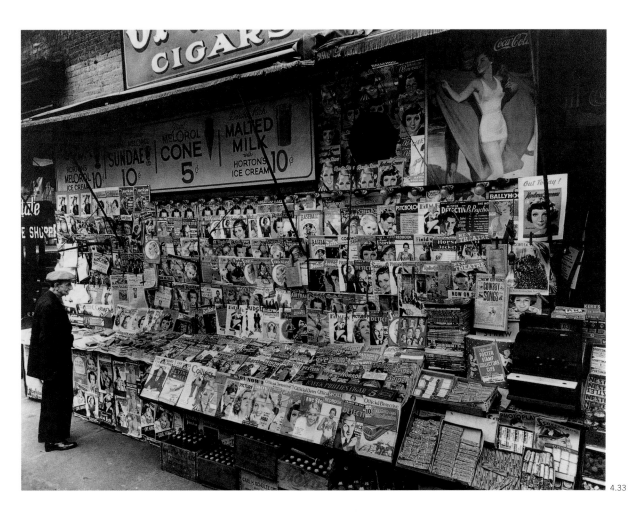

4.33

4.34

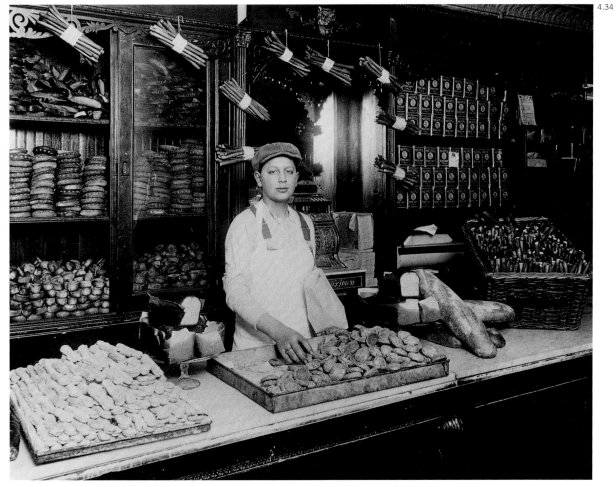

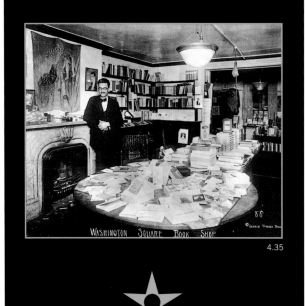

WASHINGTON SQUARE BOOK SHOP

4.35

★

**Specialized
commercial districts
catered to different classes
and tastes.**

dent of the Village and a proprietor of a combination tea shop/photography studio on Sheridan Square, photographed the Washington Square Book Shop at 17 West Eighth Street and its proprietor (4.35).

The Bronx developed several shopping districts for borough residents, including Irish, Germans, Italians, and Jews from Eastern Europe. Figure 4.36 shows the stores at 148th Street and Willis Avenue, part of a larger retail area known as "the Hub" that was easily accessible by elevated train and offered many of Manhattan's amenities (hats, clothes, hosiery). In an urban world of shifting boundaries, argues historian Mona Domosh, "classes distinguished themselves by the clothes they wore, the shops they frequented, the parks they strolled in, and the houses they inhabited."[11]

In 1900, when Union Square was still a fancy shopping area in the heart of Ladies' Mile along Broadway (Tiffany's jewelry store stood on the west side of the square), a photograph produced by Ewing Galloway's firm captures the leisurely stroll of the predominantly female crowd (4.37). The large plate glass windows that held displays of the latest fashions compete with well-dressed, affluent shoppers.

By 1936, Union Square was the hub of working-class shopping and protest (see fig. 4.142). The stores along Fourteenth Street now offered bargains to savvy shoppers, a step up from Grand Street on the Lower East Side. The trend to lower-priced merchandise, begun at the turn of the century with Henry Siegel's Fourteenth Street Store, accelerated after World War I.

Herald Square in 1902 presaged a new locale for fashionable shopping that would soon eclipse Union Square with a recently built Saks and Co. on the south side of Thirty-fourth Street and R. H. Macy's on the north side. In the foreground of this image

4.35. Jessie Tarbox Beals, *Washington Square Book Shop.* **4.36.** Roege Studio, *Willis Avenue, 148th Street*, 1930. **4.37.** Ewing Galloway, *Henry's Siegel's 14th Street Store*, ca. 1900. **4.38.** Joseph and Percy Byron, *Saks and Co. and Macy and Co.*, 1902.

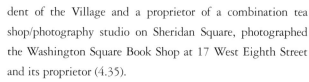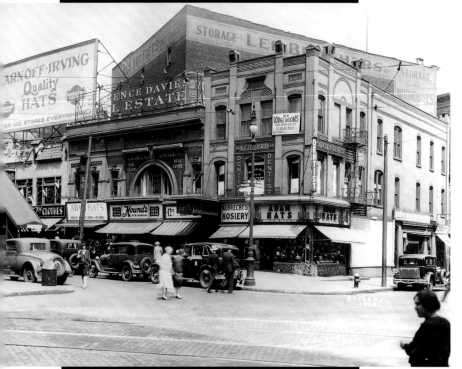

4.36

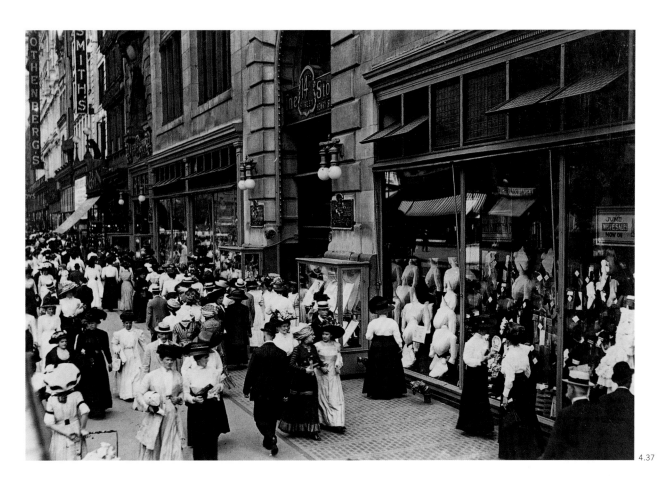

4.37

4.38

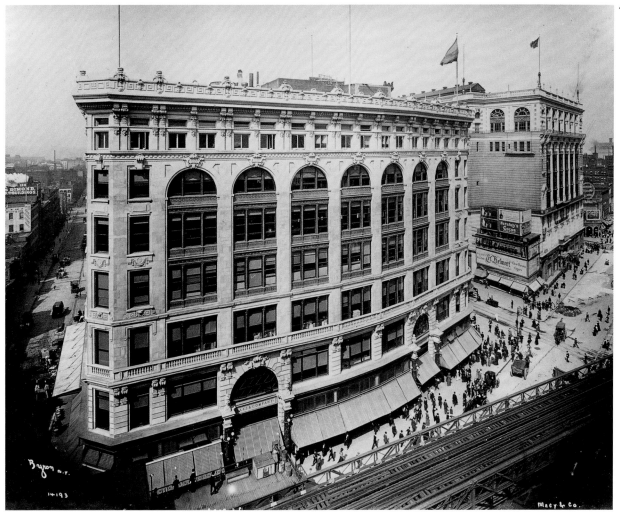

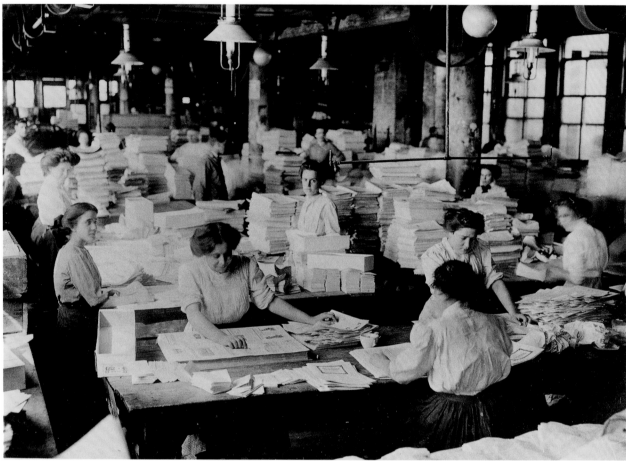

4.39

can be seen the elevated train that brought shoppers and female sales clerks to the district (4.38). The large department stores gradually evolved into "mercantile palaces designed expressly for retailing."[12] The stores championed a one-price policy and money-back guarantees to discourage bargaining. Working in a department store paid less than factory labor, but women thought the genteel atmosphere worth the pay differential.

4.40

Wealthy New Yorkers savored the pastime of dining out in elegant eating and drinking establishments and Delmonico's achieved renown as one of the best restaurants in the United States. Its Brooklyn farm supplied its chefs with fresh fruit and vegetables. Although women usually did all the cooking at home, the restaurant kitchen staff was male, as were the waiters. Patrons, also usually men, were encouraged to enjoy leisurely meals. The Byrons' photograph of the chefs at Delmonico's third Fifth Avenue location, on the northeast corner of Forty-fourth Street, dates from 1902, several years after it opened (4.40).

The Byrons photographed all types of labor in the city at the turn of the century. Although African-American women could acquire secretarial skills, prejudice prevented them from holding pink-collar jobs except in their own institutions. St. Philips Guild House of St. Philips Church, the oldest and one of the largest black Episcopal congregations in the city, ministered to the poor (4.42). Almost twice as many black women as white worked for wages, most in menial jobs.

New York City's workplaces were gendered spaces. The printing industry had flourished in the city since the middle of the nineteenth century. During the first half of the twentieth century nearly one-fifth of all U.S. workers employed in printing and publishing worked in New York City, a center of book and magazine publishing as well as newspaper and commercial printing. Many printers were unionized, and the New York Typographical Union No. 6 included women and men. Nevertheless, most of the compositors and those who ran the presses were men (4.41), while women worked at

4.41

sorting and binding (4.39).

Immigrants used their living quarters as workshops, adapting traditional practices to New York's industrial economy. Jacob Riis photographed a staple of urban manufacturing: the fabrication of ready-to-wear clothing (4.43). Jewish immigrants labor as units to produce as many neckties as possible in their Division Street tenement.

4.42

Paid by the piece, their speed determined how much they could earn each day. East European Jewish contractors bid furiously for bundles of cut garments, driving down the price per item and gaining for themselves the sobriquet "the moths of Division Street." Many immigrants found employment through relatives or former neighbors from back home so that

branches of the industry supported networks from a single town or region in the old country. The women and men making neckties in this Division Street tenement sweatshop probably hailed from Plotsk or Warsaw.

Massive buildings disguised the small scale of much manufacturing in the city. In men's clothing, 78 percent of the firms averaged only five workers. Ely Jacques Kahn designed many of the loft buildings that housed the clothing industry in Manhattan. He enjoyed working for the self-made and self-taught Jewish garment manufacturers who gave him freedom to experiment. Bounded by Thirtieth and Forty-second Streets, from Tenth to Fifth Avenues, the garment district developed after World War I, relocating northward from the Bowery in lower Manhattan. The concentration of small and large manufacturers in loft buildings reflected a convergence of urban forces: commercial, industrial, and architectural. In the windows of Kahn's Arsenal Building at Seventh Avenue and Thirty-fifth Street can be seen the names of five different dress manufacturers (4.45).

4.39. Lewis W. Hine, *Women Workers*. **4.40.** Joseph and Percy Byron, *Delmonico's Kitchen Staff*, 1902. **4.41.** Joseph and Percy Byron, *Publishers Printing Company*, 1910. **4.42.** Joseph and Percy Byron, *Saint Philip's Guild House*, 1896–98.

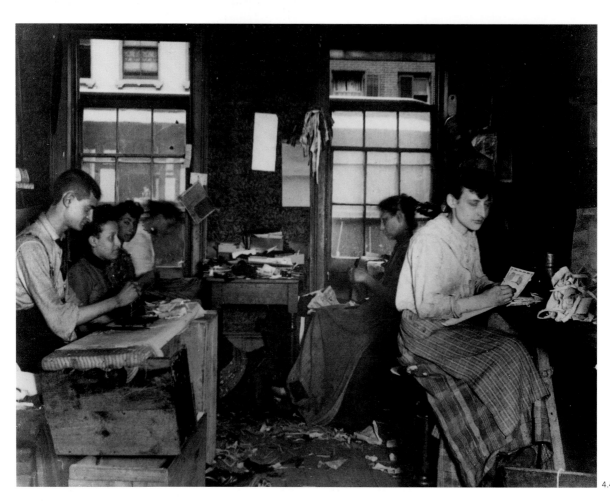

4.43

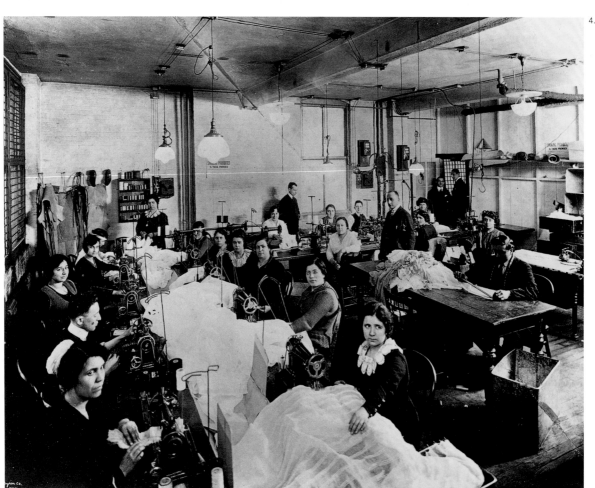

4.44

This interior shot shows young women operators making dresses in Joseph J. Keyser's factory around the corner on Thirty-sixth Street and Seventh Avenue (4.44). The well-lit and airy loft marks a major improvement over "inside" clothing factories in lower Manhattan and the notorious sweatshops. Note the male foremen and cutter, the latter holding one of the most skilled and highly paid jobs in a recently unionized garment industry.

The ready-made clothing industry, one of the city's largest, employed thousands of immigrant workers: men, women, and children. Lewis Hine, teacher and social worker himself, turned to photography in part to dramatize the plight of the poor. Work could ennoble a worker, but it could also degrade and exploit. The sight of women carrying heavy bundles of unfinished clothes on their heads was common on the streets of the Lower East Side (4.46). Living within a few blocks of the contractors and factories, Italian women performed almost 95 percent of the finishing work in the city by 1901, sewing garments in the tenements where they lived. Clothing manufacture was divided into many unskilled tasks, and young children quickly could learn how to baste. Families were paid by the piece. In the sweatshops everyone worked as fast as possible to maximize income.

The popularity and ubiquity of hats for women—the fashionable would not leave their homes without one—fueled the city's millinery industry. Immigrant Italian women from Sicily sewed hats at home; they also made artificial flowers to decorate the hats (4.47).

The beauty industry, still in its infancy, appealed to middle-class and wealthy women. Born in Louisiana, Madame C. J. Walker developed beauty products for African-Americans before moving to New York City in 1914. She located her salon

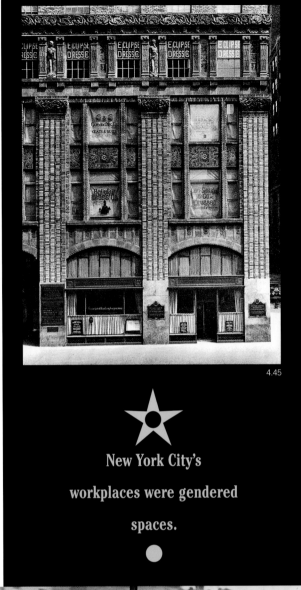

4.45

★

New York City's workplaces were gendered spaces.

●

4.43. Jacob Riis, *Necktie Workshop in a Division Street Tenement*, ca. 1889.
4.44. Joseph and Percy Byron, *Interior, Dressmaking Factory*, 1920. **4.45.** Sigurd Fischer, *Arsenal Building*. **4.46.** Lewis W. Hine, *An Italian Mother, Lower East Side, New York City*.

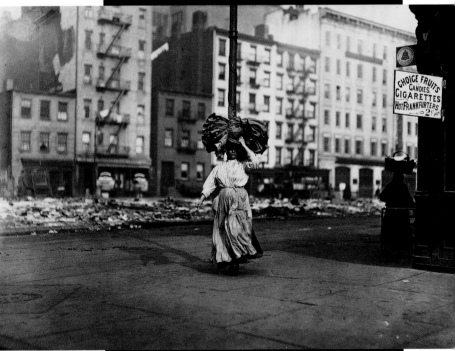

4.46

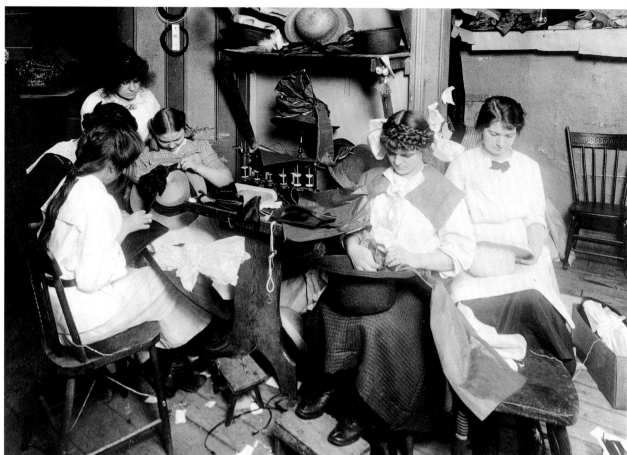

4.47

where she lived in Harlem, in an elegant townhouse on 108–10 West 136th Street. Her daughter took over the successful company and beauty parlor after Walker's death in 1919. A'lelia Walker became the wealthiest woman in Harlem and a grand patron of the arts. James VanDerZee captured the mode of refined elegance of the salon in this photo from 1929 (4.48).

As demonstrated by the diversity of its products, New York remained an industrial city despite its skyscrapers. Abbott's photo of the massive nineteen-story Starrett-Lehigh Building, which covered an entire block from Twenty-sixth to Twenty-seventh Street between Eleventh and Twelfth Avenues, pays tribute to the city's centrality in shipping and manufacture (4.49). Completed in 1931, the terminal "came as close as any American building of its time to the stylistic tenets of the International Style," according to architectural historians.[13] Russell G. and Walter M. Cory designed the building, which boasted elevators strong enough to lift a fully loaded boxcar

from the railroad depot at its base. The boxcars were transported to Manhattan from New Jersey on ferries.

"East Side, West Side," ran the popular song. New Yorkers lived all around the town in neighborhoods with their own personalities. One of the most photographed neighborhoods was the Lower East Side, a cramped immigrant section close to, but definitely apart from, the burgeoning financial district. In the early years of the century, the Lower East Side was the city's most crowded section, with more people per square mile than Bombay.

Jacob Riis, an immigrant social reformer, ventured into the slums with a bulky camera to convince middle-class New Yorkers to accept civic responsibility for miserable housing conditions. Bottle Alley, one of the many alleys Riis pho-

4.47. Lewis W. Hine, *Milliners Performing Home Work.*
4.48. James VanDerZee, *Reception, Office of C. J. Walker,* 1929.
4.49. Berenice Abbott, *Starrett-Lehigh Building,* July 14, 1936.

tographed, housed more than thieves and their fences (4.50). Like most of the rear tenements, the alley's buildings provided shelter to poor workingmen and -women. Riis's indignation at the slums as breeding places for crime and disease accompanied a passionate faith that changes could be accomplished. "What, then, are the bald facts with which we have to deal in New York?" he asked. His answers were forthright. "I. That we have a tremendous, ever swelling crowd of wage-earners which it is our business to house decently. II. That it [the crowd of wage earners] is not housed decently." Perhaps most tellingly, he also argued "IV. That it pays high enough rents to entitle it to be so housed, as a right."[14] After Riis and fellow reformer Lewis Hine pointed the way, New York City agencies increasingly paid attention to how immigrants and their children lived.

City investigators employed cameras to document living conditions. In figure 4.51 two girls and two boys play house on a fire escape beside the elevated tracks. On the street and above it, Jewish and Italian children adapted to the harsh conditions of the Lower East Side. Despite its unsavory reputation for pimps and prostitutes, gambling dens and illegal activities, Allen Street (pictured here) also housed hard-working immigrant families struggling to earn a livelihood in the new world.

The character of backyards varied far less than the streets; clotheslines were ubiquitous, as were fences and outhouses behind old-law tenements. Harry Rubenstein called this photograph of clothes hanging out to dry on a clear day *Petrified Forest*, an odd title suggesting that the clotheslines represented vestiges of an ancient past (4.52). The Citizens Housing Council and other reform organizations saw little that was picturesque in backyard clotheslines. Nor did they appreciate the

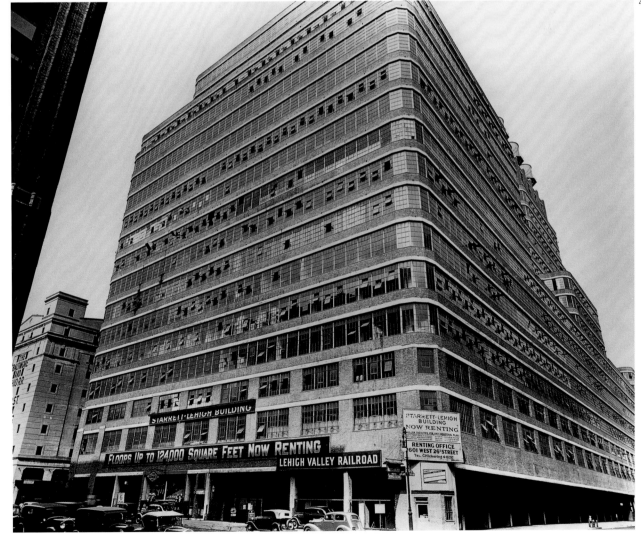

4.50

skill required to hang clothes to dry effectively. Rather, the lines represented poverty, visible signs of inadequate housing for working people whose private laundry hung in public.

The family gathered on the back steps of a house on York Street near the Brooklyn Navy Yard probably did so at the request of the photographer (4.53). Even so, this 1903 photo speaks more about the human condition than the housing situation, although the photographer did take care to include the pile of manure, located far too close to people's homes to be healthy.

Walker Evans saw symmetry and repetitions in the apartment building facade on Sixth Avenue in 1934. His photo evokes the stillness and anonymity that many artists of the period associated with urban life (4.54). Apartment buildings, built for the middle class, rapidly acquired respectability as housing, especially in the early twentieth century. More spacious than tenements, they offered economies of scale compared to individual brownstones. Shops providing neighborhood services from groceries to laundries occupied the ground floors. (For a view of how such buildings looked a half century later, see fig. 6.55.)

For middle-class New Yorkers, summer in the city before air conditioning meant awnings to shade apartment rooms from the sun's rays. The superintendent would install the awnings after Memorial Day, signaling the summer's start. Unlike Evans, Wendell MacRae emphasized a rhythmic syncopation in the interplay of shadows on a large, affluent apartment building (4.55). The Knickerbocker Ice Truck parked out front undoubtedly was replenishing the ice boxes used to keep food from spoiling. Soon electric refrigerators would replace ice boxes in such comfortable apartments. (For

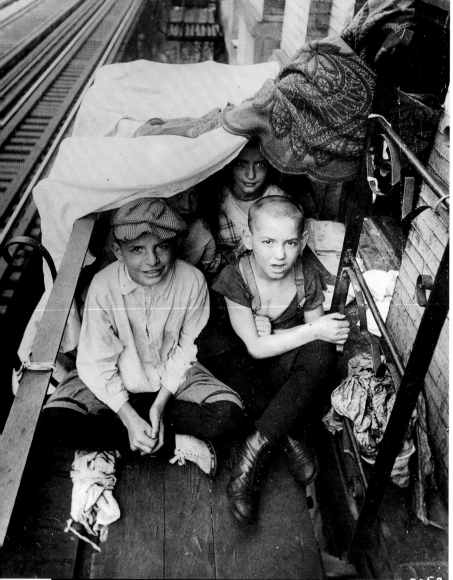

4.51

4.50. Jacob Riis, *Bottle Alley, Mulberry Bend*, ca. 1890. **4.51.** *Allen Street, Third Story Front, Group of Children on Fire Escape*, August 4, 1916. **4.52.** Harry Rubenstein, *Petrified Forest*, 1938–39. **4.53.** #221 York Street, *Family in Courtyard*, May 1903.

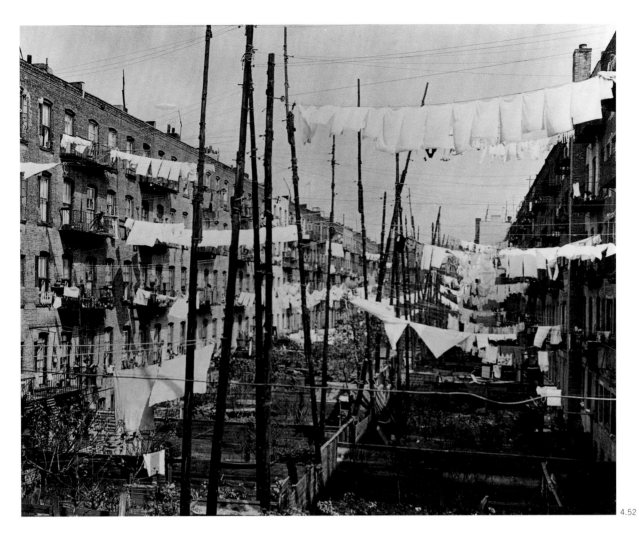

4.52

4.53

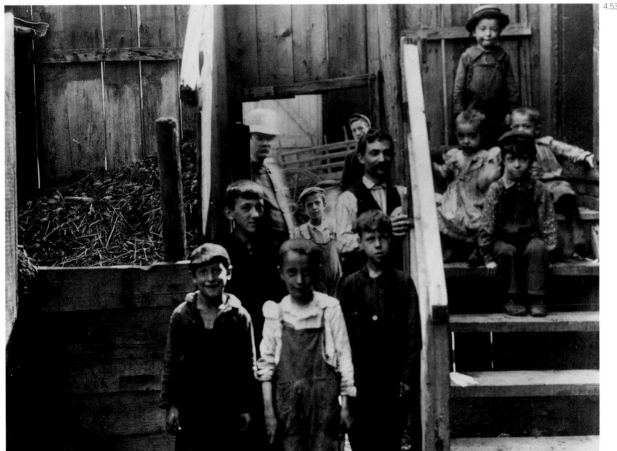

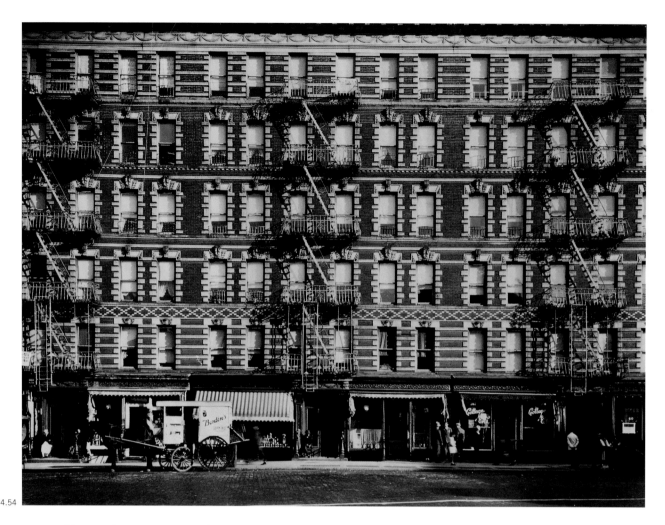

4.54

a view of how working-class New Yorkers obtained their ice, see fig. 4.32.)

Wealthy New Yorkers could choose the East or West Side, preferably with a park nearby. The Plaza Hotel, at the eastern foot of Central Park between Fifty-eighth and Fifty-ninth Streets, occupies land considered far too valuable for even the expensive townhouses on the east side of Grand Army Plaza along Fifth Avenue. The first hotel on the site, which opened in 1890, suffered from the high expectations of its investors, went into foreclosure, and was torn down to make way for a new eight-hundred-room hotel designed by Henry J. Hardenburg in 1907 (4.56). After the old Waldorf-Astoria was demolished to provide the land for the Empire State Building, the Plaza became the city's grand Edwardian-style hotel. Its elegant rooms and entertaining areas, including the Persian Room and Palm Court, attracted visitors and well-to-do New Yorkers.

Across town, Charles M. Schwab built a mansion overlooking Riverside Drive at Seventy-third Street designed to rival his partner in the United States Steel Corporation, Andrew Carnegie (4.57). Schwab spent $865,000 for the building lot

alone, an unprecedented sum in 1901. Maurice Hébert designed the mansion to look like a French Renaissance chateau, which nonetheless contained many modern amenities, including a garage for four cars and an indoor swimming pool. Despite Schwab's decision to settle on the West Side, the neighborhood never acquired the Upper East Side's social cachet. By 1939 Schwab closed the building, one of the last representatives of "lavish domestic metropolitanism."[15]

Interiors as well as exteriors demonstrated vividly the contrast between rich and poor. Consider the "Cozy Corner" of Elsie de Wolfe's home on Seventeenth Street at Irving Place (4.58). The plush pillows and draperies, along with the plants, indicate a life of comfort. An actress in 1896 when Byron photographed her, de Wolfe left the stage to become an interior decorator in 1905, pioneering as a woman in the field.

Compare this to the contemporary Byron photograph of a

4.54. Walker Evans, *Sixth Avenue, New York*, 1934.
4.55. Wendell MacRae, *Summer in New York*, 1930s.

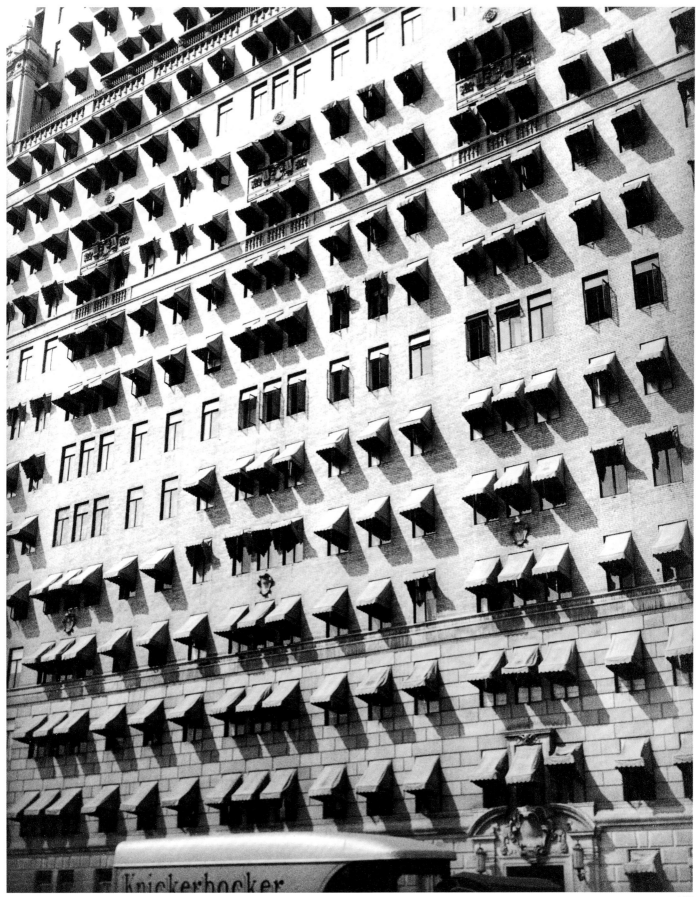

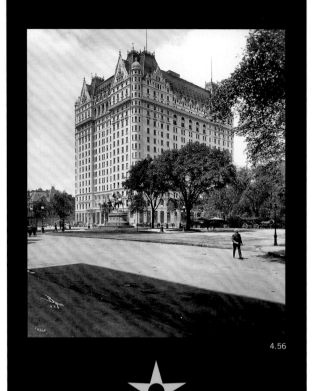

4.56

Lower East Side tenement interior (4.59). The image broadcasts poverty, from the torn wallpaper revealing the wall slats to the meager possessions, from the two pots on the coal stove to the reclining barefoot child, lying on a board that probably also served as dining table.

Airplanes also provided new perspectives on the streets below, showing how close rich, poor, and middle class often lived. This aerial photo of Fifth and Madison Avenues displays the megablock created by the construction of Mount Sinai Hospital facing Central Park (4.63). The modest six-story tenements on Madison between 98th and 101st Street stand around the corner from elegant apartment buildings on Fifth Avenue and 98th Streets. The hospital complex of ten buildings opened in 1904. Note the extensive use of available land by the apartments. There is no room here for clotheslines.

In Harlem, a mix of rich, poor, and middle class increasingly yielded to the common denominator of race. Segregation of black Americans coupled with accelerating migration to New York City from the American South and the West Indies provided the critical mass. The Harlem Renaissance of the 1920s drew attention to the extraordinary concentration of African-American cultural creativity in the neighborhood. James VanDerZee photographed many emerging stars as well as members of the black bourgeoisie. A Massachusetts native, VanDerZee won his first camera as a premium for selling perfume. Self-taught, he rapidly developed technical skills. He moved to New York City in 1916, where he opened a studio in Harlem on 135th Street. VanDerZee tried to have each photograph tell a story, whether it was a formal portrait or a street shot. Here, he portrays himself and his wife, who is holding their cat, in their well-appointed living room (4.60).

Further north on Manhattan Island, land remained undeveloped, but nothing could compare to the fresh air of the Bronx. New construction in the Bronx overlooked farms. One builder recalls

4.56. Joseph and Percy Byron, *Plaza Hotel*, ca. 1907.
4.57. *Riverside Drive*, 1907. **4.58.** Joseph and Percy Byron, *The Residence of Elsie de Wolfe, Cozy Corner*, 1896. **4.59.** Joseph and Percy Byron, *Tenement Interior*, 1896.

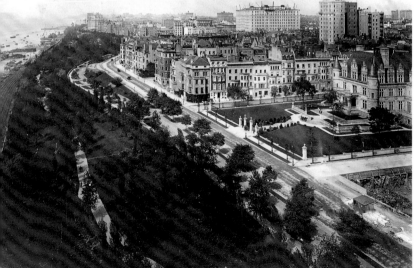

4.57

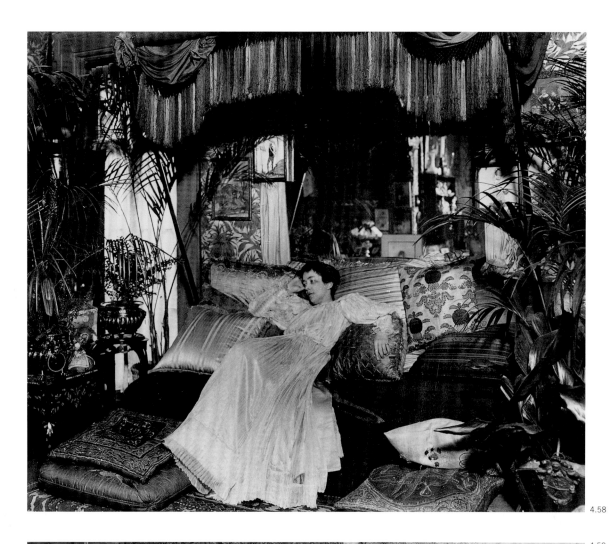

4.58

4.59

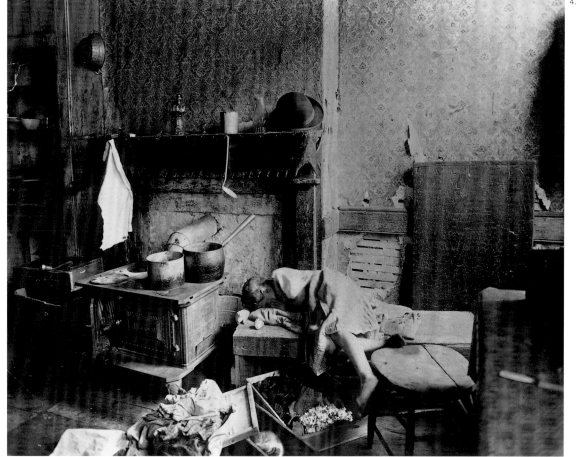

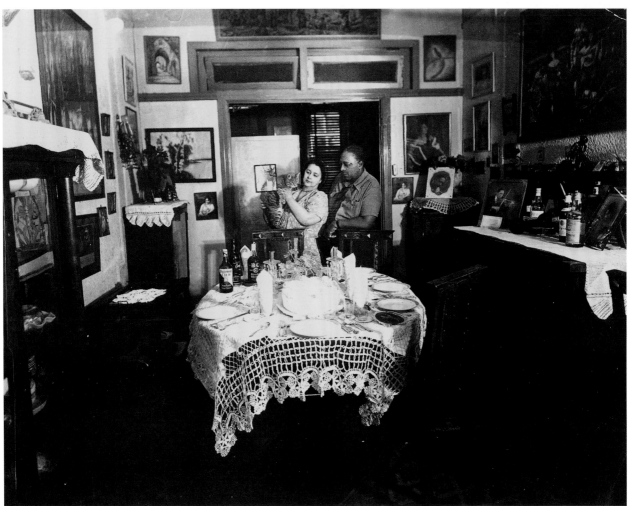

4.60

Neighborhoods
acquired
personalities.

chasing goats off his lot on Wayne Avenue before he could start to dig. Even when six-story tenements lined blocks like Simpson Street in Hunts Point, they exuded an aura of secure well-being, providing working-class New Yorkers with solid, decent apartments (4.62). Observers would later describe such buildings as constructed on a human scale. Note the popular striped awnings over the windows of the more expensive apartments in the corner buildings. The stores on East 163rd Street, a major thoroughfare with streetcars, sold clothing and hats; on the second floor a dentist established an office.

Looking at Queens, photographers saw the glories of individual home ownership. Abbott's photo of 805 Twenty-seventh Avenue in Astoria, with its clapboard and shingle siding, suggests the borough's quiet comfort (4.64). Its air of genteel disrepair, on the other hand, indicates the area's gradual decline in status as working-class families moved into the neighborhood. Astoria, in northwestern Queens, had attracted

well-to-do New Yorkers in the nineteenth century, who built mansions like this one. But with fewer than five hundred thousand residents in 1920, Queens scarcely seemed part of the nation's largest city, while Brooklyn, the city of churches, contained all the contradictions of Manhattan.

The squalid old-law tenements on Talman Street—located in "Irishtown," near the Brooklyn Navy Yard—were condemned for public housing when Abbott photographed them in May 1936 (4.61). They housed Irish immigrants and their children in the nineteenth century. Here lived the maids and handymen

4.60. James VanDerZee, *James VanDerZee and Wife, Gaynella,* ca. 1930. **4.61.** Berenice Abbott, *Talman Street, Between Jay and Bridge Streets,* May 22, 1936. **4.62.** *Simpson Street, Bronx, 1920.* **4.63.** *Looking Across Madison Avenue to Show Back of Mount Sinai Hospital.* **4.64.** Berenice Abbott, *Twenty-Seventh Avenue, #805,* May 25, 1937.

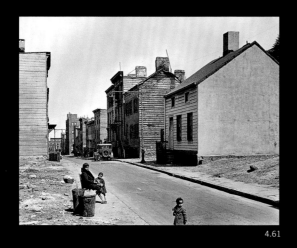

4.61

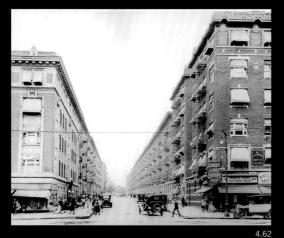

4.62

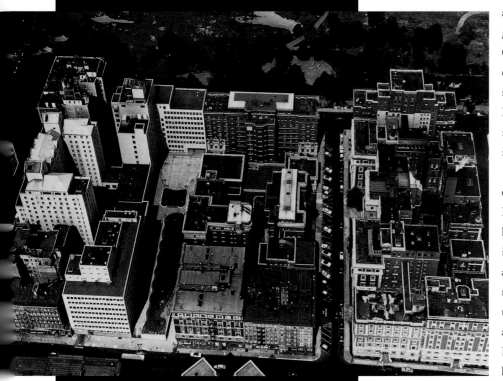

4.63

who worked in the Heights' brownstones. Although physically close, the neighborhoods, separated by the Fulton Street elevated, seemed worlds apart to their respective residents. African Americans moved into the low-rent housing during the Depression. The buildings had no hot water, central heating, or even bathtubs.

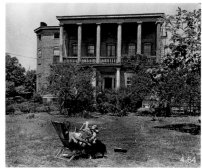

4.64

Inside the homes of the poor, photographers illuminated the cramped spaces that made the streets so attractive by comparison. Freedom beckoned on the streets, a chance to escape the watchful eyes of relatives at home. Hine photographed the bedroom of an Italian family in a rear tenement, which was located in the backyard of a building facing the street, in 1910 (4.67). The narrow room had barely enough space for a bed, in which several children probably slept. His perspective distances the viewer from the mother and her children while conveying a sense of claustrophobia.

Arnold Eagle and David Robbins took this photo of a child in an unidentified tenement apartment bedroom for the Citizens Housing Council during the Great Depression (4.65). The same constricted space confronts the viewer, although the rooms had windows, graced by curtains. The photo's title, *One Third of a Nation* (the title of the collaborative documentary project), refers to President Franklin Delano Roosevelt's inaugural address declaring that one-third of the nation was ill housed, ill clothed, and ill fed.

Born on the Lower East Side and educated in the city's schools, Roy Perry returned to his old neighborhood to see what had changed during the Depression. Knowing the area and its people, Perry focused not only on the squalor but also on the everyday events of the streets and the passions of the residents. Perry began taking pictures as a boy. He subsequently found work

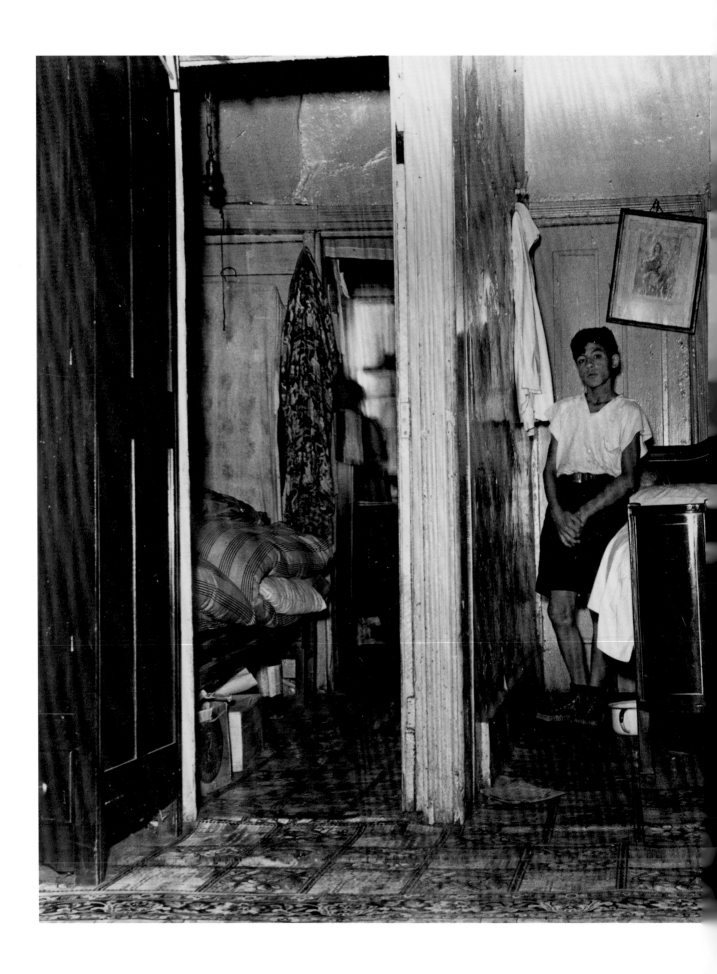

4.65

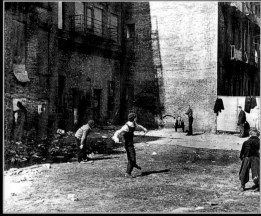

4.66

Inside, the homes of the poor were cramped spaces that made the streets so attractive by comparison.

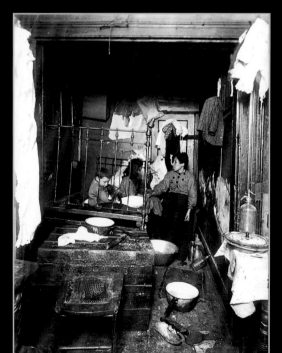

4.67

4.65. David Robbins and Arnold Eagle, *One Third of a Nation*, ca. 1939. **4.66.** Roy Perry, *Baseball Played on Lot Cleared by Abandoned Building*, 1938–40.
4.67. Lewis W. Hine, *Bedroom of Italian family in a Rear Tenement of New York East Side*, 1910.

4.68

**On the streets,
men staked out their territory
while children entertained
themselves.**

4.69

4.70

with social service agencies in the city that sought documentary evidence of their activities to help solicit funds. Perry brought an empathy to his images that extended beyond the requirements of documentation. His photographs share in the documentary tradition of Hine, portraying with passion the grittiness and social costs of urban life.

Perry went up on the roofs of the Lower East Side to find men raising pigeons, a hobby ignored by most New Yorkers (4.68). Above Madison Street, between Rutgers and Jefferson Streets, the pressures of the city lessened, the noise dimmed, and there was that precious commodity: privacy. Quintessential urban birds, pigeons are as much a presence in the city as people. Raising pigeons in coops on the roof entails competition. A flock is sent out in the hope that it will pick up other pigeons before returning to the home roost and the quiet of the roof.

In summer, "tar beach" beckoned. On hot summer nights, tenement dwellers climbed to the roofs with their bedding to try to catch some sleep, outside of stifling, airless bedrooms. Above the city's streets sexuality could be displayed. By day, the sun caresses the skin, the skyline feasts the eyes; one is in the city yet beyond its urban whirl.

Walter Rosenblum often visited tar beach. He enjoyed its freedom and quiet and appreciated its perspective on the city below. A native New Yorker who grew up on the Lower East Side, Rosenblum joined the Photo League, studying there with Lewis Hine and Paul Strand and participating in its collective documentary projects. After World War II, Rosenblum followed in Abbott's footsteps, teaching photography at Brooklyn College at a time when few schools offered such courses. Figure 4.70 from the Pitt Street document, a collective photographic documentary of a Lower East Side street, speaks intimately of tar beach's simple pleasures.

On the streets below, men staked out their territory, while children entertained themselves. Lee Sievan's photograph captures gestures of urbanity and masculinity: the grace of bodies lounging, the cut of clothes with sharp, clean lines (4.71). These men hanging out on the corner, waiting for work and

4.68. Roy Perry, *Man on Roof Tending Pigeon Brood*, ca. 1940. **4.69.** Reginald Marsh, *Tattoo-Shave-Haircut*, 1932. **4.70.** Walter Rosenblum, *Tar Beach*, 1938. **4.71.** Lee Sievan, *Mulberry Bend—Gentlemen of Leisure*, 1938. **4.72.** Lewis W. Hine, *Bootblacks*.

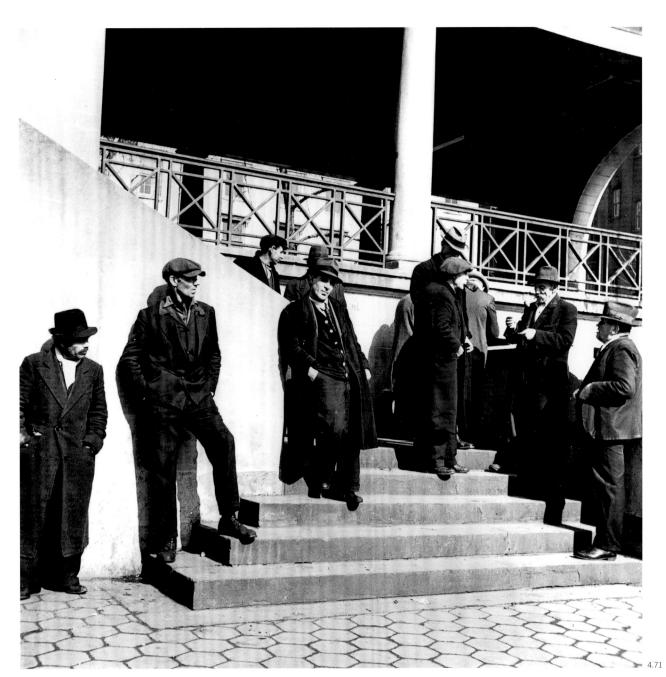

4.71

watching the scene, stake their claim to Mulberry Bend by their forceful presence. On the right, a padrone, an Italian boss, signs up several laborers as others deliberately ignore the curbside employment bureau. Adept street performers, these are quintessential New Yorkers.

The down-and-out men and women who

4.72

loitered beneath the elevated trains belong to their sites as much as the Italian-American men at Mulberry Bend. Reginald Marsh sketched their world of cheap stores, aggressive signs, and lives lived on the edge (4.69). Fascinated by the city's display, Marsh painted its tawdry variety and reveled in its vital physicality. "There is enormous and endless material

to paint in New York, exciting, rarely touched, and waiting for the artist to make use of it," he proclaimed.[16]

Hine photographed these boys taking a break from their work as bootblacks to roll dice or marbles (4.72). Probably they were playing craps. Children "claimed the street as their social center, playground, and workplace," writes historian David Nasaw. Nonetheless, he continues, "the street belonged to the city, not the children."[17]

Older boys played stickball behind the tenements of the Lower East Side when they could find a lot that had been cleared. The game appealed to many New Yorkers, even the orthodox Jewish boys pictured in Roy Perry's photograph (4.66).

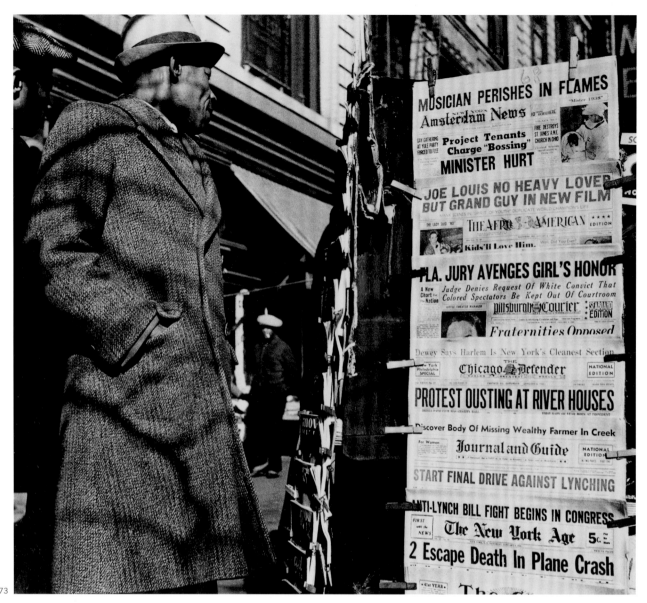

4.73

In New York's segregated public spaces residents gleaned news and information. The African-American man pictured in Alexander Alland's photo could choose among six black papers, from Chicago and Washington as well as New York, at this newsstand at the corner of Lenox Avenue and 125th Street, Harlem's main intersection (4.73). White papers often ignored black readers and rarely gave headline attention to such important issues as a congressional antilynching bill.

Games and friendship also flourished on the streets, especially in summertime. A perennial favorite, card playing attracted men from diverse immigrant backgrounds. Sidney Kerner photographed these three sharing a game and a bench (4.74). To ward off the sun, two of the men have tied their handkerchiefs on their heads, unconcerned with their sartorial appearance.

Reformers worked hard to get children off the streets and into playgrounds, where adults could supervise them. Such scenes as this one, where fire hydrants provided relief from the heat during the summer, disturbed reformers. These girls were cooling off on 105th Street near Park Avenue in the late 1930s, on the block near their homes (4.75).

Adults agitated for playgrounds where children could play in an organized fashion. The joy of water, however, whether from a hydrant or a WPA-constructed spray shower in a park, invited self-expression. Roy Perry's photo suggests two water nymphs (4.76).

4.73. Alexander Alland, *Harlem Newstand*, 1939. **4.74.** Sidney Kerner, *Game of Cards*, 1938. **4.75.** Alexander Alland, *Children and Street Hydrant*, 1938–39. **4.76.** Roy Perry, *Cooling Off Under WPA-Constructed Spray Shower*, 1938–40. **4.77.** Joseph and Percy Byron, *Salvation Army Christmas Dinner Kettle*, 1906.

4.74

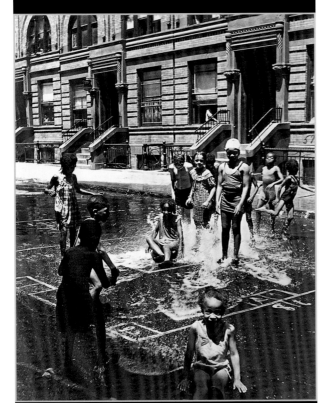

4.75

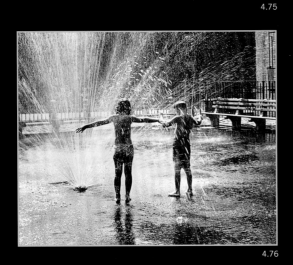

4.76

Solicitation on the street reminded passersby of the less fortunate. The Salvation Army recruited on the streets with music and marching. Its uniforms set both men and women apart. As Christmas approached, Salvationists staked out streets with signs and pots to raise funds for the needy (4.77). An early slogan—"Soup, Soap and Salvation"—announced founder William Booth's conviction that one couldn't preach salvation to someone whose stomach was empty. The Salvation Army "made feeding, sheltering and nursing a spiritual engagement," argues scholar Diane Winston.[18]

When winter came, the visual aspects of the streets changed, and figures became dark shapes against the snow. John Albok took this photograph in 1932, of two boys on a sled on Ninety-sixth Street and Madison Avenue, near his tailor shop (4.80). An immigrant from Hungary, Albok arrived at Ellis Island (see fig. 4.4) in 1921. In his bag he had packed his three most precious possessions: tailor's shears, a violin, and a wooden camera with a Geolitz f4.5 lens. "From the first day I arrived in the United States, I took a keen interest in amateur photography," Albok wrote.[19] Albok made a living working as a tailor and devoted his free time to taking pictures, often from

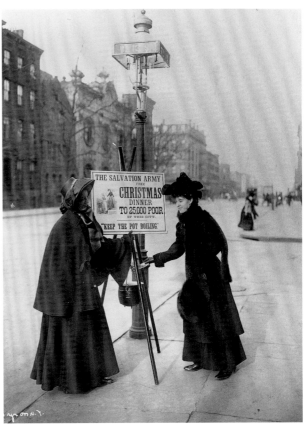

4.77

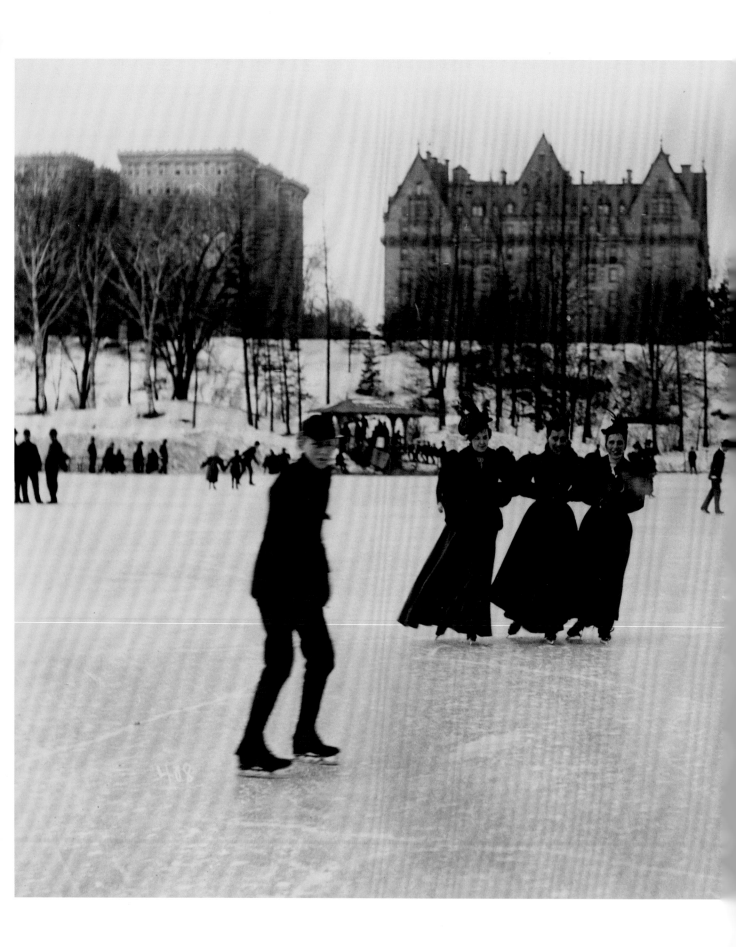

For relief from the city's

pressures,

New Yorkers escaped

into their parks.

4.78. Joseph and Percy Byron, *Skating in Central Park*, 1894. **4.79.** Samuel Gottscho, *Pond in Central Park*. **4.80.** John Albok, *Snow Scene on Ninety-sixth Street*, 1932.

4.81

Parks served New Yorkers as backyards and front lawns, reflecting and refracting images of the city around them.

4.82

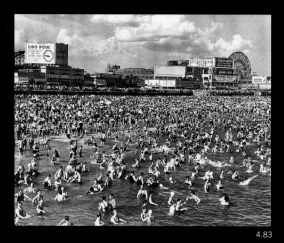

4.83

his shop window on Madison Avenue.

Parks served New Yorkers as backyards and front lawns, reflecting and refracting images of the city around them. Boys played in parks, working women found safe spaces to sit during the day to talk or read, families went skating together, on the ice in winter and on the pavement in warmer weather.

In winter, ice skating won first place in popularity, with sledding a comfortable second choice. Women and men excelled in the sport. The Byrons' 1894 photograph perfectly captures gendered behaviors (4.78). Three women skate together arm in arm, socializing as they go, while the men, one smoking a cigarette, display their skill for the women and the photographers to admire. The Central Park setting shows off the elegant Dakota Apartments (built in 1882) and the Hotel Majestic (built in 1889), facing each other across Seventy-second Street on Central Park West. Their splendid isolation endured even years after their completion, despite new construction that came in the wake of the elevated trains.

The ponds and lakes of Central Park dramatically revealed how the park improved land values. Gottscho took this photograph from a vantage point similar to the Byrons', albeit in the summer (4.79). On the southern end, at Fifty-ninth Street, hotels cast their shadows onto the pond, while on Central Park West the Majestic Apartments (which replaced the hotel in 1930) and the Dakota (with the Oliver Cromwell on Seventy-second Street) shimmered in the water. The visual luxury of these images became part of the city's iconography. Gottscho's photographs taken before World War II inscribe Central Park and its buildings as emblematic of New York.

John Muller's photo of the snowy park at night lets the light add glamour and elegance to the sparkling hotel buildings, themselves symbols of sophistication and style (4.84). From the left are pictured the Ritz Tower Hotel, the Sherry-Netherland Hotel, the Savoy-Plaza Hotel, the Squibb Building, and the Plaza Hotel.

For serious amusement, New Yorkers flocked to the beaches, boardwalks, and fantasy rides of Coney Island, a two-mile beach

4.81. Sealy Rock Beach, Astoria Park. 1910. **4.82.** Breading Way, Coney Island, Brooklyn, ca. 1888. **4.83.** John Muller, Coney Island. **4.84.** John Muller, *View of Central Park at Night in the Snow.* **4.85.** Joachim Oppenheimer, *Coney Island Nocturne,* 1939.

on the Atlantic Ocean. Bathing in the sea, people could flirt without fear of disapproval. The crowds gave individuals a kind of license for the display of sexuality. In Muller's photo of a typical hot day at the beach at Coney Island a couple stands waist deep in the water, arms around each other, right in the center of the picture (4.83). The men and women around them are too busy enjoying themselves to notice.

At night, Luna Park with its miles of 250,000 electric light bulbs, shimmering canals, and pulsing boardwalk transformed a short stretch of beach into a dream spectacle, an enchanted garden for the masses. Opened in 1903, Luna Park enfolded its thousands of daily visitors in a "mysterious palace of play," as remote from the streets and sidewalks of the city as another planet.[20] Joachim Oppenheimer's photo of the Ghost Train at midnight dates from 1939, shortly before it burned down (4.85).

The popular resort "quickly became a symbol not only of fun and frolic but also of major changes in American manners and morals," asserts John Kasson, its historian. Coney Island vividly demonstrated "the growing cultural revolt against genteel standards of taste and conduct that would swell to a climax in the 1920s."[21] Breading Way's lyrical photograph reminds us of those standards even as it evokes the sensation of the shore (4.82). One can almost feel the ocean breeze billowing through the women's skirts though there is no water in sight. Going down to the seashore, New Yorkers could leave the city behind them, although, as their clothing indicates, they took their manners and mores with them to the beach.

The rise of homosocial leisure activities among young women characterized the new century and reflected changing patterns of socializing. Before there were municipal pools, women went swimming at Astoria Park's Sealy Rock Beach in the East River (4.81).

Professional athletics attracted thousands of fans; baseball was seen as the quintessentially American game, racism included. Rooting for the home team at a time when New Yorkers had a choice of three could divide families and unite friends. The Giants played at the venerable Polo Grounds, located near the Harlem River Speedway, from 155th to 157th Streets. The Giants' rival in the National League, the Brooklyn Dodgers, played in proletarian Ebbets Field on Bedford

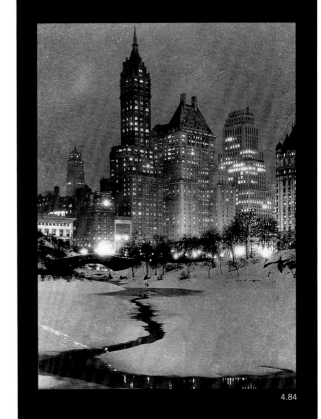

4.84

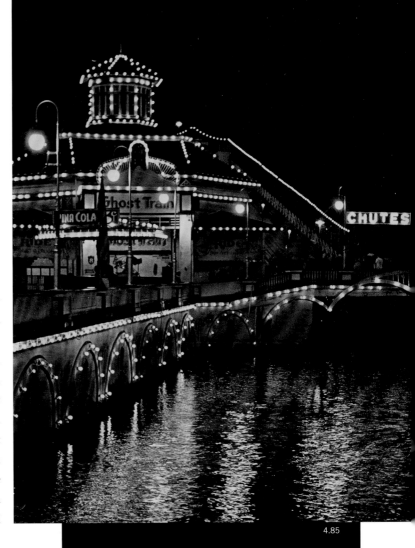

4.85

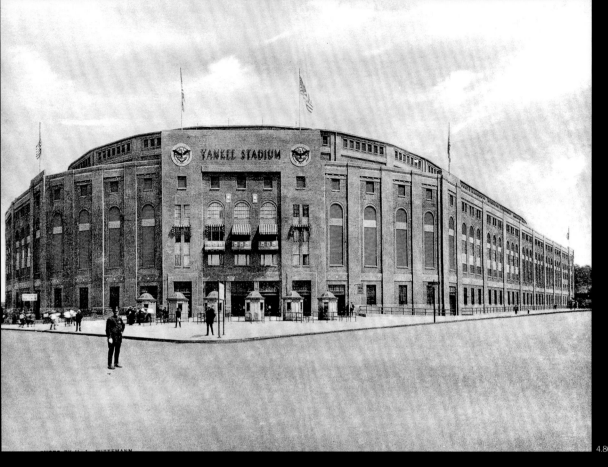

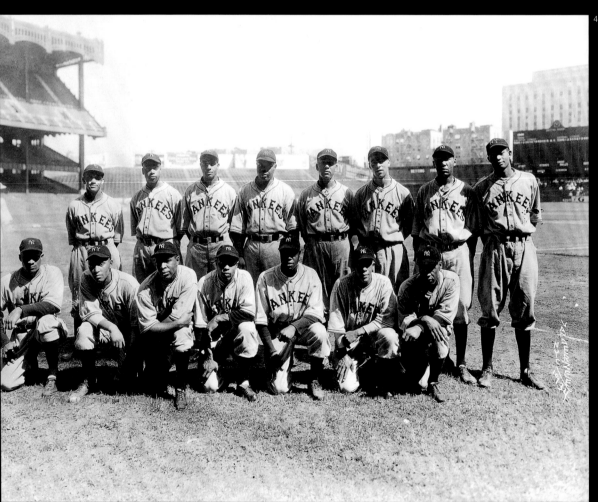
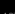

Avenue and Montgomery Street. Yankee Stadium, the largest baseball park in the world when it opened in 1923, with seats for 67,224 fans, stood at 161st Street and Jerome Avenue at the foot of a prosperous middle-class Bronx neighborhood (4.86). From inside the stadium spectators could see the modern apartment buildings of the area. For four decades from 1921, the Yankees were the best team in baseball.

The "House that Ruth built," as it was known in deference to its greatest hitter, Babe Ruth, also hosted a second team, the New York Black Yankees. James VanDerZee took their formal portrait in 1934 (4.87). The team was affiliated with the Negro National League from 1936 to 1948. In 1947 Jackie Robinson racially integrated baseball when he joined the Brooklyn Dodgers, signaling the beginning of the end of segregated Negro teams.

Like work, entertainment at the turn of the century was gendered, with men enjoying more forms of public sport and amusement than women. Poolrooms and billiard parlors were off limits to women of any class. The sailors pictured at the Young Men Christian Association's Naval Branch in Brooklyn in 1908 undoubtedly took for granted male leisure activities (4.88). The YMCA offered pool tables to tempt the sailors not to visit the commercial poolrooms, with their unsavory reputations.

Bowling also attracted men, though Hine's image focuses on the children who labor—these were the years before mechanized pin setups—so men can play (4.89). The irony of the photo requires knowledge of the game, who played it and who worked to make it possible. The foreman keeps a sharp eye on his boy workers and hides the youngest ones from view.

McSorley's Ale House on East Seventh Street, just off the Bowery, catered to men. Drinking was a male pastime, although its popularity varied among different immigrant groups. McSorley's attracted a diverse group of patrons: German and Irish immigrants, Wall Street brokers, and politicians. The saloon operated under the motto "Good Ale, Raw Onions, and No Ladies." Berenice Abbott received permission to enter and take her photo in 1937 (4.90).

Public amusements flourished in the 1890s in the wake of electrified streetlights. "Electrification made going out at night not only safer and more exciting but easier and cheaper than ever before," asserts historian David Nasaw. New York, always a city of work, created more and more places to play. Vaudeville especially appealed to the growing armies of white-

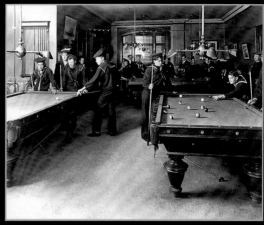

4.88

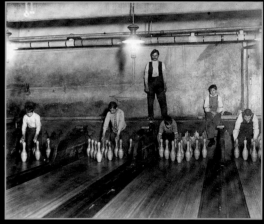

4.89

4.86. H. L. Wittemann, *The Yankee Stadium.*
4.87. James VanDerZee, *New York Black Yankees, Yankee Stadium*, 1934. **4.88.** Joseph and Percy Byron, *Y.M.C.A. Naval Branch*, 1908. **4.89.** Lewis W. Hine, *Subway Bowling Alleys at 65 South Street, Brooklyn, NY*, 1910. **4.90.** Berenice Abbott, *McSorley's Ale House*, November 1, 1937.

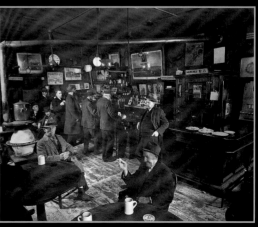

4.90

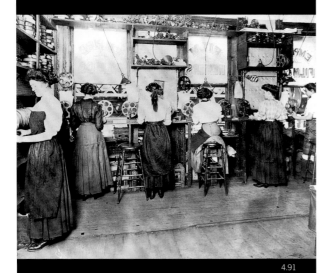

4.91

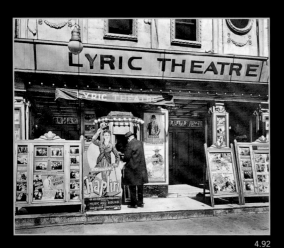

4.92

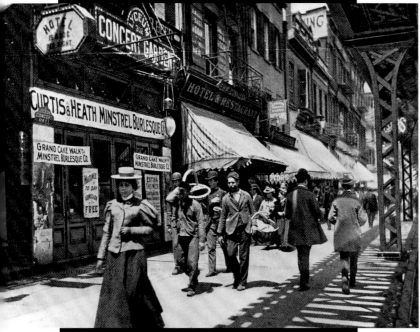

4.93

collar workers who had the money and time, as well as the desire, for pleasure after a long day of tedious labor. Vaudeville cleaned up its acts yet gave its patrons an "opportunity to display their emotions in public."[22] At the turn of the century on the Bowery, just north of Houston Street, the Lyceum Concert Garden advertised a minstrel show by Curtis and Heath, one of the most successful vaudeville circuit promoters (4.93).

As the movie industry blossomed, it pushed vaudeville from the stage. First shown in nickelodeons and later in movie palaces, motion pictures offered entertainment for everyone, appealing to young and old, women and men, immigrants and native-born, black and white. The Lyric Theatre on Third Avenue and Thirteenth Street, less than a mile north of the Concert Garden, acquired in 1910 its current facade, which retained the flavor of the old silent movie houses. Abbott's photo dates from 1936 but evokes an earlier era despite the prominence of the regular feature films advertised (4.92).

Many New Yorkers went to the movies regularly each week; children often spent Saturday afternoons at matinees absorbing American dreams. There were over one thousand movie theaters in the city; many doubled as civic centers, hosting high school graduations and other events.

Making motion pictures became an important industry in the city. Although Americans idolized movie stars with their glamorous lives, most work in the motion picture industry lacked any glamour at all. As a new industry, motion pictures gave women and immigrants opportunities for employment. Women processed film for distribution, as shown in a 1910 photo of the Empire Film Company's laboratory located on Broadway, just north of Times Square (4.91). Movies positioned themselves on the edge of the theater district, near other purveyors of popular culture such as Tin Pan Alley. Attuned to urban tastes, immigrant entrepreneurs experimented with new techniques to attract customers. Compared to Hollywood, however, New York accounted for only a small fraction of feature films produced prior to World War II.

Segregated neighborhoods released creative energies by giving artists and musicians of various backgrounds an appreciative audience. New Yorkers gathered on Harlem's streets at night seeking the entertainment that made the area famous.

Nightclubs, fancy restaurants (several for whites only), theaters, and speakeasies during Prohibition drew crowds of pleasure-seeking New Yorkers, as did the exoticism associated with African Americans. Though James Weldon Johnson might insist that "Harlem talks American, reads American, thinks American," many whites saw Harlem only through popular racist stereotypes.[23]

The Cotton Club, at the corner of 142nd Street and Lenox Avenue, admitted only white patrons, booking some of the best jazz musicians and entertainers for wealthy New Yorkers to enjoy. Inside, the bands played to audiences eager to hear sounds they thought modern and sexy, music that epitomized the harsh cadences of the metropolis, jazz in the asphalt jungle. In this photo taken from the balcony, Eddie Mallory conducts the Mills Blue Rhythm Band (4.95).

Backstage at the Apollo Theater on 125th Street, dancers relaxed between acts. Although they performed on a stage distorted by racial prejudice, women valued the chance to work during the Depression and to hone their craft. Morgan and Marvin Smith photographed both Harlem's renaissance and its resistance (4.94).

For most New Yorkers, entertainment meant Times Square, renamed in honor of the *New York Times* after it moved to 43rd Street at the turn of the century. By World War I many theaters had relocated to 42nd Street and Times Square became the heart of the theater district, a shining landscape of pleasure. Viewed from above or at street level, what caught photographers' attention was the advertisements. Not just theater marquees shone at night but also giant ads for drinks and cigarettes, cars and toothpaste. Gotham glimmered and shimmered at Times Square. The blaze of lights prompted its nickname: the Great White Way. The city that never sleeps dwells at Times Square, a district like no other.

Looking south toward the Times Building and Forty-second Street, with the large movie theaters on Broadway, the Loew's

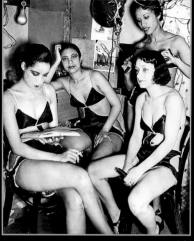
4.94

Segregated neighborhoods
released creative energies by
giving artists and
musicians an appreciative
audience.

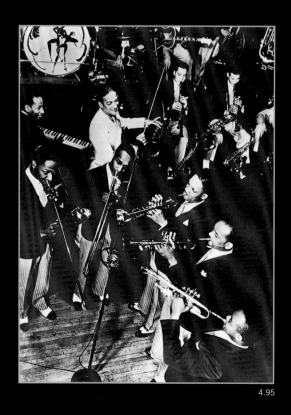
4.95

4.91. Joseph and Percy Byron, *Empire Film Co.*, 1910.
4.92. Berenice Abbott, *Lyric Theater,* April 24, 1936.
4.93. *A typical scene on the Bowery*, 1899. **4.94.** Morgan and Marvin Smith, *backstage at the Apollo Theater,* 1936–37.
4.95. Eddie Mallory conducting Mills Blue Rhythm Band at the Cotton Club, 1920s.

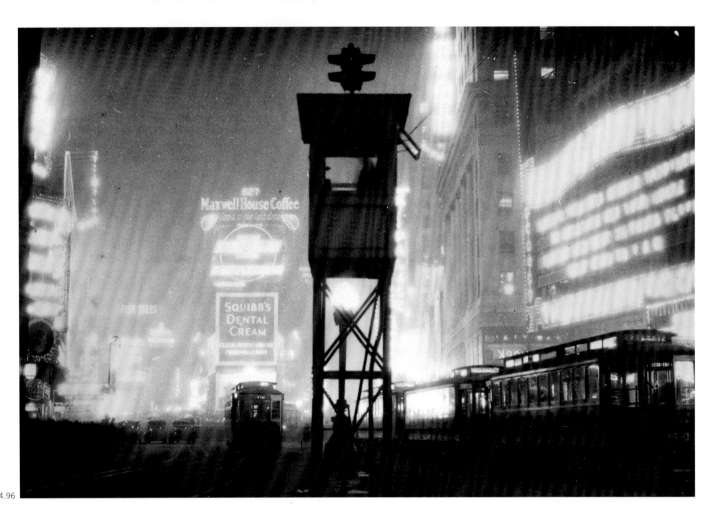

4.96

4.97

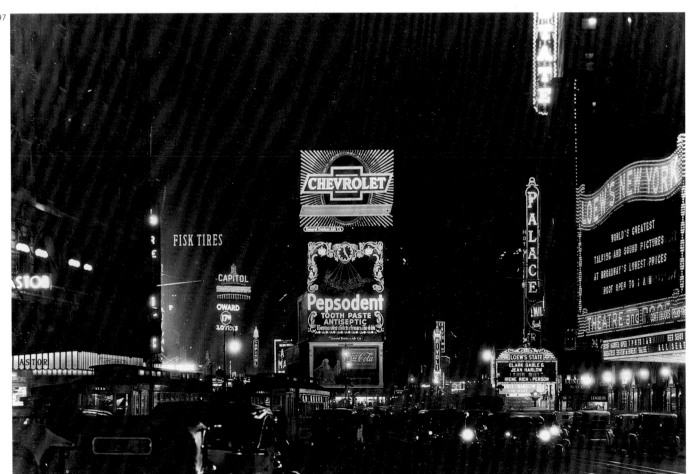

New York and the Loew's State on the right, Gottscho's photograph captures the frenetic pace (4.97). Times Square symbolized a potent, influential city, in a very different fashion from Wall Street finance.

Government buildings registered the city's ambitions as much as Times Square. City Hall, built in 1812 (see fig. 2.75), appeared classically quaint a century later (4.99). The twenty-five-story Municipal Building, designed by McKim, Mead, and White and completed in 1913, shares some classical features with City Hall and expressed political aspirations of the city's leaders. Its tower, with overtones suggesting imperial Rome, simultaneously rendered homage to the older building's cupola and the city's new metropolitan character. The close proximity of newspaper row to City Hall pays tribute to politics as a steady source of news. The World Building and the Herald Tribune Building on Park Row obscure a view of the Brooklyn Bridge.

Cass Gilbert designed the U.S. Customs House at Bowling Green (see fig. 2.4) in a beaux-art style (4.98). The building and its site testified to the federal government's power to collect duties from the port of New York. They also signified the city's importance as the leading American metropolis.

A metropolitan vision lay behind the 1898 consolidation of Brooklyn and New York that, together with the Bronx, Queens, and Staten Island, created Greater New York. The law itself represented a compromise among the region's mercantile, banking, and real estate elites, regular Republicans in the city and upstate, and a few Tammany Democrats. Most of the working classes and all the city's substantial immigrant population exerted no direct influence on the merger. Yet the coalition that produced Greater New York lacked stability,

4.98

For most New Yorkers, entertainment meant Times Square and Broadway, the Great White Way.

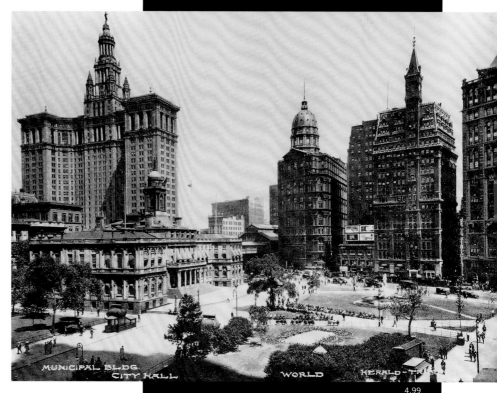

4.99

4.96. Rudolph Simmon, *Times Square,* 1929–30. **4.97.** Samuel Gottscho, *Times Square at Night.* **4.98.** Wurts Brothers, *New York Customs House,* 1934. **4.99.** H. L. Wittemann, *City Hall Park and Park Row.*

4.100

4.101

4.100. Waiting for the train at the Fifth Avenue elevated line in Brooklyn, ca. 1920. **4.101.** Reginald Marsh, *Three Girls on Subway Platform*, 1928. **4.102.** James VanDerZee, *Yellow Taxi Cab with Driver*, ca. 1932. **4.103.** Berenice Abbott, *Greyhound Bus Terminal*, July 14, 1936. **4.104.** Opening of LaGuardia Airport in 1939.

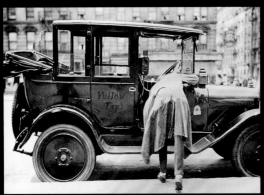

4.102

and the new century would see many unexpected changes, including an increasing dispersal of power in the city beyond its wealthy elites.

Public transit, so critical to the city's expansion and its concentration of work in skyscrapers, operated under competing private auspices. Getting to work from Brooklyn during rush hour, despite a choice of elevated trains or streetcars, involved crowds and discomfort, both apparent in this photo from around 1920. The elevated station of the Fifth Avenue, Brooklyn, line above and the Flatbush and Seventh Avenue streetcar lines below in summer held mobs of men and women (4.100). Despite the daily hazards of commuting to work, residents continued to leave Manhattan for new homes in Brooklyn, Queens, and the Bronx.

Traffic lights, first introduced on Fifth Avenue at Forty-fourth Street in 1919, borrowed their technology from railroads. Rudolph Simmon photographed this one at Times Square (see fig. 4.96) around 1930, just as the lights were about to be dismantled and removed. Notice the blaze of light from the advertisements and theaters.

A diversity of forms of transportation shared an uneasy coexistence. Berenice Abbott photographed the Greyhound Bus Terminal on West Thirty-fourth Street in the 1930s (4.103). Located behind Pennsylvania Station (see fig. 4.105), the terminal's sleek lines and streamlined shape proclaimed its modernity. Greyhound buses took travelers to distant places for less money than railroads.

The future dominance of automobiles and airplanes was far from visible. Taxicabs adopted gas engines in 1907, the same year that the drivers went on strike for better wages and the right to organize in unions. The new taxis had meters to prevent fare gouging and soon became a popular mode of transportation for New Yorkers. In the 1920s there were thousands of drivers, most of them independents, like the man pictured here. In the Depression, earnings dropped and the number of drivers increased. In 1933 there were seventy-five thousand drivers operating nineteen hundred vehicles. James VanDerZee recorded the driver and his cab on the streets of Harlem (4.102).

LaGuardia Airport in Queens opened in December 1939, the first airport designed and constructed with federal funds. Intended to be a commercial airport, LaGuardia charged spectators a fee to watch the airplanes from the observation deck. The money came in handy until commercial flights became

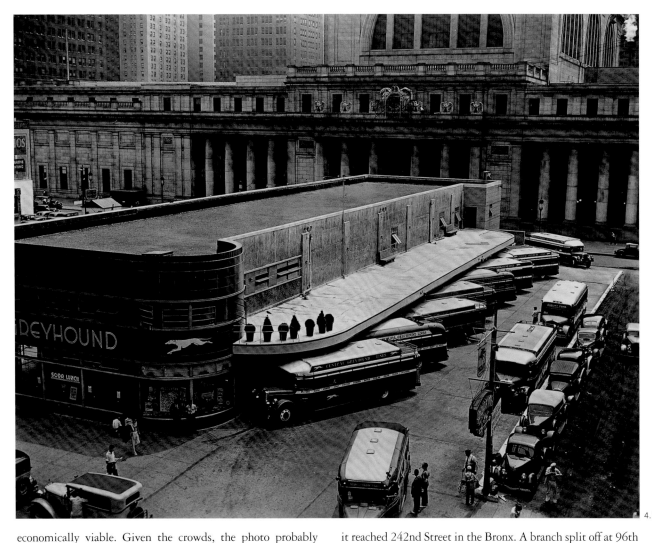

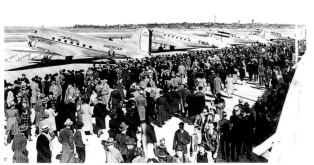

economically viable. Given the crowds, the photo probably documents the airport's opening (4.104).

With their engineering and efficiency, subways epitomized modern rapid transit. New York City's subway construction began at the turn of the century (4.108). The first subway opened in 1904, running from city hall north to 42nd Street, then west to Times Square, and then north up Broadway until it reached 242nd Street in the Bronx. A branch split off at 96th Street and went up Lenox Avenue, crossing the Harlem River, to finish in the central Bronx. From the first, the subway emphasized speed, introducing express and local service. Trains operated around the clock. Within a decade, the system carried over 800 million passengers annually. The subway's immediate popularity led to the extension of service into Brooklyn and Queens and other parts of Manhattan. By 1930 ridership reached 2,049 million, sealing the elevateds' fate (4.108).

Almost everyone rode the subways. Artists gravitated to the constantly moving scene, the physical closeness of men and women, young and old, poor and affluent. Reginald Marsh captured the body language of three women in the subway waiting for a train (4.101). The young women exude an aura of confidence and a feeling of comfort in their daily ritual. Marsh's subway is a place not of alienation but of movement and sociality.

Increasingly seen as relics of another century, els acquired strange grace and beauty, framing the city's aggressive modernity. Gottscho's photo from beneath the curve of tracks at

4.103

4.104

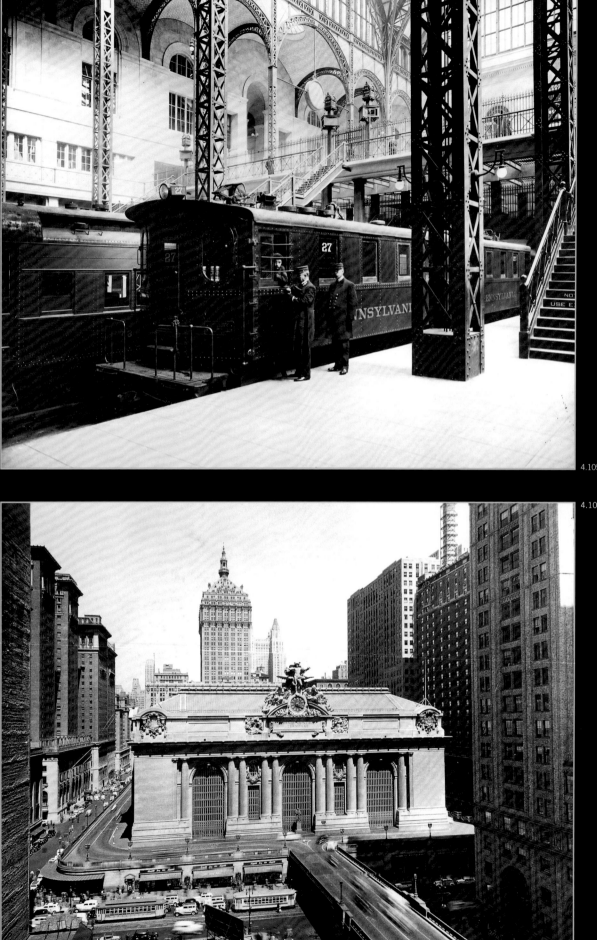

Coenties Slip dramatizes the el's sweep, the sharp dynamic pattern of its shadows (4.109). The steel strutwork on the left vigorously answers the skyscrapers' paler display of windows. In this photo, the City Bank Farmer's Trust has none of the prominence as seen from Brooklyn (see fig. 4.10).

Railroad trains retained their vigor and their usefulness as they were brought underground; their enormous passenger terminals enfolded glorious space and light, tributes to civic greatness. Grand Central Terminal, completed in 1914, stands at Forty-second Street and Park Avenue, a monument to rail travel. Its beaux-arts facade faces south, toward the nineteenth-century city (4.106). The triple arches frame enormous windows, whose light fills the cavernous main concourse, a vast space 120 feet wide, 375 feet long, and 125 feet high (4.107). Whitney Warren of Warren and Wetmore designed the sculptures to be an integral crowning statement. The three figures represent Minerva, Mercury, and Hercules surrounding a clock, a fitting reminder of the railroads' role in standardizing time. The exterior and interior photos date from the 1930s, when large office buildings and hotels lined the blocks around Forty-second Street.

Pennsylvania Station, designed by McKim, Mead, and White, covered two city blocks from Seventh to Eighth Avenue, Thirty-first to Thirty-second Street (4.105). Built to compete with Grand Central Terminal, Penn Station was modeled after the Baths of Caracalla. The concourse of glass and wrought iron, completed in 1911, revealed the structural supports for the building. The decision to build a low, free-standing building with classical references indicates the civic dimensions of the enterprise.

Other public institutions operated on a more modest scale. Free public baths, authorized in 1895 but not constructed until the turn of the century, gave tenement dwellers living in buildings without hot water a clean and inexpensive place to bathe. Children especially appreciated the swimming facilities, and flocked to the utilitarian Public Bath Number 10 on Fifty-first Street and the Hudson River (4.111). Far more elegant was the pool on Avenue A and Twenty-third Street. William Wurts's photo of the Avenue A baths shows the classical styling of the design by Aiken and Brunner (4.113). Note the separate entrances for men (on the left) and women (on the right).

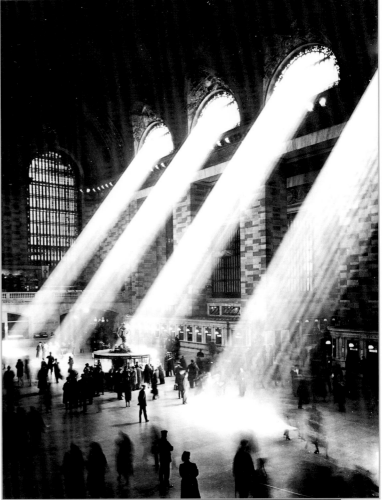

4.107

4.108

4.105. Interior Scene at Pennsylvania Station.
4.106. Federal Writers Project, *Grand Central Station, exterior*, ca. 1937. **4.107.** Federal Writers Project, *Grand Central Station, interior*, 1930s. **4.108.** Joseph and Percy Byron, *Fourteenth Street Subway Construction*, July 29, 1921.

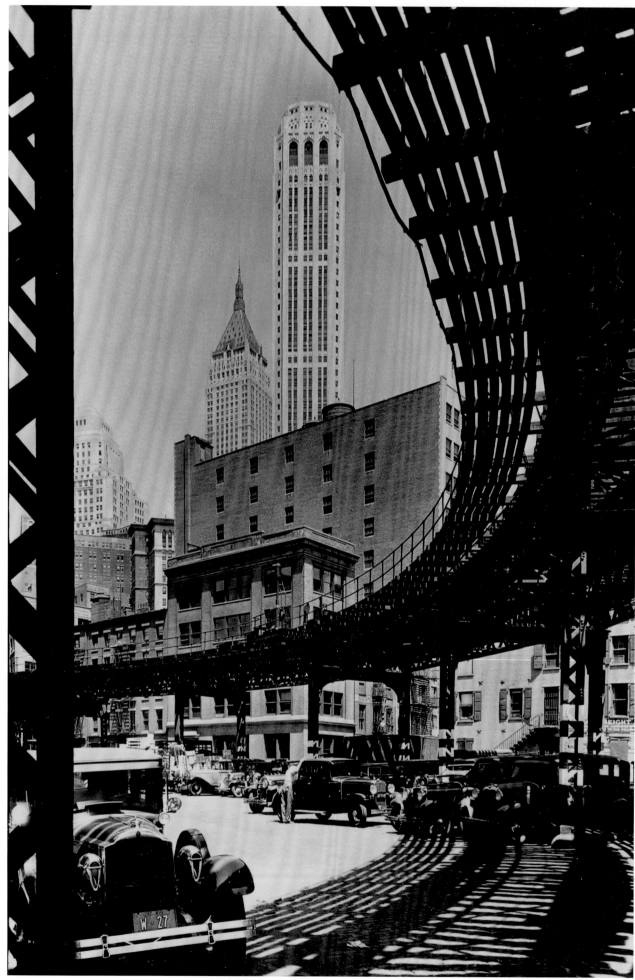

Medicine involved a partnership of public and private. Visiting nurses helped immigrant families care for their children, not waiting for parents to come to a clinic. Roy Perry's photograph of a nurse attending to a baby in a Chinese laundry conveys the concern of public health nurses (4.112). The mother and her older children watch, but the father can't afford to pause from his ironing. New York City's Chinese immigrants created a small community in Chinatown near the Lower East Side, but Chinese hand laundries were found throughout the city, and families usually lived wherever they worked.

Columbia University finished construction of Columbia Presbyterian Hospital and its medical school, the College of Physicians and Surgeons, in Washington Heights in 1928. Unlike the Morningside Heights campus, the Heights buildings

4.111

4.112

4.109. Samuel Gottscho, *El Track at Coenties Slip*.
4.110. Columbia Presbyterian Hospital, 1938–39.
4.111. Public Bath #10, 1905–10. **4.112.** Roy Perry, *Checking Ears of Chinese Infant*, 1938–40. **4.113.** Wurts Brothers, *Free Public Baths*.

4.113

4.110

rose to almost twenty stories and appeared even taller when viewed from Riverside Drive (4.110).

Medical discoveries advanced the professionalization of medicine, including the authority of male physicians. At the turn of the century, New York City became a nationally prominent center of medical instruction, with partnerships between teaching hospitals and medical schools. The Byrons' 1902 photo shows Dr. John Allan Wyeth performing an operation for male medical students at the New York Polyclinic Medical School and Hospital, one of the first postgraduate schools, located on East Thirty-fourth Street (4.114).

Tammany Hall, the Democratic Party machine's central headquarters, controlled garbage disposal in the city through patronage. Alice Austen took this photo of a street sweeper at Forty-eighth Street and Eighth Avenue when the area was a middle-class neighborhood. His white uniform suggested cleanliness, but the realities of city sanitation belied such optimism (4.118).

The real monuments of civic endeavor could be found in every city neighborhood. In an overwhelmingly immigrant city, public schools proclaimed a commitment to education as the path to American identity. Although the architecture varied, school buildings invariably towered over local residences. Curtis High School, set on a hill, dominates its Staten Island neighborhood (4.115). Its

4.114

4.115

4.116

location made it visible from everywhere, a symbol of American public aspirations.

"Just in their physical presence, schools became a representation of the American ideal that we the people have provided you with this magnificent opportunity to learn," observes scholar Stephan Brumberg. "The schools were more awesome than any building an immigrant child would have come into contact with. And in their grandeur, their attractiveness—the marble wainscotting, the stained glass—they were an invitation to become an American."[24] Few children refused such an enticing and compelling summons.

The Gothic castle on Convent Avenue housed the New York Training School for Teachers in the years before college education was required of elementary school teachers (4.116). In 1936 it became the home of the newly created High School of Music and Art, one of several schools for talented teenagers established by Mayor Fiorello LaGuardia.

High schools experienced the most growth after World War I. Once schools for a small fraction of teenagers, the elite students whose parents could afford not to have them work, they became standard bearers for the neighborhood. High school enrollment in New York City increased from 11,072 in 1898 to 154,512 in 1928 and then doubled during the Depression, when the mandatory age when a child could leave school rose from fourteen to sixteen.

During the 1920s the New York City Board of Education embarked on an ambitious program of expansion to keep up with the increasing student population, many of them children of immigrants. The board constructed on average almost thirty schools a year—the equivalent of one new school every twelve days—for almost an entire decade.

Schools also expanded the reach of their curricula, teaching good health and hygiene as well as English and citizenship. Nutrition programs provided free milk and hot lunches to public school children. During the Depression, children often ate their only full meal in school. Public schools also promoted physical fitness, although the types of activities changed from calisthenics in the school courtyard at the turn of the century to sports in gymnasia in new school buildings. Figure 4.117 shows boys and a few girls in the courtyard of P.S. 21 in Manhattan. Note the large, double-hung windows to provide classrooms with plenty of natural light. The board of education's first superintendent of school buildings championed the

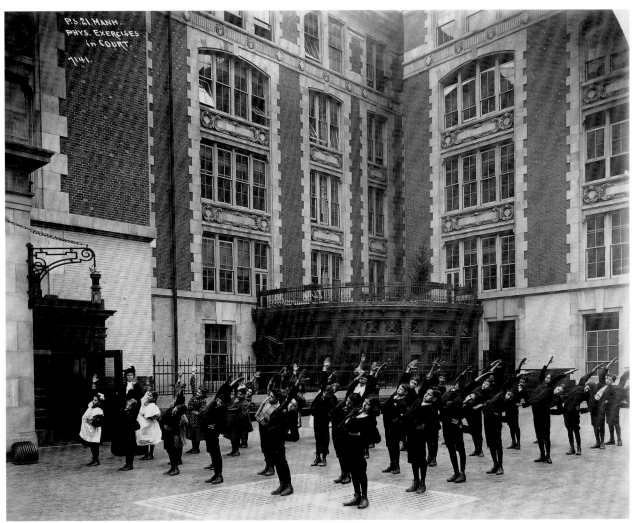

4.117

H plan for school design, with generous courtyards that increased the external wall space for windows.

As theories of progressive education spread, formal classroom structures with rows of desks bolted to the floor gradually disappeared in favor of arrangements that could accommodate more flexible approaches to learning. Figure 4.119 is a 1900 photo of a class of thirty-five young boys and girls in P.S. 7 at Twenty-first Street and Astoria Boulevard in Astoria, Queens. It portrays a typical well-ordered classroom. A photo of a nursery school in a South Jamaica public housing project (4.120), with its organized play designed to stimulate learning, shows a typical 1940 program. Note that both classrooms are integrated, with a few African-American students among the white majority.

Becoming an American involved changes in gender roles, cultural tastes, and aspirations for the future. Voluntary organ-

izations, from settlement houses to sister-hoods, sponsored education programs to Americanize immigrants and their children. Educators both in and outside the public school system tried to mold children's cultural tastes by teaching them the benefits of white bread and the dangers of olive oil along with literature and science. The Byrons' 1906 photo portrays a music class sponsored by the National Fruit and Flower Guild on Spring Street (4.121). Notice the children's proper posture, with hands neatly folded in laps, and the prominent place on the wall accorded the "Epworth League Pledge" of the Methodist Episcopal Church. Most of the children are probably Italian-American Catholics from the neighborhood. A few are clearly distracted by the camera, but one young boy has found the music completely soporific.

College education beckoned to the most ambitious. Columbia retained its prominence as the city's preeminent

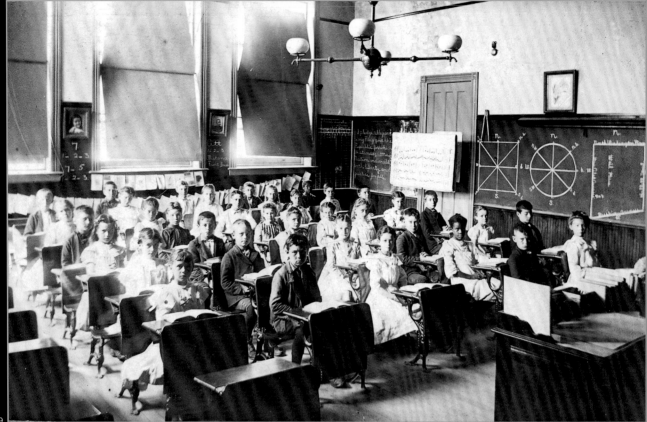

.119

.120

university. It moved up to its Morningside Heights campus, designed by McKim, Mead, and White in a neoclassical style, in 1897. Under the leadership of Nicholas Murray Butler (1902–45), the university modernized its curriculum and emphasized the importance of graduate and professional training with a bachelor's degree as a vital prerequisite.

The availability of a free college education at City College whetted the appetites of smart New Yorkers who saw in advanced study a ticket out of poverty (4.122). Jewish parents in particular encouraged their sons to study hard to make the grade at City College, nicknamed the "heder on the hill" because 80 percent of its students were Jews in the 1920s and 1930s. From its neo-Gothic campus on Convent Avenue and 138th Street, CCNY, the workingman's Harvard, competed with Columbia University on Morningside Heights for academic excellence. In the 1930s CCNY also gained a reputation for student radicalism. The buildings, designed by George B. Post, used Manhattan schist excavated from digging subway tunnels. The new campus opened in 1907 and inaugurated decades of expansion in student enrollment.

Innovations in public housing matched the city's pathbreaking efforts in education. However, not until unions and other workers' organizations constructed cooperative houses in the Bronx in the 1920s did the idea of public housing gain support.

Then the first projects were built on the Lower East Side. Unlike the diversity of public school buildings and the fine quality of their construction, public housing followed a basic standardized pattern. Most buildings were six stories high, arranged in modernist fashion to disrupt the city's gridiron. Provision was made for communal space and playgrounds for children, but the housing projects were exclusively

4.119. P.S. 7 classroom, Astoria, 1900. **4.120.** New York City Housing Authority, *South Jamaica Nursery*, September 24, 1940. **4.121.** Joseph and Percy Byron, *National Fruit and Flower Guild*, 1906. **4.122.** Ewing Galloway, *City College*, ca. 1925.

4.121

★

Public schools proclaimed a commitment to education as the path to an American identity.

●

4.122

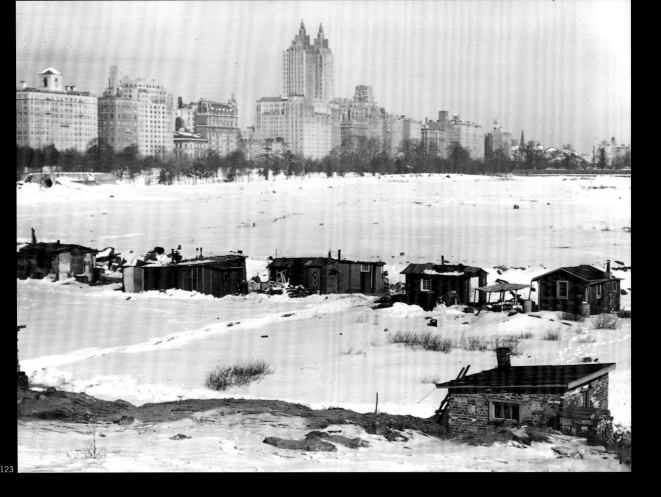

123

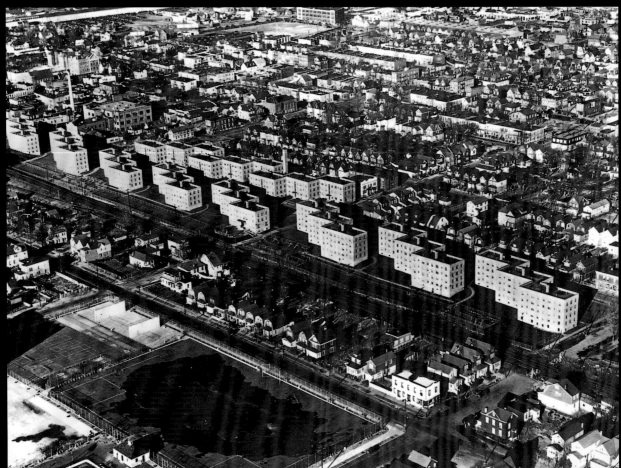

124

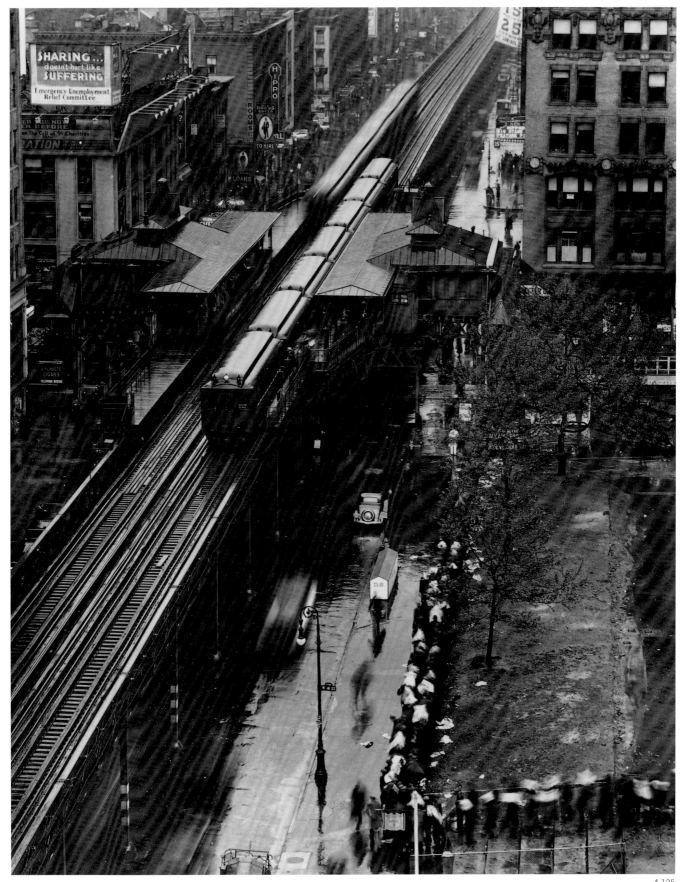

4.123. Nat Norman, *Hooverville, Central Park*, ca. 1930.
4.124. New York City Housing Authority, *South Jamaica, Aerial View*,
1940. **4.125.** Edward Steichen, *Bryant Park Breadline*, 1933.

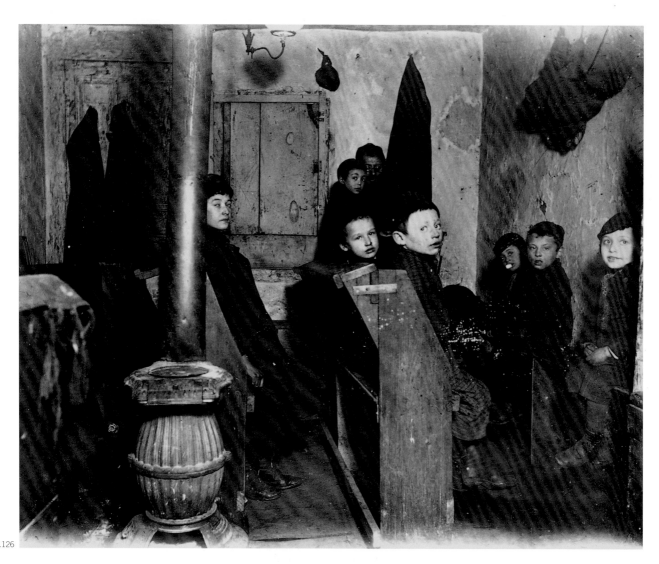

4.126

residential enclaves. Built during the Depression in poor sections of the city, the projects made no effort to adopt architectural styles that related to the neighborhood. An ascetic aesthetic governed public housing: it should be "safe, sanitary, and secure."[25] The view of South Jamaica houses in figure 4.124 shows how they stood out in an area of mostly one- and two-family homes in Queens.

The proliferation of squatter colonies during the Depression pointed up the need for public housing. Forced out of their homes, men and women built shacks wherever they could. They were dubbed "Hoovervilles," to mock President Herbert Hoover's inability to stem the deepening Depression. The stark poverty of so many New Yorkers accentuated the great gap between rich and poor. In Brooklyn a squatter's colony developed on Columbia Street, while in Manhattan hovels were built in Central Park

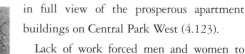

in full view of the prosperous apartment buildings on Central Park West (4.123).

Lack of work forced men and women to wait on lines for food and other necessities. Edward Steichen photographed a breadline in Bryant Park in the shadow of the Sixth Avenue elevated (4.125). A sign sponsored by the Emergency Unemployment Relief Committee proclaims: "sharing . . . doesn't hurt like suffering." Standing in the rain, the men have placed newspapers over their heads to stay dry. Gloom pervades the photograph, as it did the lives of so many dispossessed.

In times of trouble and joy, New Yorkers turned to their diverse faiths for comfort. Father Divine moved his Peace Mission Movement to Harlem during the Depression. He preached a religion of peace and interracial harmony, social justice and freedom from want. As evidence of his sacred gifts, he

promised to feed his followers. His lunchrooms in Harlem served good, plentiful, and cheap meals; his hotels offered clean, modest rooms at bargain prices (4.131). Those who joined the church feasted at banquets, signs of the father's abundant love.

On festive occasions, religious observances spilled out onto the sidewalks. The Easter Parade on Fifth Avenue in front of St. Patrick's Cathedral at Fiftieth Street provided an occasion to display sartorial finery. For at least half a century, the fashionable promenade exemplified the holiday and was a popular cultural rite of spring. Irving Berlin immortalized this New York custom in his hit song "Easter Parade," even as he nationalized it. Visitors came from out of town to view the spectacle, transforming the procession of privileged churchgoers into a jostling crowd. This 1906 photo captures the scene (4.128).

On the Lower East Side, Italian Catholic immigrants celebrated the feast of St. Rocco on May 23. This photograph shows such a festival in Bandit's Roost in 1895 (4.130). Setting up a shrine in the alley, celebrants blended their ethnic and religious identities, their old home with their new, by transplanting the service of their local patron saint to Manhattan's rocky soil. The *festa* of St. Rocco featured a processional march between the Church of Transfiguration on Mott Street and the Baxter Street Church. Immigrants believed St. Rocco protected them against diseases and pests, so supplicants often carried wax arms, legs, and hands during the procession.

Rites of passage, especially weddings, prompted a turn toward tradition. Brides often donned clothing that proclaimed their ethnic identity as well as their religious faith. Immigrants spent lavishly on weddings, hoping to recoup their expenses in gifts. Marriage ceremonies allowed couples to demonstrate their acculturation to America or their commitment to treasured folkways. Y. S. Wan posed for this formal portrait before her wedding at the Hotel Astor in 1907 (4.127).

4.126. Jacob A. Riis, *Talmud School in Hester Street Tenement*, ca. 1890. **4.127.** Joseph and Percy Byron, *Y. S. Wan Before Her Wedding*, 1894. **4.128.** Easter Sunday, 1906. **4.129.** Joseph and Percy Byron, *Greenwood Cemetery on Decoration Day*, 1899.

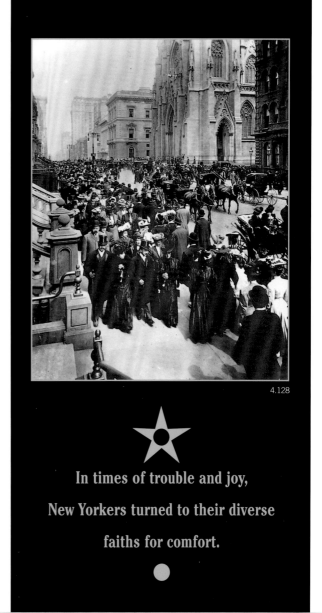

4.128

★

In times of trouble and joy, New Yorkers turned to their diverse faiths for comfort.

●

4.129

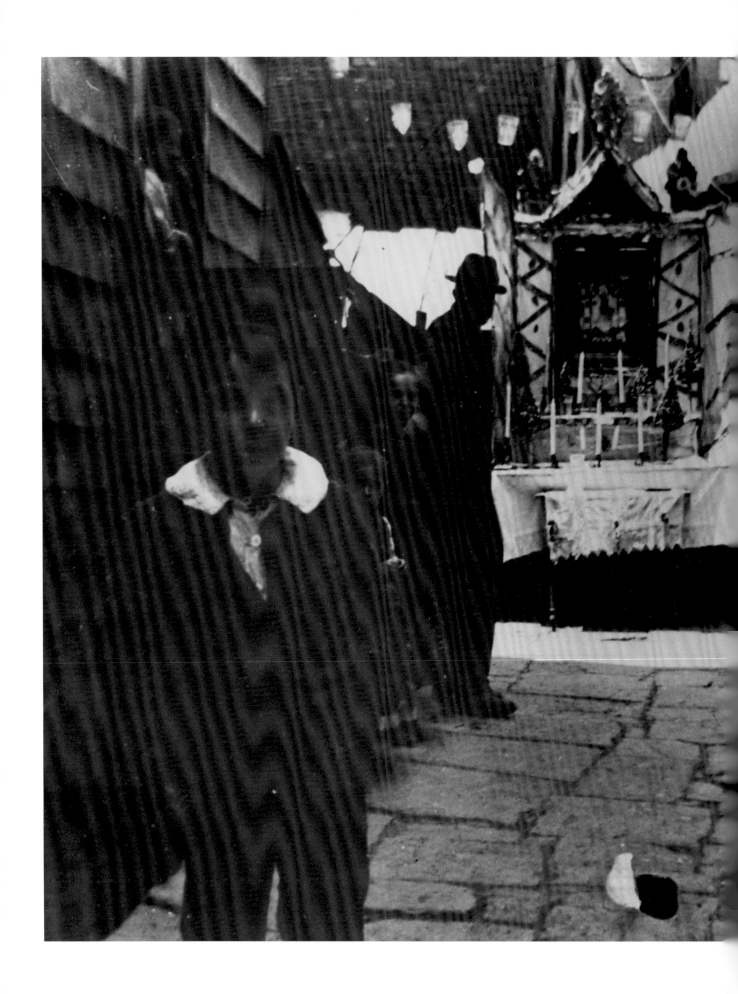

4.130

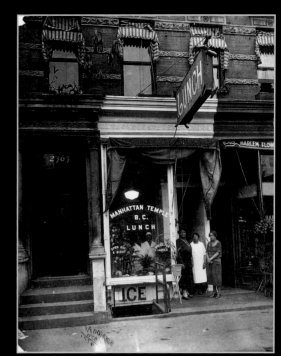

4.131

4.132

4.130. Jacob A. Riis, *Feast of St. Rocco, Bandit's Roost, Mulberry Street*, 1895. **4.131.** James VanDerZee, *Manhattan Temple, B.C. Lunch*, 1936. **4.132.** First Communion, 1921. **4.133.** Jacob A. Riis, *Ludlow St. Hebrew Making Ready for Sabbath Eve in His Coal Cellar*, 1895.

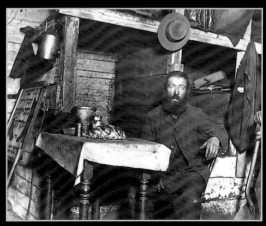

4.133

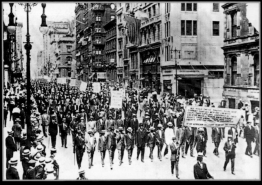

4.134

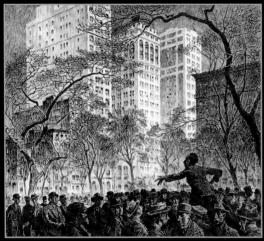

4.135

4.134. Silent march, July 1917. **4.135.** Martin Lewis, *Orator, Madison Square*, 1916. **4.136.** Morgan and Marvin Smith, *Street Mass Meeting*, 1938–39. **4.137.** Joseph and Percy Byron, *Women's Trade Union League*, 1910. **4.138.** Suffrage parade, 1913.

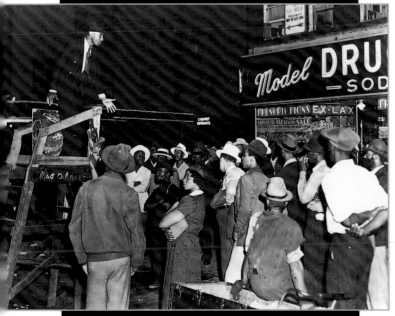

4.136

First communion also marked a special moment in the life cycle. The white dress and formal suit hint at the transformation of sister and brother. Unable to afford a professional photographer for the occasion, Estelle and Frank Gismondi stand near the grape arbor of their house in Elmhurst, Queens, in this 1921 photo (4.132).

Despite deep poverty and difficult living conditions, immigrants struggled to pass on a religious heritage to their children. At the heart of Judaism lies study of the Torah and its commentaries. More advanced students go on to learn the Talmud, the multivolume compendium of law and lore that has guided Jewish religious observance for centuries. Riis photographed an elementary school, or *heder*, in 1889 (4.126). There were hundreds scattered throughout the Lower East Side.

Jacob Riis recorded the terrible poverty pervading the lives of recent Jewish immigrants on the Lower East Side from the standpoint of an outsider, a Christian reformer. In 1895 he entered a Ludlow Street coal cellar on a Friday evening before the beginning of the Sabbath to photograph an observant Jewish immigrant without his family (4.133). On the table is the traditional braided challah loaf and a tattered prayer book.

The final resting place of necessity accommodated both religious beliefs and urban realities. Greenwood Cemetery in Brooklyn held the graves of New York's upper classes. Part of the natural cemetery movement in the mid-nineteenth century, Greenwood resembled a park with a lovely lake and rolling hills, and Brooklyn residents often treated it that way (see fig. 3.179). The Byrons' photo shows an 1899 Decoration Day parade to remember the Civil War's fallen dead at Greenwood Cemetery (4.129). Richard Upjohn designed the Gothic Revival gatehouses in 1861.

Although parades and funerals remained popular in the twentieth century, key elements of the city's public culture, New Yorkers increasingly adopted processions to argue the justice of various causes. The 1913 suffrage parade brought women into public view (4.138). After failing to convince Congress to give women the right to vote, suffrage leaders adopted a state-by-state approach. New York State defeated suffrage in 1915 but conferred the vote on women in 1917, three years before a federal amendment passed. In New York City the votes of immigrants, especially Jews, helped give a margin of

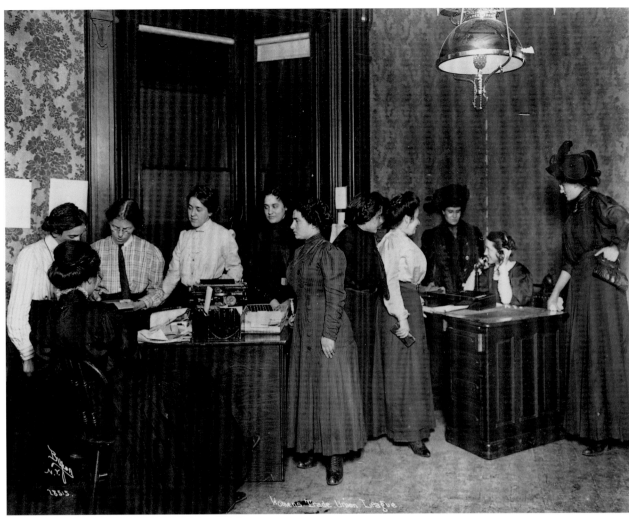

4.137

victory. The lead banner proclaimed: "FOR-
WARD OUT OF ERROR/ LEAVE BEHIND THE
NIGHT/ FORWARD THROUGH THE DARKNESS/
FORWARD INTO LIGHT." Other banners
demanded lower costs for food.

Political mobilization by women involved
recruiting immigrant support. Suffragists
encouraged striking women garment workers
during the 1909 "uprising of the twenty
thousand." The three-month strike involved
the largest number of women workers of any
strike to date and helped to establish the
International Ladies Garment Workers Union
on a secure basis. The Byrons photographed one of the strike
headquarters at the Women's Trade Union League on East
Twenty-second Street in January 1910 (4.137).

World War I sparked passionate debate on the sidewalks,
street corners, and squares of New York City. Streetcorner ora-
tory blossomed, especially in working-class areas. Martin

A key element in the city's public culture, New Yorkers adopted processions to argue the justice of their cause.

Lewis's print of a noonday orator in Madison
Square details the speaker's gendered appeal
and the grace of his gestures (4.135). As
World War I sundered Europe, its divisions
echoed among the city's immigrants, who
fiercely championed the causes of their
respective homelands. After the United States
entered the war, feelings intensified, espe-
cially during the 1917 mayoral race, when
Morris Hillquit, a Socialist, ran on a peace
platform.

In 1917, barely three months after the
United States entered World War I, Harlem
turned out for a silent march down Fifth Avenue in protest
against the East St. Louis race riot (4.134). Led by the writer
James Weldon Johnson and the intellectual W. E. B.
DuBois, nearly ten thousand African-Americans joined the
disciplined protest. Banners proclaimed: MR PRESIDENT, WHY
NOT MAKE AMERICA SAFE FOR DEMOCRACY? Mobilizing

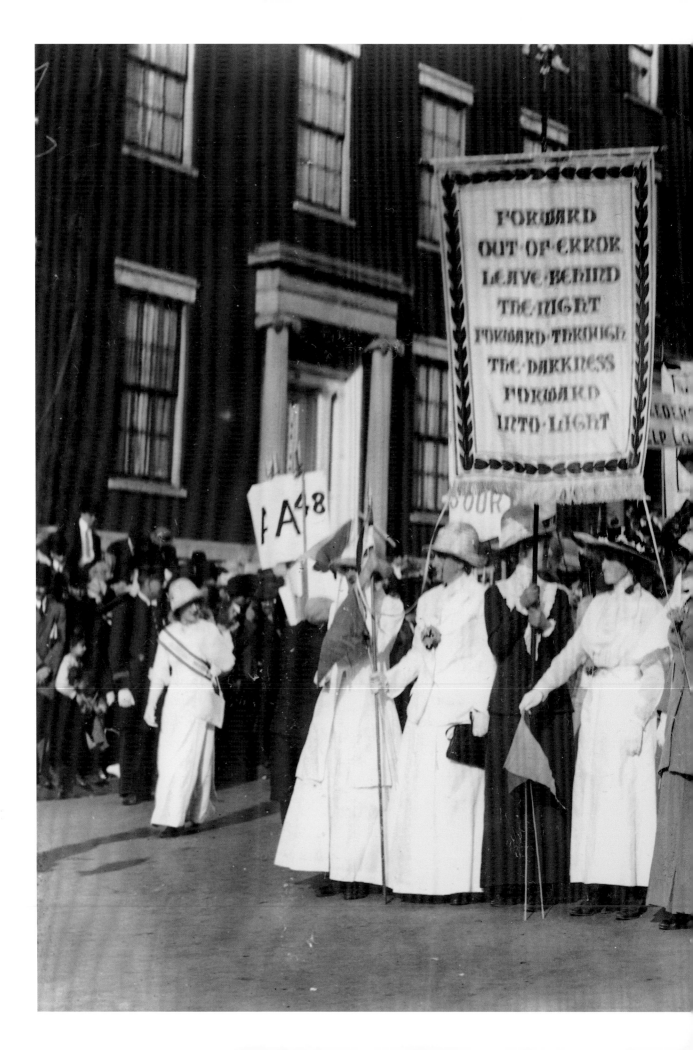

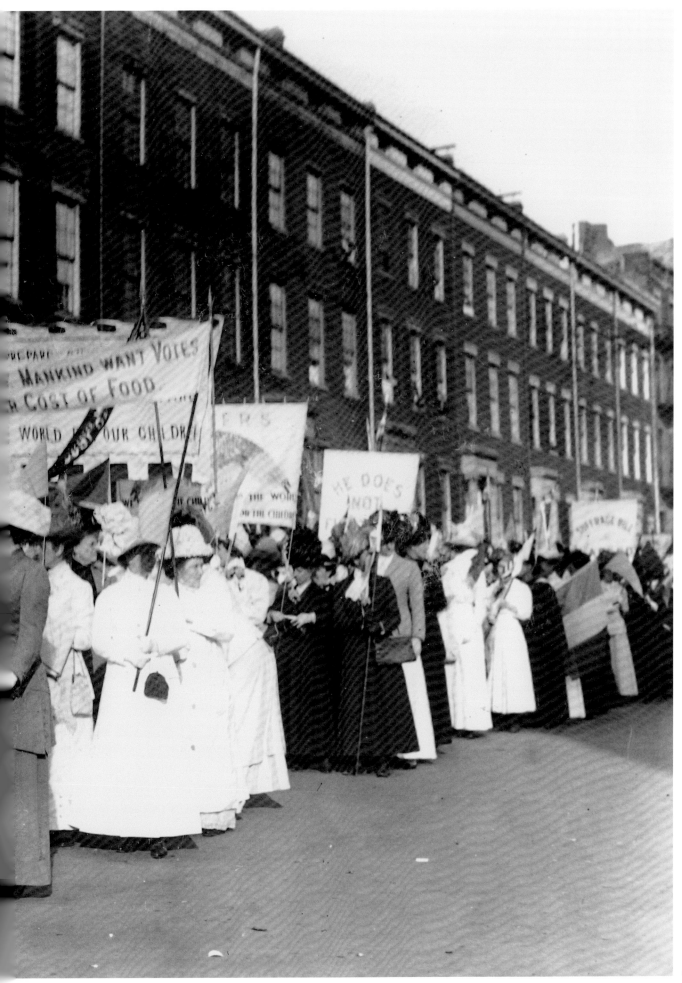

4.138

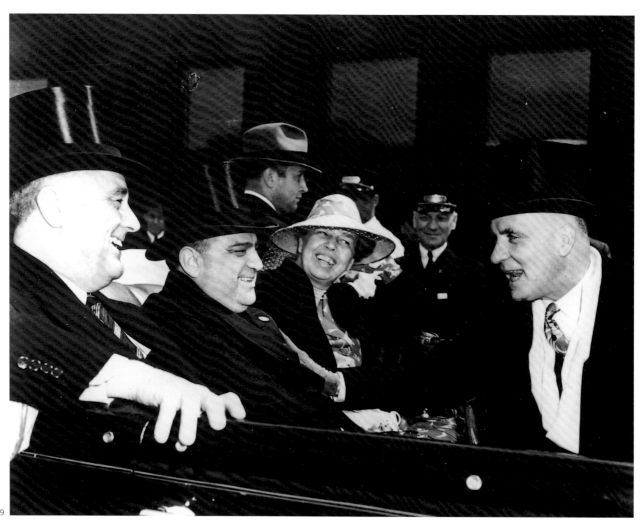

4.139

African-Americans to protest injustice was possible in part because of their concentration in Harlem.

Expressing their politics, demonstrating their loyalty, and proclaiming their service, women Red Cross workers marched on Fifth Avenue past the New York Public Library at Forty-second Street as part of the Armistice Day parade in 1922 (4.141). Completed in 1911, the library, designed by Carrere and Hastings, quickly established a powerful presence on Fifth Avenue with its landscaped terraces and broad steps, becoming a favorite site to review parades.

With the deepening of the Depression came increasing efforts to mobilize New Yorkers to protest injustice. Orators took to the streets to get their messages across. In Harlem on 125th Street political activists tried to convince local residents to boycott neighborhood stores that discriminated against African-Americans when hiring (4.136).

The opening of the 1939 World's Fair promised a better tomorrow.

May Day rallies drew socialists, communists, and labor unions to Union Square, near Tammany headquarters as well as those of many union locals. Marchers carried banners proclaiming their politics. This photo, taken by P. L. Sperr in 1934, demands the release of Ernst Thaelman, the German Communist Party leader incarcerated by the Nazis, and includes several signs in Yiddish (4.142). Antifascist rallies increased during the Depression and the heyday of the Popular Front.

The opening of the 1939 World's Fair promised a better tomorrow, or so hoped Mayor Fiorello LaGuardia as he rode with President Franklin D. Roosevelt and Eleanor Roosevelt, with Bronx Democratic leader Edward Flynn in the front seat,

4.139. Political leaders en route to the New York World's Fair, April 30, 1939. **4.140.** Adolph Fassbender, *Dynamic Symbol*, ca. 1939.

4.140

4.141

4.141. Armistice Day parade, 1922. **4.142.** P. L. Sperr, *May Day rally*, 1934. **4.143.** Wendell S. MacRae, *United States Army Bomber in Flight Over New York City*, ca. 1938.

to the opening ceremonies at Flushing Meadow Park on April 30, 1939 (4.139). A Republican mayor in a Democratic city, LaGuardia won reelection on fusion tickets and through adroit handling of tensions between the Tammany machine and the Democratic New Deal president.

Adolph Fassbender photographed the fair's Trylon and Perisphere as symbols of the future (4.140). Certainly the transformation of Corona dump into Flushing Meadow Park, a meeting ground for suburbanites and subway straphangers, represented one beneficial future for the city. Another future faced the Trylon and Perisphere: their four thousand tons of steel were scrapped during World War II to make bombs and military equipment.

Wendell MacRae's photo *United States Army Bomber in Flight Over New York City* proved to be a more accurate harbinger of the immediate future (4.143). Harnessing the power of flight with that of finance, bomber and city merge. The advent of war would freeze construction, leaving powerful images of the metropolis as constructed by immigrants and their children.

4.142

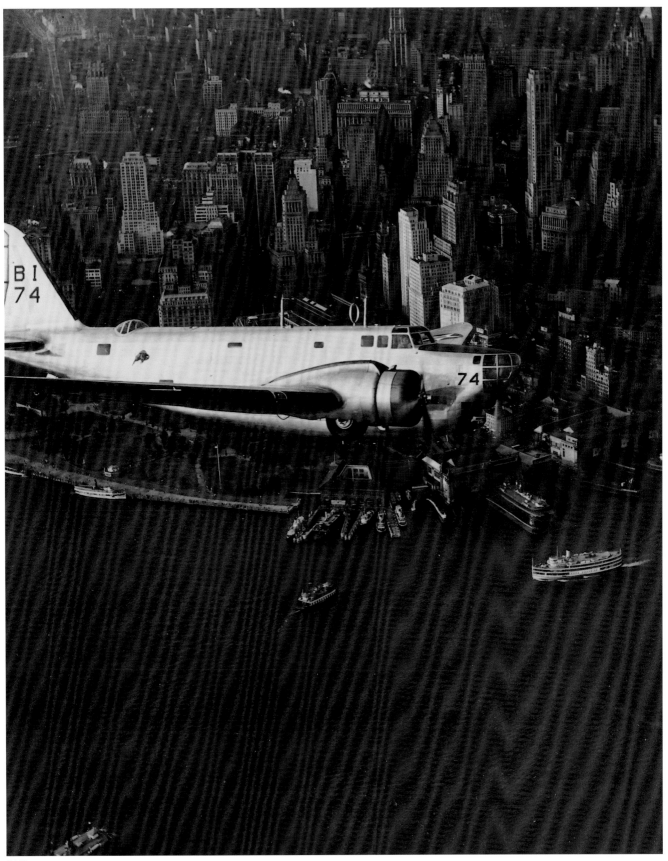

4.143

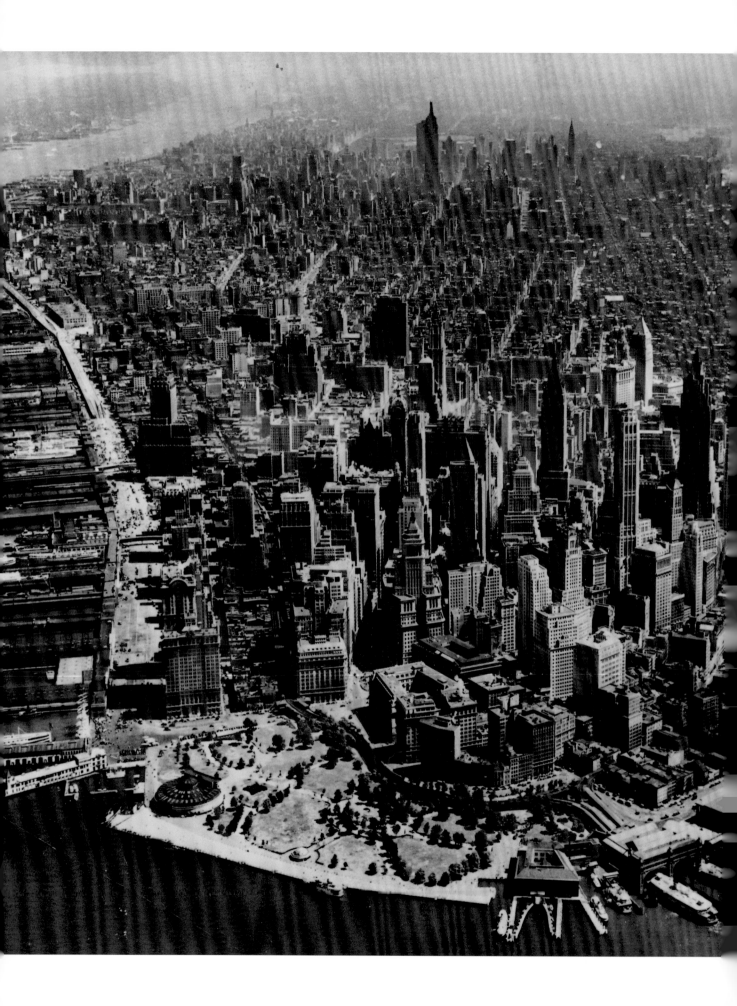

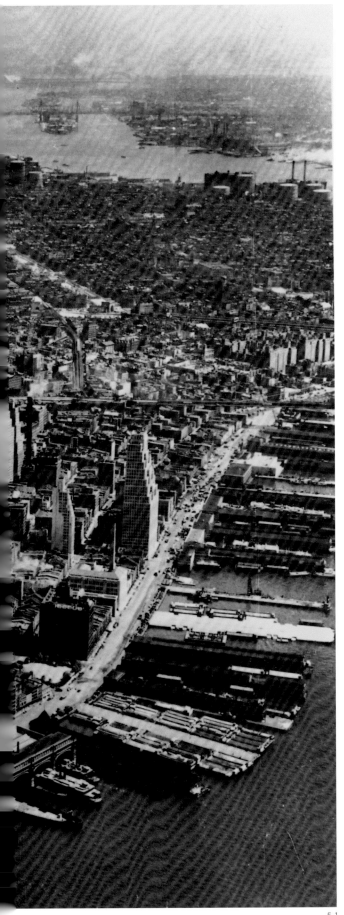

5

COSMOPOLITAN COMMUNITY

1940-1965

Mobilization for World War II pervaded all aspects of city life. As men entered military service, civilians rallied to support them. Many said goodbye at Penn Station, the departure point for recently recruited G.I.s and those who returned on furlough before shipping out overseas.

Rallies and parades stimulated civilian support for the war effort, especially important as the nation mobilized in the face of grim war news. The fight against racism abroad would inspire similar struggles for civil rights at home. The United States Armed Forces segregated its African-American soldiers, initially consigning them to labor and engineering battalions. As the war progressed and demands for more fighters grew, however, African-Americans entered combat in both ground and air forces. John Albok photographed all aspects of city life around his neighborhood in east Harlem, but human drama, on a large and small scale, particularly caught his eye (5.4). The banner proclaims: "REMEMBER PEARL HARBOR." An immigrant and patriot, Albok used his camera to express his sentiments.

Victory in 1945 arrived tinged with loss: of a president overwhelmingly beloved by New Yorkers and of many men who would never return. So dear did Franklin Delano Roosevelt

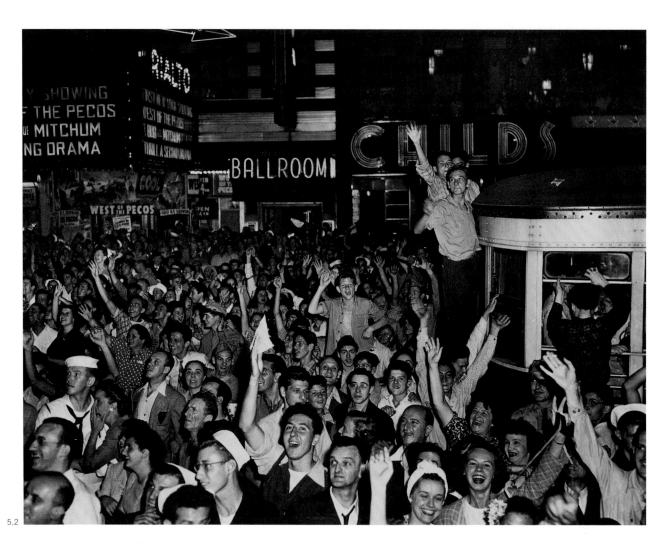

5.2

become to New York City voters that they organized a new party, the American Labor Party, so that loyal Socialists and union members could vote for FDR without pulling the Democratic Party lever in 1936. Austin Hansen photographed a newsstand in Harlem outside the subway station as the tabloids announced President Franklin D. Roosevelt's death on April 12, 1945 (5.5). The boys reading the news together were too young to have known any president other than Roosevelt. His death and the impending victory in Europe left the future uncertain.

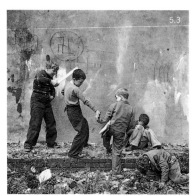

5.3

Arthur Leipzig's famous photograph of V-E Day in Times Square on May 8, 1945, captures the enormous enthusiasm that engulfed New Yorkers (5.2). As predominantly immigrants or the children of immigrants from Europe, to them victory in Europe mattered more than victory in the Pacific. Native New Yorker Leipzig photographed his city with an empathetic eye. A member of the

Photo League, he shared that organization's commitment to using the photograph as an instrument of social change.

After the celebrations, legacies of armed conflict remained in children's games. Vivian Cherry photographed children playing with guns in Yorkville, on the Upper East Side of Manhattan, in 1948 (5.3). The neighborhood housed a sizable concentration of German Americans, and in the prewar years rallies in support of Nazi Germany drew both opponents and sympathizers. In the postwar decade, the streets, complete with graffiti swastikas, served as a dramatic backdrop for children's imaginary battles. War games lost little of their appeal for the baby boomer generation. Frank Paulin's arresting photograph of a Lower East Side playground dates from 1956 (5.6). Some of the boys are playing tag, but the one with the surplus gas mask seems to share his elders' fantasies and fears of impending nuclear catastrophe.

Paulin's photo also offers an unfamiliar image of the

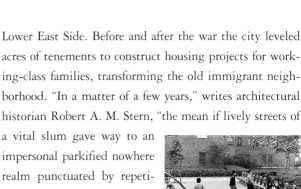

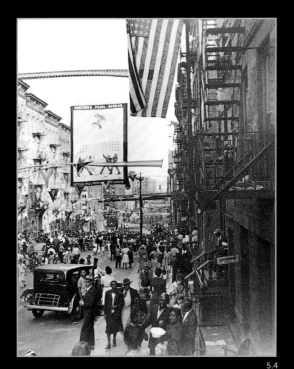

5.4

Mobilization for World War II pervaded all aspects of city life as men entered military service and civilians rallied to support them.

●

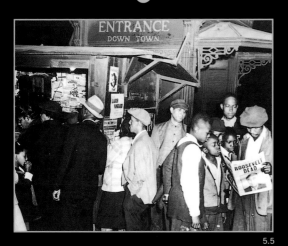

5.5

5.1. Andreas Feininger, *Lower Manhattan*, from *The Face of New York*, ca. 1954. **5.2.** Arthur Leipzig, *V.E. Day Times Square*, 1945. **5.3.** Vivian Cherry, *Yorkville Swastika*, 1948. **5.4.** John Albok, *World War II Demonstration in Harlem*, 1942. **5.5.** Austin Hansen, 1945. **5.6.** Frank Paulin, *Lower East Side Playground*, 1956.

Lower East Side. Before and after the war the city leveled acres of tenements to construct housing projects for working-class families, transforming the old immigrant neighborhood. "In a matter of a few years," writes architectural historian Robert A. M. Stern, "the mean if lively streets of a vital slum gave way to an impersonal parkified nowhere realm punctuated by repetitious, banal housing blocks."[1]

5.6

The war's end brought New York City unrivaled influence and power. Already a center of commerce and culture, it achieved renown as the epitome of urbanism. With its European and Asian rivals devastated by war, the city emerged without peer as a thriving metropolis. Its physical shape, increasingly familiar because of airplane photographs, expressed cosmopolitanism, usurping the place occupied by the great cities of Europe in preceding years (5.1). Later, other American cities desirous of recognition as urban centers would emulate New York's concentration and scale. It broadcast sophisticated urbanity, modernist style, and restless energy, and beneath this veneer lay an impressive concentration of power and wealth. The median income of city residents exceeded the national average by 14 percent in 1949. Manhattan, crowded with skyscrapers and ringed with piers, represented human power and American creativity.

In fact, New York's prominence obscured significant trends away from manufacturing and the population growth that had fueled its economy for over a century. With a population of 7.891 million in 1950, New York City reached a plateau. The marginal increase over the 7.454 million in 1940 represented a dramatic change from preceding decades, when the population grew by approximately a million every ten years. The figures actually disguised substantial migration out of the city to the suburbs (mostly Westchester, Long Island, and New Jersey), as well as a decline in numbers of foreign-born residents and their children. Both trends reflected the impact of federal policies, on the one hand, to encourage home ownership through the G.I. bill, and, on the other, to restrict immigration in 1924. For those who remained, the outer boroughs, as they came to be called—Brooklyn, Queens, the

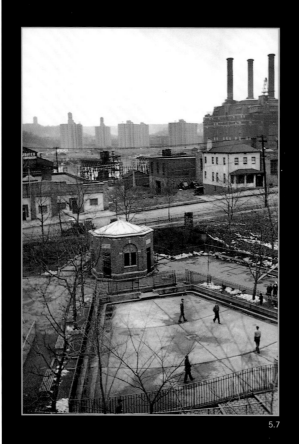

5.7

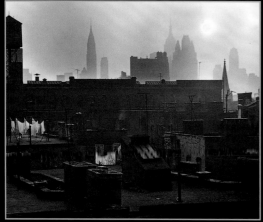

5.8

Bronx, and Staten Island—offered housing for the city's middle and working classes.

Andreas Feininger, born in Paris and educated in Germany, came to New York on the eve of World War II. He photographed the city in the 1940s and 1950s with the clarity of vision of someone seeing it for the first time. His photographs, especially those from his book *The Face of New York* (1954) (5.1 and 5.9), like Abbott's *Changing New York* of the 1930s, have decisively shaped our image of the postwar city.

William Glover took this photograph from an unusual perspective, looking west toward Manhattan from 179th Street and Sedgewick Avenue in the Bronx (5.7). His photo conveys a powerful sense of class contrasts. Children growing up in Brooklyn, the Bronx, Queens, or Staten Island saw Manhattan from afar and spoke of the island as "the city." Unlike Brooklynites, who approached Manhattan where its concentration of skyscrapers was most visible, Bronx residents crossed the Harlem River to enter a section far removed from the dazzling power of the financial district. Beyond the power plant on the right stand rows of public housing that transformed parts of East Harlem.

The United Nations, hope for a world without war, signified New York's global importance. Feininger's photograph of the UN from Queens juxtaposes the immense cemetery with the sheer glass wall of Le Corbusier's Secretariat Building (5.9). Built along the East River, between Forty-second and Forty-seventh Streets on First Avenue, the UN complex replaced a concentration of slaughterhouses and dramatically changed the character of Manhattan's East Side. The French architect's design provoked controversy, but its completion in 1950 also inaugurated a new era of office-building construction that combined air conditioning with central heating. Urbanist and critic Lewis Mumford thought the building "symbolize[d] the worst practices of New York, not the best hopes of the United Nations."[2]

5.7. William Glover, *Skyline Looking NW Towards Manhattan from 179th Street and Sedgewick Avenue*, February 19, 1950.
5.8. Scott Hyde, *View South from 411 East Seventy-first Street*, 1953. **5.9.** Andreas Feininger, *UN, View from Queens*, from *The Face of New York*, 1953.

5.9

5.10

Living in Manhattan in the postwar years meant cohabiting with skyscrapers. Scott Hyde's photo from the roof of the six-story tenement at 411 East Seventy-first Street dramatizes the city's shapes and rhythms as a tonal interplay of forms (5.8). His view captures elements of urban living that typify New York City sight lines. These include water towers (on the far left and in the center), a ubiquitous feature of rooftop architecture made by several family firms, as well as delicate antennas to catch television signals. The latter were new rooftop denizens, a trademark of the entertainment and communications revolution of the 1950s, which was centered in New York City. Such popular television shows as *The Goldbergs* and *I Love Lucy* would broadcast versions of New York throughout the nation. Behind these objects figure iconic symbols of the city—the monumental Chrysler (on the left) and Empire State (center) Buildings—though the mundane clotheslines and skylights in the foreground compete with background skyscrapers for our attention. The telephoto lens Hyde used condensed and flattened the planes.

From the skies to the streets, the city's geometry, its irregular patterns, invited a modernist aesthetic of repetition. Innovations in photography made New York City look and feel different in the postwar era, although the buildings were not new. Figures walk down Forty-sixth Street, but Feininger focuses on the march of windows and

stoops of the brownstone rowhouses (5.13). He sees the uniformity of urban buildings in the era of the organizational man. New York gave Feininger "the basic material for that special way in which I like to do photography—right angles and straight lines, repetition of formal elements (windows!), three dimensionality in its most pronounced form, and spatial order."[3]

Godfrey Frankel's dramatic view beneath the last remaining elevated train on Third Avenue similarly accentuates

5.10. Rebecca Lepkoff, *20 Prince Street, Clothesline, Lower Manhattan*, 1947. **5.11.** Godfrey Frankel, *NYC, 1946*.

the city's geometry (5.11). Although the rectangles of light on the cobblestones are far from regular, their repetition invokes a kind of urban talisman. Frankel came to New York City in 1946 to study social work after spending the war years in Washington, D.C., where he photographed children, subsequently published as *In the Alleys*. He joined the Photo League and got to know the Lower East Side. There Frankel "captured a piece of the street, and made a history of the commonplace."[4]

As most New Yorkers traveled to work, neighborhoods increasingly became places of residence and commerce rather than sites of production. The Lower East Side, once the city's poorest and most crowded area, still held many

5.12

cheap apartments, but far fewer of them housed sweatshops. New residents to the neighborhood included Puerto Ricans and African-Americans. Walter Rosenblum took this photo of a boy on the roof of a tenement on Pitt Street in 1950 (5.12). Behind the boy snake the angular shapes of airshafts, designed to satisfy early tenement house legislation. In the background can be seen the Manhattan Bridge.

5.13

Clotheslines still fluttered high above backyard tenements, but the clothing hanging out to dry revealed a modest prosperity. Photographers, too, looked at the clothes differently, not just as symbols of poverty but for their abstract beauty, their power to punctuate space. Rebecca Lepkoff photographed these clotheslines behind tenements on Prince Street in Little Italy (5.10). Reluctant to leave the old neighborhood for the suburbs despite postwar pros-

perity, Italian families often remodeled their tenement apartments, introducing modern amenities. They sustained their ethnic community in the heart of the city, and at times three generations would live within a few doors of each other. Those who moved away regularly returned to shop, eat in the restaurants, or visit in the coffeehouses.

Corner luncheonettes, bars, and food shops gave a neighborhood character and its residents a place to meet, vital components of a humane urbanism. Kosher eateries on the Lower East Side catered to the changing tastes of the remaining Jewish population, many of them orthodox (as the young men pictured in Scott Hyde's photo [5.14]). Notice that each man is wearing a yarmulke, considered by an earlier generation of Jews to be indoor headgear. For those who came of age after the establishment of the State

of Israel in 1948, wearing a yarmulke on the street expressed pride in Jewish identity. Notice, too, that the kosher food is pizza, a mingling of flavors that suggested how much New Yorkers enjoyed eating from the ethnic melting pot.

Chains, like the distinctive White Tower hamburger shops, competed with individually owned restaurants for residents' patronage and loyalty, becoming integral to a neighborhood as in this case, the area around City College. Scott Hyde took this photo of a White Tower on the corner of 136th Street and Broadway, near City College, on a summer evening in the mid-1950s (5.15). For two decades starting during the Depression, radical students gravitated to City College, giving it a reputation as a leftist school. At the same time, admission standards rose. In 1941 high school students needed a minimum grade-point average of 3.5 to enter. Next door to the White Tower is a restaurant and, above that, a gym. Up the block was Lewisohn Stadium, a large open-air stadium that offered diverse concerts at popular prices in the summertime.

Born in Minnesota, Scott Hyde arrived in New York City after the war. Photography's inherent capacity to generate inexpensive multiple images stimulated him to explore the creative possibilities of offset lithography. Hyde's aesthetic vision reinforced his democratic commitments. He photographed the city's daily life with empathy for its ordinary dimensions.

As gendered spaces, eating and drinking places fostered sociability and solidarity. Scott Hyde's photos of a bar and a luncheonette preserve the interiors of two very different social spaces circa 1952. The simple bar on Second Avenue and Thirty-fourth Street has a barmaid (5.17); the modest luncheonette located on Second Avenue in the fifties has a male proprietor (5.16). Yet the latter invites men, women, and children, while the former appeals to only men. Both, however, could be considered homes away from home that cemented people's connections to the neighborhood, their urban community. The sociologist Philip Slater writes: "A

5.12. Walter Rosenblum, *Boy on a Roof*, 1950. 5.13. Andreas Feininger, *Brownstones, Forty-sixth Street*. 5.14. Scott Hyde, *Noah Zark Kosher Pizza Parlor, Lower East Side*, 1965. 5.15. Scott Hyde, *136 and Broadway*, ca. 1955.

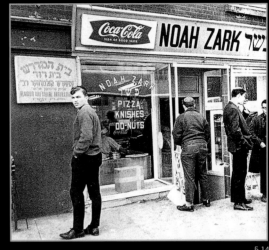

5.14

As most New Yorkers traveled to work, neighborhoods increasingly became places of residence and commerce rather than sites of production.

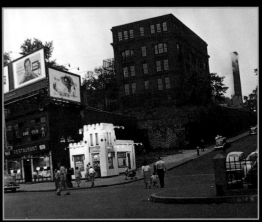

5.15

community life exists when one can go daily to a given location at a given time and see many of the people one knows."[5]

The bar's muted light, its wooden counter, and glittering juke box spelled relaxation, entertainment, and homosocial friendship. By contrast, the metallic surfaces of the luncheonette appear utilitarian and shiny, as if waiting for customers. These would vary depending on the time of day: workers grabbing a morning coffee, businessmen eating a quick lunch, children ordering five-cent egg creams after school, single men and women enjoying the blue plate special. Full pots of coffee sit ready on the burner, as do dishes for ice cream on the shelves above them, unlike the liquor bottles lined up in the bar. The luncheonette's twin mirrors flank a Coca Cola sign with a place to list three or four Schrafft's ice cream flavors. (Known for its ice cream desserts and luncheon sandwiches, Schrafft's, a restaurant chain that catered to middle-class women—unlike this luncheonette with its varied clientele—numbered over fifty restaurants.)

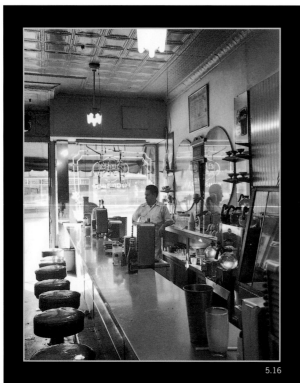

5.16

5.16. Scott Hyde, *Unknown Restaurant, Second Avenue at About Fifty-third Street,* 1952. **5.17.** Scott Hyde, *Barmaid, Second Avenue at Thirty-third or Thirty-fourth Street,* 1952.

5.17

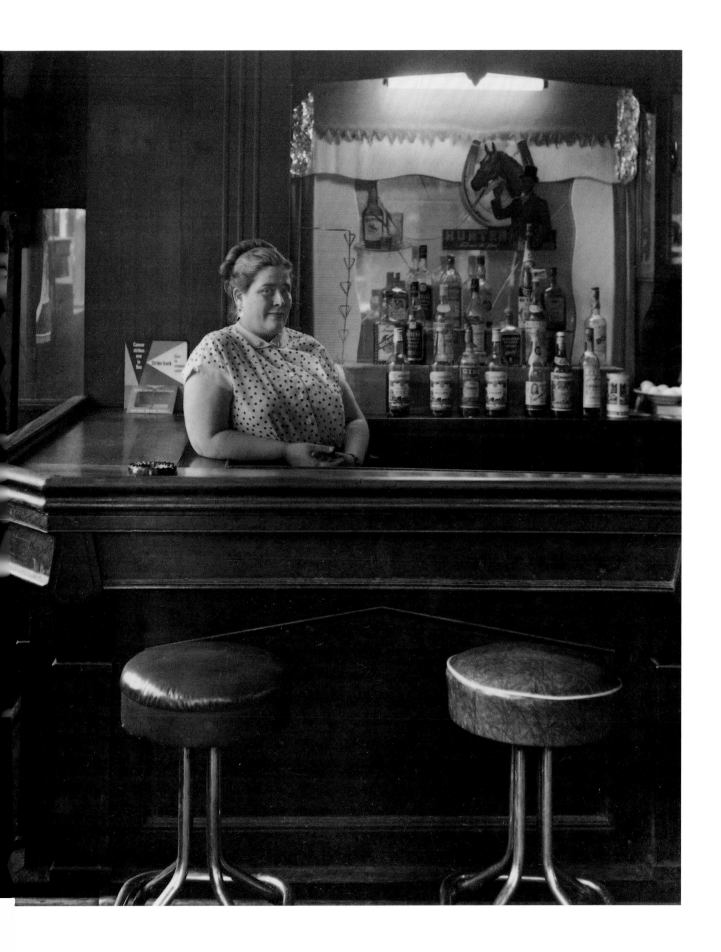

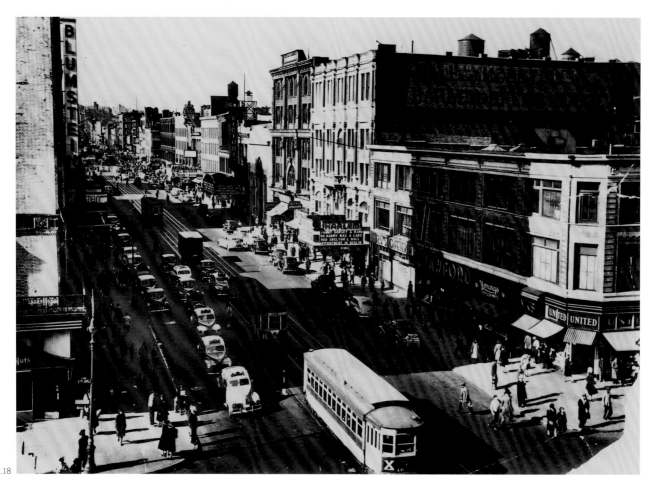

5.18

The round stools show signs of wear, but the counter is clean. Fluorescent lights hanging from the hammered tin ceiling indicate that the shop has been modernized.

Class and race defined city neighborhoods, but many areas contained a mix of buildings and residents. The Depression and war froze new construction, leaving neighborhoods with diverse buildings dating from different eras and immobile residents living in aging apartments. Irving Underhill's firm took this photo of the northwest corner of Broadway and 107th Street on October 25, 1946 (5.19). The image portrays a combination of buildings that typified many neighborhoods in the postwar years and not just the Upper West Side. It includes prosperous tall apartment buildings serviced by elevators (the one on the far right is a good example), modest five-story walk up apartment houses constructed before World War I (such as on the left, on the corner of 107th Street), and apartment hotels with single-room occupants (e.g., the building in the middle of the

5.19

block). The mix of food stores—a dairy grocery, bakery, meat market, and Asian food shop—reflects both the tastes of local residents, many of them Jews, and the opportunities for small-scale commerce before competition from supermarkets.

The Murray Hill neighborhood east of Fifth Avenue in midtown Manhattan similarly included mixed residences, only here all of them were expensive. This Underhill photo taken on the same clear October day pictures the Princeton Club at the corner of Park Avenue and Thirty-ninth Street, with large elevator apartment buildings behind it to the left and a tall office tower in the background to the right (5.20). The Princeton Club offered its male Ivy League members dining facilities, lounges, a library, and opportunities to socialize with business associates and other alumni. Clubs provided alternatives to the home visits popular among the upper classes of an earlier era.

Andre Kertesz's photo of Greenwich Village rooftops taken from his twelfth-floor apartment at 2 Fifth Avenue

next to Washington Square Park (see fig. 5.26) conveys the mixture of building styles from different periods that characterized that neighborhood (5.21). Diverse types of residences usually meant residents whose income and ethnicity varied. Certainly that was the case in Greenwich Village, which included Irish, German, and Italian ethnics along with middle-income families and a young, bohemian population of artists, writers, and poets. The critic Kenneth Tynan called the Village "the internment camp of Manhattan nonconformity," pointing out that "for every artist it attracts a hundred civilians, so that the secret garden is ridden with vagabond neurotics and trampled underfoot by tourism."[6] The appeal of the neighborhood, its intimate physical scale and offbeat reputation, drew developers eager to cash in on such virtues yet seemingly unaware that the massive conventional apartment houses they built to entice newcomers would also destroy the area's distinctiveness.

Although Harlem rebounded from the Depression, it never regained the cultural creativity and renown of its 1920s' heyday. Harlem's "talented tenth" included writers, artists, poets, musicians, composers, intellectuals, religious and political leaders, businessmen, and entrepreneurs. Those with the most money sought out homes on Sugar Hill, along Edgecomb Avenue with a view facing east across Colonial Park and Harlem to the river. Its lavishly decorated apartment houses were home to some of Harlem's most famous, including jazz greats Duke Ellington and Cab Calloway, championship boxer Jack Johnson, and Walter White, head of the National Association for the Advancement of Colored People. Harlem's main street, 125th Street, stretched from river to river (5.18). Lined with theaters, stores, and eating places, it attracted crowds of shoppers from the neighborhood. The city's changing economy coupled with enduring occupational discrimination denied most native-born black New Yorkers social mobility in the postwar era. This view from above shows the streetcar, truck, and taxi traffic, as well as the largely undistin-

5.18. 125th Street, Harlem, 1943. 5.19. Irving Underhill, *2781–2785 Broadway*, October 25, 1946. 5.20. Irving Underhill, *Princeton Club*, October 25, 1946. 5.21. Andre Kertesz, *Greenwich Village Rooftops, Day*, ca. 1952.

5.20

Class and race defined city neighborhoods, but many areas contained a mix.

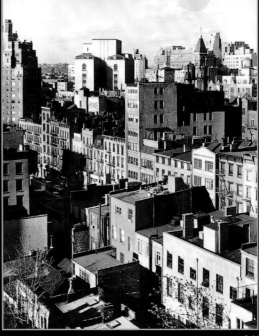

5.21

5.22

⭐

**Demolition
invaded Manhattan's
old residential
neighborhoods as business
districts expanded.**

●

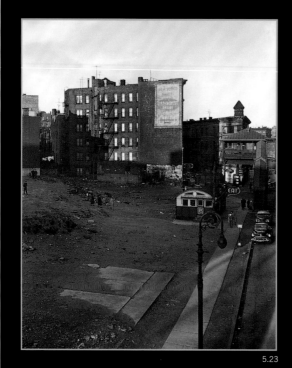

5.23

guished architecture characteristic of most of the buildings.

Brooklyn retained its reputation as the borough of homes, with crowded living conditions for all but the wealthy. Its working-class areas lacked much sense of grace. Immigrant Jewish neighborhoods like Brownsville measured success by the distance a native could travel away from home. To cross the bridge to live in Manhattan signified an immense move up the social ladder. Unlike the Lower East Side, Brownsville evoked little nostalgia in the postwar decades. The densely Jewish area bred rabbis and gangsters, novelists and entrepreneurs. As new housing opened in Queens and on Long Island, Jews left the area for a larger piece of the American dream than a tenement apartment.

An infantry squad leader in combat in World War II, N. Jay Jaffee returned home to Brooklyn and adopted photography to make sense of his world. He subsequently studied with Sid Grossman, a leader of the Photo League. Jaffee appreciated photography's cathartic power. His photographs of East New York and Brownsville record an ethnic neighborhood on Brooklyn's eastern edges rarely visited by other photographers. In this image from 1950, winter's slanting shadows catch two columns framing an apartment house doorway in East New York that speak to its builder's aspirations (5.22). The abandoned candy store and corner luncheonette announce the area's decline.

In the Bronx, demolition promised little improvement. Hyde's crisp photo of the Jackson Avenue elevated station taken on a quiet Sunday morning in 1950 captures the glint of the sun on tenement windows (5.23). The vacant lot in the foreground shows no promise of construction; the weathered buildings and faded sign for Goldencrust Bread, a local product, give the image an aged quality. In the postwar decades, baking declined as a significant manufacturing industry in New York. Similarly, the new wave of residential construction sweeping the city largely bypassed the Bronx, except on its western and northern fringes, in the Riverdale section.

In the 1950s demolition invaded Manhattan's old resi-

5.22. N, Jay Jaffee, *Pillars in Sunlight #2*, 1950. **5.23.** Scott Hyde, *Jackson Avenue Elevated Station, Bronx*, 1950. **5.24.** Scott Hyde, *Seagram Building Under Construction*, ca. 1954.

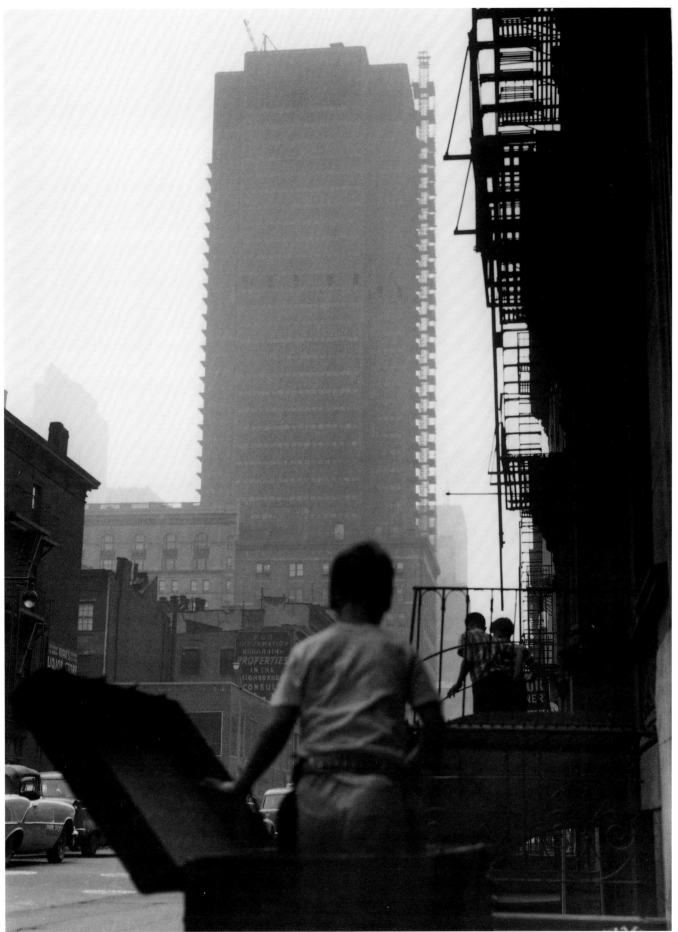

5.25

5.25. John Albok, *The New York Reservoir at Dusk*, 1959. **5.26.** Lee Sievan, *Washington Square Park with Restroom*, 1940s. **5.27.** Andre Kertesz, *Washington Square, Winter*, 1954.

5.26

dential neighborhoods as business districts expanded and the population shifted decisively to the outer boroughs, especially Queens. Hyde chose to photograph the construction of the Seagram Building from the vantage point of the residential neighborhood to its east (5.24). This area housed immigrants and their children, many from Central and Eastern Europe. The Seagram Building, built on the site of several apartment houses on Park Avenue between Fifty-second and Fifty-third Streets, would attract universal acclaim for its bold expression of the international style. It represented the new corporate urbanism that followed in the wake of the UN Building. At the end of the war, 140 of the nation's 500 largest corporations had their headquarters in New York City, and despite the decline in manufacturing, the city's business appeal continued to grow. The midtown choice of location signaled a new round of demolition and construction that would rearrange urban space, transforming Park Avenue north of Forty-second Street into commercial blocks.

In an increasingly pressured city, people escaped into the parks, urban oases of nature surrounded by the workaday world of business. Parks offered photographers a kind of template on which to encode their individual aesthetic sensibilities. Repeatedly drawn to the parks' drama—their configuration of light and shadow, the movement of people on pathways amid trees and shrubbery, the reflections of the city recast in bodies of water—photographers represented parks as central features of the modern urban landscape. Ironically, the borough with the largest proportion of land devoted to park uses, the Bronx, rarely attracted as much attention as its park-starved neighbor, Manhattan.

Bryant Park, a small urban park, is located at Forty-second Street and Sixth Avenue, behind the New York Public Library. N. Jay Jaffee's photo catches a moment of respite from the day's pressures as well as the sun's lure for those working in offices nearby (5.28). As the city increasingly became the site of corporate headquarters, it supported firms in such service industries as banking, law, advertising, accounting, communications, security and commodity trading, and management consulting. The

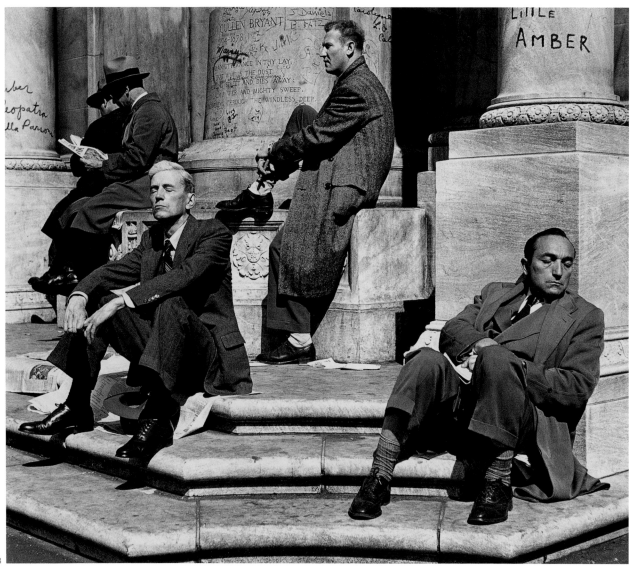

5.28

numbers working in professional and related services rose steadily from 1940 through 1990, with the biggest boom coming in the 1960s. Jaffee's dynamic composition of businessmen catching some noonday sun, seated haphazardly on the graffiti-scarred columns of the monument to William Cullen Bryant, the indefatigable editor and advocate of public parks, shows no trace of nature or nature's beauty. The photo comments ironically on New York's gritty urban world, even in a park.

Lee Sievan, by contrast, focuses on friendship. Parks for her are meeting places, spaces to nourish encounters that create ties between New Yorkers. These spaces allowed young and old, men and women, to play and relax, especially on weekends. Sievan's photo of Washington Square Park in Greenwich Village presents a classic account of its separate yet intertwined worlds (5.26). Carefully composed, the image reminds us of relationships built one move at a time. The photo of two men sitting on a bench with a little girl playing in the puddle before them pays attention not only to the textures of water versus concrete but also to the implicit connection between the men and the girl. In the city's built environment, all people are interdependent.

Andre Kertesz brought a completely different aesthetic to the park. Living across the street, he often photographed it from his living room terrace. His images are studies in abstract composition, the play of positive and negative spaces, as in this photo of the park in winter (5.27). The small dark figures walking through the snow appear as part of a sensual landscape, with its curving fences, lacy trees, and graceful pear-shaped lamps. Kertesz invites new ways of seeing the city.

Parks provided a vantage point to reflect on the city, to consider urbanism from a place a part of yet apart from New

York itself. Consider John Albok's photo of the reservoir in Central Park that reduces the skyline to a miniature (5.25). Here, he emphasizes nature, the sky reflected in the water, and the three ducks leaving traces of their passage behind them. This photo allows the park and its possibilities to overturn traditional urban perspectives. Like Kertesz, Albok lived a block away from the park he photographed. It was part of his neighborhood, his city, and utterly different from a suburban subdivision.

During the Depression, Robert Moses, commissioner of parks, constructed playgrounds along the periphery of Central Park and several ball fields to expand recreational opportunities. After World War II, several benefactors donated funds for ice-skating rinks and a refurbished boathouse. In 1957 the New York Shakespeare Festival, headed by Joe Papp, acquired a permanent home in the park for its free, open-air, summertime performances, albeit over Moses' opposition. These innovations drew increasingly large numbers of city residents to use the park.

Despite visions of calm, rarely did New Yorkers find solitude. Russell Lee's photograph of Central Park benches on a brisk fall day shows how many city residents enjoyed both the park and Sunday papers (5.29). Here, the park's backyard attributes emerge. Men and women find their spot in the sun to relax. Newspaper reading engrossed all New Yorkers; many families regularly bought two (often the second paper was a foreign-language daily). Choices of morning and evening papers remain, although a series of strikes in the early 1960s dramatically reduced the number of daily papers from eight to three: the *Times*, *Post*, and *Daily News*.

Coney Island remained a democratic summertime mecca in the postwar decade, before automobiles, highways, and suburban development lured New Yorkers to relax beyond the subway's reach. The constant presence of people enhanced the frenetic pace of amusement, though the numbers of visitors declined from the daily million of prewar summers. But when the beach emptied out, those who lingered paid attention to the photographer. In 1947 Sid Grossman photographed young Latino men who perform both for the camera, with an obscene gesture and erotic pose, and for their female friend's appreciation (5.30).

Photographers gravitated toward the erotically charged aspects of commercialized fun. Arthur Leipzig caught this couple at Steeplechase Park during its heyday as an amusement center for adults and teenagers (5.32). The mechanical rides were fast and fun, occasionally provocative (including blasts of hot air to raise women's skirts) but usually with a kind of exuberant innocence. Leipzig noticed the aura of eroticism in such public performances. Opened in 1897, Steeplechase and its famous Parachute Jump closed in 1964.

Lying on the beach and sunbathing, with picnic basket and thermoses, three women ignore the crowds. Their demure postures and stylish bathingsuits both invite stares and resist a penetrating gaze. Leipzig, too, negotiates just such a move with his camera (5.32). Contrast this view of three women at the shore with the turn-of-the-century image shown in figure 4.81. The same homosocial behavior now appears sexualized.

The crowds along the boardwalk did not diminish at night. Initially constructed in 1923, the boardwalk ran for four miles from Brighton Beach to Sea Gate. Robert Moses opposed commercialized amusement stands and forced many to close when he widened the beach during the Depression. By the postwar decade, Coney Island contained established communities of year-round residents. Jack Lessinger photographed the ebb and flow outside the Tornado, a fearsome

5.29

5.28. N, Jay Jaffee, *Bryant Park*, 1953.
5.29. Russell Lee, *Central Park Benches*, October 1947.

5.30

Coney Island

remained a democratic

summertime mecca.

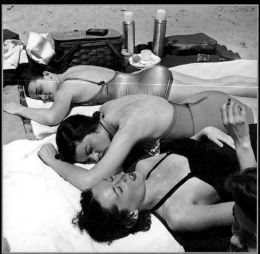

5.31

5.30. Sid Grossman, *Coney Island*, 1947. **5.31.** Arthur Leipzig, *Coney Island*, 1952. **5.32.** Arthur Leipzig, *Steeple Chase*, 1949.

5.32

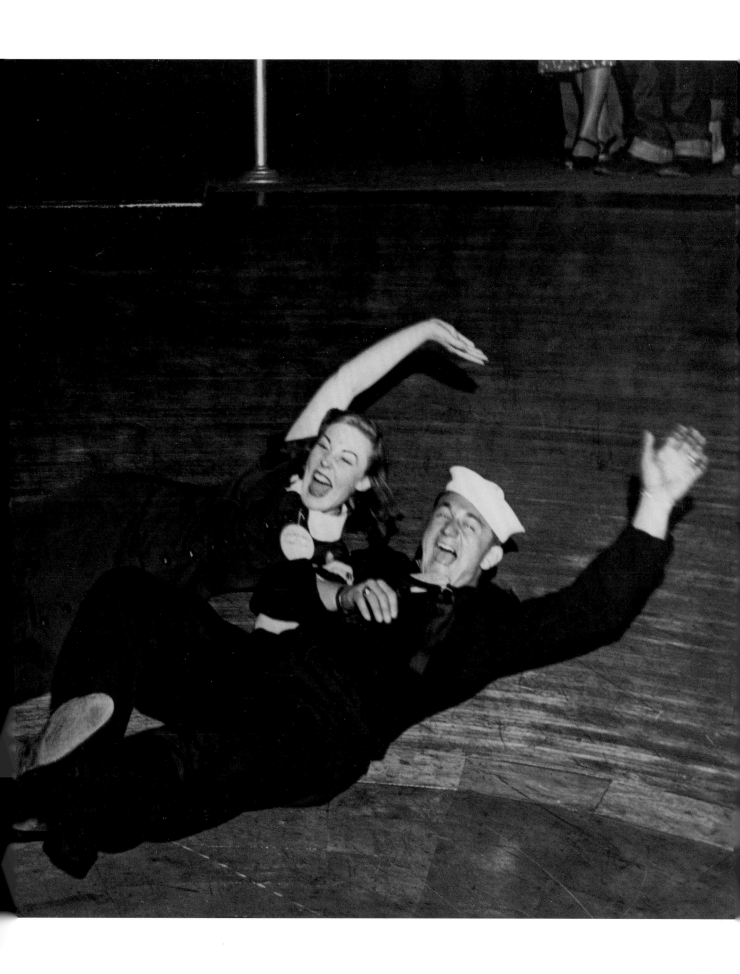

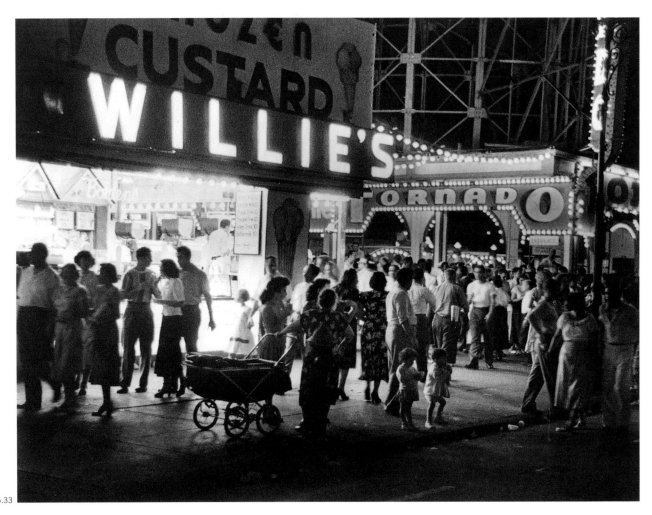

5.33

roller coaster (5.33). Frozen custard (a soft ice cream) and cotton candy, in addition to hot dogs, appealed to New Yorkers on a hot summer evening.

Crowds accompanied city dwellers wherever they turned. New Yorkers negotiated differences—of background, ethnicity, gender, and class—where they lived and worked. In the postwar decades, the number of foreign-born declined to less than 20 percent of the total population, the lowest in the century. Rather than becoming more uniform, however, New Yorkers transformed immigrant differences of language and culture into ethnic otherness, sustained by occupation, residential segregation, politics, and religion. Born in New York, Irish, Jews, and Italians spoke English and enjoyed the city's fast-paced culture. Yet each ethnic group concentrated in different jobs, shared neighborhoods with some reluctance, and competed for political advantage. Together with African-Americans, Chinese, and newly arrived Puerto Ricans, they shaped New York's urban style in the postwar decades.

The flow of pedestrians and traffic through a major crosstown street like Forty-second Street could be seen as a particular urban rhythm, a series of staccato notes, jumbled up next to each other as in Glover's photo of the corner of Fifth Avenue (5.34). New Yorkers called it "pounding the pavement," a rapid gait of walking coupled with a strong sense of determination and purpose. Notice the traffic light with the statue of Mercury; only Fifth Avenue had such distinctive lights.

Glover's photo testifies to the street's democratic character; to its dynamism, vigor, and lack of regimentation; and to fashion consciousness in a city whose garment industry still clothed many Americans. Although factories began moving to New Jersey and Connecticut during the Depression to escape the ILGWU and its organizers, out-migration of clothing firms escalated after World War II as manufacturers moved to the American South and West and to Puerto Rico and Hong Kong in an endless quest for cheap labor.

When not rushing somewhere, New Yorkers paused to chat on the sidewalks. This image of Cherry Street presents many elements of street culture of the era (5.35). A Lower

East Side girl, Rebecca Lepkoff studied dance and photography. Movement animates her photos, which document human concerns in a specific time and place. The components of neighborhood community appear in the photo, from the chance encounter on the sidewalk to the mixture of children and adults, both men and women. Yet in this enduringly poor neighborhood, over a third of the apartments lacked plumbing facilities. As opportunities to purchase homes in the suburbs increased, more and more New Yorkers looked on such scenes as examples of the difficulties of raising children in a city where there were no backyards for play.

Shawn Walker started photographing the city as a teenager. Like many Photo League members, he knew the city intimately as home as well as a site of work. His photos of Harlem in the 1960s convey the dynamism of a still vibrant neighborhood. By 1957 New York became the first city in the world to boast a black population of over one million.

The picture of a conversation between a white police officer and an African-American carries shades of implicit conflict, although the riots that would tear through Harlem were still two years distant (5.39). New York dropped its Depression-era requirement that members of the uniformed services live within the city limits in 1963 in an effort to broaden recruitment. "Rather than widening the pool of potential applicants and improving work force quality," observes urban sociologist Roger Waldinger, "repeal facilitated white migration out to the suburbs, yielding the unintended effect of making civil service jobs more attractive to incumbents."[7]

Windows let neighborhood residents observe what happened on the block. Ann Treer photographed neighbors in Chelsea in the 1960s as they watched the scene at Twenty-second Street and Seventh Avenue (5.36). The passing parade of pedestrians, the games of children, and the conver-

5.33. Jack Lessinger, *Willie's Frozen Custard*, 1940s.
5.34. William Glover, *Forty-second Street and Fifth Avenue*, 1944. **5.35.** Rebecca Lepkoff, *Cherry Street, Lower East Side*, 1940s.

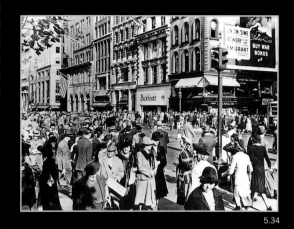

5.34

Crowds and conversations testified to the street's democratic character, its dynamism, vigor, and lack of regimentation.

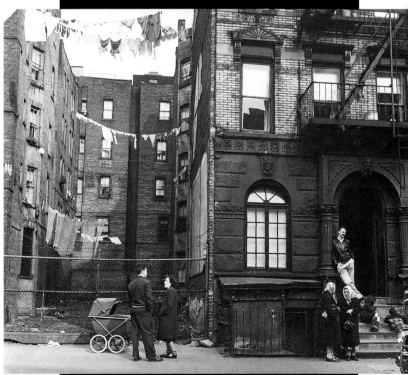

5.35

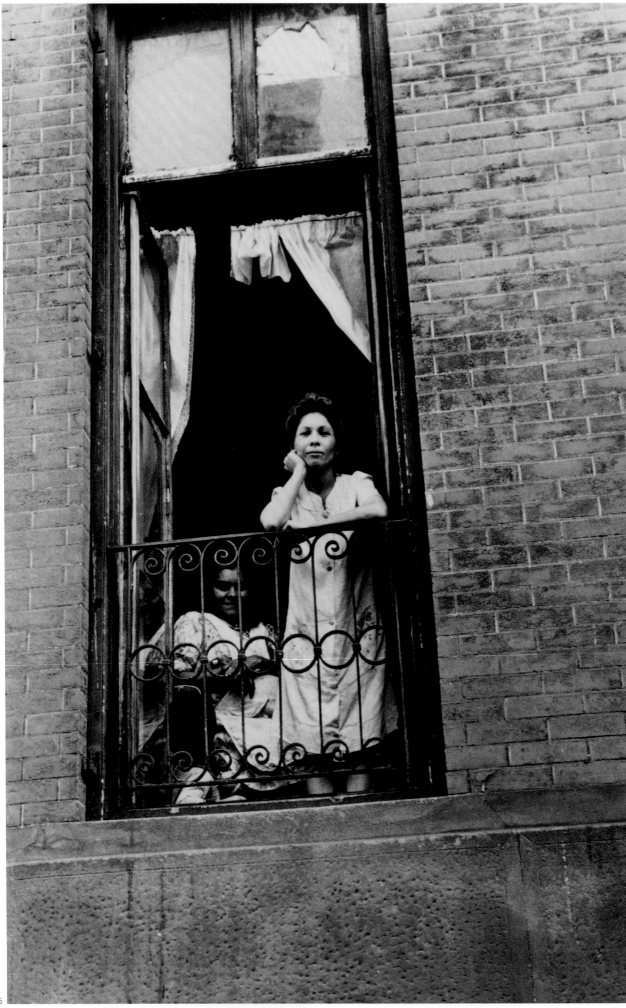

sations of men entertained women from the safety of their own homes. Puerto Ricans started migrating to New York City during the Depression, but their numbers soared in the 1950s after the initiation of direct flights from Puerto Rico. In those years of immigration restriction, they became the newest, most visible ethnic minority in the city. By 1960 well over six hundred thousand had settled in New York. Unlike previous immigrants, Puerto Ricans did not concentrate in a handful of neighborhoods but lived throughout the city, wherever they could find cheap housing.

Like lobbies in middle-class apartment buildings, windows offered liminal spaces, open to the street, its lure and charms, yet secure in the promised privacy behind the window frame. Those who walked the streets could also appreciate the view into people's homes, as Treer did when she caught the man reading a newspaper by a windowsill on Twenty-first Street between Seventh and Eighth Avenues (5.37). In 1961 the urbanist Jane Jacobs wrote about "eyes upon the street, eyes belonging to those we might call the natural proprietors of the street." But, as she notes, "nobody enjoys sitting on a stoop or looking out a window at an empty street."[8] Jacobs prescribed eyes focused on the street as a way to make them safe for strangers to live together without fear.

A generation of native New York photographers intuitively understood the city's street life. Their hometown visions changed how New Yorkers saw their city. Intimacy, faster film, and endless patience waiting for the right moment unfolded the possibilities and constraints of ordinary urban routines. Many of these photographers honed their craft at the New York Photo League. As these native daughters and sons looked at their birthplace through a camera's lens, they articulated a new relationship to the city and its inhabitants, producing images of modern urban culture that extended the documentary traditions of Lewis Hine.

Born and bred on the Lower East Side, Walter Rosenblum knew both the harsh struggle against poverty and the vibrant American idealism of Jewish immigrants. He studied photography as a teenager at the Photo League, shortly after it opened, and remained devoted to it, serving as its president during the difficult postwar years when anti-Communists attacked the organization. Rosenblum participated in the league's documentary projects, photographing

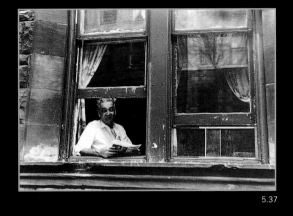

5.37

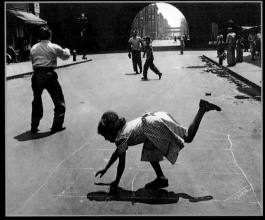

5.38

5.36. Ann Treer, 1963. **5.37.** Ann Treer, 1963.
5.38. Walter Rosenblum, *Hopskotch*, 1952.
5.39. Shawn Walker, 1962.

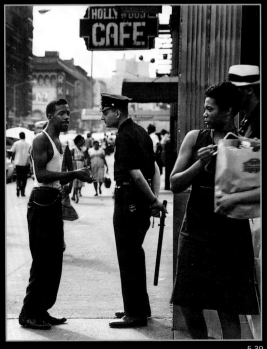

5.39

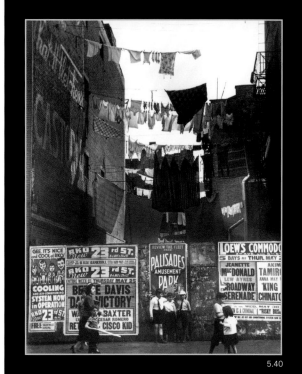

5.40

the city with rapport for its diverse peoples.

Rosenblum caught these children playing in the middle of 105th Street near Park Avenue in the summertime (5.38). The girl in the foreground picks up a potsy, the name given to hopscotch in New York City, while the boys play catch. Boys and girls both played on the streets, but they usually chose different games. Potsy was definitely a girl's game.

Despite crowded streets, enterprising children could find moments of leisure alone. Rosenblum's photo of a girl on a swing in the shadow of the Manhattan Bridge evokes a free spirit (5.42). She is swinging as high as she can go without flipping over, standing on the seat (instead of sitting, as reformers might have preferred) to get greater height. Surely Robert Lewis Stevenson's poem limning the beauty of going up in a swing refers as much to this city girl as to her country cousins.

Born on the Lower East Side, Lee Sievan stumbled into photography after marrying an artist, Maurice Sievan, in 1934. "Everything intrigued me," she recalled. "In the forties, with camera in hand, I . . . strolled the streets of New York I knew so well to capture the face and spirit of the period." Although she worked steadily as a secretary at Hunter College, she used her lunch hours and weekends to take pictures. "The vitality of New York, the people and activities captured my attention."[9] Sievan studied with Berenice Abbott and later joined the Photo League.

Sievan documented the city's "face and spirit" wherever she went. Children playing on the Lower East Side underneath the clotheslines in front of movie posters convey their resilience (5.40). New York didn't coddle its youngest citizens. Still, the Lower East Side, despite its poverty and overcrowding, was one of the city's safest neighborhoods. It was "at once revered and loathed, a place to be proud of and a place to escape from, a place," observes Robert A. M. Stern, "where dream journeys from rags to riches did come true despite enormous obstacles."[10] Note the advertisement for the air-conditioned the-

5.40. Lee Sievan, *Movie Posters and Wash Lines*, 1940s. **5.41.** Lee Sievan, *San Juan Hill*, 1939. **5.42.** Walter Rosenblum, *Girl on a Swing*, 1950.

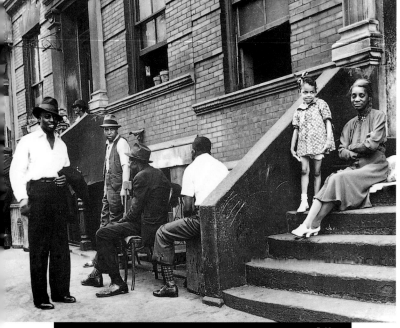

5.41

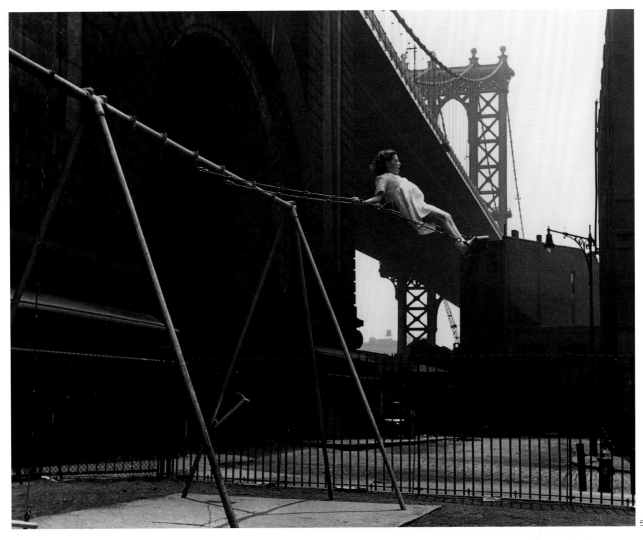

ater. In the summertime in the years before individual air-conditioning units became popular and affordable, going to the movies, especially a double feature, guaranteed several hours of cool comfort as well as amusement.

On San Juan Hill, the area west of Tenth Avenue from Sixtieth to Sixty-fifth Street that housed African-Americans, Sievan recorded a typical street scene whose details suggest relationships from which the fabric of a neighborhood is woven (5.41). The mother sitting on a newspaper-covered step with her daughter, as well as the older man who has brought a chair out onto the sidewalk, all demonstrate a measure of neighborliness. Later, after the area inspired Leonard Bernstein's *West Side Story*, it would be razed for urban renewal, including construction of part of Lincoln Center (see fig. 6.12).

Edward Schwartz grew up in the Williamsburg section of Brooklyn, a Jewish immigrant neighborhood, before mov-

ing to the Lower East Side. In 1938 he started taking one-dollar classes at the Photo League. "I had no preconceived notions," he recalls. "I knew I wanted people in motion, the drama of everyday life framed by the theatrical background of the city."[11] Schwartz's camera transforms daily routines into drama.

Waiting patiently, often for hours, Schwartz snapped the shutter at just the right second to preserve images of adolescent sexuality or upper-class snobbishness. Witness the close-up of a teenage schoolgirl, the curve of her body against a building, the enticing smile (5.44). Schwartz found beauty and charm in a working-class adolescent. His image does not remind us of any reformer's agenda.

Compare this to the woman crossing Fifth Avenue, dressed in the latest expensive fashions (5.45). Her posture and bearing proclaim her wealth as much as her clothes do. Despite the social distance between the "Clinton St.

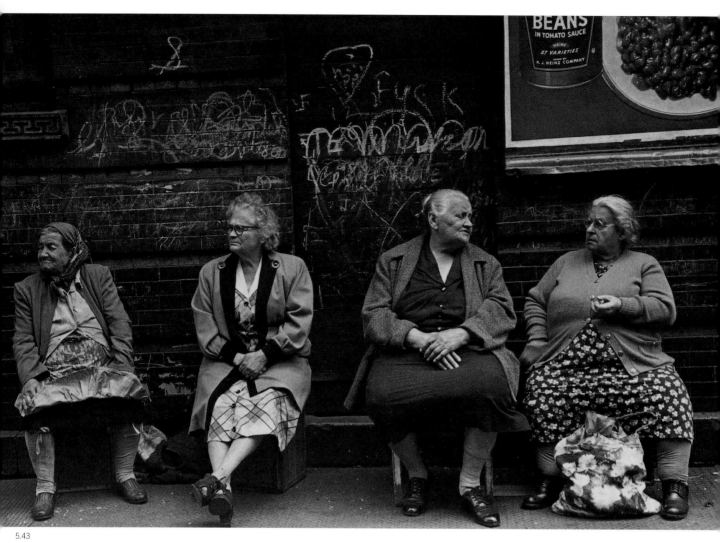

5.43

Princess" and "Fifth Ave. Lady," both belong to New York City and help to define its culture.

Fifth Avenue retained its position as the city's premiere retail street, with elegant department stores spaced between Thirty-fourth Street (B. Altman and Co.) and Fifty-eighth Street (Bergdorf Goodman). Shopping on Fifth Avenue suggested urbanity and status, as recognized by Saks Fifth Avenue, which opened an elegant department store on the avenue in 1924 and incorporated the street's name into its own. Before suburban malls moved upscale, nothing could compete with Fifth Avenue.

Vivian Cherry's photo taken on the Lower East Side in 1950 conveys another type of female presence (5.43). The older women sitting and watching indicate a residential neighborhood. With their children grown and their household responsibilities manageable, these women have time to sit and chat or even just watch the daily human drama of life

on the block. Graffiti, although written in chalk, and billboards, in this case for baked beans, act as backdrop. Here is a stage set for an urban play.

Vivian Cherry photographed the Lower East Side neighborhood where she grew up. Aware of how adults often ignored the children around them, she focused her camera on their world. Her picture of a young boy lounging on a stairwell next to rows of fruit at a greengrocer next door shows how children lived behind and beside their parents' world (5.49).

Boys and girls played an immense diversity of games on the sidewalks of New York, usually in single-sex groups but occasionally together. The adult world could become a stage for fantasies, as in this 1948 photo of a young boy peering out from a cellar stairwell, toy gun in hand (5.47). Undoubtedly, he is imitating the gestures seen in movies, dramatically fending off bad guys around the corner. In the background can be seen a sign for *Crossfire*, the first Hollywood movie to

address directly the issue of anti-Semitism, a sign of changing attitudes in the wake of World War II.

John Albok sends a message of equality with his 1942 photograph of black and white children playing together in Central Park near Ninety-sixth Street and Fifth Avenue (5.52). These children have yet to learn about the prejudices and discrimination faced by African-Americans. The photo visually reiterates some of America's wartime ideology of equality and anticipates the popular song from the Broadway musical *South Pacific*, with its refrain: "You've got to be taught to hate."

In the early 1940s Arthur Leipzig accepted an assignment from the *New York Times* to document how many of the over one hundred games pictured in Breughel's famous sixteenth-century painting *Kinderspielen* were still played by city youngsters. He recorded eighty games, including Red Rover, pictured at Clauson Avenue in Brooklyn (5.48). Street games defined growing up in the city for children, as much a part of their formative experiences as living in often small apartments. Later, as adults, many would choose suburban houses with private backyards and upstairs bedrooms as more desirable places to raise children. Yet many also retained a strong sense of nostalgia for their own urban childhoods spent on the pavement.

Born in Brooklyn, Arthur Leipzig studied photography with Sid Grossman at the Photo League in 1942 and remained an active league member until 1949. "For me," he writes, "photography is an exciting way of making order out of a chaotic world." Leipzig's interest in exploring the "human condition and human relationships" blossomed at a time of worldwide chaos.[12] His series of photographs of children in New York City documents their creativity and imagination (5.46).

Diverse peoples brought their games and tastes to city streets. Puerto Ricans and other Hispanic men enjoyed dominoes (5.50). Living in cramped apartments in Spanish Harlem, they took their games outside, turning the space at the top of the basement steps into a miniature porch.

5.43. Vivian Cherry, *Four Women*, 1950. **5.44.** Edward Schwartz, *Clinton St, Princess*, 1947. **5.45.** Edward Schwartz, *Fifth Ave, Lady*, 1949.

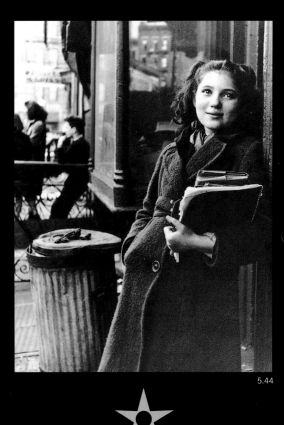

5.44

As native daughters and
sons looked at their birthplace
through a camera's lens,
they articulated a new relationship
to the city and its inhabitants.

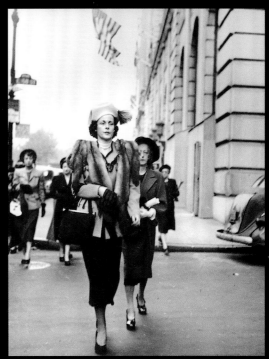

5.45

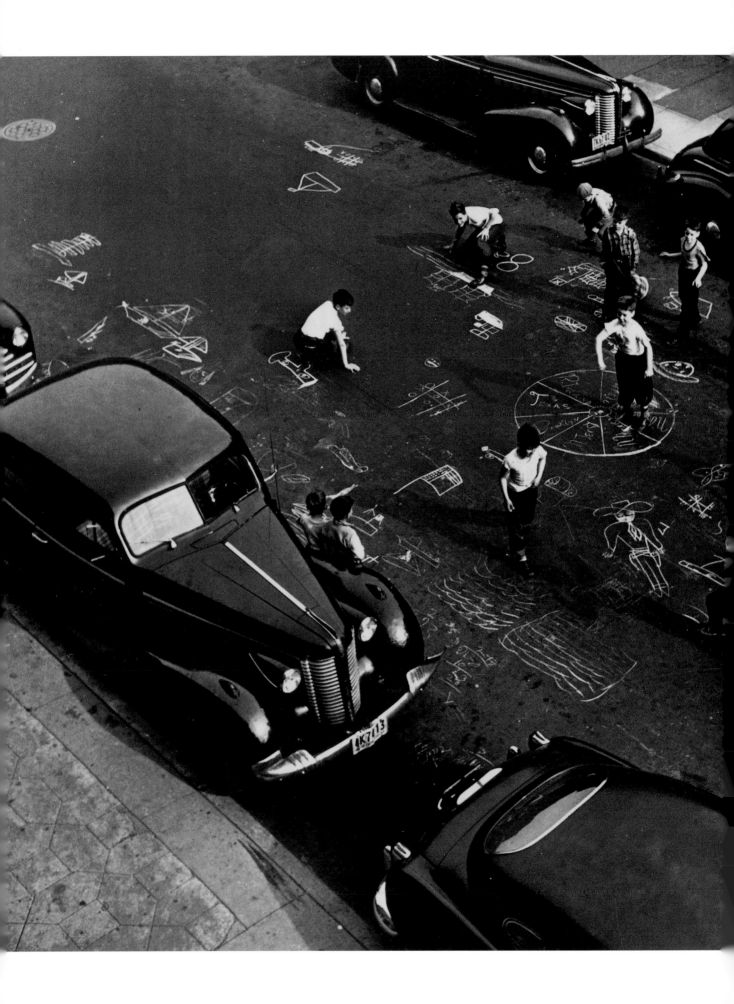

5.47

Boys and girls played
an immense variety of
games on the sidewalks
of New York.

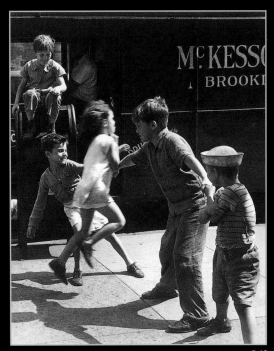

5.48

5.46

5.46. Arthur Leipzig, *Chalk Games*, 1950.
5.47. Vivian Cherry, *Crossfire*, 1948. **5.48.** Arthur
Leipzig, *Rover Red Rover*, 1943.

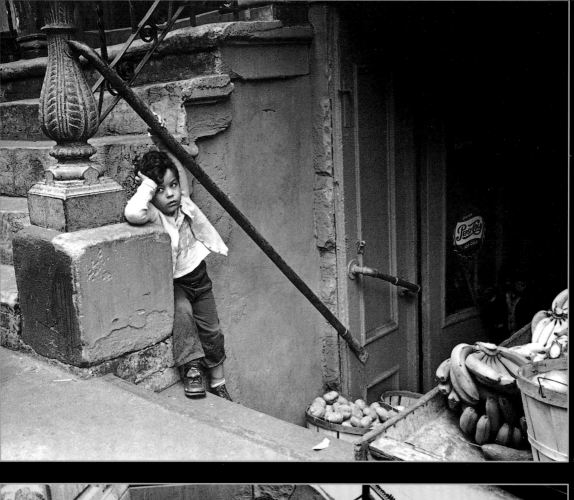

5.49

5.50

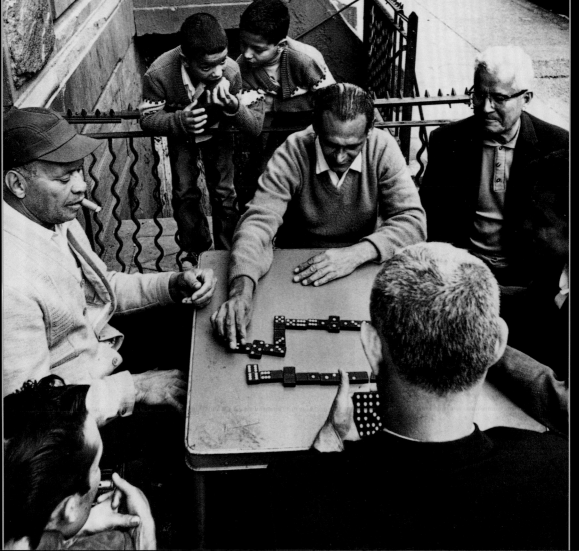

Despite claims to the contrary, ethnicity endured in most aspects of New York life, from its economy to its politics, from its neighborhoods to its schools. In a controversial book, Nathan Glazer and Daniel Patrick Moynihan concluded that "many elements—history, family and feeling, interest, formal organizational life—operate to keep much of New York life channeled within the bounds of the ethnic group."[13]

For many adults, conversation replaced play as a vital, rewarding activity. The street provided opportunities to engage friends and strangers in good conversation. N. Jay Jaffee caught one such engagement between two men (5.51). Vivian Cherry saw a similar scene enacted among three women (5.53). Jaffee's photo, showing a hand gesture vehemently emphasizing a point, reminds us how a stimulating debate could enliven mundane male routines such as getting a shoe shine.

Cherry's image of three women on their household rounds conveys the intensity of their encounter. Notice that doing laundry has moved outside these women's homes into a commercial laundromat. Electric dryers would make clotheslines filled with wash an increasingly rare image, even in poor neighborhoods such as the Lower East Side.

Suffering and solicitation remained constant aspects of the city in good times and bad. Albok photographed the man—a bum, in New Yorker's parlance, indicating his dependence on alcohol—wearing paperbag shoes and carrying a bottle of whiskey similarly clad in a paper bag—on Madison Avenue between Ninety-sixth and Ninety-seventh Streets in 1963 (5.56). Cast in shadow against the snow, his dark image is a haunting reminder of the plight of the poor.

Paula Wright's photo from the 1940s evokes similar feelings (5.54). Although he lies in sunlight, the man's poverty and dislocation contrast with the ordinary urban life around him. Unfortunately, as the numbers of poor and homeless grew, such scenes would become ordinary parts of urban life.

5.49. Vivian Cherry, *Boy with Fruit*, 1940s. **5.50.** Inger McCabe, *Henry and Ray Watching Dominoes*. **5.51.** N, Jay Jaffee, *Shoe Shine Conversation #2*, 1949. **5.52.** John Albok, *children playing*, 1942. **5.53.** Vivian Cherry, *Three Women*, 1950s.

5.51

5.52

5.53

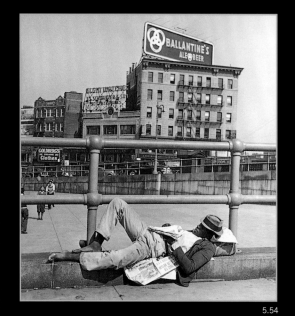

5.54

Suffering and solicitation

remained constant aspects of the city,

in good times and bad.

●

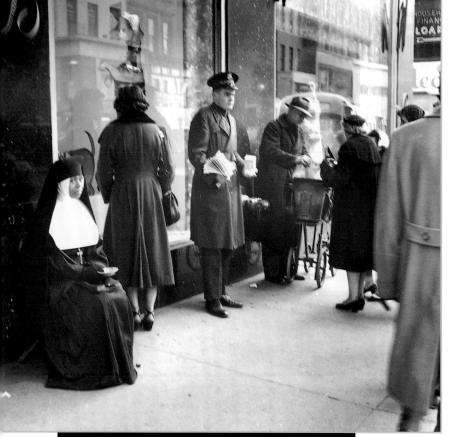

5.55

Organized charities institutionalized collecting drives, especially outside department stores like Bloomingdale's that catered to the wealthy (5.55). Nuns, wearing a distinctive habit, shared the streets with others seeking to help the unfortunate. Although New Yorkers accepted the idea that the poor deserved to be succored by the state, they also contributed to assist those who fell through the social safety net erected during the Depression. That net included Social Security, unemployment insurance, and Aid to Families with Dependent Children.

Amidst continued efforts to document the city's mundane existence with clarity and empathy, modernist perspectives also emerged in the postwar decades as photograhers responded to the urban landscape with singular, unexpected images. Consider these photographs of Rockefeller Center by Gordon Parks and Elliot Erwitt. Rockefeller Center, the city's major building project during the Depression, covered six square blocks in the heart of Manhattan, between Fifth and Sixth Avenues. Completed in 1939, Rockefeller Center incorporated its skyscrapers into a uniform plan. Parks's photo catches a pedestrian struggling against a driving rain storm (5.57). The buildings stand implacably as she makes her way across an almost deserted street.

Erwitt's photo speaks less about Rockefeller Center than about the play of light, shadow, and texture on the urban landscape (5.58). The man, his collar turned up against the wind, appears to be engaged in a weird metropolitan encounter, followed by a shadow man (who is probably looking at the photographer). Just as Rockefeller Center transformed urban space in midtown, so do these images of pedestrians against its hard facade introduce new ways of seeing and thinking about the city and its culture. They emphasize a desolate

5.54. Paula Wright, *Man Sleeping*. **5.55.** William Glover, *Charity Collectors; Outside Bloomingdale's*, March 7, 1953. **5.56.** John Albok, *Man with Paperbag Shoes*, ca. 1963.

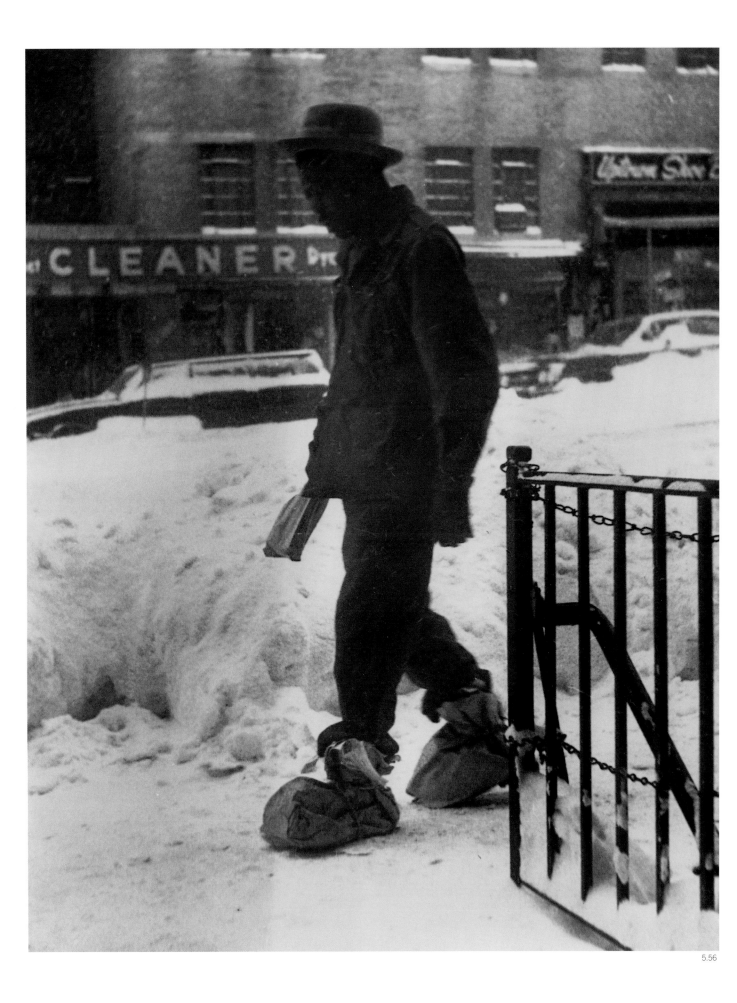

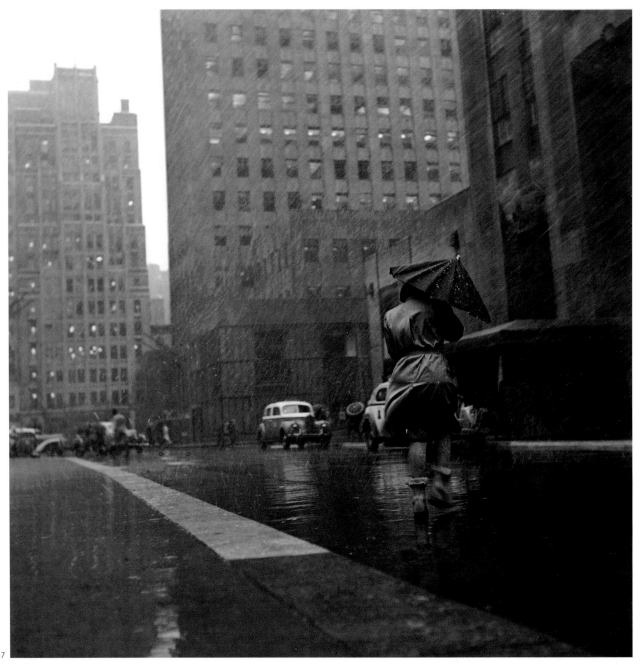

5.57

human struggle against the built environment.

In Times Square, both the people and the streets competed for public attention. Movie marquees vied with illuminated signs in an aggressive culture of display. Frank Paulin photographed the theater district in the 1950s during the heyday of the Broadway musical. His images of nightlife, as seen in figs. 5.59 and 5.63, shimmer with glamour and grit.

The sign in the lobby of the Schubert Theater lists an impressive array of musical hits, including *Brigadoon* and *The Pajama Game*, along with *The Merry Widow* and *The Beggar's Opera* (5.63). This eclectic combination attracted middle-class New Yorkers, who developed a theatergoing habit that sustained scores of shows. Theater parties to raise

funds for worthy causes also helped fill the hall. A number of Broadway musicals took the city as their subject, such as several collaborations of composer Leonard Bernstein and choreographer Jerome Robbins. The New York of Bernstein and Robbins was "a helluva town," exuberant, energetic, surprising, and beguiling.

Around the corner from Schubert Alley, Broadway crowds filled the streets. The signs above Grant's Bar advertise New Yorkers' favorite foods—hot dogs and pizza—as well as a local Brooklyn brew, Piel's Beer. (5.59) The number of breweries declined rapidly in the city; by 1950 only five had survived the high costs of labor and electricity. Clever advertising campaigns helped. Two cartoon brothers, one tall and

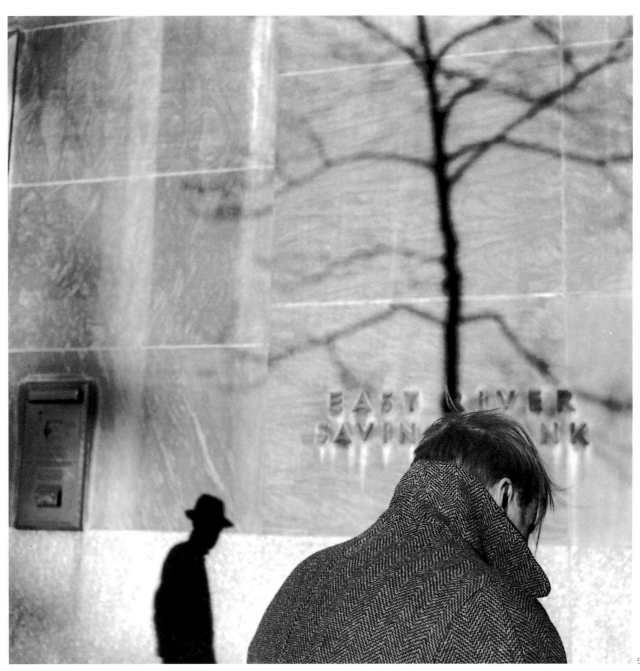

5.58

the other short, Bert and Harry Piel promoted the beer on television, that seductive new medium of entertainment. Note the cost of a slice of pizza, the same price as a subway or bus ride, as it is today.

Frank Paulin, born in Pittsburgh, found photography while serving in World War II. The army assigned Paulin to photograph portraits of thousands of displaced persons for identification. The job stirred his interest in human expression and the camera's power. He returned to Chicago after the war and studied at the Art Institute, and in 1953 he moved to New York City, where he worked as a fashion illustrator to support his family. Photography, pursued during his spare time, remained his passion.

Entertainment, whether along Forty-second Street or in Carnegie Hall, could unify or stratify the rich, middle class, and poor. Rebecca Lepkoff photographed the traffic along Forty-second Street between Broadway and Eighth Avenue (5.60). The row of theaters, including the Selwyn, Times Square, Apollo, Lyric, and Victory, built initially for stage productions when this was an elegant street, were all converted to movie houses during the Depression. (For a more recent view of the block, see fig. 6.104.)

5.57. Gordon Parks, *Rockefeller Center*, November 1944.
5.58. Elliot Erwitt, *Rockefeller Center*, January 1950.

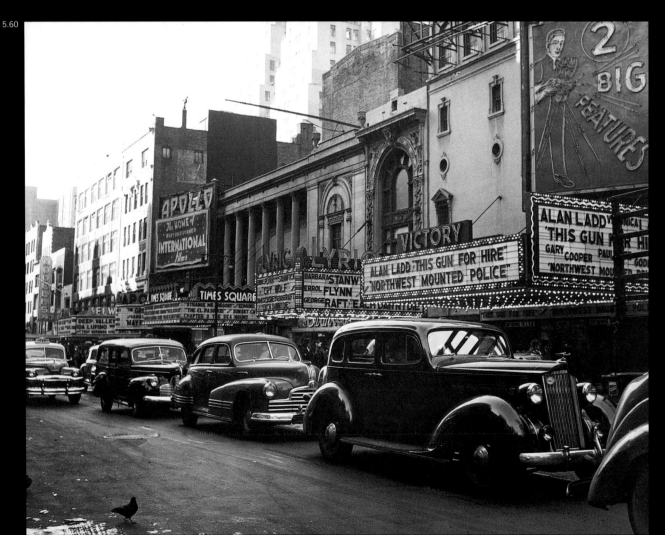

5.59

5.60

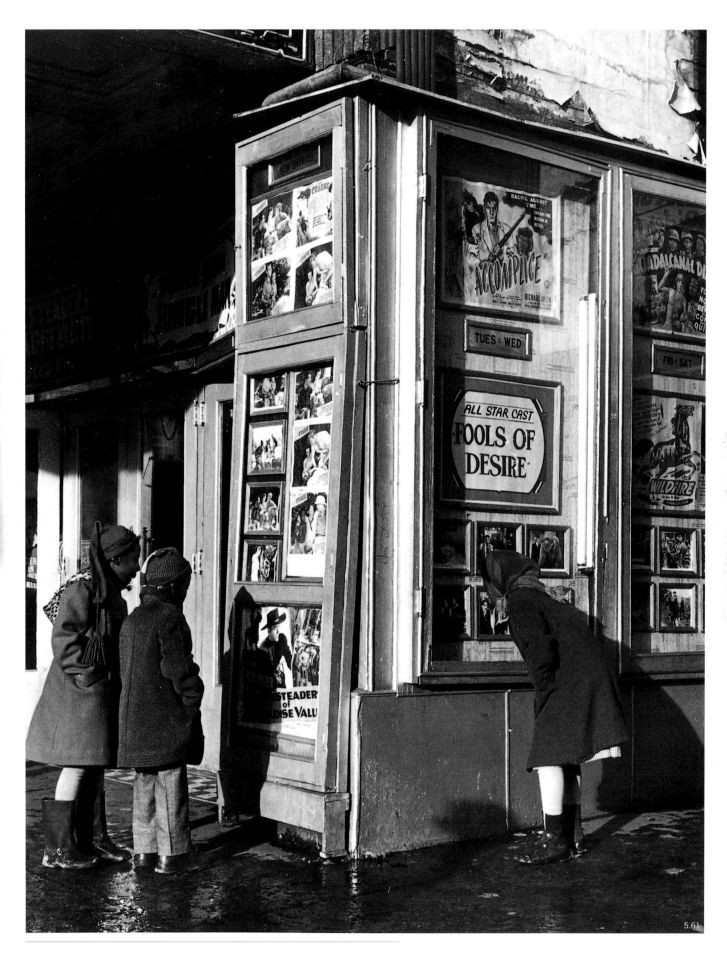

5.61.

5.59. Frank Paulin, 1956.

5.60. Rebecca Lepkoff, *Forty-second Street Between Broadway and Eighth*, 1948.

5.61. N, Jay Jaffee, *Fools of Desire*, 1953.

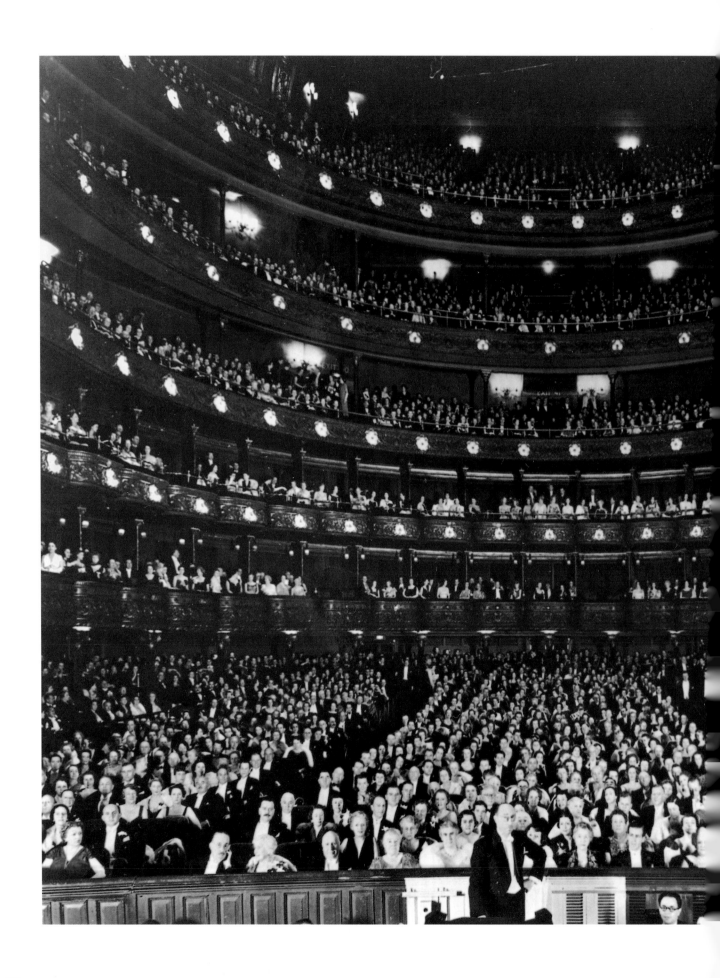

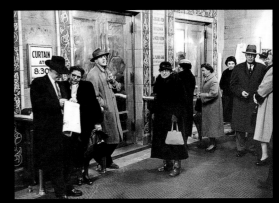

Entertainment,

whether along 42nd Street or in

Carnegie Hall, could

unify or stratify the rich,

middle class, and poor.

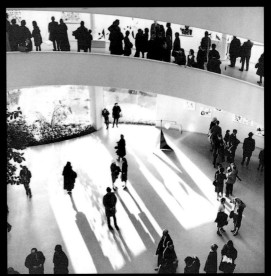

5.64

5.62. William Glover, *Interior of the Metropolitan Opera House*. **5.63.** Frank Paulin, *Shubert Alley Theatre*, 1956. **5.64.** Paula Wright, *New York, Guggenheim Museum*.

5.62

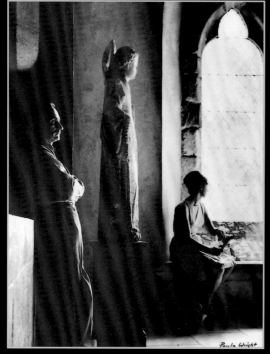

5.65

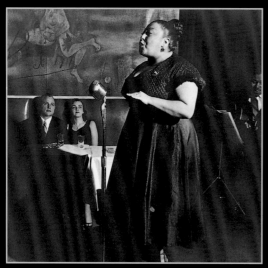

5.66

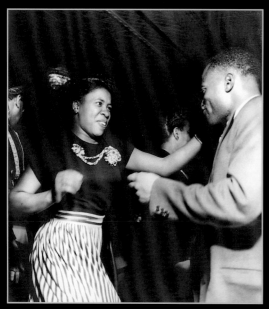

5.67

Attending the opera could mean coming to hear the classic repertory or donning elegant evening dress to socialize with the city's upper classes. The Metropolitan Opera, located on Thirty-ninth Street and Broadway, appealed to both crowds, though the former often sat far from the stage in the upper tier (or stood at the back of the orchestra, or listened faithfully to Saturday afternoon broadcasts), while the latter occupied the best seats in the house. Glover's photo shows a gala event at the opera with everyone dressed to the hilt (5.62). The two rows of boxes were called the diamond horseshoe because of the jewelry worn by wealthy patrons.

Jazz aficionados no longer had to travel uptown to hear their favorite stars. Not only did big bands like Duke Ellington's premiere pieces at Carnegie Hall (*Black, Brown, and Beige*, for example, in 1943), but individual artists performed in nightclubs and cafés in Greenwich Village and along Fifty-second Street. Listening to Sylvia Sims sing at the Village Vanguard on Seventh Avenue, Vivian Cherry preserved the intimacy and power of jazz in a luminous photo (5.66). Carl Lynch on the guitar and the Clarence Williams Trio accompany Sims as a young couple enjoys the music.

Of course, one did not need to travel at all to find entertainment. Movie theaters enticed customers in all neighborhoods, from working-class Brownsville, pictured here, to the upper-class East Side. N. Jay Jaffee's photo of three youngsters checking out the still photos at a local "itch" (a popular term for rundown theaters) presents the range of movies—from love stories, to cowboy pictures, to war films—as well as the children's keen interest (5.61).

As New York became the world's art capital, American artists introduced new forms of expression. The travails of the Depression, especially WPA projects, forged an artistic milieu in the city that gave moral sustenance to individual artists of different temperaments. After the destruction of World War II, rich artistic creativity emerged appropriate to the nuclear age. As the art historian Dore Ashton observed, "at a certain moment enough painters seemed to converge in

5.65. Paula Wright, *The Cloisters, New York*. **5.66.** Vivian Cherry, *Village Vanguard*, 1950s. **5.67.** Lee Sievan, *Dancers at Calypso Dance*, 1946. **5.68.** William Glover, *Saint Patrick's on Easter Sunday*, 1941. **5.69.** Justo A. Martí, 1958.

a loose community, with sufficient aggressive energy to command attention"[14] The Solomon R. Guggenheim Museum, designed by Frank Lloyd Wright, opened to the public in 1959 on Fifth Avenue between Eighty-eighth and Eighty-ninth Streets. Its curving shape displayed the work of modern artists, such as those of the New York School, to particular advantage, highlighting nonobjectivist and abstract expressionist painting. Paula Wright's photo of the Guggenheim takes the art audience's point of view (5.64).

The Cloisters, in Fort Tryon Park at the northern tip of Manhattan, stands at the other end of artistic endeavor. Opened as a branch of the Metropolitan Museum of Art in 1938 on land donated by the Rockefeller family, the Cloisters incorporates architecture from five French monasteries and exhibits examples of Gothic and Romanesque art. Paula Wright's photo conveys the contemplative mood a visit inspires (5.65).

Dance also flourished in the city. In the postwar decades, New York became an international center of ballet, a position of prominence it had achieved in modern dance a decade earlier. Modern dancers often espoused a left-wing form of cultural activism, creating dances on political themes. A popular venue for dance performances was the Ninety-second Street Young Men's Hebrew Association. Styles from around the world could be seen in New York, as in Lee Sievan's photograph of calypso dancers in the 1940s at Irving Plaza, a hall east of Union Square in Manhattan (5.67). The dancing attracted men and women from the Caribbean islands as well as native New Yorkers. Sievan's image pulses with movement as it captures the improvisation essential to calypso.

Flamenco dancing appealed to Hispanic New Yorkers, especially those from Puerto Rico. Dramatic and sensual, flamenco dancers performed to enthusiastic fans. Justo A. Martí took this photograph at a party sponsored by the Spanish

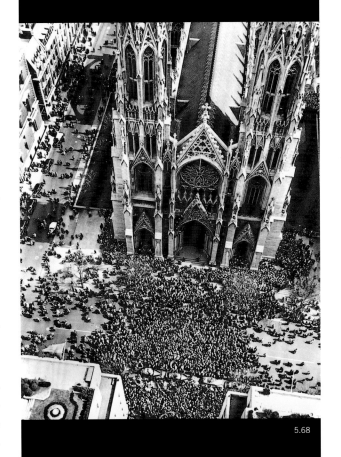

5.68

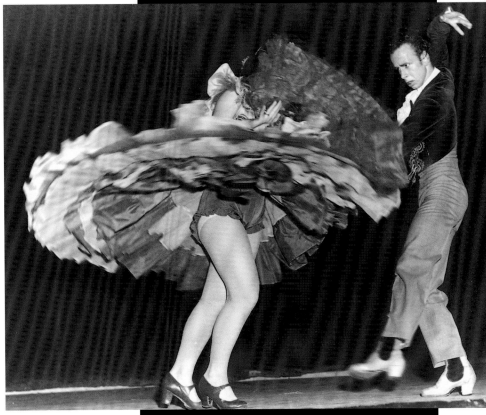

5.69

323

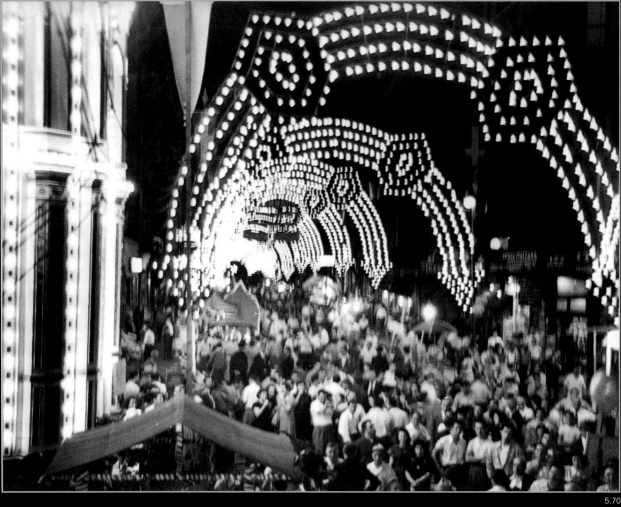

5.70

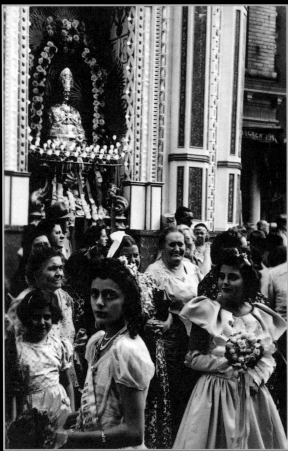

5.71

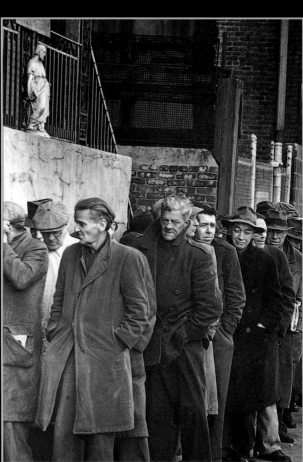

5.72

newspaper *La Prensa* in 1958 at the Manhattan Center, on Thirty-fourth Street and Eighth Avenue (5.69). Founded in 1913, *La Prensa* was the oldest Spanish daily in the city. In 1948 *El Diario* started to compete for Spanish readers; by 1963 it absorbed its rival, becoming the dominant voice in the city's Puerto Rican community.

Religious observances blended art and performance, often spilling out of churches onto the city's streets. By 1950 almost every other New Yorker was Catholic (the best estimates put the figure at 48 percent), albeit from varied ethnic backgrounds. Yet on a holy day like Easter differences mattered less than commonalities as thousands celebrated. Glover went up into Rockefeller Center to shoot this photograph of New Yorkers swarming outside St. Patrick's Cathedral in 1941 (5.68). (Compare his image to the dignified turn-of-the-century Easter Parade shown in fig. 4.128.)

Parading in one's Easter best nonetheless took its toll, especially if new shoes pinched the feet. An unknown photographer with a sense of humor snapped this image of four young women on a roof resting their tired feet after joining the Easter Parade in Astoria, Queens, in 1943 (5.75).

Ethnic festivals cemented ties to faith and homeland. Puerto Ricans marched in the Procession of the Three Kings at Christmas; Chinese welcomed each new year with firecrackers and dragon dances. But no ethnic group drew as large an audience of New Yorkers for its festivals as did the city's Italians. Sid Grossman photographed the lighted arches and surging crowds at the San Gennaro *festa* in Greenwich Village (5.70). Dedicated to the immigrants' village patron saint, the *festa* fused religious devotion and nostalgia for Sicily with the release of carnival, its food and games of chance. By 1947 the annual *festa* attracted New Yorkers from all ethnic backgrounds, who watched the drama, ate the meat and pastries, and played the games. Many ignored the

5.70. Sid Grossman, *Festival*, 1947. **5.71.** Sid Grossman, *Festival*, 1947. **5.72.** Vivian Cherry, *Soupline—Catholic Worker*, 1955. **5.73.** Alexander Alland, *Succah*, 1940. **5.74.** Andreas Feininger, *Mordecai Grossmark Shop*, 1950s. **5.75.** After the Easter Parade, 1943.

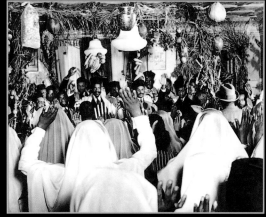

5.73

5.74

5.75

festa's sacred dimensions, but Grossman's photographs convey the *festa*'s spirituality and its power to sanctify neighborhood streets. The young and old women by the shrine on Mulberry Street give a glimpse of the *festa*'s role in strengthening family bonds (5.71). The prosperity of the city's Italian Americans can be gauged by comparing these photos to Riis's image of the modest shrine at the feast of St. Rocco fifty years earlier (fig. 4.130).

Religious commitment spurred collective and personal action. Dorothy Day started the Catholic Worker Mission in 1933 after converting to Catholicism. The Chrystie Street mission on the Lower East Side served soup to roughly twelve hundred hungry people each day and within five years spawned similar missions in other cities. The *Catholic Worker* newspaper espoused pacifism and anarchist utopianism within the framework of Catholic social thought. Vivian Cherry lived on Chrystie Street near the mission and photographed the daily breadline in 1955 (5.72).

Jews, people of the book, left their imprint on the city. In 1950 statisticians estimated that Jews made up 26 percent of the city's population, making New York the largest Jewish city in history, with over one thousand synagogues. Although Jews lived throughout four of the five boroughs (Staten Island held no appeal), the Lower East Side remained their symbolic place of origin. Many returned there regularly to shop for religious items, such as those offered in this bookstore photographed by Feininger in the early 1950s (5.74). The store sold Hebrew, Yiddish, and English books, as well as prayer shawls, mezuzahs, and flags, including the new Israeli one.

A tiny minority of black Jews worshipped together in Harlem. Sharing religious traditions but not an ethnic history with other Jewish New Yorkers, they formed a cohesive community. Alexander Alland photographed a celebration in a sukkah (a booth or hut built to observe the fall harvest festival) as the community engaged in prayer (5.73).

New Yorkers also shared secular rituals, like the game of baseball, whose "boys of summer" continued to captivate the city's heart. In Brooklyn, the Dodgers reigned supreme.

After Jackie Robinson joined the team in 1947, many fans felt pride that their team led the way in integrating baseball. During the 1940s and the 1950s New York City dominated the sport, with three outstanding Major League teams, the Dodgers, the Giants and the Yankees. Intercity rivalry between the Dodgers and the Giants erupted in 1951 when Bobby Thomson hit the "shot heard 'round the world" to win the National League pennant for the Giants. The Dodgers won seven pennants from 1941 to 1956, while the Yankees won the American League pennant almost every year. This resulted in seven World Series played between Brooklyn and the Bronx. In the fiercely contested subway series against the usually victorious Yankees, the Dodgers were honored in a royal parade by an enthusiastic borough.

Ben Greenhaus photographed the mobs who turned out on the streets of downtown Brooklyn to cheer the Dodgers to victory (5.77). The banner, sponsored by Abraham and Straus and Oppenheim Collins, two major Brooklyn department stores, proclaims "Beat The Yanks."

Lou Bernstein's evocative photo from 1955 takes one out to the ball game, in this case to witness the pregame ritual of hosing down the infield (5.78). Brooklyn's love affair with baseball would end with many broken hearts after 1957, when the Dodgers moved to Los Angeles and the Giants left for San Francisco. Only the Yankees—the Bronx Bombers—remained steadfast, loyal to New York City.

Boxing maintained its hold on fans throughout the city. The sport continued to recruit young men from the poorest neighborhoods who dreamed of literally fighting their way out of poverty. As in other endeavors, ethnic succession, when one ethnic group follows another, ruled. Irish, Italian, Jewish, and African-American boxers became heroes to fellow New Yorkers. Thousands would fill a stadium to see Joe Louis, heavyweight champion, knock out contenders for the

5.76. Ben Greenhaus, *Joe Louis fight.*
5.77. Ben Greenhaus, *Parade*, 1940s.
5.78. Louis Bernstein, *Ebbets Field, Brooklyn, NY*, 1955.

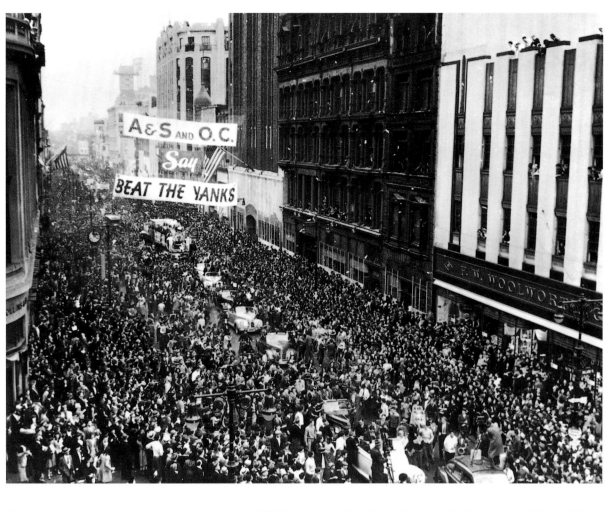

5.77

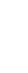

5.78

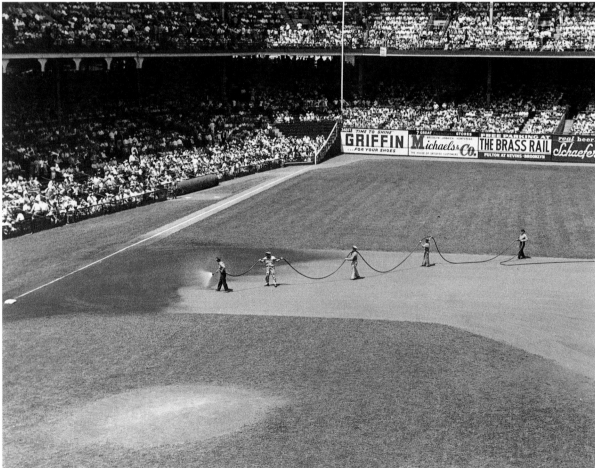

5.79

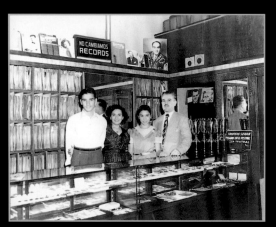

5.80

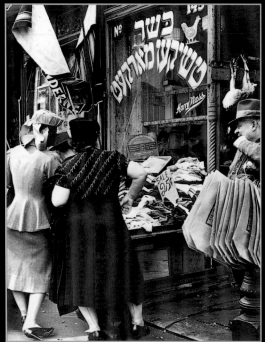

5.81

title. Known as the "Brown Bomber," Louis held his title longer than any previous champion and defended it successfully against any number of "white hopes." Ben Greenhaus managed to catch Louis watching as one opponent, probably Nate Mann, falls to the mat during a fight at Madison Square Garden (5.76).

Keeping shop preoccupied hundreds of thousands of New Yorkers. Hunting for bargains on the Lower East Side appeared to change very little over the years. From the street, Feininger photographed a proprietor observing two prospective customers as they check out clothes in front of a kosher chicken market (5.81). The stylish attire of the women reveals a measure of prosperity and modernity absent from earlier images of street shopping.

Ethnicity and convenience steered shoppers to local outlets. In lower Manhattan in Chinatown, Chinese immigrants and their children found spices and other items that helped them to preserve the tastes and smells of home. Most Chinese came from the area near Canton. As a result of China's alliance with the United States in World War II, restrictions on immigration were lifted for war brides, and approximately nine thousand women emigrated. Their presence allowed more and more Chinese New Yorkers to raise families. This merchant sits outside his store on Bayard Street and smokes his pipe while waiting for customers, both locals and tourists (5.82).

In figure 5.79 a family poses proudly in front of their fruit and vegetable market on 113th Street and Jamaica Avenue in the Richmond Hill section of Queens. The neighborhood initially attracted prosperous businessmen who purchased its substantial homes at the turn of the century. In the 1920s second-generation German and Irish New Yorkers settled in more modest houses. The area changed little during the postwar decades; Jamaica Avenue remained the main commercial street. In this photo, the father stands in the store's shadow, letting his sons take the sunlight. Parents worked hard to pass on to their children a thriving business. Notice that both father and one son wear neckties and white shirts, a formality of attire charac-

teristic of many middle-class New Yorkers in the forties.

Frank and Mary Becerra pose with their children, who undoubtedly helped keep shop, for Justo A. Martí's photograph in their record and jewelry store, La Virgen del Carmen, at 155 East 116th Street (5.80). East Harlem, once a heavily Italian immigrant neighborhood, changed to Puerto Rican settlement during the postwar period. Nicknamed "El Barrio," Spanish Harlem sustained a diverse array of organizations, many located on 116th Street, its commercial center. The combination of music and jewelry, like the mixture of items on display in the Bayard Street shop, enticed fellow ethnics.

On Blake Avenue in East New York a plethora of stores catered to Jewish residents (5.83). The Morris Meat Market stood next to Feller's Dairy. Since Jewish kosher laws required the separation of meat and milk products, stores usually followed suit and specialized in one or the other. On the curb several pushcart vendors selling vegetables are doing business. A woman in a fur coat inspects the produce.

By contrast, department stores appealed to all classes and ethnic groups. Lee Sievan took this photo in the 1940s in Woolworths (5.90). The two women playing the piano and singing reveal how the five-and-dime served customers in unexpected ways. The prices, including a turkey dinner for forty cents, were reasonable; the atmosphere was standardized.

Alexander's department store, on Fordham Road, became a Bronx landmark and success story during the postwar period (5.89). Named for his father by George Farkas, who started the first discount retail shop in 1928 at Third Avenue and 152nd Street, Alexander's eventually opened a store downtown across from Bloomingdale's on Lexington Avenue and Fifty-ninth Street in 1969. Unlike Bloomingdale's, Alexander's concentrated on lower- and middle-income customers. Women made most of the purchases from these retail outlets. Department stores also offered opportunities for women to work in management and fashion, not just behind the sales counter.

Although Sig. Klein never built a retail empire out of his speciality shop with its clever

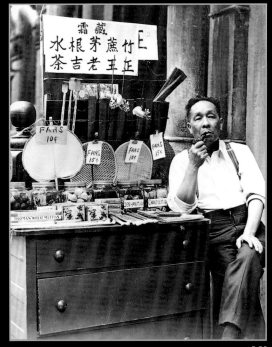

5.82

5.79. Grocery store at 113th St. and Jamaica Ave., 1941. **5.80.** Justo A. Martí, *La Virgen del Carmen.*
5.81. Andreas Feininger, *Orchard Street,* 1940s.
5.82. Alexander Alland, *Chinese shopkeeper,* 1940.
5.83. N, Jay Jaffee, *Morris Meat Market,* 1950.

5.83

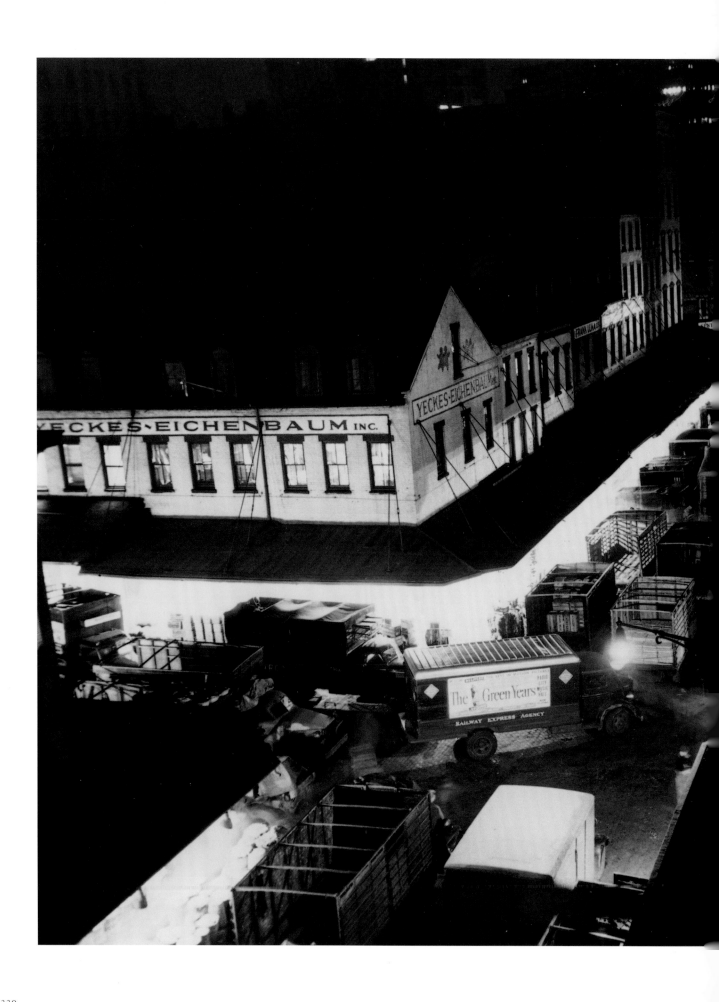

Feeding seven million New Yorkers required immense wholesale markets— and thousands of small retail stores.

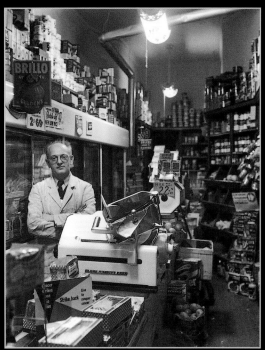

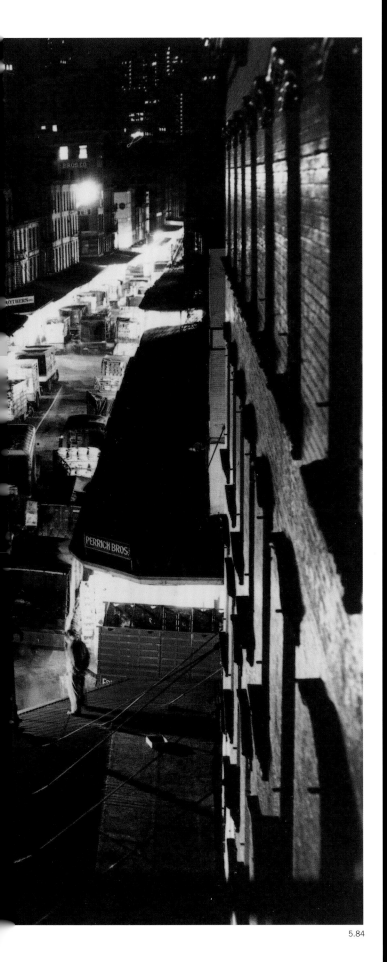

5.84. Arthur Leipzig, *Washington Market*.
5.85. Godfrey Frankel, *Bread Window*, 1947.
5.86. Scott Hyde, *Henry Jicha's grocery store*, 1952.

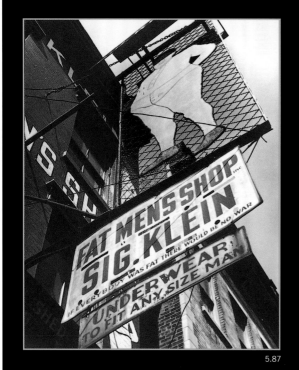

5.87

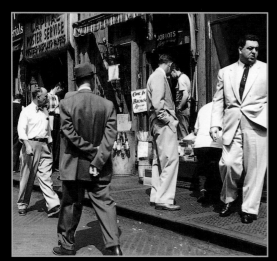

5.88

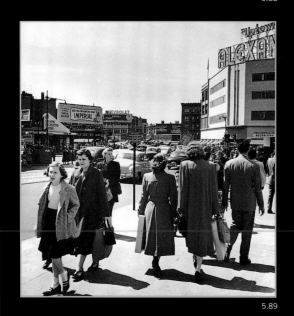

5.89

advertising, Barney Pressman parlayed a similar type of men's store into a major retailing firm, the eponymous Barney's. Godfrey Frankel obviously couldn't resist Klein's slogan—if everybody was fat there would be no war—or the sign's distinctive shape. Frankel photographed the Fat Men's Shop on Third Avenue in 1947 (5.87).

Feeding seven million New Yorkers required immense wholesale markets. Arthur Leipzig photographed the Washington Street produce market at night, the time when it hummed with traffic and customers (5.84). North of the market was the meatpacking district, located around Fourteenth Street. The lights from the buildings give a festive feel to what was an ordinary sight on Manhattan's Lower West Side.

Across town on the East Side, the Fulton Fish Market flourished. The largest fish market in the nation and among the largest in the world, the Fulton Fish Market even had a slip devoted to freshwater fish. Behind the fish dealers' stalls on Water Street stood coffee warehouses. Gordon Parks photographed the daytime action as part of a story on New York's harbor in 1946 (5.91). Compare this photo of the Fulton market to the scene at the turn of the century and at its demise in the 1980s (figs. 4.14 and 6.2).

The kinds of bread and cakes lined up in the store window indicate that this was a Jewish bakery (5.85). On the top shelves stand large loaves of rye bread next to braided egg challah used to usher in the Sabbath on Friday evening. On the bottom lie neat stacks of hard rolls, while pound and marble cakes fill the middle shelf. Notice the union label tags on the bread. There were more than one hundred bakery union locals in the city, many divided along ethnic lines, and several thousand bakeries. Baking was the fourth largest industry in New York City in terms of the value of its products and second to garment manufacturing in number of employees.

Czech immigrant Henry Jicha owned his grocery store on Seventy-first Street between First and York Avenues as well as his building, a five-story old-law tenement (5.86). Jicha's decision to purchase the building that housed his store was

5.87. Godfrey Frankel, *Side View, Fat Men's Shop*, 1947.
5.88. N. Jay Jaffee, *Canal Street*, 1950. **5.89.** William Glover, *Views in Fordham Road, Grand Concourse Area*, April 21, 1951.
5.90. Lee Sievan, *Turkey Dinner 40 cents*, 1938.

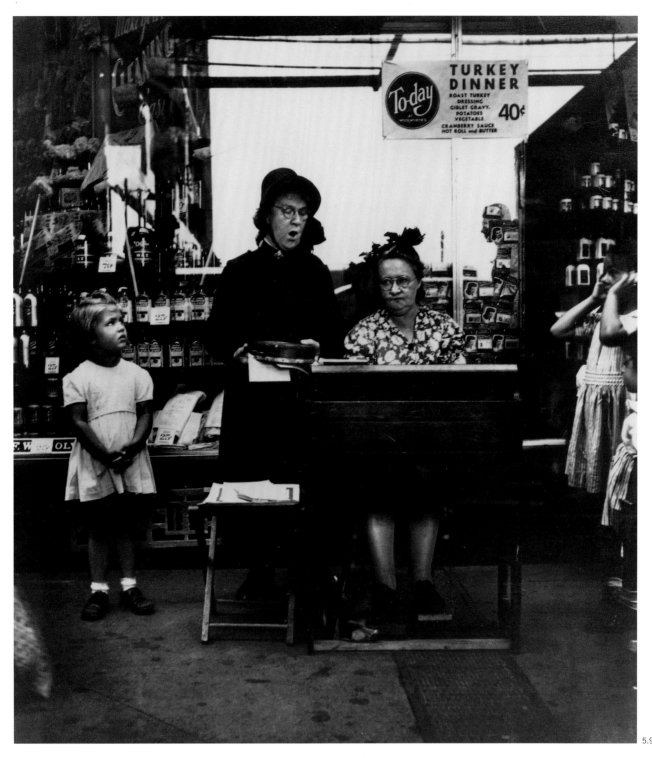

5.90

not atypical for a prosperous ethnic merchant. The gleaming machine on the counter for slicing meat and cheese characterizes his store as a delicatessen, a step above a regular grocery. Its prosperity appears in the well-stocked shelves and spotless displays.

Window displays tempted the casual passerby, but once inside service mattered even more. Godfrey Frankel photographed a pawnshop on Third Avenue in 1947 (5.92). The variety of items displayed, including musical instruments

and kitchen knives, suggest diverse clientele. Pawnshops flourished in poor city neighborhoods and provided customers who had no access to bank loans a way to manage in hard times. Middle-class customers down on their luck also turned to pawnshops to tide them over.

Canal Street offered men a dazzling array of hardware items, perfect for browsing. The stores specialized in job lots, all sorts of bargains for the man who liked odds and ends. N. Jay Jaffee's photo conveys the spirit of such sidewalk perusal

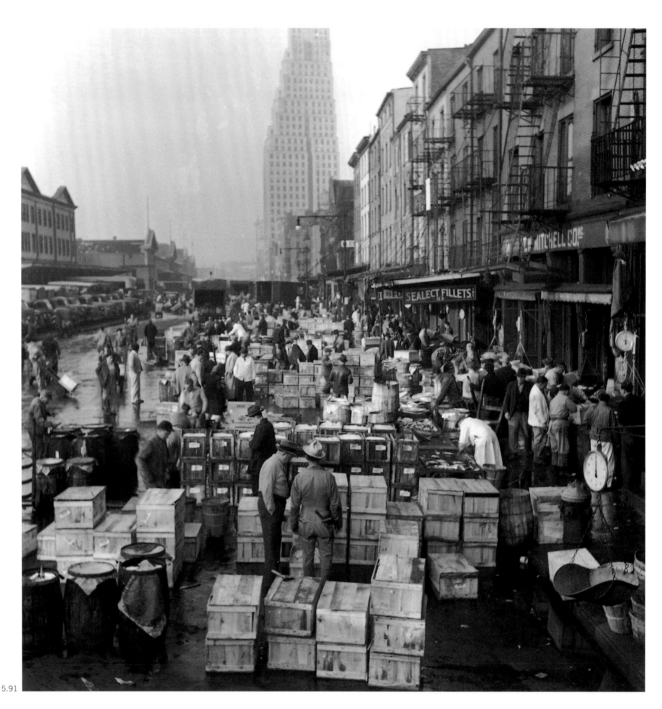

5.91

(5.88). The men are nattily dressed in summer suits, despite the heat.

Technological changes threatened old ways of work but class and gender distinctions endured. Chinese hand laundries that catered to the middle class could be found in most neighborhoods. They delivered a vital service to housewives living in modest apartments. The laundry association formed one of the mainstays of the Chinese ethnic economy. Arthur Leipzig's photo of a Brooklyn laundry records the reality that child care did not exist for working families, many of whom lived above or behind their shops (5.93).

Only men worked as teamsters in years when help want-

ed ads routinely distinguished between male and female. Truckers organized the International Brotherhood of Teamsters at the turn of the century. Exclusive and racist, the union nonetheless enrolled workers in other trades, including taxi drivers and warehousemen. By the mid-fifties, its Joint Council of New York City was the nation's largest, with sixty locals and 123,000 members. It exerted significant influence on city politics and played a key role in garment industry disputes. In the 1960s scandal rocked the union, which faced charges of racketeering, corruption, mishandling of pension funds, and links to organized crime. Morris Engel catches men waiting on a summer morning to

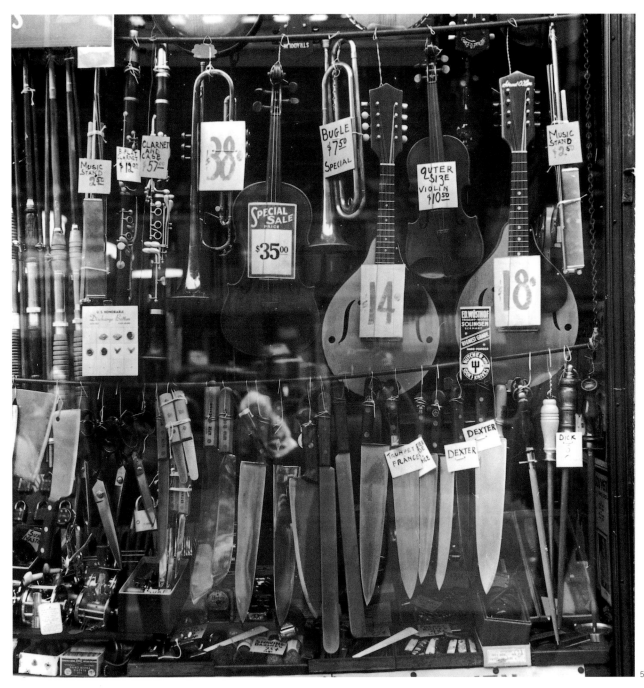

start work at Pier 32 (5.94). Their postures indicate resignation; waiting was part of the job.

Tourism to New York City required guides, who were licensed on an annual basis. Lisette Model shot this crusty guide in Times Square (5.95). One can imagine him regaling tourists with savory stories of the glamourous, dangerous big city. Model's portrait invites storytelling.

John Muller's photo catches nannies as they take a break from their child-rearing duties to chat in Central Park (5.97). Wealthy New Yorkers employed women to care for their children, a practice unchanged from the previous century. Most of the expensive apartment houses on Fifth or

Park Avenues near the park included servants' quarters. In an era of restricted immigration, however, many nannies were native-born.

Hotel maid services also continued to employ women. The signs posted list the laws relating to hotel employment that were designed to protect workers, but the long hours of labor produced little pay. Fenno Jacobs photographed the Murray Hill hotel in the 1940s (5.96).

5.91. Gordon Parks, *Fulton Fish Market*, 1946.
5.92. Godfrey Frankel, *Third Avenue Store, NYC*, 1947.

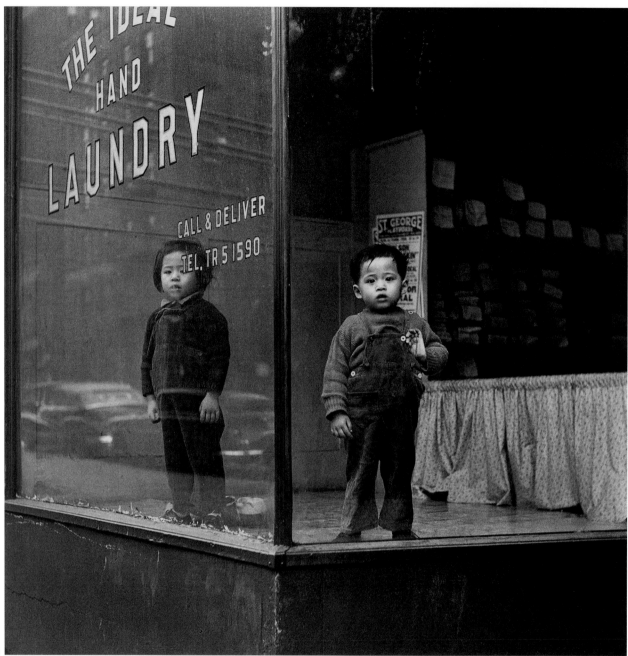

5.93

Even as telephone service modernized, women worked the switchboards. This 1953 photo shows overseas operators and looks like a public relations shot in comparison to Jacobs's photo of hotel workers (5.101). The woman in the foreground handles calls for Paris, to her left sits the woman in charge of London switching, and to her left is the Lisbon operator. The phone company maintained discriminatory employment practices against black, Hispanic, and Jewish women into the postwar decade.

New York's ethnic enterprises expanded even as the city's corporate culture flourished. The Chinese Hand Laundry Association, formed in 1933 to protest a city ordinance forcing hand laundries to cease operation, helped launch the *China Daily News* in 1940. The newspaper carried local news as well as information about China. Alexander Alland photographed the print room in 1940 (5.98).

Victor Laredo photographed men working in a matzo factory in 1950 (5.99). Jewish immigrants introduced matzo production to the city in the nineteenth century. In the postwar years the large firms expanded to year-round operations

5.93. Arthur Leipzig, *Ideal Laundry*, 1945. **5.94.** Morris Engel, August 1947. **5.95.** Lisette Model, *Sightseeing Guide on Broadway*, May 1948. **5.96.** Fenno Jacobs, *Women at Work, Murray Hill Hotel*. **5.97.** John Muller, *Central Park Nursemaids*.

5.94

5.95

5.96

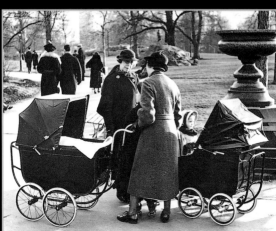

5.97

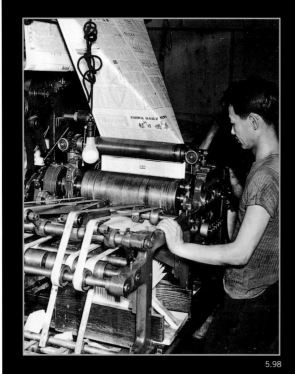

5.98

★

**New York's ethnic
enterprises expanded even
as the city's corporate
culture flourished.**

●

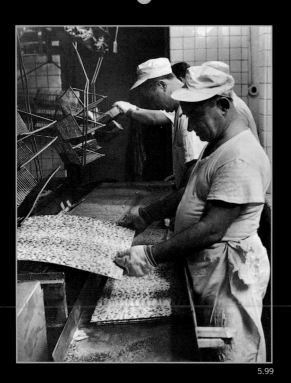

5.99

rather than just baking for the Passover holiday, when Jews may eat only unleavened bread for eight days.

Skyscrapers required window washers with special skills and no fear of heights. The man in figure 5.107 is cleaning the Secretariat Building of the United Nations, using just a belt to hook himself to the window frame. In the background can be seen the Chrysler Building.

Pink-collar work expanded enormously after the war as increasing numbers of women continued to labor in offices after marriage. New York's growing postindustrial economy depended on reliable staffs of secretaries, bookkeepers, accountants, file clerks, and office workers. Lunchtime was an oasis in the workday. In contrast to intimate luncheonettes and outdoor hot dog vendors, the Automat, a chain of self-service cafeterias, served up anonymous space and food. The walls of shelves with their miniature doors held food that could be purchased with nickels, thus hiding the workers from view. The small tables in the high-ceilinged space allowed for privacy or conviviality. A cup of coffee bought you the right to sit and linger over conversation or private thoughts (5.104).

Consider these types of labor: repairing shoes, maintaining bridges, building tunnels. Each photographer pays tribute to the work performed by siting the worker within his distinctive space. Shoe repairing remained overwhelmingly an immigrant Italian occupation, and in Lepkoff's photo opera posters on the wall signal the cobbler's ethnicity (5.102). Esther Bubley's photo similarly honors the workers' consummate skill, climbing the cables of the Brooklyn Bridge (5.100). John Vachon valorizes the equal partnership of the two men, so perfectly paired in strength and concentration that they could be brothers (5.106). Carrying narrow-gauge rails for electric locomotives in the supply yard, they demonstrate the cooperation required to build the Brooklyn-Battery Tunnel. A project of the Port Authority and Robert Moses, the tunnel spanned Upper New York Bay, connecting lower Manhattan with the Brooklyn-Queens Expressway. When completed in 1950, it was the longest continuous

5.98. Alexander Alland, *China Daily News,* 1940. **5.99.** Vincent Laredo, 1950. **5.100.** Esther Bubley, *Brooklyn Bridge*, 1946. **5.101.** Operators-Overseas, 1953.

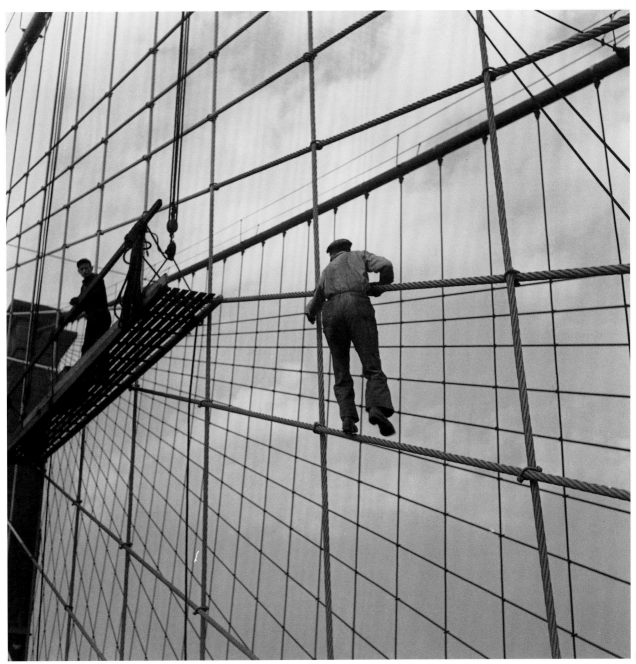

5.100

underwater tunnel for motor vehicles in North America, an unseen engineering feat comparable to the Brooklyn Bridge.

Ben Greenhaus saw the drama and heroism in fire fighting (5.108). Amid the smoke and ladders, firemen rescue a man from an old hotel. Services for the city's citizens expanded during the postwar decades. New Yorkers came to expect high levels of responsiveness from the uniformed services, which included police and sanitation workers in addition to firemen.

A more ambiguous attitude pervades Jack Lessinger's 1956 photo of an accident victim on Myrtle Avenue in

5.101

Brooklyn (5.103). As increasing numbers of New Yorkers purchased cars, the streets became more dangerous for pedestrians. New traffic regulations, including alternate-side-of-the-street parking (instituted in 1950) and one-way traffic on many streets and avenues, were intended to speed the flow of vehicles.

Once a pioneer in building decent apartments for working people, the city's housing authority succumbed to politics, especially in the allocation of construction contracts, inflation, and a new vision of urban renewal. The east displaced large numbers of residents and disrupted the com-

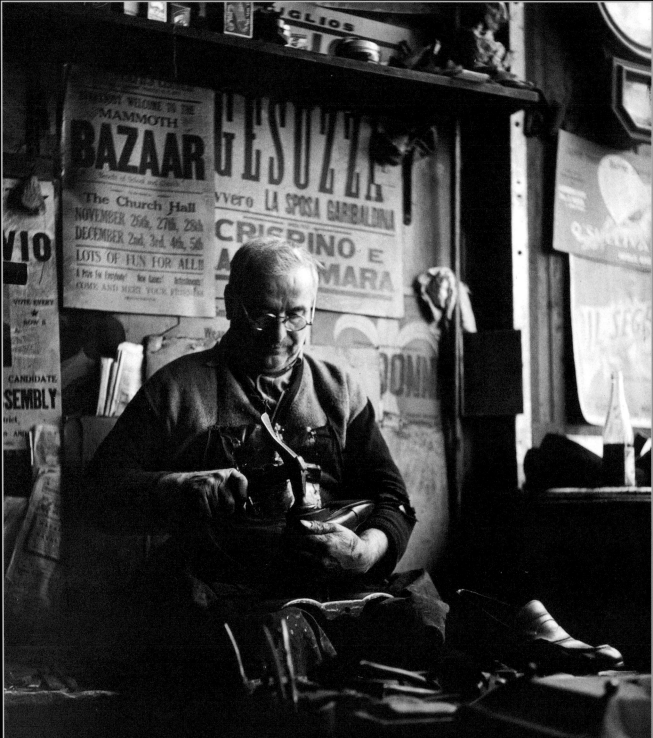

5.102

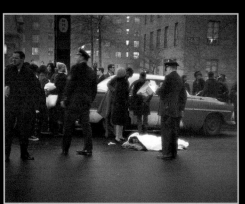

5.103

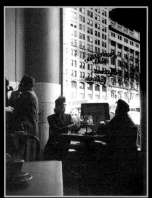

5.104

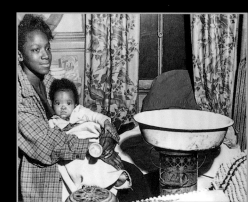

5.105

munal fabric of the neighborhood in order to build towers in the park, isolated apartment houses without commercial spaces set back from the street. The city instituted rent control laws as a wartime emergency in 1943 and retained them after the war because of extreme overcrowding and low vacancy rates. Yet the laws failed to prevent evictions, even from old-law tenements.

Many landlords refused to provide basic services. Photographers often focused on a mother and child to evoke central Christian imagery and draw attention to the plight of poor families, in the tradition of Hine (see fig. 4.3). Here a mother living at 52 East 118th Street in Harlem improvises with kerosene heaters in an effort to keep warm (5.105).

Politicians and urban planners chose methods of urban renewal that leveled large sections of the city and models of construction that emphasized suburban amenities like grass and trees. In 1943 the Metropolitan Life Insurance Company constructed a successful model for a city in the park on the blocks north of Fourteenth Street and east of First Avenue, although the tallest buildings only reached fourteen stories. Stuyvesant Town and the adjoining Peter Cooper Village, which ran from Twentieth Street to Twenty-third Street, occupied the former Gaslight District (5.109). The rent-stabilized housing opened in 1947 and barred single individuals, unmarried couples, and African Americans as tenants until 1950. Actor Paul Reiser grew up there in a secluded world. "Everything was here for me," he recalled. "Walking outside was like going into the real world. I didn't get uptown until I was like 16."[15] Scott Hyde's photograph dates from the mid-1960s.

Demolition wiped out all traces of previous buildings. Even the gridiron street plan disappeared beneath the bulldozers. Instead architects adopted the ideal of tall buildings that occupied a small percentage of the available land, leaving the rest free for parks. Frank Paulin's 1959 photo of Columbus Avenue and Ninety-seventh Street conveys the extensive

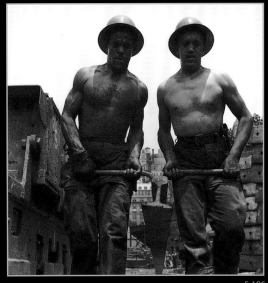

5.106

Technological changes threatened old ways of work, but class and gender distinctions endured.

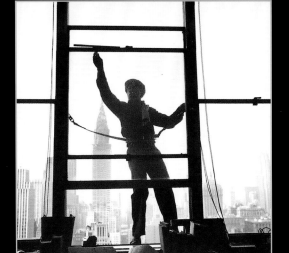

5.107

5.102. Rebecca Lepkoff, *Shoemaker, Madison Street, Lower East Side*, 1940–42. **5.103.** Jack Lessinger, *Myrtle Avenue, New York*, 1956. **5.104.** Rebecca Lepkoff, *Fifty-seventh Street*, 1947. **5.105.** Nichols, December 6, 1950. **5.106.** John Vachon, July 1947. **5.107.** Window washer, from *Photographic Views of New York*.

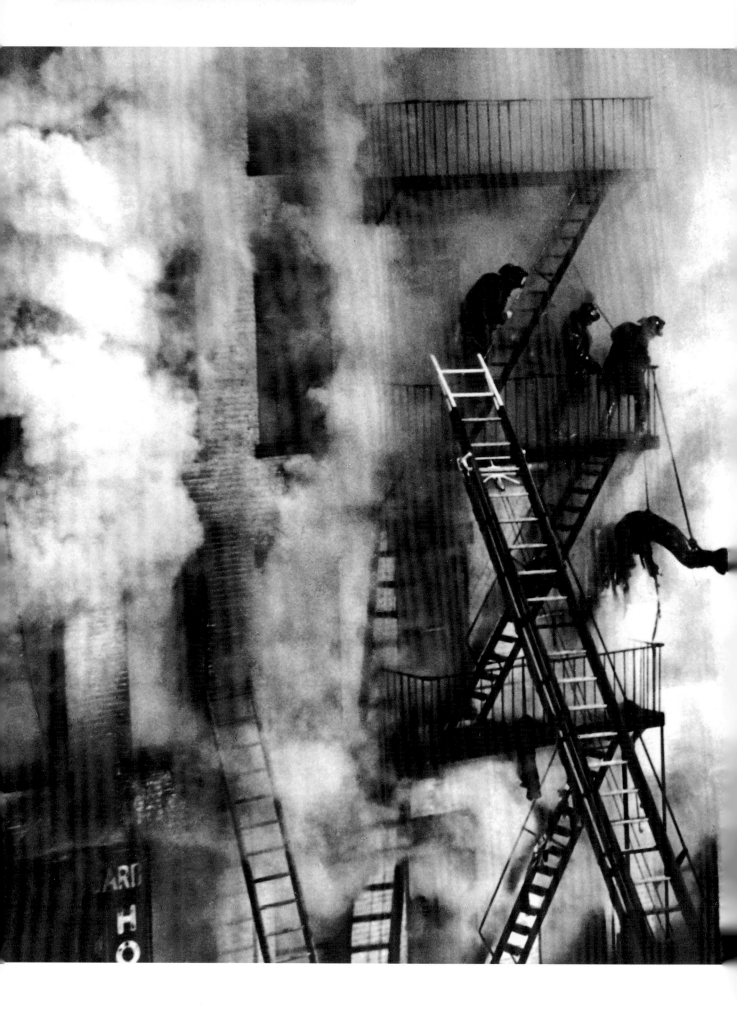

5.108

5.109

A generous city supported
an expansive public sector
of uniformed services,
public transportation and
housing, and free education
through college.

5.110

5.108. Ben Greenhaus. **5.109.** Scott Hyde, *Peter Cooper Village/Stuyvesant Town*, 1966.
5.110. Vivian Cherry, *From the Third Avenue El*, 1955.

5.111

The rapid dismantling of all but one elevated line transformed its perspective from commonplace to unique.

●

5.111. Frank Paulin, 1959. **5.112.** Vivian Cherry, *On the Platform, Third Ave El*, ca. 1953.
5.113. Scott Hyde, *Third Avenue Elevated Station, Third Avenue at Sixty-seventh Street*, 1950.

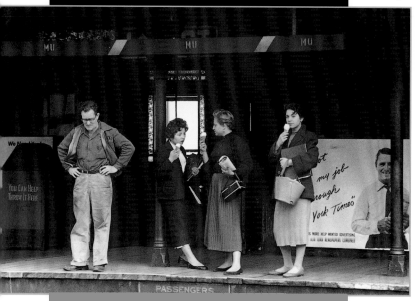

impact of urban renewal as well as showing how remaining area residents went about their ordinary lives (5.111).

The rapid dismantling of all but one elevated line due to loss of riders transformed its perspective from commonplace to unique. Photographers looked at and through the elevated windows and platforms with fresh vision, discerning beauty, drama, and flux in quotidian details and postures. Peering down from the stairs into a dentist's office, Cherry caught the patient with his mouth open (5.110). Such a view would soon be unavailable. The Third Avenue elevated was the last remaining el in the postwar decade.

Three coeds wait for a train, enjoying ice cream cones and conversation, and probably en route to Hunter College at Sixty-seventh Street (5.112). Their postures of waiting recall not only earlier etchings of women waiting for a subway train (see fig. 4.101) but also the modern dance of Paul Taylor, which drew inspiration from the movements and gestures of ordinary urban life. Higher education expanded rapidly during the postwar decades, initially for returning G.I.'s and subsequently for women. The city's free public colleges opened their doors to women, giving them opportunities for advancement similar to those of men. In 1961 the City University of New York was established. It included four four-year colleges (the recent Brooklyn and Queens Colleges, in addition to City and Hunter Colleges) and four community colleges, all funded by the city. Hunter College was a woman's institution, comparable in its character to City College.

Night transformed the Third Avenue el station at Sixty-seventh Street into a dazzling cityscape. The elevated tracks seem to float on their steel supports in Scott Hyde's photograph from 1950 (5.113).

The razing of the Third Avenue El in 1955 definitively marked the end of an era. Vivian Cherry documented its dismantling, captivated by the worker's skill and nonchalance (5.115). In these years before mandated hard hats, a worker relied on his sense of timing and trusted his fellow workers not to slip. Cherry recorded the process as light gradually flooded a street hitherto shaded by metal beams. New Yorkers enjoyed observing their city changing around them—buildings coming down and going up, new shapes arising—and predictably people watched the el coming down.

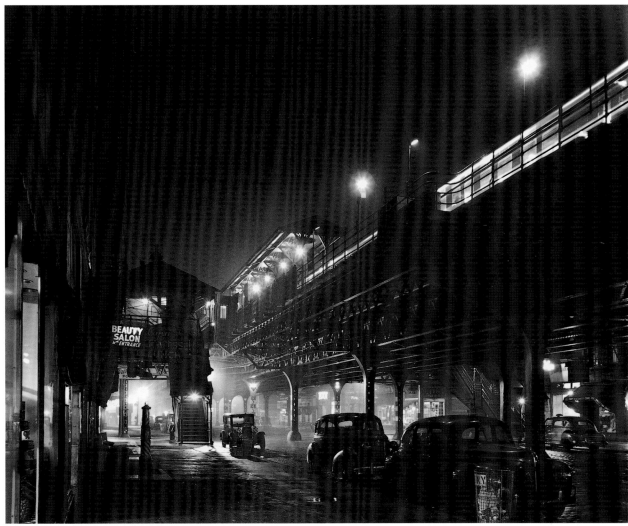

Schoolchildren even took field trips to survey its demise.

The commuting continued, even as ferries succumbed to increasing travel by car from the suburbs and even the outer boroughs. The Lackawanna Ferry connecting Manhattan with New Jersey survived until 1967, a good four decades after the end of ferry service across the East River. It brought railroad cars to Manhattan, vital for the city's manufacturing and commercial firms. Esther Bubley photographed the ferry in 1946 as it approached the New Jersey pier, with the skyline of Manhattan visible through the slip (5.117).

Rebecca Lepkoff transmits the pace of the morning rush-hour commute for workers in midtown Manhattan in her photo from 1947–8 (5.119). The long shadows of winter, the slanting light, and the steam from the manhole covers animate her image of a daily ritual performed by hundreds of thousands of New Yorkers.

Increasingly commuters traveled by bus from the suburbs. The Port Authority Bus Terminal Building stretched an entire block between Fortieth and Forty-first Streets and Eighth and Ninth Avenues (5.114). Completed in 1950, it housed competing bus companies and connected via ramps with the Lincoln Tunnel under the Hudson River. The building helped restore popularity to the bistate authority, which had suffered during the Depression, demonstrating the value of efficiency and cooperation in an independent public agency.

Thousands of commuters poured out of the buses into the terminal each morning, reversing their paths in the evening (5.118). Suburbanization in the postwar era expanded the number of people living within the city's orbit, what commentators called "the greater metropolitan area." The terminal came equipped with thirty-one escalators to handle

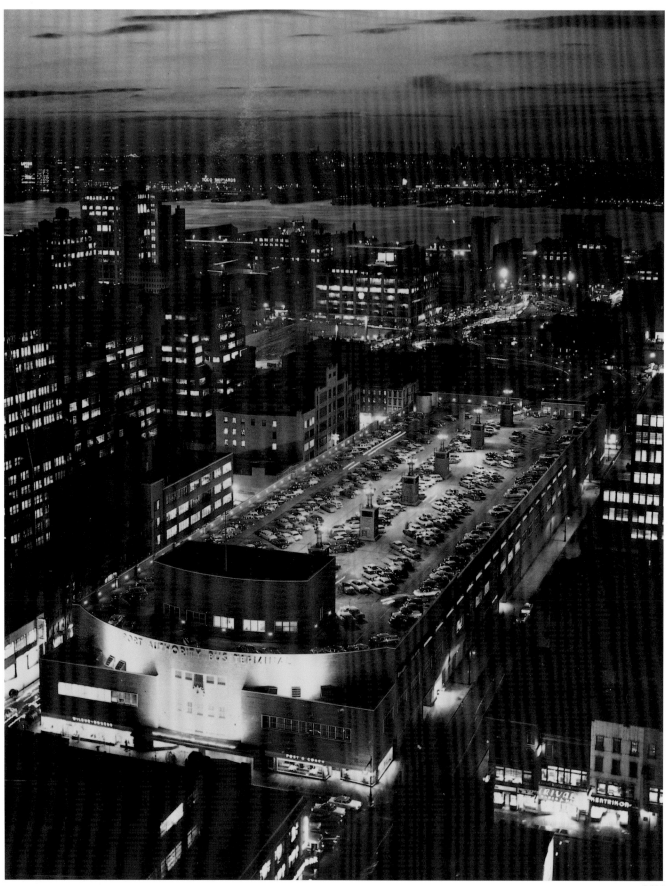

5.114

the crowds descending into the subway station. Notice the number of working women, most of them young. (Compare this photo to MacRae's image of commuters leaving the Staten Island Ferry in the 1930s, fig. 4.17.)

Esther Bubley documented long-distance bus travel in 1947 (5.116). This image from the Greyhound Bus Terminal imparts a sense of the heaviness of time. Reading a newspaper helped the hours pass; so did watching the world. Through its details, Bubley's photography reproduces middle- and working-class mores in the postwar period, including an increasing number of women who traveled alone.

Speedy and efficient, subways surpassed other modes of public transit. New York City consolidated its subways into a single municipally owned system, allowing for free transfers

5.115

The commuting continued from ever more distant suburbs.

5.114. Port Authority Bus Terminal. **5.115.** Vivian Cherry, *Tearing Down the Third Ave El*, 1955. **5.116.** Esther Bubley, 1947.

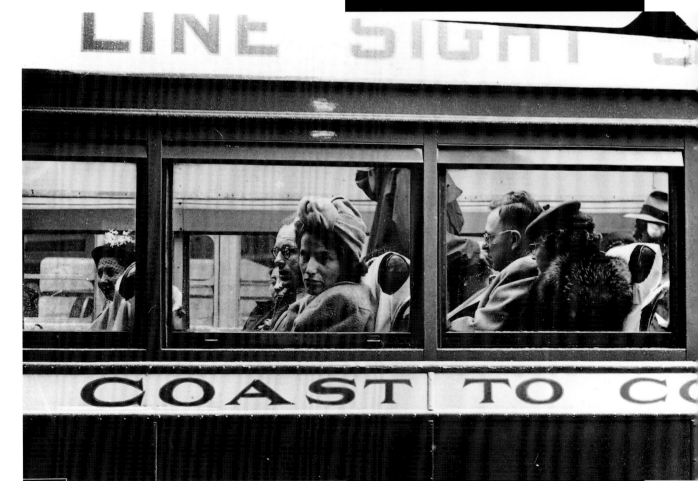
5.116

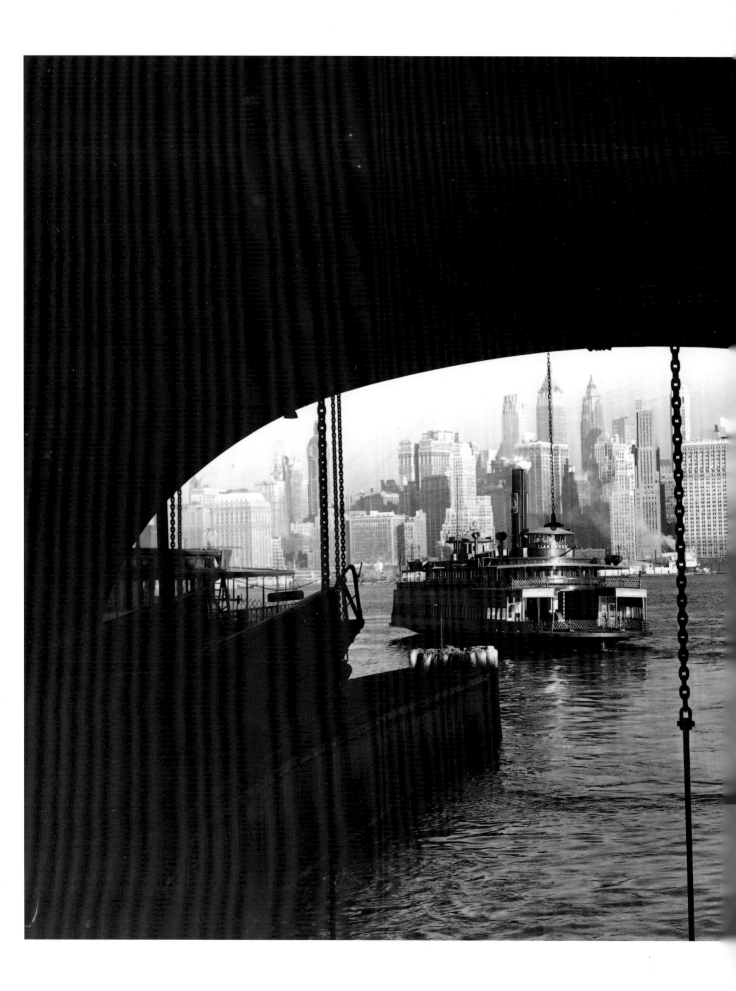

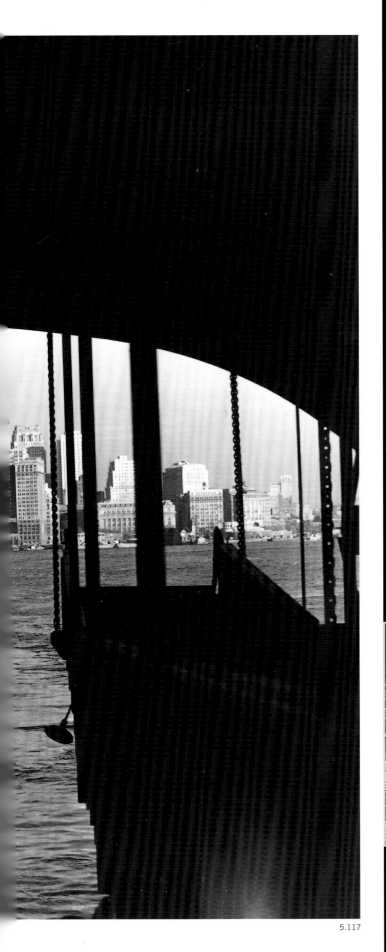

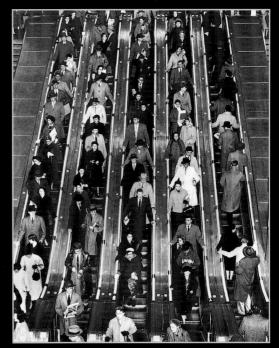

As much as New York

was a subway city,

it was a port city, the world's

largest at the end

of World War II.

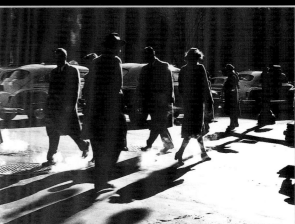

5.117

5.118

5.119

5.117. Esther Bubley, *Jersey City Terminal*, 1946.
5.118. Escalators. **5.119.** Rebecca Lepkoff, *Morning Rush, Midtown*, 1947–48.

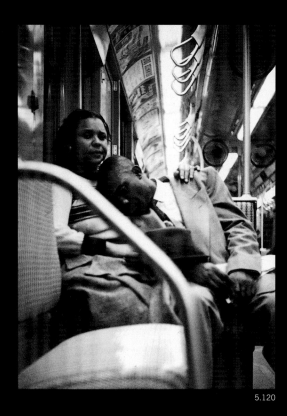

5.120

between lines. The horizontal subway system, extending over seven hundred miles throughout Manhattan, Brooklyn, the Bronx, and Queens, constituted a counterpoint to the vertical skyscrapers. William Glover photographed a crowded car during the war (5.124).

Influenced perhaps by Walker Evans's subway series in the 1930s, by their own experience riding the trains, or by technological advances in cameras, photographers discovered human drama underneath the city streets. Arthur Leipzig saw this couple in the evening and fixed their tenderness in his image (5.120). Notice the modern subway car lights, the chrome handles to hold when standing, and the fans. For a sense of changing ridership and attitudes toward the subway, compare these images with those from the 1970s and 1980s, when many middle-class New Yorkers shunned the trains (see fig. 6.110).

Entering the subway in one part of the city, the traveler

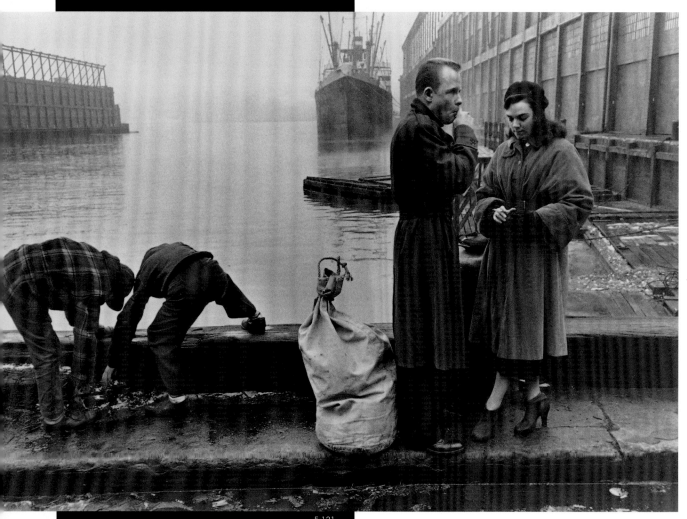

5.121

exited in another world. In the mid-
fifties as the el was coming down, Frank
Paulin turned his camera on the subway
entrances and exits, recording people as
they ascended or descended the steps.
Democratic means of transit, subways
allowed individuals to choose their own
pathways. The women are entering the
IND line at Twenty-third Street and
Sixth Avenue as several other women
exit on the right (5.123). In the 1960s
this would become one of the stops of the
PATH train system, another Port
Authority project, linking Newark and
Hoboken to Manhattan.

Subway romances connected New
Yorkers separated by neighborhoods or
even boroughs. But if the guy lived in Brooklyn and the gal
lived in the Bronx, the hour and a half of travel time tested
the mettle and commitment of any lover. Here, a couple
lingers at the subway entrance after a date (5.122). Note her
white gloves, a touch of class.

As much as New York was a subway city, it was a port
city, the world's largest at the end of World War II. Ships of
all sizes filled New York's harbor during the postwar
decades. Their presence lulled port authorities to ignore the
need to modernize to cope with container cargo, the domi-
nant trend of the future. Irony notwithstanding, Leipzig's
photo of the garbage barge chugging by the Statue of
Liberty recorded a fairly common sight (5.129). City
garbage collection had improved since the turn of the cen-
tury. Dumping vast quantities of trash in the ocean and
landfills on Staten Island disposed of it in the short term.

Boys swimming in the East River off coal barges continued
despite dangerous levels of pollution (5.125). Now the boys
wore bathing suits, in contrast to an earlier era (see fig. 4.14).

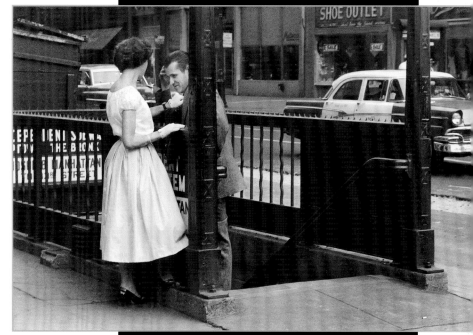

5.122

5.123

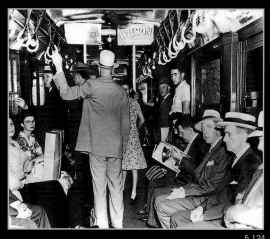

5.124

5.120. Arthur Leipzig, *Subway*, 1950. 5.121. Vivian Cherry,
Merchant Seaman Saying Goodbye, 1950s. 5.122. Frank Paulin,
New York City (Couple at Subway Stop), 1950s. 5.123. Frank
Paulin, *Subway Stop at Twenty-third Street and Sixth Ave*, 1954.
5.124. William Glover, *Subway*, 1942–45.

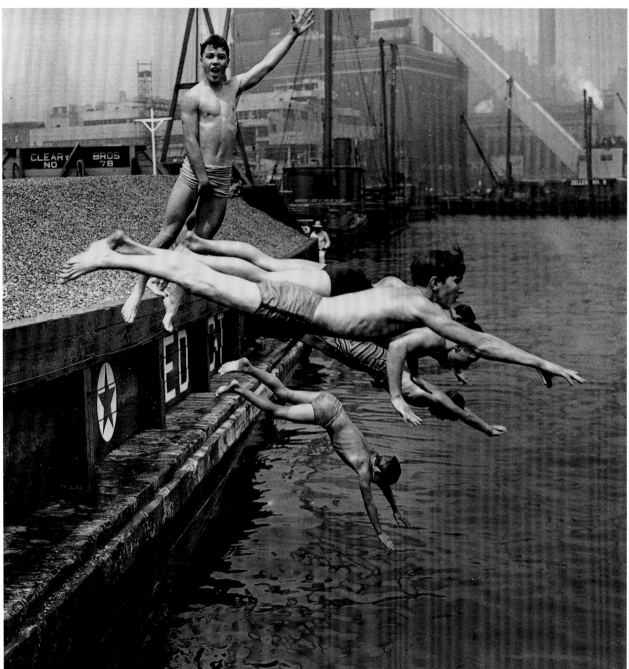

5.125

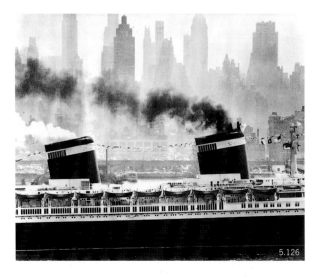

5.126

Vivian Cherry photographed a couple saying good-bye at a West Side pier in Manhattan before the man set off as a merchant marine (5.121). While such good-byes lacked the sharp pain of the war years, when danger threatened from enemy submarines, shipping off still meant months apart. Notice the children playing, ignoring the couple beside them.

When completed, the *United States* liner surpassed the *Queen Elizabeth* as the largest ship in the world. Transatlantic ocean liners docked regularly on the West Side piers, attracting affluent customers even as transatlantic flights competed for passengers to Europe. The piers, located north of Forty-second Street, combined an upper floor with passenger facilities with a lower level used for cargo and baggage. The former

space, open and illuminated by skylights, often ran for hundreds of feet. Feininger's photo imparts a sense of the ocean liner's grandeur against the backdrop of skyscrapers (5.126).

After the war Esther Bubley documented New York Harbor for Roy Stryker at Standard Oil Corporation. Born in Wisconsin, Bubley fell in love with photography through the photo stories in the popular new *Life* magazine. In 1940 she set out for New York City to become a photographer. Two years later she moved to the nation's capital, where she met Roy Stryker and other documentary photographers. Although she traveled extensively on assignment, Bubley made her home in New York, photographing the city and its people throughout her life.

Looking at the city from the New York Central railroad yards in Weehauken, New Jersey, Bubley documented the extensive freight connections that fed New York harbor (5.128). The boxcars would be loaded onto ferries for the trip across the river and then transported to large warehouses, such as the Starrett-Lehigh Building (see fig. 4.49), on Manhattan's west side.

Ships unloaded at piers on the East River, on either the Manhattan or Brooklyn side. After World War II a series of wildcat strikes drew public attention to corrupt practices on the docks and in the longshoremen's union. Approximately forty-eight thousand men worked as longshoremen in the 1950s. Esther Bubley's backlit photo highlights the cargo as it is being lowered onto a smaller barge from a large freighter (5.127). The rhythm of waterfront work endured for two decades after the war, with men lining up each morning for the day's shape-up. New York's waterfront culture was captured for popular consumption in the Elia Kazan movie *On the Waterfront*, starring Marlon Brando.

While all kinds of ships plied the waters of New York's magnificent harbor, the automobile would dictate the city's future. The extensive approaches to the George Washington Bridge, largely bereft of traffic, suggest how highway con-

5.127

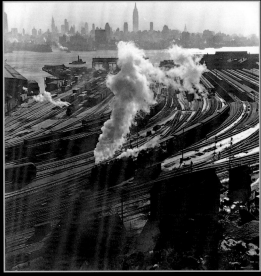

5.128

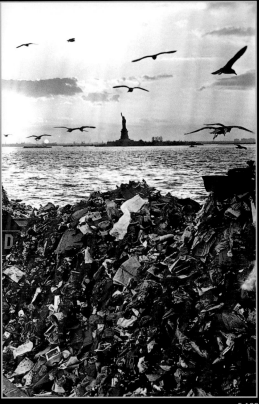

5.129

5.125. Arthur Leipzig, *East River Divers*, 1948. **5.126.** Andreas Feininger, United States *Liner Passing Forty-second Street*, ca. 1952. **5.127.** Esther Bubley, August 1947. **5.128.** Esther Bubley, *Rail Yards*, January 1947. **5.129.** Arthur Leipzig, *Garbage Scow*.

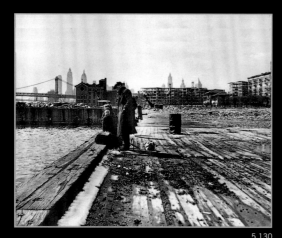

5.130

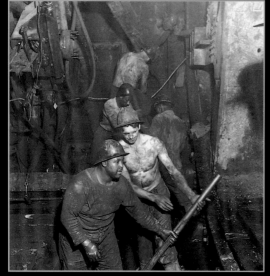

5.131

5.130. Roy Perry, *Waterfront Cleared Prior to Construction of East Side Driveway*, 1938–40.
5.131. John Vachon, *Tunnel Construction*, August 1947.
5.132. Woodhaven Boulevard, 1940. 5.133. Scott Hyde, *FDR Drive—UN Secretariat Building Under Construction*, 1950. 5.134. William Glover, *Upper Manhattan Seen from the New Jersey Shore.*

5.132

struction anticipated and encouraged a changing way of life (5.134). After the war federal monies would help transform large tracts of farmland into housing, creating a huge network of suburbs around New York City. A few of those houses can be seen in the lower right, in contrast to the tall apartment buildings of Castle Village in the upper left.

Few people owned cars in 1940, especially in New York City. Gas was expensive, costing 98 cents a gallon. This view looking north from Jamaica Avenue up Woodhaven Boulevard, then under construction, shows how empty the roads were (5.132). A working-class village in the nineteenth century, Woodhaven became a middle-class suburb in the twentieth, populated largely by Irish and Italian residents.

Anticipating automobile travel and eager to facilitate it, the city built parkways along the edges of Manhattan. Robert Moses, a Republican city planner and master builder of New York City for forty years, convinced politicians to underwrite his dreams. He manipulated his positions as the head of several public agencies (at one point he simultaneously held twelve top jobs at state and municipal levels), including the authorities that built the Triborough Bridge, to fund a circumferential highway network around Manhattan. When he failed to build a bridge connecting the Battery to Brooklyn, he took over a combined public authority that constructed the Brooklyn-Battery Tunnel (see fig. 5.106). He helped gain tax relief that assisted the construction of Stuyvesant Town (see fig. 5.109) and advocated urban renewal projects that leveled large sections of the city (see fig. 5.111). One of his most controversial projects, the Cross-Bronx Expressway, ran through vital working-class neighborhoods. Despite prescient protests by residents that the highway would eviscer-

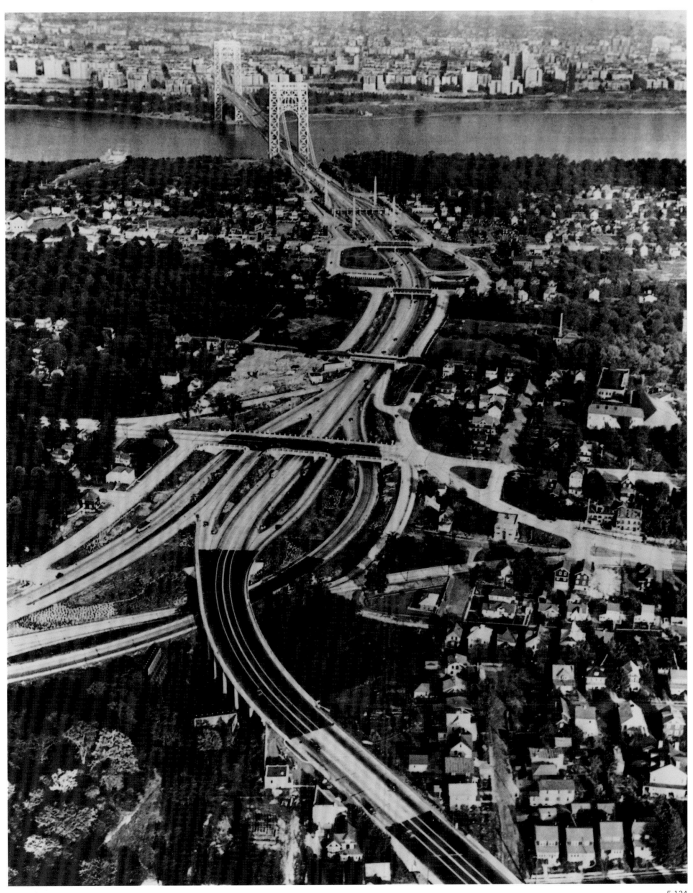

5.135

ate the Bronx, Moses insisted on the route. Moses admired automobiles, though he never learned to drive, and built over four hundred miles of highways in New York.

Roy Perry's photo of a family fishing on the East River exposes the extent of waterfront clearance prior to the construction of what became the Franklin Delano Roosevelt Drive (5.130). A staggering 12,600 tenement apartments were torn down between East Houston and Delancey Streets, creating superblocks for public housing that stretched east from the FDR Drive to Columbia Street (see fig. 5.6). What had been a teeming neighborhood succumbed to the wrecker's ball. In the background can be seen the Manhattan bridge and the Alfred E. Smith projects rising on the Lower East Side.

Scott Hyde's photo a decade later shows the finished drive, complete with cars (5.133). The view of the river, with the UN Secretariat Building under construction, is truly grand. The apartment buildings at Beekman Place appear on the right. Notice the absence of any road mark-

ings indicating lanes, a sign of leisurely driving.

John Vachon's photo of the construction of the Brooklyn-Battery tunnel in 1947 speaks not only to the engineering involved but also to its integrated labor force (5.131). As during the construction of the New York City subway system, African Americans found employment doing some of the most difficult and dangerous work. Construction jobs above ground, however, remained segregated, sustained by strong unions and family ties.

New York led the nation in innovative hospital care. Public and private hospitals experienced soaring admissions during the postwar period as a result of the rising prestige of modern medicine and its miracle drugs. Health insurance plans like the Health Insurance Plan (HIP) of New York, instituted in 1945, provided city residents and workers with affordable care and fueled hospital expansion and specialization. Twenty years later Congress passed legislation subsidizing health care for poor and elderly people. One year later Medicaid and Medicare accounted for

over half the income of the city's hospitals.

Volunteers did their best to help underpaid hospital workers. In 1940 volunteers at Triboro Hospital in Jamaica, Queens, put on a minstrel show to amuse the patients (5.136). With their racism, minstrel shows retained their popularity as amateur entertainments long after they disappeared from the professional stage and screen.

Increasingly unhappy with their long hours, low wages, and difficult jobs, the nonprofessional hospital workers of Local 1199 struck to get union recognition and rectify abuses (5.135). Most of the union members were women and African-American or Puerto Rican. Martí pictured a strike in 1962 at the Manhattan Eye, Ear, and Throat Hospital, a private hospital on East Sixty-fourth Street.

Not only unions demonstrated during the postwar decades. All types of political expression registered on the city's streets as protesters took their cases to the public. In 1946 John Albok photographed an early antiwar demonstration by a war veteran who had lost his legs (5.137). Such protests subsequently coalesced around nuclear weapons, demanding a policy of restraint in testing as well as unilateral disarmament. Women in particular took the lead in advocating a sane nuclear policy.

Looking down at a rally from a window, Leipzig saw a sea of hats (5.138). The cause, a Transport Workers Union demonstration, drew men, not women. Formed in 1934, the TWU rapidly signed up thirty thousand members during the Depression and secured contracts with several of the still privately owned subway lines, the BMT, and the IRT. A heavily Irish union led by an outspoken radical, Michael J. Quill, the TWU repeatedly threatened to strike. After the city took over all the subway lines, the union set a precedent in collective bargaining for other civil service unions. Radicalism, active participation in local politics (including its support for the American Labor Party), and militance characterized TWU policies until 1948. Eventually the union won recognition from the New York City Transit Authority, the agency established in 1953 to run the city's subways and buses. Leipzig's image pays homage to democracy, both its pluralism and its uniformity.

As a college student, Builder Levy attended a protest outside the UN during the Cuban Missile Crisis in 1962. The faces in the crowd communicate the fear of nuclear war that

5.136

New York led
the nation in innovative
hospital care.

5.137

5.135. Justo A. Martí, 1962. **5.136.** Hospital minstrel show, 1940. **5.137.** John Albok, *War Veteran Demonstrating Against the War*, 1946. **5.138.** Arthur Leipzig, *TWU Rally*, 1947.

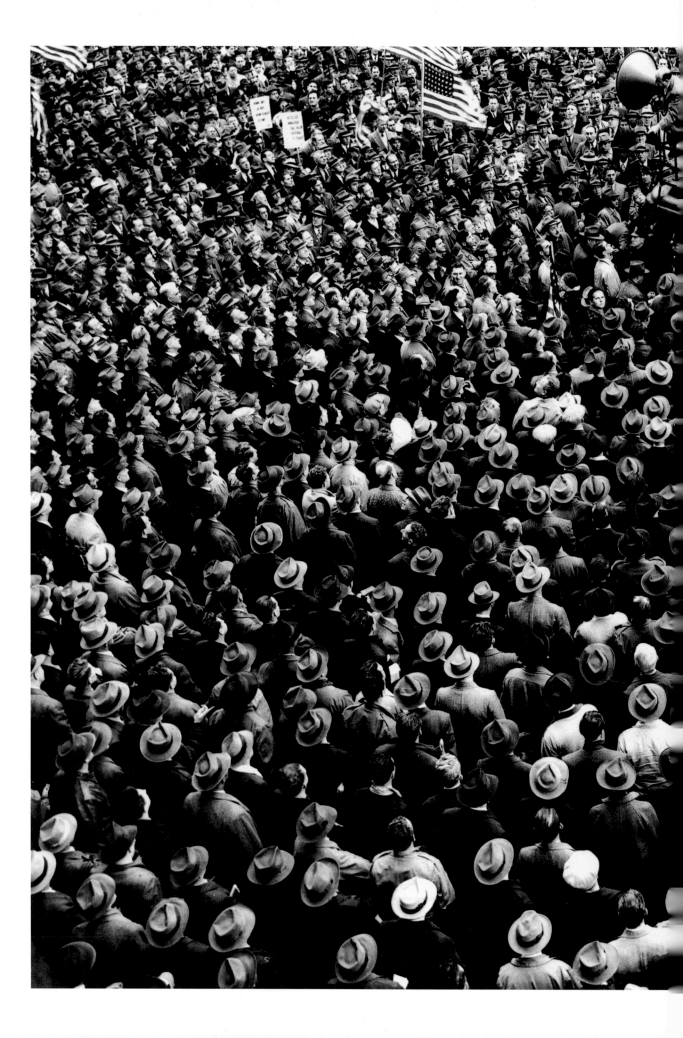

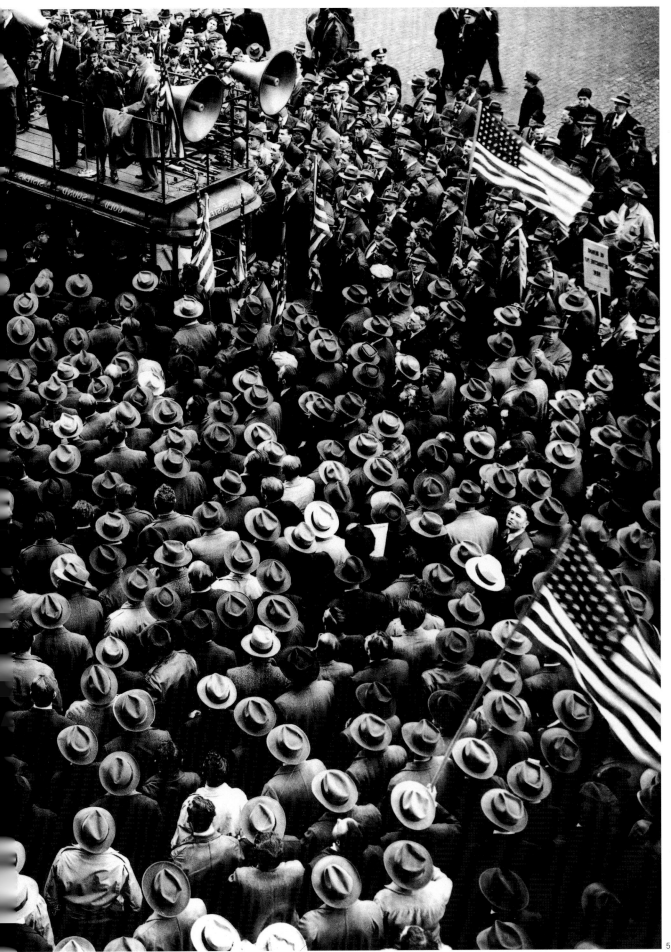

5.138

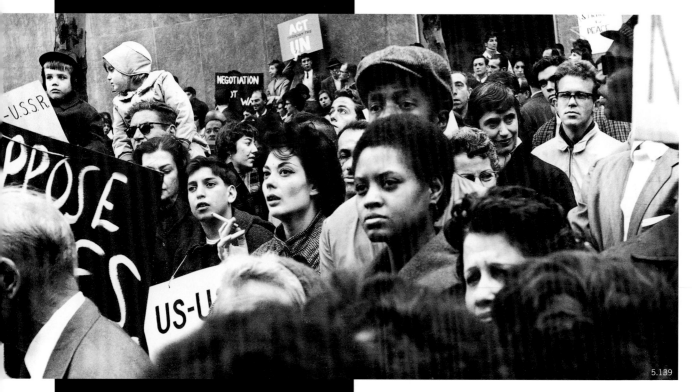

5.139

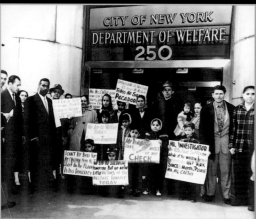

5.140

swept through many New Yorkers during those tense days of standoff between President John F. Kennedy and Nikita Khrushchev, premier of the Soviet Union (5.139).

Local political issues, particularly those concerning housing and discrimination, provoked meetings and protests among many New Yorkers who believed the wartime rhetoric of democracy and equality (5.143). Tenants' meetings to deal with the housing shortage caused by the Depression and the war multiplied after the war ended. When negotiation didn't work, tenants went on rent strikes, withholding their rent until improvements were made. Many slum landlords preferred not to invest in their properties, hastening the decline of such neighborhoods as Harlem. Notice the litter in the streets. The parents pictured here were organized by the Harlem Tenant Council.

New York City expanded its welfare rolls after the war even as median incomes rose in the city. By 1960 328,000 received welfare, largely seen by New Yorkers, in the spirit of the New Deal, as a right, not as charity. Allocations, however, while generous compared to those in other states, failed to keep up with inflation or secure men, women,

5.139. Builder Levy, *No War Over Cuba*, 1962. **5.140.** Justo A. Martí, *Welfare Protest*. **5.141.** Picketing *Birth of a Nation*, 1947.

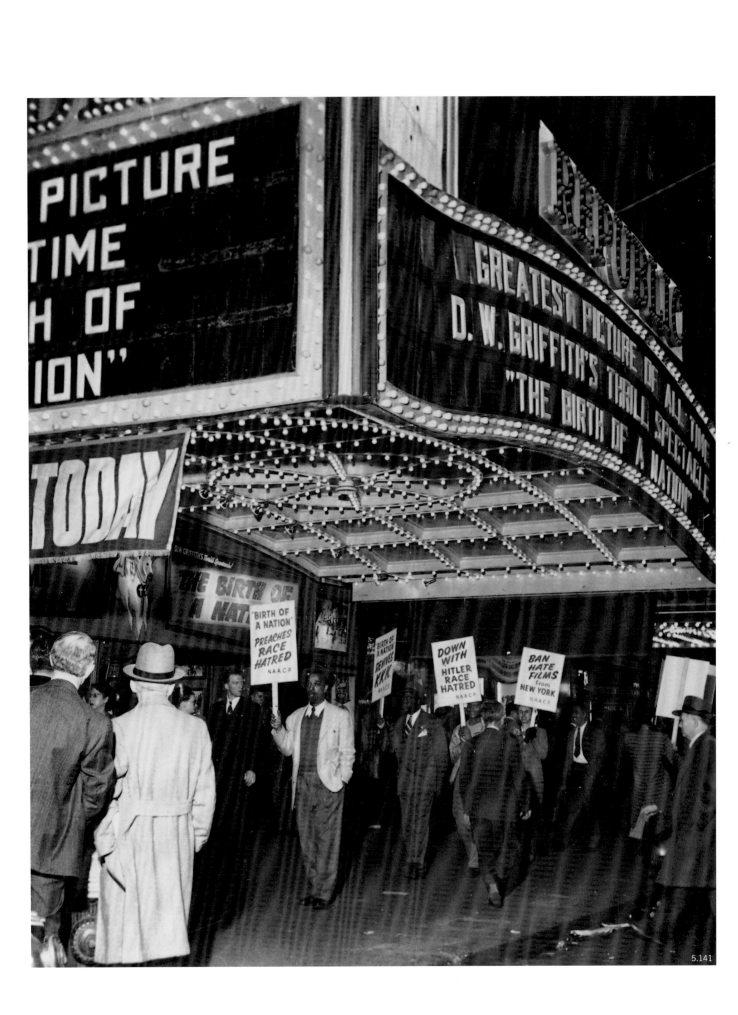

361

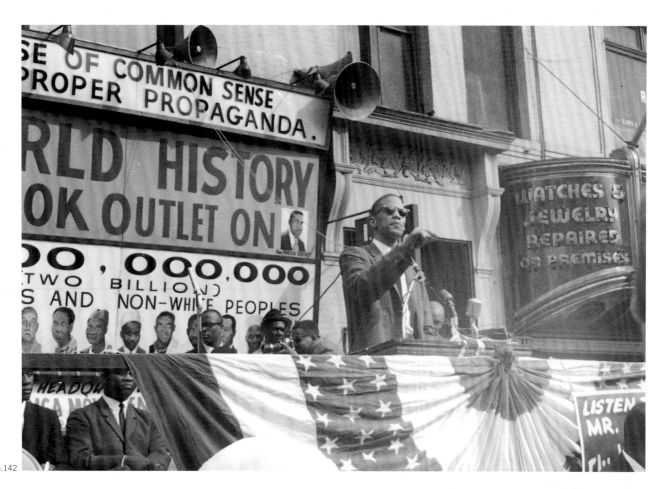

5.142

and children a decent existence. Protests about the injustice of inadequate welfare in front of the city's offices elicited sympathy for those suffering but produced few changes (5.140). One of the signs says "My Rent Takes Most of My Check," referring to the high cost of housing in the city.

Energized by wartime idealism, African-Americans mobilized to fight discrimination and prejudice. The 1947 re-release of D. W. Griffith's famous movie *The Birth of a Nation*, which had inspired the rebirth of the Ku Klux Klan when it first appeared, sparked a picket line in front of the Broadway theater at Fifty-first Street (5.141). The movie pictured newly enfranchised slaves during Reconstruction as lecherous and evil, an image unlikely to inspire respect and equality for African-Americans.

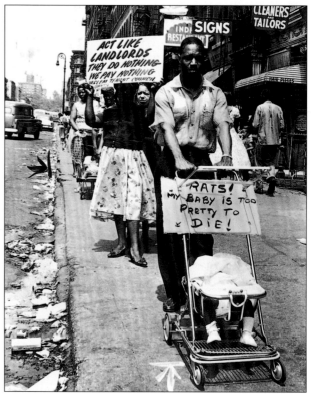

5.143

5.142. Beuford Smith, *Malcolm X, Harlem*, 1964.
5.143. Richard A. Martin, *Tenant Strike*. **5.144.** Garry Winogrand, *World's Fair, New York*, 1964.

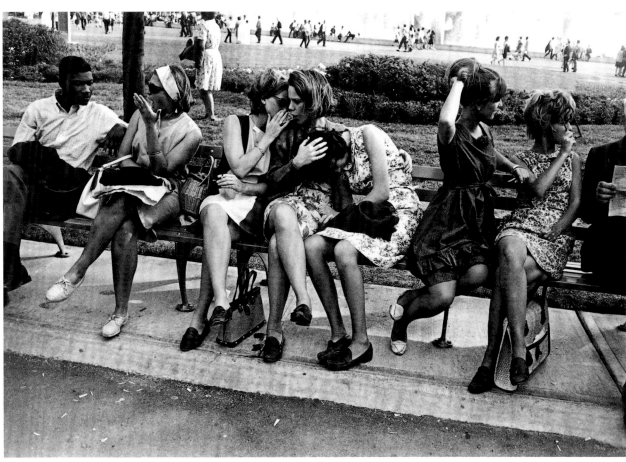

5.144

In the early 1960s rhetoric heated up and the pace of protest increased. By 1964, when Beuford Smith took this photo in Harlem, Malcolm X's influence extended way beyond the boundaries of New York City (5.142). The fiery and controversial spokesman for the Nation of Islam articulated an alternative vision to that of Martin Luther King, Jr., one that spoke to the enormous frustrations and anger of urban blacks. Self-discipline and community building came with Malcolm's message of separatism and inspired thousands to struggle to change their world.

The 1964 World's Fair, held in New York, chose the unisphere as its symbol, without any irony intended. The world seemed to be growing closer, despite the cold war. Confident of its record at integrating diverse men and women from many nations into common citizenship, New York aspired

Confident of its record in integrating diverse men and women from many nations into common citizenship, New York aspired to status as a global city.

to status as a global city. Turid Lindahl photographed the unisphere under construction in 1963, a perfect globe framed within the angles created by the surrounding cranes (5.145). The image shows a work in progress, an apt symbol for the World's Fair even when completed.

This aerial view portrays the finished unisphere set within a circle of fountains (5.146). On the horizon stands Shea Stadium, built in 1964 to house the city's new baseball team, the Mets. The Mets aimed to fill the gap left by the departure of the Dodgers and Giants for the West Coast.

Even more than the unisphere, Garry Winogrand's photo of the shared world of a public bench expresses the hopes for future coexistence among diverse people (5.144). New York City's future as well would rest on its ability to continue to harness its citizens' creative powers.

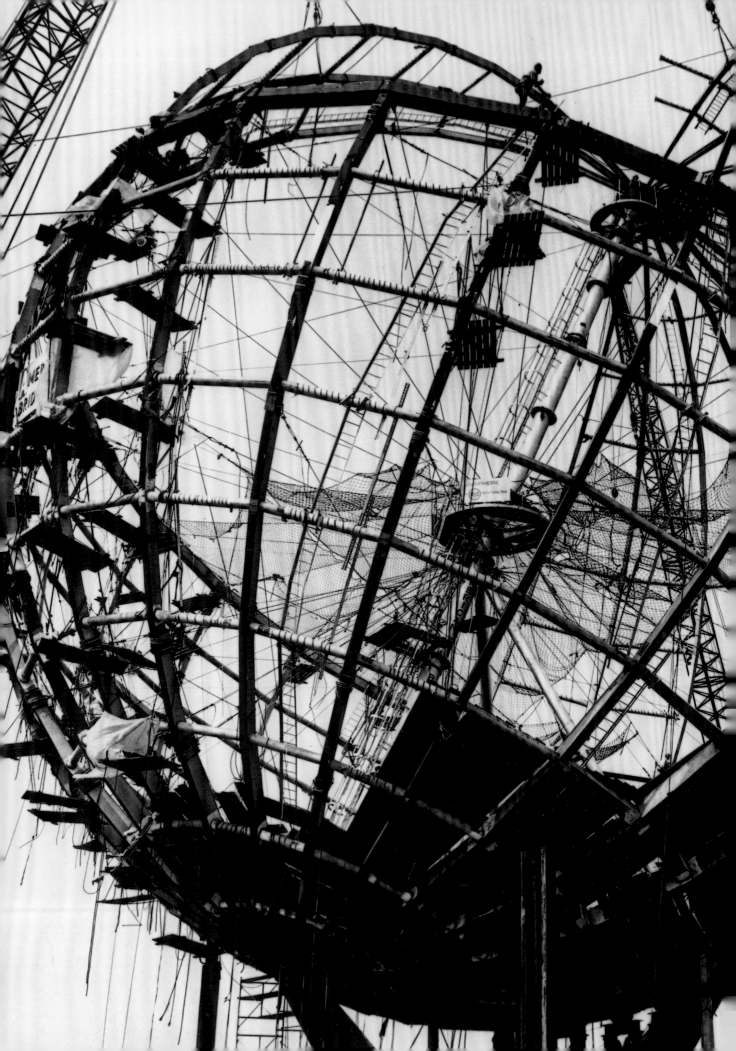

New York City's

future would rest

on its ability to continue

to harness

its citizens' creative

powers.

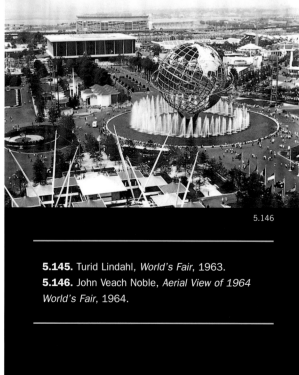

5.146

5.145. Turid Lindahl, *World's Fair*, 1963.
5.146. John Veach Noble, *Aerial View of 1964 World's Fair*, 1964.

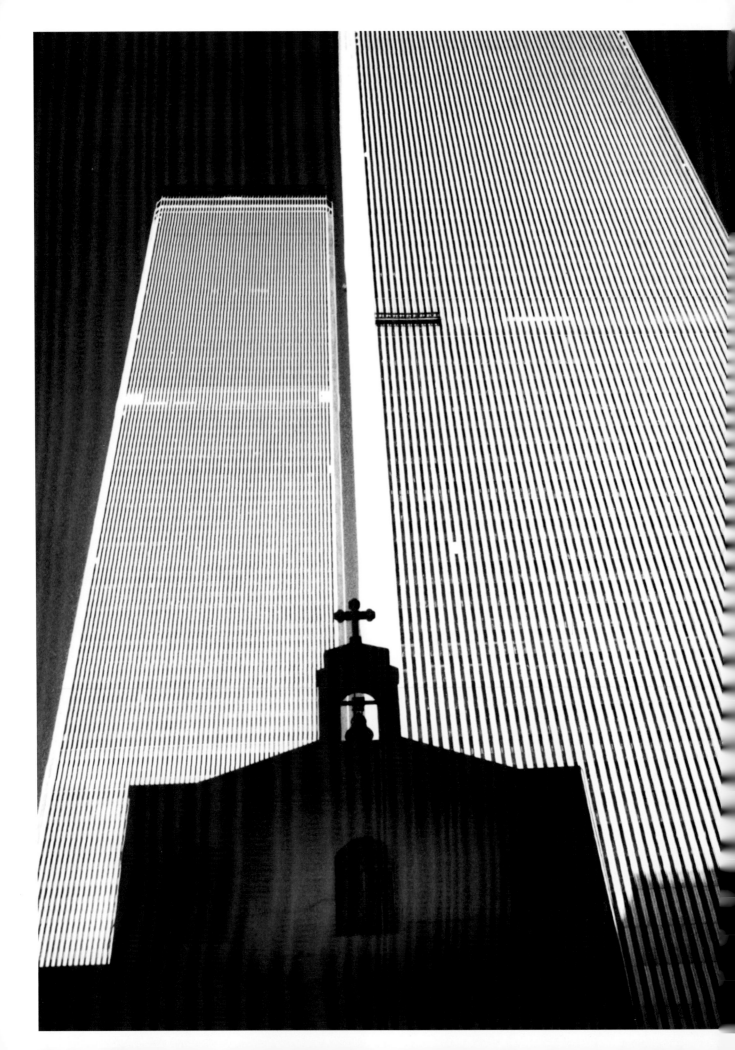

6

1966–1999

wo decades after World War II, the global city of New York stood on a world stage without rivals, its financial power embodied in Lower Manhattan's new building boom. Although the city's population declined from a peak of 7.8 million in 1970 to 7.0 million in 1980 and would only rise slightly to 7.3 million in 1990, the figures masked significant changes. Most important, New York once again became an immigrant destination, drawing ambitious migrants from every continent.

Fascinated by the interplay of old and new, photographers captured the image of the former as reflected in the latter. They responded to the city before them aware, too, of previous documentary and modernist visual traditons that had produced a powerful record of New York life. Contemporary photographers engaged in an explicit conversation with the past, commenting on and interpreting the city as a palimpsest. An immigrant from France, Marc Kaczmarek arrived in New York City a month after John F. Kennedy's assassination. He studied with Alexey Brodovitch in the 1960s and tackled the dynamism of New York's streets in the 1970s. In his photos a dialogue emerges between two expressions of urbanism, two modes of finance capitalism. His urban portraits convey tensions inherent in living in a landscape of outsized scale. The buildings loom over ordinary life, transforming workers in the new cityscape. Unlike the empathy pervading images of the city created by Photo League and other documentary photographers, irony and humor animate Kaczmarek's pictures. Here is a different way of seeing a city transformed.

Perhaps nothing symbolized the new urban scale better than the World Trade Center's twin towers. Completed in 1973, the towers dwarfed everything within sight. Designed by architect Minoru Yamasaki and financed by the Port Authority of New York and New Jersey, they rose 1,350 feet, for 110 stories. Clad with aluminum, the towers shimmered in the light. One critic called them "the largest aluminum siding job in the history of the world."[1] Unlike the privately financed Empire

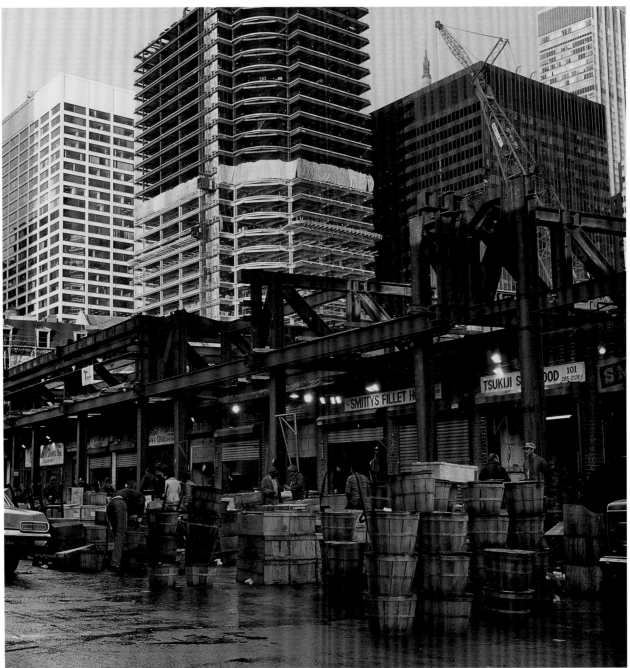

6.2

State Building, the Trade Center towers failed to excite public enthusiasm.

Kaczmarek's photo of the towers foregrounds a small church located south of the Trade Center on the edge of the fifteen-block area cleared for development (6.1). The image juxtaposes the buildings' imposing financial power against the exceedingly modest claims of religion and faith. It recalls Berenice Abbott's image dramatizing the eclipse of religion by the cathedrals of commerce (see fig. 4.7).

The juxtaposition of old and new, in buildings and signage, reverberates in figure 6.3. Kaczmarek frames the image so that the signs and buildings compete with each other. On the right, traditional stone and modernist neon angle for our attention; on the left, the arrow points aggressively skyward as the towers lurch in the opposite direction.

6.1. Marc Kaczmarek, 1978. **6.2.** Barbara Mensch, *Building the Mall*, 1983–84. **6.3.** Marc Kaczmarek, 1974. **6.4.** Marc Kaczmarek, 1978. **6.5.** Marc Kaczmarek.

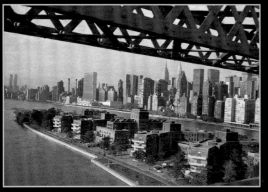

6.6

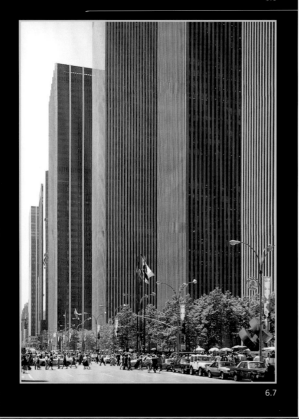

6.7

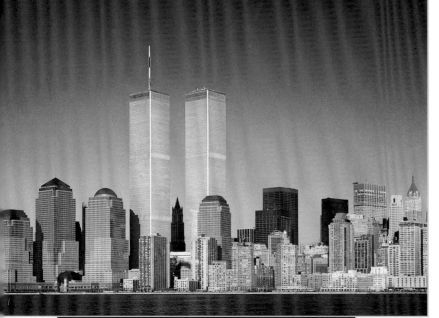

6.8

Kaczmarek saw the City Bank Farmer's Trust building and the Bank of the Manhattan Company, both much-photographed skyscrapers of the interwar period (see figs. 4.10, 4.109), as almost quaint miniatures in the windows of downtown's new glass and steel facades (6.4).

An office building boom in the 1960s added millions of square feet of space in Lower Manhattan, much of it used for back offices for financial and insurance firms where the unseen clerical, technical and maintenance staff worked. Kaczmarek shot office towers on Church Street from an unfamiliar angle, looking up at them with the kind of wonder a child might have (6.5). The photo's sense of rhythm is syncopated: triangles press against the sky, carving it into a dramatic vault.

Barbara Mensch set out to document the Fulton Fish Market in its waning days before it was overwhelmed by new construction and the creation of the South Street Seaport as a commercial and tourist mecca. Her 1983 photograph foregrounds the market in its ongoing gritty life even as white skyscrapers rise above the remaining stalls (6.2). Steel beams stand ready to swallow up a venerable site of life and labor.

Although a project of government, the World Trade Center epitomized the city's global ambitions and dominated its skyline. Bror Karlsson, also an immigrant, shuttled between his native Sweden and New York City during the 1980s. His photograph shrinks the Trade Center's scale as we glimpse the twin towers from among six granite columns engraved with the names of servicemen who died during World War II. The thin columns of light edging the towers echo the narrow ridges holding each panel of names (6.10).

Bror Karlsson crossed the Hudson River to Liberty State Park in New Jersey to view the dramatic scope of landfill construction on

6.6. Harvey Zipkin, *View from Fifty-ninth Street Bridge*. **6.7.** Bror Karlsson, 1983. **6.8.** Bror Karlsson, 1990. **6.9.** Robert Setcik, *View from Empire State Building South*, 1981. **6.10.** Bror Karlsson, 1986.

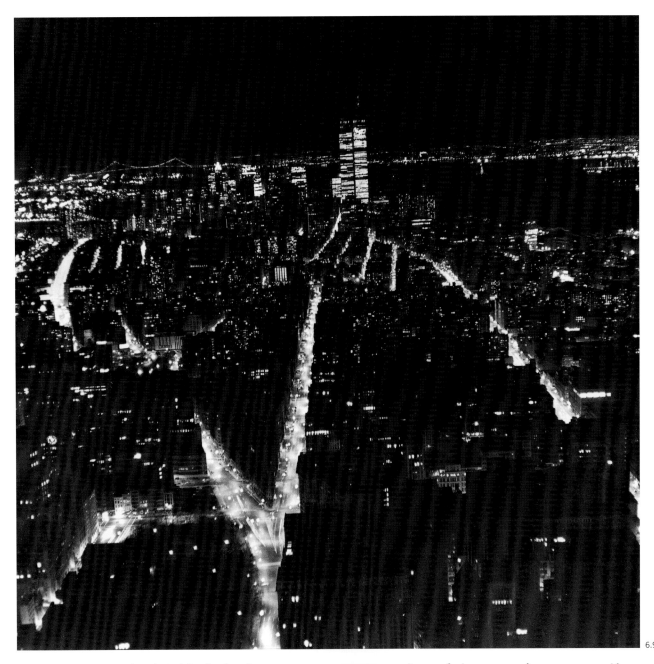

6.9

Manhattan's West Side (6.8). The landmark Woolworth Building, once one of the city's tallest skyscrapers (see fig. 4.22), stands sandwiched between the twin towers, cast in shadow. Battery Park City, built on landfill from the World Trade Center, introduced a place where people lived as well as worked, a village next door to the mammoth skyscrapers of multinational corporations. Close to the World Trade Center is 140 Broadway, a fifty-two-story office building that rose without setbacks, a model of curtain-wall minimalism encouraged by new zoning legislation that went into effect in 1961.

International-style architecture and new zoning legisla-

6.10

tion crafted a spare urban geometry. Along Manhattan's wide avenues, where elevated trains had rumbled earlier in the century, glass and steel slabs lined up in rows, introducing austere urban rhythms. Sixth Avenue, renamed Avenue of the Americas in 1945 to boost its fortunes as the commercial capital of the Western Hemisphere, gradually assumed its shape as a street of office towers in the 1960s and 1970s. The first one completed was the Time and Life Building in 1961 located on the corner between Fifty-first and Fifty-second Streets. Moving south (and from right to left) come the Exxon Building (1971), the McGraw-Hill Building (1972), the Celanese Building (1973), and the J.

6.11

6.12

6.13

P. Stevens Tower (1971), each one rising sheer from a street-level plaza (6.7). Karlsson's use of a telephoto lens flattens the perspective in a manner similar to Feininger's (see figs. 5.9, 5.13).

Seen from a distance, the city's spatial geometry articulated its grandness, the scope of its global embrace. Immediately recognizable, Manhattan's grid epitomized the romance of the urban landscape, especially at night. Robert Sefcik's photograph of the city at night looks south from mid-Manhattan toward the twin towers and the Verrazano Bridge linking Brooklyn and Staten Island in the distance (6.9). The last great bridge designed by Othmar Ammann, it opened in November 1964. Although it displaced thousands of Bay Ridge residents, it promoted residential development on Staten Island. In Sefcik's photo the splash of light from traffic and streetlights turns every avenue into a "Great White Way," the name formerly reserved for Broadway's entertainment district. High-intensity streetlights designed to deter crime coupled with patterns of late-night labor, blurred temporal distinctions for New Yorkers.

Harvey Zipkin also faces south from the Fifty-ninth Street Bridge to record Manhattan's East River facade (6.6). The twin towers are visible on the far left, and the United Nations, Empire State, and Chrysler Buildings are also easily recognized. Far less distinctive is the Pan Am Building directly behind Grand Central Station. Zipkin's photo shows both prosperous neighborhoods with river views and the extensive construction in midtown Manhattan that created two central business districts. In the foreground on Roosevelt Island (formerly Welfare Island) stands Goldwater Memorial Hospital, which opened in 1939. The island also housed an entire urban village north of the bridge.

Marc Kaczmarek photographed the Citicorp Building, situated between Fifty-third and Fifty-fourth Streets between Lexington and Third Avenues as it neared completion in 1978 (6.14). Hugh Stubbins, the architect, intended the building to rebuke the "anonymous—cool and inhumane" slabs that marched up Sixth Avenue.[2] Stubbins wanted to revitalize urban development with an

6.11. Paula Wright. **6.12.** Marc Kaczmarek, 1973. **6.13.** N. Jay Jaffee, *Tour Group Suitcases*, 1984. **6.14.** Marc Kaczmarek, 1978.

6.14

emphasis on people, in the plaza and lobbies. Kaczmarek suggests a different view. His austere photo composes the glass and aluminum against a flat sky that reaches down below the horizon. In this image of an utterly built environment, clouds float only reflectively, in windows.

An immigrant from Hungary, Paula Wright arrived in New York City in the 1920s and immediately obtained work in a photographer's studio. In the 1960s and 1970s Wright explored her city as it changed around her. Her photographs portray the city's architecture as expressive of its cultural flair. In this photo of Atlas seen against the spires of St. Patrick's Cathedral on Fifth Avenue, Wright juxtaposed

art and faith (6.11). Usually viewed against the modern walls of Rockefeller Center, the sculpture engages in a different dialogue with the cathedral across the street.

New York's cultural reach extended beyond its architecture to embrace all the arts. Music, opera, and dance each received prominent billing around Lincoln Center's main plaza, designed by Philip Johnson. On its edges stood popular performing arts, theater, and cinema, along with schol-

6.15

6.16

arship and education. In the 1980s classic jazz would also find a home within Lincoln Center's precincts. One of the last projects of Robert Moses, the creation of Lincoln Center in the 1960s involved the razing of working-class buildings that had housed many musicians and artists. Moses expected that Lincoln Center would enhance real estate values and transform the neighborhood, a process that occurred twenty years after the center opened.

Evening provides a soft light that tempers the relentless white stone of Lincoln Center's buildings and plaza. During the day, the space boldly and baldly announces the city's cultural claims. Marc Kaczmarek photographed the encounter of the plaza as it meets Sixty-fifth Street (6.12). The young woman emerging from beneath the overpass strides forcefully, with the rapid gate typical of New Yorkers.

The city's museums pioneered in presenting a rich array of American artists, defining contemporary art for the world. The Museum of Modern Art, on Fifty-third Street, west of Fifth Avenue, expanded in 1951, again in 1963, and once more in 1977. Esther Bubley's 1987 photograph shows the original 1939 building designed by Philip Goodwin and Edwin Durrell Stone as well as Philip Johnson's 1963 addition (6.16). The large banners hanging in front of the museum indicate the growing popularity of its shows. Attending museums, once a pleasure cultivated largely by the wealthy or those dedicated to art, increasingly appealed to a broad spectrum of middle-class New Yorkers. Blockbuster shows drew thousands, who waited in line to enter the museum.

The Whitney Museum, devoted exclusively to American art, opened its headquarters on Madison Avenue and Seventy-fifth Street in 1966, enhancing the avenue's reputation as a center for art. Previously, many galleries had relocated from Fifty-seventh Street to Madison Avenue. The close proximity of the museum to galleries suggests their intimate financial and aesthetic connections. The building, designed by Marcel Breuer, secured the museum's image as upscale and contemporary. Its rooms accommodated easily

6.15. Paula Wright. **6.16.** Esther Bubley, *Museum of Modern Art*, 1987. **6.17.** Barbara Mensch, *Early Morning Ice House, South Street*, 1984. **6.18.** Barbara Mensch, *Last Fishing Boat to South Street*, 1985.

the enormous scale of American painting. Paula Wright's photograph shows one of the Whitney's distinctive windows that thrust out at angles over the street (6.15).

As the nation's cultural capital, New York attracted thousands of visitors each year. The city's appeal cut across lines of race, class, gender, and religion. Foreign tourists often came in groups, visiting a city whose reputation for danger in the 1980s invited the security of numbers. N. Jay Jaffee conveys an artifact of mass tourism in the neat rows of suitcases outside the Plaza Hotel (6.13). Once a symbol of elegance and individuality, the Plaza now filled its rooms by catering to well-heeled but less individualist tourists.

As New York City lost its industrial, small-manufacturing base, traditional blue-collar jobs disappeared. In addition, when the city relocated many of the wholesale markets from Lower Manhattan to Hunts Point in the Bronx in the 1980s, workers followed, changing the character of Manhattan. One of the last to leave, the Fulton Fish Market operated according to time-honored rhythms. Photographers gravitated to this male working world of hard hand labor that persisted on the edges of the city, near the expanding, booming financial district. No longer motivated by a desire to expose exploitation of workers, as Jacob Riis and Lewis Hine had been, or to document New York's harbor story, as Gordon Parks did (see fig. 5.91), Barbara Mensch and Nuriel Guedalia caught the market's tempo and movement with a nostalgia-tinged empathy. Guedalia's perspective composes his images as aesthetic as well as documentary statements. Mensch's photos seem almost artless, although their intimacy belies their seeming simplicity.

Compare Guedalia's photo of men carrying boxes of fish on hand trucks, a large fish in the foreground and the sweep of Brooklyn Bridge in the distance (6.19), with Mensch's photo of the same activity, which emphasizes the men's patience as they wait for cargo to be unloaded (6.17). Or consider Guedalia's image of the crates at night, taken from above (6.21, in contrast to Mensch's daytime shot of the last fishing boat to arrive at Fulton Street (6.18). Both images, so different, evoke an earlier era, when the process of feeding a city of over seven million inhabitants engaged thousands of men in backbreaking labor.

Workingmen's faces invited an urban portraiture that linked men to their jobs. Barbara Mensch grew up in

6.17

As New York City lost its industrial, small-manufacturing base, traditional blue-collar work acquired a nostalgic tinge.

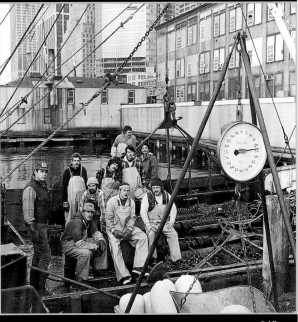

6.18

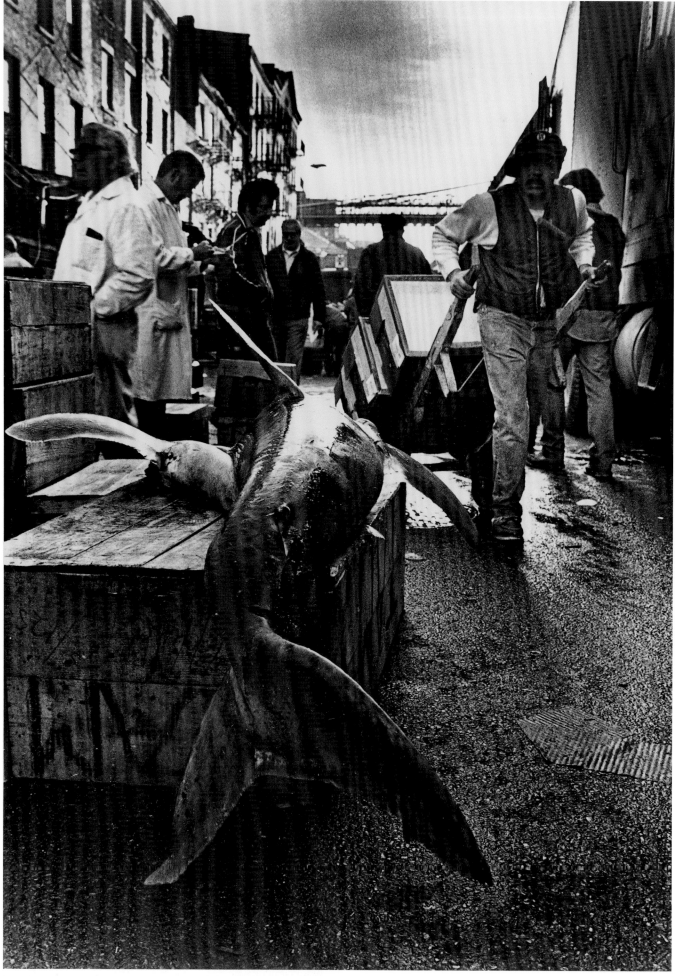

6.19

Brooklyn, the granddaughter of Jewish immigrants. Knowing well the working-class world, Mensch was grabbed by the power of photography and she taught herself its techniques. Her portrait of Harry the Hat, pictured leaning on his handtruck at a loading dock for trucks, conveys the knowledge and skill of a seasoned worker (6.20).

Although many industries left the city, the garment industry survived, albeit in reduced circumstances. In the decades following a liberalized immigration bill in 1965, thousands of women from China and the Dominican Republic found employment in small and large shops. African-Americans had tried to enter the industry after World War II only to be rebuffed, relegated to some of the most marginal jobs as "pushboys." Beuford Smith's portrait of a pushboy behind his rack of clothes depicts a man's daily effort to earn a living (6.24).

Working in the city routinely involved seeing the world from the tenth or twentieth floor. Although apparel pro-

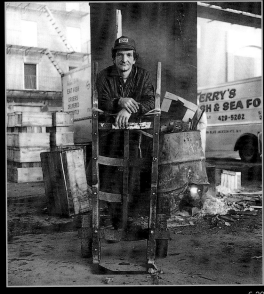

6.20

6.19. Nuriel Guedalia, ca. 1980.
6.20. Barbara Mensch, *Harry the Hat*, 1983.
6.21. Nuriel Guedalia, *Street Scene*, ca. 1980.

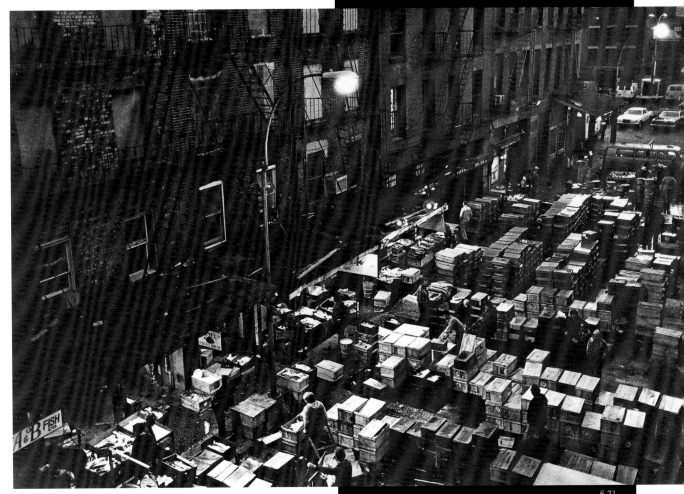

6.21

6.22

6.23

6.22. Marc Kaczmarek, 1972. **6.23.** N. Jay Jaffee, *Skyline Facing South*, 1973. **6.24.** Beuford Smith, *Garment District*, 1966. **6.25.** Len Speier.

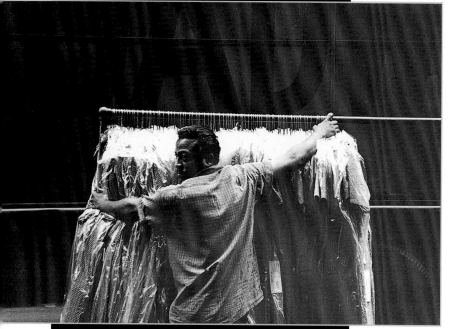

6.24

duction lost over fifty thousand workers in the 1980s and sweatshops returned to the Lower East Side and Brooklyn, it remained a leading manufacturing industry in the city, second only to printing and publishing in the value of its product and the numbers employed. N. Jay Jaffee's shot looking south from a window on Thirty-seventh Street conveys the details of a perspective observed daily by thousands of New Yorkers (6.23).

Protective service work expanded rapidly, often recruiting African-American men. Marc Kaczmarek's portrait of a security guard at Fordham University signals the anonymity of such work by obscuring his face (6.22). Only the swing of the nightstick relieves the harsh drama of an isolated, urban milieu. The growth of private security services throughout the city in the 1970s and 1980s highlighted concerns of many residents and businesses that police were unable to control spiraling crime rates.

Len Speier's portrait of a security guard at the New York Telephone Company Building contextualizes the man and his work (6.25). Speier juxtaposes the guard with the ornate ceiling and soaring columns in the lobby. Despite the earnestness and clarity of the man's face, the space overwhelms him. New York's urban scale increasingly seemed to threaten to rob workers of their identity and sense of self.

Financial activities, including insurance and real estate, assumed ever larger proportions of the city's economy, by 1990 employing more workers than did manufacturing industries. The city's downtown financial district followed a workweek that regularly emptied the streets on weekends, as N. Jay Jaffee's photo demonstrates (6.26). The narrow canyons of brick skyscrapers symbolized the power and vacuum of money's inhabitants.

Fast food, eaten on the street or in corner shops, appealed to the city's army of clerical and technical workers, and the growth of this and other service industries accompanied the booming finance-based economy. Although automats disappeared, chains such as Chock Full O'Nuts, which offered limited menus and good coffee, provided inexpensive popular alternatives to street

6.26

vendors (6.28). Chock Full O'Nuts started as a firm of coffee importers and then expanded during the Depression into one of the city's first fast-food chains. At its height in the 1960s and 1970s, the firm operated over 150 restaurants throughout the city. Its last restaurants closed in 1983 as the company focused on coffee sales.

Hot dog stands enlarged their fare, adding such items as shish kebob and gyros to the old standbys of frankfurters and potato knishes. N. Jay Jaffee conveys the city's human side despite the blank walls promising new construction in this photograph of a street vendor on the corner of Fortieth Street and Second Avenue (6.27). The Chrysler Building, with its distinctive gargoyles, shimmers in the morning sun. Note the cobblestones on Second Avenue, remnants of an earlier era.

Immigrants not only added new tastes to street-corner fare but also reinvigorated ancient traditions and converted established neighborhoods into enclaves of newcomers. Seymour Edelstein photographed Rabbi Eisenbach repairing a scroll of the Torah, the sacred text of the Five Books of Moses, at 49 Essex Street on the Lower East Side (6.34). Orthodox Judaism flourished in New York during the 1970s and 1980s, attracting Jews who had strayed from religious practice.

A specialized field, the manufacture of religious articles lingered in the city. Bill Aron photographed a worker at the Muncash Talis factory on the Lower East Side watching the looms weave white prayer shawls for Jewish worship (6.31).

Bill Aron traveled downtown to photograph the Lower East Side, recording its receding Jewish mores with an anthropologist's eye. His shot of Scotty's Deli on Essex Street, with its barrels of pickled fish and counter filled with delicacies, is redolent of elements of Jewish culture, from the food, to the gestures, to the gaze of the counterman watching the interaction with a customer (6.33).

Union Street, in downtown Flushing, photographed in 1995,

6.27

6.26. N. Jay Jaffee, *Financial District*, 1973. **6.27.** N. Jay Jaffee, *Hot Dog Stand*, 1971. **6.28.** Marc Kaczmarek, 1974.

6.28

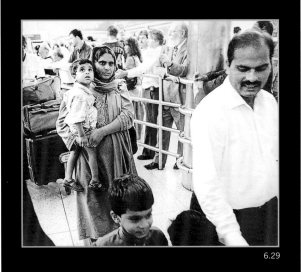

6.29

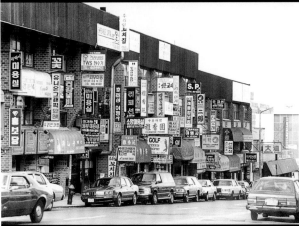

6.30

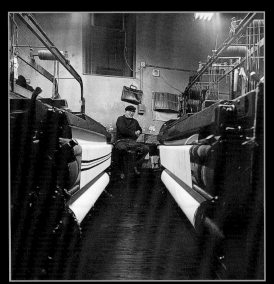

6.31

shows an array of store signs hung in the vertical patterns typical of Korean streets (6.30). In the first half of the decade, close to twenty thousand immigrants from China, Taiwan, and Hong Kong settled in Flushing, changing what had been "Koreatown" into a Chinese neighborhood. Ethnic enterprise flourished throughout the city as different groups specialized, catered to fellow immigrants, and injected a previously unimaginable diversity into New York City's commercial mainstream. Korean immigrants took over many of the greengrocers and dry cleaners in the city's five boroughs, and introduced nail salons.

The southeast Asian family in figure 6.29 is entering the United States through Kennedy Airport. New arrivals came by plane, not boat. Despite extensive international communications, most immigrants quickly discovered that New York did not match their expectations. Movies were no substitute for the living reality. As in the past, men usually preceded their wives and children, who arrived after an economic foothold had been secured.

The largest single group of new immigrants came from China. By 1980 New York City held the largest Chinese community in the United States, surpassing San Francisco. Many settled in Chinatown, expanding its boundaries to include substantial portions of the old Jewish Lower East Side and raising prices of local real estate. On crowded streets, Chinese entrepreneurs established stalls selling vegetables, pastries, or seafood, as pictured in figure 6.32. By the 1990s twelve banks flourished in the neighborhood as well as nine daily papers and half a dozen movie theaters.

Distinctive neighborhoods, such as Harlem and the Lower East Side, sustained stores that served local clienteles by providing for ethnic tastes in everything from hairstyles to cuisine. Jeffrey Scales visited his local barbershop regularly before he thought to photograph it. His series of images of the ordinary activities animating House's Barbershop catch the elements that made it integral to neighborhood life, a source of news and solidarity for local folk (6.36).

Arriving in large numbers during the 1950s and 1960s, Puerto Ricans settled in neighborhoods throughout Manhattan, the Bronx, and Brooklyn. By the 1980s a native-born generation of Nuyoricans was shaping city culture. For example, they championed bilingual education in the public schools and often filled teaching positions.

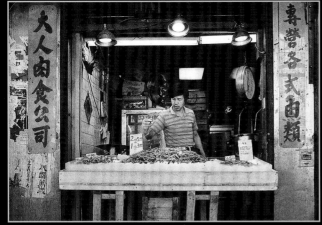

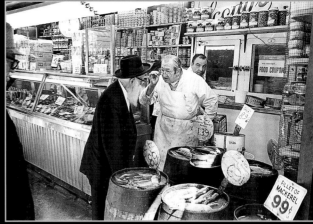

6.32

6.33

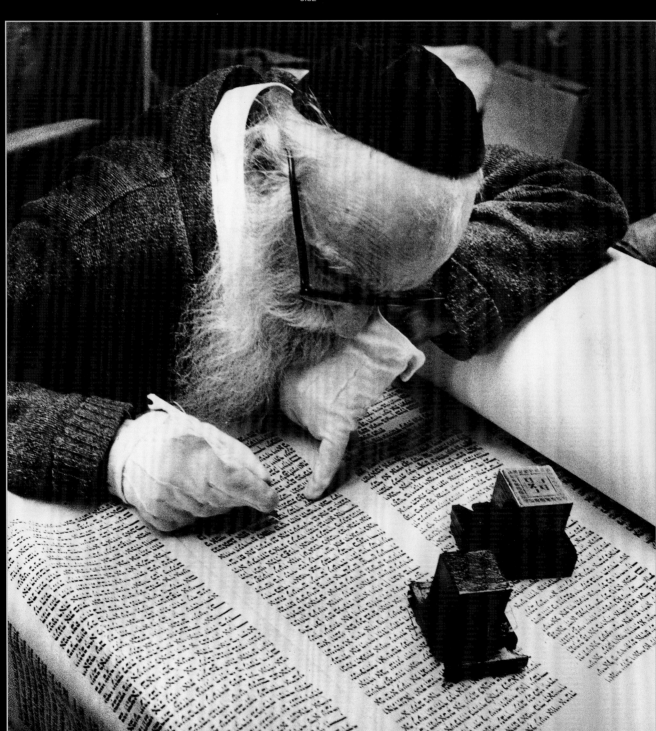

6.34

6.35

6.36

Jeanine El'Gazi photographed a Puerto Rican couple in their apartment in the Carver Houses, public housing on East 104th Street and Park Avenue in El Barrio, or Spanish Harlem (6.35). Their four sons grew up in the city and joined the New York City police, following a well-trod immigrant path to upward mobility. Their apartment exhibits the prosperity and security they found in New York as well as their taste in furnishings.

The streets of El Barrio also reflected immigrant tastes. Entrepreneurial newcomers opened *bodegas*, small grocery stores that catered to local residents with ethnic items not available in large supermarkets. This Puerto Rican man sells avocados and plantains along with other staples such as cabbage and potatoes (6.37). The Puerto Rican flag flutters prominently in the front of his stall; the stars and stripes, though larger, hangs in the rear. Later, following ethnic suc-

cession, more recent immigrants from the Dominican Republic would take over both stalls and bodegas.

The Lower East Side endured as an immigrant area, and like Spanish Harlem and parts of the Bronx, its walls and empty lots often yielded to ethnic inspiration. The lush mural painted on a vacant wall transports the viewer to an island paradise, far from the dirty, gray streets (6.38). Whenever they could, Puerto Ricans reclaimed abandoned sites for impromptu gardens, planting trees, flowers, and bushes and even building *casitas*, small shacks for socializing during warm weather reminiscent of the countryside of their native land. For many marginally employed men, the *casita* was the closest they could come to controlling property.

Unlike earlier eras, when immigrant cultures flourished most vividly in Manhattan, during the last decades of the twentieth century newcomers from dozens of countries

transformed the outer boroughs. Especially in Brooklyn and Queens, diverse and distinctive groups created independent, thriving communities. Photographers increasingly visited these sites, exploring the transplanted village mores.

In Brooklyn, Puerto Ricans established stores and clubs that expressed the gender distinctions in their culture. Justo A. Martí captured the sense of Christmas time camaraderie of these male friends lounging at a club at 749 Flushing Avenue in Brooklyn (6.39). The bar provided an alternative place to relax, away from home, women, and children.

Many women found solace in religion, both Catholicism and Santeria, a popular blend of African gods and Catholic saints. *Botanicas*, like the one portrayed here on Central Avenue in Bushwick, Brooklyn, sold herbs and icons, candles and prayer cards, used in devotional and healing practices (6.43). Builder Levy's photo of the plate glass window not only reveals the merchandise for sale but also reflects the surrounding neighborhood.

Home to breweries and German immigrants in the early part of the century, the northeastern Brooklyn neighborhood of Bushwick became heavily Italian in midcentury. When Italians moved out to Queens, Puerto Ricans and African Americans took their place. In 1976 Rheingold and Schaefer, the last of the breweries, closed, and during the 1977 blackout arson and looting damaged the area. In the 1980s immigrants from the Dominican Republic settled there, strengthening its Latin character.

Born in New York City, Builder Levy studied photography at Brooklyn College with Walter Rosenblum (see fig. 5.12), learning from him some of the perspectives of the New York Photo League. Levy photographed Bushwick intensively for several years in the mid-1980s while he taught photography at a local intermediate school. His images depict a section of the city often ignored by photographers and interpret patterns of daily life. *Snow on Melrose Street* views the block by the school transformed by falling

6.35. Jeanine El'Gazi, 1985. **6.36.** Jeffrey Scales, 1988. **6.37.** Rene H. Hep. **6.38.** Beuford Smith, 1998. **6.39.** Justo A. Martí, 1966–74.

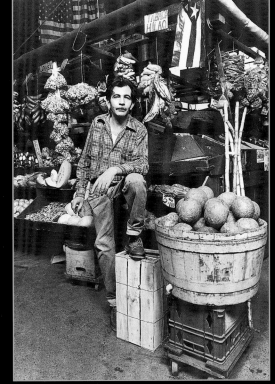

6.37

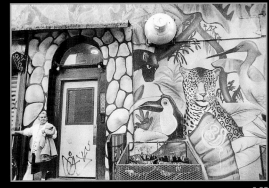

6.38

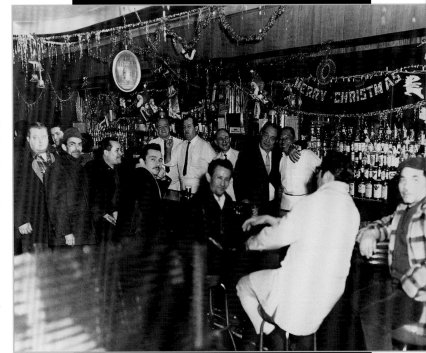

6.39

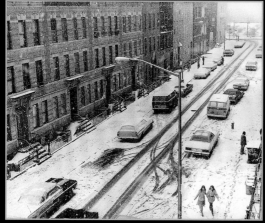

6.40

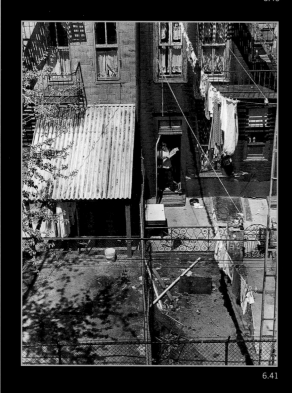

6.41

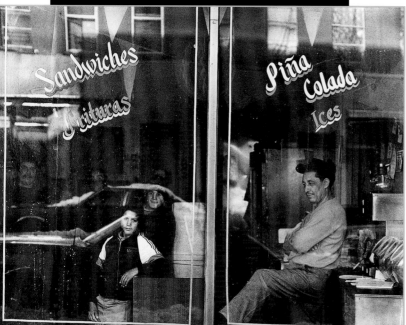

6.42

snow, the angled rooftop vision, and the choreography of Carmen Alvarez and her sister Sonia walking up the street (6.40).

On Central Avenue, near the school, a local grocery store served as neighborhood hangout for students and adults (6.42). The painted signs on the window advertise items in English and Spanish, addressing a bilingual clientele. In a city whose residents spoke over ninety different languages by the 1990s, bilingualism characterized many New Yorkers.

Behind the facades of three-story tenements on Melrose Street were modest backyards, patches of private space, sometimes shaded by a tree or shed, other times used to hang laundry (6.41). Tenants living on the ground floor could use this extra space to extend their cramped apartments.

On the southern shores of Brooklyn, Brighton Beach, once a resort, absorbed a large permanent population in the 1920s with the construction of apartment houses. Public housing, built in the postwar era, brought more residents, many of them living on modest budgets. During the 1970s Soviet Jews from Ukraine settled in the area, reviving stores along Brighton Beach Avenue and giving the neighborhood a new moniker: Little Odessa. Only more hardy folk ventured below the boardwalk to the beach in winter. A select group, mostly men, savors the invigorating power of moist sea air and shares conversation. Stephen Lewis photographed these aging Jewish residents in the 1980s (6.45).

Neighborhoods depend on neighbors for character and cohesion. And neighbors must leave their homes to meet each other for any public life to flourish. On a bright sunny winter day, women and men choose a cozy and convenient stop in front of the local Brighton Beach supermarket to chat (6.44). Some carry bags for shopping. Others make no pretense and bring folding chairs so that they can converse in comfort.

6.40. Builder Levy, *Snow on Melrose Street*, 1981. **6.41.** Builder Levy, *Backyards*, 1987. **6.42.** Builder Levy, *Central Avenue Reflection*, 1987. **6.43.** Builder Levy, *Botanica*, 1975.

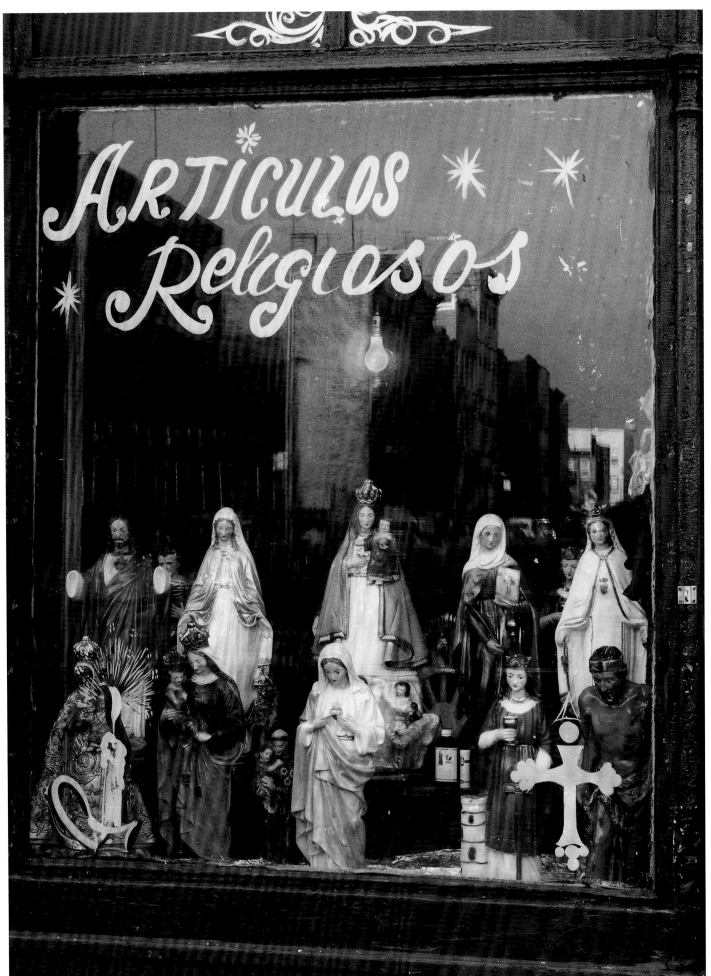

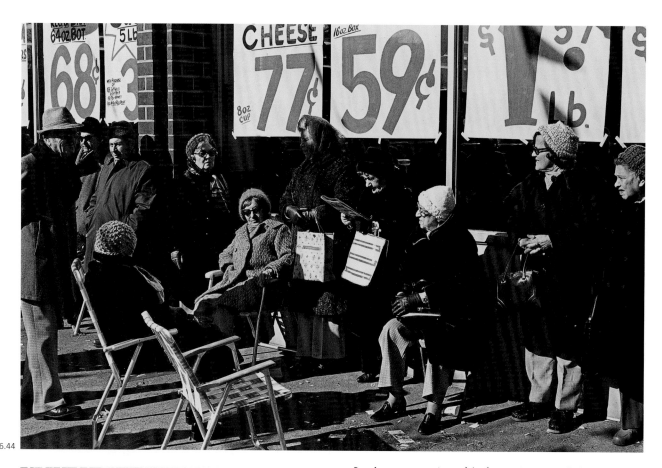

6.44

6.45

In the summertime, block parties provided a welcome excuse to socialize. Bror Karlsson caught this conversation at a Greenpoint waterfront festival (6.47). The women's flowered dresses counterpoint the wall's graffiti. Once an industrial area in northwestern Brooklyn, Greenpoint housed many Polish immigrants and served as the center of Polish life in the city in the 1980s.

In Manhattan, gentrification seeped into working- and middle-class sections of the city. Usually state-sponsored developments, such as middle-income cooperatives or tax-abatement programs, initiated the process. Fraught with controversy, the process benefited more prosperous New Yorkers at the expense of its poorer citizens.

Scott Hyde moved down to the Lower East Side to live in middle-income housing in 1965. Looking northwest, his photo shows his home at 430 East Sixth Street as well as the large number of low-rise tenements on the East Side and several isolated skyscrapers, including the Empire State Building in the middle, the New York Life Insurance Building to its left, and the Metropolitan Life Insurance Tower to its left (6.48).

Further uptown, at Union Square, Builder Levy's photo looking north up Broadway reveals the changing use of

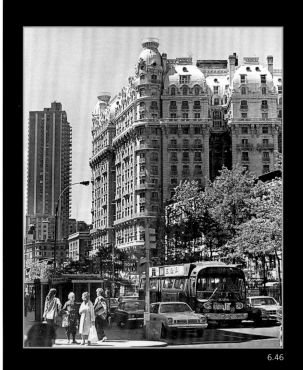

6.46

6.47

6.48

aging loft buildings (6.49). Once home to garment factories, as well as manufacturers of trimmings, notions, and toys, lofts increasingly housed residents, especially those like Levy who lived and worked in the same space. On the horizon can be seen the Chrysler Building at the far right and, to its left, the PanAm Building towering over Grand Central Station. In the center stands the Metropolitan Life Insurance Building with the clock, while to its left can be seen the midsection of the Empire State Building.

Three miles north, the venerable Ansonia Hotel, now transformed into apartments, occupies the block fronting on Broadway between Seventy-third and Seventy-fourth streets, a few blocks from a new, expensive apartment building, built in the neighborhood of Lincoln Center (see fig. 6.12). Victor Laredo's photo looking south on Broadway from West Seventy-fifth Street illustrates the typical tenor of those Upper West Side blocks on a sunny November day (6.46).

With a keen eye for architectural detail, Bror Karlsson focused on typical features of New York neighborhoods. The repetitious rows of brownstone steps that struck photographers of the city in an earlier era (see fig. 5.13) again attracted attention for their pleasing patterns, emblematic rhythms, and enduring appeal (6.51). Standing on the north side of West Seventy-eighth Street, Karlsson faced east to picture the march of brownstone stoops in the spring light.

Another mile and half north, on Broadway at 103rd Street, on a block before gentrification, a mural of working people and a Puerto Rican flag adorns an abandoned building (6.52). Both subjects testify to the strengths and tribulations of Nuyorican culture.

Bill Aron recorded an encounter just around the corner on 102nd and West End Avenue (6.56). There three friends enjoy a beer and a smoke on the street, escaping the summer heat that made apartments without air conditioning unbearable. Both Len Speier and Bill Aron caught their neighborhood on the brink of gentrification, a liminal moment in a city of transitions.

6.44. Stephen Lewis, 1980s. **6.45.** Stephen Lewis, 1980s.
6.46. Victor Laredo, 1980. **6.47.** Bror Karlsson, 1981.
6.48. Scott Hyde, *Village View Middle Income Housing Development, Sixth Street at First Avenue,* 1965.

6.49

6.50

Artists often proved to be the vanguard of gentrification, as when they transformed old industrial lofts south of Houston Street into the avant-garde section of the city dubbed Soho. In 1968 the city legalized loft living in certain sections, including Soho, spurring their reconstruction. Among the early artists to move into a loft on Greene Street, Donald Greenhaus photographed the blocks nearby with a sensibility for the subtle play of light and shadow that this image of Crosby Street reveals (6.50).

A few blocks from his apartment in Chelsea, Bror Karlsson fixed the city's flux in his photo of the east side of Eighth Avenue between Fifteenth and Sixteenth Streets (6.55). The five-story tenements watch a changing parade of ground-floor retail tenants that tells a story of a neighborhood in transition. Probably the oldest tenant on the block, the Army and Navy Store sells work clothes to working-class residents, including postal workers. La Famosa Food Market serves Puerto Rican immigrants who moved into the area in the 1950s and 1960s. The Chelsea Lion Restaurant, on the other hand, appeals to new locals, many of them single, gay men with middle-class incomes. Smile NY, a walk-in dental office, refers newcomers without contacts in the city to a dentist and commercialized health care.

New construction of apartment buildings dramatically altered the Upper East Side. It extended the range of where wealthy New Yorkers lived beyond the radius of Fifth through Park Avenues further toward the East River. Harvey Zipkin photographed the area around Sutton Place, south of the Fifty-ninth Street Bridge, from one of the new office towers in the 1980s (6.53). In the distance is Queens, with 'smoke coming from a chemical factory. Also visible are the hospital buildings on Roosevelt Island.

Looking south from a similar vantage point at night, the city sparkles from the thousands of lighted apartment windows (6.54). In the distance the Williamsburg, Manhattan, and Brooklyn Bridges appear graceful and gay against the black sky.

Unlike the Upper East Side, Harlem changed relatively

6.49. Builder Levy, *North of Union Square*, 1986. **6.50.** Donald Greenhaus, *Nighttime.* **6.51.** Bror Karlsson, 1990. **6.52.** Len Speier.

6.51

In Manhattan, gentrification seeped into working and middle-class sections of the city.

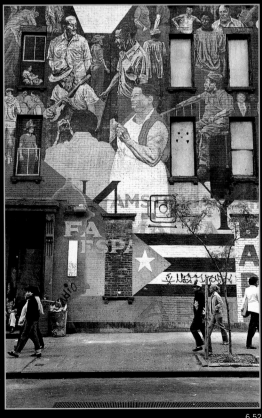

6.52

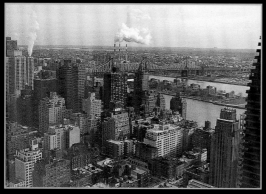

6.53

6.53. Harvey Zipkin. **6.54.** Peter Fink, ca. 1966.
6.55. Bror Karlsson, 1983. **6.56.** Bill Aron.

little during the last three decades of the century despite its excellent location near parks and the quality of some of its housing. Most New Yorkers associated it with abandoned buildings, such as those photographed on 117th Street (6.57). Although the irony of Coca-Cola's white Santa juxtaposed against a dumbbell tenement (with its characteristic air shaft indentations) undoubtedly sends a pointed political message, Scales also knew another, more normal Harlem, as the photograph from 116th Street reveals. In figure 6.59 a solitary figure, wearing a cape and fedora, strides along snow-covered sidewalks through the streetlight reflections. The mood is almost romantic, in sharp contrast to the empty lot.

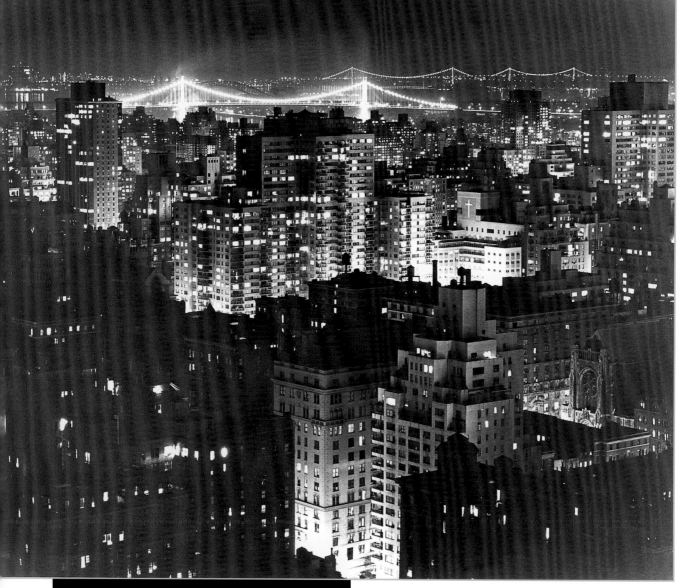

6.54

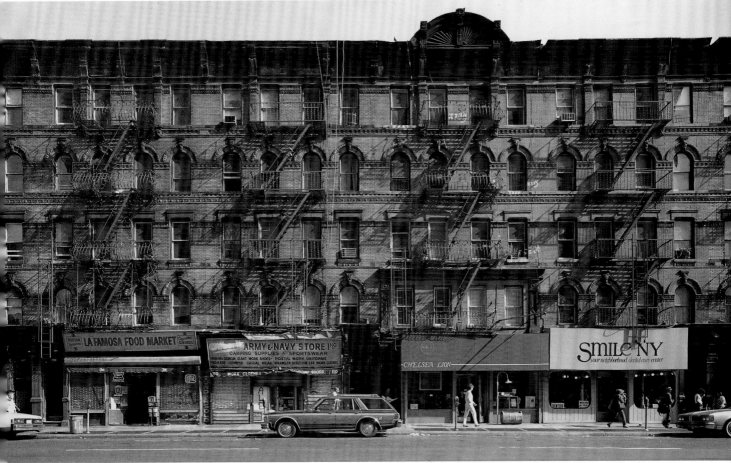

6.55

Harlem supported an array of African-American institutions, as Coreen Simpson's view of 116th Street reveals (6.60). Along with storefronts including the Shabazz Modern Barber Salon and Seven Grain Health Food, there stands Malcolm Shabazz Mosque No. 7 Elementary and Secondary School, a tribute to the fiery Black Muslim leader Malcolm X. The architecture visible on the upper stories indicates Harlem's history as a middle-class neighborhood.

Jimmy's Soul Food presented a different legacy: the cuisine of the South. Barbecued ribs, scallops, four different types of puddings (rice, banana, bread, and sweet potato), five different types of salads (macaroni, potato, cucumber, pickled beet, and cole slaw) enticed customers inside. The proprietor posed outside for photographer Austin Hansen (6.61).

Like Harlem, Queens acquired a reputation derived from a distance. Most New Yorkers identified the borough as the site of the city's two airports, LaGuardia and Kennedy. Traveling on highways to reach those spots meant passing

enormous cemeteries, the final resting places of thousands of New Yorkers. Intrigued by the vision, N. Jay Jaffee paused to photograph the eerie image of an enormous Long Island City chemical factory seemingly rising out of an almost treeless cemetery (6.62). Later, like many city sights, this one disappeared from view, hidden behind a highway barrier.

Those who lived in the borough knew it as a more intimate place of private homes, like those lining this street in

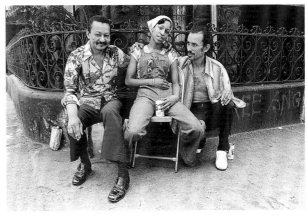

6.56

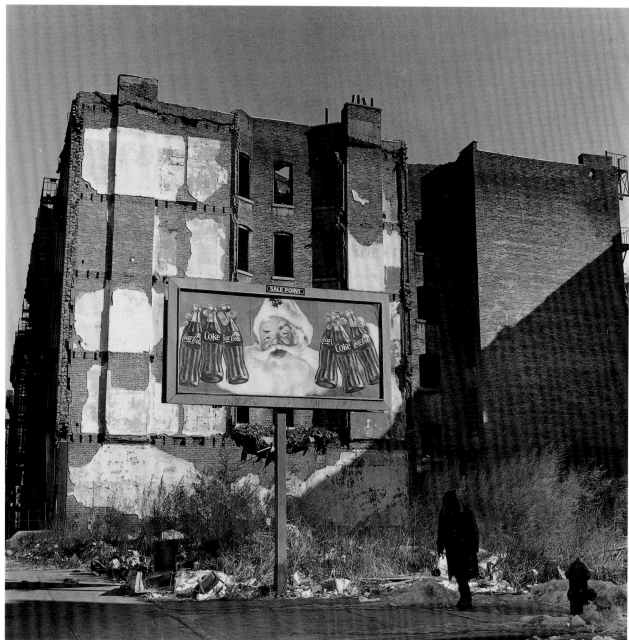

6.57

Elmhurst (6.58). Located in northwestern Queens, Elmhurst evolved into an extraordinarily diverse neighborhood, as immigrants from China, Korea, India, and the Philippines displaced older Italian and Jewish residents. By the end of the century, with immigrants from 112 countries, Elmhurst was one of the city's most multicultural areas.

6.58

In the 1980s increasing numbers of New Yorkers found themselves dispossessed, forced to lived on the city's streets. As homelessness became a national shame and outrage, New Yorkers discovered the homeless wherever they turned. No longer confined to the Bowery, whose cheap flophouses were disappearing with gentrification and the

expansion of Chinatown, homeless men and women sought shelter wherever they could find it. This homeless pair lived under cardboard boxes (6.63).

Like homelessness, the presence of drugs registered throughout the city's neighborhoods in rising crime rates and violence. Despite drastic penalties for drug possession enacted during the governorship of Nelson Rockefeller, drug use escalated, ravaging families and the city's social fabric. Although less visible than the homeless, drug users often appeared on the streets and in the city's parks and public places. Donald Greenhaus shot this photo of two women preparing a dose of heroin in the 1960s (6.64). (Compare

this image to figure 3.119, a scene from the nineteenth century, when drugs were legal.)

Islands of nature in a world of glass and concrete, brick and mortar, cast iron and aluminum, New York City's parks attracted all the city's residents, from the homeless to the wealthy. Photographers, too, approached parks as an integral counterpoint to urban life. Most gravitated to Central Park, which seemed to offer everything one could desire in a park. Robert Sefcik captured the beauty and quiet of a spring day in the shadow of Belvedere Castle (6.71). Reading the newspapers—always popular among New Yorkers (see fig. 5.29)—strolling, and even taking photographs amid the daffodils all offered opportunities to relax outdoors, unencumbered by heavy coats. Harvey Zipkin's photo from afar, echoing views taken by Gottscho, Feininger, and others, reveals the park as an oasis (6.65). Its serenity shocks amid the solid peaks of buildings.

Many of the activities New Yorkers had enjoyed since the park opened in the nineteenth century continued to be popular. Ice skating, now done at a rink rather than on the lake, attracted residents of all ages. Paula Wright photographed the Wollman Rink on a crisp winter afternoon (6.69). (Compare her photo to the Byrons' shot of ice skating on the lake, fig. 4.78.) The classic prewar skyscraper hotels, the Pierre and the Sherry Netherland, and the 1968 General Motors Building on Fifth Avenue provide a vivid backdrop to circling skaters. The contrasting styles, each of its era—the park with its arched bridge, the hotels of the 1920s, and the massive GM Building—epitomized New York's new landscape.

Popular summertime activities included rowing on the lake, pictured here by Victor Laredo (6.66), and playing follow-the-leader on the rocks, captured by Bror Karlsson (6.68). More strenuous sports, such as football, involved larger groups of people. Team sports required regulars to share a common enthusiasm, meeting at a fixed place and time to play together. Len Speier caught the players at a particularly dramatic moment, as the setting sun cast long shadows and silhouetted the buildings on the park's southwestern edges (6.67).

New Yorkers took their recreation beyond the city's parks. Although no longer the nation's playground, Coney Island survived as a summertime pleasure spot, especially

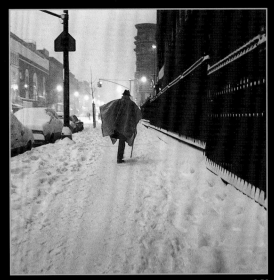

6.59

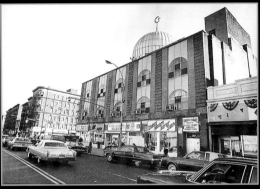

6.60

6.57. Jeffrey Scales, *Christmas, 117th Street, Harlem, NY*, 1986. **6.58.** *Elmhurst, Queens*, 1970s. **6.59.** Jeffrey Scales, *Snowman, 116th Street, Harlem, NY*, 1987. **6.60.** Coreen Simpson, 1977–78. **6.61.** Austin Hansen.

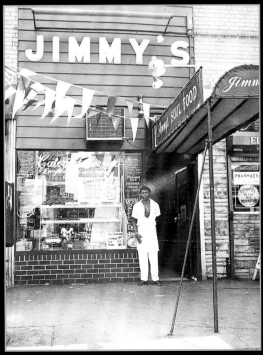

6.61

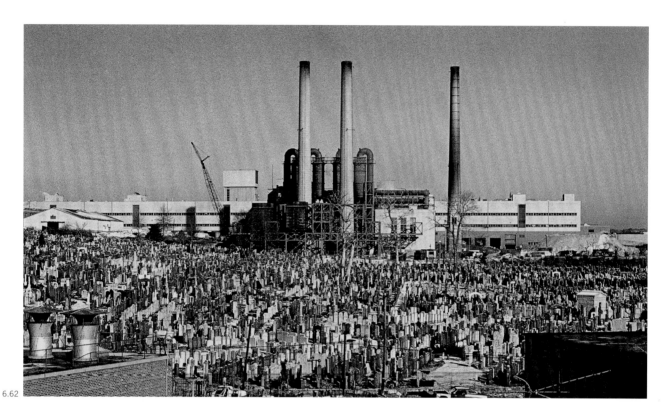

6.62

for those who could only afford a subway ride to the beach. Harvey Zipkin, a native New Yorker, visited Coney Island to photograph its working-class delights (6.74). His view from the distance captures the grand sweep of carnival happiness, but without the brimming crowds of an earlier era (see fig. 4.83).

When Bror Karlsson visited Coney Island, he saw how its world of make-believe released emotions in both children and adults. His shot of a young boy riding the wild horses of the merry-go-round with abandon evokes an innocence absent from earlier images of amusement rides (6.77). Poise and imagination carried the boy into another world. The magnificent carved wooden horses were manufactured by Russian Jewish immigrants in Brooklyn at the turn of the century.

New sports competed with old ones for popularity on the city's streets. Roller skating and bike riding, once associated almost exclusively with children, now appealed to expanding circles of adults as New York joined the country's fitness craze. City residents provided a natural audi-

Homelessness and drug use registered throughout the city's neighborhoods.

ence for those who mastered these skills. This roller skater regularly showed off his expertise (6.72). By the late 1980s, such style was an anomaly among rollerbladers.

Kids still dominated the sport of skateboarding. The city's miles of concrete and asphalt offered relatively smooth sailing for those who wanted four-wheeled speed. But the ultimate drama, beyond jumping curbs and skimming banisters, required special ramps, such as these constructed in Riverside Park. (6.73)

Traditional urban recreation endured on the city's streets, often segregated by gender. In her neighborhood of Jamaica, Queens, Cheryl Miller photographed girls jumping double Dutch, a game requiring dexterity and speed as well as cooperation (6.75). Younger

6.62. N. Jay Jaffee, *Chemical Factory and Cemetery, Maspeth, Queens, NY*, 1981. **6.63.** Beuford Smith, *Homeless Couple*, 1996. **6.64.** Donald Greenhaus. **6.65.** Harvey Zipkin, *Central Park from 9 E. Fifty-seventh St. Building.*

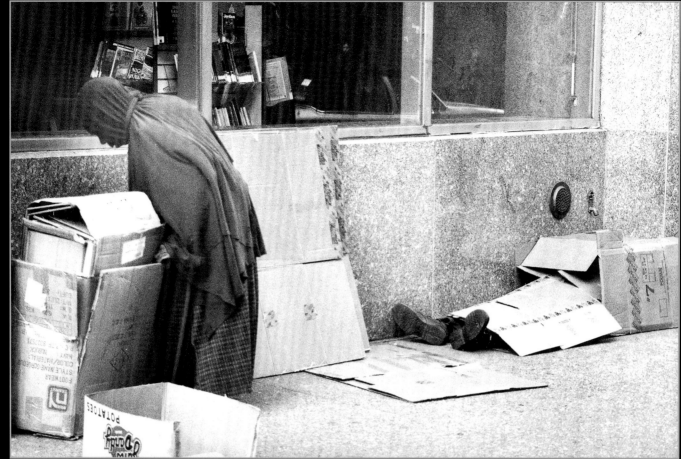

6.63

6.64

6.66

6.67

6.68

brothers watch their older sisters, who are probably responsible for minding them. Double Dutch could be enjoyed on sidewalks close to home, where girls often were required to stay.

Boys, on the other hand, played basketball on neighborhood courts further away. The court is uniquely adaptable, accommodating games involving from two to as many as ten players. These men are competing in a three-on-three tournament. Like their sisters, the boys attracted an audience, which watches the game with interest. Cheryl Miller caught the action just as one man went for a lay-up (6.76).

Bocce courts on the Lower East Side persisted, undaunted by a changing neighborhood. The striking similarities in the men's dress indicate a sporting tradition dominated by Italian men. Scott Hyde photographed this game in March, when the slanting shadows of the watching men lining the court at First Avenue and Houston Street made a distinctive pattern (6.70).

As it had for decades, summertime heat prompted children to cool off in the cold water from fire hydrants. Firefighters deplored the flooding and loss of water pressure and occasionally attached hoses to help moderate the flow, but manipulating the spray on friends, siblings, or oncoming cars was half of the fun. On the city's streets, Peter Fink photographed boys and girls playing under parental supervision (6.78).

6.66. Victor Laredo, *The Lake,* 1970. **6.67.** Len Speier. **6.68.** Bror Karlsson, 1981. **6.69.** Paula Wright. **6.70.** Scott Hyde, *Bocce Players, First Avenue at Houston Street,* 1966. **6.71.** Robert Sefcik, *Belvedere Castle,* 1973.

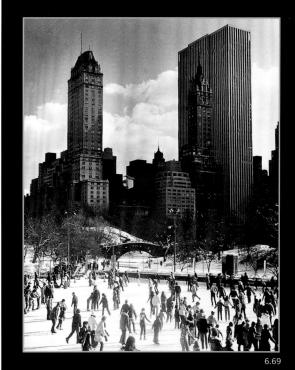
6.69

6.70

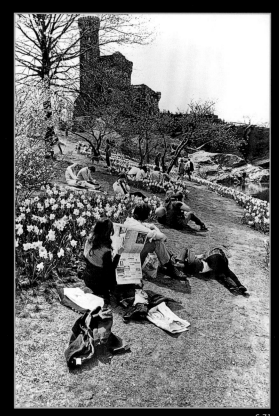
6.71

6.72

**New sports competed
with old ones for popularity on the
city's streets.**

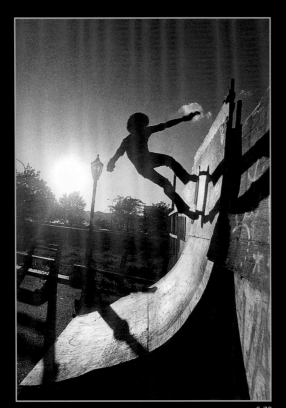

6.73

Street life encoded urban realities, inflecting gestures, postures, and movement with meanings. The 1960s invited public performances that exploited the anonymity of city life. Regarding the streets as a complex, evolving stage set, New Yorkers displayed themselves for fun and profit. Sometimes the presence of Hare Krishna missionaries at public gathering places or self-made preachers spreading the word on street corners recalled earlier religious efforts to recruit urbanites (see fig. 4.77 for a photo of the Salvation Army). Other events, like the parades of homosexuals and ethnic groups, represented a radical departure from such long-standing traditions as the Macy's Thanksgiving Day Parade. Both types of performances expanded an essential New Yorker habit: watching and being watched.

Observing the urban scene never lost its fascination for old and young. Shawn Walker and Len Speier each captured a pairing of young and old on the streets near their respective homes in Harlem and the Upper West Side. Walker photographed his neighbors perched at the entry to his apartment building (6.79). The man, well dressed, sits on a folded newspaper to avoid dirtying his suit and enjoys a smoke, which antismoking ordinances increasingly made an outdoor activity in the 1990s. The girl, similarly well dressed, sits on a paper, too; instead of a cigarette she enjoys her fingers.

Len Speier asked a young man with his boom box and child if he could take their photo (6.80). The man's smile and gesture suggest a kind of urban etiquette: if you sit outside, then someone can photograph you. Boom boxes rapidly usurped the popularity of transistor radios in the 1980s. Louder than radios, the boxes proclaimed one's taste in music, letting neighbors listen (whether they cared to or not). Music expressed a personal identity, often rebellious; blasting it claimed aural space in a noisy city.

The next best thing to sitting on the street was standing.

6.72. Bror Karlsson, 1985. **6.73.** Len Speier, 1979. **6.74.** Harvey Zipkin, *Coney Island*, 1980s. **6.75.** Cheryl Miller, *Double Dutch Bunch, Jamaica, N.Y.,* 1989. **6.76.** Cheryl Miller, *Keith's Roundball Classic at Liberty Park, Jamaica, N.Y.,* 1984. **6.77.** Bror Karlsson, 1982.

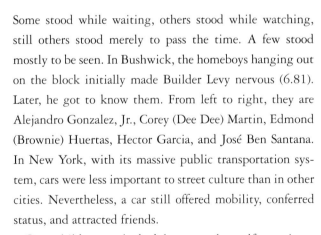

6.74

Some stood while waiting, others stood while watching, still others stood merely to pass the time. A few stood mostly to be seen. In Bushwick, the homeboys hanging out on the block initially made Builder Levy nervous (6.81). Later, he got to know them. From left to right, they are Alejandro Gonzalez, Jr., Corey (Dee Dee) Martin, Edmond (Brownie) Huertas, Hector Garcia, and José Ben Santana. In New York, with its massive public transportation system, cars were less important to street culture than in other cities. Nevertheless, a car still offered mobility, conferred status, and attracted friends.

Once children reached adolescence, they self-conscious-ly recognized the public possibilities of street culture. Photographers observed performances of ethnicity, gender, and sexuality. Here we are worlds apart from reformers' turn-of-the-century depictions of children as poor and pitiful. Learning from Arthur Leipzig, Vivian Cherry, Helen Levitt, and Walter Rosenblum, contemporary photographers typically strove to capture the unvarnished daily lives of young people with a clarity unfettered by sentiment. The directness of these images speaks both to popular artistic sensibilities and to the growing presence of adolescents in American culture since the 1960s. Fashion designers, taking their cues from street culture,

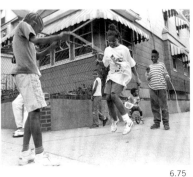
6.75

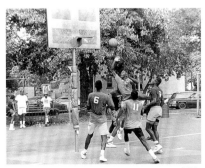
6.76

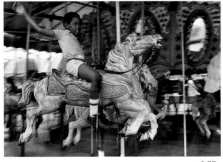
6.77

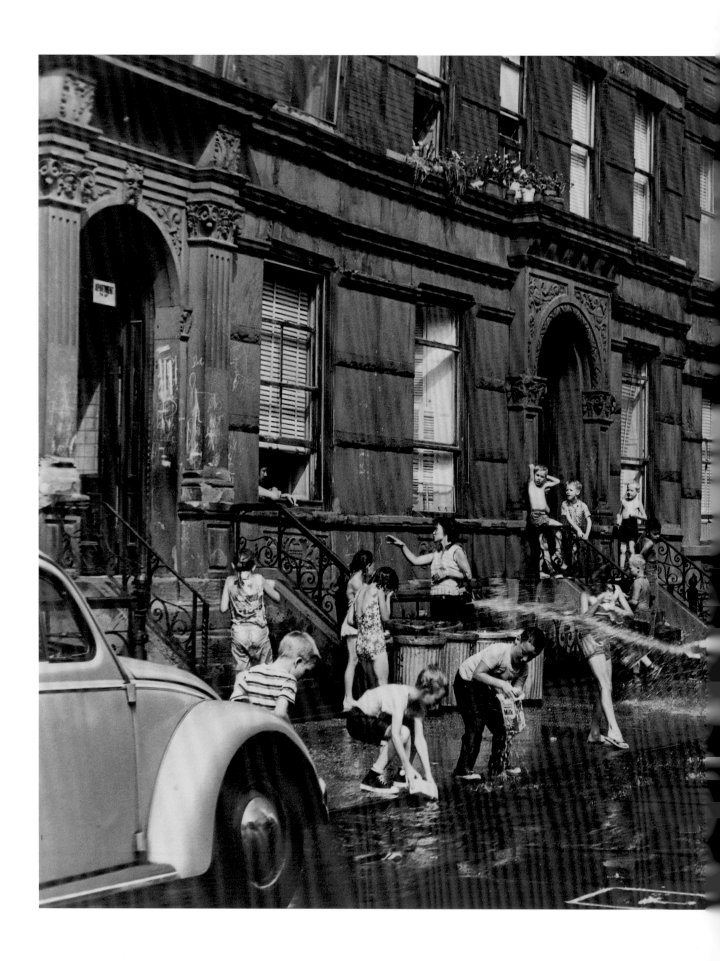

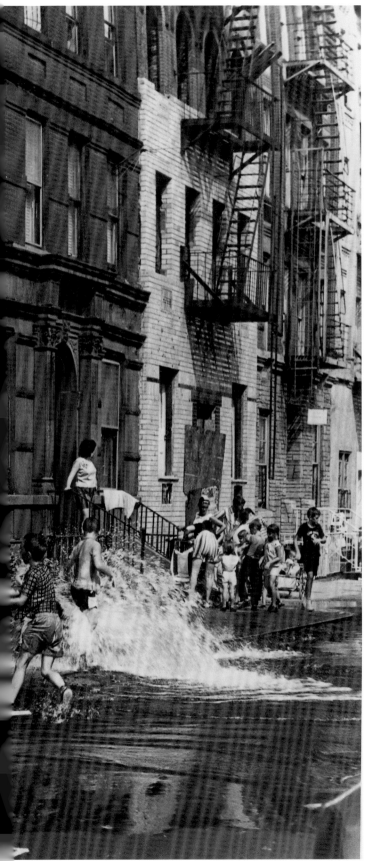

6.78

Street life encoded urban
realities, inflecting gestures, postures,
and movement with meanings.

6.80

6.78. Peter Fink, *Street Scene: Children Playing with Water*, 1968. **6.79.** Shawn Walker. **6.80.** Len Speier. **6.81.** Builder Levy, *Volkswagen Group*, 1978.

6.81

6.82

6.83

Regarding the

streets as a complex, evolving

stage set, New Yorkers

displayed themselves

for fun and profit.

6.84

incorporated elements of innovation developed by teenagers and then broadcast these throughout the world.

Beuford Smith portrayed four hip-hoppers, dressed in the latest 1998 styles (6.82). They are young and black and wearing attitude for all to admire. Hip-hop began in the Bronx, championed as an alternative to gang fights in the 1970s. Young men competed in break dancing as disc jockeys mixed music. Competitors included not just dancers but rappers and DJs who battled for audience acclaim. The dancing contests, with their spins and athleticism, soon moved downtown. From there, hip-hop culture expanded beyond break dancing and rap, eventually reaching a white urban and suburban audience.

Bror Karlsson recorded sexuality on the street as young, bare-chested men catcalled a young woman dressed in a miniskirt (6.83). Such summer lunchtime scenes regularly recurred in the city, despite feminists' efforts to change public culture. Feminists organized in the 1970s beyond consciousness-raising groups. They mobilized to open employment opportunities (the separate male and female job listings in the newspapers disappeared under the impact of feminism) and education to women. They also struggled to get equal pay for equal work (women earned an average of fifty-nine cents to every dollar a man earned) and to make abortions safe and legal.

A man standing in a Chelsea doorway, distinctively dressed in tight plaid pants, a revealing shirt, light suede shoes, and an amazing basketlike hat, hesitates before venturing in to the sidewalk's bustle (6.84). Poised and erect, he commands attention as he stands on the threshold. Public gay culture flourished in New York in the last decades of the century.

Like Jeffrey Scales's series on young men, in the late 1960s and 1970s Garry Winogrand photographed a series of women, seeking to portray their varied beauty. In figure 6.85 he views a busy crosswalk filled with shopping crowds. The image conveys the gendered ritual of shop-

6.82. Beuford Smith, *Hip-Hoppers*, 1998. **6.83.** Bror Karlsson, 1981. **6.84.** Jeffrey Scales, *Young Man in Plaid, New York City*, 1991. **6.85.** Garry Winogrand, *New York*, ca. 1970s. **6.86.** Bror Karlsson, 1983. **6.87.** Garry Winogrand, *New York*, ca. 1968.

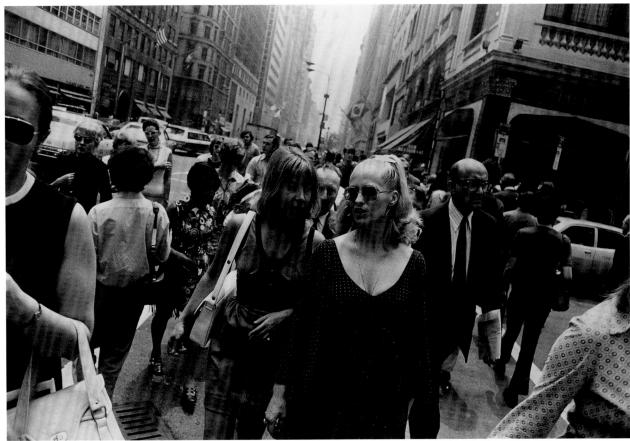

6.85

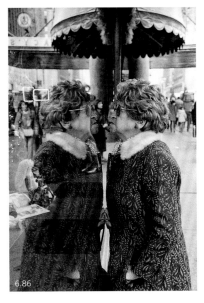

6.86

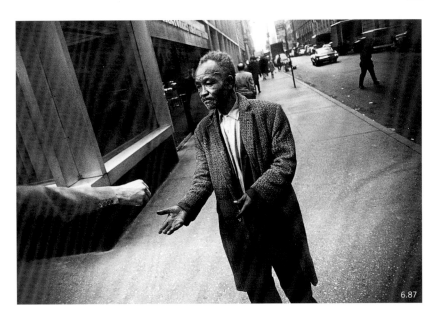

6.87

ping for the prosperous. Compare this image to turn-of-the-century shopping on Fourteenth Street (see fig. 4.37).

Women also engaged in window-shopping, especially those on modest budgets. This woman presses against a Macy's Christmas window to see past the reflection of the sidewalks (6.86). Her humorous and oblivious image intrigued Bror Karlsson.

Soliciting—for sales or handouts, customers or con-verts—held a well-established place in urban practice. The solicitors might change with the period, but the acts abid-ed. Garry Winogrand's stunning image of begging reduces the act to its bare minimum (6.87). Only the donor's hand is visible as the man accepts the spare change being offered. The photo speaks powerfully in black and white.

A Senegalese street vendor, wearing a New York T-shirt, stands before his wares, which are carefully laid out on the

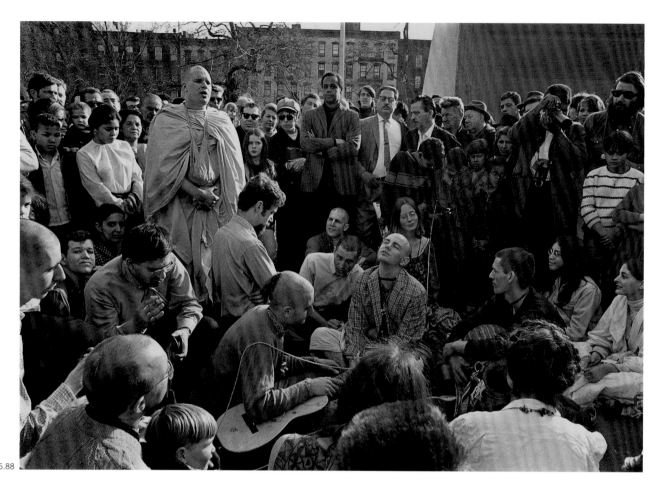

6.88

streets of Jamaica, Queens, just as he might have arranged them in a market in his native land (6.89). In the 1980s a steady stream of immigrants from Senegal reinvigorated street vending, introducing this style of selling directly on the sidewalk rather than from pushcarts.

In the 1970s it was impossible to miss the throngs of distinctively clad chanting Hare Krishna devotees. They walked the city's streets, congregated in its parks, and sought converts in its airports and bus stations. Donald Greenhaus's photograph taken in Tompkins Square Park in the East Village captures the mix of curious onlookers and enraptured converts at a Hare Krishna gathering (6.88).

Increasingly in the late 1960s members of the Nation of Islam, identified by their neat suits and bow ties, fanned out on the city's streets and subways to sell their paper, *The Final Call*, and spread their message. Rarely traveling alone, their discipline and seriousness of purpose presented an alternative image of black masculinity to that of hip-

6.89

hoppers. Shawn Walker views them as they cross a Harlem street with fresh copies of the paper. (6.90)

New York City's parading tradition continues today, though individual parades rise and fall in popularity. A few, like the venerable Labor Day Parade, gradually faded into insignificance, unable to compete with the increasingly popular West Indian Day Parade, scheduled for the same time. John Albok photographed the former in 1968 when it still drew many participants, who used it to express their different ethnic heritages and working-class solidarity (6.92). By the 1970s, as immigration renewed awareness of ethnic origins, individual groups increasingly preferred to march in their own, separate parades rather than in a common one.

The extraordinarily colorful costumes, vibrant music, and voluptuous dancers made the West Indian Day Parade, held in Brooklyn on Labor Day, a particularly dynamic one. Large numbers of Caribbean immigrants settled in Brooklyn in the 1980s; migrants from Jamaica alone accounted for over

6 percent of the city's immigrant population in the 1990 census. The parade and carnival started in 1967 and grew by incorporating traditions from several different islands. By 1990, huge crowds traveled to Brooklyn to watch the parade. Many islanders themselves began to visit New York to attend the parade.

At the end of the Puerto Rican Day Parade Len Speier took this picture of a young girl wearing a crown and gown made with the colors of the Puerto Rican flag (6.91). As her mother watches, her father gently makes his daughter perfect for the picture. The Puerto Rican Day Parade up Fifth Avenue began in 1956, during the peak years of Puerto Rican migration, and celebrated both island traditions and a growing Nuyorican consciousness.

Macy's Thanksgiving Day Parade, started in 1924, has always been an occasion of commercial fantasy and fun rather than an expression of ethnic pride or working-class solidarity. The enormous balloons of popular cartoon characters regularly enticed thousands of children, their parents in tow. The event has maintained its popularity as a Thanksgiving Day ritual, drawing many out-of-towners to visit the city before sitting down to their turkey dinners. Paula Wright took this photo at the parade's start, on Central Park West just south of the Museum of Natural History (6.96).

In 1974 a mask maker and theater director in Greenwich Village organized a parade on Halloween and invited adults to don costumes as well as children. The parade quickly became a popular local event encouraging political satire, cross-dressing, social commentary, and artistic license. Open to all, the parade mushroomed in the 1980s into a citywide affair. It attracted many gays and lesbians involved in creative design and arts occupations, who set the tone. Costumes ranged a broad gamut but specialized in daring and raunchy excess. Even spectators often dressed up, blurring the distinction between observer and participant. "Little wonder that so many who are present," writes anthropologist Jack Kugelmass, "consider the parade a

6.88. Donald Greenhaus, 1970s. **6.89.** Cheryl Miller, *Senegalese Vendor on Jamaica Ave*, 1985. **6.90.** Shawn Walker. **6.91.** Len Speier, *Puerto Rican Day*. **6.92.** John Albok, *Labor Day Parade*, 1968.

6.90

6.91

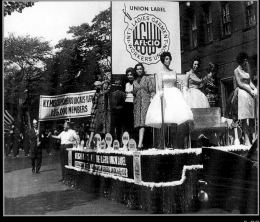
6.92

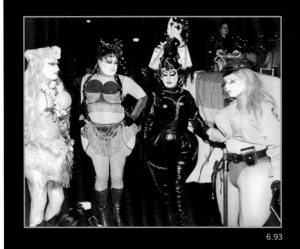

6.93

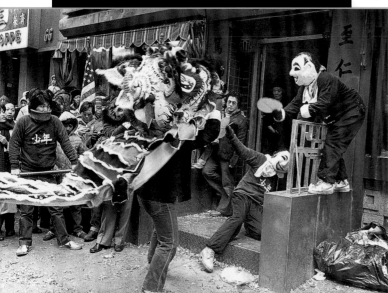

6.94

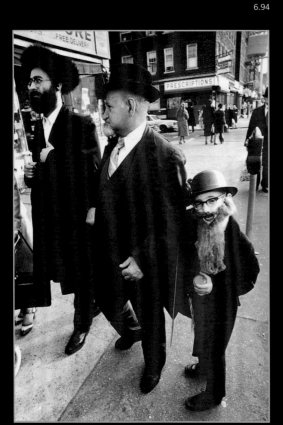

6.95

metaphor for the peculiar combination of chaos and creativity that characterizes daily life in New York City."[3]

In the 1960s Shawn Walker began photographing many of the city's parades, fascinated by their orchestrated performance of religion, race, and culture. Arriving early, he would catch the bands warming up and the participants getting ready in their costumes. In figure 6.93 he focuses on a few participants in the Halloween parade who are gearing up for their trek through the district.

In a city with an increasing non-Christian population, New Yorkers have a chance to observe parades celebrating different religious cultures. Orthodox Jews shun such holidays as Halloween, but they enjoy their own costumed festival (at least for children) during Purim. Bill Aron's photograph of a young boy dressed in beard, glasses, and hat comments not only on the festival but also on three generations of Jews (6.95). The grandfather, with a small goatee, fedora, and necktie, represents a form of modern orthodox Judaism increasingly rejected by traditionalizing sons. His son, pictured here, wears a full beard, no tie, and a *shtrayml*, the fur-rimmed hat of Hasidic Jews. Contrary to expectations, Borough Park, Brooklyn, the site of the photo, evolved from a diverse Jewish neighborhood into an exclusively orthodox one during the 1970s, reversing expectations of modernization and assimilation.

Chinese immigrants don masks and dragon costumes each year to welcome the New Year with firecrackers, dance, and family celebration. Len Speier caught one playful moment in Chinatown as dancers and children interact in a tenement doorway (6.94). The firecrackers, which litter the street, frighten away evil spirits and inaugurate an auspicious new year. When Mayor Rudolph Giuliani banned them in 1999, the parade itself fizzled.

From the mid-1960s protests over the Vietnam War, political activism spilled onto the streets as blacks, women, gays, and other groups brought their causes to the atten-

6.93. Shawn Walker. **6.94.** Len Speier, 1980s. **6.95.** Bill Aron, 1980s. **6.96.** Paula Wright.

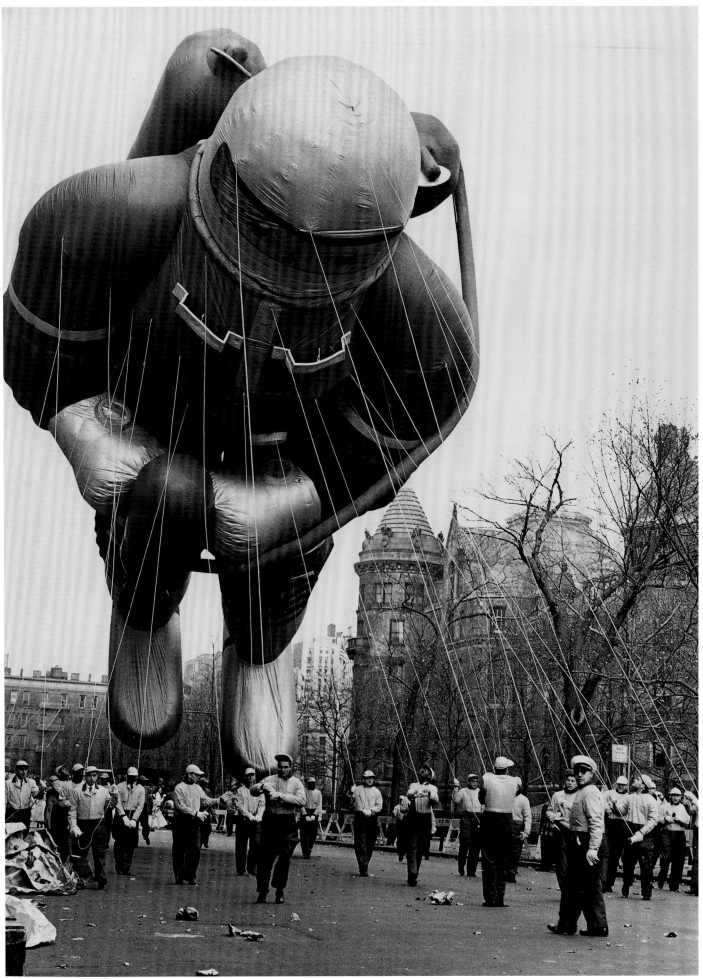

6.96

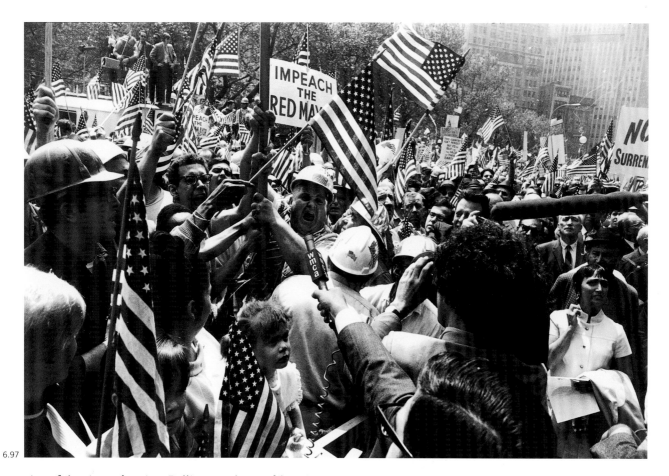

6.97

tion of the city and nation. Rallies, marches, and hanging out en masse all had their advocates.

Beuford Smith stood at the back of an early anti–Vietnam War rally in 1965 (6.100). The leaflets littering the ground carry a similar message to the discarded poster: "STOP THE WAR IN VIETNAM NOW!" A generation raised after World War II protested U.S. involvement abroad in what seemed to be an endless quagmire.

As the war escalated, so did protests and counterprotests. Where you stood on the war divided and agitated a generation. Garry Winogrand's shot of a hard-hat rally in lower Manhattan expresses the passion of those opposed to anti-

6.97. Garry Winogrand, *Hard-Hat Rally, New York,* 1969. **6.98.** Robert Sefcik, *Rally at Battery Park City,* 1979. **6.99.** Shawn Walker. **6.100.** Beuford Smith, 1965.

war protests (6.97). Not all the participants worked in construction, but the hard hat had become a symbol of workers' patriotism and Americanism, much as long hair and beads stood for radicalism and rebellion. The placard calls for the impeachment of Mayor John Lindsay, who was considered to be far too liberal.

Shawn Walker's image of young men and women march-

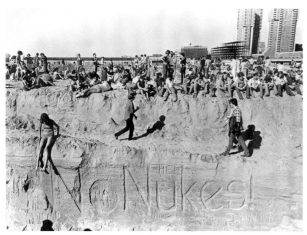

6.98

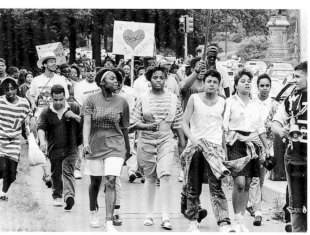

6.99

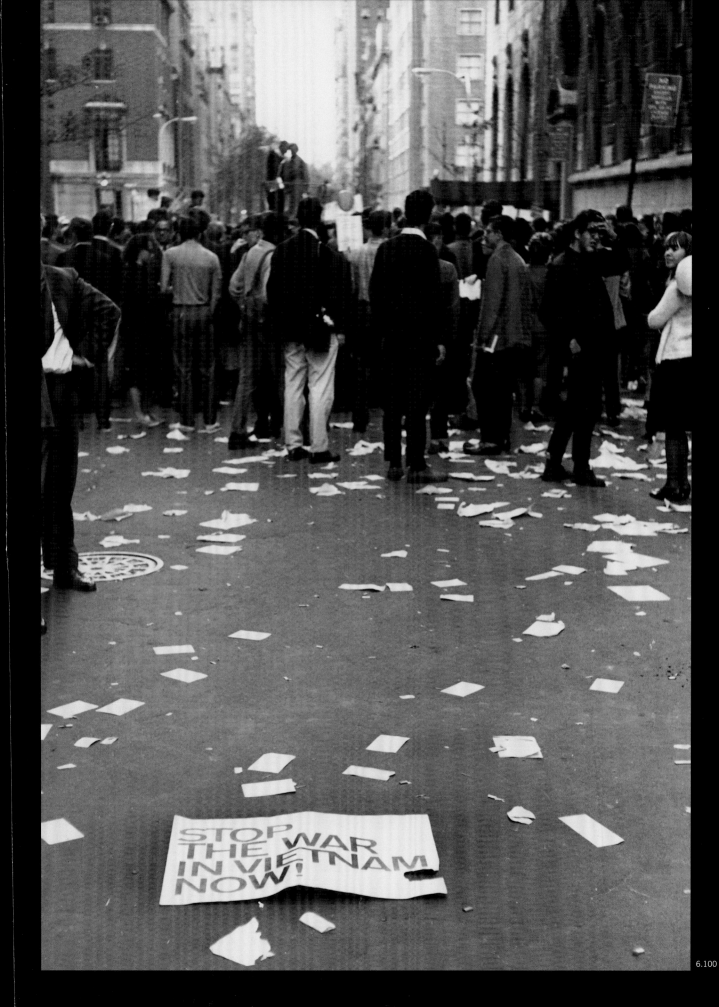

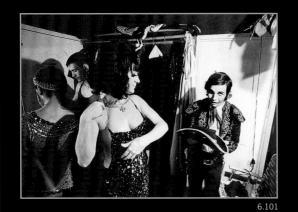

6.101

The Big Apple,

a moniker for New York

popularized in the

1980s, signified a diverse

world of popular

entertainment.

ing in Central Park against violence indicates how protest entered the mainstream as a popular form of political expression (6.99). The deplored violence of the era, by police and criminals alike, required a peaceful demonstration to awaken the city's conscience because organizers of the march believed there was no other way to make their voices heard. Standard forms of political representation did not reach City Hall.

Robert Sefcik's photo of an antinuclear protest at the Battery Park landfill site conveys the blend of hippie be-in and political protest characteristic of the counterculture of the 1970s (6.98). The laid-back quality of the demonstration, however, belied the convictions of its participants. (For an image of the buildings subsequently constructed on the site, see fig. 6.8.)

Public culture in New York extended beyond parades and protests to the realm of commercial entertainment. In the 1970s the New York Convention and Visitors Bureau revived the nickname Big Apple, originally applied to the city (and especially Harlem) by jazz musicians in the 1930s. As popularized in the 1970s and 1980s, the moniker referred not to New York as the jazz capital of the world but rather signified a diverse world of popular entertainment, from night spots and movies to jazz and rock concerts. Most images of entertainment events and individuals, produced for profit and promotion, are utterly familiar, part of a commercialized world. One way to gain a different perspective

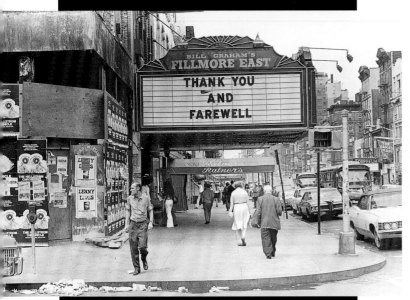

6.102

6.103

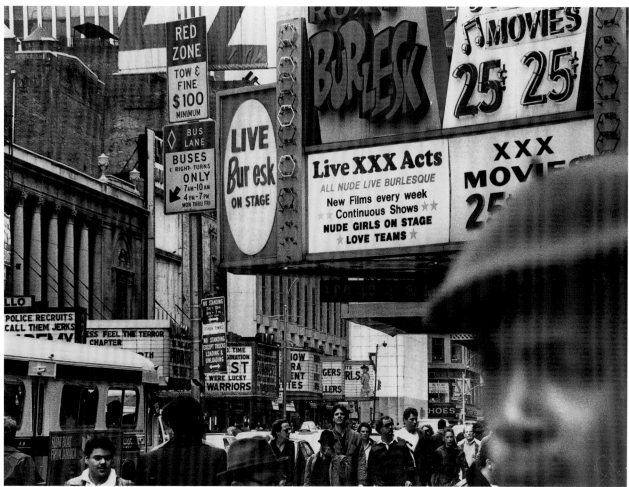

6.104

is to go backstage—or up to the roof.

Donald Greenhaus worked with film companies in New York, shooting still images for movies. Deeply enmeshed in commercial culture, including the East Village rock and art scene of the 1960s, he sought another view. This photo of the Velvet Underground on a tenement rooftop, with the uniform windows of public housing behind them, dates from before their collaboration with Andy Warhol when they were one of a number of aspiring alternative bands. (6.103)

Brooklyn born, Greenhaus grew up with photography, acquiring his first camera at age nine from his father, Ben (see figs. 5.76, 5.77, 5.108). In 1968 he started taking pictures of things not everybody wanted to see. His photo of a transvestite show portrays the work of entertaining as well as the transformation of the artist into a performer, capturing a blend of fantasy and labor critical to cultural production (6.101). (See fig. 4.94 for an earlier backstage image from the Apollo in Harlem.)

Starting in the 1960s the East Village flourished as a center for alternative culture, its aging ethnic population accommodating the artists and musicians who flocked to its cheap apartments. On Second Avenue, several of the old Yiddish theaters were converted into venues for Off-Off Broadway performances and rock concerts. Perhaps the most famous was the Fillmore East, pictured here in 1971 when it closed (6.102). Behind the Fillmore is Ratner's Dairy Restaurant, a kosher dairy restaurant famous for its fresh rolls. It, too, subsequently closed as Second Avenue gradually gentrified.

An enduring site of entertainment, West Forty-second

6.101. Donald Greenhaus, *Woman Impersonator at Gay Follies on 8th Avenue*, 1970. **6.102.** Beuford Smith, *East Village*, 1971. **6.103.** Donald Greenhaus. **6.104.** Andreas Feininger, 1984.

**Dreams of New York
and its possibilities reverberated
even as the city changed,
reincarnating itself for
generations of newcomers.**

6.105

Street between Broadway and Eighth Avenue transformed into a burgeoning locale of pornographic theaters, burlesque acts, massage parlors, and video sex stores in the 1970s. Some of the large movie houses that began as theater stages resisted the trend toward screening X-rated films, instead showing action movies at bargain prices. Andreas Feininger compresses all of Forty-second Street's lurid appeal into a single photo (6.104). Note the predominance of young men on the street.

In one of New York's more shocking reincarnations, raunchy Forty-second Street disappeared at the century's end, emerging as a Disney center of family entertainment. A combination of politics and real estate interests effected the destruction of the old and creation of the new, although some theater facades survived demolition. Aware of the rapidly disappearing city, in 1997 Beuford Smith photographed Freddy in his luncheonette, last holdout on the block, two weeks before he, too, was gone (6.105).

After the Dodgers left Brooklyn and the Giants abandoned Manhattan, New York City had only one baseball team: the Yankees. In 1962 the city won the franchise for a new team, the New York Metropolitans, who played initially in the Polo Grounds. The team's colors, blue and orange, were vestiges of the Dodgers and Giants, respectively. The Mets and Yankees, not to mention the Rangers and Islanders, Giants and Jets, Knicks and Nets (and at the end of the century, the New York Liberty), united New Yorkers across class, racial, and ethnic lines. Rooting for professional sports teams also divided New Yorkers, giving them one more reason to argue. Barbara Mensch caught the performance of fans during a night game at Yankee Stadium (6.106).

6.105. Beuford Smith, *Freddy,
Owner of the Grand,* 1997.
6.106. Barbara Mensch, 1985.
6.107. Bror Karlsson, 1984.

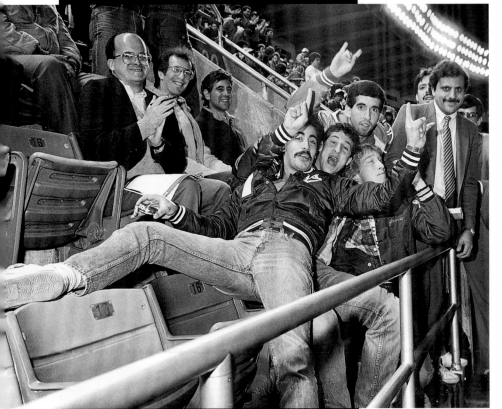

6.106

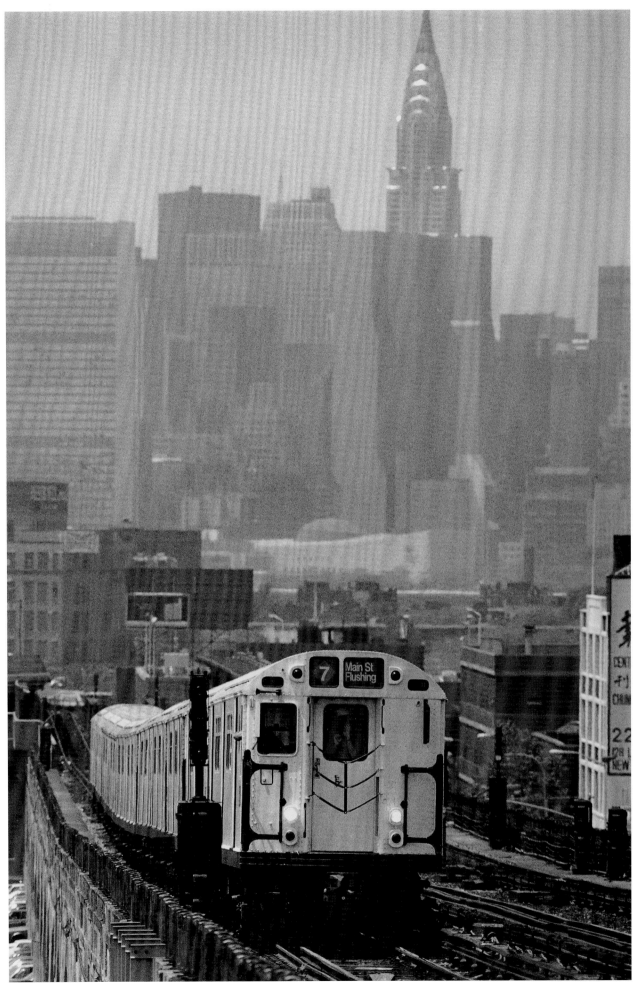

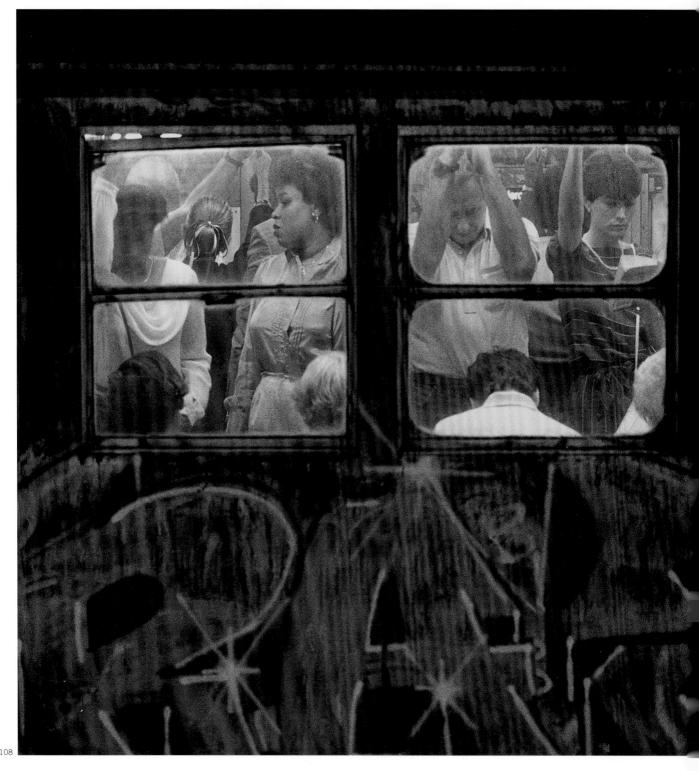

6.108

As more immigrants settled in the city, documented and undocumented, they appeared on the subway, along with lifelong New Yorkers and wary tourists. Photographers discovered in the subway's anarchy, in the constant bustle of individuals navigating their separate paths to their various destinations, both metaphor and reality for forging a polyglot urban society. Lee Wexler developed a photographic series on subways in different cities around the globe. His images of New York's underground trains observe its democratic conventions without passing judgment (6.110).

Regular subway riders used the time to read, think, daydream, converse, eat, and stare into the void. Traveling the trains inevitably meant rubbing up against New York's diversity. Although the wealthy were less likely to ride the subways, middle- and working-class New Yorkers, young and old, men and women, all recognized its efficiency as a

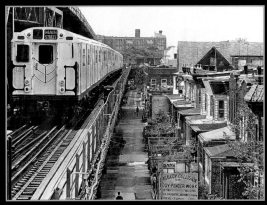

6.109

As more immigrants

settled in the city,

they appeared on the subway,

along with lifelong

New Yorkers and wary

tourists.

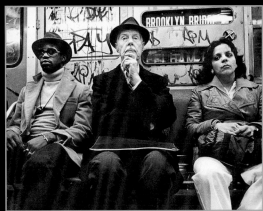

6.110

mode of transportation. Sitting next to strangers, something that happened every day, urbanites negotiated carefully the boundaries of public and private space.

Not all subway trains stayed underground. In the outer boroughs, trains rumbled on elevated tracks above the street. At the century's close one route achieved recognition as a national treasure. Nicknamed the "international express" because of the diversity of immigrants who rode it

6.108. Bror Karlsson, 1985. **6.109.** Bror Karlsson, 1984. **6.110.** Lee Wexler, *Three Subway Riders Sitting*, 1982. **6.111.** Bror Karlsson, 1984.

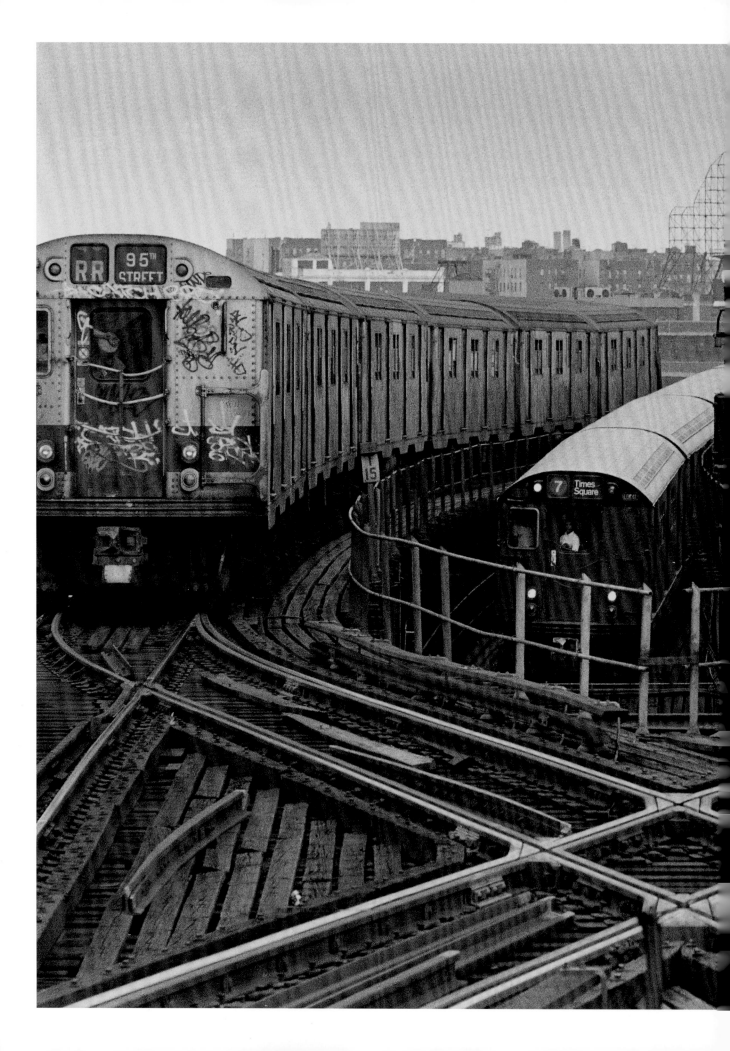

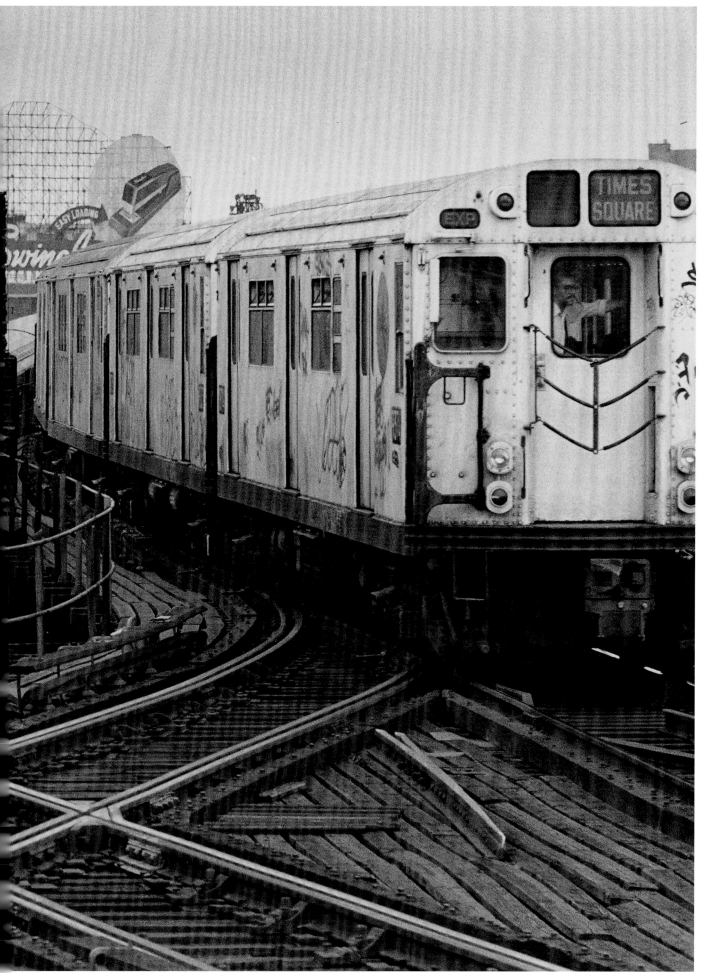

from their homes in Queens to work in Manhattan, the Number 7 train traversed scores of ethnic neighborhoods—Sunnyside, Woodside, Jackson Heights, Elmhurst, and Corona—en route to Main Street, Flushing. The backyards of modest attached dwellings are visible from the platform (6.109).

Graffiti transformed the cars' exteriors (and sometimes interiors), carrying messages along the subway system's hundreds of miles of track. Although hardly new to the city (see figs. 5.3, 5.28), graffiti exploded as a form of urban expression in 1970, when scores of teenagers imitated a Washington Heights resident who adopted the "tag" "Taki 183" and sprayed their own "tags" on subway exteriors and interiors, monuments, and walls, signaling their presence to friends and strangers. Within two years, graffiti spawned an urban subculture with its own rules and organization. Graffiti divided New Yorkers. On the one hand, the Metropolitan Transit Authority poured hundreds of thousands of dollars into efforts to remove it. On the other hand, United Graffiti Artists championed the work, exhibiting it in galleries and museums. Conflict over graffiti raged for more than a decade. By the 1990s, the MTA succeeded in wiping subway cars clean of graffiti. Combined with changes in street culture and a program of repainting subway stations, new graffiti-resistant silver cars forced persistent "writers" to scratch their "tags" on windows. Graffiti artists gravitated to painting the sides of buildings and storefront gates, or even neighborhood institutions like the Graffiti Wall of Fame that rings the schoolyard on 106th Street and Park Avenue.

Viewed in figure 6.108 during the evening rush hour, the lighted interior of the car juxtaposed to the graffiti suspends tired passengers in time and space. Unlike the bus rider in Esther Bubley's photo (see fig. 5.116), no one bothers to gaze out the window. Karlsson snapped this image in the summer of 1985 at the IRT's Brooklyn Bridge station.

At the end of the century, New York City is once more a city of immigrants and their children.

Bror Karlsson waited almost four hours one June day for the three trains to arrive at the Queens Plaza station at the same moment (6.111). Pictured here are two Number 7 trains, one heading out to Flushing and the other coming into Manhattan, along with an RR train that looped from Queens to Brooklyn via Manhattan.

Arriving at its terminus at Main Street, the Flushing line leaves behind "the city." Manhattan shimmers in the distance, beckoning ambitious newcomers to find there the fulfillment of their dreams. In any twenty-four hours in 1999, nearly forty-five thousand people went through the turnstiles heading for New York. The vision is not quite the same as the one immigrants saw crossing the river from Brooklyn or approaching on the ferry from Ellis Island, but it reverberates with similar aspirations. Queens itself, with immigrants from more than one hundred nations—the largest concentration in the city—represents a version of the United Nations, whose building and Secretariat are visible on the left and center, respectively (6.107).

At the end of the century, New York City is once more a city of immigrants and their children. With over half its population first or second generation, New York's crime rates are plummeting, and its public culture has grown remarkably respectful. As at the beginning of the previous century, religious diversity characterizes the city. Since no religious group possesses a majority, all eagerly assert their presence. Mosques, Hindu and Buddhist temples, Voudou and Santeria shrines blossom beside synagogues and churches. The public schools, struggling to integrate newcomers who speak over ninety different languages, search for threads of a common culture to bind their students into a community. The city's streets—open to innovation within its rigid democratic grid—offers all a shared way to see themselves as New Yorkers.

In the late 1970s, Len Speier gave his students at New York University an assignment: to photograph a familiar icon, the Statue of Liberty, in a new way. Deciding it was a challenging task, he assigned it to himself as well (6.112). Looking at Lady Liberty as she strides away from us serves as a fitting reminder of the necessity of seeing the familiar afresh.

6.112. Len Speier.

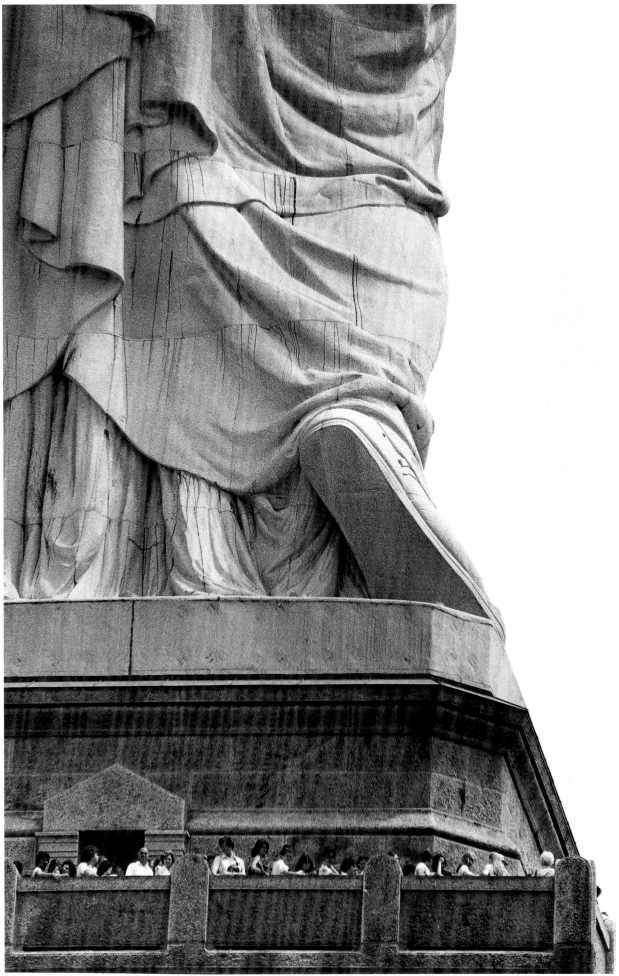

6.112

NOTES

CHAPTER 1 / COLONIAL SEAPORT

1. Introduction to I. N. Phelps Stokes, comp., *The Iconography of Manhattan Island, 1408–1909* (New York: Robert H. Dodd, 1915), 1:23.

2. Ibid., 1:92.

3. Henri Van Der Zee and Barbara Van Der Zee, *A Sweet and Alien Land: The Story of Dutch New York* (New York: Viking, 1978), p. 347.

4. Gloria G. Deak, *Picturing America: Prints, Maps, and Drawings Bearing on the New World Discoveries and on the Development of the Territory That Is Now the United States* (Princeton: Princeton University Press, 1988), 1:50.

5. Roderic H. Blackburn, *Remembrance of Patria: Dutch Arts and Culture in Colonial America, 1609–1776* (Albany: Albany Institute of Art, 1988), p. 58.

6. John A. Kouwenhoven, *The Columbia Historical Portrait of New York: An Essay in Graphic History* (New York: Doubleday, 1953), p. 57.

CHAPTER 2 / REPUBLICAN TOWN

1. Gloria G. Deak, *Picturing America: Prints, Maps, and Drawings Bearing on the New World Discoveries and on the Development of the Territory That Is Now the United States* (Princeton: Princeton University Press, 1988), 1:34.

2. Frank Monaghan and Marvin Lowenthal, *This Was New York: The Nation's Capital in 1789* (Garden City, N.Y.: Doubleday, 1943), pp. 43–44.

3. Quoted in Howard B. Rock, *Artisans of the New Republic: The Tradesmen of New York City in the Age of Jefferson* (New York: New York University Press, 1979), p. 225.

4. Ibid., p. 222.

5. Ibid., p. 216.

6. Paul A. Gilje and Howard Rock, "Sweep O! Sweep O! African-American Chimney Sweeps and Citizenship in the New Nation," *William and Mary Quarterly* 51 (July 1994): 524.

7. Ibid., p. 527.

8. Rock, *Artisans*, p. 281.

9. Edwin G. Burrows and Mike Wallace, *Gotham: A History of New York City to 1898* (New York: Oxford University Press, 1999), p. 366.

10. Raymond A. Mohl, *Poverty in New York, 1783–1825* (New York: Oxford University Press, 1971), p. 123.

11. Robert M. McClung and Gale S. McClung, "Tammany's Remarkable Gardiner Baker: New York's First Proprietor, Menagerie Keeper and Promotor Extraordinaire," *New York Historical Society Quarterly* 42 (April 1958).

12. *Columbian Gazetteer*, quoted in ibid., p. 143.

13. Brooks McNamara, *Day of Jubilee: The Great Age of Public Celebrations in New York, 1789–1909* (New Brunswick, N.J.: Rutgers University Press, 1997), p. 23.

CHAPTER 3 / FRAGMENTED CITY

1. George C. Foster, *New York in Slices*, quoted in Edward K. Spann, *The New Metropolis: New York City, 1840–1857* (New York: Columbia University Press, 1981), p. 286.

2. James D. McCabe, Jr., *Lights and Shadows of New York Life* (Philadelphia: National Publishing Company, 1872), pp. 293–94.

3. Spann, *The New Metropolis*, p. 10.

4. *Harper's Monthly* (1851), quoted in ibid., p. 405.

5. Richard B. Stott, *Workers in the Metropolis: Class, Ethnicity, and Youth in Antebellum New York City* (Ithaca: Cornell University Press, 1990), p. 54.

6. Mona Domosh, *Invented Cities: The Creation of Landscape in Nineteenth-Century New York and Boston* (New Haven: Yale University Press, 1996), p. 55.

7. Quoted in Robert A. M. Stern, Thomas Mellins, and David Fishman, *New York, 1880: Architecture and Urbanism in the Gilded Age* (New York; Monacelli, 1999), p. 708.

8. John A. Kouwenhoven, *The Columbia Historical Portrait of New York: An Essay in Graphic History* (New York: Doubleday, 1953), p. 277.

9. Charles Lockwood, *Bricks and Brownstone: The New York Row House, 1783–1829* (New York: McGraw-Hill, 1972), p. 55.

10. Stern, Mellins, and Fishman, *New York, 1880*, p. 562.

11. Ibid., p. 570.

12. Spann, *The New Metropolis*, p. 185.

13. Charles M. Lombard, "An Old New York Salon—French Styles," *New York Historical Society Quarterly* 55 (1971): 45.

14. Leigh Eric Schmidt, "The Easter Parade: Piety, Fashion, and Display," in *Religion and American Culture*, ed. David G. Hackett (New York: Routledge, 1995), p. 250.

15. Karen Ahlquist, *Democracy at the Opera: Music Theater and Culture in New York City, 1815–1860* (Urbana: University of Illinois Press, 1997), p. 185.

16. Roy Rosenzweig and Elizabeth Blackmar, *The Park and the People: A History of Central Park* (Ithaca: Cornell University Press, 1992), p. 357.

17. Quoted in Spann, *The New Metropolis*, p. 227.

18. Quoted in Edwin G. Burrows and Mike Wallace, *Gotham: A History of New York City to 1898* (New York: Oxford University Press, 1999), p. 1008.

19. *New York Illustrated News*, January 31, 1863, p. 196, N-YHS.

20. Quoted in Spann, *The New Metropolis*, p. 71.

21. Quoted in Eric Homberger, *Scenes from the Life of a City: Corruption and Conscience in Old New York* (New Haven: Yale University Press, 1994), p. 35.

22. Quoted in ibid., p. 80.

23. Quoted in Spann, *The New Metropolis*, p. 345.

24. Robert C. Toll, *Blacking Up: The Minstrel Show in Nineteenth-Century America* (New York: Oxford University Press, 1974), p. 272.

25. Quoted in Paul A. Gilje, *Rioting in America* (Bloomington: Indiana University Press, 1996), p. 75.

26. Quoted in Carl F. Kaestle, *The Evolution of an Urban School System: New York City, 1750–1850* (Cambridge: Harvard University Press, 1973), p. 154.

27. Quoted in Spann, *The New Metropolis*, p. 90.

28. Ibid., p. 333.

29. Quoted in ibid., pp. 314, 315.

30. Alan Trachtenberg, *Brooklyn Bridge: Fact and Symbol* (Chicago: University of Chicago Press, 1965), p. 79.

31. Stern, Mellins, and Fishman, *New York, 1880*, p. 89.

CHAPTER 4 / IMMIGRANT METROPOLIS

1. Stephen Graham, *With Poor Immigrants* (1914), p. 41, quoted in Irving Howe, *World of Our Fathers* (New York: Harcourt, Brace, 1976), p. 42.

2. Quoted in Judith Mara Gutman, *Lewis W. Hine and the American Social Conscience* (New York: Walker, 1967), p. 19.

3. Colin Westerbeck and Joel Meyerowitz, *Bystander: A History of Street Photography* (Boston: Little, Brown, 1994), pp. 271, 272.

4. Ann Douglas, *Terrible Honesty: Mongrel Manhattan in the 1920's* (New York: Farrar, Straus, 1995), pp. 437, 438.

5. *The Encyclopedia of New York City*, ed. Kenneth T. Jackson (New Haven: Yale University Press, 1995), s.v. "Empire State Building," p. 376. See also Carol Willis, *Form Follows Finance: Skyscrapers and Skylines in New York and Chicago* (Princeton: Princeton Architectural Press, 1995).

6. Quoted in Alan Trachtenberg, *Reading American Photographs: Images as History, Matthew Brady to Walker Evans* (New York: Hill and Wang, 1989), p. 227.

7. Kevin Bone, "Horizontal City: Architecture and Construction in the Port of New York," in *The New York Waterfront: Evolution and Building Culture of the Port and Harbor*, ed. Kevin Bone (New York: Monacelli, 1997), p. 135.

8. Daniel Bluestone, "The Pushcart Evil," in *The Landscape of Modernity: Essays on New York City, 1900–1940*, ed. David Ward and Oliver Zunz (New York: Russell Sage, 1992), p. 293.

9. Ibid., p. 291.

10. From a biography by Merrill Roseman produced in connection with an exhibition mounted at the Museum of the City of New York.

11. Mona Domosh, *Invented Cities: The Creation of Landscape in Nineteenth-Century New York and Boston* (New Haven: Yale University Press, 1996), p. 156.

12. *Encyclopedia of New York City*, p. 327.

13. Robert A. M. Stern, Gregory Gilmartin, and Thomas Mellins, *New York, 1930: Architecture and Urbanism Between the Two World Wars* (New York: Rizzoli, 1987), p. 520.

14. Jacob A. Riis, *How the Other Half Lives* (New York: Hill and Wang, 1957), p. 215.

15. Stern, Gilmartin, and Mellins, *New York, 1930*, p. 20.

16. Albert Reese, *American Prize Prints of the Twentieth Century* (New York: American Artists Group, 1949), p. 136.

17. David Nasaw, *Children of the City: At Work and at Play* (New York: Oxford University Press, 1985), p. viii.

18. "Uniforms and Fund-raising: Material Practices in the Salvation Army" (interview with Diane Winston), *Material History of American Religion Project*, spring 1998, p. 4.

19. Introduction to *John Albok for the Children*, catalog of an exhibit at Photographic Archives Gallery, Dallas, in 1995.

20. John F. Kasson, *Amusing the Millions: Coney Island at the Turn of the Century* (New York: Hill and Wang, 1978), p. 8.

21. Ibid., p. 9.

22. David Nasaw, *Going Out: The Rise and Fall of Public Amusements* (New York: Basic, 1993), pp. 9, 33.

23. Quoted in David Levering Lewis, *When Harlem Was in Vogue* (New York: Knopf, 1981), p. 113.

24. Quoted in Samuel G. Freedman, "A Century of Art on a Blackboard Canvas," *New York Times*, May 17, 1998, sec. 2, p. 36. See Stephan Brumberg, *Going to America, Going to School* (New York: Praeger, 1986).

25. Stern, Gilmartin, and Mellins, *New York, 1930*, p. 499.

CHAPTER 5 / COSMOPOLITAN COMMUNITY

1. Robert A. M. Stern, Thomas Mellins, and David Fishman, *New York, 1960: Architecture and Urbanism Between the Second World War and the Bicentennial* (New York: Monacelli, 1995), p. 136.

2. Ibid., p. 619.

3. Ibid., p. 1173.

4. From a biography produced in connection with an exhibition mounted at the Hemphill Fine Arts gallery, Washington, D.C.

5. Ray Oldenberg, *The Great Good Place: Cafes, Coffee Shops, Community Centers, Beauty Parlors, General Stores, Bars, Hangouts, and How They Get You Through the Day* (New York: Paragon, 1991), p. 32.

6. Stern, Mellins, and Fishman, *New York, 1960*, p. 221.

7. Roger Waldinger, *Still the Promised City? African-Americans and New Immigrants in Postindustrial New York* (Cambridge: Harvard University Press, 1996), p. 222.

8. Jane Jacobs, *The Death and Life of Great American Cities* (New York: Vintage, 1961), p. 35.

9. Leslie Nolan, "Lee Sievan (1907–1990), a New York Photographer," in *Creative Lives* (New York: Museum of the City of New York, 1997), p. 4.

10. Stern, Mellins, and Fishman, *New York, 1960*, p. 135.

11. Samuel Schindler, "Lower East Side Story: Half a Century Later, a Photographer Looks Back," *The Forward*, August 15, 1997, p. 12.

12. *Contemporary Photographers*, ed. Colin Naylor, 2d ed. (Chicago: St. James), p. 590.

13. Nathan Glazer and Daniel Patrick Moynihan, *Beyond the Melting Pot* (Cambridge: MIT Press, 1963), p. 19.

14. Dore Ashton, *The New York School: A Cultural Reckoning* (New York: Viking, 1972). p. 1.

15. *New York Times*, September 5, 1997, p. C4.

CHAPTER 6 / GLOBAL VILLAGE

1. Robert A. M. Stern, Thomas Mellins, and David Fishman, *New York, 1960: Architecture and Urbanism Between the Second World War and the Bicentennial* (New York: Monacelli, 1995), p. 206.

2. Ibid., p. 492.

3. Jack Kugelmass, *Masked Culture: The Greenwich Village Halloween Parade* (New York: Columbia University Press, 1994), p. 22.

BIBLIOGRAPHY

PROLOGUE

Burrows, Edwin G. and Mike Wallace. *Gotham: A History of New York City to 1898*. New York: Oxford University Press, 1999.

Deak, Gloria G. *Picturing America: Prints, Maps, and Drawings Bearing on the New World Discoveries and on the Development of the Territory That Is Now the United States*. 2 vols. Princeton: Princeton University Press, 1988.

The Encyclopedia of New York City. Ed. Kenneth T. Jackson. New Haven: Yale University Press, 1995.

Homberger, Eric. *The Historical Atlas of New York City*. New York: Henry Holt, 1994.

Kouwenhoven, John A. *The Columbia Historical Portrait of New York: An Essay in Graphic History*. New York: Doubleday, 1953.

Macdonald, Robert R. *Our Town: Image and Stories from the Museum of the City of New York*. New York: Abrams, 1997.

Pare, Richard. *Photography and Architecture: 1839–1949*. Montreal: Canadian Centre for Architecture, 1982.

Patterson, Jerry E. *The City of New York: A History Illustrated from the Collections of the Museum of the City of New York*. New York: Abrams, 1978.

Reynolds, Martin R. *The Architecture of New York City*. New York: Wiley, 1994.

Robinson, Cervin and Joel Herschman. *Architecture Transformed: A History of the Photography of Buildings from 1839 to the Present*. Cambridge, Mass.: MIT Press, 1987.

Schoener, Allon. *New York: An Illustrated History of the People*. New York: Norton, 1998.

Still, Bayard. *Mirror for Gotham: New York as Seen by Contemporaries from Dutch Days to the Present*. New York: New York University Press, 1956.

Stokes, I. N. Phelps, comp. *The Iconography of Manhattan Island, 1408–1909*. 6 vols. New York: Robert H. Dodd, 1915–28.

CHAPTER 1

Archdeacon, Thomas. *New York City, 1664–1710*. Ithaca: Cornell University Press, 1976.

Blackburn, Roderic H. *Remembrance of Patria: Dutch Arts and Culture in Colonial America, 1609–1776*. Albany: Albany Institute of Art, 1988.

Bolton, Reginald. *Indian Life of Long Ago in the City of New York*. New York: Joseph Graham, 1934.

Bonomi, Patricia F. *A Factious People: Politics and Society in Colonial New York*. New York: Columbia University Press, 1971.

Danckaerts, Jaspar and Peter Sluyter. *Journal of a Voyage to New York {1679–80}*. Brooklyn: Long Island Historical Society, 1867.

De Sola Pool, David. *An Old Faith in a New World: Portrait of Shearith Israel, 1654–1954*. New York: Columbia University Press, 1955.

Goodfriend, Joyce. *Before the Melting Pot: Society and Culture in Colonial New York City, 1664–1730*. Princeton: Princeton University Press, 1992.

Hodges, Graham. *Root and Branch: African Americans in New York and East Jersey, 1613–1863*, Chapel Hill: University of North Carolina Press, 1999.

Innis, J. H. *New Amsterdam and Its People: Studies, Social and Topographical, of the Town Under Dutch and Early English Rule*. 1902. Reprint. Port Washington, N.Y.: Ira Friedman, 1969.

Kammen, Michael. *Colonial New York: A History*. Millwood, N.Y.: KTO, 1975.

Kenney, Alice P. *Stubborn for Liberty: The Dutch in New York*. Syracuse: Syracuse University Press, 1975.

Kessler, Henry. *Peter Stuyvesant and His New York*. New York: Random House, 1959.

Lamb, Martha J. *The History of the City of New York: Its Origins, Rise, and Progress*. 3 vols. New York: A. S. Barnes, 1877–96.

Leonard, John W. *The History of the City of New York, 1609–1909, From the Earliest Discoveries to the Hudson Fulton Celebration*. New York: Journal of Commerce and Commercial Bulletin, 1910.

Matson, Cathy. *Merchants and Empire: Trading in Colonial New York*. Baltimore: Johns Hopkins University Press, 1998.

Rink, Oliver A. *Holland on the Hudson: An Economic and Social History of Dutch New York*. Ithaca: Cornell University Press, 1986.

Strong, John A. *The Algonquian Peoples of Long Island from Early Times to 1700*. Interlaken, N.Y.: Empire State Books, 1997.

Tiedemann, Joseph S. *Reluctant Revolutionaries: New York City and the Road to Independence*. Ithaca: Cornell University Press, 1997.

Van Der Zee, Henri and Barbara Van Der Zee. *A Sweet and Alien Land: The Early History of New York*. New York: Viking, 1978.

Wilkenfeld, Bruce. *The Social and Economic Structure of the City of New York, 1695–1796*. New York: Arno, 1978.

Wilson, James G. *The Memorial History of the City of New York, From Its First Settlements to the Year 1892*. 5 vols. New York: New York History Company, 1892–94.

CHAPTER 2

Albion, John R. *The Rise of New York Port, 1815–1860*. New York: Scribner, 1939.

Blackmar, Elizabeth. *Manhattan for Rent, 1785–1850*. Ithaca: Cornell University Press, 1989.

Gilchrist, David T., ed. *The Growth of the Seaport Cities, 1790–1825*. Charlottesville: University Press of Virginia, 1967.

Gilje, Paul A. *The Road to Mobocracy: Popular Disorder in New York City, 1763–1834*. Chapel Hill: University of North Carolina Press, 1987.

Hartog, Henrik. *Public Property and Private Power: The Corporation of the City of New York in American Law, 1730–1870*. Ithaca: Cornell University Press, 1983.

Headley, Joel T. *The Great Riots of New York: 1712–1873*. New York: E.B. Treat, 1873.

Hodges, Graham R. *New York City Cartmen, 1667–1850*. New York: New York University Press, 1986.

Humphrey, David C. *From King's College to Columbia, 1746–1800*. New York: Columbia University Press, 1976.

McNamara, Brooks. *Day of Jubilee: The Great Age of Public Celebrations in New York, 1788–1909*. New Brunswick: Rutgers University Press, 1997.

Mohl, Raymond A. *Poverty in New York, 1783–1825*. New York: Oxford University Press, 1971.

Monaghan, Frank and Marvin Lowenthal. *This Was New York: The Nation's Capital in 1789*. Garden City, N.Y.: Doubleday, 1943.

Otter, William. *A History of My Own Times*. Ed. Richard B. Stott. Ithaca: Cornell University Press, 1995.

Pomerantz, Sidney I. *New York: An American City, 1783–1803*. New York: Columbia University Press, 1938.

Rock, Howard B. *Artisans of the New Republic: The Tradesmen of New York City in the Age of Jefferson*. New York: New York University Press, 1979.

White, Shane. *Somewhat More Independent: The End of Slavery in New York City, 1770–1810*. Athens: University of Georgia Press, 1991.

Young, Alfred F. *The Democratic Republicans of New York: The Origins, 1763–1797*. Chapel Hill: University of North Carolina Press, 1967.

CHAPTER 3

Ahlquist, Karen. *Democracy at the Opera: Music Theater and Culture in New York City, 1815–1860*. Urbana: University of Illinois Press, 1997.

Bender, Thomas A. *New York Intellect: New York, a History of Intellectual Life in New York City, from 1750 to the Beginnings of Our Own Time*. New York: Knopf, 1987.

Bernstein, Iver. *The New York City Draft Riots: Their Significance for American Society and Politics in the Age of the Civil War*. New York: Oxford University Press, 1990.

Black, Mary. *Old New York in Early Photographs: 196 Prints, 1853–1901, from the Collection of the New-York Historical Society*. New York: Dover, 1973.

Bridges, Amy. *A City in the Republic: Antebellum New York and the Origins of Machine Politics*. New York: Cambridge University Press, 1984.

Cohen, Patricia C. *The Murder of Helen Jewett: The Life and Death of a Prostitute in Nineteenth-Century New York*. New York: Knopf, 1998.

Diner, Hasia R. *Erin's Daughters: Irish Immigrant Women in the Nineteenth Century*. Baltimore: Johns Hopkins University Press, 1983.

——. *A Time for Gathering: The Second Migration, 1820–1880*. Baltimore: Johns Hopkins University Press, 1992.

Ellington, George. *Women of New York or the Underworld of the Great City*. New York: New York Book Company, 1869.

Ernst, Robert. *Immigrant Life in New York City, 1825–1863*. 1949. Reprint. Port Washington, N.Y., Ira Friedman, 1965.

Foster, George C. *New York by Gaslight and Other Urban Sketches*. 1850. Reprint. Berkeley: University of California Press, 1990.

Fowler, William W. *Twenty Years in Wall Street*. New York: Orange Judd Co., 1880.

Geist, Charles R. *Wall Street: A History*. New York: Oxford University Press, 1997.

Gilfoyle, Timothy J. *City of Eros: New York City, Prostitution, and the Commercialization of Sex*. New York: Norton, 1992.

Gilje, Paul A. *Rioting in America*. Bloomington: Indiana University Press, 1996.

Gordon, Michael A. *The Orange Riots: Irish Political Violence in New York City, 1870 and 1871*. Ithaca: Cornell University Press, 1993.

Grafton, John. *New York in the Nineteenth Century: 321 Engravings from Harper's Weekly and Other Contemporary Sources*. New York: Dover, 1977.

Hill, Marilyn W. *Their Sisters' Keeper: Prostitution in New York City, 1830–1870*. Berkeley: University of California Press, 1993.

Homberger, Eric. *Scenes from the Life of a City: Corruption and Conscience in Old New York*. New Haven: Yale University Press, 1994.

Kaestle, Carl F. *The Evolution of an Urban School System: New York City, 1750–1850*. Cambridge: Harvard University Press, 1973.

Lemon, James T. *Liberal Dreams and Nature's Limits: Great Cities of North America Since 1600*. New York: Oxford University Press, 1996.

Lewis, Arnold, James Turner, and Steven McQuillan. *The Opulent Interiors of the Gilded Age: All 203 Photographs from "Artistic Houses."* New York: Dover, 1987.

Lockwood, Charles. *Bricks and Brownstone: The New York Row House, 1783–1829*. New York: McGraw-Hill, 1972.

——. *Manhattan Moves Uptown: An Illustrated History*. New York: Houghton Mifflin, 1976.

McCabe, James D. Jr. *Lights and Shadows of New York Life*. Philadelphia: National Publishing Company, 1872.

Nadel, Stanley. *Little Germany: Ethnicity, Religion, and Class in New York City, 1845–80*. Urbana: University of Illinois Press, 1990.

Reps, John W. *Bird's Eye Views: Historic Lithographs of North American Cities*. Princeton: Princeton Architectural Press, 1998.

Rosenzweig, Roy and Elizabeth Blackmar. *The Park and the People: A History of Central Park*. Ithaca: Cornell University Press, 1992.

Ryan, Mary P. *Civic Wars: Democracy and Public Life in the American City During the Nineteenth Century*. Berkeley: University of California Press, 1997.

Scherzer, Kenneth A. *The Unbounded Community: Neighborhood Life and Social Structure in New York City, 1830–1875*. Durham: Duke University Press, 1992.

Schmidt, Leigh Eric. *Consumer Rights: The Buying and Selling of American Holidays*. Princeton: Princeton University Press, 1995.

Spann, Edward K. *The New Metropolis: New York City, 1840–1857*. New York: Columbia University Press, 1981.

Stansell, Christine. *City of Women: Sex and Class in New York, 1789–1860*. New York: Knopf, 1986.

Stern, Robert A. M., Thomas Mellins, and David Fishman. *New York, 1880: Architecture and Urbanism in the Gilded Age*. New York: Monacelli, 1999.

Stott, Richard B. *Workers in the Metropolis: Class, Ethnicity, and Youth in Antebellum New York City*. Ithaca: Cornell University Press, 1990.

Toll, Robert C. *Blacking Up: The Minstrel Show in Nineteenth-Century America*. New York: Oxford University Press, 1974.

Trachtenberg, Alan. *Brooklyn Bridge: Fact and Symbol*. Chicago: University of Chicago Press, 1965.

Widmer, Edward L. *Young America: The Flowering of Democracy in New York City*. New York: Oxford University Press, 1999.

Wilentz, Sean. *Chants Democratic: New York City and the Rise of the American Working Class, 1788–1850*. New York: Oxford University Press, 1984.

CHAPTER 4

Abbott, Berenice. *Photographs*. Washington: Smithsonian Institution Press, 1990.

Binder, Frederick M. and David M. Reimers. *All the Nations Under Heaven: An Ethnic and Racial History of New York City*. New York: Columbia University Press, 1995.

Bone, Kevin, ed. *The New York Waterfront: Evolution and Building Culture of the Port and Harbor*. New York: Monacelli, 1997.

Brumberg, Stephan. *Going to America, Going to School*. New York: Praeger, 1986.

Chauncey, George. *Gay New York: Gender, Urban Culture, and the Making of the Gay Male World, 1890–1940*. New York: Basic, 1994.

Cromley, Elizabeth Collins. *Alone Together: A History of New York's Early Apartments*. Ithaca: Cornell University Press, 1990.

Domosh, Mona. *Invented Cities: The Creation of Landscape in Nineteenth-Century New York and Boston*. New Haven: Yale University Press, 1996.

Douglas, Ann. *Terrible Honesty: Mongrel Manhattan in the 1920's*. New York: Farrar, Straus, 1995.

Dubofsky, Melvyn. *When Workers Organize: New York City in the Progressive Era*. Amherst: University of Massachusetts Press, 1968.

Gabaccia, Donna R. *From Sicily to Elizabeth Street: Housing and Social Change Among Italian Immigrants, 1880–1930*. Albany: SUNY Press, 1984.

Gandal, Keith. *The Virtues of the Vicious: Jacob Riis, Stephen Crane, and the Spectacle of the Slum*. New York: Oxford University Press, 1997.

Gilmartin, Gregory F. *Shaping the City: New York and the Municipal Art Society*. New York: Clarkson Potter, 1995.

Gutman, Judith Mara. *Lewis W. Hine and the American Social Conscience.* New York: Walker, 1967.

Hammack, David C. *Power and Society: Greater New York at the Turn of the Century.* New York: Columbia University Press, 1987.

Heinze, Andrew. *Adapting to Abundance: Jewish Immigrants, Mass Consumption, and the Search for American Identity.* New York: Columbia University Press, 1990.

Hood, Clifton. *722 Miles: The Building of the Subways and How They Transformed New York.* New York: Simon and Schuster, 1993.

Howe, Irving. *World of Our Fathers.* New York: Harcourt, Brace, 1976.

Huggins, Nathan Irvin. *Harlem Renaissance.* New York: Oxford University Press, 1971.

Kasson, John F. *Amusing the Millions: Coney Island at the Turn of the Century.* New York: Hill and Wang, 1978.

Landau, Sarah Bradford and Carl W. Condit. *Rise of the New York Skyscraper, 1865–1913.* New Haven: Yale University Press, 1996.

Lewis, David Levering. *When Harlem Was in Vogue.* New York: Knopf, 1981.

Lieberman, Janet E. and Richard K. Lieberman. *City Limits: A Social History of Queens.* Dubuque, Iowa: Kendall/Hunt, 1983.

Lieberman, Richard K. *Steinway and Sons.* New Haven: Yale University Press, 1995.

Makielski, Stanislaw J., Jr. *The Politics of Zoning: The New York Experience.* New York: Columbia University Press, 1966.

McKay, Claude. *Harlem: Negro Metropolis.* New York: Harcourt, Brace, 1968.

Moore, Deborah Dash. *At Home in America: Second Generation New York Jews.* New York: Columbia University Press, 1981.

Nasaw, David. *Children of the City: At Work and at Play.* New York: Oxford University Press, 1985.

———. *Going Out: The Rise and Fall of Public Amusements.* New York: Basic, 1993.

Nolan, Leslie. "Lee Sievan (1907–1990), A New York Photographer." In *Creative Lives*, 2–32. New York: Museum of the City of New York, 1997.

Orsi, Robert A. *The Madonna of 115th Street: Faith and Community in Italian Harlem, 1880–1950.* New Haven: Yale University Press, 1985.

Osofsky, Gilbert. *Harlem: The Making of a Ghetto.* New York: Harper and Row, 1963.

Peiss, Kathy. *Cheap Amusements: Working Women and Leisure in Turn-of-the-Century New York.* Ithaca: Cornell University Press, 1985.

Reese, Albert. *American Prize Prints of the Twentieth Century.* New York: American Artists Group, 1949.

Riis, Jacob A. *How the Other Half Lives.* New York: Hill and Wang, 1957.

Rischin, Moses. *The Promised City: New York's Jews, 1870–1914.* Cambridge: Harvard University Press, 1962.

Snyder, Robert. *Voice of the City: Vaudeville and Popular Culture in New York.* New York: Oxford University Press, 1989.

Stern, Robert A. M., Gregory Gilmartin, and John Massengale. *New York 1900: Metropolitan Architecture and Urbanism, 1890–1915.* New York: Rizzoli, 1983. Reprint. New York: Rizzoli, 1992.

Stern, Robert A. M., Gregory Gilmartin, and Thomas Mellins. *New York, 1930: Architecture and Urbanism Between the Two World Wars.* New York: Rizzoli, 1987.

Taylor, William. *The Pursuit of Gotham: Culture and Commerce in New York.* New York: Oxford University Press, 1992.

———, ed. *Inventing Times Square: Commerce and Culture at the Crossroads of the World.* Baltimore: Johns Hopkins University Press, 1996.

Trachtenberg, Alan. *Reading American Photographs: Images as History, Matthew Brady to Walker Evans.* New York: Hill and Wang, 1989.

Ward, David and Oliver Zunz, eds. *The Landscape of Modernity: Essays on New York City, 1900–1940.* New York: Russell Sage, 1992.

Ware, Caroline F. *Greenwich Village, 1920–1930.* Berkeley: University of California Press, 1963.

Willensky, Elliot. *When Brooklyn Was the World.* New York: Harmony, 1986.

Willis, Carol. *Form Follows Finance: Skyscrapers and Skylines in New York and Chicago.* Princeton: Princeton Architectural Press, 1995.

Winston, Diane. *Red Hot and Righteous: The Urban Religion of the Salvation Army.* Cambridge: Harvard University Press, 1999.

CHAPTER 5

Ashton, Dore. *The New York School: A Cultural Reckoning.* New York: Viking, 1972.

Caro, Robert. *The Power Broker: Robert Moses and the Fall of New York.* New York: Knopf, 1974.

Dargan, Amanda and Steven Zeitlin. *City Play.* New Brunswick, N.J.: Rutgers University Press, 1990.

DeCarava, Roy. *Roy DeCarava: A Retrospective.* New York: Museum of Modern Art, 1996.

Federal Writers' Project. *The WPA Guide to New York City.* 1939. Reprint. New York: Pantheon, 1982.

Feininger, Andreas. *New York in the Forties.* New York: Dover, 1978.

Freeman, Joshua. *In Transit: The Transport Workers Union in New York City, 1933–1966.* New York: Oxford University Press, 1989.

Glazer, Nathan and Daniel Patrick Moynihan. *Beyond the Melting Pot.* Cambridge, Mass.: MIT Press, 1963.

Jacobs, Jane. *The Death and Life of Great American Cities.* New York: Vintage, 1961.

Katznelson, Ira. *City Trenches: Urban Politics and the Patterning of Class in the United States.* Chicago: University of Chicago Press, 1981.

Kugelmass, Jack. *Miracle of Intervale Avenue: The Story of a Jewish Congregation in the South Bronx.* New York: Schocken, 1996.

LaRuffa, Anthony L. *Monte Carmelo: An Italian-American Community in the Bronx.* New York: Gordon and Breach, 1988.

Livingston, Jane. *The New York School: Photographs, 1936–1963.* New York: Steward, Tabori, and Chang, 1992.

McNickle, Chris. *To Be Mayor of New York: Ethnic Politics in the City.* New York: Columbia University Press, 1993.

Oldenberg, Ray. *The Great Good Place: Cafes, Coffee Shops, Community Centers, Beauty Parlors, General Stores, Bars, Hangouts, and How They Get You Through the Day.* New York: Paragon, 1991.

Schwartz, Joel. *The New York Approach: Robert Moses, Urban Liberals, and Redevelopment of the Inner City.* Columbus: Ohio State University Press, 1993.

Stern, Robert A. M., Thomas Mellins, and David Fishman. *New York, 1960: Architecture and Urbanism Between the Second World War and the Bicentennial.* New York: Monacelli, 1995.

Stettner, Louis. *Louis Stettner's New York, 1950s–1990s.* New York: Rizzoli, 1996.

Ultan, Lloyd. *The Beautiful Bronx (1920–1950).* New Rochelle, N.Y.: Arlington House, 1979.

Westerbeck, Colin and Joel Meyerowitz. *Bystander: A History of Street Photography.* Boston: Little, Brown, 1994.

CHAPTER 6

Brooks, Michael W. *Subway City: Riding the Trains, Reading New York*. New Brunswick, N.J.: Rutgers University Press, 1997.

Foner, Nancy, ed. *New Immigrants in New York*. New York: Columbia University Press, 1987.

Kugelmass, Jack. *Masked Culture: The Greenwich Village Halloween Parade*. New York: Columbia University Press, 1994.

Kwong, Peter. *The New Chinatown*. New York: Hill and Wang, 1996.

Markowitz, Fran. *A Community in Spite of Itself: Soviet Jewish Emigrés in New York*. Washington, D.C.: Smithsonian Institution Press, 1993.

Mollenkopf, John H. and Manuel Castells, ed. *Dual City: Restructuring New York*. New York: Russell Sage, 1991.

Shokeid, Moshe. *Children of Circumstance: Israeli Immigrants in New York*. Albany: SUNY Press, 1988.

——. *A Gay Synagogue in New York*. New York: Columbia University Press, 1995.

Tanenbaum, Susie J. *Underground Harmonies: Music and Politics in the Subways of New York*. Ithaca: Cornell University Press, 1995.

Waldinger, Roger. *Still the Promised City? African-Americans and New Immigrants in Postindustrial New York*. Cambridge: Harvard University Press, 1996.

Winnick, Louis. *New People in Old Neighborhoods: The Role of New Immigrants in Rejuvenating New York's Communities*. New York: Russell Sage, 1990.

ADDITIONAL CREDITS

The following images come from the Eno Collection, Miriam and Ira D. Wallach Division of Art, Prints and Photographs, the New York Public Library, Astor, Lenox and Tilden Foundations: P.1, 1.9, 1.10, 2.62, 3.12, 3.15, 3.31, 3.41, 3.47, 3.50, 3.57, 3.74, 3.77, 3.114, 3.139, 3.140, 3.151, 3.155, 3.160.

The following images come from the Emmet Collection, Miriam and Ira D. Wallach Division of Art, Prints and Photographs, the New York Public Library, Astor, Lenox and Tilden Foundations: 1.27, 2.18.

The following images come from the I. N. Phelps Stokes Collection, Miriam and Ira D. Wallach Division of Art, Prints and Photographs, the New York Public Library, Astor, Lenox and Tilden Foundations: 1.3, 1.8, 1.13, 1.15, 1.20, 1.52, 1.64, 1.69, 1.70, 1.74, 1.75, 1.77, 2.3, 2.4, 2.5, 2.8, 2.9, 2.10, 2.12, 2.18, 2.62, 2.75, 2.80, 2.92, 3.1, 3.3, 3.4, 3.5, 3.39.

The following image comes from the Rare Books Divison, Miriam and Ira D. Wallach Division of Art, Prints and Photographs, the New York Public Library, Astor, Lenox and Tilden Foundations: 2.39.

The following image comes from the Spencer Collection, Miriam and Ira D. Wallach Division of Art, Prints and Photographs, the New York Public Library, Astor, Lenox and Tilden Foundations: 1.71.

The following images come from the Milstein Division of United States History, Local History and Genealogy, the New York Public Library, Astor, Lenox and Tilden Foundations: 1.1, 4.4.

The following images come from the Prints Collection, Miriam and Ira D. Wallach Division of Art, Prints and Photographs, the New York Public Library, Astor, Lenox and Tilden Foundations: 2.7, 2.21, 2.32, 2.37, 2.45, 2.54, 2.56, 2.57, 2.59, 2.60, 2.67, 2.99, 3.75, 4.69, 4.101

The following images come from the Photography Collection, Miriam and Ira D. Wallach Division of Art, Prints and Photographs, the New York Public Library, Astor, Lenox and Tilden Foundations: 4.11, 4.12, 4.23, 4.103, 5.4, 5.26, 5.52, 5.67, 5.116, 5.137.

The following images come from the Romana Javitz Collection, Miriam and Ira D. Wallach Division of Art, Prints and Photographs, the New York Public Library, Astor, Lenox and Tilden Foundations: 5.36, 5.37, 5.44, 5.45.

The following images come from the Lewis Hine Collection, Milstein Division of United States History, Local History and Genealogy, the New York Public Library, Astor, Lenox and Tilden Foundations: 4.3, 4.5, 4.29, 4.34, 4.39, 4.46, 4.47, 4.67, 4.72, 4.89.

The following images come from the Photographic Views of New York City, Milstein Division of United States History, Local History and Genealogy, the New York Public Library, Astor, Lenox and Tilden Foundations: 4.37, 4.73, 4.75, 4.110, 4.111, 4.117, 4.122, 4.138, 4.141, 5.73, 5.81, 5.98, 5.107.

The following images come from the Photographs and Prints Division, Schomburg Center for Research in Black Culture, The New York Public Library, Astor, Lenox and Tilden Foundations: 4.94, 4.95, 4.136, 5.5, 5.18, 5.105, 5.141, 5.143, 6.60, 6.61.

The following images come from the Metropolitan Museum of Art, Edward W.C. Arnold Collection of New York Prints, Maps, and Pictures, bequest of Edward W.C. Arnold, 1954: 2.13 (54.90.511), 2.30 (54.90.493), 2.33 (54.90.512), 2.46 (54.90.507), 2.65 (54.90.515), 2.66 (54.90.502), 2.68 (54.90.489), 2.69, 2.94 (54.90.514).

ABBREVIATIONS OF SOURCES

AJHS	American Jewish Historical Society
CEP	Centro de Estudios Puertorriqueños
CUNY	City University of New York
LC	Library of Congress
LCC/CUNY	LaGuardia Community College, City University of New York
MCNY	Museum of the City of New York
MMA	Metropolitan Museum of Art
NYPL	New York Public Library, Astor, Lenox and Tilden Foundations
N-YHS	New York Historical Society
NYSHA	New York State Historical Association
SONJ	Standard Oil (New Jersey) Collections

SOURCES

TITLE PAGE & ACKNOWLEDGMENTS
p.ii-iii. MCNY. / **p.x.** N-YHS.

PROLOGUE
P.1. NYPL; **P.2.** N-YHS; **P.3.** MCNY; **P.4.** Metropolitan Museum of Art, Ford Motor Company Collection, Gift of Ford Motor Company and John C. Waddell, 1987 (1987.1100.466); **P.5.** MCNY; **P.6.** MMA, The Alfred Stieglitz Collection, 1933 (33.43.43). Reprinted with permission of Joanna T. Steichen.

CHAPTER ONE
1.1. NYPL; **1.2.** Reginald Bolton, *Indian Life of Long Ago in the City of New York* (New York: Joseph Graham, 1934); **1.3.** NYPL; **1.4.** MCNY; **1.5.** LC; **1.6.** Holland Society; **1.7.** Martha J. Lamb, *History of the City of New York: Its Origins, Rise, and Progress,* vol. 1 (New York: A. S. Barnes, 1877); **1.8.** NYPL; **1.9.** NYPL; **1.10.** NYPL; **1.11.** N-YHS; **1.12.** J. Schipper, Holland; **1.13.** NYPL; **1.14.** N-YHS; **1.15.** NYPL; **1.16.** MCNY; **1.17.** MCNY; **1.18.** NYPL; **1.19.** MCNY; **1.20** NYPL; **1.21.** Kings Papers, British Museum; **1.22.** MCNY; **1.23.** N-YHS; **1.24.** N-YHS; **1.25.** NYPL; **1.26.** *Rivington's New York Gazeteer,* 1773, N-YHS; **1.27.** NYPL; **1.28.** NYPL; **1.29.** N-YHS; **1.30.** MCNY; **1.31.** MCNY; **1.32.** MCNY; **1.33.** MCNY; **1.34.** MCNY; **1.35.** MCNY; **1.36.** MCNY; **1.37.** *New York Gazette,* October 27, 1763; **1.38.** James G. Wilson, *The Memorial History of the City of New York, From Its First Settlements to the Year 1892,* vol. 1 (New York: New York History Company, 1892); **1.39.** *Valentine's Manual,* 1860; **1.40.** *Valentine's Manual,* 1859; **1.41.** *The New York Magazine,* October, 1795, N-YHS; **1.42.** MCNY; **1.43.** MCNY; **1.44.** David De Sola Pool, *An Old Faith in a New World: Portrait of Shearith Israel, 1654–1954* (New York: Columbia University Press, 1955); **1.45.** Martha J. Lamb, *History of the City of New York: Its Origins, Rise, and Progress,* vol. 1 (New York: A. S. Barnes, 1877); **1.46.** AJHS; **1.47.** N-YHS; **1.48.** N-YHS; **1.49.** N-YHS; **1.50.** James G. Wilson, *The Memorial History of the City of New York, From Its First Settlements to the Year 1892,* vol. 1 (New York: New York History Company, 1892); **1.51.** Austin Baxter Keep, *History of the New York Society Library* (New York: De Vinne, 1908); **1.52.** NYPL; **1.53.** Columbiana, Columbia University; **1.54.** N-YHS; **1.55.** MCNY; **1.56.** MCNY; **1.57.** George C. D. Odell, *Annals of the New York Stage,* vol. 1 (New York: Columbia University Press, 1927); **1.58.** Harvard Theater Collection; **1.59.** N-YHS; **1.60.** MCNY; **1.61.** NYPL; **1.62.** Martha J. Lamb, *History of the City of New York: Its Origins, Rise, and Progress,* vol. 1 (New York: A. S. Barnes, 1877); **1.63.** MCNY; **1.64.** NYPL; **1.65.** N-YHS; **1.66.** N-YHS; **1.67.** N-YHS; **1.68.** Library Company of Philadelphia; **1.69.** NYPL; **1.70.** NYPL; **1.71.** NYPL; **1.72.** MCNY; **1.73.** N-YHS; **1.74.** NYPL; **1.75.** NYPL; **1.76.** Albert Greene, ed., *Recollections of the Jersey Prison Ship from the Manuscript of Captain Thomas Dring* (Providence: H. H. Brown, 1829); **1.77.** NYPL; **1.78.** N-YHS.

CHAPTER TWO
2.1. NYPL; **2.2.** MCNY; **2.3.** NYPL; **2.4.** NYPL; **2.5.** NYPL; **2.6.** N-YHS; **2.7.** NYPL; **2.8.** Peabody Views, NYPL; **2.9.** NYPL; **2.10.** NYPL; **2.11.** Martha J.

Lamb, *History of the City of New York: Its Origins, Rise, and Progress,* vol. 2 (New York: A. S. Barnes, 1880); **2.12.** NYPL; **2.13.** MMA; **2.14.** *Valentine's Manual,* 1861; **2.15** N-YHS; **2.16.** N-YHS; **2.17.** *New York Magazine* 1 (June 1790): 317, N-YHS; **2.18.** NYPL; **2.19.** *Valentine's Manual,* 1866; **2.20.** MCNY; **2.21.** Peabody Views, NYPL; **2.22.** N-YHS; **2.23.** Landauer Collection, N-YHS; **2.24.** MCNY; **2.25.** Winterthur Library; **2.26.** *American Collector,* May 1942; **2.27.** N-YHS; **2.28.** MCNY; **2.29.** N-YHS; **2.30.** MMA; **2.31.** MCNY; **2.32.** Anderson Scrapbooks, NYPL; **2.33.** MMA; **2.34.** Winterthur Museum; **2.35.** N-YHS; **2.36.** Winterthur Museum; **2.37.** Anderson Scrapbooks. NYPL; **2.38.** NYPL; **2.39.** NYPL; **2.40.** Samuel Wood, *Proof Book* (New York, 1820); **2.41.** Samuel Wood, *Proof Book* (New York, 1820); **2.42.** *New York Packet,* February 23, 1785, N-YHS; **2.43.** MCNY; **2.44.** MCNY; **2.45.** Anderson Scrapbooks, NYPL; **2.46.** MMA; **2.47.** Augustine Costello, *Our Firemen: The History of the New York Fire Departments from 1609 to 1887* (New York, 1887); **2.48.** N-YHS; **2.49.** *Freedom's Journal,* February 1, 1828; **2.50.** Anderson Scrapbooks, NYPL; **2.51.** N-YHS; **2.52.** Frances Trollope, *Domestic Manners of the Americans* (New York: Harper and Bros., 1830), vol. 2; **2.53.** MCNY; **2.54.** Anderson Scrapbooks, NYPL; **2.55.** *The Cries of New York* (New York, 1812); **2.56.** Anderson Scrapbooks, NYPL; **2.57.** Anderson Scrapbooks, NYPL; **2.58.** MCNY; **2.59.** Anderson Scrapbooks, NYPL; **2.60.** Anderson Scrapbooks, NYPL; **2.61.** Bourne Views, N-YHS; **2.62.** N-YHS; **2.63.** NYPL; **2.64.** NYPL; **2.65.** MMA; **2.66.** MMA; **2.67.** Anderson Scrapbooks, NYPL; **2.68.** MMA; **2.69.** MMA; **2.70.** Columbiana, Columbia University; **2.71.** N-YHS; **2.72.** N-YHS; **2.73.** N-YHS; **2.74.** N-YHS; **2.75.** NYPL; **2.76.** Bourne Views, N-YHS; **2.77.** *Valentine's Manual,* 1853; **2.78.** N-YHS; **2.79.** *Picture of New York* (New York: Mahlon Day, ca. 1825–30); **2.80.** NYPL; **2.81.** Joel T. Headley, *The Great Riots of New York: 1712–1873* (New York: E. B. Treat, 1873); **2.82.** Anderson Scrapbooks, NYPL; **2.83.** MCNY; **2.84.** N-YHS; **2.85.** MCNY; **2.86.** N-YHS; **2.87.** N-YHS; **2.88.** N-YHS; **2.89.** N-YHS; **2.90.** Herman Fairchild, *History of the N.Y. Academy of Science, Formerly the Lyceum of Natural History* (New York: Herman Fairchild, 1887); **2.91.** N-YHS; **2.92.** NYPL; **2.93.** N-YHS; **2.94.** MMA; **2.95.** N-YHS; **2.96.** N-YHS; **2.97.** MCNY; **2.98.** Library Company of Philadelphia; **2.99.** NYPL; **2.100** N-YHS; **2.101.** MCNY; **2.102.** Martha J. Lamb, *History of the City of New York: Its Origins, Rise, and Progress,* vol. 2 (New York: A. S. Barnes, 1880); **2.103.** N-YHS.

CHAPTER THREE

3.1. NYPL; **3.2.** N-YHS; **3.3.** NYPL; **3.4.** NYPL; **3.5.** NYPL; **3.6.** MCNY; **3.7.** MCNY; **3.8.** N-YHS; **3.9.** N-YHS; **3.10.** *Harper's Weekly,* July 23, 1870; **3.11.** *Harper's Weekly,* February 3, 1872; **3.12.** NYPL; **3.13.** William W. Fowler, *Twenty Years in Wall Street* (New York: Orange Judd Co., 1880); **3.14.** *Harper's Weekly,* September 24, 1869; **3.15.** NYPL; **3.16.** MCNY; **3.17.** MCNY; **3.18.** NYPL; **3.19.** *Harper's Weekly,* September 4, 1869; **3.20.** LC; **3.21.** *Frank Leslie's Illustrated Newspaper.* May 18, 1867; **3.22.** *Valentine's Manual,* 1864; **3.23.** NYPL; **3.24.** *Frank Leslie's Illustrated Newspaper,* July 23, 1853; **3.25.** Robert Hoe, *A Short History of the Printing Press* (New York, 1902); **3.26.** N-YHS; **3.27.** N-YHS; **3.28.** *The Printer,* 1 (1858); **3.29.** N-YHS; **3.30.** *Frank Leslie's Illustrated Newspaper,* January 11, 1873. N-YHS; **3.31.** NYPL; **3.32.** N-YHS; **3.33.** N-YHS; **3.34.** *Valentine's Manual,* 1864; **3.35.** N-YHS; **3.36.** MCNY; **3.37.** N-YHS; **3.38.** MCNY; **3.39.** Bourne View, NYPL; **3.40.** N-YHS; **3.41.** NYPL; **3.42.** MCNY; **3.43.** N-YHS; **3.44.** *Frank Leslie's Illustrated Newspaper,* September 7, 1889. NYPL; **3.45.** *Harper's Weekly,* August 14, 1869; **3.46.** MCNY; **3.47.** NYPL; **3.48.** Brooklyn Museum of Art; **3.49.** Brooklyn Public Library; **3.50.** NYPL; **3.51.** *Godey's Magazine.* January, 1845. N-YHS; **3.52.** MCNY; **3.53.** NYPL; **3.54.** *Harper's Weekly,* January 4, 1868; **3.55.** MCNY; **3.56.** NYPL; **3.57.** NYPL; **3.58.** George Ellington. *Women of New York; or, The Underworld of the Great City* (New York: New York Book Company, 1869); **3.59.** George Ellington, *Women of New York; or, The Underworld of the Great City* (New York: New York Book Company, 1869); **3.60.** George Ellington, *Women of New York; or, The Underworld of the Great City* (New York: New York Book Company, 1869); **3.61.** Landauer Collection. N-YHS; **3.62.** *Ballou's Pictorial Drawing-room Companion.* March 29, 1856; **3.63.** Baxter print. N-YHS; **3.64.** MCNY; **3.65.** *Harper's Weekly,* December 19, 1885; **3.66.** *Frank Leslie's Illustrated Newspaper,* June 3, 1865; **3.67.** MCNY; **3.68.** MCNY; **3.69.** N-YHS; **3.70.**

South Street Seaport; **3.71.** N-YHS; **3.72.** N-YHS; **3.73.** MCNY; **3.74.** NYPL; **3.75.** NYPL; **3.76.** *Harper's Weekly,* June 20, 1885; **3.77.** NYPL; **3.78.** *Frank Leslie's Illustrated Newspaper,* October 21, 1882; **3.79.** Courtesy Tom Frusciano; **3.80.** *Frank Leslie's Illustrated Newspaper,* April 16, 1870; **3.81.** *Frank Leslie's Illustrated Newspaper,* May 17, 1879; **3.82.** MCNY; **3.83.** MCNY; **3.84.** MCNY; **3.85.** NYSHA; **3.86.** *Harper's Weekly,* October 25, 1873; **3.87.** NYPL; **3.88.** N-YHS; **3.89.** *Frank Leslie's Illustrated Newspaper,* July 29, 1871, N-YHS; **3.90.** MCNY; **3.91.** *Harper's Weekly,* July 29, 1871, N-YHS; **3.92.** *Valentine's Manual,* 1862; **3.93.** N-YHS; **3.94.** *Frank Leslie's Illustrated Newspaper,* January 6, 1872. N-YHS; **3.95.** MCNY; **3.96.** *Frank Leslie's Illustrated Newspaper,* October 21, 1876, N-YHS; **3.97.** *Harper's Weekly,* November 14, 1868; **3.98.** MCNY; **3.99.** *Frank Leslie's Illustrated Newspaper,* April 10,1858. LC; **3.100.** *Valentine's Manual,* 1861; **3.101.** *Cosmopolitan,* June 1888; **3.102.** *New York Illustrated News.* January 31, 1863, N-YHS; **3.103.** N-YHS; **3.104.** MCNY; **3.105.** Peters Collection, N-YHS; **3.106.** *Harper's Weekly,* April 26, 1890; **3.107.** *Harper's Weekly,* October 23, 1869; **3.108.** *Frank Leslie's Illustrated Newspaper,* January 4, 1879, N-YHS; **3.109.** *Harper's Weekly,* November 14, 1868; **3.110.** *Frank Leslie's Illustrated Newspaper,* August 1873, LC; **3.111.** *Harper's Weekly,* February 19, 1859; **3.112.** N-YHS; **3.113.** *Frank Leslie's Illustrated Newspaper,* June 29, 1872. N-YHS; **3.114.** NYPL; **3.115.** *New York Illustrated News,* February 25, 1860, N-YHS; **3.116.** *Frank Leslie's Illustrated Newspaper,* May 8, 1869, N-YHS; **3.117.** James T. Ford, *Slums and Housing,* vol. 1 (Cambridge: Harvard University Press, 1936); **3.118.** *Harper's Weekly,* February 19, 1859. N-YHS; **3.119.** Dorsey Collection. N-YHS; **3.120.** *Harper's Weekly,* September 29, 1866; **3.121.** *Harper's Weekly,* January 30, 1869; **3.122.** James D. McCabe, *Lights and Shadows of New York Life* (Philadelphia: National Publishing Company, 1872; **3.123.** *Harper's Weekly,* June 26, 1869; **3.124.** *Harper's Weekly,* May 18, 1867; **3.125.** George G. Foster, *New York by Gaslight* (New York, 1850), MCNY; **3.126.** *Valentine's Manual,* 1857; **3.127.** *Harper's Weekly,* August 8, 1868; **3.128.** Jonathan Slick, *Snares of New York* (New York, 1879); **3.129.** *National Police Gazette.* July 26, 1879. N-YHS; **3.130.** *Harper's Weekly,* May 20, 1871, MCNY; **3.131.** MCNY; **3.132.** American Antiquarian Society; **3.133.** American Antiquarian Society; **3.134.** MCNY; **3.135.** LC; **3.136.** N-YHS; **3.137.** *Angel in Top Hat,* 1880. N-YHS; **3.138.** *Gleason's Pictorial Drawing Room Companion,* January 29, 1853. MCNY; **3.139.** MCNY; **3.140.** NYPL; **3.141.** N-YHS; **3.142.** *Frank Leslie's Illustrated Newspaper,* September 17, 1881; **3.143.** MCNY; **3.144.** N-YHS; **3.145.** *Manna-hatin: The Story of New York* (New York: Manhattan Company, 1929). Courtesy Tom Frusciano; **3.146.** N-YHS; **3.147.** MCNY; **3.148.** MCNY; **3.149.** James D. McCabe, *Lights and Shadows of New York Life* (Philadelphia: National Publishing Company, 1872); **3.150.** *Harper's Weekly,* September 19, 1868. MCNY; **3.151.** NYPL; **3.152.** MCNY; **3.153.** *Harper's Weekly,* November 25, 1871; **3.154.** N-YHS; **3.155.** NYPL; **3.156.** *Harper's Weekly,* May 7, 1870; **3.157.** *Gleason's Pictorial Drawing Room Companion,* December 16, 1853. MCNY; **3.158.** *Frank Leslie's Illustrated Newspaper,* February 13, 1875; **3.159.** *Harper's Weekly,* December 14, 1867. N-YHS; **3.160.** NYPL; **3.161.** N-YHS; **3.162.** MCNY; **3.163.** N-YHS; **3.164.** *Harper's Weekly,* May 8, 1886; **3.165.** *Harper's Weekly,* 1870. LC; **3.166.** LC; **3.167.** *Harper's Weekly,* May 26, 1883; **3.168.** *Harper's Weekly,* November 24, 1877; **3.169.** MCNY; **3.170.** MCNY; **3.171.** NYPL; **3.172.** *Harper's Weekly,* November 19, 1859; **3.173.** Courtesy Tom Frusciano; **3.174.** *Harper's Weekly,* September 9, 1871; **3.175.** *Harper's Weekly,* April 16, 1870. NYHSA; **3.176.** N-YHS; **3.177.** MCNY; **3.178.** *Frank Leslie's Illustrated Newspaper,* July 18, 1857. N-YHS; **3.179.** *Frank Leslie's Illustrated Newspaper,* July 18, 1857. N-YHS; **3.180.** N-YHS; **3.181.** MCNY; **3.182.** MCNY; **3.183.** N-YHS.

CHAPTER FOUR

4.1. MCNY; **4.2.** NYHS; **4.3.** NYPL; **4.4.** NYPL; **4.5.** NYPL; **4.6.** MCNY; **4.7.** Berenice Abbott/Commerce Graphics Ltd., Inc; **4.8.** MMA, Rogers Fund; Elisha Whittelsey Collection, Elisha Whittelsey Fund; Mary Livingston Griggs and Mary Griggs Burke Foundation; and Mrs. Vincent Astor Gifts, 1984 (1984.1083.22); **4.9.** MCNY; **4.10** MCNY; **4.11** NYPL; **4.12.** NYPL; **4.13.** MCNY; **4.14.** NYHS; **4.15** MMA, Rogers Fund; Elisha Whittelsey Collection,

Elisha Whittelsey Fund; Mary Livingston Griggs and Mary Griggs Burke Foundation; and Mrs. Vincent Astor Gifts, 1984 (1984.1083.19); **4.16.** MMA, Purchase, Rogers Fund; Elisha Whittelsey Collection, Elisha Whittelsey Fund; Mary Livingston Griggs and Mary Griggs Burke Foundation; and Mrs. Vincent Astor Gifts, 1984 (1984.1083.80); **4.17.** Wendell S. MacRae. Reprinted by permission of Scotia Wendell MacRae and the Witkin Gallery. Courtesy MMA, Purchase; Lila Acheson Wallace Gift, 1983 (1983.1189.10); **4.18.** MCNY. **4.19.** MCNY. **4.20.** MCNY. **4.21** Berenice Abbott/Commerce Graphics Ltd., Inc; **4.22.** MCNY. **4.23.** NYPL. **4.24.** MCNY. **4.25** MCNY. **4.26.** MCNY. **4.27** MCNY. **4.28.** MCNY. **4.29** NYPL. **4.30.** MCNY. Reprinted by permission of Gertrud Feininger; **4.31.** Berenice Abbott/Commerce Graphics Ltd., Inc; **4.32.** Sidney Kerner. MCNY. Permission of the artist; **4.33.** MCNY. **4.34.** NYPL. **4.35.** MCNY. **4.36** MCNY. **4.37.** NYPL. **4.38.** MCNY. **4.39.** NYPL. **4.40.** MCNY. **4.41.** MCNY. **4.42.** MCNY. **4.43.** MCNY. **4.44.** MCNY. **4.45.** MCNY. **4.46.** NYPL. **4.47.** NYPL. **4.48.** Donna Mussenden VanDerZee. Courtesy MMA, gift of the James VanDerZee Institute, 1970 (1970.539.10); **4.49.** MCNY. **4.50.** MCNY. **4.51.** MCNY. **4.52.** MCNY. **4.53.** MCNY. **4.54.** MMA, gift of Arnold H. Crane, 1972 (1972.742.13); **4.55.** Wendell S. MacRae. Reprinted by permission of Scotia Wendell MacRae and the Witkin Gallery; courtesy MMA, Ford Motor Company Collection, gift of Ford Motor Company and John C. Waddell, 1987 (1987.1100.313); **4.56.** MCNY. **4.57.** MCNY. **4.58.** MCNY. **4.59.** MCNY. **4.60.** Donna Mussenden VanDerZee. Courtesy MMA, gift of the James VanDerZee Institute, 1970 (1970.539.14); **4.61.** MCNY. **4.62.** MCNY. **4.63.** MCNY. **4.64.** MCNY. **4.65.** MCNY. **4.66.** MCNY. **4.67.** NYPL. **4.68.** MCNY. **4.69.** NYPL. **4.70.** Walter Rosenblum. Courtesy the artist; **4.71.** MCNY. Reprinted by permission of Howard Sieven; **4.72.** NYPL; **4.73.** from *Photographic Views of New York*. NYPL. Reprinted by permission of the Estate of Alexander Alland, Sr; **4.74.** Sidney Kerner. Courtesy MCNY. Permission of the artist; **4.75.** From *Photographic Views of New York*. NYPL. Reprinted by permission of the Estate of Alexander Alland, Sr; **4.76.** MCNY. **4.77.** MCNY. **4.78.** MCNY. **4.79.** MCNY. **4.80.** MCNY. Reprinted by permission of Ilona Albok Vitarius; **4.81.** LaGuardia and Wagner Archives, LCC/CUNY. **4.82.** Brooklyn Museum of Art. (X892.14). **4.83.** MCNY. **4.84.** MCNY. **4.85.** Joachim Oppenheimer. Courtesy the artist; **4.86** MCNY. **4.87.** Donna Mussenden VanDerZee. Courtesy MMA, gift of the James VanDerZee Institute, 1970 (1970.539.58); **4.88.** MCNY. **4.89.** NYPL. **4.90.** MCNY. **4.91.** MCNY. **4.92.** MCNY. **4.93.** MCNY. **4.94.** Schomburg Center for Research in Black Culture; **4.95.** Schomburg Center for Research in Black Culture; **4.96.** MCNY. **4.97.** MCNY. **4.98.** MCNY. **4.99.** MCNY. **4.100.** MCNY. **4.101.** NYPL. **4.102.** Donna Mussenden VanDerZee. Courtesy MMA, gift of the James VanDerZee Institute, 1970 (1970.539.5); **4.103.** NYPL. **4.104.** LaGuardia and Wagner Archives, LCC/CUNY. **4.104.** NYPL. **4.105.** N-YHS. **4.106.** Municipal Archives of the City of New York; **4.107.** Municipal Archives of the City of New York; **4.108.** MCNY. **4.109.** MCNY. **4.110.** From *Photographic Views of New York*. NYPL. **4.111.** From *Photographic Views of New York*. NYPL. **4.112.** MCNY. **4.113.** MCNY. **4.114.** MCNY. **4.115.** New York City Board of Education Archives, Milbank Memorial Library, Teachers College, Columbia University; **4.116.** New York City Board of Education Archives, Milbank Memorial Library, Teachers College, Columbia University; **4.117.** From *Photographic Views of New York*. NYPL. **4.118.** MCNY. **4.119.** LaGuardia and Wagner Archives, LCC/CUNY. **4.120.** MCNY. **4.121.** MCNY. **4.122.** From *Photographic Views of New York*. NYPL. **4.123.** MCNY. **4.124.** MCNY. **4.125.** MCNY. Reprinted with permission of Joanna T. Steichen; **4.126.** MCNY. **4.127.** MCNY. **4.128.** MCNY. **4.129.** MCNY. **4.130.** MCNY. **4.131.** Donna Mussenden VanDerZee. Courtesy MMA, gift of the James VanDerZee Institute, 1970 (1970.539.53); **4.132.** LaGuardia and Wagner Archives, LCC/CUNY. **4.133.** MCNY. **4.134.** Schomburg Center for Research in Black Culture; **4.135.** Old Print Shop; **4.136.** Schomburg Center for Research in Black Culture; **4.137.** MCNY. **4.138.** From *Photographic Views of New York*. NYPL. **4.139.** LaGuardia and Wagner Archives, LCC/CUNY. **4.140.** MMA, gift of Mr. and Mrs. Joseph G. Blum, 1970 (1970.527.1); **4.141.** From *Photographic Views of New York*. NYPL. **4.142.** NYPL. **4.143.** Wendell S. MacRae. Reprinted by permission of Scotia Wendell MacRae and the Witkin Gallery. Courtesy MMA, Purchase, Lila Acheson Wallace Gift, 1983 (1983.1189.8).

5.1. MCNY. Reprinted by permission of Gertrud Feininger; **5.2.** Arthur Leipzig. Courtesy Howard Greenberg Gallery, NYC; **5.3.** Vivian Cherry. Courtesy the artist; **5.4.** NYPL. Reprinted by permission of Ilona Albox Vitarius; **5.5.** Schomburg Center for Research in Black Culture; **5.6.** Frank Paulin. Courtesy Howard Greenberg Gallery, NYC; **5.7.** MCNY; **5.8.** Scott Hyde. Courtesy the artist; **5.9.** MCNY. Reprinted by permission of Gertrud Feininger; **5.10.** Rebecca Lepkoff. Courtesy Howard Greenberg Gallery, NYC; **5.11.** Hemphill Gallery of Art; **5.12.** Walter Rosenblum. Courtesy the artist; **5.13.** MCNY. Reprinted by permission of Gertrud Feininger; **5.14.** Scott Hyde. Courtesy the artist; **5.15.** Scott Hyde. Courtesy the artist; **5.16.** Scott Hyde. Courtesy the artist; **5.17.** Scott Hyde. Courtesy the artist; **5.18.** Schomburg Center for Research in Black Culture; **5.19.** MCNY. **5.20.** MCNY. **5.21.** MMA, Rogers Fund, the Elisha Whittelsey Collection, the Elisha Whittelsey Fund, Mary Livingston Griggs and Mary Griggs Burke Foundation and Mrs. Vincent Astor Gifts, 1984 (1984.1083.18); **5.22.** N. Jay Jaffee. Courtesy the N. Jay Jaffee trust; **5.23.** Scott Hyde. Courtesy the artist; **5.24.** Scott Hyde. Courtesy the artist; **5.25.** MMA, Rogers Fund, 1967 (1967.543.31). Reprinted with permission of Ilona Albok Vitarius; **5.26.** NYPL. Reprinted by permission of Howard Sieven; **5.27.** MMA, gift of Harriette and Noel Lavine, 1981 (1981.1112.1); **5.28.** N. Jay Jaffee. Courtesy the N. Jay Jaffee trust; **5.29.** SONJ, Special Collections: Photographic Archives, University of Louisville; **5.30.** Sid Grossman. Courtesy Howard Greenberg Gallery, NYC. Reprinted by permission of Miriam Grossman Cohen; **5.31.** Arthur Leipzig. Courtesy MCNY. **5.32.** Arthur Leipzig. Courtesy the artist; **5.33.** Jack Lessinger. Courtesy Howard Greenberg Gallery, NYC; **5.34.** MCNY. **5.35.** Rebecca Lepkoff. Courtesy Howard Greenberg Gallery, NYC; **5.36.** NYPL. Reprinted by permission of David Vestal; **5.37.** NYPL. Reprinted by permission of David Vestal; **5.38.** Walter Rosenblum. Courtesy the artist; **5.39.** Shawn Walker. Courtesy the artist; **5.40.** MCNY. Reprinted by permission of Howard Sieven; **5.41.** MCNY. Reprinted by permission of Howard Sieven; **5.42.** Walter Rosenblum. Courtesy the artist; **5.43.** Vivian Cherry. Courtesy the artist; **5.44.** Edward Schwartz. NYPL; **5.45.** Edward Schwartz. NYPL; **5.46.** Arthur Leipzig. Courtesy the artist; **5.47.** Vivian Cherry. Courtesy the artist; **5.48.** Arthur Leipzig. Courtesy Howard Greenberg Gallery, NYC; **5.49.** Vivian Cherry. Courtesy the artist; **5.50.** MCNY. **5.51.** N. Jay Jaffee. Courtesy the N. Jay Jaffee Trust; **5.52.** NYPL. Reprinted by permission of Ilona Albok Vitarius; **5.53.** Vivian Cherry. Courtesy the artist; **5.54.** Paula Wright. Courtesy the artist; **5.55.** MCNY. **5.56.** MCNY. Reprinted by permission of Ilona Albok Vitarius; **5.57.** SONJ, Special Collections: Photographic Archives, University of Louisville; **5.58.** SONJ, Special Collections: Photographic Archives, University of Louisville; **5.59.** Frank Paulin. Courtesy Howard Greenberg Gallery, NYC; **5.60.** Rebecca Lepkoff. Courtesy Howard Greenberg Gallery, NYC; **5.61.** Courtesy the N. Jay Jaffee Trust; **5.62.** MCNY; **5.63.** Frank Paulin. Courtesy Howard Greenberg Gallery, NYC; **5.64.** Paula Wright. Courtesy the artist; **5.65.** Paula Wright. Courtesy the artist; **5.66.** Vivian Cherry. Courtesy the artist; **5.67.** NYPL. Reprinted by permission of Howard Sieven; **5.68.** MCNY. **5.69.** Justo A. Martí Photographic Collection, CEP, Hunter College, CUNY; **5.70.** Sid Grossman. Courtesy Howard Greenberg Gallery, NYC. Reprinted by permission of Miriam Grossman Cohen; **5.71.** Sid Grossman. Courtesy Howard Greenberg Gallery, NYC. Reprinted by permission of Miriam Grossman Cohen; **5.72.** Vivian Cherry. Courtesy the artist; **5.73.** NYPL. Reprinted by permission of Estate of Alexander Alland, Sr; **5.74.** MCNY. Reprinted by permission of Gertrud Feininger; **5.75.** LaGuardia and Wagner Archives, LCC/CUNY; **5.76.** Ben Greenhaus. Courtesy Donald Greenhaus; **5.77.** Ben Greenhaus. Courtesy Donald Greenhaus; **5.78.** Louis Bernstein. Courtesy Howard Greenberg Gallery, NYC; **5.79.** LaGuardia and Wagner Archives, LCC/CUNY; **5.80.** Justo A. Martí Photographic Collection, CEP, Hunter College, CUNY; **5.81.** NYPL. Reprinted by permission of Estate of Alexander Alland, Sr; **5.82.** MCNY. Reprinted by permission of Gertrud Feininger; **5.83.** N. Jay Jaffee. Courtesy N. Jay Jaffee trust; **5.84.** Arthur Leipzig. Courtesy Brooklyn Museum of Art (86 152.18). Gift of the artist; **5.85.** Courtesy Hemphill Gallery Art; **5.86.** Scott Hyde. Courtesy the artist; **5.87.** Courtesy Hemphill Gallery of Art; **5.88.** N. Jay Jaffee. Courtesy N. Jay Jaffee trust; **5.89.** MCNY. **5.90.** NYPL.

Reprinted by permission of Howard Sieven; **5.91.** SONJ, Special Collections: Photographic Archives, University of Louisville; **5.92.** Hemphill Gallery of Art; **5.93.** Arthur Leipzig. Courtesy Howard Greenberg Gallery, NYC; **5.94.** SONJ, Special Collections: Photographic Archives, University of Louisville; **5.95.** SONJ, Special Collections: Photographic Archives, University of Louisville; **5.96.** MCNY; **5.97.** MCNY; **5.98.** NYPL. Reprinted by permission of Estate of Alexander Alland, Sr; **5.99.** Vincent Laredo. Courtesy MCNY. Used by permission of Victor Laredo, Photography; **5.100.** SONJ, Special Collections: Photographic Archives, University of Louisville; **5.101.** MCNY; **5.102.** Rebecca Lepkoff. Courtesy Howard Greenberg Gallery, NYC; **5.103.** Jack Lessinger. Courtesy Howard Greenberg Gallery, NYC. Reprinted by permission of Minnie Lessinger; **5.104.** Rebecca Lepkoff. Courtesy Howard Greenberg Gallery, NYC; **5.105.** Schomburg Center for Research in Black Culture; **5.106.** SONJ, Special Collections: Photographic Archives, University of Louisville; **5.107.** NYPL; **5.108.** Ben Greenhaus. Courtesy Donald Greenhaus; **5.109.** Scott Hyde. Courtesy the artist; **5.110.** Vivian Cherry. Courtesy the artist; **5.111.** Frank Paulin. Courtesy Howard Greenberg Gallery, NYC; **5.112.** Vivian Cherry. Courtesy the artist; **5.113.** Scott Hyde. Courtesy the artist; **5.114.** MCNY; **5.115.** Vivian Cherry. Courtesy the artist; **5.116.** NYPL. Reprinted by permission of Jean Bubley; **5.117.** SONJ, Special Collections: Photographic Archives, University of Louisville; **5.118.** MCNY; **5.119.** Rebecca Lepkoff. Courtesy Howard Greenberg Gallery, NYC; **5.120.** Arthur Leipzig. Courtesy Howard Greenberg Gallery, NYC; **5.121.** Vivian Cherry. Courtesy the artist; **5.122.** Frank Paulin. Courtesy Howard Greenberg Gallery, NYC; **5.123.** Frank Paulin. Courtesy Howard Greenberg Gallery, NYC; **5.124.** MCNY; **5.125.** Arthur Leipzig. Courtesy the artist; **5.126.** MMA, gift of Phyllis D. Massar, 1971 (1971.531.3). Reprinted by permission of Gertrud Feininger; **5.127.** SONJ, Special Collection: Photographic Archives, University of Louisville; **5.128.** SONJ, Special Collection: Photographic Archives, University of Louisville; **5.129.** Arthur Leipzig. Courtesy Howard Greenberg Gallery, NYC; **5.130.** MCNY; **5.131.** SONJ, Special Collections: Photographic Archives, University of Louisville; **5.132.** LaGuardia and Wagner Archives, LCC/CUNY; **5.133.** Scott Hyde. Courtesy the artist; **5.134.** MCNY; **5.135.** Justo A. Martí Photographic Collection, CEP, Hunter College, CUNY; **5.136.** LaGuardia and Wagner Archives, LCC/CUNY; **5.137.** NYPL. Reprinted by permission of Ilona Albok Vitarius; **5.138.** Arthur Leipzig. Courtesy Howard Greenberg Gallery, NYC; **5.139.** Builder Levy. Courtesy the artist; **5.140.** Justo A. Martí Photographic Collection, CEP, Hunter College, CUNY; **5.141.** Schomburg Center for Research in Black Culture; **5.142.** Beuford Smith. Courtesy the artist; **5.143.** Schomburg Center for Research in Black Culture; **5.144.** The Estate of Garry Winogrand, courtesy Fraenkel Gallery, San Francisco. Courtesy MMA, gift of William Berley, 1978 (1978.660.7); **5.145.** Turid Lindahl. Courtesy MCNY. Permission of the artist; **5.146.** MCNY.

CHAPTER SIX

6.1. Marc Kaczmarek. Courtesy the artist; **6.2.** Barbara Mensch. Courtesy MCNY; **6.3.** Marc Kaczmarek. Courtesy the artist; **6.4.** Marc Kaczmarek. Courtesy the artist; **6.5.** Marc Kaczmarek. Courtesy the artist; **6.6.** Harvey Zipkin. Courtesy the artist; **6.7.** Bror Karlsson. Courtesy the artist; **6.8.** Bror Karlsson. Courtesy the artist; **6.9.** Robert Sefcik. Courtesy MCNY; **6.10.** Bror Karlsson. Courtesy the artist; **6.11.** Paula Wright. Courtesy the artist; **6.12.** Marc Kaczmarek. Courtesy the artist; **6.13.** N. Jay Jaffee. Courtesy N. Jay Jaffee Trust; **6.14.** Marc Kaczmarek. Courtesy the artist; **6.15.** Paula Wright. Courtesy the artist; **6.16** Courtesy Jean Bubley; **6.17.** Barbara Mensch. Courtesy MCNY; **6.18.** Barbara Mensch. Courtesy MCNY; **6.19.** Nuriel Guedalia. Courtesy MCNY; **6.20.** Barbara Mensch. Courtesy MCNY; **6.21.** Nuriel Guedalia. Courtesy MCNY; **6.22.** Marc Kaczmarek. Courtesy the artist; **6.23.** N. Jay Jaffee. Courtesy N. Jay Jaffee Trust; **6.24.** Beuford Smith. Courtesy the artist; **6.25.** Len Speier. Courtesy the artist; **6.26.** N. Jay Jaffee. Courtesy N. Jay Jaffee Trust; **6.27.** N. Jay Jaffee. Courtesy N. Jay Jaffee Trust; **6.28.** Marc Kaczmarek. Courtesy the artist; **6.29.** LaGuardia and Wagner Archives, LCC/CUNY; **6.30.** LaGuardia and Wagner Archives, LCC/CUNY; **6.31.** Bill Aron. Courtesy the artist; **6.32.** Bror Karlsson. Courtesy the artist; **6.33.** Bill Aron. Courtesy the artist; **6.34.** Seymour Edelstein.

Courtesy MCNY; **6.35.** Jeanine El'Gazi. Courtesy MCNY; **6.36.** Jeffrey Scales. Courtesy the artist; **6.37.** MCNY; **6.38.** Beuford Smith. Courtesy the artist; **6.39.** Justo A. Martí Photographic Collection, CEP, Hunter College, CUNY; **6.40.** Builder Levy. Courtesy the artist; **6.41.** Builder Levy. Courtesy the artist; **6.42.** Builder Levy. Courtesy the artist; **6.43.** Builder Levy. Courtesy the artist; **6.44.** Stephen Lewis. Courtesy the artist; **6.45.** Stephen Lewis. Courtesy the artist; **6.46.** Victor Laredo. MCNY; **6.47.** Bror Karlsson. Courtesy the artist; **6.48.** Scott Hyde. Courtesy the artist; **6.49.** Builder Levy. Courtesy the artist; **6.50.** Donald Greenhaus. Courtesy the artist; **6.51.** Bror Karlsson. Courtesy the artist; **6.52.** Len Speier. Courtesy the artist; **6.53.** Harvey Zipkin. Courtesy the artist; **6.54.** MCNY; **6.55.** Bror Karlsson. Courtesy the artist; **6.56.** Bill Aron. Courtesy the artist; **6.57.** Jeffrey Scales. Courtesy the artist; **6.58.** LaGuardia and Wagner Archives, LCC/CUNY; **6.59.** Jeffrey Scales. Courtesy the artist; **6.60.** Coreen Simpson. Courtesy Schomburg Center for Research in Black Culture; **6.61.** Schomburg Center for Research in Black Culture; **6.62.** N. Jay Jaffee. Courtesy N. Jay Jaffee Trust; **6.63.** Beuford Smith. Courtesy the artist; **6.64.** Donald Greenhaus. Courtesy the artist; **6.65.** Harvey Zipkin. Courtesy the artist; **6.66.** Victor Laredo. Courtesy MCNY; **6.67.** Len Speier. Courtesy the artist; **6.68.** Bror Karlsson. Courtesy the artist; **6.69.** Paula Wright. Courtesy the artist; **6.70.** Scott Hyde. Courtesy the artist; **6.71.** Robert Sefcik. Courtesy MCNY; **6.72.** Bror Karlsson. Courtesy the artist; **6.73.** Len Speier. Courtesy the artist; **6.74.** Harvey Zipkin. Courtesy the artist; **6.75.** Cheryl Miller. Courtesy the artist; **6.76.** Cheryl Miller. Courtesy the artist; **6.77.** Bror Karlsson. Courtesy the artist; **6.78.** MCNY; **6.79.** Shawn Walker. Courtesy the artist; **6.80.** Len Speier. Courtesy the artist; **6.81.** Builder Levy. Courtesy the artist; **6.82.** Beuford Smith. Courtesy the artist; **6.83.** Bror Karlsson. Courtesy the artist; **6.84.** Jeffrey Scales. Courtesy the artist; **6.85.** The Estate of Garry Winogrand. Courtesy Fraenkel Gallery, San Francisco. Courtesy MMA, gift of Virginia M. Zabriskie, 1986 (1986.1216.3); **6.86.** Bror Karlsson. Courtesy the artist; **6.87.** The Estate of Garry Winogrand, courtesy Fraenkel Gallery, San Francisco. Courtesy MMA, Warner Communications Inc. Purchase Fund, 1997 (1997.27); **6.88.** Donald Greenhaus. Courtesy the artist; **6.89.** Cheryl Miller. Courtesy the artist; **6.90.** Shawn Walker. Courtesy the artist; **6.91.** Len Speier. Courtesy the artist; **6.92.** Reprinted by permission of Ilona Albok Vitarius; **6.93.** Shawn Walker. Courtesy the artist; **6.94.** Len Speier. Courtesy the artist; **6.95.** Bill Aron. Courtesy the artist; **6.96.** Paula Wright. Courtesy the artist; **6.97.** The Estate of Garry Winogrand, courtesy Fraenkel Gallery, San Francisco. Courtesy MMA, gift of Barbara and Eugene Schwartz, 1994 (1994.543); **6.98.** Robert Sefcik. Courtesy MCNY; **6.99.** Shawn Walker. Courtesy the artist; **6.100.** Beuford Smith. Courtesy the artist; **6.101.** Donald Greenhaus. Courtesy the artist; **6.102.** Beuford Smith. Courtesy the artist; **6.103.** Donald Greenhaus. Courtesy the artist; **6.104.** MCNY. Reprinted by permission of Gertrud Feininger; **6.105.** Beuford Smith. Courtesy the artist; **6.106.** Barbara Mensch. Courtesy MCNY; **6.107.** Bror Karlsson. Courtesy the artist; **6.108.** Bror Karlsson. Courtesy the artist; **6.109.** Bror Karlsson. Courtesy the artist; **6.110.** Lee Wexler. Courtesy the artist; **6.111.** Bror Karlsson. Courtesy the artist; **6.112.** Len Speier. Courtesy the artist.

INDEX

manufacturing in, 103; population shift to, 296; shops in, **328**; subway extension into, 257; views of, 391, **392**; views of Manhattan from, **285**, **417**; Woodhaven, 354
Queens College, 344
Queens Plaza Station, **420–21**, 422
Queensboro Bridge, **212**

racism, 309, 357; in labor unions, 334, 356; in politics, 98–99, 194, **195**, 198; protests against, **361**; and World War II, 281. *See also* discrimination
railroads, 107, 110, 112, 114, 131, 259, **353**
Rapalje, Sara, 13
Raskob, John J., 207
Ratner's Dairy Restaurant, **414**, 415
Ratzer, Bernard, 40, 43
recreation, 51, 91, 138, 171, 396–97; of immigrants, 154, **155**, 179–80; summertime, 395–96, **400**, **401**, **404–5**. *See also* arts; entertainment; movies; sports
Rector Street, 26
reform movements, 71, 73, 83, 89, 178, 180–82; temperance, **178**, 179, 197; women's suffrage, 161–82, 204, 272–73, **274–75**
Reiser, Paul, 341
religion, 23, 26–27, 138, 325, 326, 422; Anglicanism, 15, 27, 30, 74; Black Muslim, 363, 393, 408, **409**; Calvinism, 36, 154; Catholicism, 34, 74–75, 174–75, **193**, 197, 385; Dutch Reformed, 27, 74, 136, 146; Episcopalian, 136; evangelical, 75, 180–81; German Reform, 151; Great Awakenings, 26, 75; Hare Krishna, 402, **408**; Judaism, 26, 27, 65, 156, **268**, **271**, 381, 410; Lutheran, 151, 154; Methodist, 26; Presbyterian, 27, 146; Quakers, 180; rituals of, **27**, 76, **77**, **156**, **271–72**, 381; Salvation Army, 402; Santeria, 385, **387**; Unitarianism, 154
rent control, 341
rent strikes, 360, **362**
Renwick, James, 146, 149
Republican era, 49–101, 174
Republican Party, 99, 197, 255, 278
republicanism, 54, 79, 82
restaurants, **226**, 227, **289–91**, 290, 378–79, 381, **381**, **383**, 391, **414**, 415
Revere, Paul, 42
Rheingold brewery, 385
Rhinelander Sugar House, 45–46
Rice, Thomas "Daddy," 170
Richard III (Shakespeare), 32
Richmond Hill, 57, **58**, 59
Riis, Jacob, 227, 229, 230–31, 232, 269, 271, 272, 326, 375
riots, **150**, 151, 168–69; and alcohol prohibition, 197; and anti-slavery movement, 178; in Astor Place, 171, **172–73**, 185; Doctors', 85; draft, **196–97**, 198; race, 273
Ritz Tower Hotel, 248, **249**
Riverdale (Bronx), 294
Riverside Drive, 234, **236**, 261
Riverside Park, 396, **402**
Robbins, David, 239, 241

Robbins, Jerome, 316
Robertson, Alexander, 50
Robertson, Archibald, 43, 50, 54, 58, 59
Robinson, H. R., 122
Robinson, Jackie, 251, 326
Robinson, Richard, 169, **170**
The Rockaways, 155
Rockefeller, Nelson, 394
Rockefeller Center, 314, **316**, **317**, 325, 374
Roebling, John A., 188
Roebling, Washington, 188
Rogers, Isaiah, 111
Roosevelt, Eleanor, **276**
Roosevelt, Franklin Delano, 239, **276**, 281–82
Roosevelt Island (Welfare Island), 183, 372, 391, **392**
Roosevelt Street, 55
Rosenberg, Charles G., 114
Rosenblum, Walter, 242, 289, 305, 306, 385, 403
Rotunda Gallery, 89, **90**, **91**
Rubenstein, Harry, 231, 232
Ruggles, Samuel, 105, 145
Russian immigrants, 386
Rutgers, Henry, 77
Ruth, Babe, 251

Sailors' Snug Harbor, 127
St. Clement's Episcopal Church, 105
St. George Church, 105
St. George Hotel (Brooklyn), **206**
St. John the Divine Cathedral, 150
St. Nicholas Hotel, **122,** 123
St. Patrick's Cathedral, 74, **76**, 82, 148, **149**, 150, 269, 322, **323**, 325
St. Patrick's Day parade, 150, **151**, 180
St. Paul's Church, **26**, 27, **52**, 84, 105, **106**, 107
St. Peter's Church, 74
St. Philips Church, 226
St. Philips Guild House, 226, **227**
Saint Memin, Charles-Balthazar-Julien Fevret de, 56
Saks and Company, 224, **225**
Salvation Army, 244, **245**, 402
San Gennaro *festa*, **324**, 325
San Juan Hill, **306**, 307
sanitation, 54, 85–86, 163, **164**, 165, 180, **181**, 182–83, 185, 351, **353**
Santana, José Ben, 403
Savoy-Plaza Hotel, 248, **249**
Scales, Jeffrey, 382, 385, 392, 395, 406
Schaefer brewery, 154, 385
Schampen block, 8
Schenk, Peter, 52
Schermerhorn Row, 115
Scherzer, Kenneth, 147
Schleisner, William H., 206
Schmidt, Frederick, 155
schools: Catholic, 149, 174–75, **193**, 197; English, 27, **28–29**, 30; grammar, **174**, **175**; medical, **146**, 261, **262**; nursing, 85; private, 74, 393; religious, **268**; for teachers, **262**; trade, 74, 77. *See also* colleges and universities; public schools

Schrafft's restaurants, 290
Schreyers Hoek (Weeper's Point), 8
Schwab, Charles M., 234
Schwartz, Edward, 307, 309
Scotty's Deli, 381, **383**
Scudder Museum, 84, 171, 174
Sea Gate, 299
Seagram Building, 294, **295**, 296
Sealy Rock Beach (Astoria Park), **248**, 249
Searle, John, 87, 88
Second Avenue, 162, **163**, 415
Second Bank of the United States, 110, 112
Second Reformed Dutch church, 16
Sefcik, Robert, 370, 372, 395, 401, 412, 414
segregation, 69, 79, 157. *See also* discrimination
Seneca Chief, **95**
Senegalese immigrants, 407, **408**, 409
service industries, 296, 298, 379. *See also* restaurants
Seventy-eighth Street, 389, **391**
sexuality, 169, 182, 299, **300**, 403, **406**; on tar beach, **242**
Shabazz Modern Barber Saloon, 393
Shakedown dancing, 69, **70**
Shakespeare, William, 32, 88, 170, 299
Shea Stadium, 363, **365**
Shearith Israel Congregation, 65
Shelley, Percy Bysshe, 75
Sheraton, Thomas, 63
Sherry-Netherland Hotel, 248, **249**, 395, **401**
shipbuilding industry, **18**, 19, 63–64
ships, **36–37**, 351; *Clermont*, **64**; *Great Western* (steamship), 115; *Hamilton*, 91, **99**; *Ohio*, 63, **64**; *Pearl*, 44; prison ship *Jersey*, **45**, 46; *Queen Elizabeth*, 352; *S.S. Pennland*, **200–201**; steamships, 64, 115; *United States*, **352**
shoemaking industry, **68**, 117; shoe repair, **340**
Shubert Alley, 316, **321**
Siegel, Henry, 224
Sievan, Lee, 242, 296, 298, 306, 307, 322, 323, 329, 332
Sievan, Maurice, 306
Sille, Nicasius de, 9
Simmon, Rudolph, 218, 255, 256
Simpson, Coreen, 393, 395
Sims, Sylvia, **322**
Singer Sewing Machine Company, 117, **118**
Sixth Avenue, 104, 107, **370**, 371
Sixth Street, 388, **389**
Sixtieth Foot Regiment, 43
Sixty-fifth Street, **372**, 374
Sixty-Ninth regiment, 151
skyscrapers, 144–45, 204, **205**, **206**, **284**, 286, **352**, 353, **370**, 371–72; and advertisements, 215; and finance, 213; in Rockefeller Center, 314; window cleaners on, 338, **341**
slavery, 98–99, 157, 179; abolition of, 69, 154, 157; and anti-slavery movement, 158, **176**, 178–79; in New Amsterdam, 9, **11**, 12–13; in New York, 22, **23–25**, 69
slaves: advertisements for, **22**, 23, 68, **69**; freed, 45, 46; trade in, **11**, 12–13, 22, **23**, 68, **177**